CRIME
AND JUSTICE

Volume III
THE CRIMINAL
UNDER RESTRAINT

CRIME AND JUSTICE

(SECOND AND REVISED EDITION)

edited by Sir Leon Radzinowicz and Marvin E. Wolfgang

CRIME

AND JUSTICE

Volume III

THE CRIMINAL UNDER RESTRAINT

(SECOND AND REVISED EDITION)

EDITED BY

Sir Leon Radzinowicz
and
Marvin E. Wolfgang

Basic Books, Inc., Publishers

NEW YORK

Library of Congress Cataloging in Publication Data

Radzinowicz, Leon, Sir, comp.
 The criminal under restraint.

 (Their Crime and justice; v. 3)
 Includes index.
 1. Corrections—Addresses, essays, lectures.
2. Criminal behavior, Prediction of—Addresses,
essays, lectures. 3. Prisons—Addresses, essays,
lectures. I. Wolfgang, Marvin E., 1924— joint
comp. II. Title.
HV6025.R36 1977 vol. 3 [HV8665] 364′.08s
 [365′.08] 77-1922
ISBN: 0–465–01464–X (cloth)
ISBN: 0–465–01467–4 (paper)

Contents

Part IV
NEO-CLASSICAL REVIVAL

Preface

We hope we may be permitted to say how gratified we were by the warm reception accorded to the first edition of *Crime and Justice*. We were still more gratified to find it so widely used at various levels, both undergraduate and graduate, and in various schools, departments of sociology, of law, and of criminal justice throughout the United States.

Our publisher has urged us to consider a second edition partly because of the response evoked by the first, but primarily because of the changes that have recently taken place not only in the state of crime and the working of criminal justice, but in attitudes and interpretations.

These trends have been so far-reaching as to convince us that merely patching up the previous edition would not suffice. We felt the need to look at the three volumes and to introduce substantial fresh material that would reflect some of the profound shifts in activity and outlook. As a result, about 70 percent of this edition consists of new material.

Certain basic principles have guided us in preparing this second selection. First, there has been the need for an extended perspective on the state of crime, taking account of trends in the vast areas of the developing world as well as in already industrialized countries like our own. Second, there has been the availability of new empirical knowledge about crime and attempts to contain it. Third, there has been the shaking of assumptions about the chances of checking crime or reforming offenders: doubts, already apparent at the time of the first edition, have since been dramatically reinforced by research and experience. Fourth, we felt it imperative to recognize the ideological ferment in criminological and penal ideas, which has sprung partly from the disturbing condition of crime, partly from the disillusion of progressive and liberal forces, and partly from the aggression of authoritarian regimes.

Thus, a broad look at the three volumes of this new collection clarifies the direction of change in crime and criminal law. We have added a broader and more detailed survey of contemporary trends in crime in an international context wherever possible. We have also given examples of some of crime's modern, most sophisticated manifestations. We have selected passages reflecting concern over and suggesting controls on abuses by those entrusted with the enforcement of the law: these include aspirations to achieve an international code of ethics for the police and to guide discretion and reduce injustices and disparities at all stages of prosecution and sentencing. We have felt it necessary to devote a whole new section to

the horrifying theme of torture, even though it can be no more than a pale reflection of what is really going on. The older studies of prison communities, sophisticated as they are, have been supplemented by additional material on the ways that prisons, in many parts of the world, reflect the political, social, and racial tensions outside. We have made room for discussions on prisoners' rights, not only in abstract and juridical terms, but in relation to the feelings of prisoners themselves. Because we have been anxious to explore various means of reducing imprisonment, we have introduced illustrations of diversionary schemes. But we have been anxious also to avoid arousing exaggerated hopes and have, therefore, included as well some objective and reliable assessments of results so far. Indeed, we have brought into this collection the most up-to-date evaluative surveys of the wide range of measures that are being tried in attempts to contain crime and to reduce recidivism.

There can be no doubt that optimism has gone and platitudes have been proven empty. We are living through a time when, more than ever before, there can be no consensus on how to tackle crime. We do not feel it our business to try to resolve the current conflicts, but we feel it our duty, in the section entitled "The Neo-Classical Revival," to try to reflect it. Thus, both teachers and students will find, in the concluding part of the third volume, a collection of materials which we hope will give them the flavor of what we have described as the "contemporary ferment of criminological and penal ideas."

We have tried to maintain throughout the strict criteria we applied in the first edition, choosing only materials which represent solid, relatively rigorous empirical research or sound and sensitive theory. Items carried over from the first to the second edition remain because of their relative timelessness, their special insight or provocative character. In both new and old we have tried to preserve high standards of excellence. And, since we believe that the authors should be left to speak for themselves, we have kept editorial intervention to a strict minimum. Though we have made some changes and rearranged footnotes, the essence of the articles and extracts remains unaltered.

Miss Joan King of the Cambridge Institute of Criminology, who helped us with the introductory essay for the original edition, has again proved to be a most valuable adviser; we should like to convey our thanks for her mellow wisdom.

Deep gratitude is also due to Mrs. Selma Pastor, the librarian of the Center for Studies in Criminology and Criminal Law, who contributed enormously to the task of bringing together this material.

Our publisher, Basic Books, has shown the same enthusiasm for this

new enterprise as for the previous one, and has brought the same energy and dynamism to the massive work involved in bringing the volumes into being.

Perhaps we may be allowed to conclude this preface with a reference to ourselves. Our friendship and our ideas are complementary, and have been yet further enriched by once again working so closely together. We shall always remember this collaboration with the greatest of pleasure.

LEON RADZINOWICZ MARVIN E. WOLFGANG

Part I

EFFECTIVENESS OF INTERVENTION

1: What Works?—A Comparative Assessment / *Robert Martinson**

In the past several years, American prisons have gone through one of their recurrent periods of strikes, riots, and other disturbances. Simultaneously, and in consequence, the articulate public has entered another one of its sporadic fits of attentiveness to the condition of our prisons and to the perennial questions they pose about the nature of crime and the uses of punishment. The result has been a widespread call for "prison reform," i.e., for "reformed" prisons which will produce "reformed" convicts. Such calls are a familiar feature of American prison history. American prisons, perhaps more than those of any other country, have stood or fallen in public esteem according to their ability to fulfill their promise of rehabilitation.

One of the problems in the constant debate over "prison reform" is that we have been able to draw very little on any systematic empirical knowledge about the success or failure that we have met when we *have* tried to rehabilitate offenders with various treatments and in various institutional and noninstitutional settings. The field of penology has produced a voluminous research literature on this subject, but until recently there has been no comprehensive review of this literature and no attempt to bring its findings to bear, in a useful way, on the general question of "What works?". My purpose in this essay is to sketch an answer to that question.

The Travails of a Study

In 1966, the New York State Governor's Special Committee on Criminal Offenders recognized their need for such an answer. The Committee was organized on the premise that prisons could rehabilitate, that the prisons of New York were not in fact making a serious effort at rehabilitation, and that New York's prisons should be converted from their existing custodial basis to a new rehabilitative one. The problem for the Committee was that there was no available guidance on the question of what had been shown to be the most effective means of rehabilitation. My colleagues and I were hired by the committee to remedy this defect in our knowledge; our job

* From Robert Martinson, "What Works? Questions and Answers about Prison Reform," *The Public Interest,* no. 36 (June 1974): 22–54. Copyright © 1974 by National Affairs, Inc. Reprinted with permission.

was to undertake a comprehensive survey of what was known about rehabilitation.

In 1968, in order to qualify for federal funds under the Omnibus Crime Control and Safe Streets Act, the state established a planning organization, which acquired from the Governor's Committee the responsibility for our report. But by 1970, when the project was formally completed, the state had changed its mind about the worth and proper use of the information we had gathered. The Governor's Committee had begun by thinking that such information was a necessary basis for any reforms that might be undertaken; the state planning agency ended by viewing the study as a document whose disturbing conclusions posed a serious threat to the programs which, in the meantime, they had determined to carry forward. By the spring of 1972—fully a year after I had reedited the study for final publication—the state had not only failed to publish it, but had also refused to give me permission to publish it on my own. The document itself would still not be available to me or to the public today had not Joseph Alan Kaplon, an attorney, subpoenaed it from the state for use as evidence in a case before the Bronx Supreme Court.*

During the time of my efforts to get the study released, reports of it began to be widely circulated, and it acquired something of an underground reputation. But this article is the first published account, albeit a brief one, of the findings contained in that 1,400-page manuscript.

What we set out to do in this study was fairly simple, though it turned into a massive task. First we undertook a six-month search of the literature for any available reports published in the English language on attempts at rehabilitation that had been made in our corrections systems and those of other countries from 1945 through 1967. We then picked from that literature all those studies whose findings were interpretable—that is, whose design and execution met the conventional standards of social science research. Our criteria were rigorous but hardly esoteric: A study had to be an evaluation of a treatment method, it had to employ an independent measure of the improvement secured by that method, and it had to use some control group, some untreated individuals with whom the treated ones could be compared. We excluded studies only for methodological reasons: They presented insufficient data, they were only preliminary, they presented only a summary of findings and did not allow a reader to evaluate those findings, their results were confounded by extraneous factors, they used unreliable measures, one could not understand their descriptions of the treatment in question, they drew spurious conclusions from their data, their samples were undescribed or too small or provided no true comparability between treated and untreated groups, or they had used inappropriate

* Following this case, the state finally did give its permission to have the work published: Douglas Lipton, Robert Martinson, and Judith Wilks, *The Effectiveness of Correctional Treatment* (New York: Praeger Publishers, 1975).

statistical tests and did not provide enough information for the reader to recompute the data. Using these standards, we drew from the total number of studies 231 acceptable ones, which we not only analyzed ourselves but summarized in detail so that a reader of our analysis would be able to compare it with his independent conclusions.

These treatment studies use various measures of offender improvement: recidivism rates (that is, the rates at which offenders return to crime), adjustment to prison life, vocational success, educational achievement, personality and attitude change, and general adjustment to the outside community. We included all of these in our study; but in these pages I will deal only with the effects of rehabilitative treatment on recidivism, the phenomenon which reflects most directly how well our present treatment programs are performing the task of rehabilitation. The use of even this one measure brings with it enough methodological complications to make a clear reporting of the findings most difficult. The groups that are studied, for instance, are exceedingly disparate, so that it is hard to tell whether what "works" for one kind of offender also works for others. In addition, there has been little attempt to replicate studies; therefore one cannot be certain how stable and reliable the various findings are. Just as important, when the various studies use the term "recidivism rate," they may in fact be talking about somewhat different measures of offender behavior—i.e., "failure" measures such as arrest rates or parole violation rates, or "success" measures such as favorable discharge from parole or probation. And not all of these measures correlate very highly with one another. These difficulties will become apparent again and again in the course of this discussion.

With these caveats, it is possible to give a rather bald summary of our findings: *With few and isolated exceptions, the rehabilitative efforts that have been reported so far have had no appreciable effect on recidivism.* Studies that have been done since our survey was completed do not present any major grounds for altering that original conclusion. What follows is an attempt to answer the questions and challenges that might be posed to such an unqualified statement.

Education and Vocational Training

1. *Isn't it true that a correctional facility running a truly rehabilitative program—one that prepares inmates for life on the outside through education and vocational training—will turn out more successful individuals than will a prison which merely leaves its inmates to rot?*

If this *is* true, the fact remains that there is very little empirical evidence to support it. Skill development and education programs are in fact quite

common in correctional facilities, and one might begin by examining their effects on young males, those who might be thought most amenable to such efforts. A study by New York State (1964) * found that for young males as a whole, the degree of success achieved in the regular prison academic education program, as measured by changes in grade achievement levels, made no significant difference in recidivism rates. The only exception was the relative improvement, compared with the sample as a whole, that greater progress made in the top 7 percent of the participating population—those who had high I.Q.'s, had made good records in previous schooling, and who also made good records of academic progress in the institution. And a study by Glaser (1964) found that while it was true that, when one controlled for sentence length, more attendance in regular prison academic programs slightly decreased the subsequent chances of parole violation, this improvement was not large enough to outweigh the associated disadvantage for the "long-attenders": Those who attended prison school the longest also turned out to be those who were in prison the longest. Presumably, those getting the most education were also the worst parole risks in the first place.†

Studies of special education programs aimed at vocational or social skill development, as opposed to conventional academic education programs, report similarly discouraging results and reveal additional problems in the field of correctional research. Jacobson (1965) studied a program of "skill reeducation" for institutionalized young males, consisting of ten weeks of daily discussions aimed at developing problem-solving skills. The discussions were led by an adult who was thought capable of serving as a role model for the boys, and they were encouraged to follow the example that he set. Jacobson found that over all, the program produced no improvement in recidivism rates. There was only one special subgroup which provided an exception to this pessimistic finding: If boys in the experimental program decided afterwards to go on to take three or more regular prison courses, they did better upon release than "control" boys who had done the same. (Of course, it also seems likely that experimental boys who did *not* take these extra courses did *worse* than their controls.)

Zivan (1966) also reported negative results from a much more ambitious vocational training program at the Children's Village in Dobbs Ferry, New York. Boys in his special program were prepared for their return to the community in a wide variety of ways. First of all, they were given, in sequence, three types of vocational guidance: "assessment counseling," "development counseling," and "preplacement counseling." In addition,

* All studies cited in the text are referenced in the bibliography which appears at the conclusion of this article.
† The net result was that those who received *less* prison education—because their sentences were shorter or because they were probably better risks—ended up having better parole chances than those who received more prison education.

they participated in an "occupational orientation," consisting of role-playing, presentations via audio-visual aids, field trips, and talks by practitioners in various fields of work. Furthermore, the boys were prepared for work by participating in the Auxiliary Maintenance Corps, which performed various chores in the institution; a boy might be promoted from the Corps to the Work Activity Program, which "hired" him, for a small fee, to perform various artisans' tasks. And finally, after release from Children's Village, a boy in the special program received supportive after-care and job placement aid.

None of this made any difference in recidivism rates. Nevertheless, one must add that it is impossible to tell whether this failure lay in the program itself or in the conditions under which it was administered. For one thing, the education department of the institution itself was hostile to the program; they believed instead in the efficacy of academic education. This staff therefore tended to place in the pool from which experimental subjects were randomly selected mainly "multi-problem" boys. This by itself would not have invalidated the experiment as a test of vocational training for this particular type of youth, but staff hostility did not end there; it exerted subtle pressures of disapproval throughout the life of the program. Moreover, the program's "after-care" phase also ran into difficulties; boys who were sent back to school before getting a job often received advice that conflicted with the program's counseling, and boys actually looking for jobs met with the frustrating fact that the program's personnel, despite concerted efforts, simply could not get businesses to hire the boys.

We do not know whether these constraints, so often found in penal institutions, were responsible for the program's failure; it might have failed anyway. All one can say is that this research failed to show the effectiveness of special vocational training for young males.

The only clearly positive report in this area comes from a study by Sullivan (1967) of a program that combined academic education with special training in the use of IBM equipment. Recidivism rates after one year were only 48 percent for experimentals, as compared with 66 percent for controls. But when one examines the data, it appears that this difference emerged only between the controls and those who had successfully *completed* the training. When one compares the control group with all those who had been *enrolled* in the program, the difference disappears. Moreover, during this study the random assignment procedure between experimental and control groups seems to have broken down, so that towards the end, better risks had a greater chance of being assigned to the special program.

In sum, many of these studies of young males are extremely hard to interpret because of flaws in research design. But it can safely be said that they provide us with no clear evidence that education or skill development programs have been successful.

Training Adult Inmates

When one turns to adult male inmates, as opposed to young ones, the results are even more discouraging. There have been six studies of this type; three of them report that their programs, which ranged from academic to prison work experience, produced no significant differences in recidivism rates, and one—by Glaser (1964)—is almost impossible to interpret because of the risk differentials of the prisoners participating in the various programs.

Two studies—by Schnur (1948) and by Saden (1962)—*do* report a positive difference from skill development programs. In one of them, the Saden study, it is questionable whether the experimental and control groups were truly comparable. But what is more interesting is that both these "positive" studies dealt with inmates incarcerated prior to or during World War II. Perhaps the rise in our educational standards as a whole since then has lessened the differences that prison education or training can make. The only other interesting possibility emerges from a study by Gearhart (1967). His study was one of those that reported vocational education to be nonsignificant in affecting recidivism rates. He did note, however, that when a trainee succeeded in finding a job related to his area of training, he had a slightly higher chance of becoming a successful parolee. It is possible, then, that skill development programs fail because what they teach bears so little relationship to an offender's subsequent life outside the prison.

One other study of adults, this one with fairly clear implications, has been performed with women rather than men. An experimental group of institutionalized women in Milwaukee was given an extremely comprehensive special education program, accompanied by group counseling. Their training was both academic and practical; it included reading, writing, spelling, business filing, child care, and grooming. Kettering (1965) found that the program made no difference in the women's rates of recidivism.

Two things should be noted about these studies. One is the difficulty of interpreting them as a whole. The disparity in the programs that were tried, in the populations that were affected, and in the institutional settings that surrounded these projects make it hard to be sure that one is observing the same category of treatment in each case. But the second point is that despite this difficulty, one can be reasonably sure that, so far, educational and vocational programs have not worked. We don't know why they have failed. We don't know whether the programs themselves are flawed, or whether they are incapable of overcoming the effects of prison life in general. The difficulty may be that they lack applicability to the world the inmate will face outside of prison. Or perhaps the type of educational and skill improvement they produce simply does not have very much to do with an individual's propensity to commit a crime. What we do know is that, to

date, education and skill development has not reduced recidivism by reha-
bilitating criminals.

The Effects of Individual Counseling

2. *But when we speak of a rehabilitative prison, aren't we referring to more than education and skill development alone? Isn't what's needed some way of counseling inmates, or helping them with the deeper problems that have caused their maladjustment?*

This, too, is a reasonable hypothesis; but when one examines the pro-
grams of this type that have been tried, it's hard to find any more grounds
for enthusiasm than we found with skill development and education. One
method that's been tried—though so far, there have been acceptable re-
ports only of its application to young offenders—has been individual psy-
chotherapy. For young males, we found seven such reported studies. One
study, by Guttman (1963) at the Nelles School, found such treatment to be
ineffective in reducing recidivism rates; another, by Rudoff (1960), found it
unrelated to *institutional* violation rates, which were themselves related to
parole success. It must be pointed out that Rudoff used only this indirect
measure of association, and the study therefore cannot rule out the possi-
bility of a treatment effect. A third, also by Guttman (1963) but at another
institution, found that such treatment was actually related to a slightly
higher parole violation rate; and a study by Adams (1959b and 1961b) also
found a lack of improvement in parole revocation and first suspension
rates.

There were two studies at variance with this pattern. One by Persons
(1967) said that if a boy was judged to be "successfully" treated—as op-
posed to simply being subjected to the treatment experience—he did tend
to do better. And there was one finding both hopeful and cautionary: At the
Deuel School (Adams, 1961a), the experimental boys were first divided into
two groups, those rated as "amenable" to treatment and those rated "non-
amenable." Amenable boys who got the treatment did better than non-
treated boys. On the other hand, "nonamenable" boys who were treated
actually did *worse* than they would have done if they had received no
treatment at all. It must be pointed out that Guttman (1963), dealing with
younger boys in his Nelles School study, did not find such an "amenabil-
ity" effect, either to the detriment of the nonamenables who were treated
or to the benefit of the amenables who were treated. But the Deuel School
study (Adams, 1961a) suggests both that there is something to be hoped for
in treating properly selected amenable subjects and that if these subjects
are *not* properly selected, one may not only wind up doing no good but
may actually produce harm.

There have been two studies of the effects of individual psychotherapy on young incarcerated *female* offenders, and both of them (Adams, 1959a, 1961b) report no significant effects from the therapy. But one of the Adams studies (1959a) does contain a suggestive, although not clearly interpretable, finding: If this individual therapy was administered by a psychiatrist or a psychologist, the resulting parole suspension rate was almost two-and-a-half times *higher* than if it was administered by a social worker without this specialized training.

There has also been a much smaller number of studies of two other types of individual therapy: counseling, which is directed towards a prisoner's gaining new insight into his own problems, and casework, which aims at helping a prisoner cope with his more pragmatic immediate needs. These types of therapy both rely heavily on the empathetic relationship that is to be developed between the professional and the client. It was noted above that the Adams study (1961b) of therapy administered to girls, referred to in the discussion of individual psychotherapy, found that social workers seemed better at the job than psychologists or psychiatrists. This difference seems to suggest a favorable outlook for these alternative forms of individual therapy. But other studies of such therapy have produced ambiguous results. Bernsten (1961) reported a Danish experiment that showed that sociopsychological counseling combined with comprehensive welfare measures—job and residence placement, clothing, union and health insurance membership, and financial aid—produced an improvement among some short-term male offenders, though not those in either the highest-risk or the lowest-risk categories. On the other hand, Hood, in Britain (1966), reported generally nonsignificant results with a program of counseling for young males. (Interestingly enough, this experiment *did* point to a mechanism capable of changing recidivism rates. When boys were released from institutional care and entered the army directly, "poor risk" boys among both experimentals *and* controls did better than expected. "Good risks" did worse.)

So these foreign data are sparse and not in agreement; the American data are just as sparse. The only American study which provides a direct measure of the effects of individual counseling—a study of California's Intensive Treatment Program (California, 1958a), which was "psychodynamically" oriented—found no improvement in recidivism rates.

It was this finding of the failure of the Intensive Treatment Program which contributed to the decision in California to deemphasize individual counseling in its penal system in favor of group methods. And indeed one might suspect that the preceding reports reveal not the inadequacy of counseling as a whole but only the failure of one *type* of counseling, the individual type. *Group* counseling methods, in which offenders are permitted to aid and compare experiences with one another, might be thought to have a better chance of success. So it is important to ask what results these alternative methods have actually produced.

Group Counseling

Group counseling has indeed been tried in correctional institutions, both with and without a specifically psychotherapeutic orientation. There has been one study of "pragmatic," problem-oriented counseling on *young* institutionalized males, by Seckel (1965). This type of counseling had no significant effect. For adult males, there have been three such studies of the "pragmatic" and "insight" methods. Two (Kassebaum, 1971; Harrison, 1964) report no long-lasting significant effects. (One of these two did report a real but short-term effect that wore off as the program became institutionalized and as offenders were at liberty longer.) The third study of adults, by Shelley (1961), dealt with a "pragmatic" casework program, directed towards the educational and vocational needs of institutionalized young adult males in a Michigan prison camp. The treatment lasted for six months and at the end of that time Shelley found an improvement in attitudes; the possession of "good" attitudes was independently found by Shelley to correlate with parole success. Unfortunately, though, Shelley was not able to measure the *direct* impact of the counseling on recidivism rates. His two separate correlations are suggestive, but they fall short of being able to tell us that it really is the counseling that has a direct effect on recidivism.

With regard to more professional group *psychotherapy*, the reports are also conflicting. We have two studies of group psychotherapy on young males. One, by Persons (1966), says that this treatment did in fact reduce recidivism. The improved recidivism rate stems from the improved performance only of those who were clinically judged to have been "successfully" treated; still, the overall result of the treatment was to improve recidivism rates for the experimental group as a whole. On the other hand, a study by Craft (1964) of young males designated "psychopaths," comparing "self-government" group psychotherapy with "authoritarian" individual counseling, found that the "group therapy" boys afterwards committed *twice* as many new offenses as the individually treated ones. Perhaps some forms of group psychotherapy work for some types of offenders but not others; a reader must draw his own conclusions, on the basis of sparse evidence.

With regard to young females, the results are just as equivocal. Adams, in his study of females (1959a), found that there was no improvement to be gained from treating girls by group rather than individual methods. A study by Taylor of borstal (reformatory) girls in New Zealand (1967) found a similar lack of any great improvement for group therapy as opposed to individual therapy or even to no therapy at all. But the Taylor study does offer one real, positive finding: When the "group therapy" girls *did* commit new offenses, these offenses were less serious than the ones for which they had originally been incarcerated.

There is a third study that does report an overall positive finding as opposed to a partial one. Truax (1966) found that girls subjected to group psychotherapy and then released were likely to spend less time reincarcerated in the future. But what is most interesting about this improvement is the very special and important circumstance under which it occurred. The therapists chosen for this program did not merely have to have the proper analytic training; they were specially chosen for their "empathy" and "nonpossessive warmth." In other words, it may well have been the therapists' special personal gifts rather than the fact of treatment itself which produced the favorable result. This possibility will emerge again when we examine the effects of other types of rehabilitative treatment later in this article.

As with the question of skill development, it is hard to summarize these results. The programs administered were various; the groups to which they were administered varied not only by sex but by age as well; there were also variations in the length of time for which the programs were carried on, the frequency of contact during that time, and the period for which the subjects were followed up. Still, one must say that the burden of the evidence is not encouraging. These programs seem to work best when they are new, when their subjects are amenable to treatment in the first place, and when the counselors are not only trained people but "good" people as well. Such findings, which would not be much of a surprise to a student of organization or personality, are hardly encouraging for a policy planner, who must adopt measures that are generally applicable, that are capable of being successfully institutionalized, and that must rely for personnel on something other than the exceptional individual.

Transforming the Institutional Environment

3. *But maybe the reason these counseling programs don't seem to work is not that they are ineffective* per se, *but that the institutional environment* outside *the program is unwholesome enough to undo any good work that the counseling does. Isn't a truly successful rehabilitative institution the one where the inmate's whole environment is directed toward true correction rather than toward custody or punishment?*

This argument has not only been made, it has been embodied in several institutional programs that go by the name of "milieu therapy." They are designed to make every element of the inmate's environment a part of his treatment, to reduce the distinctions between the custodial staff and the treatment staff, to create a supportive, nonauthoritarian, and nonregimented atmosphere, and to enlist peer influence in the formation of constructive values. These programs are especially hard to summarize because of their variety; they differ, for example, in how "supportive" or "permis-

sive" they are designed to be, in the extent to which they are combined with other treatment methods such as individual therapy, group counseling, or skill development, and in how completely the program is able to control all the relevant aspects of the institutional environment.

One might well begin with two studies that have been done of institutionalized adults, in regular prisons, who have been subjected to such treatment; this is the category whose results are the most clearly discouraging. One study of such a program, by Robison (1967), found that the therapy did seem to reduce recidivism after one year. After two years, however, this effect disappeared, and the treated convicts did no better than the untreated. Another study by Kassebaum, Ward, and Wilner (1971), dealt with a program which had been able to effect an exceptionally extensive and experimentally rigorous transformation of the institutional environment. This sophisticated study had a follow-up period of thirty-six months, and it found that the program had no significant effect on parole failure or success rates.

The results of the studies of youth are more equivocal. As for young females, one study by Adams (1966) of such a program found that it had no significant effect on recidivism; another study, by Goldberg and Adams (1964), found that such a program *did* have a positive effect. This effect declined when the program began to deal with girls who were judged beforehand to be worse risks.

As for young males, the studies may conveniently be divided into those dealing with juveniles (under sixteen) and those dealing with youths. There have been five studies of milieu therapy administered to juveniles. Two of them—by Laulicht (1962) and by Jesness (1965)—report clearly that the program in question either had no significant effect or had a short-term effect that wore off with passing time. Jesness does report that when his experimental juveniles did commit new offenses, the offenses were less serious than those committed by controls. A third study of juveniles, by McCord (1953) at the Wiltwyck School, reports mixed results. Using two measures of performance, a "success" rate and a "failure" rate, McCord found that his experimental group achieved both less failure and less success than the controls did. There have been two positive reports on milieu therapy programs for male juveniles; both of them have come out of the Highfields program, the milieu therapy experiment which has become the most famous and widely quoted example of "success" via this method. A group of boys was confined for a relatively short time to the unrestrictive, supportive environment of Highfields; and at a follow-up of six months, Freeman (1956) found that the group did indeed show a lower recidivism rate (as measured by parole revocation) than a similar group spending a longer time in the regular reformatory. McCorkle (1958) also reported positive findings from Highfields. But in fact, the McCorkle data show, this improvement was not so clear: The Highfields boys had lower recidivism rates at twelve and thirty-six months in the follow-up period, but not at

twenty-four and sixty months. The length of follow-up, these data remind us, may have large implications for a study's conclusions. But more important were other flaws in the Highfields experiment: The populations were not fully comparable (they differed according to risk level and time of admission); different organizations—the probation agency for the Highfields boys, the parole agency for the others—were making the revocation decisions for each group; more of the Highfields boys were discharged early from supervision, and thus removed from any risk of revocation. In short, not even from the celebrated Highfields case may we take clear assurance that milieu therapy works.

In the case of male youths, as opposed to male juveniles, the findings are just as equivocal, and hardly more encouraging. One such study by Empey (1966) in a residential context did not produce significant results. A study by Seckel (1967) described California's Fremont Program, in which institutionalized youths participated in a combination of therapy, work projects, field trips, and community meetings. Seckel found that the youths subjected to this treatment committed *more* violations of law than did their nontreated counterparts. This difference could have occurred by chance; still, there was certainly no evidence of relative improvement. Another study, by Levinson (1962–1964), also found a lack of improvement in recidivism rates—but Levinson noted the encouraging fact that the treated group spent somewhat more time in the community before recidivating, and committed less serious offenses. And a study by the state of California (1967) also shows a partially positive finding. This was a study of the Marshall Program, similar to California's Fremont Program but different in several ways. The Marshall Program was shorter and more tightly organized than its Fremont counterpart. In the Marshall Program, as opposed to the Fremont Program, a youth could be ejected from the group and sent back to regular institutions before the completion of the program. Also, the Marshall Program offered some additional benefits: the teaching of "social survival skills" (i.e., getting and holding a job), group counseling of parents, and an occasional opportunity for boys to visit home. When youthful offenders were released to the Marshall Program, either directly or after spending some time in a regular institution, they did no better than a comparable regularly institutionalized population, though both Marshall youth and youth in regular institutions did better than those who were directly released by the court and given no special treatment.

So the youth in these milieu therapy programs at least do no worse than their counterparts in regular institutions and the special programs may cost less. One may therefore be encouraged—not on grounds of rehabilitation but on grounds of cost-effectiveness.

What about Medical Treatment?

4. *Isn't there anything you can do in an institutional setting that will reduce recidivism, for instance, through strictly medical treatment?*

A number of studies deal with the results of efforts to change the behavior of offenders through drugs and surgery. As for surgery, the one experimental study of a plastic surgery program—by Mandell (1967)—had negative results. For nonaddicts who received plastic surgery, Mandell purported to find improvement in performance on parole; but when one reanalyzes his data, it appears that surgery alone did not in fact make a significant difference.

One type of surgery does seem to be highly successful in reducing recidivism. A twenty-year Danish study of sex offenders, by Stuerup (1960), found that while those who had been treated with hormones and therapy continued to commit both sex crimes (29.6 percent of them did so) and nonsex crimes (21.0 percent), those who had been castrated had rates of only 3.5 percent (not, interestingly enough, a rate of zero; where there's a will, apparently there's a way) and 9.2 percent. One hopes that the policy implications of this study will be found to be distinctly limited.

As for drugs, the major report on such a program—involving tranquilization—was made by Adams (1961b). The tranquilizers were administered to male and female institutionalized youths. With boys, there was only a slight improvement in their subsequent behavior; this improvement disappeared within a year. With girls, the tranquilization produced worse results than when the girls were given no treatment at all.

The Effects of Sentencing

5. *Well, at least it may be possible to manipulate certain gross features of the existing, conventional prison system—such as length of sentence and degree of security—in order to affect these recidivism rates. Isn't this the case?*

At this point, it's still impossible to say that this is the case. As for the degree of security in an institution, Glaser's (1964) work reported that, for both youth and adults, a less restrictive "custody grading" in American federal prisons was related to success on parole; but this is hardly surprising, since those assigned to more restrictive custody are likely to be worse risks in the first place. More to the point, an American study by Fox (1950) discovered that for "older youths" who were deemed to be good risks for the future, a minimum security institution produced better results than a maximum security one. On the other hand, the data we have on youths under 16—from a study by McClintock (1961), done in Great Britain—

indicate that so-called borstals, in which boys are totally confined, are more effective than a less restrictive regime of partial physical custody. In short, we know very little about the recidivism effects of various degrees of security in existing institutions; and our problems in finding out will be compounded by the probability that these effects will vary widely according to the particular *type* of offender that we're dealing with.

The same problems of mixed results and lack of comparable populations have plagued attempts to study the effects of sentence length. A number of studies—by Narloch (1959), by Bernsten (1965), and by the state of California (1956)—suggest that those who are released earlier from institutions than their scheduled parole date, or those who serve short sentences of under three months rather than longer sentences of eight months or more, either do better on parole or at least do no worse.* The implication here is quite clear and important: Even if early releases and short sentences produce no improvement in recidivism rates, one could at least maintain the same rates while lowering the cost of maintaining the offender and lessening his own burden of imprisonment. Of course, this implication carries with it its concomitant danger: the danger that though shorter sentences cause no worsening of the recidivism rate, they may increase the total amount of crime in the community by increasing the absolute number of potential recidivists at large.

On the other hand, Glaser's (1964) data show not a consistent linear relationship between the shortness of the sentence and the rate of parole success, but a curvilinear one. Of his subjects, those who served less than a year had a 73 percent success rate, those who served up to two years were only 65 percent successful, and those who served up to three years fell to a rate of 56 percent. But among those who served sentences of *more* than three years, the success rate rose again—to 60 percent. These findings should be viewed with some caution since Glaser did not control for the preexisting degree of risk associated with each of his categories of offenders. But the data do suggest that the relationship between sentence length and recidivism may not be a simple linear one.

More important, the effect of sentence length seems to vary widely according to type of offender. In a British study (1963), for instance, Hammond found that for a group of "hard-core recidivists," shortening the sentence caused no improvement in the recidivism rate. In Denmark, Bernsten (1965) discovered a similar phenomenon: That the beneficial effect of three-month sentences as against eight-month ones disappeared in the case of these "hard-core recidivists." Garrity found another such distinction in his 1956 study. He divided his offenders into three categories: "prosocial,"

* A similar phenomenon has been measured indirectly by studies that have dealt with the effect of various parole policies on recidivism rates. Where parole decisions have been liberalized so that an offender could be released with only the "reasonable assurance" of a job rather than with a definite job already developed by a parole officer (Stanton, 1963), this liberal release policy has produced no worsening of recidivism rates.

"antisocial," and "manipulative." "Prosocial" offenders he found to have low recidivism rates regardless of the length of their sentence; "antisocial" offenders did better with short sentences; the "manipulative" did better with long ones. Two studies from Britain made yet another division of the offender population, and found yet other variations. One (Great Britain, 1964) found that previous offenders—but not first offenders—did better with *longer* sentences, while the other (Cambridge, 1952) found the *reverse* to be true with juveniles.

To add to the problem of interpretation, these studies deal not only with different types and categorizations of offenders but with different types of institutions as well. No more than in the case of institution type can we say that length of sentence has a clear relationship to recidivism.

Decarcerating the Convict

6. *All of this seems to suggest that there's not much we know how to do to rehabilitate an offender when he's in an institution. Doesn't this lead to the clear possibility that the way to rehabilitate offenders is to deal with them* outside *an institutional setting?*

This is indeed an important possibility, and it is suggested by other pieces of information as well. For instance, Miner (1967) reported on a milieu therapy program in Massachusetts called Outward Bound. It took youths 15½ and over; it was oriented toward the development of skills in the out-of-doors and conducted in a wilderness atmosphere very different from that of most existing institutions. The culmination of the twenty-six day program was a final twenty-four hours in which each youth had to survive alone in the wilderness. And Miner found that the program did indeed work in reducing recidivism rates.

But by and large, when one takes the programs that have been administered in institutions and applies them in a noninstitutional setting, the results do not grow to encouraging proportions. With casework and individual counseling in the community, for instance, there have been three studies; they dealt with counseling methods from psychosocial and vocational counseling to "operant conditioning," in which an offender was rewarded first simply for coming to counseling sessions and then, gradually, for performing other types of approved acts. Two of them report that the community-counseled offenders did no better than their institutional controls, while the third notes that although community counseling produced fewer arrests per person, it did not ultimately reduce the offender's chance of returning to a reformatory.

The one study of a noninstitutional skill development program, by Kovacs (1967), described the New Start Program in Denver, in which offenders participated in vocational training, role playing, programmed in-

struction, group counseling, college class attendance, and trips to art galleries and museums. After all this, Kovacs found no significant improvement over incarceration.

There have also been studies of milieu therapy programs conducted with youthful male probationers not in actual physical custody. One of them found no significant improvement at all. One, by Empey (1966), did say that after a follow-up of six months, a boy who was judged to have "successfully" completed the milieu program was less likely to recidivate afterwards than was a "successful" regular probationer. Empey's "successes" came out of an extraordinary program in Provo, Utah, which aimed to rehabilitate by subjecting offenders to a nonsupportive milieu. The staff of this program operated on the principle that they were *not* to go out of their way to interact and be empathetic with the boys. Indeed, a boy who misbehaved was to be met with "role dispossession": He was to be excluded from meetings of his peer group, and he was not to be given answers to his questions as to why he had been excluded or what his ultimate fate might be. This peer group and its meetings were designed to be the major force for reform at Provo; they were intended to develop, and indeed did develop, strong and controlling norms for the behavior of individual members. For one thing, group members were not to associate with delinquent boys outside the program; for another, individuals were to submit to a group review of all their actions and problems; and they were to be completely honest and open with the group about their attitudes, their states of mind, their personal failings. The group was granted quite a few sanctions with which to enforce these norms: They could practice derision or temporary ostracism, or they could lock up an aberrant member for a weekend, refuse to release him from the program, or send him away to the regular reformatory.

One might be tempted to forgive these methods because of the success that Empey reports, except for one thing. If one judges the program not only by its "successful" boys but by all the boys who were subjected to it—those who succeeded and those who, not surprisingly, failed—the totals show *no* significant improvement in recidivism rates compared with boys on regular probation. Empey did find that both the Provo boys and those on regular probation did better than those in regular reformatories—in contradiction, it may be recalled, to the finding from the residential Marshall Program, in which the direct releases given no special treatment did *worse* than boys in regular institutions.

The third such study of nonresidential milieu therapy, by McCravey (1967), found not only that there was no significant improvement, but that the longer a boy participated in the treatment, the *worse* he was likely to do afterwards.

Psychotherapy in Community Settings

There is some indication that individual psychotherapy may "work" in a community setting. Massimo (1963) reported on one such program, using what might be termed a "pragmatic" psychotherapeutic approach, including "insight" therapy and a focus on vocational problems. The program was marked by its small size and by its use of therapists who were personally enthusiastic about the project; Massimo found that there was indeed a decline in recidivism rates. Adamson (1956), on the other hand, found no significant difference produced by another program of individual therapy (though he did note that arrest rates among the experimental boys declined with what he called "intensity of treatment"). And Schwitzgebel (1963, 1964), studying other, different kinds of therapy programs, found that the programs *did* produce improvements in the attitudes of his boys—but, unfortunately, not in their rates of recidivism.

And with *group* therapy administered in the community, we find yet another set of equivocal results. The results from studies of pragmatic group counseling are only mildly optimistic. Adams (1965) did report that a form of group therapy, "guided group interaction," when administered to juvenile gangs, did somewhat reduce the percentage that were to be found in custody six years later. On the other hand, in a study of juveniles, Adams (1964) found that while such a program did reduce the number of contacts that an experimental youth had with police, it made no ultimate difference in the detention rate. And the attitudes of the counseled youth showed no improvement. Finally, when O'Brien (1961) examined a community-based program of group psychotherapy, he found not only that the program produced no improvement in the recidivism rate, but that the experimental boys actually did worse than their controls on a series of psychological tests.

Probation or Parole versus Prison

But by far the most extensive and important work that has been done on the effect of community-based treatments has been in the areas of probation and parole. This work sets out to answer the question of whether it makes any difference how you supervise and treat an offender once he has been released from prison or has come under state surveillance in lieu of prison. This is the work that has provided the main basis to date for the claim that we do indeed have the means at our disposal for rehabilitating the offender or at least decarcerating him safely.

One group of these studies has compared the use of probation with other dispositions for offenders; these provide some slight evidence that, at least

under some circumstances, probation may make an offender's future chances better than if he had been sent to prison. Or, at least, probation may not worsen those chances.* A British study, by Wilkins (1958), reported that when probation was granted more frequently, recidivism rates among probationers did not increase significantly. And another such study by the state of Michigan in 1963 reported that an expansion in the use of probation actually improved recidivism rates—though there are serious problems of comparability in the groups and systems that were studied.

One experiment—by Babst (1965)—compared a group of parolees, drawn from adult male felony offenders in Wisconsin, and excluding murderers and sex criminals, with a similar group that had been put on probation; it found that the probationers committed fewer violations if they had been first offenders, and did no worse if they were recidivists. The problem in interpreting this experiment, though, is that the behavior of those groups was being measured by separate organizations, by probation officers for the probationers, and by parole officers for the parolees; it is not clear that the definition of "violation" was the same in each case, or that other types of uniform standards were being applied. Also, it is not clear what the results would have been if subjects had been released directly to the parole organization without having experienced prison first. Another such study, done in Israel by Shoham (1964), must be interpreted cautiously because his experimental and control groups had slightly different characteristics. But Shoham found that when one compared a suspended sentence plus probation for first offenders with a one-year prison sentence, only first offenders under twenty years of age did better on probation; those from twenty-one to forty-five actually did *worse*. And Shoham's findings also differ from Babst's in another way. Babst had found that parole rather than prison brought no improvement for recidivists, but Shoham reported that for recidivists with four or more prior offenses, a suspended sentence was actually *better*—though the improvement was much less when the recidivist had committed a crime of violence.

But both the Babst and the Shoham studies, even while they suggest the possible value of suspended sentences, probation, or parole for some offenders (though they contradict each other in telling us *which* offenders), also indicate a pessimistic general conclusion concerning the limits of the effectiveness of treatment programs. For they found that the personal characteristics of offenders—first-offender status, or age, or type of offense—were more important than the form of treatment in determining future recidivism. An offender with a "favorable" prognosis will do better than one without, it seems, no matter how you distribute "good" or "bad," "enlightened" or "regressive" treatments among them.

Quite a large group of studies deals not with probation as compared to other dispositions, but instead with the type of treatment that an offender

* It will be recalled that Empey's report on the Provo program made such a finding.

receives once he is *on* probation or parole. These are the studies that have provided the most encouraging reports on rehabilitative treatment and that have also raised the most serious questions about the nature of the research that has been going on in the corrections field.

Five of these studies have dealt with youthful probationers from thirteen to eighteen who were assigned to probation officers with small caseloads or provided with other ways of receiving more intensive supervision (Adams, 1966—two reports; Feistman, 1966; Kawaguchi, 1967; Pilnick, 1967). These studies report that, by and large, intensive supervision does work—that the specially treated youngsters do better according to some measure of recidivism. Yet these studies left some important questions unanswered. For instance, was this improved performance a function merely of the number of contacts a youngster had with his probation officer? Did it also depend on the length of time in treatment? Or was it the quality of supervision that was making the difference, rather than the quantity?

Intensive Supervision: the Warren Studies

The widely-reported Warren studies (1966a, 1966b, 1967) in California constitute an extremely ambitious attempt to answer these questions. In this project, a control group of youths, drawn from a pool of candidates ready for first admission to a California Youth Authority institution, was assigned to regular detention, usually for eight to nine months, and then released to regular supervision. The experimental group received considerably more elaborate treatment. They were released directly to probation status and assigned to twelve-man caseloads. To decide what special treatment was appropriate within these caseloads, the youths were divided according to their "interpersonal maturity level classification," by use of a scale developed by Grant and Grant. And each level dictated its own special type of therapy. For instance, a youth might be judged to occupy the lowest maturity level; this would be a youth, according to the scale, primarily concerned with "demands that the world take care of him. . . . He behaves impulsively, unaware of anything except the grossest effects of his behavior on others." A youth like this would be placed in a supportive environment such as a foster home; the goals of his therapy would be to meet his dependency needs and help him gain more accurate perceptions about his relationship to others. At the other end of the three-tier classification, a youth might exhibit high maturity. This would be a youth who had internalized "a set of standards by which he judges his and others' behavior. . . . He shows some ability to understand reasons for behavior, some ability to relate to people emotionally and on a long-term basis." These high-maturity youths could come in several varieties—a "neurotic acting out," for instance, a "neurotic anxious," a "situational emotional reactor," or a

"cultural identifier." But the appropriate treatment for these youths was individual psychotherapy, or family or group therapy for the purpose of reducing internal conflicts and increasing the youths' awareness of personal and family dynamics.

"Success" in this experiment was defined as favorable discharge by the Youth Authority; "failure" was unfavorable discharge, revocation, or recommitment by a court. Warren reported an encouraging finding: Among all but one of the "subtypes," the experimentals had a significantly lower failure rate than the controls. The experiment did have certain problems: The experimentals might have been performing better because of the enthusiasm of the staff and the attention lavished on them; none of the controls had been *directly* released to their regular supervision programs instead of being detained first; and it was impossible to separate the effects of the experimentals' small caseloads from their specially designed treatments, since no experimental youths had been assigned to a small caseload with "inappropriate" treatment, or with no treatment at all. Still, none of these problems was serious enough to vitiate the encouraging prospect that this finding presented for successful treatment of probationers.

This encouraging finding was, however, accompanied by a rather more disturbing clue. As has been mentioned before, the experimental subjects, when measured, had a lower *failure* rate than the controls. But the experimentals also had a lower *success* rate. That is, fewer of the experimentals as compared with the controls had been judged to have successfully completed their program of supervision and to be suitable for favorable release. When my colleagues and I undertook a rather laborious reanalysis of the Warren data, it became clear why this discrepancy had appeared. It turned out that fewer experimentals were "successful" because the experimentals were actually committing more offenses than their controls. The reason that the experimentals' relatively large number of offenses was not being reflected in their failure rates was simply that the experimentals' probation officers were using a more lenient revocation policy. In other words, the controls had a higher failure rate because the controls were being revoked for less serious offenses.

So it seems that what Warren was reporting in her "failure" rates was not merely the treatment effect of her small caseloads and special programs. Instead, what Warren was finding was not so much a change in the behavior of the experimental youths as a change in the behavior of the experimental *probation officers,* who knew the "special" status of their charges and who had evidently decided to revoke probation status at a lower than normal rate. The experimentals continued to commit offenses; what was different was that when they committed these offenses, they were permitted to remain on probation.

The experimenters claimed that this low revocation policy, and the greater number of offenses committed by the special treatment youth, was *not* an indication that these youth were behaving specially badly and that

policy makers were simply letting them get away with it. Instead, it was claimed, the higher reported offense rate was primarily an artifact of the more intense surveillance that the experimental youth received. But the data show that this is not a sufficient explanation of the low failure rate among experimental youth; the difference in "tolerance" of offenses between experimental officials and control officials was much greater than the difference in the rates at which these two systems detected youths committing new offenses. Needless to say, this reinterpretation of the data presents a much bleaker picture of the possibilities of intensive supervision with special treatment.

"Treatment Effects" versus "Policy Effects"

This same problem of experimenter bias may also be present in the predecessors of the Warren study, the ones which had also found positive results from intensive supervision on probation; indeed, this disturbing question can be raised about many of the previously discussed reports of positive "treatment effects."

This possibility of a "policy effect" rather than a "treatment effect" applies, for instance, to the previously discussed studies of the effects of intensive supervision on juvenile and youthful probationers. These were the studies, it will be recalled, which found lower recidivism rates for the intensively supervised.*

One opportunity to make a further check on the effects of this problem is provided, in a slightly different context, by Johnson (1962a). Johnson was measuring the effects of intensive supervision on youthful *parolees* (as distinct from probationers). There have been several such studies of the effects on youths of intensive parole supervision plus special counseling, and their findings are on the whole less encouraging than the probation studies; they are difficult to interpret because of experimental problems, but studies by Boston University in 1966, and by Van Couvering in 1966, report no significant effects and possibly some bad effects from such special programs. But Johnson's studies were unique for the chance they provide to measure both treatment effects and the effect of agency policy.

Johnson, like Warren, assigned experimental subjects to small caseloads and his experiment had the virtue of being performed with two separate populations and at two different times. But in contrast with the Warren case, the Johnson experiment did not engage in a large continuing attempt to choose the experimental counselors specially, to train them specially, and to keep them informed about the progress and importance of the exper-

* But one of these reports, by Kawaguchi (1967), also found that an intensively supervised juvenile, by the time he finally "failed," had had more previous *detentions* while under supervision than a control juvenile had experienced.

iment. The first time the experiment was performed, the experimental youths had a slightly lower revocation rate than the controls at six months. But the second time, the experimentals did *not* do better than their controls; indeed, they did slightly worse. And with the experimentals from the first group—those who *had* shown an improvement after six months—this effect wore off at eighteen months. In the Johnson study, my colleagues and I found, "intensive" supervision did *not* increase the experimental youths' risk of detection. Instead, what was happening in the Johnson experiment was that the first time it had been performed—just as in the Warren study—the experimentals were simply revoked less often per number of offenses committed, and they were revoked for offenses more serious than those which prompted revocation among the controls. The second time around, this "policy" discrepancy disappeared; and when it did, the "improved" performance of the experimentals disappeared as well. The enthusiasm guiding the project had simply worn off in the absence of reinforcement.

One must conclude that the "benefits" of intensive supervision for youthful offenders may stem not so much from a "treatment" effect as from a "policy" effect—that such supervision, so far as we now know, results not in rehabilitation but in a decision to look the other way when an offense is committed. But there is one major modification to be added to this conclusion. Johnson performed a further measurement (1962b) in his parole experiment: He rated all the supervising agents according to the "adequacy" of the supervision they gave. And he found that an "adequate" agent, whether he was working in a small *or* a large caseload, produced a relative improvement in his charges. The converse was not true: An *in*adequate agent was more likely to produce youthful "failures" when he was given a *small* caseload to supervise. One can't much help a "good" agent, it seems, by reducing his caseload size; such reduction can only do further harm to those youths who fall into the hands of "bad" agents.

So with youthful offenders, Johnson found, intensive supervision does not seem to provide the rehabilitative benefits claimed for it; the only such benefits may flow not from intensive supervision itself but from contact with one of the "good people" who are frequently in such short supply.

Intensive Supervision of Adults

The results are similarly ambiguous when one applies this intensive supervision to adult offenders. There have been several studies of the effects of intensive supervision on adult parolees. Some of these are hard to interpret because of problems of comparability between experimental and control

groups (general risk ratings, for instance, or distribution of narcotics offenders, or policy changes that took place between various phases of the experiments), but two of them (California, 1966; Stanton, 1964) do not seem to give evidence of the benefits of intensive supervision. By far the most extensive work, though, on the effects of intensive supervision of adult parolees has been a series of studies of California's Special Intensive Parole Unit (SIPU), a ten-year-long experiment designed to test the treatment possibilities of various special parole programs. Three of the four "phases" of this experiment produced "negative results." The first phase tested the effect of a reduced caseload size; no lasting effect was found. The second phase slightly increased the size of the small caseloads and provided for a longer time in treatment; again there was no evidence of a treatment effect. In the fourth phase, caseload sizes and time in treatment were again varied, and treatments were simultaneously varied in a sophisticated way according to personality characteristics of the parolees; once again, significant results did not appear.

The only phase of this experiment for which positive results were reported was Phase Three. Here, it was indeed found that a smaller caseload improved one's chances of parole success. There is, however, an important caveat that attaches to this finding: When my colleagues and I divided the whole population of subjects into two groups—those receiving supervision in the north of the state and those in the south—we found that the "improvement" of the experimentals' success rates was taking place primarily in the north. The north differed from the south in one important aspect: Its agents practiced a policy of returning both "experimental" and "control" violators to prison at relatively high rates. And it was the north that produced the higher success rate among its experimentals. So this improvement in experimentals' performance was taking place only when accompanied by a "realistic threat" of severe sanctions. It is interesting to compare this situation with that of the Warren studies. In the Warren studies, experimental subjects were being revoked at a relatively *low* rate. These experimentals "failed" less, but they also committed more new offenses than their controls. By contrast, in the northern region of the SIPU experiment, there was a policy of *high* rate of return to prison for experimentals; and here, the special program *did* seem to produce a real improvement in the behavior of offenders. What this suggests is that when intensive supervision *does* produce an improvement in offenders' behavior, it does so not through the mechanism of "treatment" or "rehabilitation," but instead through a mechanism that our studies have almost totally ignored—the mechanism of *deterrence*. And a similar mechanism is suggested by Lohman's study (1967) of intensive supervision of probationers. In this study intensive supervision led to higher total violation rates. But one also notes that intensive supervision combined the highest rate of technical violations with the lowest rate for *new* offenses.

The Effects of Community Treatment

In sum, even in the case of treatment programs administered outside penal institutions, we simply cannot say that this treatment in itself has an appreciable effect on offender behavior. On the other hand, there is one encouraging set of findings that emerges from these studies. For from many of them there flows the strong suggestion that even if we can't "treat" offenders so as to make them do better, a great many of the programs designed to rehabilitate them at least did not make them do *worse*. And if these programs did not show the advantages of actually rehabilitating, some of them did have the advantage of being less onerous to the offender himself without seeming to pose increased danger to the community. And some of these programs—especially those involving less restrictive custody, minimal supervision, and early release—simply cost fewer dollars to administer. The information on the dollar costs of these programs is just beginning to be developed but the implication is clear: *that if we can't do more for (and to) offenders, at least we can safely do less.*

There is, however, one important caveat even to this note of optimism: In order to calculate the true costs of these programs, one must in each case include not only their administrative cost but also the cost of maintaining in the community an offender population increased in size. This population might well not be committing new offenses at any greater rate; but the offender population might, under some of these plans, be larger in absolute *numbers*. So the total number of offenses committed might rise, and our chances of victimization might therefore rise too. We need to be able to make a judgment about the size and probable duration of this effect; as of now, we simply do not know.

Does Nothing Work?

7. *Do all of these studies lead us irrevocably to the conclusion that nothing works, that we haven't the faintest clue about how to rehabilitate offenders and reduce recidivism? And if so, what shall we do?*

We tried to exclude from our survey those studies which were so poorly done that they simply could not be interpreted. But despite our efforts, a pattern has run through much of this discussion—of studies which "found" effects without making any truly rigorous attempt to exclude competing hypotheses, of extraneous factors permitted to intrude upon the measurements, of recidivism measures which are not all measuring the same thing, of "follow-up" periods which vary enormously and rarely extend beyond the period of legal supervision, of experiments never replicated, of "system effects" not taken into account, of categories drawn up without any

theory to guide the enterprise. It is just possible that some of our treatment programs *are* working to some extent, but that our research is so bad that it is incapable of telling.

Having entered this very serious caveat, I am bound to say that these data, involving over two hundred studies and hundreds of thousands of individuals as they do, are the best available and give us very little reason to hope that we have in fact found a sure way of reducing recidivism through rehabilitation. This is not to say that we found no instances of success or partial success; it is only to say that these instances have been isolated, producing no clear pattern to indicate the efficacy of any particular method of treatment. And neither is this to say that factors *outside* the realm of rehabilitation may not be working to reduce recidivism—factors such as the tendency for recidivism to be lower in offenders over the age of thirty; it is only to say that such factors seem to have little connection with any of the treatment methods now at our disposal.

From this probability, one may draw any of several conclusions. It may be simply that our programs aren't yet good enough—that the education we provide to inmates is still poor education, that the therapy we administer is not administered skillfully enough, that our intensive supervision and counseling do not yet provide enough personal support for the offenders who are subjected to them. If one wishes to believe this, then what our correctional system needs is simply a more full-hearted commitment to the strategy of treatment.

It may be, on the other hand, that there is a more radical flaw in our present strategies—that education at its best, or that psychotherapy at its best, cannot overcome, or even appreciably reduce, the powerful tendency for offenders to continue in criminal behavior. Our present treatment programs are based on a theory of crime as a "disease"—that is to say, as something foreign and abnormal in the individual which can presumably be cured. This theory may well be flawed, in that it overlooks—indeed, denies—both the normality of crime in society and the personal normality of a very large proportion of offenders, criminals who are merely responding to the facts and conditions of our society.

This opposing theory of "crime as a social phenomenon" directs our attention away from a "rehabilitative" strategy, away from the notion that we may best insure public safety through a series of "treatments" to be imposed forcibly on convicted offenders. These treatments have on occasion become, and have the potential for becoming, so draconian as to offend the moral order of a democratic society; and the theory of crime as a social phenomenon suggests that such treatments may be not only offensive but ineffective as well. This theory points, instead, to decarceration for low-risk offenders—and, presumably, to keeping high-risk offenders in prisons which are nothing more (and aim to be nothing more) than custodial institutions.

But this approach has its own problems. To begin with, there is the

moral dimension of crime and punishment. Many low-risk offenders have committed serious crimes (murder, sometimes) and even if one is reasonably sure they will never commit another crime, it violates our sense of justice that they should experience no significant retribution for their actions. A middle-class banker who kills his adulterous wife in a moment of passion is a "low-risk" criminal; a juvenile delinquent in the ghetto who commits armed robbery has, statistically, a much higher probability of committing another crime. Are we going to put the first on probation and sentence the latter to a long term in prison?

Besides, one cannot ignore the fact that the punishment of offenders is the major means we have for *deterring* incipient offenders. We know almost nothing about the "deterrent effect," largely because "treatment" theories have so dominated our research, and "deterrence" theories have been relegated to the status of a historical curiosity. Since we have almost no idea of the deterrent functions that our present system performs or that future strategies might be made to perform, it is possible that there is indeed something that works—that to some extent is working right now in front of our noses, and that might be made to work better—something that deters rather than cures, something that does not so much reform convicted offenders as prevent criminal behavior in the first place. But whether that is the case and, if it is, what strategies will be found to make our deterrence system work better than it does now, are questions we will not be able to answer with data until a new family of studies has been brought into existence. As we begin to learn the facts, we will be in a better position than we are now to judge to what degree the prison has become an anachronism and can be replaced by more effective means of social control.

BIBLIOGRAPHY OF STUDIES REFERRED TO BY NAME

Adams, Stuart. "Effectiveness of the Youth Authority Special Treatment Program: First Interim Report." Research Report No. 5. California Youth Authority, March 6, 1959. Mimeographed.

Adams, Stuart. "Assessment of the Psychiatric Treatment Program: Second Interim Report." Research Report No. 15. California Youth Authority, December 13, 1959. Mimeographed.

Adams, Stuart. "Effectiveness of Interview Therapy with Older Youth Authority Wards: An Interim Evaluation of the PICO Project." Research Report No. 20. California Youth Authority, January 20, 1961. Mimeographed.

Adams, Stuart. "Assessment of the Psychaitric Treatment Program, Phase I: Third Interim Report." Research Report No. 21. California Youth Authority, January 31, 1961. Mimeographed.

Adams, Stuart. "An Experimental Assessment of Group Counseling with Juvenile Probationers." Paper presented at the 18th Convention of the California State Psychological Association, Los Angeles, December 12, 1964. Mimeographed.

Adams, Stuart. "Development of a Program Research Service in Probation." Research Report No. 27 (Final Report, NIMH Project MH007 18). Los Angeles County Probation Department, January 1966. Processed.

Adams, Stuart; Rice, Rogert E.; and Olive, Borden. "A Cost Analysis of the Effectiveness of the Group Guidance Program." Research Memorandum 65-3. Los Angeles County Probation Department, January 1965. Mimeographed.

Adamson, LeMay, and Dunham, H. Warren. "Clinical Treatment Of Male Delinquents. A Case Study in Effort and Result." *American Sociological Review,* 21, no. 3 (1956): 312–320.

Babst, Dean V., and Mannering, John W. "Probation versus Imprisonment for Similar Types of Offenders: A Comparison by Subsequent Violations." *Journal of Research in Crime and Delinquency,* 2, no. 2 (1965): 60–71.

Bernsten, Karen, and Christiansen, Karl O. "A Resocialization Experiment with Short-term Offenders," *Scandinavian Studies in Criminology.* 1 (1965): 35–54.

California, Adult Authority, Division of Adult Paroles. "Special Intensive Parole Unit, Phase I: Fifteen Man Caseload Study." Prepared by Walter I. Stone. Sacramento, Calif., November 1956. Mimeographed.

California, Department of Corrections. "Intensive Treatment Program: Second Annual Report." Prepared by Harold B. Bradley and Jack D. Williams. Sacramento, Calif., December 1, 1958. Mimeographed.

California, Department of Corrections. "Special Intensive Parole Unit, Phase II: Thirty Man Caseload Study." Prepared by Ernest Reimer and Martin Warren. Sacramento, Calif., December 1958. Mimeographed.

California, Department of Corrections. "Parole Work Unit Program: An Evaluative Report." A memorandum to the California Joint Legislative Budget Committee, December 30, 1966. Mimeographed.

California, Department of the Youth Authority. "James Marshall Treatment Program: Progress Report." January 1967. Processed.

Cambridge University, Department of Criminal Science. *Detention in Remard Homes.* London: Macmillan, 1952.

Craft, Michael; Stephenson, Geoffrey; and Granger, Clive. "A Controlled Trial of Authoritarian and Self-Governing Regimes with Adolescent Psychopaths." *American Journal of Orthopsychiatry,* 34, no. 3 (1964): 543–554.

Empey, LeMar T. "The Provo Experiment: A Brief Review." Los Angeles: Youth Studies Center, University of Southern California. 1966. Processed.

Feistman, Eugene G. "Comparative Analysis of the Willow-Brook-Harbor Intensive Services Program, March 1, 1965 through February 28, 1966." Research Report No. 28. Los Angeles County Probation Department, June 1966. Processed.

Forman, B. "The Effects of Differential Treatment on Attitudes, Personality Traits, and Behavior of Adult Parolees." Unpublished Ph.D. dissertation, University of Southern California, 1960.

Fox, Vernon. "Michigan's Experiment in Minimum Security Penology," *Journal of Criminal Law, Criminology, and Police Science,* 41, no. 2 (1950): 150–166.

Freeman, Howard E., and Weeks, H. Ashley. "Analysis of a Program of Treatment of Delinquent Boys," *American Journal of Sociology,* 62, no. 1 (1956): 56–61.

Garrity, Donald Lee. "The Effects of Length of Incarceration upon Parole Adjustment and Estimation of Optimum Sentence: Washington State Correctional Institutions." Unpublished Ph.D. dissertation, University of Washington, 1956.

Gearhart, J. Walter; Keith, Harold L.; and Clemmons, Gloria. "An Analysis of the Vocational Training Program in the Washington State Adult Correctional Institutions." Research Review No. 23. State of Washington, Department of Institutions, May 1967. Processed.

Glaser, Daniel. *The Effectiveness of a Prison and Parole System.* New York: Bobbs-Merrill, 1964.

Goldberg, Lisbeth, and Adams, Stuart. "An Experimental Evaluation of the Lathrop Hall Program." Los Angeles County Probation Department, December 1964. Summarized in Adams, Stuart. "Development of a Program Research Service in Probation," pp. 19–22.

Great Britain. Home Office. *The Sentence of the Court: A Handbook for Courts on the Treatment of Offenders.* London: Her Majesty's Stationery Office, 1964.

Guttman, Evelyn S. "Effects of Short-Term Psychiatric Treatment on Boys in Two California Youth Authority Institutions." Research Report No. 36. California Youth Authority, December 1963. Processed.

Hammond, W. H., and Chayen, E. *Persistent Criminals: A Home Office Research Unit Report.* London: Her Majesty's Stationery Office, 1963.

Harrison, Robert M., and Mueller, Paul F. C. "Clue Hunting About Group Counseling and Parole Outcome." Research Report No. 11. California Department of Corrections, May 1964. Mimeographed.

Havel, Joan. "A Synopsis of Research Report No. 10, SIPU Phase IV—The High Base Expectancy Study." Administrative Abstract No. 10. California Department of Corrections, June 1963. Processed.

Havel, Joan. "Special Intensive Parole Unit—Phase Four: 'The Parole Outcome Study.' " Research Report No. 13. California Department of Corrections, September 1965. Processed.

Havel, Joan, and Sulka, Elaine. "Special Intensive Parole Unit: Phase Three." Research Report No. 3. California Department of Corrections, March 1962. Processed.

Hood, Roger. *Homeless Borstal Boys: A Study of Their After-Care and After-Conduct*. Occasional Papers on Social Administration No. 18. London: G. Bell & Sons, 1966.

Jacobson, Frank, and McGee, Eugene. "Englewood Project: Re-education: A Radical Correction of Incarcerated Delinquents." Englewood, Colo.: July 1965. Mimeographed.

Jesness, Carl F. "The Fricot Ranch Study: Outcomes with Small versus Large Living Groups in the Rehabilitation of Delinquents." Research Report No. 47. California Youth Authority, October 1, 1965. Processed.

Johnson, Bertram. "Parole Performance of the First Year's Releases, Parole Research Project: Evaluation of Reduced Caseloads." Research Report No. 27. California Youth Authority, January 31, 1962. Mimeographed.

Johnson, Bertram. "An Analysis of Predictions of Parole Performance and of Judgments of Supervision in the Parole Research Project." Research Report No. 32. California Youth Authority, December 31, 1962. Mimeographed.

Kassebaum, Gene; Ward, David; and Wilnet, Daniel. *Prison Treatment and Parole Survival: An Empirical Assessment*. New York: Wiley, 1971.

Kawaguchi, Ray M., and Siff, Leon M. "An Analysis of Intensive Probation Services—Phase II." Research Report No. 29. Los Angeles County Probation Department, April 1967. Processed.

Kettering, Marvin E. "Rehabilitation of Women in the Milwaukee County Jail: An Exploration Experiment." Unpublished Master's thesis, Colorado State College, 1965.

Kovacs, Frank W. "Evaluation and Final Report of the New Start Demonstration Project." Colorado Department of Employment, October 1967. Processed.

Lavlicht, Jerome, et al., in *Berkshire Farms Monographs*, 1, no. 1 (1962): 11–48.

Levinson, Robert B., and Kitchenet, Howard L. "Demonstration Counseling Project." 2 vols. Washington, D.C.: National Training School for Boys, 1962–1964. Mimeographed.

Lohman, Joseph D., et al., "The Intensive Supervision Caseloads: A Preliminary Evaluation." The San Francisco Project: A Study of Federal Probation and Parole. Research Report No. 11. School of Criminology, University of California, March 1967. Processed.

McClintock, F. H. *Attendance Centres*. London: Macmillan, 1961.

McCord, William and Joan. "Two Approaches to the Cure of Delinquents." *Journal of Criminal Law, Criminology, and Police Science*. 44, no. 4 (1953): 442–467.

McCorkle, Lloyd W.; Elias, Albert; and Bixby, F. Lovell. *The Highfields Story: An Experimental Treatment Project for Youthful Offenders*. New York: Holt, 1958.

McCravy, Newton, Jr., and Delehanty, Dolores S. "Community Rehabilitation of the Younger Delinquent Boy, Parkland Non-Residential Group Center." Final Report, Kentucky Child Welfare Research Foundation, Inc., September 1, 1967. Mimeographed.

Mandell, Wallace, et al., "Surgical and Social Rehabilitation of Adult Offenders." Final Report, Montefiore Hospital and Medical Center, with Staten Island Mental Health Society. New York City Department of Correction, 1967. Processed.

Massimo, Joseph L., and Shore, Milton F. "The Effectiveness of a Comprehensive Vocationally Oriented Psychotherapeutic Program for Adolescent Delinquent Boys." *American Journal of Orthopsychiatry*, 33, no. 4 (1963): 634–642.

Minet, Joshua, III; Kelly, Francis J.; and Hatch, M. Charles. "Outward Bound Inc.: Juvenile Delinquency Demonstration Project, Year End Report." Massachusetts Division of Youth Service, May 31, 1967.

Narloch, R. P.; Adams, Stuart; and Jenkins, Kendall J. "Characteristics and Parole Performance of California Youth Authority Early Releases." Research Report No. 7. California Youth Authority, June 22, 1959. Mimeographed.

New York State, Division of Parole, Department of Correction. "Parole Adjustment and Prior Educational Achievement of Male Adolescent Offenders, June 1957–June 1961." September 1964. Mimeographed.
O'Brien, William J. "Personality Assessment as a Measure of Change Resulting from Group Psychotherapy with Male Juvenile Delinquents." The Institute for the Study of Crime and Delinquency, and the California Youth Authority, December 1961. Processed.
Persons, Roy W. "Psychological and Behavioral Change in Delinquents Following Psychotherapy." *Journal of Clinical Psychology*, 22, no. 3 (1966): 337–340.
Persons, Roy W. "Relationship Between Psychotherapy with Institutionalized Boys and Subsequent Community Adjustment." *Journal of Consulting Psychology*, 31, no. 2 (1967): 137–141.
Pilnick, Saul, et al., "Collegefields: From Delinquency to Freedom." A Report . . . on Collegefields Group Educational Center. Laboratory for Applied Behavioral Science, Newark State College, February 1967. Processed.
Robison, James, and Kevotkian, Marinette. "Intensive Treatment Project: Phase II. Parole Outcome: Interim Report." Research Report No. 27. California Department of Corrections, Youth and Adult Correctional Agency, January 1967. Mimeographed.
Rudoff, Alvin. "The Effect of Treatment on Incarcerated Young Adult Delinquents as Measured by Disciplinary History." Unpublished Master's thesis, University of Southern California, 1960.
Saden, S. J. "Correctional Research at Jackson Prison." *Journal of Correctional Education*, 15 (October 1962): 22–26.
Schnur, Alfred C. "The Educational Treatment of Prisoners and Recidivism." *American Journal of Sociology*, 54, no. 2 (1948): 142–147.
Schwitzgebel, Robert and Ralph. "Therapeutic Research: A Procedure for the Reduction of Adolescent Crime." Paper presented at meetings of the American Psychological Association, Philadelphia, Pa., August 1963.
Schwitzgebel, Robert and Kolb, D. A. "Inducing Behavior Change in Adolescent Delinquents." *Behavior Research Therapy*, 1 (1964): 297–304.
Seckel, Joachim P. "Experiments in Group Counseling at Two Youth Authority Institutions." Research Report No. 46. California Youth Authority, September 1965. Processed.
Seckel, Joachim P. "The Fremont Experiment, Assessment of Residential Treatment at a Youth Authority Reception Center." Research Report No. 50. California Youth Authority, January 1967. Mimeographed.
Shelley, Ernest L. V., and Johnson, Walter F., Jr. "Evaluating an Organized Counseling Service for Youthful Offenders." *Journal of Counseling Psychology*, 8, no. 4 (1961): 351–354.
Shoham, Shlomo, and Sandberg, Moshe. "Suspended Sentences in Israel: An Evaluation of the Preventive Efficacy of Prospective Imprisonment." *Crime and Delinquency*, 10, no. 1 (1964): 74–83.
Stanton, John M. "Delinquencies and Types of Parole Programs to Which Inmates are Released." New York State Division of Parole, May 15, 1963. Mimeographed.
Stanton, John M. "Board Directed Extensive Supervision." New York State Division of Parole, August 3, 1964. Mimeographed.
Stuerup, Georg K. "The Treatment of Sexual Offenders." *Bulletin de la societe internationale de criminologie* (1960), pp. 320–329.
Sullivan, Clyde E., and Mandell, Wallace. "Restoration of Youth Through Training: A Final Report." Staten Island, New York: Wakoff Research Center, April 1967. Processed.
Taylor, A. J. W. "An Evaluation of Group Psychotherapy in a Girls' Borstal." *International Journal of Group Psychotherapy*, 17, no. 2 (1967): 168–177.
Truax, Charles B.; Wargo, Donald G.; and Silber, Leon D. "Effects of Group Psychotherapy with High Adequate Empathy and Nonpossessive Warmth upon Female Institutionalized Delinquents." *Journal of Abnormal Psychology*, 71, no. 4 (1966): 267–274.
Warren, Marguerite. "The Community Treatment Project after Five Years." California Youth Authority, 1966. Processed.
Warren, Marguerite, et al., "Community Treatment Project, an Evaluation of Community Treatment for Delinquents: a Fifth Progress Report." C.T.P. Research Report No. 7. California Youth Authority, August 1966. Processed.
Warren, Marguerite, et al., "Community Treatment Project, an Evaluation of Community

Treatment for Delinquents: Sixth Progress Report." C.T.P. Research Report No. 8. California Youth Authority, September 1967. Processed.

Wilkins, Leslie T. "A Small Comparative Study of the Results of Probation." *British Journal of Criminology*, 8, no. 3 (1958): 201–209.

Zivan, Morton. "Youth in Trouble: A Vocational Approach." Final Report of a Research and Demonstration Project, May 31, 1961–August 31, 1966. Dobbs Ferry, N.Y., Children's Village, 1966. Processed.

2: Some Further Doubts / *Douglas Lipton* / *Robert Martinson* / *Judith Wilks**

The Effectiveness of Correctional Treatment

1. In general, offenders serving very short sentences (one to three months) and relatively longer sentences (approximately two years or more) seem to perform better with respect to recidivism than offenders serving sentences of an intermediate length.

2. Early release from institutions (ninety days prior to normal release date) does not produce any noticeable increase in recidivism; and for juvenile and youthful offenders, early release seems to be associated with reductions in recidivism. There is evidence that considerable cost benefits may be obtained by early release with no increase in harm to the community.

3. Adult first offenders seem to have lower recidivism rates when subjected to less restrictive institutional custody, whereas in the case of adult recidivists more restrictive institutional custody is associated with lower recidivism rates. A study of *federal* offenders indicates that both first offenders and recidivists perform better on parole when institutional custody has been less restrictive (medium and minimum custody). These findings, however, must be viewed as very tentative because of the limited comparability among populations studied and because of shortcomings of the research methods utilized.

4. For young offenders who must receive institutionalization, institu-

* Douglas Lipton, Robert Martinson, and Judith Wilks, *The Effectiveness of Correctional Treatment: A Survey of Treatment Evaluation Studies* (New York: Praeger Publishers, 1975), pp. 88, 149, 194, 213, 228, 253, 271, 290, 300, 308, 315, 324, 343, 402, 414, 471, 479. Reprinted by permission.

tions with relative restrictive conditions, combined with two-year terms, may be more effective than less restrictive institutions with shorter terms. Older youthful offenders (ages sixteen to twenty-one) seem to be better able to succeed after being released from less restrictive institutions, particularly when they do not identify themselves with the criminal world.

5. Improvement on psychological personality tests, when coupled with little change on skill tests, seems to be associated with parole success while the converse seems to be associated with parole failure.

6. Good behavior in prison—that is, few institutional rule infractions—seems to be associated with parole success; however, certain institutional treatment problems may actually increase institutional rule infractions while simultaneously contributing to success on parole. Thus, the association between good institutional behavior and parole success may be altered by the effect of treatment programs.

Juvenile and Youthful Offenders

CASE LOAD SIZE

There is no convincing evidence that small case loads have a "treatment" effect—that is, that they alter the behavior of parolees. However, changes in case-load size may produce system effects that influence the success and failure rates of parolees without necessarily altering their behavior. This may come about because parole agents alter *their* behavior, particularly their use of revocation and suspension.

ADEQUACY OF SUPERVISION

Adequate supervision is related to success on parole, is more likely to be given in smaller case loads, and is equally as effective when given in large as when given in smaller case loads. On the other hand, inadequate supervision is negatively related to success, is more likely to be given in larger case loads, but is somewhat more successful when given in larger case loads than when given in smaller case loads. Adequacy of supervision has a stronger impact on success and failure than does the amount of stress or support in the parolee's environment.

Adult Offenders

REDUCED CASE LOADS

There is no evidence that small case loads are significantly different from large case loads in proportions returned to prison or in proportions experiencing a major arrest. There is some evidence that parolees in small case

loads are more likely to remain arrest-free and have fewer minor arrests than those in large case loads, provided supervision is continued through at least a year of parole.

DETERRENCE ON PAROLE

There is some evidence that when frequent contact with a parole agent is combined with a policy of high return to prison, a realistic threat is created. This realistic threat deters offenders within all risk levels from committing new offenses. Combining frequent contact with a policy of low return to prison does not create a realistic threat and therefore does not deter offenders. This latter combination leads to greater toleration of minor (and perhaps major) misbehavior of offenders on parole, thereby keeping larger numbers of offenders out of the penal system.

EMPLOYMENT STATUS ON RELEASE TO PAROLE

Selected offenders may be released to parole without definite assurance of employment with some cost savings to the state but without increased harm to the community. There is fair evidence that releasing offenders to parole-developed jobs is much more likely to be associated with parole failure than releasing offenders to jobs developed by themselves or by family and friends.

The Effect of Vocational Training on Youthful Males

There is evidence that vocationally oriented training programs for youthful offenders (over sixteen) both in institutions and in the community are associated with lower rates of recidivism than standard institutional care or standard parole. These programs appear to be most successful when they provide the offender with a readily marketable skill.

The Effect of Institutional Education on Youthful Males

As mentioned previously, it is difficult to draw conclusions from this group of disparate studies. In general, the special educational programs seem to be more successful, especially when combined with vocational training (and perhaps when taking place in the community), than standard institutional education or standard parole. The evidence indicates that among those experiencing standard institutional instruction, those with the lowest recidivism rates have had previous satisfactory educational experience. (These studies also seem to indicate that such variables as I.Q., level of education on admission, and educational progress during incarceration—

either independently or in combination—condition the effect of education
on recidivism. However, the findings are insufficient to clearly establish
what these relationships are.)

The evidence also indicates that standard institutional education is asso-
ciated with parole success, but not to such a degree as to counteract fully
the negative effects of longer periods of institutional confinement. Unfortu-
nately, the great majority of prison educational programs are simply carbon
copies of standard educational techniques, most of which require lengthy
periods of time. Since for youthful offenders, time spent in institutions is
positively related to recidivism, the possible positive effects of long-term
community educational programs may not be transferable to a penal set-
ting. Perhaps what is needed for institutionalized youth are short-term,
highly intensive, and concentrated programs similar to the techniques cur-
rently used to teach foreign languages.

Finally, the studies indicate that those who improve their educational
achievement are more successful than those who do not, although these
differences are not significant (at the 0.05 level).

The Effect of Vocational Training on Adult Males

In general, vocational training as investigated in the studies surveyed had
little or no effect on recidivism. This lack of effect may be because of the
fact that these programs were applied indiscriminately to all offenders.

From an overall perspective, no clearly positive or negative general
statement can be made as to the effectiveness of individual psychotherapy
in reducing recidivism. Further, adult offenders were not used as subjects
in evaluations, thus limiting the ability to generalize on these study find-
ings. What appears to be tenable is that individual psychotherapy is more
likely to be an effective treatment method (a) when subjects are males
rather than females; (b) when subjects are between sixteen and twenty,
rather than under sixteen years of age; (c) when the therapy has a prag-
matic orientation (that is, is oriented toward "street" problems) rather than
a psychoanalytic orientation; (d) when the subjects are amenable to treat-
ment rather than nonamenable; it may, in fact, do more harm than good to
nonamenable youngsters; (e) when it is enthusiastically administered by
interested and concerned therapists rather than routinized; and (f) when it
is administered in conjunction with other treatment methods rather than
administered independently.

Considering the amount of support group treatment methods have re-
ceived, it is surprising that there are so few reliable and valid findings
concerning their effectiveness. In addition, where favorable results were
found, reductions in recidivism were relatively small.

Male Offenders

1. With incarcerated young male offenders (under eighteen) group counseling alone is no more effective in reducing recidivism than community meetings, or than community meetings in combination with group counseling, or than routine institutional care.

2. With incarcerated young male adult offenders (eighteen to twenty-five), group counseling does not significantly contribute to parole success.[1]

3. With incarcerated male adult offenders (over twenty-one), group counseling seems to be effective with good risks and first offenders but is much less effective with "hardened" offenders—that is, those with long criminal histories, or those who have committed serious criminal acts.[2]

4. Community meetings or the combination of group counseling and community meetings with male adult offenders seem more effective than group counseling sessions alone.

In Robison,[3] two forms of milieu therapy are compared with each other and with standard institutional treatment. The first form involved large group meetings followed by small group meetings; the second involved daily community meetings within a highly structured living situation. After one year of follow-up, those in milieu therapy had a significantly lower recidivism rate than those receiving standard institutional care. However, this difference disappeared after two years. There was no apparent difference between the success rates of the two types of milieu therapy.

In a major California study,[4] a form of milieu therapy ("community living") was evaluated. "Community living" consisted of fifty-man living groups meeting as a whole four times a week with three specially trained leaders attached to the unit. These large group meetings were supplemented with small group counseling once a week. Participation in this program was mandatory. (This study was conducted in a newly opened medium-security facility—California Men's Colony East—composed of four "quads" separated by a central control area so that interquad movement could be monitored and controlled via television from a centrally located guard tower. The study randomly assigned incoming inmates to the various treatment and control conditions within three of the quads. Hence, this study involved the most extensive research intervention ever attempted in the correctional field.)

Community living was compared with voluntary regular group counseling (a type of group counseling led by regular institutional staff widely utilized in California corrections), with "Research Counseling" (mandatory intensive counseling with specially trained lay leaders), with voluntary nonparticipation in group counseling (that is, the group counseling was available to the inmate but he chose not to participate), and with routine institutional care (group counseling was not available).

At thirty-six months' follow-up, there were no significant differences between any treatment group and the controls on any measure of recidivism—number of misdemeanor arrests and felony arrests, total number of weeks spent in jail, most serious disposition received, proportions returned to prison, jailed for "major" or "minor" trouble, and the proportions with no recorded arrest. When success is defined as no dispositions or only arrest or jail for less than ninety days, the highest rates of success were for controls (42 percent) and Research Counseling (43 percent); the *lowest* rates of success were for community living (30 percent) and voluntary nonparticipation (34 percent). The success rate for regular group counseling was 40 percent.

Because of the noncomparability of this small number of studies, and the lack of consistency of results, it is difficult to interpret these findings. However, the apparent lack of success of these halfway house experiences may constitute an additional period of deprivation of liberty for the experimentals when compared with the controls. For example, at the East Los Angeles Halfway House, Fisher reported that when halfway house residents compared their status to the relatively greater freedom of parolees released to standard parole, they became resentful.[5] The one study that reported some positive effects for a halfway house program (Hall, n.d.) released federal prisoners to the halfway houses prior to their normal parole release dates and thus may have avoided such resentment.[6] However, the program had differential effects on different categories of offenders. The program was most successful with offenders with prior commitments who were also Dyer Act offenders with or without codefendants; it was least successful, and perhaps harmful, with offenders without prior commitments who were also not car thieves and were involved with one or more codefendants.

Another factor contributing to the apparent lack of success of halfway houses as currently operated may be the authoritarian reaction of halfway house staff to attempts by residents to avoid restrictions on their behavior—for example, many residents may feel that the standard rules of halfway houses are unrealistic.

There is a clear need for research designed to determine the effectiveness of such programs with parolees released to halfway houses one, two, or three months (or more) prior to their parole dates and to halfway houses with different kinds of restriction on the behavior of residents.

Effects of Castration on Sex Offenders

Stürup [7] investigated the effects of castration on habitual sexual offenders in Denmark. The recidivism rates of castrated sexual offenders were compared over a twenty-year period with rates of noncastrated sexual offenders who had been treated with hormones and psychoanalysis. Interpre-

tation of this study is hindered by its ex post facto design and by the fact that the two groups were incarcerated for differing lengths of time. Castrated sex offenders committed far fewer new sex crimes than noncastrated sex offenders. Castrated offenders also committed fewer nonsex crimes than noncastrated sexual offenders.

Summary

1. Tranquilization (alone) of incarcerated youth does not seem to produce any reduction of recidivism, and for incarcerated girls when combined with routine institutional care, it may be less effective than simply providing routine care alone.

2. Tranquilization combined with psychotherapy seems to be more effective with incarcerated male youth in reducing recidivism than either psychotherapy alone or drugs alone, but with incarcerated girls tranquilization with or without psychotherapy seems to be contraindicated.

3. Plastic surgery alone given to addict or to nonaddict disfigured misdemeanants is not superior to no treatment. However, addicts and nonaddicts appear to stay out of prison significantly longer if they have undergone surgery. The combination of plastic surgery with private casework services seems to reduce recidivism for addict offenders but not for nonaddict offenders. For addicts, private casework services alone (a much less costly treatment than plastic surgery) is also significantly better than no treatment. Private casework given to nonamenables may have a harmful effect, but more research is needed to substantiate this finding.

It is difficult to draw any specific conclusion on the basis of two studies, especially since they used different measures of institutional adjustment. In fact, these studies reach different conclusions: Cohen [8] found increasing adjustment with length of time in prison and Rudoff [9] found the reverse. Since the Rudoff findings may be accepted with greater certainty, one may feel safer in concluding that shorter time leads to better adjustment. However, the relationship between length of incarceration and adjustment still needs to be investigated. It may well be that the individual in prison does improve his attitude toward prison as he settles in (Cohen), but that as his exposure to prison increases, he has more opportunity to commit and to be observed committing rule infractions.

Unfortunately, no studies were found in the survey that could provide correctional administrators with information useful in facilitating the institutional adjustment of different types of inmates. Such research is needed.

More important, however, is the question of what institutional adjustment means and how it is related to the offender's behavior when he is returned to the community. Clearly, it does not take the same skills to

adjust to a rigidly structured, highly disciplined environment that it takes to adjust in a free society.

Effects on Institutionalized Adults

At the Federal Reformatory in Chillicothe, Ohio, Persons [10] found that among young male adults who received twenty individual psychotherapy sessions over a ten-week period, there was only one disciplinary report, contrasted to thirty-eight disciplinary reports lodged against comparable control group members during the same period. (It is unclear whether institutional staff knew which men were in therapy and which were controls; thus it is not known whether favoritism was exercised in the form of greater tolerance of institutional violations by experimentals than by controls.)

Rudoff,[11] in a study of the impact of individual psychotherapy upon institutional adjustment of young adult males, reported that there were no significant differences in disciplinary rates between those receiving the psychodynamically oriented therapy and those receiving routine institutional care. (It is interesting to note that those experimentals judged nonamenable to this treatment had the lowest mean disciplinary rate, followed by nonamenable controls, amenable experimentals, and amenable controls.) However, there was an evident trend favoring those who received greater treatment exposure and spent less time in the institution. Although no significant differences between E's and C's were found relative to institutional adjustment, those offenders (whether they had been E's or C's) who were most successful on parole had significantly better institutional disciplinary histories than did parole violators. This implies that something other than participation in an individual psychotherapy program is related to the institutional and postinstitutional performance of the offenders studied by Rudoff.

In summary, individual psychotherapy appears to have different effects upon the institutional adjustment of younger and older offenders. Younger male offenders appear either to be unaffected by the treatment or to have more disciplinary problems than untreated youngsters; older (but still relatively young) male inmates appear either to be unaffected or they have fewer disciplinary problems during treatment.

Kassebaum [12] evaluated the impact of group counseling led by lay counselors (institutional staff untrained in counseling techniques) who met with the newly admitted adult inmates of California Men's Colony-East approximately once a week. These group sessions were oriented around inmate problems typically associated with institutional living. When the participants in these sessions were compared with a group not receiving such counseling, there were no significant differences between the two groups

relative to prison rule violations or in the degree to which the groups endorsed the inmate code.

The negative findings reported in the Kassebaum study of older offenders (over eighteen) seem to indicate that early group counseling improves the institutional adjustment only of youthful offenders and that it may improve institutional adjustment only when administered by "professional therapists."

Effects in a Maximum-Security Institution

Kessemeier [13] investigated the effect of group counseling on the number and seriousness of disciplinary infractions among offenders in a maximum security institution (Folsom, California). He found that those enrolled in group counseling had significantly fewer disciplinary infractions than those not enrolled; and that those enrolled had, in addition, less serious rule violations. However, this finding is confounded by the fact that those who volunteer for treatment in an institution are inmates who are less likely to be troublemakers.

These studies indicate that institutional group counseling, particularly when administered to newly admitted youthful offenders, does improve institutional adjustment. Furthermore, this impact is most pronounced when the "right" counselor is assigned to the "right" group of offenders.

It should be kept clearly in mind, however, that therapeutic techniques that produce good institutional adjustment may or may not produce good adjustment in free society. As noted in previous discussions of institutional adjustment, skills required to get along in an institution may not be the same skills required to get along in the community.

In general, regardless of whether the program is operated for juvenile, youthful, or adult offenders, milieu therapy appears to increase institutional adjustment. Although there may not be significant reductions in the number of rule infractions that occur, there does appear to be a change in the social structure and atmosphere within units that operate with milieu therapy. The result of these changes is that inmates who participate actively in treatment are not discriminated against by other inmates as they appear to be when living units are not organized around milieu therapy. Thus, Levinson [14] found that the most popular boys in the treatment unit were the "rule-followers," and Studt [15] found that inmates with problem-solving adaptations were not isolated.

Programs of this sort appear to increase positive inmate-staff relationships and tend to be productive of positive attitudes among staff members in the milieu therapy unit toward inmates. However, whether the type of

institutional adjustment encouraged by milieu therapy is comparable to the type of adjustment required by the offender in the community is debatable. Milieu therapy may produce a "cool" institution, but further evidence is required to determine whether institutional adjustment of this sort benefits the offender outside the institution.

In general, it appears that offenders can learn vocational skills in both institutional and noninstitutional settings. However, it is not clear that these skills benefit the offender once he is released from the training program. There is only one fairly solid finding of increased vocational adjustment as the result of an institutional program.[16] Williams [17] shows that after treatment in an in-patient clinic and participation in a vocational rehabilitation program in the community, alcoholics tend to increase their job stability, but, overall, his findings are difficult to interpret. Gearhart's findings [18] are clearly negative and Glaser's findings [19] fail to show any substantial, positive result from institutional training.

The current emphasis on job training as a solution to social problems does not seem to be supported by these few findings. Apparently, something more needs to be added if vocational training, particularly in the institutional setting, is going to improve the vocational adjustment of offenders. Perhaps what is needed is more intensive follow-up training for the offender once he is released from the institution. This follow-up training would have to be geared to the needs of the particular individual and might take the form of teaching him how to get and keep a job under the employment conditions he is likely to confront.

It should be noted that institutional vocational training may serve to develop unrealistic expectations. That is, the offender may conclude that after training he has all the job skills necessary to succeed as an employee in the open community, but once he encounters employment difficulties he, in effect, gives up. Furthermore, it is important to make certain that the vocational training programs and work experience in institutions are geared to the job opportunities that are available for offenders. To teach offenders building trades when positions in unions are not available to them or to teach them to be electronic data-processing machine operators when employers are unwilling to hire them in that capacity may very well be more detrimental than not training them at all.

When the independent and dependent variables are as varied as they are in studies of "probation" and "attitude and personality change," it is difficult to state any general findings. An equally serious problem encountered in attempting to draw conclusions concerning the impact of probation and related programs on offenders' attitudes and personality characteristics is the atheoretical nature of most programs and of the research evaluating these programs. Thus, it is not clear why it should be anticipated that probation or its component operations (for example, counseling, surveillance) should produce attitude and personality changes in general, or par-

ticular changes measured by the available tests or why attitude and personality change among probationers would be considered beneficial.* Only infrequently has evaluative research attempted to link attitude and personality changes to criminal behavior. Research findings have not conclusively indicated that possession of certain attitudes or personality traits is directly linked (or even indirectly linked) to specific criminal behavior in general or to their avoidance of specific forms of criminal behavior or criminal behavior in general.

In general, it appears that institutions do have an impact upon personality traits measured by psychological tests, attitudes toward self and others, and value orientations. It is reasonable to conclude that offenders both in institutions for juveniles, and in minimum- and medium-security institutions for adults, display less aberrant patterns of test results after incarceration. On the other hand, offenders in maximum-security institutions do not display this tendency. Juvenile institutions do appear to generate feelings of anxiety and defensiveness in their inmates while at the same time making them conscious of rules and regulations. This implies that such institutions may be more oriented toward discipline than many might think. However, the sample of cases is too limited to consider this as more than a speculation.

In general, milieu therapy had a positive effect upon attitudes and responses to personality tests, when comparisons were made of offenders' scores at intake into the program and at some later date or when milieu therapy was compared with regular institutional treatment. However, this effect did not appear to be as great when the offenders were youthful recidivists, or when the milieu therapy was of a nonresidential sort. In one study it appeared that probation had more impact on personality and attitude change than did milieu therapy.[20]

Unfortunately, there are few studies that assess the relationship between attitude and personality change and performance outside of the institutional

* In addition to apparently assuming that probationers have certain personality traits or attitudes that should be changed or supplanted with more constructive traits or attitudes, treatment attempts designed to change attitudes and personality traits assume that there are universally agreed-upon, acultural concepts defining what constitutes mature, acceptable, constructive behavior under most circumstances. However, what is mature, acceptable, constructive behavior varies with time, culture, community, and with the person who is doing the defining. Attempts to change personality characteristics and attitudes tend to exalt unduly one particular set of attitudes and characteristics at the expense of others. Furthermore, the idea that the state has the right to supervise the individual for the purpose of coercing him to have selected attitudes and personality characteristics clashes with the presumption that the individual is entitled to the freedom of developing his own attitudes and personality traits. Unless it can be established that some particular personality traits and attitudes that characterize the individuals are actually the cause of his criminal or delinquent behavior, there is little basis for the state to require him to change. In addition, program planners should recognize that to the degree that attitudes and personality traits held by individuals assist them to adjust to their environment, changes in the probationers' attitude and personality traits unaccompanied by environmental changes may be more harmful than helpful to the individual.

setting.* Furthermore, few studies have indicated the stability of the changes that occur—that is, we do not know the degree to which positive and negative changes that may occur within the institution persist after the offender is released from the program. It may well be the milieu therapy programs generate changes because of institutional and group support, and when these are removed at the time of institutional release, the individual reverts to his previous attitudes. Or it may be that milieu therapy "shakes up" the offender, and he is in a state of change, which may be unstable and problematic, at the time of release. Or milieu therapy may generate "great expectation," which cannot be met by the offender once he is released into the community. These are all things that require further investigation before we can assess the importance of the attitude and personality changes that occur as a result of the experience of milieu therapy.

Effects on Disturbed Youths

Splitter tested the use of nortriptyline, another psychic stimulant, to alleviate behavior difficulties of sociopathic youngsters ten to twenty years of age.[21] He noted that almost three-fourths of the subjects were rated at follow-up as excellent or good and that abnormal impulsive behavior and impaired concentration seemed to improve early with the drug. Depression and mild anxiety improved readily as well. The drug made psychotherapy possible for almost half the subjects. However, the conclusions from this report must be viewed with some caution because of the absence of control subjects.

Effects on Disturbed Adult Females

In a New York City women's prison, O'Malley measured the effect of trifluoperazine, a systemic tranquilizer, on disturbed female inmates who were referred to the psychiatric service.[22] After eliminating patients who reacted to a placebo from the study, the authors determined that the drug

* Irwin Deutscher argues that we have "sufficient grounds to reject any evaluation program which employs attitudinal change as a criterion of 'success,' except in the unlikely event that the goal of the program is solely to change attitudes without concern for subsequent behavioral changes." ("Words and Deeds," *Social Problems* 13, no. 2 [Winter 1966]: 250.) This is especially true for correctional research, which has spent half a century developing a set of criteria (recidivism) that are both socially legitimate and measurable in relatively reliable and sophisticated ways. However, it is equally true to say that many of the studies in this survey that use only recidivism as the criterion of success are unable to provide any cogent explanation of why they achieved the results they did. A good piece of correctional research should assess the process by which the program produces changes in recidivism.

did relieve symptomatic distress, and for most patients relief occurred within the first two weeks. The findings of the report unfortunately are somewhat uninterpretable because of sample attrition and other internal validity questions.

The conclusions to be drawn from the chemotherapy reports cited above are relatively simple. Like free citizens, prisoners react to chemical agents with the expected personality change or the expected amelioration of distress symptoms. It seems evident that some drugs may be employed to prevent acting-out inside jails and institutions. This utilization of drugs should not be confused with attempts to reduce crime, protect public safety, or restore offenders safely to the community.

If institutional administrators have as their goal the management of disturbed inmates or inmates who are potentially dangerous either to themselves or others, drugs may be useful. For the nervous, depressed, and anxious inmate, the drugs amitriptyline, protriptyline, and nortriptyline seem to be useful. For the aggressive and agitated inmate, stronger tranquilizers such as diazepam seem appropriate. Administrators should be aware of the possible negative physical, social, and political results which may occur when drugs are administered to offenders and should carefully weigh costs and benefits of drugs as a management device.

NOTES

1. Gene G. Kassebaum, David A. Ward, and Daniel M. Wilner, *Prison Treatment and Parole Survival: An Empirical Assessment* (New York: John Wiley & Sons, 1970).

2. Robert M. Harrison and Paul F. C. Mueller, "Clue Hunting about Group Counseling and Parole Outcome," Research Report No. 11, California Department of Corrections, May, 1964, mimeographed.

3. James Robison and Robert Ogle, "Intensive Treatment Program: Phase II—Group Interaction Study," Research Report No. 26, mimeographed. (California Department of Corrections, February 1967).

4. Kassebaum, Ward, and Wilner, *Prison Treatment*.

5. Sethard Fisher, "The Rehabilitative Effectiveness of a Community Correctional Residence for Narcotic Users," *Journal of Criminal Law, Criminology, and Police Science* 56(1965): 190–196.

6. Reis H. Hall, Mildred Milazzo, and Judy Posner, *A Descriptive and Comparative Study of Recidivism in Pre-Release Guidance Center Releasees* (Washington, D.C.: U.S. Department of Justice, Bureau of Prisons, n.d.).

7. Georg K. Stürup, "The Treatment of Sexual Offenders," *Bulletin de la Societe Internationale de Criminologie*, 1960, pp. 320–329.

8. Bruce J. Cohen, "Differential Correctional Treatment Programs and Modification of Self Image," unpublished Ph.D. dissertation, Michigan State University, 1965.

9. Alvin Rudoff, "The Effect of Treatment on Incarcerated Young Adult Delinquents as Measured by Disciplinary History," unpublished Master's thesis, University of Southern California, 1960.

10. Roy W. Persons, "Psychotherapy with Sociopathic Offenders: An Empirical Evaluation," *Journal of Clinical Psychology* 21(1965): 205–207.

11. Rudoff, "Effect of Treatment."

12. Kassebaum, Ward, and Wilner, *Prison Treatment*.

13. L. A. Kessemeier, "Does Group Counseling Pay Its Way?" *Correctional Review*, March-April, 1966, pp. 26–30.

14. Robert B. Levinson and Howard L. Kitchener, "Treatment of Delinquents: Comparison of Four Methods for Assigning Inmates to Counselors," *Journal of Consulting Psychology* 30(1966): 364.

15. Elliot Studt, Sheldon L. Messinger, and Thomas P. Wilson, *C-Unit: Search for Community in Prison* (New York: Russell Sage Foundation, 1974).

16. Clyde E. Sullivan and Wallace Mandell, *Restoration of Youth Through Training: A Final Report* (Staten Island, N.Y.: Wakoff Research Center, April, 1967).

17. James H. Williams, *Florida Project on Follow-Up Adjustment of Alcoholic Referrals for Vocational Rehabilitation* (Florida: Alcoholic Rehabilitation Program, 1967).

18. J. Walter Gearhart, Harold L. Keith, and Gloria Clemmons, "An Analysis of the Vocational Training Program in the Washington State Adult Correctional Institutions," Research Review No. 23, State of Washington, Department of Institutions, May, 1967.

19. Daniel Glaser, *The Effectiveness of a Prison and Parole System* (New York: Bobbs-Merrill, 1964).

20. Richard M. Stephenson and Frank R. Scarpitti, "The Rehabilitation of Delinquent Boys: Final Report," Rutgers University, 1967.

21. Samuel R. Splitter and Milton Kaufman, "A New Treatment for Under-Achieving Adolescents: Psychotherapy Combined with Nortriptyline Medication," *Psychosomatics* 7(1966): 171–174.

22. E. P. O'Malley and H. Bluestone, "Trials and Tribulations in Conducting a Drug Study in a Women's Prison," *Psychosomatics* 61(1965): 95–99.

3: An Evaluation of Eighteen Projects Providing Rehabilitation and Diversion Services[1] / *Robert Fishman**

Background

The Criminal Justice Coordinating Council (CJCC) was set up by the City of New York to administer, at the local level, national funds channeled to it, through the state's Office of Crime Control Planning, from the Law Enforcement Assistance Administration (LEAA) that was created by Congress in 1968.

* This article is part of a summary, with updating, of "An Evaluation of the Effect on Criminal Recidivism of New York City Projects Providing Rehabilitation and Diversion Services: A Final Report to the Mayor's Criminal Justice Coordinating Council, March 31, 1975." The report will be published, in slightly modified form, as Robert Fishman, *Criminal Recidivism in New York City: An Evaluation of the Impact of Rehabilitation and Diversion Services* (New York: Praeger Publishers, 1977). Reprinted by permission.

In addition to supporting such institutionalized elements of the criminal justice system (CJS) as police, courts, and prisons, the CJCC found itself heavily committed, through a variety of projects, to a strategy of rehabilitation programs. The emphasis in these was on services to offenders, ex-offenders and, in some cases, "pre-offenders."

The target groups of clients for these "people programs" were described in the CJCC annual plans of 1971–1973. They were generally those clients who pose a major problem in the control and prevention of crime, particularly serious and violent crime, and who comprise a large segment of the criminal justice system population in New York City. The CJCC placed particular emphasis on males: juveniles, youths, and young adults; blacks and Hispanics; ex-convicts; the poor and undereducated; drug addicts; and, for preventive purposes, some first offenders.

The rehabilitation relied primarily on combinations of remedial education, job referral—training or placement; counseling; and legal aid and drug-addiction treatment (provided by, or referred to by, municipal or voluntary agencies and community groups). Many of the projects also provided "diversion" from the processes of the criminal justice system. Under this concept, offenders (mainly juveniles and young adults) who are thought to be better suited for "people projects" than for the conventional CJS, are remanded or released to such programs (while some are conditionally released without service, as on bail or probation).

For purposes of orderly administration, the CJCC found that it had to know a variety of things about these programs:

—To make decisions about modifying, re-funding, and institutionalizing them, it had to know their individual and collective criminological effects on their clients.

—To make the same or similar decisions, it needed information that would enable it to compare the criminological effect of different projects on the same types of clients.

—To monitor the programs and to be able to make program adjustments in midstream, it needed information about how criminological impact was related to such program characteristics as type, mix and quality of services offered, staff-client ratio, and the proportion of professional to paraprofessional staff.

—To make policy and broader programmatic decisions, it had to know the relationship between a client's criminal history and his criminal behavior after he entered a project.

To satisfy these needs, a part of a project's gross budget—usually 5 to 10 percent—was set aside for evaluation, generally by academics or consulting firms on subcontracts. Since these evaluators were responsible to the individual project directors rather than to the CJCC, their objectivity, in some cases, was questionable. Moreover, the natural and inescapable outcome was an enormous variety of evaluation goals, designs, methods, resources, and competence of the individual evaluators. This variety made it virtually impossible for the CJCC to compare the criminological effectiveness of different program models in serving similar types of clients: an

evaluation that defined recidivism as reincarceration, for instance, could not be compared with evaluations that defined it as rearrest, reconviction, or change on an attitude scale.

In response to these problems and some of the agency's management information needs, an evaluation plan was proposed for a centrally conducted, standardized effort. It was funded in July 1971, and completed in March 1975.

During the evaluation, special emphasis was directed at violent crime against persons—the most traumatic of the crime problems shared by large cities. The thrust of this emphasis shaped the analysis and the conclusions that follow.

Method

DESIGN

As a common goal for the CJCC and its projects, the evaluation used the reduction of crime mandated by the enabling legislation.[2] Services were to be evaluated on their ability to achieve *that* goal; accordingly, a particular program's services—education or job placement, for example—would be measured *criminologically*. These services were treated as the methods (the independent variables) by which the goal was to be reached. The common measure of achievement (the dependent variable) was criminal *behavior,* as opposed to legal dispositions, of which arrests were considered to be the most accurate measure available. Convictions appeared to be a less accurate measure because plea-bargaining and legal considerations of guilt skew this figure in the direction of understating criminal behavior. (In 1974, for example, 80 percent of all felony arrests in New York City were disposed of by lower courts empowered to adjudicate only misdemeanors.) [3] In addition, the incarceration rate in New York City was found to be so low that it was deemed the least accurate measure of criminal behavior.

The study, from the very outset, was designed to allow assessment of the projects' criminological effects (individually and comparatively) on the primary CJCC target groups of clients described above.[4] In so doing, it had to control for those client characteristics most related to recidivism. It was important, for example, to be able to ascertain separate recidivism rates for a project's seven- to twelve-year-old male juvenile first offenders and for nineteen- to twenty-year-old male serious offenders among its clients, since the project might be effective with one group but not the other. This was, of course, even more essential in comparing the project's criminological effectiveness with seven- to twelve-year-olds or nineteen- to twenty-year-olds with those age groups in other "competing" projects. The three client characteristics selected were age, sex, and prior criminal history.[5]

AGE

Age, in New York State, is a key deciding factor in arrest, type of court, dispositions available, and conditions of release or incarceration. The four basic age groups were seven to fifteen for juveniles, sixteen to eighteen for youthful offenders, nineteen to twenty for adults, and twenty-one and older for a second adult category.[6]

SEX

Only males were analyzed since females make up a relatively small proportion of those who commit serious crimes and the number of females in most of the projects was too low for valid statistical analysis.

PRIOR CRIMINAL HISTORY

Severity of criminal history before project entry is generally considered as an important predictor of recidivism after entry.

DATA COLLECTION

Because the unit of measurement was to be arrests, it was necessary to collect and prepare the data about project clients to allow accurate matching with official arrest records. This created many problems, since the projects were not only different from each other in programmatic format but also enjoyed considerable autonomy. Their record-keeping systems and their records were as individual as their programs.

A first evaluation step was to design and implement a Standard Intake Form in the projects that would, among other things, yield data necessary to retrieve arrest records. In addition, the evaluation had to create an entire system for making that form a practical instrument and for checking constantly to see that it remained so. Initially, there was a very high error rate on important items of the form; e.g., misspelled names and incorrect ages. In some projects, there was resistance to providing any data. The problems and resistance were encountered for such reasons as incompetence by project staff and objections related to the principle of confidentiality.

Other data-retrieval problems had to be solved in obtaining arrest records from the police. Juvenile and adult records were kept in different places and in different ways and required different methods of identification for retrieval. After resolving problems of implementation, the evaluation achieved one of its intended goals by establishing an ongoing system of measuring the criminological effects of larger projects. But this system was not institutionalized by the CJCC.

PROJECTS

As Table 3–1 shows, four out of fifty-three projects under the CJCC did not submit intake forms; [7] the remaining forty-nine submitted a total of

27,733 intake forms. Data from thirty-one of the forty-nine projects were not analyzed because there was not enough time to process their records or because they did not contain enough clients to permit analysis or because their clients were female.[8]

To understand fully the reasons for the lack of time and clients, it should be noted that for a client to be included in the analysis there had to be a minimum twelve-month duration after project entry, during which criminal behavior would be measured. For any project, there had to be enough male clients of the required ages who met these criteria, at the time of selection, to satisfy statistical requirements for analysis (initially 100, finally 50). Furthermore, the fifty-three projects were funded and became fully operational at widely differing times during (and prior to) the evaluation. Thus, newer projects generally did not have enough clients who met evaluation criteria at the time of selection.

Because the evaluation had to meet a deadline for a final report, identification of the clients who met the criteria had to be cut off in time for use in that report. The interaction of these factors made it impossible to analyze thirty-one of the projects, as mentioned above.[9]

This left eighteen projects, with a total of 20,924 intake forms. The eighteen projects were not a "sample" selected from the fifty-three at one point in time, but constituted *the universe of all projects* that had enough clients to satisfy evaluation criteria at the time of selection.

The eighteen projects were similar in that they all provided rehabilitative or diversion services primarily outside of prison. However, they varied enormously in such important characteristics as auspices (community-based groups, private foundations, or city agencies); staffing (by para-professionals and professionals); status (new projects versus existing ones); nature of service (diversion and nondiversion); funding (a few hundred thousand dollars versus several million—Table 3–2). In addition to some combination of services toward remediation, jobs, counseling, and/or diversion, residence was provided by three, recreation by three, and legal assistance by two. The total LEAA funding for the eighteen projects which varied in duration was $14,590,000.

It appeared, upon careful inspection of the projects and their records, that the eighteen projects were basically representative of most nonprison approaches to rehabilitation of this type in New York City and elsewhere.

CLIENTS

As with the projects, there was no "sampling" of the standard intake forms for the clients.[10] Sampling implies the use of only a portion of all forms that meet criteria. The *universe* of all forms was used for all clients from the eighteen projects who met the evaluation project's strict criteria for age, sex, twelve-month duration after project entry by the analytic cutoff dates, and availability of all data needed for police-record retrieval at the times clients were selected for evaluation. Thus, from the total of

TABLE 3-1
Summary of Information Retrieval, Processing and Reporting

Project Name	Acronym for Analysis	Contract Number	Monthly Case Activity Report	Client Intake Forms			
				Number Received	Number Punched	Validation at Project	Analyzed for Report
1. Addict Diversion Program	ASA	57798	+	1,772	979	+	333
2. Addicts Rehabilitation Center	ARC	56964	+	2,040	477	+	264
3. Alternative School for Exceptional Children		62964	+	151	41	—	117
4. Altern. to Detention – HRA	ATD-HRA	50411	—	938	401	+	117
5. Altern. to Detention – Probation	ATD-PROB	50411	—	602	529	+	220
6. Bed.-Stuy. Ex-Offender		56965	+	210	79	—	—
7. Corrections Educ. Career Dev. Prog.		69838	+	—	—	—	—
8. Co-Workers Cooperative Project		64558	+	178	47	—	—
9. East Harlem Halfway House		73300	+	79	—	—	—
10. Encounter		59315	—	116	—	—	—
11. Family Court Rapid Intervention		59895	+	—	—	—	—
12. Fortune Society Employment Unit		68313	+	372	—	—	—
13. Frontiers for Families		62012	+	458	249	+	—
14. Harlem Probation		62762	+	175	144	+	—
15. Holy Apostles Center		72177	+	103	—	—	—
16. Independence House	INDH	61685	+	569	321	+	56
17. Juvenile Employment Ref.		74937	+	—	—	+	—
18. Legal Aid Society – Juvenile Services		67752	+	1,409	622	+	—
19. Legal Propinquity	LPQ	60372	+	207	150	+	55
20. Mobilization for Youth – Juv. Court Div.		66559	+	178	51	—	—
21. Morrisania Youth Serv. Center	MLA	55332	+	410	379	+	166
22. NAACP Project Rebound	NAACP	56445	+	795	541	+	190
23. Neighborhood Youth Diversion	NYD	57871	+	702	598	+	133
24. N.Y. Lawyers Com. for Civil Rights – Supv. Rel.		57980	—	84	—	—	—

No.	Program	Abbr.	Code						
25.	The Osborne Residence		62418	+	100	29	—	—	—
26.	Positive Altern. – Univ. of the St.		63977	+	138	71	—	—	—
27.	Pre-trial Services Agency		66635	+	236	—	+	—	—
28.	Private Concerns, Inc.		73298	+	76	—	—	—	—
29.	Probation – Urban League	PUL	60785	+	372	336	+	92	
30.	Project BYCEP	BYCEP	50803	+	559	469	+	63	
31.	Project Manhood	MANHD	49764	+	1,787	1,135	+	185	
32.	Project Second Chance	SCH	59545	+	733	539	+	160	
33.	Project Share	SHARE	58945	+	346	160	+	31	
34.	Protestant Board of Guardians	PBG	57872	+	839	532	+	172	
35.	Puerto Rican Assoc. for Com. Action		70723	+	157	—	—	—	
36.	Puerto Rican Forum Offender Prog.		72027	+	96	—	—	—	
37.	Queens Probation Reading Clinic		65715	+	374	207	+	—	
38.	QUERER		72179	+	324	—	+	—	
39.	Richmond Probation Reading Clinic		70724	+	183	—	—	—	
40.	SERA Manpower Unit		73092	+	215	—	+	—	
41.	Sloane House YMCA – Dept. of Corr.		68176	+	171	—	—	—	
42.	St. Peter's Youthful Offender Prog.		74538	+	46	—	—	—	
43.	Theatre for the Forgotten		63710	+	—	—	—	—	
44.	United Neighborhood Houses		66466	+	268*	124*	—	—	
45.	Vera Supportive Work Program: Wildcat	VERA	62914	+	1,712*	815*	+	219*	
46.	Vocational Remedial Educ. Trng. Proj.		70473	+	155	—	+	—	
47.	VOI – Bronx Com. Counseling	BCC	56446	+	1,260	882	+	283	
48.	Wiltwyck Bklyn. Com. Care		55722	+	225	192	—	—	
49.	Wiltwyck School Group Homes		56870	+	19	10	—	—	
50.	Women's Diversion		58498	–	38	—	—	—	
51.	Women's Education		55161	+	180	165	—	—	
52.	Youth Counsel Bureau	YCB	57933	+	5,281	2,288	+	121	
53.	Youth Services Bureau – Bushwick		61463	+	295	180	—	—	
	TOTAL			48	27,733	13,742		2,860	

*Includes a control group.

TABLE 3-2
Project Summaries

Project-Component	Duration	LEAA Funds	Client Types	Services Provided	Funding
1. ADDICTS REHABILITATION CENTER (ARC) Resident and Non-Resident Day Care	01.01.72 to 06.30.74	$ 971,000	Narcotics Addicts Male and Female Ages 9+	Residency, drug-free treatment, counseling emergency referrals	CJCC ended – Picked up by NIMH
2. ASA ADDICTS DIVERSION (ASA)	01.22.71 to 11.30.74	$ 2,032,000	Narcotics related court cases; Male and Female; 17+	Diversion, screening, and placement in treatment; follow up	CJCC ended – picked up by ASA
3. VERA SUPPORTIVE WORK (VERA) Wildcat Control Group	07.01.72 to 06.30.75	$ 2,000,000	Ex-addicts and ex-offenders; Male-Female; Ages 18+	Supervised work and training in Wildcat Corp.; counseling	CJCC extended to 06.30.75
4. INDEPENDENCE HOUSE (INDH) Long-Term Service Short-Term Service	07.01.72 to 06.30.74	$ 561,000	Ex-offenders and YSA referrals; Male only; Ages 17-21	Residency, vocational and educational counseling	CJCC extended to 06.30.75
5. MORRISANIA YOUTH SERVICES CENTER (MLA) Legal Services	09.07.71 to 03.26.74	$ 760,000	Criminal Court and Fam. Court cases; M-F; Ages 9-21	Diversion, legal assistance, counseling and referral	CJCC ended – not picked up
6. PROBATION-URBAN LEAGUE (PUL)	04.26.72 to 04.15.74	$ 1,546,000	Probation cases; Male and Female; Ages 14-21	Diversion, probation supervision; counseling and recreation	CJCC ended – not picked up
7. PROJECT BYCEP (BYCEP)	04.01.71 to 11.30.73	$ 498,000	Ex-inmates Adol. Remand. Shelter; Males; Ages 16-21	Counseling, referral, and follow up	CJCC ended – not picked up
8. LEGAL PROPINQUITY (LPQ)	05.01.72 to 04.30.74	$ 127,000	Misdemeanor or low felony arrest; M-F; Ages 15-20	Legal assistance, counseling and referral	CJCC ended – not picked up
9. YOUTH COUNSEL BUREAU (YCB) Long-Term Parole	12.01.71 to 04.26.74	$ 298,000	First offenders and DA-referred cases; M-F; Ages 16+	Diversion, supervision, counseling, follow up	CJCC ended – city continued

	Dates	Amount	Population	Services	Status
10. VOI BRONX COMMUNITY COUNSELING (BCC) Day, Evening, Teenage	06.01.70 to 07.15.73	$ 873,000	Addicts and ex-offenders; Male and Female; Ages 13+	Diversion, counseling, remedial ed. job training, addiction treatment	CJCC ended – picked up by NIMH
11. PROJECT SHARE (SHARE) Resident Non-Resident	03.01.72 to 06.30.75	$ 533,000	Ex-offenders; Males; Ages 18+	Counseling, job prep and referral, emergency residence	CJCC extended to 06.30.75
12. SECOND CHANCE (SCH)	02.01.72 to 10.31.74	$ 283,000	Ex-offenders; Males; Ages 21+	Job counseling and referral; follow up	CJCC ended – picked up by MCDA
13. MANHOOD (MANHD) Counseling Sessions only, Job Referral	01.01.71 to 07.31.73	$ 617,000	Ex-offenders; Male and Female; Ages 16+	Job counseling and referral	CJCC-funded as Operation Upgrade
14. NAACP REBOUND (NAACP) Intensive Non-Intensive	09.15.71 to 07.31.74	$ 322,000	Ex-offenders; Male and Female; Ages 21+	Job and educational counseling, job referral	CJCC ended – picked up by MCDA
15. NEIGHBORHOOD YOUTH DIVERSION (NYD)	10.01.70 to 11.30.73	$ 1,016,000	Probation; Male and Female; Ages 7-15	Diversion, supervision, counseling, remediation, recreation	CJCC ended – picked up by HRA
16. ALTERNATIVES TO DETENTION – PROBATION (ATD – PROB) Sup. Det. Release and Day-Evng. Ctr.; Pre-Court Inten. Serv.	11.01.70 to 06.30.73	$ 462,000	Probation, parole case pending, DC, PINS; Male and Female; Ages 8-17	Diversion, counseling referral, supervision	CJCC ended – picked up by NYC
17. ALTERNATIVES TO DETENTION – HRA (ATD-HRA) Family Boarding Home Group Home	11.01.72 to 02.28.74	$ 852,000	DC & PINS, Family Court; Male and Female; Ages 10-16	Diversion, family and group boarding homes, supervision, counseling	CJCC ended – picked up by HRA
18. PROTESTANT BOARD OF GUARDIANS (PBG)	11.15.71 to 06.30.75	$ 839,000	Probation, Family Court, Youth AID; Male and Female; Ages 7-17	Diversion, short term crisis intervention, family aid, counseling, referral	CJCC extended to 06.30.75
		TOTAL $14,590,000			

20,924 intake forms from the eighteen projects, only 2,860 arrest records were used for analysis. The unused balance of the 20,924 forms are analogous to unreturned, incomplete, or incorrect forms in an election-type survey.

Of the 2,860 males analyzed, 687 (24 percent) were juveniles, 606 (21 percent) were sixteen to eighteen, and the remainder (55 percent) were nineteen and older. Sixty-eight percent were black, 25 percent Spanish-surnamed, and 7 percent white or "other." Only a third of those eighteen or older had completed twelve or more years of school or had high-school equivalency diplomas, while 60 percent had had nine to eleven years of school. More than 90 percent had at least one prior arrest and most of the remainder had some kind of police record.

Table 3–5 (pp. 60–61) shows that the average number of arrests before project entry ranged from .8 to 4.6 for those twenty and younger, while clients twenty-one and older ranged from 3.3 to 18.7.[11] For both juveniles and adults, these arrests included many serious charges.

To those who are familiar with the New York City CJS population, these clients appear to be representative of the primary target groups of clients described on p. 55—young, male, undereducated, and poor blacks and Hispanics with prior arrest histories (see Table 3–3).[12] This type of offender accounts for the major share of violent crimes—the most serious crime problem—in New York City. Since the prior arrest histories of these clients were to be controlled in assessing the comparative or collective effectiveness of the eighteen projects, it was important to obtain a method of measuring its severity.

SEVERITY

Such a measure was thought to require a resolution of the problem of combining the frequency of an individual's arrests with the nature of the arrest charges. The *Sellin-Wolfgang Index* was the best standardized measure available for the task.[13] The actual scale could not be used in its original form because the information required was not available within the fiscal and time restraints of the study, but an alternative approach was suggested by Wolfgang and Figlio.[14] This consisted of using mean seriousness scores (MSS) for each of the twenty-six Uniform Crime Reporting (UCR) categories based on data collected in the Philadelphia "cohort" study.[15] It was necessary, therefore, to test the predictive and concurrent validity of the MSS for a New York City population.

Validation of the MSS was guided by its intended use, which was to permit comparison only of client groups with similar severity of prior criminal history. The predictive validity would be shown by how well the MSS predicted arrest recidivism after project entry—a higher severity before entry should have indicated a greater likelihood of, and more severe, recidivism after project entry. The concurrent validity would be demonstrated by correlation between MSS and other related measures of sever-

TABLE 3-3
The Measures of Criminal Recidivism by Age and Severity of Prior Arrest History

Age (1)	Severity Level (2)	Total No. of Clients (3)	No. of Clients One or More Arrests (4)	Percentage of Client-Arrest Recidivism (4) ÷ (3) (5)	No. of Arrests (6)	Ratio of Arrests to Recidivists (6) ÷ (4) (7)	Arrests to Clients Ratio (6) ÷ (3) (8)	No. of Clients One or More Arrests for Violent Crime (9)	Percentage of Client Arrest for Violent Crime (9) ÷ (3) (10)	No. of Arrests for Violent Crime (11)	Violent Crime Arrests As % of Total Arrests (11) ÷ (6) (12)
7-12	1	128	39	30	74	1.9	0.6	20	16	26	35
13-15	1	187	69	37	116	1.7	0.6	33	18	39	34
	2	100	55	55	107	1.9	1.1	26	26	36	34
	3	272	162	60	329	2.0	1.2	82	30	109	33
16-18	1	121	29	24	45	1.6	0.4	11	9	12	27
	2	182	73	40	142	1.9	0.8	33	18	43	30
	3	93	56	60	110	2.0	1.2	27	29	32	29
	4	210	118	56	223	1.9	1.1	46	22	61	27
19-20	1	104	47	45	61	1.3	0.6	14	13	18	30
	2	130	70	54	129	1.8	1.0	33	25	46	36
21-29	1	303	105	35	172	1.6	0.6	35	12	47	27
	2	309	118	38	191	1.6	0.6	44	14	55	29
	3	352	136	39	203	1.5	0.6	39	11	47	23
30-39	1	137	42	31	71	1.7	0.5	10	7	15	21
	2	177	50	28	76	1.5	0.4	12	7	13	17
40-71	1	55	13	24	23	1.8	0.4	5	9	6	26
	TOTAL	2,860	1,182	41	2,072	1.8	0.7	470	16	605	29
7-12		128	39	30	74	1.9	0.6	20	16	26	35
13-15		559	286	51	552	1.9	1.0	141	25	184	33
16-18		606	276	46	520	1.9	0.9	117	19	148	28
19-20		234	117	50	190	1.6	0.8	47	20	64	34
21-29		964	359	37	566	1.6	0.6	118	12	149	26
30-39		314	92	29	147	1.6	0.5	22	7	28	19
40-71		55	13	24	23	1.8	0.4	5	9	6	26
	TOTAL	2,860	1,182	41	2,072	1.8	0.7	470	16	605	29

ity. Two possible alternative measures were number of arrests before project entry and type of arrest charges, such as violent crimes. (The MSS synthesized both and contained more information than either.)

The relationship between prior criminal history and recidivism (the dependent variable) was assessed by a number of analyses using stepwise linear regression. For most of these analyses, the independent variables were combinations of total MSS and number of arrests before project entry and the year of age at project entry and the interactions.

In almost all cases, the F-value was highly significant for the independent variables and their interactions. However, this may have stemmed from the large numbers of degrees of freedom for the residual sum of squares, which ranged from approximately 100 to 600 for age subgroups used. Surprisingly, the total variance accounted for by the independent variables was generally less than 15 percent for each analysis—an outcome without a ready explanation.

In the testing of predictive validity, the inconclusive results of the regression analyses and analysis of variance suggested that any relationship between severity of prior criminal history (both MSS and number of arrests prior to project entry) and recidivism was not linear.

However, it was decided that for evaluation purposes, both the MSS and the number of arrests before project entry were sufficiently valid predictively for use as measures of severity of criminal history before project entry. The decision was reached because the results of t-tests, Kolmogorov-Smirnov tests, and chi-square trend analyses supported a significant relationship between both measures of severity and recidivism for the thirteen- to fifteen-, sixteen- to eighteen-, and nineteen- to twenty-year-old groups, and marginally for the older clients, (although the relationship might not be linear). Since the MSS predicted recidivism as well, and in a similar manner as the average number of arrests, the concurrent-validity requirement appeared to be satisfied.

However, although the average number of prior arrests and the MSS appeared to be equally effective as a measure of severity in predicting recidivism, the former was easier to use, far less expensive, and more easily understood by readers and, therefore, was selected as the evaluation's measure of severity.[16]

LEVELS OF SEVERITY

The method of determining levels of severity used the Duncan Multiple Range Test, as adjusted by the method of Dalenius.[17]

One purpose of using the Duncan test and the Dalenius method of forming homogeneous groups was to identify mutually exclusive and exhaustive levels of severity of criminal history before project entry for each age group to be used in the analysis.

This was a two-step process. First, the Duncan test was used to see if, within each age group, the projects could be arranged in clusters in such a

way that, in a given cluster, the project with the lowest mean number of client arrests (MNA) before project entry would not be significantly different from the project with the highest MNA. Further, the Duncan test determined for each age group the clusters of projects that were significantly different from each other—i.e., there was at least one project with an MNA in one cluster significantly different from the MNA of at least one project in a different cluster in that age group.

Given the criteria above, when the Duncan test was applied to the projects within an age group, the clusters that resulted might not have been mutually exclusive. In other words, there might have been some projects in more than one cluster. This overlap among the clusters could have created confusion in interpreting the outcomes.

Therefore, as a second step, the method of Dalenius was applied to the clusters of projects in each age group in order to make the clusters mutually exclusive. The clusters that resulted were then defined as levels of severity for that age group. (See Table 3–5 for one resultant example of exclusive levels of MNA.)

Categorization of the clients by the levels of severity of their prior arrest history has two functions. For those twenty and younger, the levels are related to recidivism and are also a descriptive characteristic. For clients twenty-one and older, the levels of severity are not related to recidivism (pp. 60–61), but are descriptive characteristics only. This should be noted in interpretation of Tables 3–3 and 3–5.

ANALYSIS

Several evaluation questions stemmed from the tasks described on p. 48 and a variety of analytic methods were used to answer them under the following conditions. The 2,860 clients were divided into seven age groupings—seven to twelve, thirteen to fifteen, sixteen to eighteen, nineteen to twenty, twenty-one to twenty-nine, thirty to thirty-nine and forty to seventy-one. For each age group, the outcomes of clients in different service components in a project would be combined for use in an analysis if there was reason to believe that clients in one component had also received services from another component. (This woud result in double counting by overlap—see Project Share, Components Resident and Non-Resident, Table 3–2.) The remaining service components were combined if their respective clients' average number of arrests before project entry were not significantly different; if they were different they were analyzed separately. (See NAACP components Intensive and Non-Intensive, Age 30–39, and NAACP Intensive and Non-Intensive, Age 21–29 in Table 3–5.) For combined and separated components, if a group of project clients classified by age and/or severity of arrest history contained less than twenty members it was dropped from the analysis. For the juveniles age seven to fifteen, "YD-1" cards were not included as arrests in the analysis (see footnote 6). The arrest recidivism was measured over the period of twelve months after

TABLE 3-4

Arrests by the Twenty-Six Types of Crimes of the Uniform Crime Reporting (UCR) System

Class	No.*	Type	All Ages 1182 Clients			Age 7-12 39 Clients			Age 13-15 286 Clients			Age 16-18 276 Clients			
			No. of Arrests	%	Cum. %	No. of Arrests	%	Cum. %	No. of Arrests	%	Cum. %	No. of Arrests	%	Cum. %	
I N D E X	V I O L E N T														
	1	Homicide	23	1.1	1.1	—	—	—	3	0.5	0.5	6	1.2	1.2	
	2	Rape, Forcible	26	1.3	2.4	1	1.4	1.4	7	1.3	1.8	4	0.8	1.9	
	3	Robbery	416	20.1	22.4	21	28.4	29.7	137	24.8	26.6	104	20.0	21.9	
	4	Assault, Aggrav.	140	6.8	29.2	4	5.4	35.1	37	6.7	33.3	34	6.5	28.5	
	P R O P E R T Y	5	Burglary	336	16.2	45.4	20	27.0	62.2	121	21.9	55.3	96	18.5	46.9
		6	Larceny	301	14.5	59.9	10	13.5	75.7	73	13.2	68.5	65	12.5	59.4
		7	Auto Theft	149	7.2	67.1	5	6.8	82.4	37	6.7	75.2	50	9.6	69.0
N O N I N D E X		8	Assault, Other	126	6.1	73.2	3	4.1	86.5	27	4.9	80.1	27	5.2	74.2
		9	Arson	3	0.1	73.4	—	—	—	1	0.2	80.3	1	0.2	74.4
		10	Forgery, Counterft.	9	0.4	73.8	—	—	—	—	—	—	1	0.2	74.6
		11	Fraud	5	0.2	74.0	—	—	—	1	0.2	80.4	1	0.2	74.8
		13	Property, Stolen	78	3.8	77.8	1	1.4	87.8	14	2.5	83.0	16	3.1	77.9
		14	Vandalism	50	2.4	80.2	2	2.7	90.5	23	4.2	87.1	12	2.3	80.2
		15	Weapons	98	4.7	84.9	1	1.4	91.9	27	4.9	92.0	19	3.7	83.8
		17	Sex Offenses	23	1.1	86.1	1	1.4	93.2	4	0.7	92.8	8	1.5	85.4
		18	Narcotics	151	7.3	93.3	1	1.4	94.6	7	1.3	94.0	39	7.5	92.9
		19	Gambling	3	0.1	93.5	—	—	—	—	—	—	2	0.4	93.3
		21	Drunken Driving	3	0.1	93.6	—	—	—	—	—	—	—	—	—
		23	Drunkenness	7	0.3	94.0	—	—	—	—	—	—	1	0.2	93.5
		24	Disorderly Conduct	21	1.0	95.0	—	—	—	6	1.1	95.1	8	1.5	95.0
		25	Vagrancy	23	1.1	96.1	—	—	—	2	0.4	95.5	7	1.3	96.3
		26	Offenses, Other	81	3.9	100.0	4	5.4	100.0	25	4.5	100.0	19	3.7	100.0
		Total	2072	100.0	100.0	74	100.0	100.0	552	100.0	100.0	520	100.0	100.0	

*UCR rank

Note: Percents and cumulative percents may be off by .1% due to rounding errors.

Age 19-20 117 Clients			Age 21-29 359 Clients			Age 30-39 92 Clients			Age 40-71 13 Clients		
No. of Arrests	%	Cum. %	No. of Arrests	%	Cum. %	No. of Arrests	%	Cum. %	No. of Arrests	%	Cum. %
2	1.1	1.1	12	2.1	2.1	—	—	—	—	—	—
7	3.7	4.7	4	0.7	2.8	3	2.0	2.0	—	—	—
42	22.1	26.8	97	17.1	20.0	13	8.8	10.9	2	8.7	8.7
13	6.8	33.7	36	6.4	26.3	12	8.2	19.0	4	17.4	26.1
27	14.2	47.9	55	9.7	36.0	16	10.9	29.9	1	4.3	30.4
27	14.2	62.1	95	16.8	52.8	29	19.7	49.7	2	8.7	39.1
7	3.7	65.8	34	6.0	58.8	10	6.8	56.5	6	26.1	65.2
12	6.3	72.1	39	6.9	65.7	18	12.2	68.7	—	—	—
—	—	—	1	0.2	65.9	—	—	—	—	—	—
4	2.1	74.2	3	0.5	66.4	1	0.7	69.4	—	—	—
2	1.1	75.3	1	0.2	66.6	—	—	—	—	—	—
7	3.7	78.9	30	5.3	71.9	9	6.1	75.5	1	4.3	69.6
2	1.1	80.0	9	1.6	73.5	2	1.4	76.9	—	—	—
11	5.8	85.8	34	6.0	79.5	6	4.1	81.0	—	—	—
1	0.5	86.3	7	1.2	80.7	2	1.4	82.3	—	—	—
17	8.9	95.3	70	12.4	93.1	15	10.2	92.5	2	8.7	78.3
—	—	—	—	—	—	1	0.7	93.2	—	—	—
1	0.5	95.8	1	0.2	93.3	1	0.7	93.9	—	—	—
1	0.5	96.3	4	0.7	94.0	1	0.7	94.6	—	—	
1	0.5	96.8	3	0.5	94.5	3	2.0	96.6	—	—	—
1	0.5	97.4	10	1.8	96.3	2	1.4	98.0	1	4.3	82.6
5	2.6	100.0	21	3.7	100.0	3	2.0	100.0	4	17.4	100.0
190	100.0	100.0	566	100.0	100.0	147	100.0	100.0	23	100.0	100.0

TABLE 3-5

Projects Grouped by Statistically Equivalent or Different Arrest Recidivism Rates
Within Each Level of Severity of Mean Number of Arrests Prior to Project Entry

Age of Client	Level of Severity by Mean Number of Arrests Prior to Project Entry		Project and Component	No. of Clients	Arrest Recidivism Rates by Percent	Projects Grouped by Arrest Recidivism Rates Within the Level of Severity
	Level	Arrests				
7-12	1	0.8	PROTESTANT BOARD OF GUARDIANS	43	19	Same
		1.2	ALTERNATIVES TO DETENTION – HRA Family Boarding Home	28	29	
		1.0	ALTERNATIVES TO DETENTION – PROBATION Pre-court Intensive Service	25	40	
		1.1	NEIGHBORHOOD YOUTH DIVERSION	32	41	
13-15	1	1.2	ALTERNATIVES TO DETENTION – HRA Family Boarding Home	58	29	Same
		1.0	PROTESTANT BOARD OF GUARDIANS	129	40	
	2	1.5	MORRISANIA YOUTH SERVICE CENTER Legal Services	45	47	Same
		1.4	ALTERNATIVES TO DETENTION – PROBATION Pre-Court Intensive Service	55	62	
	3	2.9	ALTERNATIVES TO DETENTION – HRA Group Home	31	55	Same
		2.4	ALTERNATIVES TO DETENTION – PROBATION Supvd. Deten. Release & Day/Eve Ctr.	140	59	
		1.8	NEIGHBORHOOD YOUTH DIVERSION	101	62	
16-18	1	1.6	YOUTH COUNSEL BUREAU Long-term Parole	121	24	Same
	2	2.8	ADDICTS REHABILITATION CENTER	32	34	Same
		2.1	MORRISANIA YOUTH SERVICE CENTER Legal Services	95	41	
		2.1	LEGAL PROPINQUITY	55	42	
	3	3.1	PROBATION – URBAN LEAGUE	62	60	Same
		2.9	INDEPENDENCE HOUSE	31	61	
	4	4.6	ASA – ADDICTS DIVERSION PROGRAM	47	53	Same
		3.4	VOI – BRONX COMMUNITY COUNSELING	100	56	
		3.6	PROJECT BYCEP	63	59	

Age Group	Rank	%	Program			Note
19-20		2.7	VOI – BRONX COMMUNITY COUNSELING	48	44	
	1	2.7	MORRISANIA YOUTH SERVICE CENTER Legal Services	26	46	Same
		2.8	PROBATION – URBAN LEAGUE	30	47	
		4.3	ASA – ADDICTS DIVERSION PROGRAM	53	49	
	2	3.0	ADDICTS REHABILITATION CENTER	52	50	Same
		3.8	INDEPENDENCE HOUSE	25	72	
		3.3	VOI – BRONX COMMUNITY COUNSELING	115	33	
	1	4.7	PROJECT MANHOOD	141	36	Same
		4.3	NAACP PROJECT REBOUND Intensive	47	36	
21-29		4.8	PROJECT SECOND CHANCE	116	28	1
	2	5.5	VERA SUPPORTIVE WORK PROGRAM Control Group	62	44	2
		5.2	ADDICTS REHABILITATION CENTER	131	44	
		5.7	PROJECT SHARE	31	29	
	3	5.6	VERA SUPPORTIVE WORK PROGRAM Wildcat	76	33	1
		6.2	ASA – ADDICTS DIVERSION PROGRAM	182	36	
		5.6	NAACP PROJECT REBOUND Non-Intensive	63	59	2
30-39		6.6	VOI – BRONX COMMUNITY COUNSELING	20	10	
	1	7.7	PROJECT SECOND CHANCE	44	32	Same
		9.9	ADDICTS REHABILITATION CENTER	29	34	
		7.7	PROJECT MANHOOD	44	36	
		10.6	VERA SUPPORTIVE WORK PROGRAM Wildcat	38	21	
	2	11.8	VERA SUPPORTIVE WORK PROGRAM Control	43	26	Same
		11.4	ASA – ADDICTS DIVERSION PROGRAM	51	31	
		10.6	NAACP PROJECT REBOUND Intensive and Non-Intensive	45	33	
40-71		12.8	ADDICTS REHABILITATION CENTER	20	15	
	1	18.7	NAACP PROJECT REBOUND Intensive and Non-Intensive	35	29	Same

Total 2860

project entry although a client may not have been in the project during that entire period. Throughout this paper, the term *significant,* unless otherwise qualified, means that P is equal to or is less than .05.

WHAT WAS THE MAGNITUDE AND SERIOUSNESS OF CRIMINAL RECIDIVISM?

Arrest recidivism was the ratio of clients arrested one or more times during the twelve months after project entry to all clients, arrested or not.

The magnitude was measured by (1) the recidivism rates and (2) a ratio of the total number of arrests for recidivists to the total number of clients (recidivists and nonrecidivists).

Seriousness was measured by the types of crimes charged, as classified by the Uniform Crime Reporting system, into seven severe (index) crimes composed of "violent crimes against persons"—homicide, rape, robbery, and assault—and "crimes against property"—burglary, larceny, and auto theft. (See Table 3–4.)

The relationship of these measures to the client characteristics of age and severity of prior criminal history was then assessed. It should be noted that no significant relationship was found between race/ethnicity and arrest recidivism or violent crime arrest rates for six of the seven age groups when tested by the X^2. The relationship was significant only for the sixteen- to eighteen-year-olds on both measures, probably because the whites had less severe criminal histories than the blacks and Hispanics of those ages.

The relationship between heroin addiction and recidivism could not be evaluated, mainly because the type of drug used could not be determined from charges on arrest records. But some evidence suggested that there were fairly high proportions of users or ex-users of heroin in all the projects with clients twenty-one and older.

WAS CRIME REDUCED BY THE PROJECTS?

This question was addressed in three ways. First, the arrest recidivism of clients who received project services was compared with that of similar clients who did not receive services (a control or comparison group). The evaluation was unsuccessful in forming an intended "post hoc" matched control group for some of the younger clients. But a valid control group was obtained by one of the projects, Vera Wildcat, and was used by the evaluation for clients twenty-one and older.[18] The 105 male Vera control clients were compared with the male clients of eight other projects.[19] The recidivism rates of the twenty-one- to twenty-nine-year-old clients were compared by the Duncan Multiple Range Test; those of the thirty- to thirty-nine-year-olds were compared by the X^2 test.

Secondly, the projects were assessed to see if they decreased the criminal behavior of clients. This was done by comparing the arrest rates of the second year before project entry with the rates during the year after en-

try.[20] Comparisons were made applying the X^2 test to the arrest rates by age groups.

Finally, projects were compared in their criminological effects on similar types of clients (e.g., male thirteen- to fifteen-year-olds with severe arrest histories) to see which projects lowered recidivism rates most. This effort sought to determine if project characteristics affected recidivism rates of similar clients.

The goals and priorities of this evaluation did not make it possible to measure directly project characteristics or to link, for individual projects, differences in arrest-recidivism rates and such project characteristics as services delivered, types of staff, and staff-client ratios. Moreover, the statistical methods used in assessing the effect of project characteristics on recidivism could determine only whether or not a significant difference existed among the projects. But, if there was such a difference, the method could not be used to specify which project characteristics were related to different effects on recidivism.

The application of the statistical methods to assess the relationship between differences among projects and recidivism occurred in three stages.

First, the eighteen projects were classified by age and the seriousness of their clients' arrest history before project entry. (The classification by levels of seriousness was by the method described on p. 56.) The tests of the predictive validity of the severity measures showed a relationship between the severity of prior arrest history and arrest recidivism for clients twenty and younger and no relationship for those twenty-one and older. Therefore, clients twenty and younger were classified into ten groups: ages seven to twelve at one level of seriousness; ages thirteen to fifteen at three levels of seriousness; ages sixteen to eighteen at four levels of seriousness; and ages nineteen to twenty at two levels of seriousness. (See Table 3–5.) The three older age groups, twenty-one to twenty-nine, thirty to thirty-nine, and forty to seventy-one, were not classified by levels of severity. The overall classification was of thirteen groups of clients classified by age and severity.[21] Each of the thirteen groups contained clients classified by the eighteen projects and their service components. There was a total of forty-six such subgroups.

The second step was to apply the Duncan test to determine if there were significant differences between arrest recidivism rates of projects within each of the thirteen levels of severity and/or age.

The final step was to estimate the overall probability of the thirteen outcomes observed. This was estimated with a statistic similar to the Binomial Expansion. This statistic was applied to each level of severity and/or age in order to compute the probability of each of the thirteen outcomes observed. This was followed by computation of the *overall* probability of the occurrence of no more than the observed number of differences for the thirteen outcomes (in case of no differences, at least one such difference was assumed).

The overall probability was computed under the following assumptions: (a) that the test of the null hypothesis implied determining the probability of no more than the observed number of differences between recidivism rates as the ones that occurred; (b) within each group, the probability of difference between any two arrest recidivism rates was .05 (since .05 was the level of confidence used in the second step); (c) each of the groups formed by age and/or level of severity was considered independently.

The relationship between project characteristics and recidivism was also tested by the same statistical method for an alternative assumption about the relationship between the severity of arrest history and recidivism.

The assumption was that there was a relationship between severity and recidivism for *all* clients, including those twenty-one and older. As shown by Table 3–5, this resulted in the classification of the eighteen projects by sixteen groups composed of ages seven to twelve, thirteen to fifteen, sixteen to eighteen, and nineteen to twenty at 1, 3, 4, and 2 levels of severity, respectively, and ages twenty-one to twenty-nine, thirty to thirty-nine, and forty to seventy-one were classified at 3, 2, and 1 levels of severity, respectively.

The statistical method described above was also applied to test the relationship between project characteristics and recidivism for only those clients twenty-one and older by the six levels of age and severity shown in Table 3–5, and for only those clients twenty and younger by the ten levels of age and severity shown on Table 3–5.

WHAT WAS THE RELATIONSHIP OF VIOLENT CRIMES BEFORE PROJECT ENTRY TO VIOLENT CRIMES AFTER PROJECT ENTRY?

The t-test was used to determine the difference between the rates of violent-crime arrests after project entry of clients who had no history of violent-crime arrests before project entry, and the rate of violent-crime recidivism of clients who had a history of violent-crime arrests before project entry.

Results

THE MAGNITUDE AND SERIOUSNESS OF CRIMINAL RECIDIVISM

The magnitude of the recidivism rates (the proportion of clients arrested one or more times during the twelve months after project entry) in seven age groups (across projects and levels of severity) ranged from 51 percent for thirteen- to fifteen-year-olds, to 24 percent for those 40 to 71 (Table 3–3). Those with higher levels of severity of prior arrests in the groups thirteen to fifteen and sixteen to eighteen had recidivism rates as high as 60 percent.

Since the recidivism rate understates the amount of criminal behavior, the number of arrests was converted into a ratio of the total number of arrests to the total number of clients. For the thirteen to fifteen age group at the second level of severity, for example, fifty-five of the one hundred clients had one or more arrests after project entry as shown in Table 3. This yielded a 55 percent recidivism rate. The total number of arrests for these 55 recidivists, however, was 107, or more arrests than there were clients in the project. The ratio was 1.1. If the fifty-five recidivists had each been arrested only once, the ratio would have been .5. For the 1,527 clients twenty and younger the ratio of arrests to clients was .9 or almost as many arrests as clients (col. 3, Table 3–3).

The severity of recidivism after project entry was measured by the types of serious crime classified as violent crimes (homicide, forcible rape, robbery, and aggravated assault) and crimes against property (burglary, larceny, and auto theft—see Table 3–4).

Sixty-seven percent of the total number of *arrests* of the recidivists were for index (serious) crimes. For index crimes, arrests ranged from 82 percent for seven- to twelve-year-olds to 56 percent for those thirty to thirty-nine. For violent crimes, arrests ranged from about 33 percent for seven- to fifteen-year-olds to 19 percent for those thirty to thirty-nine.

Homicide accounted for 4 percent of all arrests for violent crimes, forcible rape for 4 percent, robbery for 69 percent, and aggravated assault for 23 percent. There appeared to be little difference between each of the seven age groups in the proportions of their arrests for each of the four types of violent crime.

The highest proportion of arrests for burglary, 27 percent of all arrests, was for the thirty-nine juvenile recidivists aged seven to twelve (Table 3–3). The highest proportion of arrests for larceny, 20 percent, was in the age group thirty to thirty-nine. The proportion of arrests for auto theft was about even across the age groups, with the exception of the forty to seventy-one age group, which had a much higher percentage of its arrests in that category.

Overall, clients twenty and younger appear to have a higher magnitude and severity of criminal recidivism by every measure used. The highest was for the 559 juveniles, thirteen to fifteen, from five diversion projects, whose recidivism rate was 51 percent during the year after project entry. Their ratio of arrests to all clients was 1.0; 75 percent of their arrests were for severe (index) crimes, 33 percent were for violent crimes. For the age group seven to twelve, the percentage of arrests for violent crimes totaled 35 percent and for severe crimes, 82 percent (Table 3–3).

The relationship between average number of arrests before project entry and criminal recidivism was positive for those twenty and younger. The relationship did not appear to exist for those twenty-one and older. For those twenty and younger, the higher the average number of arrests before entry, the higher the magnitude of recidivism.

Of the 2,860 clients, 1,182, or 41 percent, were arrested 2,072 times, an arrest-to-client ratio of .7. Of the arrests, 605, or 29 percent, were for the violent crimes of homicide, forcible rape, robbery, and aggravated assault.

PROJECT EFFECTS ON CRIME

There was no significant difference between the Vera control group and the twenty-one- to thirty-nine-year-old clients of eight projects with clients of that age. Specifically, the rates for the Vera control group for the twenty-one- to twenty-nine-year-olds were statistically equal to those of projects Second Chance, SHARE, Vera Wildcat, BCC, Manhood, ASA, NAACP (Intensive), ARC, and NAACP (Non-Intensive). When the Vera control's recidivism rate for thirty- to thirty-nine-year-olds was compared to those of the projects, there were no significant differences for those projects and components—BCC, Manhood, Second Chance, ARC, Vera Wildcat, NAACP (Intensive and Non-Intensive), and ASA.

Comparing the year after project entry and the second year before project entry showed the recidivism rates significantly higher for those eighteen and younger; not different for those nineteen and twenty; lower for those twenty-one to thirty-nine; not different for those forty to seventy-one.

Differences between projects did not significantly affect the recidivism rates. The estimated probability of the outcomes observed for the thirteen groups of projects classified by ten levels of age and severity of prior arrest history for those twenty and younger and three levels of age across levels of severity for those twenty-one and older was .56.

The probabilities of the outcomes observed for the test of project differences on recidivism were (a) .56 when clients of all ages were classified by sixteen levels of age and severity (Table 3–5), (b) .69 when classified by the ten levels of age and severity for only those clients twenty and younger, (c) .52 when classified by the three age groups for only those clients twenty-one and older.

It can be concluded that not only was there no significant relationship between project characteristics and client recidivism, but that there was also no difference regardless of which of four assumptions was used about the relationship between severity of prior arrest history and recidivism at different ages to assess the effect of project characteristics. Overall, no project was better than another.

The quantity, quality, types, and mix of services provided by the projects to their clients—as well as their staff-client ratios, proportions of paraprofessional staff, per capita funding, and other project characteristics—had no apparent effect on the projects' ability to influence the arrest recidivism of their clients.

TABLE 3-6

*t-Test Values for Outcomes of Differences Between
Violent Crime Arrest Rates After Project Entry: Clients With No
Arrests for Violent Crimes Before Project Entry Versus Clients With
One or More Arrests for Violent Crimes Before Project Entry*

Age Group	Homicide	Rape	Robbery*	Aggravated Assault	All Violent Crimes*
7-12	a	a	−2.15†	a	−1.69†
13-15	a	a	−3.19†	−1.00	−3.38†
16-18	a	a	−4.82†	−2.19†	−4.39†
19-20	a	a	−1.37	−1.34	−1.21
21-29	−1.05	a	−1.79†	−3.16†	−3.07†
30-39	a	a	−0.60	−2.03†	−2.19†
40-71	a	a	−1.86†	a	−0.36
Across Ages	−0.84	−2.56†	−5.31†	−3.97†	−5.25†

* Since arrests for robbery accounted for 69 percent of all arrests for violent crimes, it was not surprising that these results tended to parallel those for all violent crimes.

a Number of clients less than 20.

† Arrest rates after project entry are highest for clients with one or more arrests for a violent crime after project entry. P is equal to or less than .05, by a one-tailed test.

A HISTORY OF VIOLENT CRIME BEFORE PROJECT ENTRY WAS RELATED TO MORE VIOLENT CRIME AFTER, WHEN COMPARED TO CLIENTS WHO HAD NO HISTORY OF VIOLENT CRIME BEFORE PROJECT ENTRY

The relationship of violent crime before and after project entry existed across ages for each of the seven age groups except those nineteen to twenty and forty to seventy-one. An examination of the relationship between a prior and subsequent history of violent crimes (homicide, forcible rape, robbery, and aggravated assault) found that the relationship held across age groups for rape, robbery, and assault but not for homicide.

One of the stepwise linear regression analyses discussed was done on the independent variables—year of age at project entry and a history of at least one arrest for violent crime before project entry. The prediction was of the dependent variable of one or more arrests for violent crimes during the twelve months after project entry.

The results indicated that any relationship between violent crimes before and after project entry was not linear.[22]

Conclusions

REHABILITATION BY THE PROJECTS WAS JUDGED A FAILURE

The failure was particularly evident with young clients and in relation to violent crime. The judgment is based on the magnitude and severity of the

project clients' criminal recidivism which resulted in great cost to both society and the victims.[23]

The 1,182 of 2,860 clients in the study (41 percent) who recidivated were arrested a total of 2,072 times. Of these arrests, 605 (29 percent) were for violent crimes. This means that about fifty persons may have been killed or raped and 555 robbed or severely assaulted by the recidivists. This portion of the outcome strongly leads the evaluator to the judgment that the costs of the recidivism are too high.

Nor does the conclusion change if the cost is examined by age. For example, the comparatively "good" 29 percent recidivism rate of the 314 clients aged thirty to thirty-nine means that of the 147 arrests about one out of five was for violent crimes (Table 3–3). When the results of representatives of the primary target groups of young males under twenty-one with severe prior criminal histories are examined, most outcomes are worse than the summary statistics for all 2,860 clients cited above (Table 3–3).[24]

It could be asserted that if there was a 41 percent recidivism rate, then 59 percent of the clients were clearly successes or non-recidivists. This argument would not be acceptable because success or failure, in terms of recidivism to serious and violent crimes, obviously is qualitatively different in its consequences from other measures such as failing to pass a test in reading achievement or job skills. Failure or recidivism in this context implies victims. To realize this, assume that we are discussing the effects of a new medication for treating disease in a group of 2,860 persons. If a side effect of curing, say 59 percent of the disease cases, were infecting more than 600 outsiders with a mutation of the disease—with even a fraction of the fatalities, injuries, and suffering of the victims of violent crimes—there is little question that the extent of adverse side effects would be considered too high a price to pay.

The judgment of failure does not stem from direct comparisons. Assume it could be shown that other types of projects, or no projects at all (a control group), or the existing CJS would yield recidivism and victimization rates 20 percent higher than the outcomes of the projects studied. The actual rates and numbers, now relatively low, would still be judged a failure because of the cost to victims.[25]

For a behavioral scientist to judge an outcome like this recidivism rate as a success solely because it was statistically lower than that of a hypothetical control group—without assessing the consequences of the recidivism in terms of victims—would be difficult to justify either empirically or ethically. It would also be difficult to understand a denial of the empirical validity and pragmatic importance of some recidivism outcomes solely on the basis of the absence of a control comparison; e.g., the recidivism findings for juveniles.[26]

But it should be stressed that there were no significant differences between a "control group" and eight of the projects for 1,270 clients aged twenty-one to thirty-nine. Moreover, the somewhat forced assumption that

a control or comparison group *necessarily has to consist* of clients who are only unserved (i.e., either on the streets or in the existing CJS) prevents comparisons with other alternatives. Some important alternatives may be the testing of the possible CJS approaches of mandatory minimum sentencing and preventive detention for their ability to reduce violent crime.

Final criteria for judging "high" and "low" or success or failure are left up to the reader; but precedents may be found in federal and state controls over drugs and foods which consider very limited pain, injury, or death too high a price for the benefits of certain products.

The before-and-after project entry comparisons showed significant increases in arrests for younger clients and decreases for older ones. These results were congruent with nationwide reports for these ages. Since the reports represent many who do not receive rehabilitation services, they may act as a weak control comparison. If one accepts the control comparison, then the projects' rehabilitation services probably did not cause either the increase or decrease in arrests.[27] If one does not accept the comparisons, then the relationship of the rehabilitation services to the outcomes is not analyzable.

The costs of criminal recidivism, especially for violent crime, are judged to be so high to victims and society that it appears unjustified to continue to use governmental crime-control funds for rehabilitation services to achieve the objectives of the Crime Control Act as amended in 1973, to "reduce and prevent crime and juvenile delinquency and . . . [particularly!] to insure the greater safety of the people. . . ." [28]

THE REHABILITATION SERVICES FAILURE WAS APPARENTLY UNRELATED TO PROGRAM CHARACTERISTICS AND OTHER FACTORS

That there was no significant difference in effect on recidivism among projects as varied as the eighteen was a very surprising finding in the evaluation. Generously funded, well planned, and administered "model" projects such as Vera Wildcat Supportive Work Program, ASA Court Diversion, and Neighborhood Youth Diversion were really expected to do better than their less endowed competitors (Table 3–4). But even if the differences between projects had been significant, the actual outcomes would have been too costly in terms of amount and type of recidivism to be judged as other than failures. In any case, the findings raise obvious questions about, and implications for, LEAA and New York agencies as to decisions about funding or program revisions. For example, can funding anything except the least expensive of these project types be justified? Why fund projects whose outcomes are not different from that of a control group?

The evaluation considered a variety of factors that might have undermined the projects' efforts, even if their models were valid, and led to their apparent failure. It could be argued, for example, that these programs were measured during an atypical year, one in which they were plagued by start-

up and implementation problems. While there were new programs in the study, there, were others that had been operational for years before receiving LEAA funding, and the arrest rates for the two categories were not statistically different.

Perhaps the available funds, staff, or services were not of sufficient magnitude to effect change, but this was not supported by the equivalent arrest rates of such massively funded projects as Probation-Urban League or Vera Wildcat with such lesser-funded ones as Independence House and Manhood.

Another possibility is that a more positive effect would have been found if the recidivism measurement had been made from the twelfth to twenty-fourth month after project entry, rather than from entry to the twelfth month after entry. But the unacceptable criminal recidivism magnitude and severity that was found in the first year could not possibly have been affected or outweighed by anything that occurred afterward.

While time in a program was not measured in the evaluation, arrest rates of projects with relatively long service periods did not differ from those of projects with short service periods.

It is fair to ask whether these eighteen projects and their types of services were enough to generalize the findings to other rehabilitative efforts locally and nationally. From a statistical standpoint, eighteen is not really enough; at least twenty, and preferably over 200 would be better. However, the question is not being asked in an academic context. Decisions about funding and modifying projects *must* be made by the CJCC, LEAA, and other agencies regardless of the number in a sample. Important decisions affecting many projects are, in fact, made on the basis of evaluations of as few as one "model" project. Furthermore, evaluations have ranged from subjective "site" visit reports to measuring program criminological effectiveness by Rorschach tests or self reports (and even these provide more information if a decision must be made than no evaluation at all). It is submitted, therefore, that if decisions must be made, and if there are no better comparable data with different results, then the findings from the eighteen projects are indeed the *best* estimate of the outcome to be predicted for a universe of projects.

All the rehabilitative efforts measured were in projects substantially removed from conventional correctional settings, and none of them used such approaches as intensive individual psychotherapy, operant conditioning, or medical treatment with drugs. In a summary of a major study by Lipton, Martinson, and Wilks [29] in which all English language reports on rehabilitation efforts were screened and 231 (covering the period 1945–67) were judged valid enough to be analyzable, Martinson stated: "With few and isolated exceptions, the rehabilitative efforts that have been reported so far have had no appreciable effect on recidivism." [30] This evidence— that most rehabilitation programs and program efforts (in the sense of independent variable categories) [31] both similar to and different from the ones

in the evaluation's study also did not work—has led this evaluation to conclude with more confidence that generalization to similar types of programs is valid and that it also appears to be applicable to models that have not been evaluated (in this study).

Environmental pressures on the projects were also considered. Given the unfavorable economic conditions—particularly the high unemployment rate for minorities—it might be asked whether it was reasonable to consider the effectiveness of service programs, particularly vocational programs.

Wilson [32] has ably made the point that so long as crime seems more attractive and more remunerative than work, even available employment may not offer an effective alternative to it.

One works at crime at one's convenience, enjoys the esteem of colleagues who think a "straight" job is stupid and skill at stealing is commendable, looks forward to the occasional "big score" that may make further work unnecessary for weeks, and relishes the risk and adventure associated with theft. The money value of all these benefits—that is, what one who is not shocked by crime would want in cash to forego crime—is hard to estimate but is almost certainly far larger than what either public or private employers could offer to unskilled or semi-skilled workers.

Wildcat, a Vera-supported work project, provided jobs with subsidized wages at prevailing rates to its clients. Yet its recidivism rates were not significantly different from those of a control or comparison group that was not provided with these services. Moreover, the rates of Vera Wildcat clients did not differ significantly from comparable clients in seven other projects whose vocational services (some did not have any) consisted almost entirely of job referral.

The job itself has to be desirable to the young blacks and Hispanics among the target groups and not just available. Many will not accept such unattractive jobs as dishwasher, although they are often available in New York City even during high unemployment. Further, with few exceptions, they are not qualified for the white-collar jobs that they do find attractive when those are available.

At the time of this writing, unemployment rates are almost at a post-World War II high for everyone—criminal and non-criminal. The rates may get worse. It is apparent, however, that neither the government, business, nor anyone else has been able to do very much about it. Therefore, even if employment were criminologically effective, it may be beyond the practical ability of society to provide sufficient and adequate employment to make an appreciable impact on crime in the near future.

Poverty and undereducation, which also might have stood between the rehabilitation services and the reduction of crime were also considered by the evaluation, but the severity of both within the target groups has been relatively stable over the five years prior to 1975 while crime has grown.[33]

As with unemployment, the question of whether sufficient changes are feasible and not just appropriate is moot. Clearly, one cannot realistically expect in the near future to provide all the poor with an adequate standard

of living. "Adequate" might be several times higher than the present some-
what arbitrary definition of poverty-level income.

Finally, there is a prevalent assumption that most criminal behavior is
attributable to mental pathology, that the pathology has been imposed on a
basically sound individual by environmental factors such as poverty, and
that the process is reversible—that the criminal, now a victim, can be
"cured."

The curative methodology usually called for is, depending on the prefer-
ence of the prescriber, either one of the many mental health techniques,
ranging from group or individual therapy or counseling to conditioning, to
one of the many social work or sociological prescriptions, ranging from
guaranteed income to "advocacy" or some blend of these.

The evaluation's results show that whichever of the variants the eighteen
projects selected, it made no significant difference. The summary by Mar-
tinson of the Lipton, Martinson, and Wilks study reported the same general
lack of results in a much broader range of projects.[34]

The assumption of pathology is hypothetical and based on a definition of
mental illness much broader than that used by psychiatry. Since even the
psychiatric definition often has proven a difficult base for rigorous studies
attempting to link syndromes and possible causal factors, it is quite clear
that the broader definition would be even more difficult to use or test. To
that extent it has been irrefutable.

On the other hand, mental health advocates have found it equally diffi-
cult to sustain their contention that many pathological syndromes, once in
effect, can be reversed in the sense of a "cure." Among the relatively few
reported cures for serious mental illness (i.e., neurotic disorders),[35] a sub-
stantial number have been attributed to either unique skills and training on
the part of the therapist, or facilities that would be prohibitively costly.
Neither such facilities nor such personnel are currently available to agen-
cies charged with the reduction of crime, or are they likely to be.

Despite the lack of a demonstrable causal relationship between these
services and crime reduction (this does not contradict the consistent re-
ports of a positive *correlation* between factors such as unemployment and
crime), it is generally accepted that the relationship has existed in the past
and can exist again in the United States in the future. There are countless,
intricate, unmeasurable causal interactions of factors that may explain why
the relationship does not exist at this time.

These factors might include: (1) the enormous popularization of violence
in television, movies and books, (2) the absence of strong, absolute reli-
gious or political positions for most of the criminals in question, (3) the
almost universal presence of a pragmatic, relativistic, materially oriented
system of ethics, in which ends justify means, (4) the rationalization by
some minority group members of such crimes as homicide, rape, or rob-
bery on the basis of an alleged debt owed to them by the white society that
exploited their forebearers (and, similarly, a "politicizing" of these crimes

by criminals as alleged reactions to poverty and prejudice), (5) the greatly increased number and proportion of young males within the population since 1960.

One of the most important factors, however, is the possible ineffectiveness of society's sanctions against crime. To assume that "curing" poverty, unemployment, or undereducation will automatically eliminate crime, without considering interactions with society's sanctions against crime or other factors, is simplistic.

In other words, *massive* socioeconomic changes which would provide everyone in the target groups with attractive, remunerative jobs, a middle-class standard of living, good housing, and extensive remedial education could *contribute* to reducing much violent crime. This, in principle, is a desirable and civilized goal. But this goal is not a substitute for effective sanctions against crime. It is naïve to think that we have to accept the consequences of countless serious crimes as long as there is unemployment and poverty. As opposed to the naïvete of such a position, it is unacceptable to rationalize, overtly or covertly, the cost of violent crime in terms of innocent victims and to oppose alternative approaches to crime in the hope that in some fashion this cost will motivate the society to take the steps necessary for the elimination of unemployment and poverty.

EDUCATIONAL, VOCATIONAL AND COUNSELING SERVICES SHOULD BE CONTINUED UNDER OTHER AUSPICES

The finding that these services did not have the desired criminological effect does not mean that they should not be undertaken, continued, or expanded for the population studied. Every effort should be made, for legal, logical, and ethical reasons, to assure that the provision of such benefits is not linked to whether the recipient is a criminal. Society is obliged to provide such services on the basis of need to criminal and non-criminal alike—in prison or out of it.

But such funding should appropriately be provided by those government departments that exist to manage vocational, educational, and health concerns as opposed to those set up to control and prevent crime. They are also the most appropriate places to determine needs, priorities, and the allocation and management of funds for such purposes—as well as whether such projects are the best way to deliver the services.

NOTES

1. This evaluation was supported by grants to the Graduate Center and Research Foundation of the City University of New York from the New York State Division of Criminal Justice Services and the Mayor's Criminal Justice Coordinating Council using LEAA funds. The views expressed here are solely the responsibility of the author. The author gives special thanks to Dr. H.R. Shiledar Baxi, Director of Statistics for the evaluation, who provided valuable and innovative applications of statistics to help achieve the project's goals and solve the problems of the research design. His approach made it possible to examine the difficult

question of whether differences between projects affected the arrest recidivism rates of their clients.

2. Declaration and Purpose, Title I, Law Enforcement Assistance, Public Law 90–351, 90th Congress, H.R. 5037, June 19, 1968.

3. *New York Times,* 11 February, 1975.

4. Robert Fishman, "A Proposal for Individual and Comparative Evaluation of Diversion Projects for the Criminal Justice Coordinating Council," May 15, 1971.

5. Heroin addiction was to have been a fourth characteristic but it was not possible to apply, primarily because police arrest records did not distinguish between heroin and other drugs. There are many other personal characteristics that might affect criminal behavior and reactions to it by the criminal justice system—including, for example, socioeconomic background, intelligence, ethnicity, and motivation. But the evaluation had to select only the most important and feasibly measurable. I.Q., for example, may be a determinant of recidivism but is very expensive to measure adequately for the large number of clients in the study. Motivation is also of great importance, but there is no known standard test for it that is recognized by the testing community as a whole.

6. As a rule, for similar crimes, juveniles aged seven to fifteen are arrested less frequently and detained or incarcerated for much shorter periods than non-juveniles. Juveniles are not arrested, but are given a summons called a "YD–1" card for minor violations such as subway turnstile jumping and some misdemeanors that an adult could be arrested for. Youthful-offender status for sixteen- to eighteen-year-olds may apply at the time of sentencing if a Class A felony or a previous felony conviction is not involved. If granted the status, the offender receives a very light sentence.

7. Numbers 7, 11, 17 and 43 (Table 3–1).

8. Numbers 3, 6, 8, 9, 10, 12, 13, 14, 15, 18, 20, 24, 25, 26, 27, 28, 35, 36, 37, 38, 39, 40, 41, 42, 44, 46, 48, 49, 50, 51, and 53 (Table 3–1).

9. The evaluation was unsuccessful in requesting additional funds to extend its duration so that it could evaluate eight of the thirty-one projects that had provided sufficient data too late for data processing to be completed for the final report (numbers 13, 14, 18, 27, 37, 38, 40, and 46—Table 3–1).

10. Except for one, YCB, which submitted over 1,300 forms, from which a simple random sample of 150 was selected (number 52, Table 3–1).

11. For clients twenty-one and over, there was no relationship between severity of criminal history and recidivism. These arrest rates are descriptive only for those twenty-one and over.

12. It could be contended that the 2,860 clients in the evaluation may not be a representative sample of the total population of the criminal justice system or of the fifty-three projects since this was not demonstrated statistically; i.e., by comparing the arrest histories of the subgroups with those not evaluated. Such a sampling was never intended nor possible.

The study was specifically designed to assess the criminological effects of the projects on certain important subgroups of clients, according to age and severity of arrest history (e.g., young black and Hispanic males of various ages with severe prior arrest histories—see Table 3–3), and not on others such as females. Given the selection method of the evaluation, *(all* who met the criteria were included), each of the sixteen types of clients shown on Tables 3–3 and 3–5 is, in the author's view, representative of clients of the same ages, criminal histories, race/ethnicity and education in the eighteen projects evaluated and of clients in the thirty-five projects not evaluated, as well as in the criminal justice system as a whole. Moreover, the types of clients represented include, in our judgment, the most important types in the system insofar as violent crime is concerned.

In other words, in comparing the effectiveness of projects, it appears far more useful and accurate to ask how they affect *specific* types of clients (by assessing each type separately) than to get one recidivism rate for a "representative sample" of *all* clients which for such a sample may be composed of different proportions of males and females of differing ages and criminal histories. This sample is a poor measure because it understates the actual higher recidivism rate of the more difficult clients; e.g., young males with long records, by masking them with the far lower rates of young male or female first offenders. (This type of error can be gross and is not "controlled" by comparisons with control groups. For example, in the measurement of projects containing small numbers of different types of clients it is sometimes impossible to determine if differences between projects and control groups are due to treatment or to the effects of the different types of clients.)

Possible "unrepresentativeness" can be ascribed to any sample. But, for the assertion to

be meaningful, the following three questions must be carefully answered: How was the method of selection biased? What kind of unrepresentativeness does this cause? How could the possible unrepresentativeness have resulted in the findings and conclusions presented?

A related point is that if the clients in *each* of the subgroups (see Table 3–3) in the study are unrepresentative, it is unlikely that they are *more* recidivistic than a comparable population in the criminal justice system, since most projects, the courts, and the probation department tried to keep out those with the more severe criminal histories. If they are *less* recidivistic (i.e., "cream") than comparable types in the criminal justice system, then the findings, conclusions, and recommendations of the evaluation are even more significant.

In any case, the study was able to evaluate separately the recidivism rates of those with severe histories, of first-offenders, *and* of each of the other types of clients shown in Table 3–3, as classified by age and severity of arrest history. It is more appropriate, therefore, that the three questions above about the representativeness of the 2,860 should be addressed to each of these types.

13. See generally, T. Sellin and M. Wolfgang, *The Measurement of Delinquency.* New York: John Wiley and Sons, 1964.

14. At a meeting in 1972.

15. See generally, M. Wolfgang, R. Figlio, T. Sellin, *Delinquency in a Birth-Cohort.* Chicago: University of Chicago Press, 1972.

16. Note that the MSS is not a Wolfgang-Sellin Score. It is a mean derived from Wolfgang-Sellin scores solely for potential use by this evaluation. The validity of the Wolfgang-Sellin Score was not tested directly by this study.

17. T. Dalenius and J. L. Hodges, Jr. "Minimum Variance Stratification." *Journal of American Statistical Association* 54: 88–101 (1959).

18. L. N. Friedman and H. Ziesel. "First Annual Research Report on Supported Employment." New York: Vera Institute of Justice, 1973.

19. This is not a true "control" group but a comparison group. The control group was "unserviced" in the sense that it was not provided with subsidized employment or other supportive services by the project; the members of the control group had to find their own jobs or services. At least some, therefore, may have received services.

20. The second year before entry was used because most of the projects, particularly diversion projects, *required* arrest as a condition of project entry. But during the twelve months after project entry, clients had the opportunity to be arrested or *not.* Therefore, comparing that twelve months to the first year prior to project entry would be invalid since the arrest requirement in that first year would artificially inflate the arrest rate.

21. Other than for the ten groups of clients twenty and younger, Table 3–5 does not represent the thirteen groups (by age or severity) discussed here. Table 3–5 represents sixteen groups of clients (by age and severity) that derive from my assumption that there is a relationship between severity and recidivism at all ages, including twenty-one and older. The analysis of the sixteen groups (and the construction of Table 3–5) was done *before* the analysis of the thirteen groups, which was the primary study in determining whether differences between projects affect recidivism. Unfortunately, a table representing the analysis of the thirteen groups was not prepared.

22. The F values and r values were significant for the age groups thirteen to fifteen, sixteen to eighteen, nineteen to twenty, twenty-one to twenty-four, and thirty-five to thirty-nine. However, the degrees of freedom were quite high for each of the age groups tested. The correlation of year of age to the dependent variable was only significant for the age group sixteen to eighteen. The total variance accounted for by the independent variables did not exceed .08 for any of the age groups.

23. The net benefits of rehabilitation by the projects must be determined solely in relation to *crime;* the possible provision of jobs and other services to clients is not a pertinent benefit, because the projects were funded by LEAA, whose intention is the prevention and control of crime. The same service outcomes might be judged beneficial, however, if funded by such non-crime control sources as HEW or the Department of Labor.

24. In addition, these summary statistics understate the actual criminal behavior because (a) the higher recidivism rates of the most important target groups (clients under twenty-one with more severe criminal histories) are masked by inclusion (see footnote 11); (b) some findings suggested that unapprehended crimes by project clients were probably more frequent than clients who were arrested but who did not commit any crimes.

25. If, in another year of operation, these projects could improve their record by 25 per-

cent, reducing to 450 the 600 or so possible victims of violent crime, the number would still be too high to be judged as anything but a failure.

26. A basic and valid commandment within the sciences is that the effect of a treatment is determined by comparing the outcomes of the treated group with those of an equivalent untreated control or comparison group. But this does not mean that the findings of a study without a control or comparison group constitute no findings at all.

Some evaluation outcomes, with or without comparisons, may be high enough—or low enough—to be essential for policy decisions affecting the health, safety, and welfare of the public—particularly in the prevention and control of crime. The extent of recidivism and violent crime among the 1,527 clients twenty and younger in this study has obvious policy implications regardless of whether these results are compared with those of a control group. Yet in the important survey by Lipton, Martinson, and Wilks of the effectiveness of correctional rehabilitation treatment, only studies which had control or comparison groups were considered for inclusion. (See Douglas Lipton, Robert Martinson, and Judith Wilks, *The Effectiveness of Correctional Treatment: A Survey of Treatment Evaluation Studies* [New York: Praeger, 1975], pp. 4–5.) Since the survey was intended and used for policy decisions in crime control, the question arises as to how this survey criterion can be reconciled with the exclusion of valid data that may be important in making such decisions.

27. Aging or maturation is probably one important determinant of the outcomes.

28. Declaration and Purpose, Title I, Law Enforcement Assistance, Public Law 93-83, 93rd Congress, H.R. 8152, August 6, 1973.

29. Lipton, Martinson, and Wilks, *Effectiveness of Correctional Treatment*. See note 26.

30. Robert Martinson, "What Works? A Comparative Assessment." See pp. 3–32 of this volume.

31. Martinson recently stated that the term "efforts" in the quotation from "What Works" means "independent variable category." See R. Martinson "California Research at the Crossroads," *Journal of Crime and Delinquency,* April, 1976, p. 184.

32. James Q. Wilson, "Lock 'Em Up and Other Thoughts on Crime," *N.Y. Times Magazine,* 9 March 1974.

33. It has frequently also been pointed out that the majority of poor, unemployed, undereducated and otherwise deprived minority group members do not commit violent crimes.

34. Martinson, "What Works."

35. The term *serious mental illness* in this context does not include schizophrenia, character disorders (i.e., psychopathy), or certain behavior disorders resulting from brain damage that psychiatrists generally do not consider "curable" at this time.

Part II

PREDICTION AND CONTROL

4: Assessment Methods /
Don M. Gottfredson*

Prediction, a traditional aim of science, is a requisite to any effective crime and deliquency prevention or control program. If we seek to control delinquent and criminal behavior, then first we will need to be able to predict it.

William James warned that we cannot hope to write biographies in advance. He asserted also, however, that we *can* establish general expectations. "We live forwards, but we understand backwards," he said, pointing out that any prediction method provides merely a way of summarizing previous experience in the hope of finding a useful guide to future decisions (see References, no. 87).

The problems of prediction in delinquency and related areas have interested many people. This has led to an extensive literature and a variety of techniques for developing and evaluating predictions. The resulting prediction methods have brought about arguments concerning the research methods used and inferences drawn, suggestions for practical uses, and complaints concerning misuses. This work has suggested avenues for further research and possibilities for more effective practice in the entire field of crime and delinquency, including delinquency prevention; and where prevention fails, each step in the process of the administration of criminal justice, from arrest to final discharge.

The nature of the prediction problem in this field is the same in many others.† A large body of literature is available concerning attempts to predict behavior in many sectors of social life. Examples are found in the prediction of social adjustment (79), of academic achievement (24, 59, 99), of vocational interest and performance (2, 133, 134, 136), and of the outcomes of marriage (16, 17).

Along with prediction studies in various social problem areas, the literature addressing theoretical and technical issues in prediction has grown. It includes studies of the logic of prediction (116), of the role of prediction in the study of personality (62, 80, 84, 96, 100, 101, 102, 103, 123), of psychometric problems (5, 6, 21, 26, 27, 55, 66, 83), and of the role of predic-

* Don M. Gottfredson, "Assessment and Prediction Methods in Crime and Delinquency," in *Task Force Report: Juvenile Delinquency,* U.S. President's Commission on Law Enforcement and Administration of Justice (Washington, D.C.: U.S. Government Printing Office, 1967) Appendix K, pp. 171–187.

† This review of prediction problems has been adapted largely from the excellent summary given by Bechtoldt (7), and it has been aided considerably by the summary of much of the pertinent literature provided by Gough (62).

tion methods in evaluating studies of different treatments (50, 57, 67, 98, 152).

The objective in this paper will be to summarize some of this extensive work in order to identify the major general problems, limitations, and potentials of methods for prediction of delinquency or crime. The general nature of the prediction problem will be reviewed. The steps followed in prediction research, some simplifying assumptions that commonly are made, and some requirements of useful prediction methods will be identified. Some basic concepts underlying prediction efforts and a number of general problems commonly found will be discussed. Some factors which influence the utility of prediction methods will be identified. This will help in evaluation of the "state of the art." Finally, various applications, in both research and practice, will be reviewed. This will suggest further research needs and point up some implications concerning appropriate roles for prediction methods in crime and delinquency treatment and control programs.

The scope of this paper will be limited to some problems of prediction for individuals. More global prediction problems (e.g., estimations of population trends, or predictions of the number of offenses or offenders to be expected in a given place at a given time) may be very useful in correctional planning, or in testing hypotheses derived from social theories (94, 150), but they will be excluded. A vast literature concerning personality assessment generally, and evaluation of offenders specifically, is relevant to the prediction problem. No attempt will be made to review comprehensively, or even to list, the many delinquency prediction devices which have been proposed, discussed, and argued about. A number of bibliographies are available (9, 57, 62, 98, 124). No attempt will be made to discuss the methods and problems of the standardization of tests, or the preparation of norms, or to review even generally the large number of methods available and in widespread use in the clinical assessment of personality (26).

Some statistical problems will be discussed briefly; but no attempt will be made to present a full discussion of assumptions underlying the use of various techniques. The basic concepts of probability and statistical inference will not be discussed, even though they are basic to any prediction.

The Nature of the Prediction Problem

The common goal of the assessment methods to be discussed is the prediction of an individual's performance, that is, an assessment of his *expected* behavior, at some future time. The criterion of performance, of course, must be defined in terms of attributes or characteristics other than those used in whatever operations are performed in arriving at the prediction. The prediction problem, viewed in this way, involves two independent as-

sessments of persons; the two assessments are separated in time. On the basis of one assessment, "predictor categories" are established (by various means). These are items of information believed to be helpful in prediction; they are the "predictors." The second assessment establishes "criterion categories;" these are the classifications of performance to be predicted. The predictions represent estimates of the expected values for the criterion categories, and these estimates are determined from earlier empirical investigations of the relations between the two sets of categories. On the basis of previously observed relationships between the predictor and criterion categories, an attempt is made to determine, for each category of persons, the most probable outcomes in terms of the criterion.

Predictions are sometimes qualified by making them conditional upon the occurrence of some later specific event, and then they are said to be conditional predictions (79). The determination of specific conditional factors which are relevant to the criterion classifications is a crucial problem, not only for prediction; it is a critical problem also in the evaluation of the effectiveness of treatment and control programs. The goals of delinquency prevention and correctional programs may be defined in terms of changing the probabilities of delinquent and criminal behavior.

A predictor category may represent any attribute or measure describing the individual. It may be defined by his own report, or by observations or judgments of others; it may be defined by what he can do or by how he perceives the world. It may be a measure of what he has done, and in this case it may include any of his past achievements or difficulties. It might be defined by exposure to specific treatment programs.

The criterion classification is based upon performance. In the area of crime and delinquency, the measurement of the performance criterion has special features which are critical but often overlooked.

The Criterion Problem

Requirements of reliability and validity must be met for the criterion classifications, as for the predictors. These requirements usually are discussed with reference to predictor variables; measures of differences among individuals which are believed to be predictive must meet certain basic requirements if we are to have confidence in them. Often it is forgotten that these same requirements apply equally to the things we wish to predict. A criterion of delinquency, of criminal behavior, or of probation or parole violation, is itself a measure of individual differences. It may be accurate, explicit, and clear in meaning, or inaccurate, vague, and ambiguous. A number of factors reduce the reliability and validity of the performance criteria commonly used in this field. To the extent that this occurs the validity of predictions will be reduced.

The need for improvement of reliability and validity of measures of criminal and delinquent behavior is a much neglected field, and it is only beginning to receive careful attention as a measurement problem (128). Criteria of delinquency, criminal behavior, and of parole or probation violations are ordinarily quite crude. For example, a common criterion of delinquency is a definition in terms of confinement. If among the confined population some are wrongly convicted, while the nonconfined group contains any individuals who are in fact engaged in delinquent behavior, the validity of the criterion is reduced to that extent. Criteria may not depend solely on the behavior of the person about whom the prediction is made, but they also may depend upon the behavior of others. In the above example, the classification may depend upon the behavior of the police and the courts as well as the accused. Commonly used parole violation criteria, when a designation as a "parole violator" is made on the basis not only of the parolee's behavior, but also on the response of the parole agent or the paroling authority, provide another example. In this situation, an increase in "parole violations" may reflect increased offending behavior by parolees, increased surveillance by parole agents, or changes in policy of the paroling authority. The argument may be carried a step further, since the behavior of a victim might be an important component in determining the "delinquency" or "parole violation." The reliability and validity of criterion categories often are related closely to the efficiency of law enforcement and the administration of criminal justice. They may be affected by policy changes in the relevant social agencies and by changes in the categories of behavior which, in a changing social context, become defined as socially acceptable or unacceptable. The need for development of more adequate assessments of delinquent and criminal behavior, in order to provide criterion measures which are not artificially tied to social agency responses to that behavior, is apparent.

An acceptable criterion of delinquency is critical to any prediction effort since it provides the standard for identification of relevant predictor variables. It constitutes the basis for determining the validity of the prediction method, and it thereby determines whether or not the prediction method will be useful for any specific practical applications.

The reliability and discrimination of criterion measures must be evaluated in terms of consistencies over periods of time and over samples of situations. If this is not done, we can have little confidence that the prediction method will "work" when later applied to new samples. A ruler made of rubber, stretching variably each time a wooden table is measured, cannot be depended upon to provide a reliable measure; similarly, a wooden ruler will be inadequate if the table continuously expands and contracts.

No procedure can predict consistently a criterion which has no reliability; but while high reliability in the criterion is desirable, it does not follow that it is completely necessary. Low reliability introduces random variation which decreases the strength of relations between the predictors and the

criterion; but it does not introduce systematic irrelevant variables (137). One consequence of this is that useful prediction methods may be developed despite relatively crude criteria; another is that improvement of the criterion measures may provide one avenue to improved prediction.

The Steps Followed in Prediction Studies

Five steps must be followed in any prediction study; the list below is modified from the steps identified by Horst (80), by Sarbin (123), and by Bechtoldt (7).

First, the criterion categories of "favorable" performance or of "delinquency" must be established. This involves the definitions of the behavior to be predicted and the development of procedures for classification of persons on the basis of their performance.

Second, the attributes or characteristics on which the predictions are to be based must be selected and defined. These predictor candidates are those that are expected to have significant relationships with the criterion classifications. Critics of prediction methods sometimes argue that the procedures ignore individual differences among persons. Actually, individual differences, often assumed to be a source of error in other problems, provide the basis for any prediction effort. If the persons studied are alike with respect to the predictor candidates, no differential prediction can be made. If they are alike with respect to the criterion categories, there is no prediction problem.

Third, the relationships between the criterion categories and the predictor candidates must be determined, in a sample representative of the population for which inferences are to be drawn.

Fourth, the relationship determined on the basis of the original sample must be verified by application of the prediction procedures to a new sample (or new samples) of the population. This verification, commonly called cross-validation, is a crucial step; but it is often omitted. Without it, there can be little confidence in the utility of a prediction method for any practical application; nevertheless applications are often suggested. Those who argue for applications of prediction methods while ignoring this critical step properly should be excluded from the argument until they learn what the first question is. There may be good reasons for not using demonstrably valid prediction methods in any specific application, but there can be no justification for confident use of these methods in the absence of cross-validation studies.

Fifth, the prediction methods may be applied in situations for which they were developed, provided that the stability of predictions has been supported in the cross-validation step and appropriate samples have been used.

Simplifying Assumptions

In prediction studies certain assumptions commonly are made in order to simplify operational procedures. As a result, statistical procedures which are not justified on the basis of logical implications of assumptions underlying measurement in science neverthless are followed. For example, numerals are used to represent differences in attributes, since this serves a practical purpose. Qualitative dichotomous attributes may be assigned numbers such as zero and one, with various statistics then computed. Qualitative variables with multiple categories may be scaled in various ways with numerical scores assigned. These practices, of ignoring a number of measurement problems pertinent to the use of various statistical procedures (130), undoubtedly will continue since the results are useful. It would not seem wise to ignore these problems, however, since the improved measurement of individual differences with hypothesized relationships to later delinquency behavior offers another means for the eventual improvement of prediction.

A second example of a simplifying assumption, common in prediction studies, is that the criterion magnitudes are linear functions of the predictor variables. A number of authors have pointed out that increased accuracy of prediction may require the use of nonlinear relations (60, 67, 98, 143, 149). In response it may be argued that a linear equation may provide a useful first approximation (7) or turn out to be entirely adequate (26). It may be argued also that nonlinearity of relationships may not be critical, since linearity might be secured by modifying the measuring devices or by a transformation of scales or scores. Furthermore, as pointed out by Bechtoldt, "empirical evidence indicates that sampling fluctuations of regression parameters are of such magnitude that very large representative samples would be required to provide accurate estimates of nonlinearity (7, 35)."

An additional example of a simplifying assumption, usually implicit in the procedures for developing prediction methods, is that the relations among predictor candidates, and between predictor candidates and the criterion, hold for subgroups of a heterogeneous population. The prediction methods are ordinarily based upon a study of a total sample of offenders, or of combined delinquent and nondelinquent populations, with no attempt to establish any relatively homogeneous subgroupings within the larger population (53, 55). This suggests a third approach toward improvement of prediction; predictive efficiency might be improved through separate study of various subgroups of persons.

Requirements of Predictor Classifications

Two requirements for any predictor candidate, aside from the relationship with the criterion, are *discrimination* and *reliability*. *Discrimination* is reflected in the number of categories to which significant proportions of persons are assigned. A classification which assigns all individuals to one class does not discriminate. An index of discrimination has been developed (33), and it may be shown that the best procedure is one which provides a rectangular distribution of categorizations for the sample. For a dichotomous item, the most discriminating item is one that has 50 percent of the cases in each of the two categories (1). However, when two or more items are used the maximum number of discriminations made by the total prediction instrument may or may not be obtained with items at this 50 percent level; the intercorrelations of items and their reliabilities must be considered (13, 19, 34, 69, 120).

One consequence of the requirement of discrimination is that the predictor items found useful in one jurisdiction may not be helpful in another. For example, in parole prediction studies in California, where 15 to 20 percent of the parolee population has a history of opiate drug use, this item has been found useful in parole prediction studies (56). However, in the state of Washington, where fewer than 1 percent of adult parolees have histories of drug use, the item would not be expected to be a helpful predictor.* The requirement of discrimination points to the need for cross-validation studies in various jurisdictions and points up one hazard in untested acceptance of prediction measures developed from study elsewhere in a single jurisdiction. (Considerations of sampling and of the concept of validity, discussed below, result in the same conclusion.) A classification procedure may discriminate but not be valid for a given criterion, and there seems to be no reason that the extent of discrimination would provide an effective weighting of the item in arriving at a prediction device.

Reliability refers to the consistency or stability of repeated observations, scores, or other classifications. If a procedure is reliable, then repetitions of the procedure lead to similar classifications. The topic of reliability of measurement is a large one indeed, and it has been discussed by many writers (25, 73, 74, 82).

Valid prediction is not possible with completely unreliable measures, but all measurement is relatively unreliable. This means that some variation is always expected. It also means that if valid prediction is demonstrated, then the predictor attributes may not be completely unreliable. The main interest in a prediction method is how well the method works; so more importance is attached to the question of validity than of reliability. This does not mean the issue of reliability is unimportant; the improvement of

* Thompson, J., Washington State Probation and Parole Board, *personal communication*.

reliability of predictor variables provides another means for the possible improvement of prediction and therefore deserves much study. Unfortunately, analyses of the reliability of individual predictor items (or of a total prediction instrument) frequently are not reported in delinquency prediction studies.

Probability and Validity

No estimate of future behavior, arrived at by any means, can be made with certainty; a statement of degree of probability is a more appropriate prediction. Individual prediction, with which this paper is concerned, is actually a misnomer. Predictions properly are applied not to individuals but to groups of persons, similar with respect to some set of characteristics (123). In any prediction problem individuals are assigned to classes, and then statements are made about the expected performance of members of the classes. The expected performance outcomes, for specific classifications of persons, ought to be those which provide the most probable values for the population as a whole (12, 72).

The validity of a prediction method refers to the degree to which earlier assessments are related to later criterion classifications. The question of validity asks how well the prediction method "works." Any prediction instrument or method, however, may be thought of as having and lacking not one but many validities of varying degrees. For example, an intelligence test might provide a valid prediction of high school grades. It might provide a much less valid, but still useful, measure of expected social adjustment, and it might have no validity for prediction of delinquency. The validity of prediction refers to the relationship between a specific criterion measure and some earlier assessment, and it is dependent upon the particular criterion used. A prediction method has as many validities as there are criterion measures to be predicted.

Evidence of validity with respect to the specific criterion of interest obviously is necessary before any practical application of the method. Nevertheless, "prediction" studies in the field of crime and delinquency frequently are reported in which the verification, or "cross-validation" step has been omitted.

The concept of validity of prediction is "the tie that binds" all prediction efforts together (101). This is the case whether they are considered clinical or statistical, and regardless of the specific procedures used in developing the method. The "proof of the pudding" in any prediction study is the degree to which the method is valid with respect to specific criterion classifications.

Predictors

The predictor items, on which expectations are based, may be obtained from the self-report of the subjects concerned, reports of observers or judges, records of past performance, or by direct observation by the individual making the prediction. Thus, predictor items may include psychological test scores, measures of attitudes or interests, biographical items, ratings, or indeed any information about the subject.

The objective in most prediction studies has been the formulation of empirical rules based upon observed relationships between individual attributes and the criteria of interest. Those engaged in these studies have tended to consider their problems in these strict empirical terms. The focus of interest has been in the empirical relationships between the predictors and the criterion. If the resulting prediction procedures work, they are accepted as useful.

Some writers have asked whether a theoretically blind prediction technique can provide the basis for effective interventions in the crime and delinquency field (140); this suggests that criminological theory can be helpful in development of more useful prediction instruments. It may be suggested also that the development of prediction methods provides opportunities for the hypothesis testing necessary for development of theory. Prediction methods do not require that hypotheses be derived from a single, consistent theoretical framework; any hypotheses (and conflicting ones) may provide a source of predictor candidates. They do require that these hypotheses be tested as the prediction methods are developed. The strictly empirical, atheoretical approach of many prediction studies has, as Toby points out, led to neglected opportunities for improvement of both prediction and criminological theory.

The Evaluation of Prediction

A number of measures have been developed for the assessment of predictive efficiency. Traditionally, for a qualitative criterion such as "Delinquent vs. Nondelinquent", the efficiency of prediction has been expressed in terms of the proportion of individuals correctly assigned to these criterion categories (72). For quantitative predictions, efficiency is usually expressed as some function of the correlation between the predictor and criterion measures. Some measures provide interpretations of a validity coefficient with special reference to the accuracy of prediction of individual scores. They include the coefficient of alienation (75) and the index of forecasting efficiency (80). Efficiency of prediction may be assessed also by the relative number of correct predictions in terms of exceeding some criti-

cal value of the criterion (81). Sometimes the correlation coefficient is re-
garded as a direct index to the efficiency of prediction (13); the square of
the correlation coefficient, called the coefficient of determination, measures
the proportion of variance in the criterion classifications which is "ac-
counted for" by the items included in the prediction method. Another
means of evaluating the efficiency of prediction is in terms of the increase
in accuracy of prediction when the prediction method is used, as compared
with selecting cases at random (88).

Ohlin and Duncan proposed an index of predictive efficiency defined by
the precentage change in errors of prediction by the prediction method
rather than the "base rate," i.e., the proportion of persons in the criterion
category to be predicted (108). Their later method (31) was modified by
Duncan and Duncan and called the "mean cost rating" (32), a procedure
which reflects the degree to which a classification method accurately as-
signs persons to a dichotomous criterion classification.

Evaluations of predictive efficiency by means of these and other avail-
able measures can provide useful comparisons of the predictive accuracy
of various prediction approaches, and they provide general statements con-
cerning the efficiency of prediction. Such comparisons of efficiency of pre-
dictions, when the expectancies are arrived at by various methods, are
needed but are quite rare in the crime and delinquency field.

It should be noted that (depending upon the purpose to which the predic-
tion method is to be put) prediction methods with even quite low validity
may be useful (27). On the other hand, prediction methods with high valid-
ity in one sample may be of little use in an application which concerns a
sample from another population, or the degree of validity required may
depend upon other components of the problem. A number of factors influ-
ence the utility of prediction methods and bear upon issues of practical
applications.

Factors Influencing the Utility of Prediction

Predictive efficiency and the utility of prediction methods both are affected
by various factors other than the relationship between the predictor items
and the criterion. Besides the reliability of predictor candidates, these fac-
tors may include the "selection ratio," the "base rate," the method of
combining predictor variables, the representativeness of the sample on
which the prediction method has been based, and the number of predictor
variables. Each of these should be discussed briefly as a basis for consider-
ation of existing prediction methods.

THE SELECTION RATIO

In any selection problem, such as placement on probation or parole,
some individuals are chosen and some are rejected. The ratio of the num-

ber who are chosen to the total number available is called the selection ratio (7). The usefulness of a selection procedure depends not only upon the validity of the prediction method but depends also upon this ratio. If the selection ratio is low, as for example when only a few individuals are to be accepted for parole, fairly low validity coefficients in a prediction device may prove useful. If only a few individuals are to be rejected, then a much higher validity would be required for the same degree of effectiveness as an aid in selection.

THE BASE RATE

The "base rate" refers to the proportion of individuals in some population who fall into a category which is to be predicted. Fortunately for society, but unfortunately for those who aspire to predict delinquency, delinquency is a rather uncommon state of affairs (76). Even more fortunate for society at large is that shocking crimes against persons are relatively infrequent in proportion to the population as a whole; but at the same time that we wish most to predict these relatively rare occurrences, the predictive task is made more difficult by the base rate. The base rate affects both our ability to discover predictors which differentiate criterion categories and the accuracy of prediction when methods are applied to new samples.

This means that for relatively rare occurrences we may expect greater difficulty in finding predictive information. At the same time, a prediction method (in order to be useful) must be a more efficient one if the event to be predicted is relatively rare.

The first problem is that if there are relatively few "failures" or "delinquents" in a population we will be hard put to find items which discriminate between the successes and the failures.* It will be more difficult to find useful predictors, because the variation in the criterion is reduced, and it is this variation which must be analyzed in the search for predictors.

The effect of base rates on the accuracy of prediction has been discussed by Meehl and Rosen (104), by Cureton (28), and with illustrations in the field of delinquency by Gough (62), Hanley (76), Grygier (67), and Walters (145).

In order for a prediction method to be useful, it must provide more information than that given by the base rate alone. For example, if 90 percent of the children in the population can be expected to be nondelinquent in any event, then there is little value in a method unless the proportion of nondelinquent individuals among those expected to be nondelinquent can be significantly increased over the 90 percent value (141). Frequently, however, a prediction method is devised on the basis of study of a sample containing equal (or about equal) numbers of delinquents and

* It can be shown also that as a sample proportion of failures (or of successes) becomes smaller, larger samples are needed in order to reduce error in estimating the numbers of successes and failures in the total population.

nondelinquents. Then it is applied to the general population where the proportion who actually become delinquent is considerably lower. This procedure can be expected to result in a serious overestimation of the practical effectiveness of the prediction device. In order to evaluate the utility of the prediction method, it is necessary to know not only how well it discriminates between the future delinquents and nondelinquents, but how common is delinquency in the general population.

It is important to know also the relative costs and utilities of forestalling delinquency in a predicted delinquent in relation to the possible costs of misclassifying an individual who will not become delinquent (27). Similarly, in probation or parole selection applications it is important to know not only the probable outcomes of probation or parole and the associated costs but the expected outcomes and costs of denial of these alternatives to confinement.

METHODS OF COMBINING PREDICTORS

If a number of predictor items are to be used in establishing a single prediction, then the items may be combined in various ways. Either the predictors all may be used without weighting them, or some procedure for weighting the various predictor items may be used, or some type of "configural" method may be employed.

The most widely used method of combining predictors has been the assignment of unit weights; many predictive characteristics are used without a weighting system. Each item found to be related to the criterion is assigned one point regardless of the strength of its association; and the sum of the points thus assigned provides a measure of the probability of delinquency, parole violation, or some other criterion classification. This has been a popular procedure (15, 36, 63, 109, 110, 117, 118, 119, 126, 138, 139, 147). As pointed out by Grygier, it is democratic as well as popular, considering all predictors equally; however, it may be inefficient (67). This procedure ignores intercorrelations among the predictors, but if a large number of items is used there is nevertheless a good argument for it. It may be assumed that as the number of positively correlated variables increases, the correlation between any two sets of weighted scores approaches one and the effect of differential weighting of the various items tends to disappear. If the number of measures to be added together is not large, however, the dispersions and intercorrelations of the measures may influence significantly the weights expected on theoretical grounds to increase predictive efficiency.

The second method (really a set of methods) employs a smaller number of predictive characteristics and some weighting system. Items with the highest correlations with the criterion are generally selected and various methods of weighting are applied.

The best known of these is found in the series of prediction studies by the Gluecks (38, 39, 40, 41, 42, 43, 44, 45, 46, 47, 48). Contingency coeffi-

cients are found, in order to measure the association of the initial assessments with the criterion classification, and to select significant predictors. Each item is weighted in scoring by assigning it the percent figure for the criterion among persons characterized by the predictor attribute. As in the case of assignment of unit weights, correlations among predictors are ignored, and there is no reason to suppose that an "optimal" weighting procedure would result. The weighting is based upon discrimination in the criterion classification and ignores overlapping of items. In two studies, the method was not found superior to assignment of unit weights (106, 144).

Two theoretically better models are provided by multiple linear regression and by linear discriminant function. These methods take account of the intercorrelations of the predictor variables as well as the correlations with the criterion. In multiple regression, the linear equation is found such that weights are assigned in order to minimize the squared deviations of observed and expected criterion values. If Fisher's discriminant function is used, the weights in the linear equation are found such that the criterion classification groups are maximally separated (in terms of the mean values for the prediction scores, in relation to their pooled standard deviations).

These methods have been used in a number of studies. Multiple regression was used by Mannheim and Wilkins (98), in their English Borstal prediction study, and they reported that more efficient prediction was thereby achieved than that found with assignment of unit weights. The method was employed in parole prediction by Kirby (90), and it has been the method used in a number of California Parole Prediction Studies (51, 52, 56). The discriminant function has been employed for prediction in various areas, including problems in classification of students (3), of farmers (11), of air force radio operators (146), of aviation cadets (93), and military delinquents (70).

A series of studies conducted for the United States Naval Retraining Command represents one of the most careful and sophisticated studies in delinquency prediction but is perhaps less well known than others (5, 70, 66, 85, 71). Discriminant functions were developed, from study of an initial sample of 20,000 naval recruits, and from study of the proportion defined as offenders from various follow-up sources (1,339 persons). Among other results, the study demonstrated clearly that a pencil and paper Delinquency Potential Scale (developed in the same study) made a unique contribution to the separation of the offender and nonoffender groups.

Regression analyses have many advantages. One is the theoretically optimal weighting of predictors (in terms of the linear assumption). Another is the special utility of the method for selection of predictors, since they may be selected after determining the proportionate reduction of unaccounted-for variance in the criterion by inclusion of each item; that is, the gain in prediction by adding the item may be determined readily as an increase in the coefficient of determination.

The method has some shortcomings. One may be the assumption of lin-

earity already discussed. Another is that the weights are derived from the correlation matrix (for all predictor candidates and the criterion) for the total sample of subjects. It is therefore assumed implicitly that these correlations are adequate estimates of comparable coefficients for subsamples, that is, for subgroups of persons, within the larger sample. This assumption may be demonstrably false (53).

Configural prediction methods also have been used in delinquency prediction, again with variations of method. In other areas, they generally have not been found to provide increases in predictive efficiency over linear models (26). One method, described by MacNaughton-Smith (95) has been called "predictive attribute analysis." This approach also has been used in parole predictions by Wilkins (153), by Grygier (67), and by Ballard (6). A closely related procedure is the "configural analysis" method of Glaser (37), also used in parole prediction studies by Mannering and Babst in Wisconsin (97). When both linear regression and the configural analysis methods were applied to the same set of Wisconsin data, results of these methods gave similar predictive efficiency (54). A shortcoming of the general approach is that the successive partitioning of the sample into subgroups may involve a capitalization on sampling error (55).

The basis for the method proposed by MacNaughton-Smith is a successive partitioning of a sample into subgroups on the basis of the single item found in each subgroup to have the closest association with the criterion. That is, first the single most predictive item is found and the total sample is divided on this attribute. Each of the two resulting subsamples is studied further, in order to identify, within each, the single best predictor. Then the two subsamples are further subdivided and the process repeated until no further items significantly associated with the criterion are found.

Another configural approach is given by the method called association analysis. The method, developed by Williams and Lambert for studies in plant ecology (154), has been employed in delinquency prediction by Wilkins and MacNaughton-Smith (152), and by Gottfredson, Ballard, and Lane (53). The method provides an empirical means for subdividing a heterogeneous population into subgroups which are relatively homogeneous with respect to the attributes studied. It is more properly called a classification method; unlike other prediction methods, the criterion classifications are ignored in establishing the subgrouping. The establishment of the classifications is not dependent upon the relationships of predictor candidates to the criterion; the classification may provide, nevertheless, a valid prediction method.

A combination of association analysis and regression methods has been suggested. Association analysis would be used in order to define relatively homogeneous subgroups of persons. Then regression methods would provide the means for development of prediction devices for each subgroup so identified. This or similar procedures providing for separate prediction

studies for meaningful subgroups of offenders may provide an avenue to improved prediction.

Despite the variety of methods which have been used for combining predictors, empirical comparisons of resulting predictive efficiency are rare; and they are needed (62).

SAMPLING

A shortcoming of many delinquency prediction studies is the use of samples, studied for development of the prediction method, which are not representative of the populations to which generalizations are to be made. If systematic biases are introduced by the sampling procedure, then the validity in new samples will be decreased. General application of prediction methods based upon study of nonrepresentative samples, as in a study completed in a high delinquency area, is very questionable; the same is true of application of probation or parole prediction procedures in jurisdictions other than those studied in developing the measures. In any such intended application, further cross-validation is necessary, attention to the base rate problem is imperative, and continued assessment of the stability of predictive validity over time is essential.

NUMBER OF PREDICTOR VARIABLES

When multiple regression is used as the method of combining predictor variables, the stability of predictions for new samples tends to decrease with an increase in the number of items included in the equation. Adding items to the original set of predictors will not reduce the accuracy of prediction in the original sample, however (80,115). If only the original sample is studied, the investigator risks being misled by an accumulation of errors; his only safeguard is found in study of new samples. This emphasizes again the need for cross-validation studies.

For stable predictive validity a small number of items which are not only predictive but relatively independent of one another is sought. In this situation, each item makes an unique contribution to the prediction.

Predictive Information

In the Glueck studies, already mentioned, attempts have been made to identify potential delinquents at a very early age. Various prediction tables have been developed. One of these, called "Social Factors" has been evaluated intensively over a long term. The tables rest on the determination of predictive items in a study comparing 500 delinquents and 500 nondelinquents.

In a ten-year validation study, with retention of a three factor scale in-

cluding "supervision of the boy by his father," "supervision of the boy by his mother," and "family cohesiveness," as well as a two factor scale including "supervision of the boy by his mother" and "family cohesiveness," the investigators concluded:

The Glueck Social Prediction Table, after nine years of study and experimentation, is showing evidence of being a good differentiator between potential delinquents (serious and persisting) and nondelinquents.

They asserted also that:

The Three-Factor Table yielded approximately a 70 percent accuracy in predicting delinquents and an 85 percent accuracy in predicting nondelinquents (22, 23).

The procedures used by the Gluecks in developing their methods and the conclusions reached on the basis of their study have been strongly supported and severely criticized. A 1951 symposium of reviews in the *Journal of Criminal Law and Criminology* was generally highly favorable. The most incisive criticisms have been addressed to the sampling methods used and the base rate problem. It has been argued that a nonrepresentative sample was studied, the research having been carried out in a high delinquency area in New York City (122, 92). The criticisms of Rubin and of Shaplin and Tiedman (129) discuss the sampling problem and the point that delinquents were not studied in their youth (extrapolations having been made from data obtained after the boys had been institutionalized in adolescence).

Similar strong objections by Reiss (119), by Gough (62), by Grygier (66), and by Hanley (76) emphasize the implications of the base rate problem and demonstrate its importance for applications in delinquency prediction. The reported accuracy of the Glueck Tables is based on the situation with equal numbers of delinquents and controls. When the base rate is set at a more realistic figure, in terms of the incidence of delinquency generally, the tables turn out to be far less discriminating than claimed. The criticism is also made by Walters (145), who demonstrates that a base rate of between 2 and 4 percent makes prediction from the tables quite inaccurate. It is clear that if the base rate problem is ignored, the practical effectiveness of the Glueck Tables will be greatly overestimated.

A sequential procedure for identifying potential delinquents has been offered by Stott (132). Based upon the incidence of symptoms of nondelinquent behavior disturbances among probationers and controls, the *Bristol Social Adjustment Guide* was developed. A preliminary screening is completed by teachers on the basis of six yes-no items concerning behavior disturbances found to be associated with delinquency. If a boy is rated adversely on one or more items, then the full *Guide* is used in assessment. Evidence from a Glasgow survey suggests these procedures as promising, but they have not been validated in the United States.

Of various prediction measures developed by Kvaraceus, the nonverbal KD Proneness Scale has undergone the most extensive validation (91).

Sixty-two circles each include four pictures based on concepts concerning reported differences between delinquents and nondelinquents. The subject indicates the item he likes most and the one he likes least. Validation data are available from a careful three-year follow-up study of 1,594 junior high school students (and for a small sample of retarded children in special classes). While some evidence of validity was reported, inconsistencies in the results of the validation study led the author to urge caution in the employment of this tool for prediction on a routine or perfunctory basis. Reported as the most significant result was that teacher nominations (based on pupil behavior) were found equally effective and sometimes more effective as predictors of future delinquency.

A procedure reported by Bower as a method for identification of children most vulnerable to or handicapped by emotional disorders also makes use of teacher ratings in a sequential screening process (10). The usefulness of the screening process has been extensively studied. Results indicate that it is a practical approach for identification of emotionally disturbed children not otherwise recognized in the school situation; further validation studies again are needed.

A number of additional prediction methods, aimed at the identification of future delinquents, give evidence of promise; all need further validation, and all require validation in specific jurisdictions before application (131, 112, 148, 114).

The Minnesota Multiphasic Personality Inventory is a widely used empirically derived set of personality scales which may be used in group administration (77). The validity of this instrument in delinquency prediction has been investigated in a sample of 4,048 ninth grade boys and girls in Minneapolis (78). Two years after administration of the test, county and city records were checked and it was found that 591 (about 22 percent of the boys and 8 percent of the girls) had been brought before the courts or the police. The criterion of delinquency employed was a broad one, including three levels of seriousness of offenses.

Two subscales of the test, namely the "Psychopathic Deviancy" subscale and the "Hypomanic" subscale were found predictive of delinquency. Considerable attention was given to the contribution of profiles of the *MMPI* as an aid to understanding the dynamics of delinquent behavior. Also, 33 *MMPI* items discriminating predelinquent from normal boys later were identified (79); further validation of these items as a separate scale is needed.

The *MMPI* was originally prepared for adult use, and it has been noted that it contains a large number of emotionally charged items to which parents and teachers frequently raise objections (92). The predictive utility of the *MMPI* in the prediction of delinquency among prisoners (in terms of misbehavior during confinement) has been investigated by Paton (111), and by Jacobson and Wirt (86).

There are many other psychological assessment procedures which may

help in development of improved prediction methods. As recently as 1950, a review of the literature concerning comparisons of delinquents and non-delinquents on personality measures led to the conclusion that no consistent significant differences between these two groups were to be found (127). More recent studies, using more recently available instruments, demonstrate that a number of these do discriminate between delinquents and nondelinquents. Already mentioned is the Psychopathic Deviate Scale of the *MMPI,* which has been found in a number of studies consistently to differentiate delinquents and nondelinquents (107, 78). Another discriminator is the Socialization Scale of the *California Personality Inventory* (58, 61); another is the already mentioned Delinquency Potential Scale. These studies themselves demonstrate that there are measurable personality differences between delinquents and nondelinquents.

In a 1961 review, Argyle points to a large number of reported differences between delinquents and nondelinquents on personality measures (4). These are enumerated under categories of tests of cheating, and of moral values; measures of extra-punitiveness; of attitude toward parents, toward authority, and toward peer groups; measures of level of aspiration, of motor control, time span, compulsiveness, and emotional maturity; measures of cruelty and aggressiveness, and of skill and social perception; and measures of neuroticism.

Still other personality measures have identified variables discriminating delinquent and nondelinquent subjects. Differences in ability between delinquent and nondelinquent boys were described by Zakolski (156). Another study demonstrated that institutionalized delinquent boys obtained lower scores than controls on a "perceptual-completion" measure (89). Differences in measured levels of aspiration were described in yet another study (20), and differences in Porteus Maze Test performance have been identified in still another (30). Differences were reported in Rorschach responses by delinquent and normal adolescents in the Glueck study; the same study reports a high degree of discrimination between delinquent and normal Rorschach records when these are made by skilled clinical workers (126).

There are promising results, though they do not hold forth much hope of immediate applicability. Often, the data describe differences between delinquent and control samples which may not be assumed to be representative of the general population, and the problem of the base rate is ignored. This does not mean they are unimportant in pointing the way to improvement of predictive efficiency. The utility of discriminators such as these in a prediction study which includes adequate investigation of the validity problem, and investigates the consequences of application of realistic base rates, can only be settled by the empirical study which is needed.

In a lengthy history of parole prediction studies, a number of consistently reported differentiators of parole performance criteria have been found. The most useful guides to prediction of parole violation behavior are

indices of past criminal behavior. This result, discouraging in terms of treatment concerns, finds support in most parole prediction studies (56, 38, 138, 15, 18, 37, 126, 142, 109, 98).

Offenders against persons have been found at least since 1923 to be generally better risks, so far as parole violations are concerned, than are offenders against property (147). Glaser includes an excellent review of evidence, from a variety of jurisdictions, that leaves little room for doubt as to the predictive nature of offense classifications (37).

In general, the probability of parole violation decreases with age (45, 41, 18, 122, 155). The contention that offenders who are older at release are less likely to return to crime is supported by parolee data from the states of Wisconsin, New York, California, and the United States federal system. Similar results have been found, as Glaser notes, for many decades, and in numerous jurisdictions, both in the United States and abroad.

Histories of opiate drug use or of alcoholic difficulties are unfavorable prognostic signs for parole performance; this has been found for both male and female parolees (49, 52, 56). Burgess and Tibbetts found a "drunkard" classification to yield an unfavorable sign, as did Ohlin. Similarly, Schiedt considered alcohol use important. The social types from earlier work were redefined by Glaser into seven general categories, "toward which the sub-jects seemed to be developing prior to their offenses," taking account of alcoholic difficulties.*

The use of aliases has been found, in California studies, to be predictive of unfavorable parole performance among both male and female adult pris-oners. When the offender's history reflects a criminal record for others in the person's immediate family, this too is an unfavorable prognostic sign.

Recent studies indicate that a combination of life history information, which provides the main basis for prediction in most studies, when com-bined with data from personality testing may result in a superior prediction of parole violations (64, 57). Measures of "social maturity," have been found helpful in prediction in a number of studies. "Social maturity" has been defined variously, but in each case has had its roots particularly in studies by Gough (60), by Gough and Peterson (63), and by Grant (65).

Clinical Assessment as an Avenue to Improvement of Prediction

Comparisons of empirically derived and "subjective experience" derived behavior predictions, along with the extensive literature dealing with this topic, have been well-reviewed by Meehl (100) and by Gough (62). When statistical prediction devices are pitted against clinical judgment and the accuracy of prediction compared, statistical prediction has generally fared

* A review of literature concerning the predictive utility of age, offense, prior record, race, intelligence, and body build is given by Glaser (37).

better. A less competitive, more collaborative, attack on prediction problems is needed.

As indicated twenty-five years ago by Horst, "The statistician and the case study investigator can make mutual gains if they'll quit quarreling with each other and begin borrowing from each other (80)." In the same vein, DeGroot has argued there is more to be gained through efforts to improve statistical prediction by way of clinical prediction than through continuation of arguments or comparisons of the predictive accuracy of the two approaches (29). This suggests that the clinician be given the best available statistical prediction device, and that he then attempt to improve, by any means, upon the accuracy of predictions which may be made through its use. When it can be demonstrated that he can do so, then the attempt should be made to define adequately the information used in establishing the expectancy. If this can be done, then a reliable measure can be developed; and ultimately it can be included in the statistical prediction device.

Prediction devices, developed by any method, can do no more than summarize experience. They can do this quite objectively and efficiently; and therefore they can provide an adequate means of summarizing that which is known about the prediction of delinquency or crime. Possible predictors which are as yet only vaguely felt or ill-defined may be refined into more adequate hypotheses which then may be tested for possible inclusion in the prediction device. In this way, a means is provided not only for the summarization of knowledge but for its extension.

Clinical Assessment and Delinquency Prediction

Personality assessment techniques of a different variety are in widespread use in schools, in private clinical practice, in evaluations prepared for courts, and diagnostic studies in detention. They are used in making decisions about individuals, often on the basis of assumptions concerning predictive validity with respect to future delinquency, criminal behavior, or probation or parole violation. A whole literature of clinical psychology, psychiatry, and social work is relevant to the problem of predictions based upon interviews, projective tests, or other samples of the person's behavior. How can the utility of this vast array of assessment methods be considered briefly?

Cronbach and Gleser have suggested an important, useful distinction between two general types of assessment methods (27, 26). Their discussion is based upon a model from information theory in which two aspects of any communication system are distinguished: bandwidth and fidelity.

Some procedures, like the interview, the psychologist's report from projective testing, written evaluations prepared by clinical or custodial institution staff, or a social history report, provide a wide variety of information.

Each of the "wide band" procedures is characteristically found to be unsatisfactory, by any usual standards of reliability and validity, for prediction of specific behavior. This does not mean they are useless; it means that the wider coverage is purchased at the price of low dependability (fidelity). What purposes, then, do these procedures fulfill?

Evidence that interviews, for example, are useful in prediction, is preponderantly negative; repeatedly, comparisons have shown statistical prediction devices to be more valid. But, as Cronbach and Gleser point out, even the most forceful advocates of statistical prediction insist on an interview when *they* must make a decision. Since interviewer judgments disagree notoriously with one another and have little relationship to outcomes, we must ask why we persist in interviewing.

The interviewer can address any aspect of the other person's personality, character, and life situation. His delinquency history, employment record, relations with his family, group identifications, feelings about authority, his disappointments and expectations are some frequent topics. The interview may reveal something of his abilities and interests, his sexual attitudes, his major conflicts, defenses against anxiety, his values, and his plans. It is a sequential process which can turn in any direction to follow leads, unexpected but judged important during the interview, that any structured objective test or prediction procedure cannot. This flexibility and potential scope is its virtue, because by covering a broad range of information it may shed light on *many different decisions*. It is clear that the interview may not bear only on a single problem or relate to a single criterion classification we wish to predict. It may suggest a further treatment plan, particular areas of weakness to be guarded against, and special potentials for favorable adjustment in certain situations.

The "wide band" methods are exhaustive but undependable; that is, they cover more of the ground we wish to know about—but any one prediction from this wide range of information cannot be depended upon to be valid. The narrow range procedures may give more accurate information with respect to *one* decision outcome when adequate validation data are available; but they give no guidance at all with respect to *other* decision outcomes.

What about "narrow band" procedures? These include any objective psychological test with established validity for prediction of a single behavioral criterion, parole or probation violation prediction devices, some delinquency prediction scales, certain college aptitude tests, and the like. Their virtue is dependability (high fidelity)—compared with the interview and other broad scope methods. Their limitation is that they cover relatively little ground; that is, they bear only on that part of the decision which is concerned with the specific question they help answer.

The narrow scope (and therefore both the potential power and limited utility) of such a prediction device is apparent. Though it gives a more dependable prediction of outcome than generally obtained by broad band

methods, it is relevant only to the *specific* criterion defined for the purpose of study. Unless it has been shown valid also for predicting other specific outcomes of interest to the decision maker, it provides no guidance for decisions based on expected behavior in other areas. It may tell nothing about appropriate treatment placement.

In general, a narrow range procedure such as an objective test, delinquency scale, or parole prediction device is more reliable (that is, different people will tend to agree on the scores for various others). It is more valid (that is, it predicts better). But it covers only a limited sector of all behavior in which there is interest. In short, it has limited range but high fidelity; if the narrow scope is unrecognized, the procedure may provide a good answer to the wrong question.

How can these two types of information be profitably used together? We wish to utilize the best features of each, recognizing the limitations of both, in order to make optimal decisions on the basis of available knowledge.

The optimal use of both, however, will depend upon the nature of the decision problem. It will depend upon the resources available, the alternative courses of action, and the goals of crime and delinquency programs. This suggests that optimal procedures for one agency might not be the best for others with differing resources, alternatives, or goals. Recently developed methods in applied statistical decision theory are pertinent to this problem; and development of applications of these methods to delinquency and crime prevention, treatment, and control problems offers one of the most promising available routes to increased effectiveness of the social agencies concerned.

Applications of Prediction Methods

Despite the painstaking studies, item analyses, and validation studies implied by the preceding pages, all currently available prediction methods still have only relatively low predictive power. In most instances the problem of any application is confounded by the base rate problem and by inadequate cross-validation in samples from populations in which practical applications might be proposed.

The routine use of any available instruments in programs for early identification and treatment of delinquency has been regarded by many as somewhat dangerous on one or more of three grounds. First, the available validity data are questionable. Second, there is the base rate problem; and finally, there is apprehension concerning the "self-fulfilling prophecy." The latter concern is with the possible negative effects of a classification procedure itself upon the persons classified, through labeling them undesirably. Toby asks:

How can early identification and intensive treatment programs avoid "self-fulfilling prophecies?"

If the treatment program concentrates its efforts on youngsters who are especially vulnerable to delinquency, how can it justify its discriminatory policy except by stigmatizing predelinquents? And may not the delinquency-producing effects of the stigmatizing equal or exceed the delinquency-preventing benefits of the treatment? (140).

In any proposed application, the question of validity of prediction is only one component of the decision problem. The objective of the decision should be to minimize errors and to make them less costly.

In the absence of a perfection which is not expected, any prediction (made by any procedure) is uncertain; the result will be errors of two kinds. Some persons will be expected to be delinquents who will not be identified later as delinquent. Some will be expected to be nondelinquent but later will be found to be delinquent. The concept of the "self-fulfilling prophecy" calls attention to the probability that the two types of error may not have equal consequences. It suggests that it may be much more damaging to treat as delinquents those persons misclassified as expected delinquents than to treat predelinquents as if they were not expected to be delinquent.

The application of statistical decision theory methods as a means of minimizing errors in placement or selection decisions will require the assignment of values to the outcomes, i.e., to the consequences, of the decision alternatives; the positive and negative values of outcomes of both correct and incorrect decisions must be considered. This points again to the need for attention to problems of measurement of the consequences of decisions, that is, to the criterion problem. It will require careful and explicit statement of the objectives of any given decision, but this may be a healthy exercise for the decision makers concerned.

Programs of early identification and prevention of delinquency have been recently reviewed by Kvaraceus (92). Pointing to the low predictive power of available instruments, he indicates that "as yet, no simple, practical, and valid tests for delinquency prediction can be found on the test market." He notes also a growing conviction that separate techniques or tests must be developed for middle-class youngsters and for lower-class children and that it may be easier to predict certain types of delinquents compared with others.

Related suggestions are made by Toby. Along with demonstrating that in both the Cambridge Somerville Youth Study (113) and the New York City Youth Board Prediction Study (135) attention to the social context can improve the accuracy of predictions, he discusses the needs for integration of prediction efforts within a consistent theoretical framework.

The entire July 1962 issue of the journal of *Crime and Delinquency* was given to discussion of parole prediction devices. Most of this discussion

relates to the applicability of parole prediction methods to individual selection for parole. Before discussing this role, however, it should be noted that parole prediction methods have demonstrated utility (in one practical situation) in broad screening programs and for parole supervision caseload assignments (50).

In the first application, as an aid to a program intended to reduce confinement costs, a large prison population was screened, first by the parole prediction device, then by further clinical criteria. The result was a small group of men referred for parole consideration at a date earlier than originally scheduled, with substantial monetary savings and no increase in parole violations, as a result. In the second application, the parole prediction measure aided the establishment of minimal supervision caseloads for both male and female parolees. Persons classed as having a high probability of successful parole completion received minimal supervision (experience having demonstrated that these cases may be given less supervision with no increase in the parole violation rates with the result that parole workers might be assigned to spend their effort in areas where help is more needed). Again, a substantial saving of money was reported.

When applications to parole selection are considered, in the light of the "band width-fidelity" concept discussed above, it appears that the best use of prediction methods will depend upon not only the established validity of the prediction method but also upon the goals of a particular decision in a specific social agency. Ultimately, the contribution of any prediction method to a particular decision process should be assessed in reference to available decision alternatives and in terms of costs and utilities (27).

The most useful role, and at any rate the most immediately feasible application for prediction methods, may be found not in selection or placement applications but in treatment evaluation research (98, 51, 52, 50, 57). Studies of effectiveness of any treatment or control program may be conducted according to experimental or statistical designs. Experimental designs provide the most rigorous approach. In the field of crime and delinquency, however, this approach often is beset with problems or is simply not feasible. When this is the case, statistical means of control must be substituted for the lacking experimental controls. The prediction method can provide a measure of the expected performance for any group of subjects. Then the expected and actual outcomes for a specific criterion classification may be compared. One such approach may be described as follows: Prediction devices, to estimate the likelihood of agency program outcomes, first must be developed and tested. These represent experience with various groups of people, summarized by appropriate statistical methods; they provide a way of quantifying expectations based upon past experience. They are needed for application to each person *before* assignment to treatment. When persons are assigned to specific kinds of treatments, then we may ask whether the actual outcome is more or less favorable than *expected* (from past experience with other, similar groups). Since we wish

to find treatments that improve the chances of success, we will be pleased if the prediction device is made invalid by helpful treatment.

If the outcome following treatment can be predicted not only before treatment but *regardless* of treatment, then it is very hard to argue that this treatment makes any difference with respect to the specific outcome studied. However, persons assigned to a given treatment may "succeed" (or "fail") significantly more often than expected from their risk classifications. If the validity of the prediction device has been established on other groups, then the observed differences in outcomes must be because of treatment, or because of factors associated with treatment, or both.

Further research, using experimental designs, might then be developed in order to test hypotheses about the source of the difference. Meanwhile, decision makers at least can be made aware of the relationship—positive, negative, or none—between the program and the outcomes. The most useful role for prediction methods, therefore, will be found when their development and validation is studied continuously as one component of an agency-wide information system for assessment of the effectiveness of programs.

Implications

In each social agency responsible for crime and delinquency treatment and control programs, a systematic study of "natural variation" is needed. Improvement of predictive efficiency and evaluations of differing treatment alternatives are closely related problems; in a concerted effort they can be attacked together. The main requirements are:

1. Systematic collection of reliable data for "predictor candidates" at critical decision points within the total system.
2. Repeated studies of the relations between predictor categories and criterion categories defined in terms of agency goals.
3. Repeated validation of any prediction methods devised.
4. Periodic determination, on the basis of prediction methods, of expected outcomes of various programs within the agency.
5. Comparisons of criterion outcomes expected (by the prediction method) and observed (in actual practice).
6. Development of experimental programs to identify the sources of discrepancies between expected and observed results, when such differences are found.
7. Periodic provision, to decision makers of the agency, of information concerning the probable criterion outcomes of program decision alternatives.

In any agency, a continuous cycle of development of prediction methods, repeated validation, comparisons of program outcomes, modification of practice, research, and practice is needed. This requires systematic collection of information over the total system and repeated study of relationships to correctional goals. Prediction methods should occupy a prominent

place in this cycle, primarily because they are needed as tools for the assessment of programs.

The next need will be for collaborative studies by agencies in various jurisdictions and by agencies whose responsibilities focus at different points in the continuum of correctional services from arrest to discharge. Examples of areas in which careful development of prediction methods, and extensive validation studies, are needed may be found throughout this continuum. Applications may be envisioned, but not yet proposed, as aids in selection or placement and the research applications of prediction methods can be immediately helpful.

Potential applications may be found at each stage of the process of the administration of justice. Problems of early identification of delinquency have been reviewed briefly. Immediately upon arrest of an alleged offender, other prediction problems arise. The general problem of "release on recognizance," includes at least the prediction question of appearance for trial. This problem demands (in fairness to the courts and to the accused) much more empirical study than ever has been attempted. Prediction of probation outcomes has received little study, despite the needs for assessment of variations in criterion outcomes associated with probation supervision alternatives. Prediction methods, with adequate validation, are needed for evaluation studies of a variety of community treatment programs. They are needed equally as tools for assessment of the wide variety of programs conducted in confinement, in detention, in jails, or in prisons. They are needed as aids in determining probable outcomes of alternative programs after institutional release.

This review shows that work is needed particularly in a number of areas:

1. Improvement of measures of the criteria of delinquency or crime to be predicted is required. This includes the development of more reliable measures, more specifically related to the behavior of offenders, and the assessment of reliability over time. There is a broader question, however, of explicit identification of the goals of social agencies concerned with delinquency and its correction. This general problem has led Wilkins to remark that one of the most important problems is not *how* to predict but *what* to predict (151).
2. Cross-validation studies of available measures in order to test their applicability in various jurisdictions is needed, and repeated assessment of validity along with social change will be in order.
3. Development of prediction measures for specific subgroups, rather than for samples of total populations of children or of offenders is apparently a promising route to improved prediction.
4. Empirical comparisons of various methods in use for combining predictors are needed.
5. Leads from studies demonstrating a variety of discriminators of delinquent and nondelinquent samples should be followed up systematically to improve current prediction methods.
6. Attempts to improve statistical prediction methods by testing hypotheses from clinical practice represent another avenue to improved prediction.
7. Studies of specific decision functions, utilizing recently developed tools in applied decision theory, are needed at various points in the correctional pro-

cess, wherever decisions are made about offenders. These will require assessment of the social and monetary costs and values associated with errors and successes along the correctional continuum.

8. Prediction methods should be built into the information system of each social agency responsible for custody, treatment, or release of offenders. This can permit necessary, repeated validation studies, or necessary modifications, of available prediction tools. It can permit programs for systematic feedback to decision makers concerning the predictive relevance of information used in arriving at individual decisions. It can provide helpful tools for evaluations of programs, thereby enabling administrators to assess the probable consequences of program decisions.

REFERENCES

1. Adkins, B. C. *Construction and Analysis of Achievement Tests.* Washington, D.C.: Superintendent of Documents, 1947.

2. Adkins, B. C. "Selecting Public Employees." *Public Personnel Review* 17(1956):259–267.

3. Ahman, J. S. "An Application of Fisher's Discriminant Function in the Classification of Students." *Journal of Educational Psychology* 46(1955):184–188.

4. Argyle, M. "A New Approach to the Classification of Delinquents with Implications for Treatment." In *Enquiries Concerning Kinds of Treatment for Kinds of Delinquents, Monograph No. 2,* pp. 15–26. Sacramento, California: Board of Corrections, July 1961.

5. Ballard, K. B. Jr.; Bobinski, C. A.; and Grant, J. D. *A Pilot Study of Factors in Retraining Which Change Delinquency Attitudes.* Third Technical Report, Rehabilitation Research, U.S. Naval Retraining Command, Camp Elliott, San Diego, California, January 1956.

6. Ballard, K. B. Jr., and Gottfredson, D. M. *Predictive Attribute Analysis and Prediction of Parole Performance.* Vacaville, California: Institute for the Study of Crime and Delinquency, December 1963.

7. Bechtoldt, H. P. "Selection." In Stevens, S. S., *Handbook of Experimental Psychology,* pp. 1237–1266. New York: Wiley, 1951.

8. Black, B. J., and Glick, S. J. *Recidivism at the Hawthorne Cedar Knolls School: Predicted vs. Actual Outcome for Delinquent Boys;* Hawthorne-Cedars, Research Monograph No. 2. New York: Jewish Board of Guardians, 1952.

9. Blum, R. N. "Predicting Criminal Behavior: An Annotated Bibliography." *Journal of Correctional Psychology,* Monograph No. 1, 1957.

10. Bower, E. M. *The Education of Emotionally Handicapped Children.* A report to the California Legislature prepared pursuant to Sec. 1, of Chap. 2385, Statutes of 1957. Sacramento, California: State Department of Education, March 1961.

11. Brandon, G. E., and Potter, A. K. "An Application of the Linear Discriminant Function." *Rural Sociology* 18(1953):321–326.

12. Bridgman, P. W. *The Logic of Modern Physics.* New York: Macmillan, 1932.

13. Brogden, H. E. "On the Interpretation of the Correlation Coefficient as a Measure of Predictive Efficiency." *Journal of Educational Psychology* 37(1946):65–76.

14. Brogden, H. E. "Variation in Test Validity with Variation in the Distribution of Item Difficulties, Number of Items, and Degree of their Intercorrelation." *Psychometrika* 11(1946): 197–214.

15. Burgess, E. W., in Bruce, Burgess and Harno. *The Working of the Indeterminate Sentence Law and the Parole System in Illinois,* pp. 205–249. Springfield: Illinois State Board of Parole, 1928.

16. Burgess, E. W., and Cottrell, L. S., Jr. *Predicting Success or Failure in Marriage.* New York: Prentice-Hall, 1939.

17. Burgess, E. W., and Wallin, T. *Engagement and Marriage.* Philadelphia: Lippincott, 1953.

18. Caldwell, N. G. "Preview of a New Type of Probation Study Made in Alabama." *Federal Probation,* June 1951.

19. Carroll, J. B. "The Effect of Difficulty and Chance Success on Correlations between Items or between Tests." *Psychometrika* 10(1945):1–19.

20. Cassell, R. N., and Van Vorst, R. "Level of Aspiration as a Means for Discerning Between 'In Prison' and 'Out of Prison' Groups of Individuals." *Journal of Social Psychology* 40(1954):121–135.

21. Cattell, R. B. "Measurement vs. Intuition in Applied Psychology." *Character and Personality* 6(1937):114–131.

22. Craig, M. M., and Glick, S. J. "Ten Years Experience with the Glueck Social Prediction Table." *Crime and Delinquency* 9(July 1963):249–261.

23. Craig, M. M., and Glick, S. J. *A Manual of Procedures for the Application of the Glueck Prediction Table*. New York: New York City Youth Board, Office of the Mayor, 1964.

24. Crawford, A. B., and Burnham, B. S. *Forecasting College Achievement*. New Haven: Yale University Press, 1946.

25. Cronbach, L. J. "Test Reliability: Its Meaning and Determination." *Psychometrika* 12(1947):1–16.

26. Cronbach, L. J. *Essentials of Psychological Testing*, 2nd ed. New York: Harper, 1960.

27. Cronbach, L. J., and Gleser, G. C. *Psychological Tests and Personnel Decisions*. Urbana: University of Illinois Press, 1957.

28. Cureton, E. E. "Recipe for a Cookbook." *Psychological Bulletin* 54(1957):494–497.

29. De Groot, A. D. "Via Clinical to Statistical Prediction." Invited address, Western Psychological Association, San Jose, California, April 1960.

30. Doctor, R. S., and Winder, C. L. "Delinquent vs. Non-Delinquent Performance on the Porteus Qualitative Test." *Journal of Consulting Psychology* 18(1954):71–73.

31. Duncan, O. D.; Ohlin, L. E.; Reiss, A. J.; and Stantoe, H. R. "Formal Devices for Making Selection Decisions." *American Journal of Sociology* 48(1953):573–584.

32. Duncan, O. D., and Duncan, B. "A Methodological Analysis of Segregation Indexes." *American Sociological Review* 20(1955):210–217.

33. Ferguson, G. A. "On the Theory of Test Discrimination." *Psychometrika* 14(1949):61–68.

34. Flanagan, J. C. "General Considerations in the Selection of Test Items and a Short Method of Estimating the Product Moment Coefficient from the Data at the Tails of the Distribution." *Journal of Educational Psychology* 30(1939):674–680.

35. Flanagan, J. C. "The Aviation Psychology Program in the Army Air Forces." *Army Aviation Psychology Research Program Report I*. Washington, D. C.: U.S. Government Printing Office, 1948.

36. Gillin, J. L. "Predicting Outcome of Adult Probationers in Wisconsin." *American Sociological Review* 15(1950):550–553.

37. Glaser, D. *The Effectiveness of a Prison and Parole System*. New York: Bobbs-Merrill, 1964, Chapter 3.

38. Glueck, S., and Glueck, E. T. *500 Criminal Careers*, New York: Knopf, 1930.

39. Glueck, S., and Glueck, E. T. *Five Hundred Delinquent Women*. New York: Knopf, 1934.

40. Glueck, S., and Glueck, E. T. *One Thousand Juvenile Delinquents*. Cambridge: Harvard University Press, 1934.

41. Glueck, S., and Glueck, E. T. *Juvenile Delinquents Grown Up*. New York: Commonwealth Fund, 1940.

42. Glueck, S., and Glueck, E. T. *Criminal Careers in Retrospect*. New York: The Commonwealth Fund, 1943.

43. Glueck, S., and Glueck, E. T. *Unraveling Juvenile Delinquency*. New York: The Commonwealth Fund, 1950.

44. Glueck, S. "Pre-Sentence Examination of Offenders to Aid in Choosing a Method of Treatment." *Journal of Criminal Law and Criminology* 41(1951):717–731.

45. Glueck, S., and Glueck, E. T. *Later Criminal Careers*. New York: The Commonwealth Fund, 1957.

46. Glueck, S., and Glueck, E. T. *Predicting Delinquency and Crime*. Cambridge: Harvard University Press, 1959.

47. Glueck, E. T. "Efforts to Identify Delinquents." *Federal Probation* 24(June 1960):49–56.

48. Glueck, E. T. "Toward Improving the Identification of Delinquents." *Journal of Criminal Law and Criminology* 53(1962):164–170.

49. Gottfredson, D. M. *A Shorthand Formula for Base Expectancies.* Sacramento, California: California Department of Corrections, December 1962.

50. Gottfredson, D. M. "The Practical Application of Research." *Canadian Journal of Corrections* 5, no. 4(1963):212–228.

51. Gottfredson, D. M., and Bonds, J. A. *A Manual for Intake Base Expectancy Scoring (Form CDC BE61A).* Sacramento, California: California Department of Corrections, April 1961.

52. Gottfredson, D. M.; Ballard, K. B., Jr.; and Bonds, J. A. *Base Expectancy: California Institution for Women.* Sacramento, California: Institute for the Study of Crime and Delinquency and California Department of Corrections, September 1962.

53. Gottfredson, D. M.; Ballard, K. B., Jr.; and Lane, L. *Association Analysis in a Prison Sample and Prediction of Parole Performance.* Vacaville, California: Institute for the Study of Crime and Delinquency, November 1963.

54. Gottfredson, D. M.; Ballard, K. B., Jr.; Mannering, J. W.; and Babst, D. V. *Wisconsin Base Expectancies for Reformatories and Prisons.* Vacaville, California: Institute for the Study of Crime and Delinquency, June 1965.

55. Gottfredson, D. M., and Ballard, K. B., Jr. "Association Analysis, Predictive Attribute Analysis, and Parole Behavior." Paper presented at the Western Psychological Association meetings, Portland, Oregon, April 1964.

56. Gottfredson, D. M., and Ballard, K. B., Jr. *The Validity of Two Parole Prediction Scales: An 8 Year Follow Up Study.* Vacaville, California, 1965.

57. Gottfredson, D. M., and Ballard, K. B., Jr. "Testing Prison and Parole Decisions." Unpublished manuscript, July 1966.

58. Gough, H. G. "A Sociological Theory of Psychopathy." *American Sociological Review* 53(1948):359–366.

59. Gough, H. G. "What Determines the Academic Achievement of High School Students?" *Journal of Educational Research* 46(1953):321–331.

60. Gough, H. G. "Systematic Validation of a Test for Delinquency." Paper presented at the American Psychological Association meeting, New York, September 1954.

61. Gough, H. G. "Theory and Measurement of Socialization." *Journal of Consulting Psychology* 24(1960):23–30.

62. Gough, H. G. "Clinical vs. Statistical Prediction in Psychology." In Postman, L., ed., *Psychology in the Making,* pp. 526–584. New York: Knopf, 1962.

63. Gough, H. G., and Peterson, D. R., "The Identification and Measurement of Predispositional Factors in Crime and Delinquency." *Journal of Consulting Psychology* 26(1952):207–212.

64. Gough, H. G.; Wenk, E. A.; and Rosynko, V. V. "Parole Outcome as Predicted from the CPI, the MMPI, and a Base Expectancy Table." *Journal of Abnormal Psychology* 70, no. 6 (December 1965).

65. Grant, J. D. *The Navy's Attack on the Problems of Delinquency.* Rehabilitation Research, U.S. Naval Retraining Command, Camp Elliott, San Diego, California, April 6, 1955. Mimeographed.

66. Grant, J. D.; Bobinski, C. A.; and Ballard, K. B., Jr. *Factors in Retraining which Affect Delinquency Proneness.* Fifth Technical Report, Rehabilitation Research, U.S. Naval Retraining Command, Camp Elliott, San Diego, California, January 1956.

67. Grygier, T. "Treatment Variables in Non-linear Prediction." Paper presented to the Joint Annual Meeting of the American Society of Criminology and the American Association for the Advancement of Science, Montreal, December 1964.

68. Guilford, J. P. *Personality.* New York: McGraw-Hill, 1959.

69. Gulliksen, H. "The Relation of Item Difficulty and Inter-Item Correlation to Test Variance and Reliability." *Psychometrika* 10(1945):79–91.

70. Gunderson, E. K.; Grant, J. D.; and Ballard, K. B., Jr. *The Prediction of Military Delinquency.* San Diego, California: U.S. Naval Retraining Command, 1956. Mimeographed.

71. Gunderson, E. K., and Ballard, K. B., Jr. *Discriminant Analysis of Variables Related to Nonconformity in Naval Recruits.* Eleventh Technical Report, Rehabilitation Research, U.S. Naval Retraining Command, Camp Elliott, San Diego, California, August 1959. Mimeographed.

72. Guttman, L. "Mathematical and Tabulation Techniques. Supplemental Study B." In Horst, P., *The Prediction of Personal Adjustment,* pp. 253–364. New York: Social Science Research Council, 1941.

73. Guttman, L. "A Basis for Analyzing Test-Retest Reliability." *Psychometrika* 10(1945): 255–282.

74. Guttman, L. "Test-Retest Reliability of Qualitative Data." *Psychometrika* 9(1946):81–95.

75. Hall, C. L. *Aptitude Testing.* New York: World, 1928.

76. Hanley, C. "The Gauging of Criminal Predispositions." In Toch, H., *Legal and Criminal Psychology,* pp. 213–242. New York: Holt, Rinehart, and Winston, 1961.

77. Hathaway, S. R., and McKinley, J. C. *The Minnesota Multiphasic Personality Inventory Manual.* Revised. New York: The Psychological Corporation, 1951.

78. Hathaway, S. R., and Monachesi, E. D. *Analyzing and Predicting Juvenile Delinquency with the MMPI.* New York: The Psychological Corporation, 1954.

79. Hathaway, S. R., and Monachesi, E. D. "The Personalities of Pre-Delinquent Boys." *Journal of Criminal Law and Criminology* 48(1957):149–163.

80. Horst, P. *The Prediction of Personal Adjustment.* New York: Social Science Research Council Bulletin No. 48, 1941.

81. Horst, P., "Mathematical Contributions. Supplemental Study E." *The Prediction of Personal Adjustment,* pp. 407–447. New York: Social Science Research Council, 1941.

82. Horst, P. "A Generalized Expression for the Reliability of Measures." *Psychometrika* 14(1949):21–32.

83. Hunt, H. F. "Clinical Methods: Psychodiagnostics." In Stone, C. B., and Taylor, V. W., eds., *Annual Review of Psychology,* vol. 1, pp. 207–220. Stanford: Annual Reviews, Inc., 1950.

84. Hunt, W. A. "An Actuarial Approach to Clinical Judgment." In Bass, B. N., and Berg, I. A. *Objective Approaches to Personality Study,* pp. 169–191. Princeton: Van Nostrand, 1959.

85. Ives, V.; Grant, M. Q.; and Ballard, K. B., Jr. *Interpersonal Variables Related to Recidivism in Military Delinquency.* Eighth Technical Report, Rehabilitation Research, U.S. Naval Retraining Command, Camp Elliott, San Diego, California, December 1957. Mimeographed.

86. Jacobson, J. L., and Wirt, R. D. *Studies in Psychological and Sociological Variables in State Prison Inmates, Section No. 1, 18 Variable Profile.* Minneapolis: University of Minnesota, December 1961.

87. James, W. "Pragmatism. A New Name for Some Old Ways of Thinking." (1907). Reprinted as "Pragmatism's Conception of Truth." In *Essays in Pragmatism.* New York: Hafner, 1955.

88. Jarrett, R. F. "Percent Increase in Output of Selected Personnel as an Index to Test Efficiency." *Journal of Applied Psychology* 32(1948):135–145.

89. Jones, D. S.; Livson, N. H.; and Sarbin, T. "Perceptual Completion Behavior in Juvenile Delinquents." *Perceptual and Motor Skills* 5(1955):141–146.

90. Kirby, B. C. "Parole Prediction Using Multiple Correlation." *American Journal of Sociology* 59(1953–54):539–550.

91. Kvaraceus, W. C. "Forecasting Juvenile Delinquency: A Three Year Experiment." *Exceptional Children* 18(April 1961):429–435.

92. Kvaraceus, W. C. "Programs of Early Identification and Prevention of Delinquency." *Social Deviancy Among Youth, 65th Yearbook of the National Society for the Study of Education,* pp. 189–220. Chicago: National Society for the Study of Education, 1966.

93. Lackman, R. *The Predictive Use of the Linear Discriminant Function in Naval Aviation Cadet Selection.* U.S. Naval Sch. Aviat. Med. Res. Rep. 1953, Rep. II N.M. 001057.16.02–11p.

94. Lunden. W. A. "Forecast for 1955: Predicting Prison Population." *The Presidio* 19, no. 2 (1952).

95. MacNaughton-Smith, P. "The Classification of Individuals by the Possession of Attributes Associated with a Criterion." *Biometrics* (June 1963).

96. McArthur, C. "Analyzing the Clinical Process." *Journal of Counseling Psychology* 1(1954):203–207.

97. Mannering, J. W., and Babst, D. V. *Wisconsin Base Expectancies for Adult Male Parolees.* Progress Report No. 4, Wisconsin State Department of Public Welfare, Bureau of Research and Division of Corrections, April 1963.

98. Mannheim, H., and Wilkins, L. T. *Prediction Methods in Relation to Borstal Training.* London: Her Majesty's Stationery Office, 1955.

99. May, M. A. "Predicting Academic Success." *Journal of Educational Psychology* 14(1923):429–440.

100. Meehl, P. E. *Clinical vs. Statistical Prediction*. Minneapolis: University of Minnesota Press, 1954.

101. Meehl, P. E. "Clinical vs. Actuarial Prediction." In *Proceedings, 1955 Invitational Conference on Testing Problems,* pp. 136–141. Princeton: Educational Testing Service, 1956.

102. Meehl, P. E. "When Should We Use Our Heads Instead of the Formula?" *Journal of Counseling Psychology* 4(1957):268–273.

103. Meehl, P. E. "A Comparison of Conditions with Five Statistical Methods of Identifying MMPI Profiles." *Journal of Counseling Psychology* 6(1959):102–109.

104. Meehl, P. E., and Rosen, A. "Antecedent Probability and the Efficiency of Psychometric Signs, Patterns, or Cutting Scores." *Psychological Bulletin* 52(1955):194–215.

105. Meehl, P. E. "The Tie That Binds." *Journal of Counseling Psychology* 3(1956):163–164, 171, 173.

106. Monachesi, E. D. *Prediction Factors in Probation*. Hanover, N.H.: The Sociological Press, 1932.

107. Monachesi, E. D. "Personality Characteristics and Socio-Economic Status of Delinquents and non-Delinquents." *Journal of Criminal Law and Criminology* 40(1950):570–583.

108. Ohlin, L. E., and Duncan, O. D. "The Efficiency of Prediction in Criminology." *American Journal of Sociology* 54(1949):441–451.

109. Ohlin, L. E. *Selection for Parole: A Manual of Parole Prediction*. New York: Russell Sage Foundation, 1951.

110. Ohlin, L. E. "Some Parole Prediction Problems in the United States." Paper presented at the Third International Congress of Criminology. London, September 1955.

111. Paton, J. H. "Predicting Prison Adjustment with the Minnesota Multiphasic Personality Inventory." *Journal of Clinical Psychology* 14(1958):308–313.

112. Porteus, S. D. *Qualitative Performance in the Maze Test*. The Psychological Corp., n.d.

113. Powers, E., and Witmer, H. *An Experiment in the Prevention of Delinquency: The Cambridge-Summerville Youth Study*. New York: Columbia University Press, 1951.

114. Quay, H., and Peterson, D. R. "A Brief Scale for Juvenile Delinquency," *Journal of Clinical Psychology* 14(April 1958):139–142.

115. Reed, R. R. "An Empirical Study in the Reduction of the Number of Variables Used in Prediction. Supplementary Study C." In Horst, P., *The Prediction of Social Adjustment*. New York: Social Science Research Council, 1941.

116. Reichenbach, M. *Experience and Prediction*. Chicago: University of Chicago Press, 1938.

117. Reiss, A. J., Jr. "The Accuracy, Efficiency, and Validity of a Prediction Instrument." Unpublished Ph.D. dissertation, University of Chicago, 1949.

118. Reiss, A. J., Jr. "Delinquency as a Failure of Personal and Social Control." *American Sociological Review* 16(1951):196–207.

119. Reiss, A. J., Jr. "Unraveling Juvenile Delinquency: II. An Appraisal of the Research Methods." *American Journal of Sociology* 57(1951):115–121.

120. Richardson, M. W. "The Combination of Measures. Supplemental Study D." In Horst, P., *The Prediction of Personal Adjustment,* pp. 379–401. New York: Social Science Research Council, 1941.

121. Rubin, S. "Unraveling Juvenile Delinquency: I. Illusions in a Research Project Using Matched Pairs." *American Journal of Sociology* 57(1951):107–114.

122. Saline, T. "Recidivism and Maturation." *National Probation and Parole Association Journal* 4, no. 3 (July 1958):241–250.

123. Sarbin, T. R. "The Logic of Prediction in Psychology." *Psychological Review* 51(1944):210–228.

124. Savitz, L. D. "Prediction Studies in Criminology." *International Bibliography on Crime and Delinquency*. New York: National Council on Crime and Delinquency, 1965.

125. Schactel, E. G. "Notes on the Use of the Rorschach Test." In Glueck, S., and Glueck, E. T. *Unraveling Juvenile Delinquency*. New York: The Commonwealth Fund, 1950.

126. Schiedt, R., *Ein Beitrag Zum Problem der Ruckfallsprognose*. München, 1936.

127. Schuessler, K. F., and Cressey, D. R. "Personality Characteristics of Criminals." *American Journal of Sociology* 55(1950):483–484.

128. Sellin, T., and Wolfgang, M. E. *The Measurement of Delinquency.* New York: Wiley, 1964.

129. Shaplin, J. T., and Tiedman, D. V. "Comment on the Juvenile Prediction Tables in the Gluecks' *Unraveling Juvenile Delinquency.*" *American Sociological Review* 16(1951):544–548.

130. Stevens, S. S. "Mathematics, Measurement, and Psychophysics." In Stevens, S. S., *Handbook of Experimental Psychology,* pp. 1–49. New York: John Wiley and Sons, 1957.

131. Stogtill, M. *Behavior Cards: A Test-Interview for Delinquent Children.* The Psychological Corporation, n.d.

132. Stott, D. H. "A New Delinquency Prediction Instrument Using Behavioral Indications." *International Journal of Social Psychiatry* 6(1960):195–205.

133. Strong, E. K., Jr. *Vocational Interests of Men and Women.* Stanford: Stanford University Press, 1943.

134. Strong, E. K., Jr. *Vocational Interests Eighteen Years After College.* Minneapolis: University of Minnesota Press, 1955.

135. Taylor, D. W. "An Analysis of Delinquency Based on Case Studies." *Journal of Abnormal and Social Psychology* 42 (January 1947).

136. Thorndike, E. L., et al. *Prediction of Vocational Success.* New York: The Commonwealth Fund, 1934.

137. Thorndike, E. L. *Personnel Selection.* New York: Wiley, 1949.

138. Tibbitts, C. "Success and Failure on Parole Can be Predicted." *Journal of Criminal Law and Criminology* 22(1932):11–50.

139. Tibbitts, C. "The Reliability of Factors Used in Predicting Success or Failure on Parole." *Journal of Criminal Law and Criminology* 22(1932):844–853.

140. Toby, J. "An Evaluation of Early Identification and Intensive Treatment Programs for Pre-Delinquents." *Social Problems* 13, no. 2 (1965).

141. Toops, H. A. "Philosophy and Practice of Personnel Selection." *Educational and Psychological Measurements* 5(1945):95–124.

142. Trunk, H. *Sociale Prognosen Strafgefangenen.* 28 Monatsschrift für Kriminolobiologie und Strafrechtsreform, 1937.

143. Vernone, P. E. "The Assessment of Children: Recent Studies in Mental Measurement and Statistical Analysis." *Studies in Education no. 7,* pp. 189–215. London: University of London Institute of Education and Evans Bros. Ltd., 1955.

144. Vold, G. B. "Prediction Methods Applied to Problems of Classification within Institutions." *Journal of Criminal Law and Criminology* 26(1936):202–209.

145. Walters, A. A. "A Note on Statistical Methods of Predicting Delinquency." *British Journal of Delinquency* 6(1956):297–302.

146. Ward, J. H., Jr. *An Application of Linear and Curvilinear Joint Functional Regression in Psychological Prediction.* U.S.A.F. Personnel Training Research Center, Research Bulletin, 1954, No. AFPTRC-TR54-86, W29p.

147. Warner, S. B. "Factors Determining Parole from the Massachusetts Reformatory." *Journal of Criminal Law and Criminology* 14(1923):172–207.

148. Washburne, J. W. *The Washburne Social Adjustment Inventory.* New York: Harcourt, Brace & World, n.d.

149. Wilkins, L. T. *Classification and Contamination.* A memorandum from the Research Unit, Home Office, London, December 1955.

150. Wilkins, L. T. *Delinquent Generations: A Home Office Research Unit Report.* London: Her Majesty's Stationery Office, 1960.

151. Wilkins. L. T. "Who Does What With What and to Whom?" Sacramento, California, Department of Corrections, *The Research Newsletter* 1, March 1959.

152. Wilkins. L. T. "What is Prediction and is it Necessary in Evaluating Treatment?" In *Research and Potential Application of Research in Probation, Parole, and Delinquency Prediction.* New York: Citizens Committee for Children of New York, Research Center, New York School of Social Work, Columbia University, July 1961.

153. Wilkins, L. T., and MacNaughton-Smith, P. "New Prediction and Classification Methods in Criminology." *The Journal of Research in Crime and Delinquency* 1(1954):19–32.

154. Williams, W. T., and Lambert, J. M. "Multivariate Methods in Plant Ecology: Parts I, II, and III." *Journal of Ecology* 47(1959):83–101; 48(1960):680–710; 49(1961):717–729.

155. Wooton, B. *Social Science and Social Pathology,* Chapter 5. New York: Macmillan, 1959.

156. Zakilski, F. C. "Studies in Delinquency: II. Personality Structure of Delinquent Boys." *Journal of Genetic Psychology* 74(1949):109–117.

5: Public Policy and Delinquency Prediction / *Alfred J. Kahn**

The claims are specific and sweeping and the agencies affected are told that a new tool is ready for use:

"The Glueck Social Prediction Table, which the New York City Youth Board set out to test in 1952, has been validated . . .," report Craig and Glick.[1] Moreover, they add, "It has yielded a sufficient degree of accuracy to warrant its use by those agencies interested in delinquency prevention and control." [2]

In this they repeat the claim of their executive director, whose introduction to *A Manual of Procedures for Application of the Glueck Prediction Table,* published some five months before the research article cited above, announced: "We are glad to note that this prediction table is a valid instrument." [3]

At the same time another major project involving prospective testing of the table announced: "The D.C. Commissioner's Youth Council will immediately begin applying it—to identify, from among the hordes of children who pass our way, those who are most in need of our protective services." [4]

Professor Sheldon Glueck has summed up these evaluations by stating that "the evidence of the various follow-up studies on a wide variety of samples, and especially the evidence of the New York and Washington investigations, constitutes proof beyond a reasonable doubt." [5]

It is easy to understand why the local and national press pick up these claims with headlines such as "Are You Raising a Delinquent? Two Criminologists Can Tell." Small wonder, too, that school board members and influential citizens ask why this instrument is not at work assisting with their local delinquency problems.

Why, then, all of the expressions of doubt and public criticism from

* Reprinted with permission of the National Council on Crime and Delinquency, from *Crime and Delinquency,* 11, no. 3 (July 1965): 218–228.

criminologists and sociologists—and the urging, in agency publications, that the user beware? [6] Fully analyzed, the controversy revolves around issues of research standards and public policy. The potential user of the Glueck tables in their current variations will want to explore both of these dimensions.

In brief, the crities are almost unanimous in the following views:

1. Neither the New York City Youth Board nor the Commissioner's Youth Council has validated the scale which they set out to test.

2. Neither of the two studies reported has shown that delinquency prediction helps the children affected—and there is reason to believe that it may harm them.

3. Even if one accepts the framework of the reported studies, the statistical interpretation of the predictive efficiency of the findings is exaggerated, to say the least.

4. There are significant reasons, from both theoretical and public policy perspectives, to doubt whether one should ever think of the Glueck tables as potential operational tools.

Validation

Researchers make a fundamental distinction between an *exploratory study* and an *experiment*. The former is tentative in its conceptualizations, flexible in its methods. It seeks leads and hypotheses. Its intent is to generate findings of sufficient significance to justify moving toward experimental work. The experiment, on the other hand, has tighter rules. Something is to be proven or disproven, shown to have or not to have a specified relationship—in this case, demonstrated as capable or not capable of predicting delinquency. Standards of reliability, validity, precision, and statistical significance must be adhered to. *The rules of the game may not be changed en route.*

Both of the projects analyzed here were obviously intended to be "experimental" from the very beginning. They are, as already indicated, the main bases for the claims by the Gluecks that their tables have been validated. [7]

When the Youth Board project began in 1952 the objectives were clear. Sheldon and Eleanor Glueck had produced a five-factor prediction table based on analysis of the differences between delinquents and nondelinquents in Massachusetts. It was derived from retrospective analysis of known institutionalized delinquents and nondelinquents and it involved rating the children's familial relationships and environment. [8]

The Glueck tables were constructed by isolating factors found to distinguish known delinquents from nondelinquents in their study. The percentage of those characterized by a factor who were delinquent is used in

developing a score for that factor. (Thus, if of the boys whose fathers' discipline could be described as "overstrict or erratic," 71.8 percent were found to be delinquent in the original group studied, the presence of an "overstrict or erratic" father would add 71.8 points to the "weighted failure score" for any boy in a new group for which predictions are being made.) Five factors were initially employed and a child's score was the sum of the weighted scores reflecting his classification on each of these factors.

The five initial factors employed in the Youth Board scale were (1) discipline of boy by father (overstrict or erratic, lax, firm but kindly), (2) supervision of boy by mother (unsuitable, fair, close or suitable), (3) affection of father for boy (indifferent or hostile, warm [including overprotective]), (4) affection of mother for boy (indifferent or hostile, warm [including overprotective]), and (5) cohesiveness of family (unintegrated, some elements of cohesion, cohesive).

When a total score is obtained in the manner described, it is compared to the table developed by the Gluecks giving the percentage of boys in their Massachusetts sample with the given score who were delinquent and the percentage who were nondelinquent. These percentages are then used as delinquency "probabilities" for the entire class of boys with the score. A prediction, in other words, is thus made relative to the *group* rate for boys with a given score.

From the very beginning various questions were raised about *Unraveling Juvenile Delinquency* which are not directly relevant here; but it was agreed, too, that testing of the Glueck tables could contribute to theory development. Special caution was expressed about the predictive instrument as an operational tool since it had been developed on the basis of a particular Massachusetts population, had not yet been validated on a new group, had not been tested in actual use with young children for whom predictions could be made, and had left unanswered the question of whether it would not, on the level of service, be more valuable to locate children "in need of help" rather than "potential delinquents." [9]

During the next several years the authors of *Unraveling* were encouraged by the results of a series of retrospective applications of their tables.[10] Where children were adjudicated delinquents (particularly where they were already institutionalized) the table was applied to ask: Would these children have been predicted as likely delinquents if the table had been used when they were younger? The answers were overwhelmingly affirmative. But by the very nature of these studies the results could not tell how many delinquents would have been missed and how many nondelinquents inappropriately labeled. Nor could an answer be given to the objection raised about *Unraveling*—contamination of the evaluations of early childhood experience and relationships by the evaluator's knowledge that certain children had actually become delinquent. Clearly, *prospective* studies were needed. Could the Glueck table predict in advance?

The New York City Youth Board in 1952 and the D.C. Maximum Benefits Project in 1954 launched such *prospective* studies. In each instance, provision was made for services to be given to a subsample of those predicted delinquent to see whether the prediction could be reversed. It is because these were prospective studies which tried to test the social usefulness of the Glueck tools that they have been given so much attention. For this same reason it is urgent to stress that the studies have not yet attained either objective: validation of the table, or successful intervention with predicted delinquents.

The Youth Board undertook testing the table to find out whether, at age five or six, the likely delinquent could be differentiated from the nondelinquent. Children would be followed up for ten years. Of those predicted as likely to become delinquent, some would be sent to a school child-guidance clinic for treatment to determine whether a method existed for making use of (and thus counteracting) a delinquency prediction.

The first Youth Board progress report, covering the 1952–56 period, was published in 1957.[11] It could not be a final report, since the children were still young, but it seemed to point to the likelihood of an overprediction of delinquency. It also indicated "high attrition" in the group predicted as probable delinquents and assigned for child guidance treatment because several had already moved away. There has been no subsequent published treatment report, but informal information suggests that treatment results were not promising after four years (nor has the D.C. project been able as yet to report success with a treatment group from among predicted delinquents). One cannot know, therefore, from current Youth Board reports whether children predicted as delinquent and served in a clinic (or elsewhere, for that matter) actually can be helped or whether the community can be protected.

Thus, at best—even if all serious questions about the research status of the scale are put aside—what has been produced is a prediction instrument of *potential* worth in identifying children who need help and for testing the Gluecks' causation theories. There is still no evidence that the prediction actually helps schools, communities, or families in any way since no test has been reported and successfully completed involving use of the predictions to help children. On the other hand, a good deal of social-psychological theory suggests—as pointed out below—that the prediction may harm rather than help if it results in application of a negative label to the child.

In 1960 the director of the Youth Board issued a press release (rather than a research report) announcing that the work had attained the status of "relatively exact science" and recommending that "the prediction scale be applied broadly through selected schools throughout the city." The Citizens' Committee for Children of New York, the New York Society for the Psychological Study of Social Issues, and others questioned the research status of the scale and its suitability, at that time, for widespread use. They noted that the scale obviously overpredicted delinquency and that the

Youth Board used definitions of delinquency which were different from those generally accepted and which included antisocial behavior, mental illness, unofficial delinquency, and delinquent traits—in addition to official delinquency. The reliability and validity of the scales were still undetermined. The Citizens' Committee's report also noted:

This specialized scale poses an additional problem. Delinquency is a stigma-bearing legal adjudication, not a specific disease or diagnosis. A child labeled as a potential delinquent may well suffer consequences in teacher attitude, school program, and his own self-respect which will contribute to maladjustment and delinquency. To label a child as a "future bad boy" (*New York Times* report of press conference) may help make him one. The Youth Board announcement did not clarify how the device would be given to the schools while labeling was to be avoided. For a delinquency instrument would be practicable for use in the schools only if it could be administered by teachers or other school-based personnel. The Youth Board experiment involves ratings and judgments by trained personnel on the basis of data assembled by a special staff from three sources: home interviews with parents, interviews with teachers, collateral information from social agencies. Thus far, there has been no public report of what has been done to convert this research tool into a practical instrument or to test what occurs in the course of such conversion. This, too, would make it premature to plan for its use in the schools even if the scale were validated.

Responding to these questions, the Youth Board announced that more time was needed and that as the boys moved into the delinquency ages, the accuracy of the scale would probably increase. The test was to continue for another three years at least. In addition, the Youth Board announced: "For the past two years simplified methods for this purpose (i.e., to convert this research tool into a practical instrument) have been under study . . . and a full report is currently in preparation."

The statement was welcomed—as was the decision not to move into the schools with this unproved instrument in 1960.

Despite the 1960 announcement, however, a 1963 research article from the Youth Board,[12] the 1964 *Manual,* and the April 1965 article [13] do not cope with the question of converting the scale into a practical instrument. All the results are based on judgments by highly trained social workers and psychologists—so that there is no way to know whether the *Manual* or scale turned over to anyone else could achieve the same results. In fact, even if one were to grant all the claims of research findings in the Craig and Glick papers of 1963 and 1965, we would know only that a highly skilled staff with a high level of foundation financing and infinite time to rate cases and reconcile differences can presumably train itself in reliable and valid use of a scale. There is no way to tell whether this would help school personnel—or any agency unable to plan for home visits, social service exchange clearance, record analysis, and highly qualified, specially trained staff!

Nor is there any indication that school personnel, given such a scale, can use the results objectively without its use affecting the way a child is seen

and dealt with. In the one published reference to the matter we are told that the teachers and guidance staff are not to have the material. Who then is to have it? The *Manual* does not deal with these matters. A new experiment with the scale, announced by the Youth Board almost three weeks after the initial story and apparently the basis of a request it has made for funding, may address these issues. If so, the need for the experiment only serves to confirm that the *Manual* was far from ready for release. A manual should be an operational tool.

From Experiment to Exploration

As indicated, the very first published report (1957) revealed problems in scoring which contributed to erroneous predictions. The 1960 public critiques noted that a greater degree of statistical accuracy could be obtained by simply predicting that no one would be delinquent than by using the Glueck scale. The public discussion and a conference of experts which confirmed the public criticism [14] were followed by an intensive period of work within the Youth Board.

As reported in the Youth Board's 1963 article, the research staff gradually came to realize that the differences betwen the New York City population and the population with which the Gluecks had worked in Massachusetts, particularly in the number of fatherless families, demanded a change in the scale if the predictive accuracy was to improve and overprediction of delinquency was to be kept down (just as the D.C. project confronted the fact that a considerable portion of its sample was black). Over a long period, "experimentation with various factors and combinations of factors led to the three-factor table." The Youth Board turned to the Gluecks for "new weighted failure scores" and dropped those factors showing low levels of agreement among raters. A three-factor table (retaining judgments about the father) was in use by the fifth year but was too inaccurate. Then the Gluecks produced another three-factor table, *using only two of the five factors with which the Youth Board had begun in 1952* and making some minor changes in one of these. (The prediction scale or table as now offered requires rating of the "discipline of boy by mother," "supervision of boy by mother," and "cohesiveness of family." It deals only with boys. The subcategories under "cohesiveness of the family unit" are reworded a bit.) Or, to put it differently, the Youth Board has gradually, and through a series of applications and modifications, had a prediction model designed that fits its group. Even the score weights were changed to give three prediction score classes ("low chance of delinquency," "high chance," "even chance") in place of its original (and too inaccurate) four classes.

A similar process has been followed in the D.C. undertaking. After a series of interim measures instituted because of the inapplicability of the

original five-factor table to the population involved, the 179 cases were rescored in 1962. We are told that only the original rating material was used, but we are not told of the degree to which knowledge of subsequent events may have "contaminated" the ratings—and we are not told of the extent to which such knowledge entered into the process of developing a three-factor table that would fit. Here, too, the Youth Board report of July 1963 is vague but there is considerable evidence that what finally emerged was a table fitted to the population under study and able to account for it, not a predictive table based *independently* on the Glueck work alone and thus *prospectively* tested by this new research.

Given the extensive "fitting" process, the new tables, as might be expected, fit the data reasonably well (although, as indicated below, the degree of erroneous prediction may still cause concern or raise questions as to whether the investment and side effects are worth it). But the constant shifting and redesigning have changed this from a prediction *experiment* to a new *exploratory study*. The results do not tell us whether the Youth Board scale actually predicts. It may be able to identify delinquents retrospectively, with a population of New York boys. The Youth Board is now at the same stage with New York data as the Gluecks were in offering a possible device for Boston in 1952. Its own July 1963 report states, "The Glueck Prediction Table has undergone many changes. . . ."

The Youth Board and the D.C. Maximum Benefits Project should now try to predict forward with a new group and not change the rules of the game en route. Until this is done, no one can claim a validated prediction scale. Nobody knows whether the scale offered in the *Manual* will or will not predict delinquency among New York boys rated while in elementary school. Or, if successful predictions are made with boys from one socioeconomic or ethnic or racial grouping, it is certainly not known whether the scale would work elsewhere in the city, in other cities, or in the suburbs. Only some years of true prospective research *with a scale not tampered with during the study* and with several different populations will tell.

Interpreting the Statistics

Even the results thus far obtained should not be exaggerated. The crucial table in the Youth Board *Manual* is summarized here in Table 5–1 with the headings rephrased to increase clarity. The Youth Board describes this as 95.6 percent accuracy (correct predictions in 236 cases of nondelinquency and in twenty-eight cases of delinquency, or 264 of 276 if one ignores "even chance" predictions). Since the real issue is the delinquency prediction (classification in the "high" group), the accuracy may better be seen as twenty-eight of thirty-three, or 84.8 percent.

Most of the predictions are inevitably predictions of nondelinquency. If

TABLE 5-1

Probability of Delinquency	Cases in Total Sample	Classification at Follow-up	
		Delinquent	Nondelinquent
Low Chance	243	7	236
Even Chance	25	9	16
High Chance	33	28	5
Total	301	44	257

the issue is not the percentage of accuracy in predicting delinquency plus nondelinquency, or the percentage of accuracy where delinquency is predicted, but rather the *efficiency* of the scale as a finder of potential delinquents, then the relevant rate is 63.6 percent. The scale places in the "high" category (children predicted to be delinquent) twenty-eight of the forty-four actually classified eventually as delinquents.

The same general point may be made with reference to the April 1965 Craig and Glick article, which states that "in predicting delinquency, the table chose 7 of the 8 white boys who became delinquent (87.5%), 16 of the 20 Negro boys (80%), and all of the 5 Puerto Rican boys (100%)."

However, the authors dismiss as irrelevant the fact that, in addition, thirteen black boys whom the Youth Board researchers had not placed in the "delinquency predicted" category did become delinquent. A scale which predicts sixteen out of twenty-nine cases accurately has an efficiency of 55 percent—a more realistic figure than the 80 percent advertised. In these terms the Puerto Rican percentage was not 100 percent but 71 percent (five correct predictions in seven cases of delinquency).

In apparently acknowledging in a footnote [15] this issue of how to read the percentages, the authors state that they are answering the following question only: "Of that group selected as potential delinquents, how many became delinquent?" They are "not concerned," they go on to say, "with the total delinquent population." Obviously a public to which a scale is offered *is* concerned.

The Trevvett article in the same issue of *Crime and Delinquency* presents a similarly debatable pattern of interpretation in all tables.[16] To select only one for illustration: Table 1 is said to show that the five-factor scale originally used predicts nondelinquency at a 79 percent rate of accuracy. This is derived from the finding that fifteen of the nineteen children predicted to be nondelinquent were, in fact, nondelinquent. However, there were, in fact, fifty-two nondelinquents, of whom thirty-seven had been predicted as likely delinquents! A more reasonable statement would be that the efficiency in predicting nondelinquency was 29 percent (fifteen out of fifty-two!).

The approach to analysis adopted by the authors "rewards" extreme

caution in predicting "sure things" and does not take account of all the cases that are missed. The public, of course, wants efficient instruments that do not miss cases. At the very least, the authors owe it to the non-statistician public—the judges, probation officers, and newspaper reporters—to record their "scores" in the two separate senses of predictive accuracy.

The Citizens' Committee for Children statement of January 1965 made the point that "all prediction is actuarial (deals with rates within groups), not individual." The Youth Board research staff concurred in a summary prepared the following month for the Legislation Information Bureau of the State Charities Aid Association. However, the difference between actuarial and individual prediction carries policy implications not reflected in Youth Board publicity and writing. It also serves to introduce a variety of relevant public policy questions.

Problems of Policy and Practice

At the time of the 1960 public debate on the Youth Board's plan to use the scale, the Council of the Society for the Psychological Study of Social Issues noted in a public statement:

Unless the utmost caution and care are taken, children who are "identified" and labeled as probable future delinquents are likely to be treated and isolated as "bad" children by teachers and others who are now subjected to the virtually hysterical climate of opinion concerning juvenile delinquency. Such treatment is likely to increase the child's sense of social alienation and, thereby, increase the probability of his becoming delinquent or of developing other forms of psychological maladjustment.

To this the Legislation Information Bureau responded: "This last objection seems as frail as a claim that no tuberculin tests should be given because a positive finding might stigmatize the individual." Unfortunately, they miss the point that delinquency is not a disease but rather an administrative category which joins together many behaviors, circumstances, and statuses and which reflects certain societal assessments and strategies for coping with deviance.[17] Social definition and self-identification are apparently large elements in the etiology of some delinquencies.[18] Unlike the case of a recognized disease entity, identification as a delinquent carries negative consequences far more often than it leads to assured help. Those who would help delinquents have yet to assert and sustain their purposes in most public institutional contexts. That is why we continue to interpose due process between the individual and the adjudicatory label. Public definitions and self-image are crucial in this domain, and the question of whether the status of "predicted delinquent" is helpful or harmful (or whether it is helpful in some ways and harmful in others, depending on how and with whom the information is shared) remains a legitimate re-

search issue which cannot be ignored by proponents of delinquency prediction scales.

The need for caution is heightened by the fact that the prediction *is* actuarial: it may tell us that a boy is in a group whose members have an 85 percent chance of being delinquent. *His* chances do not thereby become 85 out of 100, since special things may operate for him.

The Craig and Glick article of July 1963 tells us that "school personnel were unaware of the boys' delinquency prediction score." (But some *were* sent for treatment!) We are not told, however, what the case would be if and when the research ended and the system became operative. What is to be done by the many individuals and agencies now receiving the published *Manual?* What should be done with a positive prediction? Could it be used to help a child without labeling him in the teacher's eyes—once the research is over? If a prediction is not to go to a teacher, to whom will it go? Who, in fact, will rate the case? Will such ratings be as reliable and valid as those of special research staff?

Another operational issue requiring considerable research has not yet been dealt with in the reports. The results thus far are based on judgments by highly trained and specially employed social workers and psychologists with considerable time for home interviews. The *Manual* is offered to school or social agency personnel who are provided with several pages of written guidance.

Those who would develop an instrument for prediction are under obligation to deal with such issues before it is offered for general use. Otherwise they become involved in the equivalent of encouraging front-page news coverage of the "discovery" of a new drug before they have undertaken research into side effects and checked out the degree of medical supervision essential in its usage. The recent public announcement of a request for funds for planned operational research, repeating announcements of intention in 1960, does not change the scientific status of what is now offered or diminish the validity of the policy questions raised.

The scholar who approaches these matters without commitment to any particular instrument, or the tax-oriented citizen, may in fact choose to focus on the fact that, of the nondelinquent boys in the Youth Board sample, "approximately 22 percent of the group each year were reported as problems to the school personnel." A considerable body of research literature has reported that, in this respect, teachers are excellent "case finders." [19] Shouldn't one build systems of help around this fact? Many people have contended that all children in need of help should be identified as early as possible—and that the pursuit of a delinquency-identification scale as an *operational* tool is questionable.

If one wants to go beyond the teacher's perceptions and develop a formal instrument, why not perfect one of many quite successful devices now available for identification of those children who may need help, rather than concentrating on the technically more complex job of differentiation

by the type of trouble likely to emerge? Such approaches may be less costly, may be more readily used in a school system laboring under limitations of time and personnel, and may also decrease the risk of negative consequences for a child.

Theory and Prediction

The behavioral science theorist may comment at this point that prediction studies are necessary to test causal theories: a full test of a theory of causation demands in effect a predictive effort. True; consequently, one would not wish to discourage predictive efforts. But this is something quite different from producing manuals for translation of predictive devices into operational tools.

The very considerable technical problems of the Glueck research in relation to etiological theory have been thoroughly discussed in the academic literature and are not relevant here—except to note that the groups studied have similar environmental deprivation, thus eliminating this factor as a possible research finding. (Their delinquents and nondelinquents are picked from similar social backgrounds.)

Furthermore, individual delinquency prediction, while it has merits, gives up another possibility, that of identifying neighborhoods or areas which produce high rates of deviance and mobilizing services and resources in such areas, along the lines of the activities sponsored by the President's Committee on Delinquency and Youth Crime and the Office of Economic Opportunity. In addition, new services for youth (education, recreation, job counseling) may be more effective if addressed to "young people" than if shaped for (and stigmatized by reference to) those considered "predelinquent."

Other Issues

The reader may wonder about a critique as long as or longer than some of the individual articles which generated it. The truth is that the Youth Board and D.C. reports are not long enough. A ten-year study in a major policy area is under obligation to publish complete reports. These should provide details which answer questions, such as the following, of concern to researchers and policy makers:

1. Exactly what were the results of the treatment experiments?

2. What do the brief references to reliability statistics mean? Do the researchers know whether their *Manual* instructions would produce comparable ratings by different raters to whom the instrument is offered?

3. How are discrepancies between home interviews and records reconciled in judgments? What of discrepancies among records? How are corrections made for cultural differences?

4. How are the home visits justified when, at the time of rating, none of the children is delinquent? How do people respond to them? On what basis does the *Manual* recommend "the unplanned interview [as] more fruitful?" [20] Is the application of delinquency prediction devices also an excuse for invasion of privacy?

5. Exactly what was done, step by step, in fitting the new three-factor scales to the groups now studied?

What, finally, is the criterion here for the predicted delinquency? The 1957 Youth Board report combined under "delinquency traits" such diverse items as antisocial behavior, mental illness, and unofficial delinquency, as well as delinquent traits and official delinquency. The more recent reports score as correct predictions of delinquency only cases which meet the definition formulated by the Gluecks: "Delinquency refers to repeated acts of a kind which when committed by persons beyond the statutory juvenile court age are punishable as crimes (either felonies or misdemeanors). . . ." However, "Youth Board categorizing of boys as delinquent did not depend on their being so adjudicated by the court." [21]

Trevvett reports: "We define as delinquent any child whose actual offenses are serious or persistent, whether or not he has been formally adjudicated delinquent" (because the local court is understaffed and has a backlog). In fact, "Of the 110 children counted as delinquent, 68 have been thus far so adjudicated." [22]

Those to whom the tables are now offered should obviously have access to much more data about this entire evaluative process. What was *done* by all the children in the Youth Board and D.C. samples classified as delinquent, and how well is this known? Present partial reporting raises more questions than it answers. The evaluators decided, on follow-up, that certain children not in contact with the law were to be classified as delinquents. Did they make "blind" judgments, or did they know the child's prediction?

Conclusion

The issue is not the importance of the home environment or the parent-child relationship. The issue is not the validity of prediction research to test causal hypotheses about delinquency. The issue is the status of efforts to validate the Glueck scale and to determine whether delinquency prediction can be used to help children. A review of the recently published reports discussed above does not permit the expansive conclusions apparently being encouraged.

NOTES

1. M. M. Craig and S. J. Glick, "Application of the Glueck Social Prediction Table on an Ethnic Basis," *Crime and Delinquency* 11(April 1965): 175.

2. *Ibid.*

3. M. M. Craig and S. J. Glick, *A Manual of Procedures for Application of the Glueck Prediction Table* (New York: New York City Youth Board, 1964), p. 3.

4. N. B. Trevvett, "Identifying Delinquency-Prone Children," *Crime and Delinquency* (April 1965): 191.

5. S. Glueck, "Some 'Unfinished Business' in the Management of Juvenile Delinquency," *Syracuse Law Review* (Summer 1964): 650.

6. See E. Herzog, *Identifying Potential Delinquents,* Children's Bureau Facts and Facets, No. 5 (Washington, D.C.: U.S. Government Printing Office, 1960); J. Toby, "Early Identification and Intensive Treatment of Pre-Delinquents," *Social Work* (July 1961); Citizens' Committee for Children of New York and Columbia University School of Social Work Research Center, *Research and Potential Application of Research in Probation, Parole, Delinquency Prediction* (New York, 1961); *Newsday,* Jan. 29, 1965, for statements by Dr. Frank Hartung (Wayne University), Prof. Harwin Voss (San Diego State College), Sol Rubin (NCCD), and Citizens' Committee for Children of New York; "The Status of the New York City Youth Board's Delinquency Prediction" (New York: January 1965, mimeo.).

7. To simplify communication and analysis, we concentrate mainly on the New York City Youth Board research, which has been published somewhat more extensively, has been carried out more intensively, and has in some ways guided the D.C. undertaking.

8. Sheldon and Eleanor Glueck, *Unraveling Juvenile Delinquency* (Cambridge, Mass.: Harvard University Press, 1950). Subsequent reports by the Gluecks of their thinking about prediction and their assessment of progress appear in a number of places. The reader may wish to consult footnotes to the Craig and Glick articles cited *supra* n. 1 and *infra* n. 12, and the Gluecks' Foreword to the Youth Board *Manual, supra* n. 3, as well as E. T. Glueck, "Toward Improving the Identification of Delinquents" and "Toward Further Improving the Identification of Delinquents," *Journal of Criminal Law, Criminology, and Police Science* (June 1962 and June 1963, respectively). Also see Sheldon and Eleanor Glueck, *Predicting Delinquency and Crime* (Cambridge, Mass.: Harvard University Press, 1959).

9. For a sampling, see S. Rubin, "Illusions in a Research Study—Unraveling Juvenile Delinquency," *Crime and Juvenile Delinquency* (New York: Oceana Publications, 1958), pp. 219–234. See also A. J. Kahn, "Analysis of Methodology of Unraveling Juvenile Delinquency," *An Approach to Measuring Results in Social Work,* D. G. French, ed. (New York: Columbia University Press, 1952), pp. 161–172.

10. Cited in the several items in *supra* n. 8.

11. New York City Youth Board, *An Experiment in the Validation of the Glueck Prediction Scale* (New York, 1957).

12. M. M. Craig and S. J. Glick, "Ten Years' Experience with the Glueck Social Prediction Table," *Crime and Delinquency* 9(July 1963): 249–261.

13. Craig and Glick, *supra* n. 1.

14. Citizen's Committee for Children of New York and Columbia University School of Social Work Research Center, *Research and Potential Application of Research in Probation, Parole, Delinquency Prediction* (New York, 1961).

15. Craig and Glick, *supra* n., p. 178, n. 7.

16. Trevvett, *supra* n. 4.

17. For a discussion, see A. J. Kahn, "Social Work and the Control of Delinquency," *Social Work* (July 1965), and *Planning Community Services for Children in Trouble* (New York: Columbia University Press, 1963).

18. See A. Cohen, *Delinquency Boys: The Culture of the Gang* (New York: The Free Press of Glencoe, 1955), and R. A. Cloward and L. E. Ohlin, *Delinquency and Opportunity* (New York: The Free Press of Glencoe, 1960).

19. B. B. Khleif, "Teachers as Predictors of Juvenile Delinquency and Psychiatric Disturbance," *Social Problems* (Winter 1964): 270–282. Major studies are listed under footnote 1 of the Khleif article.

20. Craig and Glick, *supra* n. 3, p. 19.

21. Craig and Glick, *supra* n. 1, p. 177.
22. Trevvett, *supra* n. 4, p. 188.

6: An Economic Approach to Crime and Punishment / *Gary S. Becker**

Introduction

Since the turn of the century, legislation in Western countries has expanded rapidly to reverse the brief dominance of laissez faire during the nineteenth century. The state no longer merely protects against violations of person and property through murder, rape, or burglary, but also restricts "discrimination" against certain minorities, collusive business arrangements, "jaywalking," travel, the materials used in construction, and thousands of other activities. The activities restricted not only are numerous but also range widely, affecting persons in very different pursuits and of diverse social backgrounds, education levels, ages, races, etc. Moreover, the likelihood that an offender will be discovered and convicted and the nature and extent of punishments differ greatly from person to person and activity to activity. Yet, in spite of such diversity, some common properties are shared by practically all legislation, and these properties form the subject matter of this essay.

In the first place, obedience to law is not taken for granted, and public and private resources are generally spent in order both to prevent offenses and to apprehend offenders. In the second place, conviction is not generally considered sufficient punishment in itself; additional and sometimes severe punishments are meted out to those convicted. What determines the amount and type of resources and punishments used to enforce a piece of legislation? In particular, why does enforcement differ so greatly among different kinds of legislation?

The main purpose of this essay is to answer normative versions of these questions, namely, how many resources and how much punishment *should*

* Gary S. Becker, "Crime and Punishment: an Economic Approach," *Journal of Political Economy* 76, no. 2 (March-April 1968): 169–172, 176, 179–180, 193–199, 204–209. Reprinted by permission.

be used to enforce different kinds of legislation? Put equivalently, although more strangely, how many offenses *should* be permitted and how many offenders *should* go unpunished? The method used formulates a measure of the social loss from offenses and finds those expenditures of resources and punishments that minimize this loss. The general criterion of social loss is shown to incorporate as special cases, valid under special assumptions, the criteria of vengeance, deterrence, compensation, and rehabilitation that historically have figured so prominently in practice and criminological literature.

The optimal amount of enforcement is shown to depend on, among other things, the cost of catching and convicting offenders, the nature of punishments—for example, whether they are fines or prison terms—and the responses of offenders to changes in enforcement. The discussion, therefore, inevitably enters into issues in penology and theories of criminal behavior. A second, although because of lack of space subsidiary, aim of this essay is to see what insights into these questions are provided by our "economic" approach. It is suggested, for example, that a useful theory of criminal behavior can dispense with special theories of anomie, psychological inadequacies, or inheritance of special traits and simply extend the economist's usual analysis of choice.

Basic Analysis

THE COST OF CRIME

Although the word "crime" is used in the title to minimize terminological innovations, the analysis is intended to be sufficiently general to cover all violations, not just felonies—like murder, robbery, and assault, which receive so much newspaper coverage—but also tax evasion, the so-called white-collar crimes, and traffic and other violations. Looked at this broadly, "crime" is an economically important activity or "industry," notwithstanding the almost total neglect by economists.[1] Some relevant evidence recently put together by the President's Commission on Law Enforcement and Administration of Justice (the "Crime Commission") is reproduced in Table 6-1. Public expenditures in 1965 at the federal, state, and local levels on police, criminal courts and counsel, and "corrections" amounted to over $4 billion, while private outlays on burglar alarms, guards, counsel, and some other forms of protection were about $2 billion. Unquestionably, public and especially private expenditures are significantly understated, since expenditures by many public agencies in the course of enforcing particular pieces of legislation, such as state fair-employment laws,[2] are not included, and a myriad of private precautions against crime, ranging from suburban living to taxis, are also excluded.

Table 6-1 also lists the Crime Commission's estimates of the direct costs

TABLE 6-1
Economic Costs of Crimes

Type	Costs (Millions of Dollars)
Crimes against persons	815
Crimes against property	3,932
Illegal goods and services	8,075
Some other crimes	2,036
Total	14,858
Public expenditures on police, prosecution, and courts	3,178
Corrections	1,034
Some private costs of combatting crime	1,910
Over-all total	20,980

of various crimes. The gross income from expenditures on various kinds of illegal consumption, including narcotics, prostitution, and mainly gambling, amounted to over $8 billion. The value of crimes against property, including fraud, vandalism, and theft, amounted to almost $4 billion,[3] while about $3 billion worth resulted from the loss of earnings due to homicide, assault, or other crimes. All the costs listed in the table total about $21 billion, which is almost 4 percent of reported national income in 1965. If the sizable omissions were included, the percentage might be considerably higher.

Crime has probably become more important during the last forty years. The Crime Commission presents no evidence on trends in costs but does present evidence suggesting that the number of major felonies per capita has grown since the early thirties. Moreover, with the large growth of tax and other legislation, tax evasion and other kinds of white-collar crime have presumably grown much more rapidly than felonies. One piece of indirect evidence on the growth of crime is the large increase in the amount of currency in circulation since 1929. For sixty years prior to that date, the ratio of currency either to all money or to consumer expenditures had declined very substantially. Since then, in spite of further urbanization and income growth and the spread of credit cards and other kinds of credit,[4] both ratios have increased sizably.[5] This reversal can be explained by an unusual increase in illegal activity, since currency has obvious advantages over checks in illegal transactions (the opposite is true for legal transactions) because no record of a transaction remains.[6]

THE SUPPLY OF OFFENSES

Theories about the determinants of the number of offenses differ greatly, from emphasis on skull types and biological inheritance to family upbringing and disenchantment with society. Practically all the diverse theories

agree, however, that when other variables are held constant, an increase in a person's probability of conviction or punishment if convicted would generally decrease, perhaps substantially, perhaps negligibly, the number of offenses he commits. In addition, a common generalization by persons with judicial experience is that a change in the probability has a greater effect on the number of offenses than a change in the punishment,[7] although, as far as I can tell, none of the prominent theories shed any light on this relation.

The approach taken here follows the economists' usual analysis of choice and assumes that a person commits an offense if the expected utility to him exceeds the utility he could get by using his time and other resources at other activities. Some persons become "criminals," therefore, not because their basic motivation differs from that of other persons, but because their benefits and costs differ. I cannot pause to discuss the many general implications of this approach,[8] except to remark that criminal behavior becomes part of a much more general theory and does not require ad hoc concepts of differential association, anomie, and the like,[9] nor does it assume perfect knowledge, lightning-fast calculation, or any of the other caricatures of economic theory.

PUNISHMENTS

Mankind has invented a variety of ingenious punishments to inflict on convicted offenders: death, torture, branding, fines, imprisonment, banishment, restrictions on movement and occupation, and loss of citizenship are just the more common ones. In the United States, less serious offenses are punished primarily by fines, supplemented occasionally by probation, petty restrictions like temporary suspension of one's driver's license, and imprisonment. The more serious offenses are punished by a combination of probation, imprisonment, parole, fines, and various restrictions on choice of occupation. A recent survey estimated for an average day in 1965 the number of persons who were either on probation, parole, or institutionalized in a jail or juvenile home. The total number of persons in one of these categories came to about 1.3 million, which is about 2 percent of the labor force. About one-half were on probation, one-third were institutionalized, and the remaining one-sixth were on parole.

The cost of different punishments to an offender can be made comparable by converting them into their monetary equivalent or worth, which, of course, is directly measured only for fines. For example, the cost of an imprisonment is the discounted sum of the earnings foregone and the value placed on the restrictions in consumption and freedom. Since the earnings foregone and the value placed on prison restrictions vary from person to person, the cost even of a prison sentence of given duration is not a unique quantity but is generally greater, for example, to offenders who could earn more outside of prison.[10] The cost to each offender would be greater the longer the prison sentence, since both foregone earnings and foregone consumption are positively related to the length of sentences.

Punishments affect not only offenders but also other members of society. Aside from collection costs, fines paid by offenders are received as revenue by others. Most punishments, however, hurt other members as well as offenders: for example, imprisonment requires expenditures on guards, supervisory personnel, buildings, food, etc. Currently about $1 billion is being spent each year in the United States on probation, parole, and institutionalization alone, with the daily cost per case varying tremendously from a low of $0.38 for adults on probation to a high of $11.00 for juveniles in detention institutions.

The total social cost of punishments is the cost to offenders plus the cost or minus the gain to others. Fines produce a gain to the latter that equals the cost to offenders, aside from collection costs, and so the social cost of fines is about zero, as befits a transfer payment. The social cost of probation, imprisonment, and other punishments, however, generally exceeds that to offenders, because others are also hurt. The derivation of optimality conditions in the next section is made more convenient if social costs are written in terms of offender costs as

$$f' \equiv bf,$$

where f' is the social cost and b is a coefficient that transforms f into f'. The size of b varies greatly between different kinds of punishments: $b \cong 0$ for fines, while $b > 1$ for torture, probation, parole, imprisonment, and most other punishments. It is especially large for juveniles in detention homes or for adults in prisons and is rather close to unity for torture or for adults on parole.

THE CASE FOR FINES

Just as the probability of conviction and the severity of punishment are subject to control by society, so too is the form of punishment: legislation usually specifies whether an offense is punishable by fines, probation, institutionalization, or some combination. Is it merely an accident, or have optimality considerations determined that today, in most countries, fines are the predominant form of punishment, with institutionalization reserved for the more serious offenses? This section presents several arguments which imply that social welfare is increased if fines are used *whenever feasible*.

In the first place, probation and institutionalization use up social resources, and fines do not, since the latter are basically just transfer payments, while the former use resources in the form of guards, supervisory personnel, probation officers, and the offenders' own time.[11] Table 6-1 indicates that the cost is not minor either: in the United States in 1965, about $1 billion was spent on "correction," and this estimate excludes, of course, the value of the loss in offenders' time.[12]

Moreover, the determination of the optimal number of offenses and severity of punishments is somewhat simplified by the use of fines. A wise

use of fines requires knowledge of marginal gains and harm and of marginal apprehension and conviction costs; admittedly, such knowledge is not easily acquired. A wise use of imprisonment and other punishments must know this too, however, and, in addition, must know about the elasticities of response of offenses to changes in punishments. As the bitter controversies over the abolition of capital punishment suggest, it has been difficult to learn about these elasticities.

I suggested earlier that premeditation, sanity, and age can enter into the determination of punishments as proxies for the elasticities of response. These characteristics may not have to be considered in levying fines, because the optimal fines do not depend on elasticities. Perhaps this partly explains why economists discussing externalities almost never mention motivation or intent, while sociologists and lawyers discussing criminal behavior invariably do. The former assume that punishment is by a monetary tax or fine, while the latter assume that non-monetary punishments are used.

Fines provide compensation to victims, and optimal fines at the margin fully compensate victims and restore the status quo ante, so that they are no worse off than if offenses were not committed.[13] Not only do other punishments fail to compensate, but they also require "victims" to spend additional resources in carrying out the punishment. It is not surprising, therefore, that the anger and fear felt toward ex-convicts who in fact have *not* "paid their debt to society" have resulted in additional punishments,[14] including legal restrictions on their political and economic opportunities [15] and informal restrictions on their social acceptance. Moreover, the absence of compensation encourages efforts to change and otherwise "rehabilitate" offenders through psychiatric counseling, therapy, and other programs. Since fines do compensate and do not create much additional cost, anger toward and fear of appropriately fined persons do not easily develop. As a result, additional punishments are not usually levied against "ex-finees," nor are strong efforts made to "rehabilitate" them.

One argument made against fines is that they are immoral because, in effect, they permit offenses to be bought for a price in the same way that bread or other goods are bought for a price.[16] A fine *can* be considered the price of an offense, but so too can any other form of punishment; for example, the "price" of stealing a car might be six months in jail. The only difference is in the units of measurement: fines are prices measured in monetary units, imprisonments are prices measured in time units, etc. If anything, monetary units are to be preferred here as they are generally preferred in pricing and accounting.

Optimal fines depend only on the marginal harm and cost and not at all on the economic positions of offenders. This has been criticized as unfair, and fines proportional to the incomes of offenders have been suggested.[17] If the goal is to minimize the social loss in income from offenses, and not to take vengeance or to inflict harm on offenders, then fines should depend on the total harm done by offenders, and not directly on their income, race,

sex, etc. In the same way, the monetary value of optimal prison sentences and other punishments depends on the harm, costs, and elasticities of response, but not directly on an offender's income. Indeed, if the monetary value of the punishment by, say, imprisonment were independent of income, the length of the sentence would be *inversely* related to income, because the value placed on a given sentence is positively related to income.

We might detour briefly to point out some interesting implications for the probability of conviction of the fact that the monetary value of a given fine is obviously the same for all offenders, while the monetary equivalent or "value" of a given prison sentence or probation period is generally positively related to an offender's income. The previous discussion suggested that actual probabilities of conviction are not fixed to all offenders but usually vary with their age, sex, race, and, in particular, income. Offenders with higher earnings have an incentive to spend more on planning their offenses, on good lawyers, on legal appeals, and even on bribery to reduce the probability of apprehension and conviction for offenses punishable by, say, a given prison term, because the cost to them of conviction is relatively large compared to the cost of these expenditures. Similarly, however, poorer offenders have an incentive to use more of their time in planning their offenses, in court appearances, and the like to reduce the probability of conviction for offenses punishable by a given fine, because the cost to them of conviction is relatively large compared to the value of their time.[18] The implication is that the probability of conviction would be systematically related to the earnings of offenders: negatively for offenses punishable by imprisonment and positively for those punishable by fines. Although a negative relation for felonies and other offenses punishable by imprisonment has been frequently observed and deplored, I do not know of any studies of the relation for fines or of any recognition that the observed negative relation may be more a consequence of the nature of the punishment than of the influence of wealth.

Another argument made against fines is that certain crimes, like murder or rape, are so heinous that no amount of money could compensate for the harm inflicted. This argument has obvious merit and is a special case of the more general principle that fines cannot be relied on exclusively whenever the harm exceeds the resources of offenders. For then victims could not be fully compensated by offenders, and fines would have to be supplemented with prison terms or other punishments in order to discourage offenses optimally. This explains why imprisonments, probation, and parole are major punishments for the more serious felonies; considerable harm is inflicted, and felonious offenders lack sufficient resources to compensate. Since fines are preferable, it also suggests the need for a flexible system of installment fines to enable offenders to pay fines more readily and thus avoid other punishments.

This analysis implies that if some offenders could pay the fine for a given

offense and others could not,[19] the former should be punished solely by fine and the latter partly by other methods. In essence, therefore, these methods become a vehicle for punishing "debtors" to society. Before the cry is raised that the system is unfair, especially to poor offenders, consider the following.

Those punished would be debtors in "transactions" that were never agreed to by their "creditors," not in voluntary transactions, such as loans,[20] for which suitable precautions could be taken in advance by creditors. Moreover, punishment in any economic system based on voluntary market transactions inevitably must distinguish between such "debtors" and others. If a rich man purchases a car and a poor man steals one, the former is congratulated, while the latter is often sent to prison when apprehended. Yet the rich man's purchase is equivalent to a "theft" subsequently compensated by a "fine" equal to the price of the car, while the poor man, in effect, goes to prison because he cannot pay this "fine."

Whether a punishment like imprisonment in lieu of a full fine for offenders lacking sufficient resources is "fair" depends, of course, on the length of the prison term compared to the fine.[21] For example, a prison term of one week in lieu of a $10,000 fine would, if anything, be "unfair" to wealthy offenders paying the fine. Since imprisonment is a more costly punishment to society than fines, the loss from offenses would be reduced by a policy of leniency toward persons who are imprisoned because they cannot pay fines. Consequently, optimal prison terms for "debtors" would not be "unfair" to them in the sense that the monetary equivalent to them of the prison terms would be less than the value of optimal fines, which in turn would equal the harm caused or the "debt."

It appears, however, that "debtors" are often imprisoned at rates of exchange with fines that place a low value on time in prison. Although I have not seen systematic evidence on the different punishments actually offered convicted offenders, and the choices they made, many statutes in the United States do permit fines and imprisonment that place a low value on time in prison. For example, in New York State, Class A Misdemeanors can be punished by a prison term as long as one year or a fine no larger than $1,000 and Class B Misdemeanors, by a term as long as three months or a fine no larger than $500.[22] According to my analysis, these statutes permit excessive prison sentences relative to the fines, which may explain why imprisonment in lieu of fines is considered unfair to poor offenders, who often must "choose" the prison alternative.

COMPENSATION AND THE CRIMINAL LAW

Actual criminal proceedings in the United States appear to seek a mixture of deterrence, compensation, and vengeance. I have already indicated that these goals are somewhat contradictory and cannot generally be simultaneously achieved; for example, if punishment were by fine, minimizing the social loss from offenses would be equivalent to compensating "vic-

tims" fully, and deterrence or vengeance could only be partially pursued. Therefore, if the case for fines were accepted, and punishment by optimal fines became the norm, the traditional approach to criminal law would have to be significantly modified.

First and foremost, the primary aim of all legal proceedings would become the same: not punishment or deterrence, but simply the assessment of the "harm" done by defendants. Much of traditional criminal law would become a branch of the law of torts,[23] say "social torts," in which the public would collectively sue for "public" harm. A "criminal" action would be defined fundamentally not by the nature of the action [24] but by the inability of a person to compensate for the "harm" that he caused. Thus an action would be "criminal" precisely because it results in uncompensated "harm" to others. Criminal law would cover all such actions, while tort law would cover all other (civil) actions.

As a practical example of the fundamental changes that would be wrought, consider the antitrust field. Inspired in part by the economist's classic demonstration that monopolies distort the allocation of resources and reduce economic welfare, the United States has outlawed conspiracies and other constraints of trade. In practice, defendants are often simply required to cease the objectionable activity, although sometimes they are also fined, become subject to damage suits, or are jailed.

If compensation were stressed the main purpose of legal proceedings would be to levy fines equal to [25] the harm inflicted on society by constraints of trade. There would be no point to cease and desist orders, imprisonment, ridicule, or dissolution of companies. If the economist's theory about monopoly is correct, and if optimal fines were levied, firms would automatically cease any constraints of trade, because the gain to them would be less than the harm they cause and thus less than the fines expected. On the other hand, if Schumpeter and other critics are correct, and certain constraints of trade raise the level of economic welfare, fines could fully compensate society for the harm done, and yet some constraints would not cease, because the gain to participants would exceed the harm to others.

One unexpected advantage, therefore, from stressing compensation and fines rather than punishment and deterrence is that the validity of the classical position need not be judged a priori. If valid, compensating fines would discourage all constraints of trade and would achieve the classical aims. If not, such fines would permit the socially desirable constraints to continue and, at the same time, would compensate society for the harm done.

Of course, as participants in triple-damage suits are well aware, the harm done is not easily measured, and serious mistakes would be inevitable. However, it is also extremely difficult to measure the harm in many civil suits,[26] yet these continue to function, probably reasonably well on the whole. Moreover, as experience accumulated, the margin of error would

decline, and rules of thumb would develop. Finally, one must realize that difficult judgments are also required by the present antitrust policy, such as deciding that certain industries are "workably" competitive or that certain mergers reduce competition. An emphasis on fines and compensation would at least help avoid irrelevant issues by focusing attention on the information most needed for intelligent social policy.

THE EFFECTIVENESS OF PUBLIC POLICY

The anticipation of conviction and punishment reduces the loss from offenses and thus increases social welfare by discouraging some offenders. The increase in welfare—that is "effectiveness"—of public efforts to discourage offenses can be determined if "effectiveness" is defined as a ratio of the maximum feasible increase in income to the increase if all offenses causing net damages were abolished by fiat. The maximum feasible increase is achieved by choosing optimal values of the probability of apprehension and conviction, p, and the size of punishments, f (assuming that the coefficient of social loss from punishment, b, is given).

Effectiveness so defined can vary between zero and unity and depends essentially on two behavioral relations: the costs of apprehension and conviction and the elasticities of response of offenses to changes in p and f. The smaller these costs or the greater these elasticities, the smaller the cost of achieving any given reduction in offenses and thus the greater the effectiveness. The elasticities may well differ considerably among different kinds of offenses. For example, crimes of passion, like murder or rape, or crimes of youth, like auto theft, are often said to be less responsive to changes in p and f than are more calculating crimes by adults, like embezzlement, antitrust violation, or bank robbery. The elasticities estimated by Smigel and Ehrlich for seven major felonies do differ considerably but are not clearly smaller for murder, rape, auto theft, and assault than for robbery, burglary, and larceny.[27]

Probably effectiveness differs among offenses more because of differences in the costs of apprehension and conviction than in the elasticities of response. An important determinant of these costs, and one that varies greatly, is the time between commission and detection of an offense.[28] For the earlier an offense is detected, the earlier the police can be brought in and the more likely that the victim is able personally to identify the offender. This suggests that effectiveness is greater for robbery than for a related felony like burglary, or for minimum-wage and fair-employment legislation than for other white-collar legislation like antitrust and public-utility regulation.[29]

A THEORY OF COLLUSION

The theory developed in this essay can be applied to any effort to preclude certain kinds of behavior, regardless of whether the behavior is "unlawful." As an example, consider efforts by competing firms to collude in

order to obtain monopoly profits. Economists lack a satisfactory theory of the determinants of price and output policies by firms in an industry, a theory that could predict under what conditions perfectly competitive, monopolistic, or various intermediate kinds of behavior would emerge. One by-product of our approach to crime and punishment is a theory of collusion that appears to fill a good part of this lacuna.[30]

The gain to firms from colluding is positively related to the elasticity of their marginal cost curves and is inversely related to the elasticity of their collective demand curve. A firm that violates a collusive arrangement by pricing below or producing more than is specified can be said to commit an "offense" against the collusion. The resulting harm to the collusion would depend on the number of violations and on the elasticities of demand and marginal cost curves, since the gain from colluding depends on these elasticities.

If violations could be eliminated without cost, the optimal solution would obviously be to eliminate all of them and to engage in pure monopoly pricing. In general, however, as with other kinds of offenses, there are two costs of eliminating violations. There is first of all the cost of discovering violations and of "apprehending" violators. This cost is greater the greater the desired probability of detection and the greater the number of violations. Other things the same, the latter is usually positively related to the number of firms in an industry, which partly explains why economists typically relate monopoly power to concentration. The cost of achieving a given probability of detection also depends on the number of firms, on the number of customers, on the stability of customer buying patterns, and on government policies toward collusive arrangements (see Stigler, 1964).

Second, there is the cost to the collusion of punishing violators. The most favorable situation is one in which fines could be levied against violators and collected by the collusion. If fines and other legal recourse are ruled out, methods like predatory price-cutting or violence have to be used, and they hurt the collusion as well as violators.

Firms in a collusion are assumed to choose probabilities of detection, punishments to violators, and prices and outputs that minimize their loss from violations, which would at the same time maximize their gain from colluding. Optimal prices and outputs would be closer to the competitive position the more elastic demand curves were, the greater the number of sellers and buyers, the less transferable punishments were, and the more hostile to collusion governments were. Note that misallocation of resources could not be measured simply by the deviation of actual from competitive outputs but would depend also on the cost of enforcing collusions. Note further, and more importantly, that this theory, unlike most theories of pricing, provides for continuous variation, from purely competitive through intermediate situations to purely monopolistic pricing. These situations differ primarily because of differences in the "optimal" number of violations,

which in turn are related to differences in the elasticities, concentrations, legislation, etc., already mentioned.

SUMMARY AND CONCLUDING REMARKS

This essay uses economic analysis to develop optimal public and private policies to combat illegal bahavior. The public's decision variables are its expenditures on police, courts, etc., which help to determine the probability (p) that an offense is discovered and the offender apprehended and convicted, the size of the punishment for those convicted (f), and the form of the punishment: imprisonment, probation, fine, etc. Optimal values of these variables can be chosen subject to, among other things, the constraints imposed by three behavioral relations. One shows the damages caused by a given number of illegal actions, called offenses (O), another the cost of achieving a given p, and the third the effect of changes in p and f on O.

"Optimal" decisions are interpreted to mean decisions that minimize the social loss in income from offenses. This loss is the sum of damages, costs of apprehension and conviction, and costs of carrying out the punishments imposed, and can be minimized simultaneously with respect to p, f, and the form of f unless one or more of these variables is constrained by "outside" considerations. The optimality conditions derived from the minimization have numerous interesting implications that can be illustrated by a few examples.

If carrying out the punishment were costly, as it is with probation, imprisonment, or parole, the elasticity of response of offenses with respect to a change in p would generally, in equilibrium, have to exceed its response to a change in f. This implies, if entry into illegal activities can be explained by the same model of choice that economists use to explain entry into legal activities, that offenders are (at the margin) "risk preferrers." Consequently, illegal activities "would not pay" (at the margin) in the sense that the real income received would be less than what could be received in less risky legal activities. The conclusion that "crime would not pay" is an optimality condition and not an implication about the efficiency of the police or courts; indeed, it holds for any level of efficiency, as long as optimal values of p and f appropriate to each level are chosen.

If costs were the same, the optimal values of both p and f would be greater, the greater the damage caused by an offense. Therefore, offenses like murder and rape should be solved more frequently and punished more severely than milder offenses like auto theft and petty larceny. Evidence on actual probabilities and punishments in the United States is strongly consistent with this implication of the optimality analysis.

Fines have several advantages over other punishments: for example, they conserve resources, compensate society as well as punish offenders, and simplify the determination of optimal p's and f's. Not surprisingly,

fines are the most common punishment and have grown in importance over time. Offenders who cannot pay fines have to be punished in other ways, but the optimality analysis implies that the monetary value to them of these punishments should generally be less than the fines.

Vengeance, deterrence, safety, rehabilitation, and the compensation are perhaps the most important of the many desiderata proposed throughout history. Next to these, minimizing the social loss in income may seem narrow, bland, and even quaint. Unquestionably, the income criterion can be usefully generalized in several directions, and a few have already been suggested in the essay. Yet one should not lose sight of the fact that it is more general and powerful than it may seem and actually includes more dramatic desiderata as special cases. For example, if punishment were by an optimal fine, minimizing the loss in income would be equivalent to compensating "victims" fully and would eliminate the "alarm" that so worried Bentham; or it would be equivalent to deterring all offenses causing great damage if the cost of apprehending, convicting, and punishing these offenders were relatively small. Since the same could also be demonstrated for vengeance or rehabilitation, the moral should be clear: minimizing the loss in income is actually very general and thus is *more useful* than these catchy and dramatic but inflexible desiderata.

This essay concentrates almost entirely on determining optimal policies to combat illegal behavior and pays little attention to actual policies. The small amount of evidence on actual policies that I have examined certainly suggests a positive correspondence with optimal policies. For example, it is found for seven major felonies in the United States that more damaging ones are penalized more severely, that the elasticity of response of offenses to changes in p exceeds the response to f, and that both are usually less than unity, all as predicted by the optimality analysis. There are, however, some discrepancies too: for example, the actual trade-off between imprisonment and fines in different statutes is frequently less, rather than the predicted more, favorable to those imprisoned. Although many more studies of actual policies are needed, they are seriously hampered on the empirical side by grave limitations in the quantity and quality of data on offenses, convictions, costs, etc., and on the analytical side by the absence of a reliable theory of political decision-making.

Reasonable men will often differ on the amount of damages or benefits caused by different activities. To some, any wage rates set by competitive labor markets are permissible, while to others, rates below a certain minimum are violations of basic rights; to some, gambling, prostitution, and even abortion should be freely available to anyone willing to pay the market price, while to others, gambling is sinful and abortion is murder. These differences are basic to the development and implementation of public policy but have been excluded from my inquiry. I assume consensus on damages and benefits and simply try to work out rules for an optimal implementation of this consensus.

The main contribution of this essay, as I see it, is to demonstrate that optimal policies to combat illegal behavior are part of an optimal allocation of resources. Since economics has been developed to handle resource allocation, an "economic" framework becomes applicable to, and helps enrich, the analysis of illegal behavior. At the same time, certain unique aspects of the latter enrich economic analysis: some punishments, such as imprisonments, are necessarily nonmonetary and are a cost to society as well as to offenders; the degree of uncertainty is a decision variable that enters both the revenue and cost functions; etc.

Lest the reader be repelled by the apparent novelty of an "economic" framework for illegal behavior, let him recall that two important contributors to criminology during the eighteenth and nineteenth centuries, Beccaria and Bentham, explicitly applied an economic calculus. Unfortunately, such an approach has lost favor during the last hundred years, and my efforts can be viewed as a resurrection, modernization, and thereby, I hope, improvement on these much earlier pioneering studies.

NOTES

1. This neglect probably resulted from an attitude that illegal activity is too immoral to merit any systematic scientific attention. The influence of moral attitudes on a scientific analysis is seen most clearly in a discussion by Alfred Marshall. After arguing that even fair gambling is an "economic blunder" because of diminishing marginal utility, he says, "It is true that this loss of probable happiness need not be greater than the pleasure derived from the excitement of gambling, and we are then thrown back upon the induction [sic] that pleasures of gambling are in Bentham's phrase "impure"; since experience shows that they are likely to engender a restless, feverish character, unsuited for steady work as well as for the higher and more solid pleasures of life." Alfred Marshall, *Principles of Economics,* 8th ed. (New York: Macmillan, 1961), note x, Mathematical Appendix.

2. Expenditures by the thirteen states with such legislation in 1959 totaled almost $2 million (see William Landes, "The Effect of State Fair Employment Legislation on the Economic Position of Nonwhite Males," unpublished Ph.D. dissertation, Columbia University, New York, 1966).

3. Superficially, frauds, thefts, etc., do not involve true social costs but are simply transfers, with the loss to victims being compensated by equal gains to criminals. While these are transfers, their market value is, nevertheless, a first approximation to the direct social cost. If the theft or fraud industry is "competitive," the sum of the value of the criminals' time input—including the time of "fences" and prospective time in prison—plus the value of capital input, compensation for risk, etc., would approximately equal the market value of the loss to victims. Consequently, aside from the input of intermediate products, losses can be taken as a measure of the value of the labor and capital input into these crimes, which are true social costs.

4. For an analysis of the secular decline to 1929 that stresses urbanization and the growth in incomes, see Phillip Cagan, *Determinants and Effects of Changes in the Stock of Money, 1875–1960* (New York: Columbia University Press, 1965), chap. 4.

5. In 1965, the ratio of currency outstanding to consumer expenditures was 0.08, compared to only 0.05 in 1929. In 1965, currency outstanding per family was a whopping $738.

6. Cagan, *Determinants and Effects,* chap. 4, attributes much of the increase in currency holdings between 1929 and 1960 to increased tax evasion resulting from the increase in tax rates.

7. For example, Lord Shawness in "Crime *Does* Pay Because We Do Not Back Up the Police," (*N.Y. Times Magazine,* June 13, 1965) said, "Some judges preoccupy themselves with methods of punishment. This is their job. But in preventing crime it is of less significance

than they like to think. Certainty of detection is far more important than severity of punishment." See also the discussion of Cesare Beccaria, an insightful eighteenth-century Italian economist and criminologist, in Leon Radzinowicz, *A History of English Criminal Law and Its Administration from 1750*, vol. 1 (London: Stevens & Sons, 1948), p. 282.

8. See, however, the discussions in Arleen Smigel, "Crime and Punishment: An Economic Analysis," unpublished Master's thesis, Columbia University, New York, 1965; also Issac Ehrlich, "The Supply of Illegitimate Activities," unpublished ms., Columbia University, New York, 1967.

9. For a discussion of these concepts, see E. H. Sutherland, *Principles of Criminology* (Philadelphia: Lippincott, 1960), 6th ed.

10. In this respect, imprisonment is a special case of "waiting time" pricing that is also exemplified by queuing [see Gary S. Becker, "A Theory of the Allocation of Time," *Economic Journal* 75(1965):515–516; and E. Kleinman, "The Choice Between Two 'Bads'—Some Economic Aspects of Criminal Sentencing," unpublished ms., Hebrew University, Jerusalem, 1967].

11. Several early writers on criminology recognized this advantage of fines. For example, "Pecuniary punishments are highly economical, since all the evil felt by him who pays turns into an advantage for him who receives" (Jeremy Bentham, *Theory of Legislation* [N.Y.: Harcourt, Brace, 1931], chap. 4) and "Imprisonment would have been regarded in these old times [*ca*. tenth century] as a useless punishment; it does not satisfy revenge, it keeps the criminal idle, and do what we may, *it is costly*"(F. Pollock and F. W. Maitland, *The History of English Law* [Cambridge: Cambridge University Press, 1952]), 2nd ed; vol. II, p. 516; my italics).

12. On the other hand, some transfer payments in the form of food, clothing, and shelter are included.

13. Bentham (*Theory of Legislation*) recognized this and said, "To furnish an indemnity to the injured party is another useful quality in a punishment. It is a means of accomplishing two objects at once—punishing an offense and repairing it: removing the evil of the first order, and putting a stop to alarm. This is a characteristic advantage of pecuniary punishments."

14. In the same way, the guilt felt by society in using the draft, a forced transfer *to* society, has led to additional payments to veterans in the form of education benefits, bonuses, hospitalization rights, etc.

15. See Sutherland, *Principles of Criminology*, pp. 267–268 for a list of some of these.

16. The very early English law relied heavily on monetary fines, even for murder, and it has been said that "every kind of blow or wound given to every kind of person had its price, and much of the jurisprudence of the time must have consisted of a knowledge of these preappointed prices" (Pollock and Maitland, *History of English Law*, p. 451).

The same idea was put amusingly in a *Mutt and Jeff* cartoon which showed a police car carrying a sign that read: "Speed limit 30 M per H—$5 fine every mile over speed limit—pick out speed you can afford."

17. For example, Bentham *Theory of Legislation*, chap. 9, said, "A pecuniary punishment, if the sum is fixed, is in the highest degree unequal. . . . Fines have been determined without regard to the profit of the offense, to its evil, or to the wealth of the offender. . . . Pecuniary punishments should always be regulated by the fortune of the offender. The relative amount of the fine should be fixed, not its absolute amount; for such an offense, such a part of the offender's fortune." Note that optimal fines do depend on "the profit of the offense" and on "its evil."

18. Note that the incentive to use time to reduce the probability of a given prison sentence is unrelated to earnings, because the punishment is fixed in time, not monetary, units; likewise, the incentive to use money to reduce the probability of a given fine is also unrelated to earnings, because the punishment is fixed in monetary, not time, units.

19. In one study, about half of those convicted of misdemeanors could not pay the fines; see President's Commission on Law Enforcement and Administration of Justice, *The Courts*, "Task Force Reports" (Wash. D.C.: Govt. Printing Office, 1967) p. 148.

20. The "debtor prisons" of earlier centuries generally housed persons who could not repay loans.

21. Yet without any discussion of the actual alternatives offered, the statement is made that "the money judgment assessed the punitive damages defendant hardly seems comparable in effect to the criminal sanctions of death, imprisonment, and stigmatization." "Criminal Safeguards and the Punitive Damages Defendant," *University of Chicago Law Review* 34 (1967).

22. "Violations," however, can only be punished by prison terms as long as fifteen days or fines no larger than $250. Since these are maximum punishments, the actual ones imposed by the courts can, and often are, considerably less. Note, too, that the courts can punish by imprisonment, by fine, or by *both* (*Laws of New York*, 1965, chap. 1030, Art. 60).

23. See F. V. Harper and F. James, *The Law of Torts* (Boston: Little, Brown, 1956) vol. II, p. 1299. "The cardinal principle of damages in Anglo-American law [of torts] is that of *compensation* for the injury caused to plaintiff by defendant's breach of duty."

24. Of course, many traditional criminal actions like murder or rape would still usually be criminal under this approach too.

25. Actually, fines should exceed the harm done if the probability of conviction were less than unity. The possibility of avoiding conviction is the intellectual justification for punitive, such as triple, damages against those convicted.

26. Harper and James in *Law of Torts* said (p. 1301), "Sometimes [compensation] can be accomplished with a fair degree of accuracy. But obviously it cannot be done in anything but a figurative and essentially speculative way for many of the consequences of personal injury. Yet it is the aim of the law to attain at least a rough correspondence between the amount awarded as damages and the extent of the suffering."

27. A theoretical argument that also casts doubt on the assertion that less "calculating" offenders are less responsive to changes in p and f can be found in Gary S. Becker, "Irrational Behavior and Economic Theory," *Journal of Political Economy* 70 (1962).

28. A study of crimes in parts of Los Angeles during January 1966 found that "more than half the arrests were made within eight hours of the crime, and almost two-thirds were made within the first week" (see President's Commission on Law Enforcement and Administration of Justice, *Science and Technology*, "Task Force Reports," [Washington, D.C.: Govt. Printing Office, 1967] p. 8).

29. Evidence relating to the effectiveness of actual, which are not necessarily optimal, penalties for these white-collar crimes can be found in George J. Stigler, "What Can Regulators Regulate? The Case of Electricity," *Journal of Law and Economics* 5 (1962); "The Economic Effects of the Antitrust Law," *Journal of Law and Economics* 9 (1966); Landes, "Effect of State Fair Employment Legislation"; Thomas Johnson, "The Effects of the Minimum Wage Law," Ph.D. dissertation, Columbia University, New York, 1967.

30. Jacob Mincer first suggested this application to me.

7: Quantitative Models in Crime Control /

Benjamin Avi-Itzhak / Reuel Shinnar *

Introduction

Crime, especially violent crime, has become one of our most urgent and difficult urban problems. This is ironic since historically one of the main attractions of the city was the safety it provided. While some experts try to

* Benjamin Avi-Itzhak and Reuel Shinnar, "Quantitative Models in Crime Control," *Journal of Criminal Justice* 1 (Elmsford, New York: Pergamon Press Inc., 1973): 185–203, 212–213. Reprinted by permission.

TABLE 7-1
Reported Felonious Offenses in New York City
(New York City Police Department, Annual Reports 1960-1970)

Offenses	Manhattan	Bronx	Brooklyn	Queens	Richmond
1970					
Murder	394	229	389	93	12
Forced Rape	713	417	677	300	34
Robbery	31,738	13,578	19,528	8,919	339
Fel. Assault	6,494	3,583	6,487	1,658	188
Gr. Larceny	36,597	8,979	19,451	12,344	905
Burglary	66,161	31,817	55,108	24,962	3,646
Auto Theft	14,837	12,429	25,661	29,374	2,022
Other Felonies	17,829	10,037	14,467	6,087	665
Total Felonies	174,763	81,069·	141,768	83,737	7,811
1965					
Murder	239	129	202	57	7
Forced Rape	415	242	353	128	16
Robbery	3,739	1,608	2,654	826	77
Fel. Assault	6,922	2,915	4,688	1,655	145
Gr. Larceny	27,848	4,912	9,144	4,975	378
Burglary	16,761	9,782	16,768	5,659	1,136
Auto Theft	7,000	4,583	9,346	6,531	585
Other Felonies	6,572	1,952	3,828	1,138	160
Total Felonies	69,496	26,123	46,983	20,969	2,504
1960					
Murder	180	38	130	40	2
Forced Rape	518	204	411	148	15
Robbery	2,854	988	1,941	755	41
Fel. Assault	5,062	1,718	3,005	1,130	106
Gr. Larceny	18,874	2,309	5,976	2,925	192
Burglary	12,795	4,656	12,966	4,220	599
Auto Theft	4,177	3,164	5,364	3,609	417
Other Felonies	3,263	950	1,860	754	135
Total Felonies	47,723	14,027	31,653	13,581	1,507

TABLE 7-2
Population Distribution and Average Number of Felonies Per Capita, New York City 1970

Borough	Population	Felonies per Capita
Manhattan	1,539,233	0.113
Bronx	1,471,701	0.055
Brooklyn	2,601,852	0.054
Queens	1,973,708	0.042
Richmond	295,443	0.026
Total	7,881,937	0.062

Note: Figures based on Department of Commerce, U.S. Census, 1970.

minimize its real dangers and effects (Clark, 1970), there is no question that the problem is real and has strong effects on the way cities develop or deteriorate.

Some indication of the "explosion" in reported crimes is presented by the data from New York City in Table 7-1. Population distribution and per capita crime rates for the city for 1970 are shown in Table 7-2.

Let us translate these rates into probabilities. Suppose that n crimes were committed during a given year in a small area with population M. Assuming that each crime has one victim and that each member of the population is equally likely to be the victim of a given crime, then the probability that a given member of the population has not been affected is

$$\left(1 - \frac{1}{M}\right)^n.$$

For large values of M we assume that $n \to \alpha M$, where α is the average crime rate in the area. Under these assumptions,

$$\left(1 - \frac{1}{M}\right)^n \to e^{-\alpha}$$

as M becomes very large. The probability that a person living in an area with a crime rate α will not be affected in a given year is $e^{-\alpha}$.

Assuming that the average lifespan is seventy years, we estimate that the probability of not being affected during a lifetime is $e^{-70\alpha}$. The probability of being a victim of at least one crime in a lifetime is approximately $1 - e^{-70\alpha}$, where we assume α crime rate to prevail constantly. Table 7-3 shows the lifetime probability of persons living in New York City being affected at least once. In calculating these probabilities we used 1970 crime rates given in Table 7-2 and assumed that these rates would continue to prevail in the future. Table 7-3 also shows the number of times each person living in New York City is expected to be a crime victim during his lifetime. The numbers for Manhattan appear high since commuters and visitors were not considered. By the same token, the numbers concerning other boroughs are probably too low.

Alarming as these numbers may look, we suspect the actual situation is even worse since many offenses are never reported. To illustrate the significance of the 1970 figures, corresponding figures based on 1940 crime rates (for violent offenses only) appear in italics above the 1970 figures. Thus, Table 7-3 brings immediately into focus a major change that has occurred in the American city. At the crime rates of 1940 the average city dweller could go through his life with only a small chance of personally experiencing a violent crime. Today the small chance has become almost a certainty.

One may then wonder at the relatively mild measures, if any, taken in embattling this disturbing situation. This may be at least partially explained by the following two observations. First, while it is true that crime rates

TABLE 7-3

*Lifetime Probability of Being Affected at Least Once
and Expected Number of Times Being Affected During a Lifetime*

Place of Residence	Felonious Offenses		Felonious Offenses except Larceny and Other Felonies		Violent Offenses: Murder, Rape, Robbery, and Assault	
	Lifetime Probability	Expected Number of Times	Lifetime Probability	Expected Number of Times	Lifetime Probability	Expected Number of Times
					0.1	*0.1*
Manhattan	0.999	7.9	0.996	5.5	0.836	1.8
					0.03	*0.03*
Bronx	0.979	3.9	0.945	2.9	0.568	.84
					0.03	*0.03*
Brooklyn	0.976	3.8	0.945	2.9	0.518	.73
					0.03	*0.03*
Queens	0.946	2.9	0.899	2.3	0.323	.39
					0.04	*0.04*
Richmond	0.836	1.8	0.777	1.5	0.130	.14
Average	0.987	4.3	0.960	3.2	0.573	0.85

have risen to the striking levels described, this increase is relatively recent and the cumulative effect cannot yet fully be felt in such a short time period. Therefore, there are many people who have not yet been affected by it. In other words, people who have spent the past thirty years in New York City were subject during most of that time to the relatively low (compared to 1970) crime rates of those years. It is only during the past few years that the crime rate has been so high, so that their experiences are biased by the relatively low crime period. Our figures project the 1970 data and while they are overestimated based on the past twenty years, they are severe underestimates of what will happen to the average New Yorker between 1970 and 1990, if present trends continue.

Second, one must keep in mind that the numbers in Table 7-3 assume uniform exposure to crime over the entire population. This is clearly an oversimplification. In general, the crime rates in poorer neighborhoods are often several times the borough average. The larger part of the crime burden is carried by the poor who are least able to fight back or evade it. In fact, as high as our predicted estimates of crime per person may seem, they are probably higher for the poor, high-crime areas, while simultaneously being lower for certain relatively secure areas of the city.

The crime in Manhattan is worse than the national average. However, a similar increase in crimes exists in other large cities, and there is also an increase nationally as shown in Table 7-4. It is easily seen that the problems we are dealing with are by no means unique to New York City but

present in most of our larger cities. New York merely provides a striking example of a much broader process taking place throughout the country.

There is another significant process that has taken place over the past thirty years. While the reported crime rate has gone up by a factor of ten to thirty, the total number of people in prison has not changed significantly. This reflects the lower risk an individual runs in committing a crime today. (The expected incarceration per crime committed is derived by dividing the total number of crimes committed in a given period into the average number of people in prison—assuming a steady state.)

This decrease in prison stay per crime has several adverse effects. It improves the gain/risk ratio for the criminal and makes crime more attractive, as pointed out in a recent article by Wilson (1973). The increased gain/risk ratio also acts to minimize any deterrent effect the criminal justice system might have.

In this paper we propose simple mathematical models for describing and measuring crime systems with recidivism. We bear in mind that the subject of crime control is controversial and it is not easy to define the objective function or the permissible means for optimizing. Some claim that the only way is to improve society and then crime will decrease, while others maintain that crime prevention will always be necessary and that societies less just and more impoverished than ours were able to maintain safer cities.

Basically one would like to minimize the total damage resulting from crimes. However, this damage involves many components, most of which cannot be measured in economic terms, and is inflicted upon victims, criminals, and society at large. Scientific methods cannot necessarily offer an optimal balance between these components. Any such balance depends upon how we weight the different factors, which in turn depends on our subjective value judgments. Indeed, effective operations research is not

TABLE 7-4

Index Crime Rates Per 100,000 Population
(FBI, 1970)

Year	New York Metropolitan Area	Large Cities	National
1970	5,220	5,335	2,740
1960	1,391	2,904	1,123

Notes: Index crimes are: murder, forcible rape, aggravated assault, robbery, burglary, larceny of $50 or more, and auto theft.

The New York Metropolitan Area includes: Nassau, Rockland, Suffolk, and Westchester counties and the five boroughs of the city.

Large cities are defined as those having a population in excess of 250,000.

necessarily related to promoting a given policy or to identifying optimal decisions. More often its main contribution is illumination of the possible implications of alternatives. The absence of an overall well-defined objective function is not critical.

The purpose of the mathematical models proposed in the first part of the paper is to quantitatively interrelate crime rate, police effectiveness, and the severity of sentencing.

The models may be used in estimating, on the basis of experience and available statistics, the quantitative effects of alternative policies on crime rates. This use is restricted to policies whose net effect on police effectiveness and sentencing severity can be predicted.

One of the characteristics of the present crime situation is the high rate of recidivism in certain types of crimes, such as mugging, burglary, and robbery. While imprisonment may have little corrective or deterrent effect upon some criminals, it certainly slows them in committing additional crimes while imprisoned. It is thus to be expected that the rate of crime will depend on the severity of sentencing even when the corrective effects are discounted.

Another dominant characteristic of the present crime situation is the high rate of unsolved crimes. Since any corrective procedure, be it imprisonment or reeducation, depends on finding and convicting the criminal, effective detection of the criminal is of prime importance. It is worthwhile to note that both police effectiveness and severity of sentencing are largely determined by legal constraints.

One factor not recognized by the models is deterrence. The reason for this deficiency is that we found it impossible to measure. In fact, even the naive, intuitive premise that severe punishment acts as a deterrent is questionable. However, if one accepts this premise, then the reduction in crime rate obtained from the model, when severity of sentencing is increased, may serve as lower bound. By the same token the change due to decreased severity of sentencing may serve as an upper bound. It should be pointed out that deterrence is dependent on police effectiveness as well.

One derivative of the mathematical analyses of this part of the paper is a proposed method for measuring relative sentencing severity of a given system. This may prove useful when comparing different systems or when evaluating the same system at different points in time.

While the elementary models given in the first part of the paper describe in probabilistic terms the individual behavior of recidivists, the models proposed in the second part are essentially global and relate to the growth (or decline) of the total population of offenders. These models are deterministic in nature and must be viewed as very rough approximations at best. We intend to develop stochastic models which will, we hope, be more realistic and will enable us to estimate the response time of the system to changes in its major parameters: police effectiveness, sentencing policy, education

and welfare aimed at decreasing the input of new offenders into the system, and others.

A Simple Mathematical Model

In describing the behavior pattern of an individual offender we assume that at the start of his criminal career he commits offenses at a Poisson rate λ_0 . At this stage the probability of a crime being cleared and the criminal being prosecuted and convicted is denoted by q_0 . The first conviction results in a period of length S_1 during which the offender is neutralized. There is a probability θ_1 that the offender will emerge as still active at the end of S_1 . The probability of his criminal career terminating during S_1 is $1 - \theta_1$. In general, the random variable S_i describes the length of incarceration resulting from the ith conviction (S_i may take the value 0). Similarly, θ_1 is the probability that the offender survives (emerges still active) after the ith incarceration, λ_i is his Poisson rate of offenses after surviving the ith sentence, and q_1 is the probability of each such offense leading to a conviction.

For simplicity we assume that S_1, S_2, \ldots , are statistically independent and that the length of the criminal career is exponentially distributed with mean $1/\eta$. The survival probabilities are then given by

$$\theta_i = \int_0^\infty e^{-s} \, dF_{S_i}(s) \tag{1}$$

where $F_s(.)$ is the distribution function of S_i .

CONVICTIONS

Let the random variable D describe the number of convictions during a complete criminal career. The probability of the offender never being convicted is denoted by P_0 .

$$P_0 = P(D = 0) = \sum_{x=0}^\infty \left(\frac{\lambda_0}{\lambda_0+\eta}\right)^x (1 - q_0)^x \, \frac{\eta}{\lambda_0+\eta} \tag{2}$$

$$= \frac{\eta}{\eta+\lambda_0 \, q_0} .$$

The probability of the offender never being convicted again given that he has survived the ith sentence is denoted by P_i .

$$P_i = \sum_{x=0}^\infty \left(\frac{\lambda_i}{\eta+\lambda_i}\right) (1 - q_i)^x \, \frac{\eta}{\lambda_i+\eta} = \frac{\eta}{\eta+\lambda_i q_1} . \tag{3}$$

The distribution of D can easily be expressed in terms of P_i and θ_i, $i = 0, 1, 2, \ldots$.

$$P(D>0) = 1 - P_o,$$

and $\quad (4)$

$$P(D>n) = (1 - P_o) \prod_{i=1}^{n} (1 - P_i)\theta_i, \quad n = 1, 2, 3, \ldots$$

The expected number of convictions in a criminal career, E (D), is given by

$$E(D) = \sum_{n=0}^{\infty} P(D>n) = (1 - P_o)\left(1 + \sum_{n=1}^{\infty} \prod_{i=1}^{n} (1 - P_1)\theta_i\right). \quad (5)$$

The expected number of convictions, given that there was at least one conviction is denoted by ϕ :

$$\phi = E(D|D\geq 1) = \frac{E(D)}{1 - P_o} = 1 + \sum_{n=1}^{\infty} \prod_{i=1}^{n} (1 - P_1)\theta_1. \quad (6)$$

The quantity ϕ is of prime importance. Clearly, it is practically impossible to estimate the value of E(D) since records are available only for offenders with at least one conviction. For estimating ϕ we need records of complete criminal careers. It is therefore easy to estimate historical values of ϕ by using old records of offenders who are not now living or who have reached a very old age. This is done by averaging the number of convictions over all offenders appearing in the records.

In a steady state system (where the population of active offenders is stable in size) it is possible to estimate ϕ using the relation

$$P_v = \frac{1}{\phi} \quad (7)$$

where P_v is the probability (or proportion) of virgin convictions. Assume that from a stable population of offenders we select at random the record of an offender with a recent conviction and count the total number of re-corded convictions. Let Y denote the number of convictions recorded, then

$$P(Y = 1) = P_v. \quad (8)$$

It can be readily shown that

$$P(Y = y) = \frac{P(D\geq y|D\geq 1)}{E(D|D\geq 1)} = \frac{P(D\geq y|D\geq 1)}{\phi}, \quad y = 1, 2, 3, \ldots \quad (9)$$

Therefore

$$P(Y = 1) = \frac{P(D \geq 1 \mid D \geq 1)}{\phi} = \frac{1}{\phi}, \tag{10}$$

which proves relation (7). In reality the estimate of ϕ obtained from relation (7) may be unsatisfactory (most probably too low) because of the steady state assumption.

Still another possibility for estimating ϕ is through the repeat probabilities. Let R_i denote the probability that an offender with i convictions will be convicted again at least once more. Clearly

$$R_i = (1 - P_i)\theta_i, \quad i = 1, 2, 3, \ldots . \tag{11}$$

Substitution of this relation in equation (6) yields

$$\phi = 1 + \sum_{n=1}^{\infty} \prod_{i=1}^{n} R_i . \tag{12}$$

A simple case is when $R_1 = R_2 = \ldots = R$. For this case we have

$$\phi = \sum_{n=0}^{\infty} R^n = \frac{1}{1 - R} \tag{13}$$

and

$$R = \frac{\phi - 1}{\phi} . \tag{14}$$

To illustrate the validity of relation (14) we assume that our mathematical model deals with arrests rather than convictions. In this case R is the arrest-to-arrest repeat probability and ϕ is the expected number of arrests during the lifetime of a person who was arrested at least once. Using Christensen's (1967) estimate, $\phi = 7.6$, we obtain a value of 0.87 from relation (14). This result agrees with that of Belkin, Blumstein, and Glass (1973).

OFFENSES

Let the random variable X describe the total number of offenses committed by an individual offender during his life. The expectation of X, E(X), is of great importance since the level of crime is determined by E(X) and the size of the criminal population.

For determination of E(X) we define a sequence of random variables U_0, U_1, U_2, . . . , where U_0 is the number of offenses committed until the first conviction or until the end of the criminal career, whichever occurs first. Similarly, for an offender who has been convicted for the i*th* time, U_i stands for the number of offenses, committed between the i*th* conviction and the (i + 1)*th* conviction or the end of the criminal career, whichever occurs first. E(X) is given as

$$E(X) = \sum_{n=0}^{\infty} E\left(\sum_{i=0}^{n} U_i \Big| D = n\right) P(D = n) \quad . \tag{15}$$

It can be readily shown that

$$P(U_i = x | D = n > i) = \left(\frac{\lambda_i(1-q_i)}{\eta+\lambda_i}\right)^{x-1} \left(1 - \frac{\lambda_i(1-q_i)}{\eta+\lambda_i}\right) \quad x = 1, 2, 3, \ldots, \tag{16}$$

and

$$E(U_i | D = n > i) = E(U_i | D > i) = \frac{\eta+\lambda_i}{\eta+\lambda_i q_i} \quad . \tag{17}$$

Substitution of equation (17) into equation (15) yields

$$E(X) = \sum_{n=0}^{\infty} E(U_n | D > n) P(D > n) + \sum_{n=0}^{\infty} E(U_n | D = n) P(D = n) \quad . \tag{18}$$

From equation (4) we obtain

$$P(D = n) = \begin{cases} P_o & \text{for } n = 0 \ , \\ \\ (1 - P_o)\left((1 - \theta_n) \prod_{i=1}^{n-1} (1 - P_i)\theta_i + \theta_n P_n \prod_{i=1}^{n-1} (1 - P_i)\,\theta_i\right) & \\ & \text{for } n > 0 \ , \end{cases} \tag{19}$$

where

$$\prod_{i=1}^{0} (1 - P_i)\,\theta_i = 1 \ .$$

The event $(D = n)$ is a union of two mutually exclusive events. One is the case where the offender is convicted n times and does not survive the n*th* sentence. The second case is where he survives the n*th* sentence but is never convicted again. This is true for $n = 1, 2, 3, \ldots$, and is reflected in the two terms of the right side of equation (19). Accordingly we can show that

$$P(U_n=x | D=n) = \frac{(1-P_o)\theta_n P_n \prod_{i=1}^{n-1} (1-P_i)\theta_i}{P(D=n)} \left(\frac{\lambda_n(1-q_n)}{\eta+\lambda_n}\right)^{x}$$

$$\left(1 - \frac{\lambda_n(1-q_n)}{\eta+\lambda_n}\right) \quad n=1, 2, 3, \ldots, \quad x=1, 2, 3, \ldots, \tag{20}$$

and

$$E(U_n|D=n) = \frac{(1-P_o)\theta_n P_n \displaystyle\prod_{i=1}^{n-1} (1-P_i)\theta_i}{P(D=n)}$$

$$\frac{\lambda_n(1-q_n)}{\eta+\lambda_n q_n}, \qquad n = 1, 2, 3, \ldots \qquad (21)$$

For the case n = 0 we obtain

$$E(U_o|D=0) = \frac{\lambda_o(1-q_o)}{\eta+\lambda_o q_o} . \qquad (22)$$

Substitution of equations (22), (21), (17), (4), and (3) in equation (18) yields

$$E(X) = \sum_{n=0}^{\infty} \frac{\lambda_n}{\eta+\lambda_n q_n} \frac{P(D>n)}{1-P_n} = \sum_{n=0}^{\infty} \frac{P(D>n)}{q_n} . \qquad (23)$$

For an offender who survives the *ith* sentence, let V_i stand for the number of offenses committed between his *ith* release (survival) and his next conviction or the end of his criminal career, whichever takes place first. Clearly, V_o is identical to U_o , while

$$\begin{bmatrix} P(U_i=x) = \theta_i P(V_i=x) & x = 1, 2, 3, \ldots, \\ & (24) \\ P(U_i=0) = 1-\theta_i + \theta_i P(V_i=0) & i = 1, 2, 3, \ldots. \end{bmatrix}$$

The expectation of V_n can be shown to be

$$E(V_n) = \frac{\lambda_n}{\eta + \lambda_n q_n} , \qquad (25)$$

substituting equation (25) in (23) results in

$$E(X) = \sum_{n=0}^{\infty} E(V_n) \frac{P(D>n)}{1-P_n} . \qquad (26)$$

The parameters describing police and prosecution effectiveness, q_1, q_2, q_3, . . . , cannot be estimated individually for the simple reason that a reported offense can be related to a specific offender only when it is solved and leads to a conviction. When assuming $q_1 = q_2 = q_3 = \ldots = q$ it is possible to estimate the value of q using available aggregated data.

Estimates of q for the years 1939–1970 are given in Table 7-5. (The figures were compiled from the Uniform Crime Reports of the FBI, where violent crimes include murder, forcible rape, aggravated assault, and robbery, and index crimes include the aforementioned violent crimes plus bur-

TABLE 7-5
Estimated Police Effectiveness (q)
Adults, 1939-1970

Year	Index Crimes	Violent Crimes
Five Year Averages		
1966-1970	0.126	0.227
1961-1965	0.146	0.261
1956-1960	0.141	0.285
1951-1955	0.140	0.270
1946-1950	0.139	0.323
1941-1945	0.146	0.347
1939-1940	0.139	0.320
II. Five Most Recent Years		
1970	0.114	0.194
1969	0.120	0.194
1968	0.132	0.218
1967	0.119	0.238
1966	0.143	0.291

glary, larceny of $50 and over, and auto theft.) The method of compiling the estimates of q is illustrated by the following two examples:

Robbery 1970

In 1970, 29 percent of reported robberies were cleared by arrest (solved). Fifty-seven percent of adults arrested were charged and of those charged 60 percent were convicted. (Forty-seven percent were convicted as charged and 13 percent were convicted of a lesser offense.) The value of q for robberies in 1970 is estimated as,

$$q = (0.29) (0.57) (0.60) = 0.099.$$

Robbery 1957

In 1957, 42.6 percent of reported robberies were cleared by arrest. For each 100 cleared robberies, there were 96.6 people charged. Of those charged, 62.3 percent were convicted (49.6 percent were convicted as charged and 12.7 percent were convicted of a lesser crime). The value of q for robberies in 1957 is estimated as,

$$q = (0.426) (0.966) (0.623) = 0.256.$$

(This estimate is biased because we did not use percent charged of those arrested since that figure was not available until 1958. Instead we used the ratio of number charged to number of cleared crimes. Since there may be

several arrests for one cleared crime, or one arrest for several cleared crimes, the direction of the bias is not clear.)

A similar calculation was performed for each of the violent crimes, and the weighted average for the group was found to be q = 0.194.

In general the values of q given in Table 7-5 are biased upwards since it is possible that a solution of one crime will lead to the solution of previous crimes by the same offender.

Suppose then that $q_1 = q_2 = q_3 = \ldots = q$. Equation (23) takes the form

$$E(X) = \frac{1}{q} \sum_{n=0}^{\infty} P(D>n) = \frac{E(D)}{q}. \tag{27}$$

This result is intuitively obvious.

Since $E(D) = (1-P_0)\phi$, and $0 \leq P_0 \leq 1$, we can bound the value of $E(X)$ from above

$$E(X) = \frac{1-P_0}{q} \phi \leq \frac{\phi}{q}. \tag{28}$$

Assuming now that $1 - P_0 \leq 1 - P_i$ for $i = 1, 2, 3, \ldots$, we obtain from equation (6):

$$1 - P_0 \phi \geq \phi - 1. \tag{29}$$

Combination of relations (29) and (28) yields

$$\frac{\phi-1}{q} \leq E(X) \leq \frac{\phi}{q}. \tag{30}$$

This relation enables one to estimate the value of E (X) within two bounds.

Note that the assumption $1 - P_0 \leq 1 - P_i$, $i = 1, 2, \ldots$, is not unrealistic. $1 - P_i$ is the repeat probability of an offender released for the ith time. There is evidence indicating that the repeat probability $1 - P_i$ tends to increase with the severity of prior record of the offender.

In a recent study made in California (Select Committee on the Administration of Justice, 1970), 3,748 felons released from prison during 1964 were followed up for the next three years. Table 7-6 shows the percent returned to prison within three years, with a new felony conviction, as a function of prior record.

When considering the released felons who had no subsequent arrests during the three year follow-up period as 'clean,' the results were: Class I—60 percent clean, Class II—35 percent clean, Class III—27 percent clean (approximate numbers). Regression models developed in the same study, using ten independent variables, show that the two controlling variables are prior record and narcotic history (in order of importance). Recidivism

TABLE 7-6
New Felony Conviction

Prior Record	New Felony Conviction
Class I (None)	10%
Class II (1, 2 jail or juvenile, or one prison only)	19%
Class III (3 or more jail or juvenile or more than one prison)	25%

Note: Prior record does not include offense for which released in 1964. Numbers are approximate since they were read from a diagram.

probability increases with severity of prior record and with narcotic use history.

Another recent work, by Sellin and Wolfgang (1972), studies a cohort of about 10,000 males, born in 1945 in Philadelphia, from birth through age seventeen. The proportion of arrest-to-arrest recidivists was investigated as a function of prior number of arrests. It was found that about 54 percent recidivated after first arrest, 65 percent recidivated after the second arrest, and between 70 percent and 80 percent recidivated after subsequent arrests.

The two studies, one dealing with convictions and the second dealing with arrests, clearly indicate that repeat probabilities tend to increase with the severity of prior record.

In our model this means that

$$1 - P_1 \leq 1 - P_i, \qquad i = 1, 2, 3, \ldots \qquad (31)$$

Substitution of equation (3) in (31) yields

$$\frac{\eta}{\eta + \lambda_1 q_1} \geq \frac{\eta}{\eta + \lambda_i q_i}, \qquad i = 1, 2, 3, \ldots, \qquad (32)$$

when assuming $q_1 = q_2 = q_3 = \ldots = q$ we obtain

$$\lambda_1 \leq \lambda_i, \qquad i = 1, 2, 3, \ldots \qquad (33)$$

This implies that the crime committing intensity is lower at the beginning of the criminal career and it is, therefore, not unreasonable to assume that $\lambda_0 \leq \lambda_1$, or equivalently $1 - P_0 \leq 1 - P_i$, $i = 1, 2, 3, \ldots$.

It is worthwhile noting that in most studies of recidivist offenders the

probability P_0 (or $1 - P_0$) does not appear, since the criminal career is assumed to start with the first arrest or conviction. In actuality the criminal career starts earlier, either with the first offense, or even with the first decision to commit an offense. P_0 does not lend itself to estimation and it is possible, for example, that there exists a huge population of offenders who are never detected. This is true if λ_0 and/or q_0 are small when compared to λ_1 and q_i, $i = 1, 2, 3, \ldots$.

SENSITIVITY OF CRIME LEVEL TO CHANGES IN EFFECTIVENESS, q

Table 7-5 shows a marked process of decline in the magnitude of q for violent crimes, (q being an estimate of the probability that a violent offense will lead to a conviction).
In fact,

$$\frac{q_{66}}{q_{70}} = \frac{0.291}{0.194} = 1.5 .$$

Assuming that the behavioral pattern of the offenders was the same in 1966 and 1970 and the sentencing and parole policies stayed the same, we would like to estimate the change in the crime level due to the decline in the magnitude of q.

We use a simple version of our model, in which

$$\lambda_0 = \lambda_1 = \lambda_2 = \ldots = \lambda, \, q_0 = q_1 = q_2 = \ldots = q$$

and the random variables S_1, S_2, S_3, \ldots , possess an identical exponential density with mean $1/\mu$. We further assume, without loss of generality, that the average length of a criminal career is one time unit, $1/\eta = 1$. In such a model $P_0 = P_1 = P_2 = \ldots = P$. Then,

$$1 - P = \frac{\lambda q}{1 + \lambda q}, \tag{34}$$

and

$$E(X) = \frac{\lambda(1 + \mu)}{1 + \mu + \lambda q} , \tag{35}$$

where $1 - P$ is the release-to-conviction repeat probability, and $E(X)$ is the expected number of offenses committed during a lifetime of an offender. According to our assumption of no change in parameters, except q, we have $\lambda_{66} = \lambda_{70} = \lambda$, $\mu_{66} = \mu_{70} = \mu$, and $q_{66} = 1.5q_{70}$.

Let E_{66} and E_{70} be the values of $E(X)$ obtained when using 1966 and 1970 parameters, respectively. From equation (35) we have

$$\frac{E_{70}}{E_{66}} = \frac{1 + \mu + \lambda q_{66}}{1 + \mu + \lambda q_{70}} = \frac{1 + \mu + \lambda q_{66}}{1 + \mu + 0.67 \lambda q_{66}} . \tag{36}$$

TABLE 7-7

$\lambda q_{66}, \lambda q_{70}$ and $1 - P_{70}$
as Functions of $1 - P_{66}$

$1 - P_{66}$	λq_{66}	λq_{70}	$1 - P_{70}$
0.10	0.111	0.074	0.068
0.20	0.250	0.167	0.143
0.30	0.429	0.286	0.222
0.40	0.667	0.444	0.308
0.50	1.000	0.667	0.400
0.60	1.500	1.000	0.500
0.70	2.333	1.555	0.609
0.80	4.000	2.667	0.727
0.90	9.000	6.000	0.857
0.95	10.000	12.667	0.927

TABLE 7-8

E_{70}/E_{66} as a Function of $1 - P_{66}$ and $1/\mu$

$1 - P_{66}$ \ $1/\mu$	0.05	0.10	0.15	0.20	0.30	0.40	0.50	0.60	0.80
0.1	1.00	1.00	1.00	1.01	1.01	1.01	1.01	1.01	1.02
0.2	1.00	1.01	1.01	1.01	1.02	1.02	1.03	1.03	1.03
0.3	1.01	1.01	1.02	1.02	1.03	1.04	1.04	1.05	1.06
0.4	1.01	1.02	1.03	1.03	1.05	1.06	1.06	1.07	1.08
0.5	1.01	1.03	1.04	1.05	1.07	1.08	1.09	1.10	1.11
0.6	1.02	1.04	1.06	1.07	1.09	1.11	1.12	1.14	1.15
0.7	1.03	1.06	1.08	1.10	1.13	1.15	1.17	1.18	1.20
0.8	1.06	1.10	1.13	1.15	1.19	1.22	1.23	1.25	1.27
0.9	1.11	1.18	1.22	1.25	1.29	1.31	1.33	1.35	1.36
0.95	1.19	1.27	1.31	1.34	1.37	1.39	1.40	1.41	1.42

From equation (34) we obtain

$$1 - P_{66} = \frac{\lambda q_{66}}{1 + \lambda q_{66}} \; ; \qquad 1 - P_{70} = \frac{0.67 \lambda q_{66}}{1 + 0.67 \lambda q_{66}} . \tag{37}$$

Table 7-7, showing values of λq_{66}, λq_{70}, and $1 - P_{70}$ as functions of $1 - P_{66}$, was compiled by using equation (37). Values of E_{70}/E_{66} as a function of $1/\mu$ and $1 - P_{66}$ are shown in Table 7-8. These were calculated by using Table 7-7 and equation (36).

Taking as upper bounds $1 - P_{66} = 0.90$ (release-to-conviction repeat probability of at most 0.90 in 1966), and $1/\mu = 0.5$ (average length of incarceration not longer than 50 percent of average criminal career length) we obtain from Table 7-8: $E_{70}/E_{66} = 1.33$. This implies that at most 33 percent (one half

of the 66 percent increase [Uniform Crime Reports, 1970:3] in the rate of violent crimes from 1966 to 1970) can be attributed to a decline in police effectiveness, q. At least one half of the increase must be attributed to an increase in the offender population and/or an increase in the offense committing intensity, and/or a decrease in the severity of sentencing and parole policies.

Table 7-8 shows that the crime level is insensitive to changes in effectiveness unless the average incarceration length is appreciable. The quantitative relation between q, $1/\mu$ and $E(X)$ is given by equation (35). In general, when sentencing is severe ($1/\mu$ large), the crime level, $E(X)$, is sensitive to changes in effectiveness, as reflected by values of $1 - P_{66}$ in Table 7-8. Similarly, when effectiveness is high (and, therefore, $1 - P_{66}$ large), the crime level is sensitive to changes in severity of sentencing. On the other hand, when sentencing is light ($1/\mu$ small) little can be achieved by increasing the effectiveness of police, and when effectiveness is low ($1 - P_{66}$ small), little can be obtained by increasing $1/\mu$. A more thorough discussion of this problem will appear in a future publication.

"Nth TIME OUT" EQUIVALENCE

An "Nth time out" system is a hypothetical system in which the offender is given $N - 1$ chances to correct his ways. In such a system $S_1 = S_2 = \ldots = S_{N-1} = 0$, meaning that the sentence resulting from the ith conviction, $i = 1, 2, \ldots, N - 1$, does not include prison at all, or may include very short imprisonment or jail. However, when the offender is convicted for the Nth time he is given a very long imprisonment sentence, which is mathematically expressed by $S_N = \infty$. Clearly, in this system, the survival probabilities are given as

$$\theta_1 = \theta_2 = \ldots = \theta_{N-1} = 1 , \tag{38}$$

and

$$\theta_N = 0 .$$

Substituting equation (38) in (6) we obtain an expression for ϕ denoted by ϕ_N

$$\phi_N = 1 + \sum_{n=1}^{N-1} \prod_{i=1}^{n} (1 - P_i) . \tag{39}$$

Similarly, $E(X)_N$ is the expected number of offenses committed by an individual offender during his life. When assuming $q_0 = q_1 = \ldots = q_{N-1} = q$ we obtain from equation (28)

$$E(X)_N = \frac{1 - P_o}{q} \phi_N . \tag{40}$$

A system is "N*th* time out" equivalent if there exists an "N*th* time out" system such that η, λ_i, and $q_i + 1 = 0, 1, 2, \ldots$, are identical in both systems, and

$$E(X) = E(X)_N . \tag{41}$$

Example I:

Suppose we deal with a system where $q_0 = q_1 = q_2 = \ldots = q$. In such a system $E(X)$ is given by equation (28). When comparing this to equation (40) we notice that for equation (41) to hold, it is required that

$$\phi = \phi_N . \tag{42}$$

For simplicity we assume that $\lambda_0 = \lambda_1 = \ldots = \lambda$, and $S_1, S_2, S_3 \ldots$, all possess the same exponential density with mean $1/\mu$. These assumptions imply that $P_0 = P_1 = P_2 = \ldots = P$ and $\theta_1 = \theta_2 = \theta_3 = \ldots = \theta$, where

$$1 - P = \frac{\lambda q}{1 + \lambda q} \tag{34}$$

and

$$\theta = \frac{\mu}{\mu + \eta} . \tag{43}$$

From equation (6) we obtain

$$\phi = \frac{1}{1 - (1 - P)\theta} , \tag{44}$$

and from equation (39) we have

$$\phi_N = \frac{1 - (1 - P)^N}{P} . \tag{45}$$

For deriving the value of N we equate equations (44) and (45) to obtain

$$N = \frac{\mathrm{Log}\,(1 - P\phi)}{\mathrm{Log}\,(1 - P)} = \frac{\mathrm{Log}\left(\dfrac{1 - P}{1 - (1 - P)\theta}\right)}{\mathrm{Log}\,(1 - P)} . \tag{46}$$

Values of N as a function of release-to-conviction repeat probability, $1 - P$, and average incarceration length, $1/\mu$, are given in Table 7-9. Note that $1/\mu$ is given in fractions of the average career length, e.g., $1/\mu = 0.1$ means that the average incarceration length is 10 percent of the average criminal career length.

Example II:

In a California study mentioned earlier (Select Committee on the Administration of Justice, 1970), released felons' careers were followed up for a

TABLE 7-9
N as a Function of 1 − P and 1/μ

1 − P \ 1/μ	0.05	0.10	0.20	0.30	0.40	0.50	0.60	0.80
0.1	2	2	2	2	1	1	1	1
0.2	3	2	2	2	2	2	2	1
0.3	3	3	2	2	2	2 ·	2	2
0.4	4	3	3	2	2	2	2	2
0.5	4	4	3	2	2	2	2	2
0.6	5	4	3	3	2	2	2	2
0.7	6	5	4	3	3	2	2	2
0.8	8	6	4	3	3	3	2	2
0.9	11	8	5	4	3	3	2	2
0.95	15	9	5	4	3	3	3	2

period of three years. These released felons were originally convicted and imprisoned for one of the following offenses: murder, robbery, assault, rape, burglary, sex offenses, theft of auto and other theft, hard narcotics, marijuana, and hard drugs.

It was found that out of 7,160 released from prison in 1964 and 1966, 1,268 (18 percent) were returned to prison with *new convictions*. Of these, 1,214 (17 percent) returned for new offenses in the same offense group. It was also found that of those released in 1964 about 67 percent were re-arrested at least once within three years, (the maximum number of post-release arrests was twelve), and about 46 percent of rearrests resulted in prison terms. (The figure of 67 percent rearrested is given in Table 3-2 of the mentioned report, while the 46 percent approximate figure was compiled from Table 3-3 of the report.) We then estimate that 31 percent (46 percent out of 67 percent) returned to prison at least once within three years of their first release. Felons released to first parole in the years 1960–1968 served on the average about thirty months in prison. This figure may serve as an upper bound of average stay in prison since many of those returning to prison return to finish terms. We shall assume then that the average stay in prison is twenty months.

In trying to find the "N*th* time out" equivalence of this system we shall use the simpler model given in Example I. Let $\pi(t)$ be the release-to-conviction probability within t years

$$\pi(t) = \int_0^t \lambda q e^{-\lambda q x} e^{-\eta x}\, dx = \frac{\lambda q}{\lambda q + \eta}\left(1 - e^{-(\lambda q + \eta)t}\right). \quad (47)$$

The derivative of $\pi(t)$ is the repeat intensity as a function of time and is exponentially decreasing in time.

$$\frac{d\pi(t)}{dt} = \lambda q e^{-(\lambda q + \eta)t} , \quad t \geq 0 . \tag{48}$$

From equation (47) we obtain, after some simple manipulation,

$$\lambda q = \frac{1}{t} \log \frac{\lambda q}{\lambda q(1 - \pi(t)) - \eta\pi(t)} - \eta . \tag{49}$$

We can assume $1/\eta = 1$ time unit without loss of generality. Suppose that the average length of a criminal career is twenty years. Using $1/\eta = 1$, or twenty years as one time unit, we have $1/\mu = 20/240 = 0.083$, and t = $3/20 = 0.15$. The release-to-conviction within three years probability, $\pi (0.15)$, is assumed to equal 0.31. Substitution in equation (49) yields

$$\lambda q = 2.7.$$

From equation (34) we obtain

$$1 - P = 0.73 ,$$

and from equation (43) we obtain

$$\theta = 0.92 .$$

The values of $1 - P$ and θ are then substituted into equation (44) yielding

$$\phi = 3.1 .$$

Substitution of ϕ and P into equation (46) yields the value of N.

$$N = 7 .$$

We conclude then, that under the assumptions made, the system is "7th time out" equivalent.

In the foregoing example we considered only prison sentences. Inclusion of jail and juvenile sentences shortens the average incarceration and increases the repeat probability. We shall assume average incarceration of twelve months as a reasonable upper bound, and release-to-conviction within three years probability of 0.67 as a reasonable lower bound. For a twenty years average criminal career we obtain in this case t = $3/20$ = 0.15, $1/\mu = 12/240 = 0.05$ and $\pi(0.15) = 0.67$. In a similar manner to the previous case we obtain.

$$\lambda q = 8.25$$
$$1 - P = 0.89$$
$$\theta = 0.95$$
$$\phi = 6.45$$
$$N = 10 .$$

This system is therefore "10th time out" equivalent. If we desire to reduce the crime rate by 50 percent we must reduce ϕ by 50 percent. This

follows from equation (40). The reduced value of ϕ is $\phi = 3.2$, from which it follows that $1/\mu = 0.3$ and $N = 4$. In this new system the average incarceration must be increased from one year to six years, which is unreasonable. An alternative solution is to reduce the release-to-conviction repeat probability from $1 - P = 0.89$ to $1 - P = 0.72$, which means that $\pi(0.15)$ must be reduced from 0.67 to 0.29. Such a rehabilitative improvement cannot be expected in the near future. It is also worth noting that in case ϕ is cut by 50 percent the decline in crime level will not be immediate; rather it will be a gradual decline taking many years before the new crime level is achieved.

The notion of "N*th* time out" equivalence is suggested here as a tool for measuring and comparing criminal systems. N is mainly a measure of relative severity of sentencing. Small values of N indicate high severity of sentencing, relative to the concerned system.

Discussion

The models suggested in this study are quite elementary and we do not expect them to fit reality in all its details. Rather, we were trying to describe complex and dynamic systems by models that are at best rough approximations. Nevertheless, we feel that the simplicity of the models enables one to estimate the systems' sensitivity to changes in the major parameters.

A major obstacle in trying to model crime systems is the lack of accessible detailed data for validation of the basic assumptions. One deficiency in our assumptions is that we estimate the probability of an offense leading to a conviction, denoted as q, by using the fraction of offenses cleared by convictions. We suspect that as such, the values of q, given in Table 7-5 are grossly optimistic. In reality it is often the case that an offender when caught will confess to some, and sometimes to all, earlier undetected offenses committed by him. In fact, he may be encouraged to do so since the police are interested in clearing by conviction as many crimes as possible. This encouragement may take the form of a lesser sentence for the crime for which he was caught and no real punishment for all prior crimes admitted by him. The numbers in Table 7-5 may at best serve as an upper bound for the probability that a given committed crime will be solved on its own and will lead to conviction. Where using these numbers our models tend to overestimate police and prosecution effectiveness and underestimate the expected number of crimes committed by an offender during his criminal career. The problem of estimating the exact value of q is worthy of a special study.

Other deficiencies of the models given in the first part of the study are: (1) ignoring deterrence effects; (2) assumption of stationarity which elimi-

nates possible time related effects; (3) assumption of exponential distributions of criminal career length and sentence length. These were mentioned and discussed in the body of the paper.

An implicit assumption, which is of prime importance, is that of homogeneity of the offender population. If we assume, for example, that offenders divide into two classes—those who are always caught and those very clever ones who are never caught—we can do very little with respect to the second class. Since more than 80 percent of crimes remain unsolved the assumption of two classes is not impossible. However, we feel that in reality there are many classes of offenders each with different values of q. Using an average value of q for the total population will, in most cases, result in only a slight bias.

All shortcomings considered, we still can point out some interesting results. We have learned that increasing severity of sentencing will result in a relatively small reduction in crime rates, unless the average prison stay is increased fourfold or fivefold (see California example) or the increase is combined with an increase in effectiveness, q. Since the average prison stay per offense has probably sharply decreased lately (the total number of prisoners in U.S. prisons has changed very little during the last decades despite the spectacular increase in the number of reported offenses), an increase in prison terms and police and prosecution effectiveness may provide a partial solution to the present crime situation. How costly this solution may be is not easy to estimate. The main difficulties lie in trying to estimate the cost involved in increasing effectiveness, q. An effective remedy to the present crime situation must include effective measures preventing younger people from embarking upon criminal careers.

This brings us to the models of the second part of the paper, dealing with the growth of the offender population. These models are largely deterministic in nature. The intention of these models was less to give a basis useful for quantitative prediction than it was to demonstrate the plausible effects of a steadily growing population of criminals. Models of this same general type, but more elaborate and stochastic in nature, are presently being developed. We intend to use them for estimating the response time of crime level to the implementation of various policies. For example, it may be shown that a sharp increase in effectiveness, q, will result in an almost immediate reduction in crime level but will be very costly in terms of added prison, courts and police facilities, and manpower. This may be termed as an "Election Year Solution." On the other hand, the effects of reducing the number of persons embarking upon criminal careers may take a long time to become apparent. It seems that a good policy should combine both short- and long-term effects. We hope to be able to provide some quantitative answers to this problem.

REFERENCES

Belkin, J.; Blumstein, A.; and Glass, W. "Recidivism as a Feedback Process: An Analytical Model and Empirical Validation." *Journal of Criminal Justice* 1 (1973): 1.
Christensen, R. "Projected Percentages of U.S. Population with Criminal Arrest and Conviction Records." *Task Force Report: Science and Technology,* Appendix J., President's Commission on Law Enforcement and Administration of Justice, Washington, D.C.: Government Printing Office, 1967.
Clark, R. *Crime in America.* New York: Simon and Schuster, 1970.
Department of Commerce. *United States Census, 1970.* Washington, D.C.: U.S. Government Printing Office, 1970.
Federal Bureau of Investigation. *Uniform Crime Reports, 1939-1970.* Washington, D.C.: U.S. Government Printing Office.
Kirks, R. F. "Federal Offenders in the U.S. District Courts." Washington, D.C.: Administrative Office of the U.S. Courts, 1969.
New York City Police Department. *Annual Reports.* New York, New York, 1960–1970.
Select Committee on the Administration of Justice. "Parole Board Reform in California— Order Out of Chaos." Sacramento: Assembly of the State of California, 1970.
Wilson, J. "If Every Criminal Would Be Punished If Caught." *New York Times Magazine,* January 28, 1973.
Wolfgang, M. E., Figlio, R. M., and Sellin, T. *Delinquency in a Birth Cohort.* Chicago: University of Chicago Press, 1972.

8: Crime in a Birth Cohort / *Marvin E. Wolfgang**

In 1964 the National Institute of Mental Health began sponsoring a unique study of delinquency in the United States. Under the direction of Professor Thorsten Sellin and myself, the Center for Studies in Criminology and Criminal Law at the University of Pennsylvania launched a program to capture and analyze a group of boys born in 1945 who lived in a given locale (Philadelphia) at least from their tenth up to their eighteenth birthday. This group constitutes a birth cohort. Our main interest was to determine a fact thus far unknown, namely, the probability of becoming officially recorded as a delinquent. Only in Norway [1] and England [2] had efforts been made to discover this datum; and nowhere had a study been so elaborately designed and executed. All previous criminological research

* Marvin E. Wolfgang, "Crime in a Birth Cohort," *Proceedings of the American Philosophical Society* 117, no. 5 (October 1973): 404–411. Reprinted by permission.

had been retrospective, i.e., looking backward on a group of known and recorded delinquents of varying ages to determine their age of onset of delinquency (as the Gluecks [3] at Harvard have so often done), or prospective, i.e., looking forward from a group of delinquents of varying ages to describe their adult patterns of criminality. Neither of these types of studies, known as cross-sectional, validly provides proper probability statements, or the chances of ever becoming delinquent or an adult criminal. Neither can offer valid assertions about patterns of delinquent behavior by specific ages, about the onset of criminality, desistance (or stopping delinquency), nor about relative degrees of seriousness of offensivity.

Delinquency in a Birth Cohort [4] is the study which I published with my associates, Robert Figlio and Thorsten Sellin. Through school, police and Selective Service files we traced 9,945 boys, or all those born in 1945 who lived in Philadelphia at least from ages ten to eighteen. From this total birth cohort universe, 35 percent became delinquent, that is, had at least one contact with the police for something other than a traffic violation. These 3,475 boys committed 10,214 offenses up to the end of the juvenile court statute age of seventeen.

Our figure of 35 percent delinquent needs further clarification. First, it has commonly been said that in any given calendar year only about 2 percent of juveniles are arrested, and that probably no more than 10 percent are ever arrested. Hence, the probability that 35 percent of urban males will be arrested before their eighteenth birthday is comparatively high. Second, race is one of the most significant variables in this analysis. Nonwhites make up 29 percent of the birth cohort but 50.2 percent are recorded delinquents; whites are 71 percent of the cohort, 29 percent of whom are delinquent. The 50 percent and 29 percent delinquent populations may be used as probability statements because we have longitudinally traced the entire universe through their juvenile years, thus indicating significant racial differential probabilities of becoming labeled delinquent. Major differences in the proportions of nonwhites and whites in other cities, assuming relative constancy to the delinquent probabilities, could make for lower or higher general probabilities of delinquency.

Third, it should be clearly understood that the offense histories we have analyzed are derived from police-arrest records. We are aware of the concept and studies of "hidden delinquency," [5] or the "dark numbers" [6] of crime, which refer to illegal acts unknown or unrecorded by official agencies. For certain types of offenses, usually the less serious, racial and socioeconomic disparities found in official police records are often reduced among self-reporting studies from anonymous questionnaires or interviews. There may also be race differentials in police arrests. Therefore, we generally use the phrase "having a police record" or a "police contact." When the term "delinquent" or "delinquency" is used, officially recorded persons and acts are described. Yet, if society is concerned about the process of labeling persons as offenders and providing dispositions through

our justice systems, it is important that we know who these persons are, and what their probabilities are for being so processed.

Finally, among these preliminary considerations, there is the issue of the generalizability of a birth cohort. Each cohort is in a sense unique and time-bound, as the demographer Norman Ryder [7] has clearly remarked. How representative a single cohort may be for other communities, for different birth cohorts, for females can only be conjectured. Cohort subset comparisons as, for example, delinquents with nondelinquents, on the basis of social, economic, and personality variables, may be representatively valid and reliable beyond the single cohort itself. Moreover, the career patterns of the delinquent group, the character of their delinquency, a probability model that forms a dynamic typology of movement from one stage to another—all of these empirical findings may be converted to conclusions for other cohorts. Minimally, every finding from this cohort has the posture of an hypothesis for testing on other cohorts elsewhere and at other times.

After examining the relation between such background variables as race, socioeconomic status (SES), types of schools attended, residential and school moves, highest grade completed, I.Q., achievement level, we concluded that the variables of race and SES were most strongly related to the offender-nonoffender classification. The remaining variables in the school records had little or no relationship to delinquency status. For example, although high achievers are much less likely to be classified as offenders than are low achievers, the relation between race and achievement is such that most of the variance between achievement and delinquency status is explained by race, for being a poor achiever is highly related to being nonwhite. This relation also exists between race and the remaining background variables.

The 3,475 boys in the cohort who are recorded delinquents were responsible for 10,214 delinquent acts through age seventeen. Whites were involved in 4,458, or 44 percent, and nonwhites in 5,756, or 56 percent of these offenses. The offense rate, of course, is different from the offender rate. When the rate of delinquency is computed on the basis of the number of boys ever recorded as having had a delinquency contact with the police, the offender rate is 349.4 per 1,000 cohort subjects. But this kind of computation ignores the number of offenses committed, and statistically treats alike each boy, regardless of the number or types of acts committed. An offense rate, computed for the birth cohort by using the number of events as numerator and the 9,945 boys as denominator, multiplied by the constant, 1,000, yields a cohort rate of 1,027. The nonwhites' rate is three times as high as the whites' rate (1,983.5 to 633.0).

Besides crude rates of delinquency per population unit, the birth cohort study also scores seriousness of offense. Derived from an earlier study of psychophysical scaling by Sellin and Wolfgang, entitled *The Measurement of Delinquency*,[8] these scores denote relative mathematical weights of the

gravity of different crimes. The scores represent a ratio scale such that a murder is generally more than twice as serious as a rape; an aggravated assault, depending on the medical treatment necessary, may be two or three times more serious than theft of an automobile, and so on. The scale has been replicated [9] in over a dozen cities and countries and has proved useful in the cohort analysis. Each offense from the penal code committed by members of the cohort was scored. This process permitted us to assign cumulative scores to the biography of each offender, to average seriousness by race, SES, age, and other variables.

These scores were also applied to index and nonindex offenses. Index offenses are those used by the Federal Bureau of Investigation and students of criminology to refer to serious acts of highest utility in constructing a crime index, like a price, wage or productivity index. Index offenses are those involving bodily injury, theft, or damage to property, or a combination of any of these. Nonindex offenses are all other acts, such as truancy, disorderly conduct, and other minor violations.

The nonwhite crude rate (1,983.5) is 3.1 times as great as the white crude rate (633.0), but the rate when seriousness scores are considered is 4.4 times as great for nonwhites (2,585.9) as for whites (587.8). Among index offenses, the nonwhite crude rate is 2.4 times as great as the white rate, but the weighted rate is 4.6 times as great. Among nonindex offenses, nonwhites have a crude rate 2.6 times and a weighted rate 3.7 times as great as the respective white rates. These figures reveal that nonwhites proportionately commit not only more offenses but more serious offenses than do whites.

Among the 5,756 offenses committed by nonwhite cohort boys, 2,413 were index offenses with a mean seriousness score of 265.0. Among the 4,458 offenses committed by white cohort boys, only 1,400 were index offenses, with a mean score of 243.3. Incidence and average seriousness make for the considerable difference in the computed rates for whites and nonwhites. Nonwhites committed 3,343 nonindex offenses, with a mean seriousness score of 33.2; whites had 3,058 nonindex offenses and a mean score of 24.0.

Another way to view the weighted rates is in terms of cumulative scores for the offenses and the total amount of social harm inflicted on the community. For example, nonwhites inflicted on the city 750,433 units of social harm or seriousness points—639,455 of which were from index offenses and 110,988 from nonindex offenses. If a 10 percent reduction, not of all nonwhite offenses but of index offenses, were shifted to a 10 percent increase in nonindex offenses, the corresponding reduction in seriousness units would amount to 72,777. That is, index gravity units would dip to 565,501, and nonindex gravity units would increase to 122,087—a socially favorable trade-off. The overall crude rate of 1,983 would remain the same, but the reduction of 72,777 seriousness units (or a weighted rate reduction from 2,585.91 to 2,403.81) would be equivalent to the elimination of 28

homicides, or 104 assaults that send victims to hospitals for treatment, or 181 assaults treated by physicians without hospitalization.

In short, if juveniles must be delinquent, a major thrust of social action programs might be toward a change in the character rather than in the absolute reduction of delinquent behavior. It could also be argued that concentration of social action programs on a 10 percent reduction of white index offenses ($N = 1,400$; $WR = 483.63$) would have a greater social payoff than a 10 percent reduction of nonwhite nonindex offenses ($N = 3,343$; $WR = 382.45$). To inculcate values against harm, in body or property, to others is obviously the major means to reduce the seriousness of delinquency, among both whites and nonwhites. We are simply faced with the fact that more social harm is committed by nonwhites, so that the resources and efforts of social harm reduction should be employed among nonwhite youth, especially the very young.

Although delinquency in a birth cohort has been analyzed in many other ways, including juvenile justice dispositions that reveal significantly more severe sentences for nonwhite offenders, even holding constant seriousness of offenses and number of prior offenses, perhaps the most important and new analysis is of the dynamic flow of delinquency.

By benefit of a birth cohort, we have been able to consider offenses as a stochastic process, or more specifically, to ask whether the commission of delinquency and the types of delinquent acts are a function of frequency and the preceding history of delinquency. If offensivity is independent of time and not a function of prior offense types, the result may be designated, mathematically, as a Markov chain. Essentially, we compared the instant, or last offense (kth offense), with the immediately preceding one (k—1st offense), and then the empirical transitions between offense types for the first through the kth (in our cases, the 15th) offense. Five offense types were clustered and classified as Injury, Theft, Damage, Combination, or Nonindex. A sixth opportunity was Desistance. Assessing the k-1st and kth offense as well as all k-1st and kth offenses presented problems of distributions and trend analysis. Later we were able to examine shifts from one type of offense to another as the cohort passed from the first to their fifteenth offense.

We visualized the progression from birth to the first offense, then to the second, to the third, and so on as pathways along the branch of a tree with six alternative paths of offenses or desisting at each juncture (see Fig. 8–1). Each point of departure becomes the probability of arriving at a given location, having come from the offense type at the origin point along the path. After any offense, or from birth, one may desist from delinquency and thus become "absorbed" into the state of desistance. We call this analysis a branching probability model of offensive diversity.

We have noted that the probability of committing a first offense of any type is 0.3511. The likelihood of a second offense is 0.5358, but if a second offense is committed, the probability of a third of any type is greater,

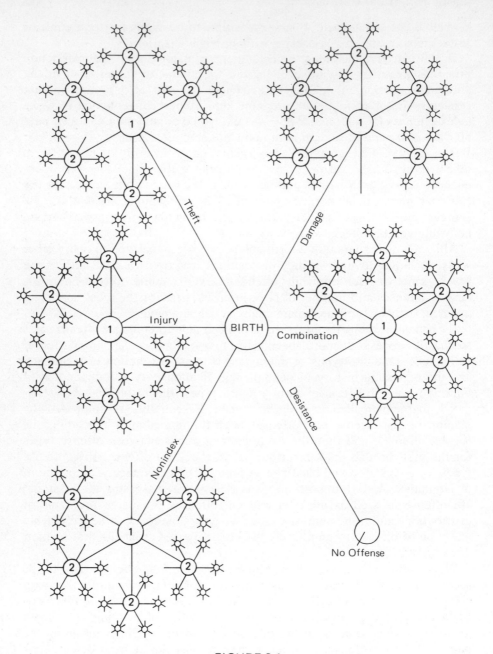

FIGURE 8-1.
Branch Probability Model of Offensive Diversity

0.6509. Beyond the third offense the likelihood of further offenses ranges from 0.70 to 0.80.

Besides these probabilities are those concerned with moving from one type of offense to another. Does the type of offense that a cohort member committed at the k-1st offense number have any bearing on the probability that he will commit a certain type of offense at the kth number? Analyzing our data for offense switching generated a set of matrices, or transition configurations, that provided an answer.

The typical offender is most likely to commit a nonindex offense next (0.47 probability), regardless of what he did in the past. He is next most likely to desist (0.35), commit a theft (0.13), an injury (0.07) or combination (0.05). With the exception of the moderate tendency to repeat the same type of offense, this pattern obtains regardless of the type of previous offense (see Table 8-1).

Knowledge of the immediate prior offense type (k-1st) does aid slightly in the prediction of the kth type, for there is some tendency to repeat the same type of offense. But this inclination is not strong. It is clear, however, that the offense history up to the immediately previous offense, or prior to the k-1st offense, has no bearing on the observed probabilities of committing the kth offense. That is, knowledge of the number and type of offenses prior to the k-1st gives us no aid in predicting the type of the next offense. Because the same process operates at each offense number, we suggest that an offender "start over," in a sense, each time he commits an offense

TABLE 8-1

Probability of Committing kth Offense by Type of Offense, All Offenders

k (Number of Offense)	All Types (Σ of N, I, T, D, C)	Nonindex	Injury	Theft	Damage	Combination	Desisted (after kth offense)
				Probability			
1	1.0000	0.6547	0.0760	0.1393	0.0725	0.0576	0.4641
2	0.5358	0.3430	0.0455	0.0794	0.0222	0.0458	0.3492
3	0.6509	0.4044	0.0483	0.1246	0.0236	0.0499	0.2838
4	0.7161	0.4439	0.0736	0.1238	0.0248	0.0503	0.2778
5	0.7223	0.4320	0.0657	0.1313	0.0264	0.0668	0.2584
6	0.7416	0.4705	0.0526	0.1435	0.0128	0.0622	0.2085
7	0.7913	0.4409	0.0925	0.1398	0.0387	0.0796	0.2337
8	0.7663	0.4511	0.0815	0.1440	0.0163	0.0734	0.2021
9	0.7978	0.4787	0.0887	0.1241	0.0177	0.0887	0.1733
10	0.8266	0.4489	0.1111	0.1956	0.0089	0.0622	0.2096
11	0.7903	0.4624	0.0645	0.1559	0.0054	0.1022	0.1974
12	0.8027	0.4830	0.0816	0.0884	0.0544	0.0952	0.2712
13	0.7288	0.4068	0.0593	0.1441	0.0254	0.0932	0.1162
14	0.8837	0.5233	0.1163	0.0814	0.0349	0.1279	0.3026
15	0.6973	0.4474	0.0263	0.1316	0.0000	0.0921	0.2453

and that there is no specialization in offense types. Thus the transition probabilities associated with commission of juvenile offenses may be modeled by a homogeneous Markov chain.

Chronic recidivists represent a special group for analysis. Of the entire cohort, 627 boys were recorded as having committed five or more offenses before age eighteen. They represented 6 percent of the cohort and 18 percent of the delinquent subset. Yet they were responsible for 52 percent of all offenses, and about two-thirds of all violent crimes. Race differences are particularly striking among chronic offenders: 417, or 10 percent, of non-whites but only 210, or 3 percent, of whites are chronic offenders. Nonwhites committed 71 percent of all offenses committed by this group. All the murders, 91 percent of the rapes, 93 percent of the robberies, and 88 percent of aggravated assaults were committed by nonwhites. Larcenies were committed by each racial group in proportion to numbers in the chronic group. Lower SES, lowest achievement in school, lowest I.Q., and other similar variables of disadvantage characterized the chronic offenders.

When we combine knowledge of chronic offenders with that of desistance rates, we arrive at a suggestion for social intervention policy. Recall that 46 percent desisted after the first offense, 35 percent after the second, and approximately 25 percent at each remaining step after the third offense. In short, a stability of stopping delinquency occurs after the third act. At what point, then, in a delinquent boy's career should an intervention program occur? Our answer would be that the best time is that point beyond which the natural loss rate, or probability of desistance, begins to level off. Because 46 percent of delinquents stop after the first offense, a major and expensive treatment program at this point would be wasteful. Intervention could be held in abeyance until the commission of the third offense. We would thus reduce the number of boys requiring attention in this cohort from 3,475 after the first offense, to 1,862 after the second offense, to 1,212 after the third offense, rather than concentrating on all 9,945 or some large subgroup under a blanket community action program.

Since 1968 the Center has been engaged in a follow-up of the original birth cohort. A systematic 10 percent random sample yielded 974 subjects. An effort was made to locate and to interview as many as possible. Despite nearly three years of diligent searching—with the use of the Selective Service address file, motor vehicle registrations, post-office assistance, Social Service Exchange, and other agencies—many of our cohort sample could not be found. We were taught a lesson about the high rate of mobility of young urban males, despite the fact that most of it is intra-urban migration. Approximately 12 percent were known to have left Philadelphia, although their scattering was wide, to suburbs, to Vietnam, and to prisons.

An important difference should be noted between our sample subjects and those of social surveys that seek to interview one or more members of national representative samples of household units, a common target for

attitude studies. In the latter, geographic, or area samples are taken, and interviewers are assigned to given addresses on predesignated blocks. Should no one be at home, or should a member of the household refuse to be interviewed, a systematic scheme provides alternates, such as the next household, or an address across the street, and so forth. In our case, no substitutes were possible; we had to locate a specific person. Once found, however, no persons refused to be interviewed.

Our interviews were between one and two hours long, covering many details concerned with the personal history of these young men whom we were tracing up to their twenty-sixth birthday: educational, occupational, and military background, marital and family history, juvenile gang activity, detailed situational aspects of their first and last contacts with the police and other agencies of the juvenile and adult justice systems. We asked about "hidden delinquency," or the amount and kinds of violations of the law for which they were not arrested, including an unusually wide range of acts from murder and serious drug offenses to petty larceny. We have applied our scale of seriousness scores to the unreported offenses as well as to the offenses known to the police and shall be able to make comparisons for the first time.

The follow-up study is in the data-processing, data-analysis stage.[10] But I can report a few basic statistical findings about the birth cohort in adulthood, from ages eighteen to twenty-six. For the first time in criminology it is possible to offer probability statements about the likelihood of being arrested up to the mid-twenties. We shall later, of course, be able to speak about the types of offenses, convictions, sentencing, and recidivism in more detail.

There is another interesting methodological note to be mentioned about the follow-up. The 10 percent sample drawn produced 974 subjects who were representative of such subsets as white and black delinquents and nondelinquents. We have collected official arrest and dispositional documentary data on all of them up to age twenty-six. But other life-history material is available only for the 567 young men who were interviewed. A fundamental issue is the extent to which the interviewed sample is statistically representative of (1) the drawn sample (974) and (2) the total universe of the birth cohort (9,945).

Research methodologists commonly refer to the problems of nonrespondents in large-scale studies, but rarely resolve those problems by specific and generally acceptable techniques. Our interviewed sample, we know, is slightly overrepresentative of white nondelinquents and underrepresentative of black former delinquents. Our chief concern has been to determine the degree of concordance or discordance, on variables about which we have background information from the total cohort, between the interview sample, the drawn sample and the whole cohort. From this analysis, we shall then be able to determine the appropriateness or validity of making inferences from the interviewed sample to the larger populations about

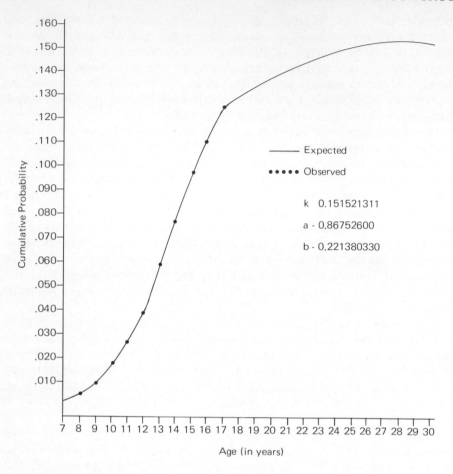

FIGURE 8-2.
Cumulative Probability of at Least One Index Offense by Age

variables known only from the drawn sample. Generalizability is the issue. Where known statistically significant differences exist between the interviewed sample and the cohort, we intend to provide a statistical correction that will permit probability inferences to be made on variables known only from the interviews. We are currently content, however, that for most variables no standardized correction need be performed; in short, our interviewed sample adequately reflects the larger universe along most dimensions.

What are the chances of ever having an official arrest record before reaching age twenty-seven? The answer is 0.4308 (see Table 8-2). This 43 percent probability is based on juvenile as well as adult police data and is considerably higher than most of us suspected. Having previously reported that there is a 0.35 probability of having a police record prior to age eigh-

TABLE 8-2
Age of Offenders and Nonoffenders,
Before Age 18, Age 18 and Over

		Age 18 and Over		
		Offender	Nonoffender	
Under age 18	Offender	149 (A)	193 (B)	342 (A + B)
	Nonoffender	77 (C)	555 (D)	632 (C + D)
		226 (A + C)	748 (B + D)	974 (E)

Probabilities of being a:

1) Juvenile offender (<18) $= 0.3511 \left(\frac{A + B}{E}\right)$

2) Offender (≤26) $= 0.4308 \left(\frac{A + B + C}{E}\right)$

3) Adult offender only (>18 to ≤26) $= 0.2320 \left(\frac{A + C}{E}\right)$

4) Adult offender, having been a juvenile offender $= 0.4357 \left(\frac{A}{A + B}\right)$

5) Adult offender, *not* having been a juvenile offender $= 0.1218 \left(\frac{C}{C + D}\right)$

teen, we may now note that an additional 8 percent of the cohort, who had no previous juvenile arrest record, became adult offenders.

Yet another way to question the data is to ask about the probability of becoming an adult offender from among those members of the cohort who escaped being arrested up to age eighteen. That probability is 0.1218. The chance of being an adult offender, regardless of juvenile record, is 0.2320. Calculation of this last probability is based on the number of previously known juvenile offenders plus new offenders in adulthood (≥18), divided by the total cohort. But most of the contribution to this relatively high rate of adult offensivity comes from persons who also had a juvenile delinquency record. Of the total adult offenders (226), 66 percent (149) had also been arrested under age eighteen, whereas only 34 percent (77) were new recruits into the arrest file after age eighteen.

Perhaps the most disquieting, albeit not unexpected, finding is that the chances of becoming an adult offender are much higher for persons who had a delinquency record than for those who did not. The probability of being arrested between eighteen and twenty-six years of age, having had at least one arrest under age eighteen, is 0.4357, which is three-and-one-half times higher than the probability (0.1218) of being arrested as an adult, having had no record as a juvenile. This is another way of saying, with new precision, that the chances of recidivating from a juvenile to an adult status are higher than commencing an adult arrest record—at least up to age twenty-six. These observed data conform very closely to the curvilinear

probability expectations we projected from our earlier Phase I study of the birth cohort.[11] It should be no surprise, therefore, if we find in later projections that half of the entire cohort had an offense record by age thirty-five.

By examining age-specific probabilities of ever being arrested, or of having a first offense, some interestingly new information can be reported (see Table 8-3). Age seventeen has the peak probability of having a first arrest (0.1007). Up to age seventeen, the probabilities increase monotonically from age eight (0.0020), for example, to age twelve (0.0284) and age sixteen (0.0801). They also decrease from age seventeen in nearly a monotonic fashion through age eighteen (0.0454), age twenty (0.0293), age twenty-two (0.0155) and age twenty-six (0.0018). However, the cumulative probabilities of ever being arrested rise much more rapidly and dramatically up to age seventeen than they do after that age. For example, the probability of at least one arrest jumps from 0.0502 at age twelve to 0.3511 at age seventeen, which is an absolute 30 percent increase, or seven-and-one-half times greater. However, this probability of ever being arrested climbs much more

TABLE 8-3

Age, Probability of Arrest by Age, Proportion Arrested by Age, and Cumulative Probability of Arrest

Age (x_i)	N	Frequency (x_i)	(a) $\left[P_i = \dfrac{x_i}{N_i - 1} \right]$	(b) (Px_i/N)	(c) $(2Px_i/N)$
7	974	0	0	0	0
8	973	1	0.0010	0.0010	0.0010
9	971	2	0.0020	0.0020	0.0030
10	966	5	0.0051	0.0051	0.0081
11	952	14	0.0145	0.0144	0.0225
12	925	27	0.0284	0.0277	0.0502
13	896	29	0.0314	0.0298	0.0800
14	857	39	0.0435	0.0400	0.1200
15	799	58	0.0677	0.0595	0.1795
16	735	64	0.0801	0.0657	0.2452
17	661	74	0.1007	0.0760	0.3212
18	631	30	0.0454	0.0308	0.3520
19	614	17	0.0269	0.0174	0.3694
20	596	18	0.0293	0.0185	0.3819
21	581	15	0.0252	0.0154	0.4033
22	572	9	0.0155	0.0092	0.4125
23	569	3	0.0052	0.0031	0.4156
24	563	6	0.0105	0.0062	0.4218
25	556	7	0.0124	0.0072	0.4290
26	555	1	0.0018	0.0010	0.4300

(a) Probability of first arrest by given age.

(b) Proportion arrested by given age.

(c) Cumulative probability of arrest by given age.

slowly after age seventeen and reaches, as we have observed, 0.4300 by age twenty-six, an absolute 8 percent increase, or only one-and-one-half times as great. Thus, based on these and other data, we know that the probability of ever being arrested, as well as of committing offenses generally, declines with age, beginning with the eighteenth year.

There are many other kinds of data by racial and socioeconomic groups, by transition matrices from one type of offense to another over frequency of offenses, by family, work, and educational history, and by varied contacts with the criminal justice system that we are currently analyzing, hoping to answer three major questions:

1. What is the desistance rate after one offense? two? three? n number of offenses? Buried in this question are others concerned with explanations about status shifts and status stabilities. For example, some multiple juvenile offenders become adult nonoffenders; juvenile nonoffenders become adult criminals; juvenile offenders remain adult criminals; and juvenile nonoffenders are also adult nonoffenders. Criminological literature is peculiarly devoid of information about why delinquents halt their offensivity and become law-abiding citizens without arrest records. Much of this desistance is what may be called "spontaneous remission," due less, perhaps, to ineffectual treatment programs than to other factors in the life history of delinquents as yet unknown to analysts. It is our hope to capture some of these variables so as to provide further insights for a concerted, purposeful social policy that might promote and encourage the development of those factors.

2. Is there a continuation of the same Markovian chain for adult offenders as was noted for juveniles? Or is there a form of offense specialization that occurs among adults which was absent in juveniles?

3. Is there an optimal point in adult offenders' lives when strong intervention should be taken to maximize efficiency and effectiveness of such intervention to reduce their further criminality and better protect society? This last question raises further ones about being able to predict future dangerousness, an omnipresent but usually unanswered question. By applying the research methods embraced by this unique longitudinal cohort study, we may come closer to answering these and other socially significant questions.

NOTES

1. Nils Christie, *Unge norske lorovertredere* (Oslo: Universitetsforlaget, 1960).

2. Glenn Mulligan, J. W. B. Douglas, W. A. Hammond, and J. Tizard, "Delinquency and Symptoms of Maladjustment: The Findings of a Longitudinal Study," *Proceedings of the Royal Society of Medicine* 56, no. 12 (December 1963):1083–1086. J. W. B. Douglas, J. M. Ross, W. A. Hammond, and D. G. Mulligan, "Delinquency and Social Class," *British Journal of Criminology* 6 (July 1966):294–302.

3. Sheldon and Eleanor T. Glueck, *Five Hundred Criminal Careers* (Millwood, N. Y.: Kraus Reprint Co., 1930). *Later Criminal Careers* (Millwood, N. Y.: Kraus Reprint Co., 1937). *Criminal Careers in Retrospect* (Millwood, N. Y.: Kraus Reprint Co., 1943). *One*

Thousand Juvenile Delinquents (Millwood, N. Y.: Kraus Reprint Co., 1934). *Juvenile Delinquents Grown Up* (Millwood, N. Y.: Kraus Reprint Co., 1940). *Unraveling Juvenile Delinquency* (Cambridge, Mass.: Harvard University Press, 1950). *Delinquents and Nondelinquents in Perspective* (Cambridge, Mass.: Harvard University Press, 1968). *Toward a Typology of Juvenile Offenders* (New York: Grune and Stratton, 1970).

4. Marvin E. Wolfgang, Robert Figlio. Thorsten Sellin, *Delinquency in a Birth Cohort* (Chicago: University of Chicago Press, 1972).

5. There are many studies of hidden delinquency. See *ibid.*, pp. 15–16, n. 32 and 34.

6. S. Oba, *Unverbesserliche Verbrecher und ihre Behandlung* (Berlin, 1908).

7. N. B. Ryder, "The Influence of Declining Mortality on Swedish Reproductivity," in *Current Research in Human Fertility* (New York: Milbank Memorial Fund, 1955), pp. 65–81.

8. Thorsten Sellin and Marvin E. Wolfgang, *The Measurement of Delinquency* (New York: John Wiley and Sons, 1964). This study was based on the work of S. S. Stevens of Harvard University, who is the modern developer of psychophysical scaling.

9. For the many replications of this study, see Thorsten Sellin and Marvin E. Wolfgang, *Delinquency: Selected Studies* (New York, John Wiley and Sons, 1969), pp. 8–9, n. 3.

10. The Center has produced a special study on the history of drug offense among our cohort members for the National Commission on Marihuana and Drug Abuse: Joseph Jacoby, Neil Weiner, Terence Thornberry, Marvin E. Wolfgang, "Drug Use and Criminality in a Birth Cohort" (1973).

11. See Fig. 8–2. From this earlier analysis in Phase 1 of the cohort study we have calculated and extrapolated as follows:

0.127 = Probability of Index offenses, ages 7–17.
0.3511 = Probability of any record, ages 7–17.
0.1520 = Probability of Index offenses, ages 18–30.
$\therefore 0.4202$ = Probability of any record, ages 18–30.

9: Incapacitation / *James Q. Wilson* / *Barbara Boland**

Two separate lines of inquiry—one using police reports of crime aggregated by states and the other using victim reports of crime aggregated by cities—suggest that differing levels of activity of the criminal justice system will, even holding economic "need" and criminal opportunities constant, produce different rates of crime. Just what this "criminal justice activity" may be and how it affects crime rates, however, is not clear. Deterrence theory rests on the assumption that would-be offenders observe and act on differences in the risk of apprehensions or imprisonment. Available data are consistent with the hypothesis that they do act on these perceived differences, but unless a controlled experiment is conducted it is possible that

differences we attribute to deterrence effects are in fact a result of incapacitation. A deterrent effect may be operating, but whether the deterrence is the result of arrest rates, conviction rates, imprisonment rates, length of prison term, or some combination of all of these is uncertain, and therefore deterrence research to date offers one little guidance about the point in the system in which one ought to invest the greatest resources. (It is also possible that the association between the criminal justice system and crime that we observe represents neither deterrence nor incapacitation but is the result of variables we have not considered or to some systematic measurement error. We think this unlikely, but it cannot be ruled out.)

Some but not all of these problems are avoided by examining the effect on crime of incapacitating (by jail or prison) the convicted offender. The effects of incapacitation require one to make no assumptions about the perceptions of offenders. A person confined in an institution cannot victimize persons outside that institution. A large proportion of the persons arrested on felony charges are not so confined.

The percentage of those convicted on felony charges who are sent to some kind of institution (jail, work camp, prison) seems to vary considerably among jurisdictions and over time. In California in 1970, of those convicted of robbery, 32 percent went to prison (meaning they received a sentence of one year or more in confinement), 8 percent went to jail (and thus were confined for periods less than one year), and 29 percent were given a sentence combining jail and probation. The remainder were fined, placed on probation, sent to the Youth Authority as minors (what disposition the YA made is unknown), or were civilly committed because of drug abuse. Within the state, however, there was considerable variation in sentencing. Only 24 percent of those convicted of robbery in Los Angeles were sentenced to prison (what proportion went to jail is unknown). Only 37 percent of those convicted of robbery with a prior prison record were sentenced to prison.[1] This last figure means that 63 percent of those convicted of robbery, who had a prior prison record, were either not confined or confined for a period of less than a year.

In Washington, D.C., by contrast, the court in 1971 found 420 persons guilty of robbery; 84 percent were imprisoned, almost all for periods in excess of one year.[2]

Further complicating this matter is the fact that the time actually served in prison is typically much less than the time to which persons are sentenced. For example, persons convicted of robbery who were released from federal prisons in 1970 had served, on the average, only 41 percent of the sentence imposed by the judge. Though the typical sentences imposed by federal judges have been increasing in severity for the last decade or so, the percent of the sentence actually served has been declining just as rapidly, so that over this period the average time served in prison has remained about the same.[3] Data from state court systems suggest that the probability of going to prison has been declining there also while average

time served has been roughly constant. Overall, the prison population of the United States dropped during the 1960s despite a sharp upsurge in the amount of crime being committed.

During the decade of the 1960s, there was a decrease nationally in both the proportion of all reported crimes that resulted in arrests and in the proportion of all arrests that resulted in imprisonment. In 1960, there were twenty-four arrests for every 100 Index crimes; in 1970, there were only sixteen arrests for every 100 Index crimes. In 1960, twenty-four persons went to state prisons for every 100 arrests for Index crimes; in 1970, only thirteen persons went to prison for every 100 Index arrests. This means that the combined probability of imprisonment for every 100 Index crimes dropped from six per hundred to two per hundred.

Some persons arrested for an Index crime might be sent to a local jail rather than to a state prison. If the proportion sent to jail rather than prison rose substantially during the 1960s, the rates in the preceding paragraph might be misleading. Jail populations did increase in the 1960s, but by less (9,510) than the prison population decrease (16,230). Furthermore, only 21 percent of the jail population at any given moment is serving a sentence for something more serious than drunkenness, traffic offenses, or nonsupport. Adding this 21 percent to the figures on imprisonment given earlier does not materially change the results: for every 100 Index arrests, thirty-five persons went to jail or prison in 1960 but only nineteen in 1970, a 47 percent decline.

Clearly, a much larger proportion of convicted persons could be sent to prison, if facilities were available, than is now the case. There are, of course, many forms of confinement short of prison—local jails, work camps, and so forth. Whatever the form or amenity of the incapacitation, the key problem is to estimate the crime reduction potential of sentencing a larger proportion of convicted persons to some institution (instead of granting them probation or suspended sentences or re-fining them) and then to estimate the costs per crime prevented by that strategy.

To carry out this analysis, one must have data on the following variables:

1. The size of the criminal population.

2. The number of crimes committed by any given criminal per year (more accurately, we want to know the frequency distribution of all crimes of a given type over the criminal population).

3. The probability that a given criminal is arrested.

4. The probability that a given arrested person is convicted.

5. The probability that a given convicted person is sentenced to prison.

6. The length of the average sentence.

Thus far, our ability to construct mathematical models of the crime reduction effects of incapacitation is substantially greater than our ability to obtain reliable estimates of the key variables. Some, such as the probability of arrest, conviction, and sentencing are known approximately and, happily, do not fluctuate much from year to year. The length of the average

sentence is in principle discoverable but, maddeningly, almost no jurisdiction in the country actually compiles these data. We skirt the problem somewhat by calculating the *marginal* crime reduction achieved by additional increments of time in prison. The size of the "criminal" population, or even the population of robbers, is unknown and perhaps unknowable. In our first use of the model, we simply assume that this population, whatever its size, is constant—i.e., that a new robber does not immediately appear to replace a robber sent to prison.

But the crucial variable is the average number of crimes per criminal per year (defined in the model as *lambda*): crucial because the results are highly sensitive to this value and because we know of no accurate way to measure it. It clearly will make an enormous difference in the robbery rate whether the imprisoned robber has committed many or few robberies. For example, a city may experience 1,000 robberies either because 1,000 persons commit one robbery each, or because ten persons commit 100 robberies each, or some combination in between. In the former case, locking up for one year one robber would spare the city only one robbery per year; in the latter case, locking up one robber would spare it 100 robberies each year. We cope with the problem of estimating *lambda* by giving estimates of the crime reduction potential of incapacitation for various assumed values of *lambda*.

The first effort with which we are familiar to develop a model such as this was that by Reuel and Shlomo Shinnar of The City College of New York.[4] Their effort was criticized by Alfred Blumstein and Jacqueline Cohen of Carnegie-Mellon University in 1975 (private communication). They pointed out some errors in calculations and noted the failure of the Shinnars to provide a rationale for the empirical values they employed. Most important, the Shinnars assumed that *lambda* was constant for the entire criminal population (surely not the case) and did not support their estimate that it had a value of ten. Another preliminary effort at measuring the results of incapacitation was carried out independently of the Shinnar work by Jeffrey Marsh and Max Singer of the Hudson Institute in 1972, though their paper does not show the mathematical properties of their model.

The version we use is a refinement of the Shinnar model developed by Ann Young of Harvard. The principal results are given in Tables 9-1 and 9-2. In Table 9-1 is shown the percentage reduction in the crime rate that would occur if everyone arrested and convicted of a crime were given sentences ranging in length from 0.2 years (about two-and-one-half months) to 5.0 years, under varying assumptions as to the average number of crimes committed per criminal and the probability of being caught and convicted. These percentages reflect the *total* reduction in crime from what would occur if *no* convicted offender were confined at all. For example, if the average criminal commits ten crimes per year and has a 10 percent chance of being caught and convicted, then sentencing all such convicted criminals

TABLE 9-1

Percent Reduction in Expected Crime Rate Produced by Prison Sentences Under Varying Conditions of Criminal Career and Probability of Conviction

Crimes per Offender	Prob. of Conviction	Length of Total Sentence (years)					
		0.2	0.5	1.0	2.0	3.0	5.0
5	.05	4.8%	11.1%	20.0%	33.3%	42.9%	55.6%
	.10	9.1	20.0	33.3	50.0	60.0	71.4
	.20	16.7	33.3	50.0	66.7	75.0	83.3
10	.05	9.1	20.0	33.3	50.0	60.0	71.4
	.10	16.7	33.3	50.0	66.7	75.0	83.3
	.20	28.6	50.0	66.7	80.0	85.7	90.9
20	.05	16.7	33.3	50.0	66.7	75.0	83.3
	.10	28.6	50.0	66.7	80.0	85.7	90.9
	.20	44.4	66.7	80.0	88.9	92.3	95.2
50	.05	33.3	55.6	71.4	83.3	88.2	92.6
	.10	50.0	71.4	83.3	90.9	93.7	96.2
	.20	66.7	83.3	90.9	95.2	96.8	98.0

(Assumes criminal population is of constant size and that all caught and convicted offenders receive same sentence.)

TABLE 9-2

Incremental Reduction in Expected Crime Rate from Increase in Initial Sentences, Assuming the Product of Criminal Careers and Probability of Conviction = 1

Initial Sentence (years)	Increased Sentence Length (years)					
	0.1	0.3	0.5	1.0	2.0	3.0
None	9.1%	23.1%	33.3%	50.0%	66.7%	75.0%
0.1	8.3	21.4	31.3	47.6	64.5	73.2
0.5	6.3	16.7	25.0	40.0	57.1	66.7
1.0	4.8	13.0	20.0	33.3	50.0	60.0
2.0	3.2	9.1	14.3	25.0	40.0	50.0
5.0	1.6	4.8	7.7	14.3	25.0	33.4

(Assumes criminal population is of constant size and that all caught and convicted are given same sentence.)

to one year in prison would lower the crime rate by 50 percent below what it would be if no one went to prison.

Obviously, some criminals are given prison sentences; what we wish to know, therefore, is what marginal reduction in crime would result from increasing the length of the sentence by varying amounts and applying that sentence to all persons convicted of the crime. The reductions given in Table 9-2 are for any state of affairs in which the product of *lambda* and the probability of being caught and convicted (qJ) equals one. For example, the values in the table are correct if the average criminal commits ten crimes per year and has a 10 percent chance of being caught and convicted; they are equally correct if he commits only five offenses a year but has a 20 percent chance of being caught. The marginal reductions in crime are substantial (25 percent or more) when the incremental sentence is six months or more over an initial sentence of six months or less or one year or more over an initial sentence of two years or less.

The cost of a policy of mandatory minimum sentences is an important consideration in evaluating that policy. If we are to double the proportion of convicted persons sentenced to prison, we must double our use of prison space; if we fill the prisons with persons serving one year and then wish them all to serve three years, we must triple the prison space. (We use the term "prison" as shorthand for all forms of separating offenders from potential victims—by jails, work camps, farms, prisons, community institutions that confine persons at night and on weekends but allow them to work during the day, and so forth.) The capital cost per inmate of such facilitates will vary enormously, from minimum security camps to maximum security prisons; operating costs will vary less, because all are labor intensive.

Figures from the U.S. Bureau of Prisons on capital and operating costs per inmate of their facilities—which are generally superior in amenity and design to many state facilites—are shown in Table 9-3.

We do not attempt a cost-benefit analysis of increased facilities because the hard-to-measure psychic and communal costs of crime are perhaps the most important of all the costs; inevitably their calculations will be made, implicitly if not explicitly, by the political process.

It is worth noting, however, that the United States has not been willing, during the last decade or so, to increase its use of prisons despite the enormous increase in crime. There were 212,957 prisoners at the end of 1960 but only 196,429 at the end of 1970, a decline from 118.6 per 100,000 population in 1960 to 96.7 per 100,000 in 1970.[5] The number of persons entering prison fell from 88,575 in 1960 to 79,351 in 1970. The decline in the use of prisons was especially marked in some states. New York, for example, experienced a decline in its year-end prison population from 17,207 in 1960 to 12,059 in 1970.[6]

There are no doubt a number of reasons why the use of prisons has been declining: Judges, believing that prisons ought to rehabilitate and noting (correctly) that they do not, may put offenders back on the street lest they

TABLE 9-3
Federal Prison System Per Capita
Operating and Capital Costs

Fiscal Year	Per Capita Operating Costs	Per Capita Capital Costs*	Per Capita Total Costs
1969	3220	47	3627
1970	3676	164	3840
1971	4200	135	4335
1972	4790	142	4932
1973	5302	143	5445
1974	6007 est.	137 est.	6144 est.
1975	7118 est.	137 est.	7255 est.

Source: The Budget of the United States Government, Appendix, U.S. Government Printing Office, appropriate years.

*It may be argued that these per capita capital costs understate the "true" cost of providing "adequate" facilities since many of the prisons within the federal system are quite old and have been fully depreciated for a number of years. Therefore, an alternative estimate of capital costs has been derived using cost figures for the recently constructed federal correctional facility in Pleasanton, California. This facility was designed to house 250 young adults between the ages of eighteen and twenty-five under conditions of low security; its initial cost was $6.6 million. Employing National Bureau of Prisons accounting rules, straight line depreciation over an average life of fifty years, yields an estimate of annual per capita capital costs of $528.

be corrupted by prison. Or judges may erroneously believe that prison cannot reduce the crime rate either by deterrence or incapacitation. We hope that judges who read our findings will reconsider these views. There is one reason for the reluctance to use prison with which we must deal, however, and that is the crowding effect that the rise in crime may produce on court and prosecutorial schedules. If the number of persons appearing in court has been rising faster than the time and resources available for disposing of them, then judges and prosecutors will either have to work harder and longer or induce accused persons to consume less time and fewer resources. About all that judges and prosecutors can offer the accused to induce him to consume less is the prospect of a lighter sentence. If true, this relationship has the ironic consequence of increasing the incentives to the criminal justice system for keeping people out of prison at the very time when crime rates are rising and the crime-reduction potential of prison is most needed.

One important rejoinder to this line of argument is that, to the extent prisons are "schools of crime" that increase the recidivism rate of those confined in them, increasing the proportion of convicted offenders sent to prison, or lengthening their terms, would produce ex-convicts who upon their release commit crimes at a greater rate than they would had they not

been imprisoned at all. This gain in recidivism, attributable to prison, might nullify most or all of the crime reduction achieved by deterrence and incapacitation.

The evidence on the "schools of crime" hypothesis is not all in. Such evidence as we have been able to find does not, however, strongly support it. Obviously prisons differ greatly in their inner life—some may have a reasonable level of amenity and privacy, others may so brutalize the convict as to embitter him. And prisoners differ as well: some may be so relieved to get out that nothing would induce them to do anything that would expose them to reimprisonment (and in fact, most ex-convicts are not reimprisoned during their first few years out of prison), while others might set about applying the criminal skills they learned while inside.

David Greenberg, in reviewing studies comparing recidivism rates of released prisoners and matched groups of probationers concluded that "there is no compelling evidence that imprisonment substantially increases (or decreases) the likelihood of subsequent criminal involvement." [7] This was the conclusion as well of studies by Wilkins, Hammond, Babst and Mannering, Shoham and Lamb and Goertzel. [8] One of the best known studies sent randomly selected youthful offenders in California to community probation programs and to regular juvenile institutions. There was, after two years, no significant difference in the recidivism rate of the two groups—suggesting both that the community-based probation system was no better at rehabilitating offenders and the juvenile institutions were no worse at inculcating criminal skills and desires.

Another objection to increasing the use of incapacitation is that our courts and correctional systems will be crushed under the increased work load, partly because more persons will be imprisoned and partly because a higher proportion of those charged will ask for time-consuming trials rather than pleading guilty. The policy we suggest does imply that more resources be devoted to courts and corrections, especially the latter. Only estimates of work loads based on alternative sentencing rules will suggest how great these resources must be, and since we propose no specific sentencing policy we make no estimates. It is hard for us to imagine, however, that the dollar cost would exceed what the federal government has already spent on criminal justice through the Law Enforcement Assistance Administration, with little or nothing to show for it. The objection based on cost is, we suspect, a disguised form of an objection based on principle: just as those who do not like programs for income redistribution, job creation, or more schooling object to their cost, so also do persons who do not like prisons object to their cost. We prefer that the issue of principle be faced and debated first in order that we be clear about the benefits, if any; then we should decide what we are willing to pay for these benefits. If citizens were asked to vote on programs that would reduce predatory crime by some significant fraction, we suspect they would approve any reasonable expenditure.

The court work load variant of this objection is more tantalizing. At one level, it suggests an objection to the idea of trials and not-guilty pleas—strange preferences coming from 'those who on other issues are strongly committed to the realization of constitutional guarantees. If more accused persons plead not guilty, that is their privilege in any event, we should not sacrifice community protection in order to lighten court work loads. Furthermore, if the chances of imprisonment are increased, there ought to be more trials in order to insure that the more certain prospect of punishment does not result in innocent persons going to jail. If all this costs more, then we should invest more resources up to the point at which additional resources purchase no more community safety or personal justice.

Studies we have seen suggest, however, that in many jurisdictions there is already a good deal of slack in the court system and that more cases could be heard, and for longer periods, without major new investments. Feeley found in his study of Connecticut criminal courts that the difference between busy and not-so-busy courts was not to be found in their sentences but in the fact that in busy courts, the judges work longer hours than in the not-so-busy ones.[9] Similarly, Gillespie's studies of circuit courts in Illinois and the federal court system suggest that, on average, excess capacity exists in both of these court systems.[10]

NOTES

1. Peter W. Greenwood et al., *Prosecution of Adult Felony Defendants in Los Angeles County* (Santa Monica, Calif.: Rand Institute, 1973), pp. 109–110.
2. Administrative Office of the U.S. Courts, *Federal Offenders in the United States District Courts, 1971* (Washington, D.C.: U.S. Government Printing Office, Oct., 1973), p. 77.
3. Michael J. Hindelang et al., eds., *Sourcebook of Criminal Justice Statistics, 1973* (Washington, D.C.: National Criminal Justice Information and Statistics Services, U.S. Department of Justice, 1974), pp. 416–418.
4. Reuel Shinnar and Shlomo Shinnar, "The Effects of the Criminal Justice System on the Control of Crime," *Law and Society Review* 9 (1975):581–612.
5. U.S. Department of Commerce, *Statistical Abstract of the United States, 1972* (Washington, D.C.: U.S. Government Printing Office, 1973), p. 160.
6. *Statistical Abstracts*, 1972, p. 161.
7. David F. Greenberg, "The Incapacitative Effects of Imprisonment: Some Estimates," *Law and Society Review* 9(1975):541–580, p. 572.
8. See Leslie T. Wilkins, "A Small Comparative Study of the Results of Probation," *British Journal of Delinquency* 8(1958):201ff.; W. H. Hammond, *The Sentence of the Court* (London: Her Majesty's Stationery Office, 1969); D. V. Babst and J. W. Mannering, "Probation versus Imprisonment for Similar Types of Offenders," *Journal of Research in Crime and Delinquency* 2(1965):53–61; Shlomo Shoham, *Crime and Social Deviance* (Chicago: Regnery, 1966); and H. R. Lamb and Victor Goertzel, "Ellsworth House: A Community Alternative," *American Journal of Psychiatry* 131(1974):64ff.
9. Malcolm M. Feeley, "The Importance of Heavy Caseloads," Yale Law School, January, 1975, mimeographed.
10. See Robert W. Gillespie, "Judicial Productivity and Court Delay: A Statistical Analysis of the Federal District Courts," typescript, submitted to National Institute of Law Enforcement and Criminal Justice, Law Enforcement Assistance Administration, U.S. Department of Justice, March 5, 1975, and "A Supply and Demand Analysis of the Judicial Services Provided by the Trial Courts of Illinois," Department of Economics, University of Illinois, September 15, 1973, mimeographed.

Part III

THE PRISON COMMUNITY

Part III

THE PRISON COMMUNITY

10: Inmate Social System / *Gresham M. Sykes / Sheldon L. Messinger**

The Prison Society

Despite the number and diversity of prison populations, observers of such groups have reported only one strikingly pervasive value system. This value system of prisoners commonly takes the form of an explicit code, in which brief normative imperatives are held forth as guides for the behavior of the inmate in his relations with fellow prisoners and custodians. The maxims are usually asserted with great vehemence by the inmate population, and violations call forth a diversity of sanctions ranging from ostracism to physical violence.

Examination of many descriptions of prison life suggests that the chief tenets of the inmate code can be classified roughly into five major groups:

1. There are those maxims that caution: *Don't interfere with inmate interests,* which center of course in serving the least possible time and enjoying the greatest possible number of pleasures and privileges while in prison. The most inflexible directive in this category is concerned with betrayal of a fellow captive to the institutional officials: *Never rat on a con.* In general, no qualification or mitigating circumstance is recognized; and no grievance against another inmate—even though it is justified in the eyes of the inmate population—is to be taken to officials for settlement. Other specifics include: *Don't be nosey; don't have a loose lip; keep off a man's back; don't put a guy on the spot.* In brief and positively put: *Be loyal to your class— the cons.* Prisoners must present a unified front against their guards no matter how much this may cost in terms of personal sacrifice.

2. There are explicit injunctions to refrain from quarrels or arguments with fellow prisoners: *Don't lose your head.* Emphasis is placed on the curtailment of effect; emotional frictions are to be minimized and the irritants of daily life ignored. Maxims often heard include: *Play it cool* and *do your own time.* As we shall see, there are important distinctions in this category, depending on whether the prisoner has been subjected to legitimate provocation; but in general a definite value is placed on curbing feuds and grudges.

3. Prisoners assert that inmates should not take advantage of one another by means of force, fraud, or chicanery: *Don't exploit inmates.* This

* From Richard Clower, et al., *Theoretical Studies in the Social Organization of the Prison,* Pamphlet 15 (New York: Social Science Research Council, 1960), pp. 5–11, 14–19.

sums up several directives: *Don't break your word; don't steal from the cons; don't sell favors; don't be a racketeer; don't welsh on debts*. More positively, it is argued that inmates should share scarce goods in a balanced reciprocity of "gifts" or "favors," rather than sell to the highest bidder or selfishly monopolize any amenities: *Be right*.

4. There are rules that have as their central theme the maintenance of self: *Don't weaken*. Dignity and the ability to withstand frustration or threatening situations without complaining or resorting to subservience are widely acclaimed. The prisoner should be able to "take it" and to maintain his integrity in the face of privation. When confronted with wrongfully aggressive behavior, whether of inmates or officials, the prisoner should show courage. Although starting a fight runs counter to the inmate code, retreating from a fight started by someone else is equally reprehensible. Some of these maxims are: *Don't whine; don't cop out* (cry guilty); *don't suck around*. Prescriptively put: *Be tough; be a man*.

5. Prisoners express a variety of maxims that forbid according prestige or respect to the custodians or the world for which they stand: *Don't be a sucker*. Guards are *hacks* or *screws* and are to be treated with constant suspicion and distrust. In any situation of conflict between officials and prisoners, the former are automatically to be considered in the wrong. Furthermore, inmates should not allow themselves to become committed to the values of hard work and submission to duly constituted authority— values prescribed (if not followed) by *screws*—for thus an inmate would become a *sucker* in a world where the law-abiding are usually hypocrites and the true path to success lies in forming a "connection." The positive maxim is: *Be sharp*.

In the literature on the mores of imprisoned criminals there is no claim that these values are asserted with equal intensity by every member of a prison population; all social systems exhibit disagreements and differing emphases with respect to the values publicly professed by their members. But observers of the prison are largely agreed that the inmate code is outstanding both for the passion with which it is propounded and the almost universal allegiance verbally accorded it.

In the light of this inmate code or system of inmate norms, we can begin to understand the patterns of inmate behavior so frequently reported; for conformity to, or deviation from, the inmate code is the major basis for classifying and describing the social relations of prisoners. As Strong has pointed out, social groups are apt to characterize individuals in terms of crucial "axes of life" (lines of interests, problems, and concerns faced by the groups) and then to attach distinctive names to the resulting roles or types.[1] This process may be discerned in the society of prisoners and its argot for the patterns of behavior or social roles exhibited by inmates; and in these roles the outlines of the prison community as a system of action [2] may be seen.

An inmate who violates the norm proscribing the betrayal of a fellow

prisoner is labeled a *rat* or a *squealer* in the vocabulary of the inmate world, and his deviance elicits universal scorn and hatred.[3] Prisoners who exhibit highly aggressive behavior, who quarrel easily and fight without cause, are often referred to as *toughs*. The individual who uses violence deliberately as a means to gain his ends is called a *gorilla;* a prisoner so designated is one who has established a satrapy based on coercion in clear contravention of the rule against exploitation by force. The term *merchant,* or *peddler,* is applied to the inmate who exploits his fellow captives not by force but by manipulation and trickery, and who typically sells or trades goods that are in short supply. If a prisoner shows himself unable to withstand the general rigors of existence in the custodial institution, he may be referred to as a *weakling* or a *weak sister*. If, more specifically, an inmate is unable to endure prolonged deprivation of heterosexual relationships and consequently enters into a homosexual liaison, he will be labeled a *wolf* or a *fag*, depending on whether his role is an active or a passive one.[4] If he continues to plead his case, he may soon be sarcastically known as a *rapo* (from "bum rap") or *innocent*. And if an inmate makes the mistake of allying himself with officialdom by taking on and expressing the values of conformity, he may be called a *square John* and ridiculed accordingly.

However, the individual who has received perhaps the greatest attention in the literature is the one who most nearly fulfills the norms of the society of prisoners, who celebrates the inmate code rather than violates it: the *right guy*, the *real con*, the *real man*—the argot varies, but the role is clear-cut. The *right guy* is the hero of the inmate social system, and his existence gives meaning to the villains, the deviants such as the *rat*, the *tough*, the *gorilla*, and the *merchant*. The *right guy* is the base line, however idealized or infrequent in reality, from which the inmate population takes its bearings. It seems worthwhile, therefore, to sketch his portrait briefly in the language of the inmates.

A *right guy* is always loyal to his fellow prisoners. He never lets you down no matter how rough things get. He keeps his promises; he's dependable and trustworthy. He isn't nosey about your business and doesn't shoot off his mouth about his own. He doesn't act stuck-up, but he doesn't fall all over himself to make friends either—he has a certain dignity. The *right guy* never interferes with other inmates who are conniving against the officials. He doesn't go around looking for a fight, but he never runs away from one when he is in the right. Anybody who starts a fight with a *right guy* has to be ready to go all the way. What he's got or can get of the extras in the prison—like cigarettes, food stolen from the mess hall, and so on—he shares with his friends. He doesn't take advantage of those who don't have much. He doesn't strong-arm other inmates into punking or fagging for him; instead, he acts like a man.

In his dealings with the prison officials, the *right guy* is unmistakably against them, but he doesn't act foolishly. When he talks about the officials with other inmates, he's sure to say that even the hacks with the best

intentions are stupid, incompetent, and not to be trusted; that the worst thing a con can do is give the hacks information—they'll only use it against you when the chips are down. A *right guy* sticks up for his rights, but he doesn't ask for pity: he can take all the lousy screws can hand out and more. He doesn't suck around the officials, and the privileges that he's got are his because he deserves them. Even if the *right guy* doesn't look for trouble with the officials, he'll go to the limit if they push him too far. He realizes that there are just two kinds of people in the world, those in the know and the suckers or squares. Those who are in the know skim it off the top; suckers work.[5]

In summary then, from the studies describing the life of men in prison, two major facts emerge: (1) Inmates give strong verbal support to a system of values that has group cohesion or inmate solidarity as its basic theme. Directly or indirectly, prisoners uphold the ideal of a system of social interaction in which individuals are bound together by ties of mutual aid, loyalty, affection, and respect, and are united firmly in their opposition to the enemy out-group. The man who exemplifies this ideal is accorded high prestige. The opposite of a cohesive inmate social system—a state in which each individual seeks his own advantage without reference to the claims of solidarity—is vociferously condemned. (2) The actual behavior of prisoners ranges from full adherence to the norms of the inmate world to deviance of various types. These behavioral patterns, recognized and labeled by prisoners in the pungent argot of the dispossessed, form a collection of social roles which, with their interrelationships, constitute the inmate social system. We turn now to explanation of the inmate social system and its underlying structure of sentiments.

The isolation of the prisoner from the free community means that he has been rejected by society. His rejection is underscored in some prisons by his shaven head; in almost all, by his uniform and the degradation of no longer having a name but a number. The prisoner is confronted daily with the fact that he has been stripped of his membership in society at large, and now stands condemned as an outcast, an outlaw, a deviant so dangerous that he must be kept behind closely guarded walls and watched both day and night. He has lost the privilege of being *trusted* and his every act is viewed with suspicion by the guards, the surrogates of the conforming social order. Constantly aware of lawful society's disapproval, his picture of himself challenged by frequent reminders of his moral unworthiness, the inmate must find some way to ward off these attacks and avoid their introjection.

In addition, it should be remembered that the offender has been drawn from a society in which personal possessions and material achievement are closely linked with concepts of personal worth by numerous cultural definitions. In the prison, however, the inmate finds himself reduced to a level of living near bare subsistence, and whatever physical discomforts this depri-

vation may entail, it apparently has deeper psychological significance as a basic attack on the prisoner's conception of his own personal adequacy.

No less important, perhaps, is the ego threat that is created by the deprivation of heterosexual relationships. In the tense atmosphere of the prison, with its perversions and constant references to the problems of sexual frustration, even those inmates who do not engage in overt homosexuality suffer acute attacks of anxiety about their own masculinity. These anxieties may arise from a prisoner's unconscious fear of latent homosexual tendencies in himself, which might be activated by his prolonged heterosexual deprivation and the importunity of others; or at a more conscious level he may feel that his masculinity is threatened because he can see himself as a man—in the full sense—only in a world that also contains women. In either case the inmate is confronted with the fact that the celibacy imposed on him by society means more than simple physiological frustration: an essential component of his self-conception, his status as male, is called into question.

Rejected, impoverished, and figuratively castrated, the prisoner must face still further indignity in the extensive social control exercised by the custodians. The many details of the inmate's life, ranging from the hours of sleeping to the route to work and the job itself, are subject to a vast number of regulations made by prison officials. The inmate is stripped of his autonomy; hence, to the other pains of imprisonment we must add the pressure to define himself as weak, helpless, and dependent. Individuals under guard are exposed to the bitter ego threat of losing their identification with the normal adult role.[6]

The remaining significant feature of the inmate's social environment is the presence of other imprisoned criminals. Murderers, rapists, thieves, confidence men, and sexual deviants are the inmate's constant companions, and this enforced intimacy may prove to be disquieting even for the hardened recidivist. As an inmate has said, "The worst thing about prison is you have to live with other prisoners." [7] Crowded into a small area with men who have long records of physical assaults, thievery, and so on (and who may be expected to continue in the path of deviant social behavior in the future), the inmate is deprived of the sense of security that we more or less take for granted in the free community. Although the anxieties created by such a situation do not necessarily involve an attack on the individual's sense of personal worth—as we are using the concept—the problems of self-protection in a society composed exclusively of criminals constitute one of the inadvertent rigors of confinement.

In short, imprisonment "punishes" the offender in a variety of ways extending far beyond the simple fact of incarceration. However just or necessary such punishments may be, their importance for our present analysis lies in the fact that they form a set of harsh social conditions to which the population of prisoners must respond or *adapt itself*. The inmate feels

that the deprivations and frustrations of prison life, with their implications for the destruction of his self-esteem, somehow must be alleviated. It is, we suggest, as an answer to this need that the functional significance of the inmate code or system of values exhibited so frequently by men in prison can best be understood.

As we have pointed out, the dominant theme of the inmate code is group cohesion, with a "war of all against all"—in which each man seeks his own gain without considering the rights or claims of others—as the theoretical antipode. But if a war of all against all is likely to make life "solitary, poor, nasty, brutish, and short" for men with freedom, as Hobbes suggested, it is doubly so for men in custody. Even those who are most successful in exploiting their fellow prisoners will find it a dangerous and nerve-racking game, for they cannot escape the company of their victims. No man can assure the safety of either his person or his possessions, and eventually the winner is certain to lose to a more powerful or more skillful exploiter. Furthermore, the victims hold the trump card, since a word to the officials is frequently all that is required to ruin the most dominating figure in the inmate population. A large share of the "extra" goods that enter the inmate social system must do so as the result of illicit conniving against the officials, which often requires lengthy and extensive cooperation and trust; in a state of complete conflict the resources of the system will be diminished. Mutual abhorrence or indifference will feed the emotional frictions arising from interaction under compression. And as rejection by others is a fundamental problem, a state of mutual alienation is worse than useless as a solution to the threats created by the inmate's status as an outcast.

As a population of prisoners moves toward a state of mutual antagonism, then, the many problems of prison life become more acute. On the other hand, *as a population of prisoners moves in the direction of solidarity, as demanded by the inmate code, the pains of imprisonment become less severe.* They cannot be eliminated, it is true, but their consequences at least can be partially neutralized. A cohesive inmate society provides the prisoner with a meaningful social group with which he can identify himself and which will support him in his struggles against his condemners. Thus it permits him to escape at least in part the fearful isolation of the convicted offender. Inmate solidarity, in the form of toleration of the many irritants of life in confinement, helps to solve the problems of personal security posed by the involuntary intimacy of men noteworthy for their seriously antisocial behavior in the past.

Similarly, group cohesion in the form of a reciprocity of favors undermines one of the most potent sources of aggression among prisoners, the drive for personal aggrandizement through exploitation by force and fraud. Furthermore, although goods in scarce supply will remain scarce even if they are shared rather than monopolized, such goods will be distributed more equitably in a social system marked by solidarity, and this may be of profound significance in enabling the prisoner to endure better the psycho-

logical burden of impoverishment. A cohesive population of prisoners has another advantage in that it supports a system of shared beliefs that explicitly deny the traditional link between merit and achievement. Material success, according to this system, is a matter of "connections" rather than skill or hard work, and thus the imprisoned criminal is partially freed from the necessity of defining his material want as a sign of personal inadequacy.

Finally, a cohesive inmate social system institutionalizes the value of "dignity" and the ability to "take it" in a number of norms and reinforces these norms with informal social controls. In effect, the prisoner is called on to endure manfully what he cannot avoid. At first glance this might seem to be simply the counsel of despair; but if the elevation of fortitude into a primary virtue is the last refuge of the powerless, it also serves to shift the criteria of the individual's worth from conditions that cannot be altered to his ability to maintain some degree of personal integration; and the latter, at least, can be partially controlled. By creating an ideal of endurance in the face of harsh social conditions, then, the society of prisoners opens a path to the restoration of self-respect and a sense of independence that can exist despite prior criminality, present subjugation, and the free community's denial of the offender's moral worthiness. Significantly, this path to virtue is recognized by the prison officials as well as the prisoners.

One further point should be noted with regard to the emphasis placed on the maintenance of self as defined by the value system of prisoners. Dignity, composure, courage, the ability to "take it" and "hand it out" when necessary—these are the traits affirmed by the inmate code. They are also traits that are commonly defined as masculine by the inmate population. As a consequence, the prisoner finds himself in a situation where he can recapture his male role, not in terms of its sexual aspects, but in terms of behavior that is accepted as a good indicator of virility.

The effectiveness of the inmate code in mitigating the pains of imprisonment depends of course on the extent to which precepts are translated into action. As we have indicated, the demands of the inmate code for loyalty, generosity, disparagement of officials, and so on are most fully exemplified in the behavior of the *right guy*. On the other hand, much noncohesive behavior occurs on the part of the *rat*, the *tough*, the *gorilla*, the *merchant*, and the *weak sister*. The population of prisoners, then, does not exhibit perfect solidarity in practice, in spite of inmates' vehement assertions of group cohesion as a value; but neither is the population of prisoners a warring aggregate. Rather, the inmate social system typically appears to be balanced in an uneasy compromise somewhere between these two extremes. The problems confronting prisoners in the form of social rejection, material deprivation, sexual frustration, and the loss of autonomy and personal security are not completely eliminated. Indeed, even if the norms of the inmate social system were fully carried out by all, the pains of imprisonment would only be lessened; they would not disappear. But the

pains of imprisonment are at least relieved by whatever degree of group cohesion is achieved in fact, and this is crucial in understanding the functional significance of the inmate code for inmates.

One further problem remains. Many of the prisoners who deviate from the maxims of the inmate code are precisely those who are most vociferous in their verbal allegiance to it. How can this discrepancy between words and behavior be explained? Much of the answer seems to lie in the fact that almost all inmates have an interest in maintaining cohesive behavior on the part of others, *regardless of the role they play themselves,* and vehement vocal support of the inmate code is a potent means to this end.

There are, of course, prisoners who "believe" in inmate cohesion both for themselves and others. These hold the unity of the group as a high personal value and are ready to demand cohesive behavior from their fellow prisoners. This collectivistic orientation may be due to a thorough identification with the criminal world in opposition to the forces of lawful society, or to a system of values that transcends such divisions. In any case, for these men the inmate code has much of the quality of a religious faith and they approach its tenets as true believers. In a second category are those prisoners who are relatively indifferent to the cohesion of the inmate population as a personal value, but who are quick to assert it as a guide to behavior because in its absence they would be likely to become chronic victims. They are committed to the ideal of inmate solidarity to the extent that they have little or no desire to take advantage of their fellow captives, but they do not go so far as to subscribe to the ideal of self-sacrifice. Their behavior is best described as passive or neutral, they are believers without passion, demanding adherence from others, but not prepared to let excessive piety interfere with more mundane considerations. Third, there are those who loudly acclaim the inmate code and actively violate its injunctions. These men suffer if their number increases, since they begin to face the difficulties of competition; and they are in particular danger if their depredations are reported to the officials. The prisoners who are thus actively alienated from other inmates and yet give lip service to inmate solidarity resemble a manipulative priesthood, savage in their expression of belief but corrupt in practice. In brief, a variety of motivational patterns underlies allegiance to the inmate code, but few inmates can avoid the need to insist publicly on its observance, whatever the discrepancies in their actions.

NOTES

1. Samuel M. Strong, "Social Types in a Minority Group," *American Journal of Sociology* 48 (March 1943):563–573. Clarence C. Schrag in "Social Types in a Prison Community," (unpublished Master's thesis, University of Washington, 1944) notes the relevance of Strong's discussion for examination of the inmate social system.

2. See Schrag, "Social Types," and Gresham Sykes, "Men, Merchants, and Toughs: A Study of Reactions to Imprisonment," *Social Problems* 4 (1956):130–138, for discussion of this approach to the prison as a system of action.

3. The argot applied to a particular role varies somewhat from one prison to another, but it is not difficult to find the synonyms in the prisoners' lexicon.

4. The inmate population, with a keen sense of distinctions, draws a line between the *fag*, who plays a passive role in a homosexual relationship because he "likes" it or "wants" to, and a *punk*, who is coerced or bribed into a passive role.

5. We have not attempted to discuss all the prison roles that have been identified in the literature, although we have mentioned most of the major types. Two exceptions, not discussed because they are not distinctive of the prison, are the *fish*, a novitiate, and the *ding*, an erratic behaver. The homosexual world of the prison, especially, deserves fuller treatment; various role types within it have not yet been described.

6. Bruno Bettelheim, "Individual and Mass Behavior in Extreme Situations," *Journal of Abnormal and Social Psychology* 38 (October 1943):417–452.

7. Gresham M. Sykes, *Crime and Society* (New York: Random House, 1956), p. 109.

11: Socialization in Correctional Institutions /

*Stanton Wheeler**

One of the most obvious but important features of socialization processes is that they take place within a broader social context. The structure of that social context may be expected to have an important effect upon the nature of the socialization process itself. A potential contribution of sociologists to the study of socialization processes, therefore, may be made through the analysis of the settings within which socialization takes place.

Increasingly in modern societies, those settings are large-scale formal organizations. Just as industrialization has brought on the development of massive industrial and business organizations, so has it led to the development of organizations for the processing of people: the school, the university, the mental hospital and prison, as well as a variety of related organizations (Brim and Wheeler, 1966). And increasingly, such organizations are thought of not merely as places to train or contain people, but as sources of fundamental change in their attitudes, beliefs, and conceptions of themselves and their place in society. The prison is one such setting. It differs from more traditional socializing organizations in many ways. But like the school or university, socialization processes do indeed go on there, whether they follow the patterns intended by the prison staff or not.

* From Stanton Wheeler in David A. Goslin, ed., *Handbook of Socialization Theory and Research* © 1969 by Rand McNally College Publishing Co., Chicago, pp. 1005–23. Reprinted by permission.

It is my purpose in this chapter to examine socialization processes within the prison, with emphasis on the social organization and culture of the prison as it has an impact on socialization, and particularly on the relationship between what an inmate experiences within the prison, and his attachments to the outside world. Although these problems could be discussed in the standard fashion of a review article, I find it easier to get into them through the tracing of the changes that have occurred in my own thinking about socialization processes in the prison over the course of some ten or twelve years during which I have been reading and reflecting on the work of others in this area, and conducting research projects of my own. Over the course of that period of time, I have been forced to modify my own thoughts on the process in response to new data and observations from studies my colleagues and I have conducted, and in response to the ideas generated and developed by others in our field. Very largely, these changes have required moving beyond the immediate experiences to which inmates are exposed in the prison, to the nature of its culture and social organization, and finally to its connection with the external world.

Socialization in a State Reformatory

Until the decade of the 1950s the most serious effort to understand the process of socialization in prison was that of Donald Clemmer (1958). Clemmer was a sociologist with many years of experience behind the walls of prisons and he produced the first book-length study of a prison as a community. Clemmer described the culture and social organization of the prison, and noted that most of the characteristics he found suggested a system distinctly harmful to anything that might be regarded as a process of rehabilitation: The norms and codes of the inmate world appear to be organized in opposition to those of conventional society. He then turned his attention to the process by which inmates become a part of that world. He used the concept of "prisonization" as a summarizing concept revealing the consequences of exposure to inmate society. He defined prisonization as "the taking on, in greater or lesser degree, of the folkways, mores, customs and general culture of the penitentiary." And while he felt that no inmate could remain completely "unprisonized," he devoted a good deal of attention to variables that he thought probably influenced both the speed and the degree of prisonization. Some of these variables reflected the inmates' participation in conventional society. Thus prisonization would be lowest, he felt, for inmates who had positive relationships during prepenal life and for those who continued their positive relationships with persons outside the walls during the time they were in prison. But the feature that he thought was most important in determining the degree of prisonization was simply the degree of close interpersonal contact that inmates had with

other inmates within the institution. Those who became affiliated with in-
mate primary groups and those whose work and cell assignments placed
them in very close contact with other inmates were likely to show the
greatest degree of prisonization.

It was possible to put these ideas to a fairly direct empirical test in a
survey research study of Washington State Reformatory (Wheeler, 1961b).
An attitude measure of attitudinal conformity versus nonconformity to the
values of the staff (and presumably, those of the conventional world) was
developed to serve as an empirical indicator reflecting Clemmer's concept
of prisonization. And although the study utilized a cross-sectional design
rather than a panel design in which we could actually trace changes in
attitudes over time, we could at least approximate the temporal aspect of
imprisonment by comparing inmates who had been in the institution for
varying lengths of time in order to test Clemmer's hypothesis that the
longer the duration of stay, the more likely one was to become prisonized.

The result of this analysis provided strong support for Clemmer's hy-
potheses. There was a general trend toward greater nonconformity to staff
values with increase in length of time in the prison. And the trend was
much stronger for those inmates who had made many friends in the institu-
tion than for those who were relatively isolated.

But one of the interesting features of Clemmer's account is that he had
little to say about what happens to inmates as they prepare to leave the
institutions. Many of his ideas about the socialization process in prison
were drawn from studies of assimilation of ethnic groups into American
life, and since by and large those groups were here to stay, the problem of
what happens to them as they prepare to return to a former way of life does
not arise. Perhaps for this reason, Clemmer's account has much to say
about the early stages of imprisonment and about the general effects of
being in prison, with no systematic attention devoted to the process of
leaving the prison, and particularly to the possibility that the impact of
prison culture is short-lived.

These concerns led us to consider the time measure in studies of prisoni-
zation in a manner different from that conceived by Clemmer. Very simply,
we divided inmates into three groups: those who had been in only a short
time, those who had only a short time remaining to serve, and those who
were near neither entry nor release. The general results of this analysis
suggested important modifications in Clemmer's original hypotheses. While
we found a larger percentage of inmates who were strongly opposed to
staff norms during the last stage of their confinement than during the first,
we also found a U-shaped distribution of high conformity responses over
the three time periods: there were fewer than half as many high conformity
respondents during the middle phase than during the early and later phases
of imprisonment. These findings suggest that while some inmates might
become increasingly alienated during the course of their stay, an even
larger number may exhibit the process of resocialization to the more con-

ventional values of the outside world. And there was further evidence in support of the latter pattern: The U-shaped pattern of conforming responses was found both for inmates who had developed many friends in the institution and for those who had not, though it was stronger for the former group. It was also found both for first offenders and for recidivists. The clear suggestion from the evidence, then, was that this may well be a systematic feature of response to imprisonment, and not simply a minor deviation from the prisonization theme.

It would be simple enough to add the idea of "anticipatory socialization" to that of prisonization in an effort to make sense of both patterns of data. Indeed, Robert K. Merton (1957) had already written about the process of anticipatory socialization, and in retrospect there was good reason to assume that such a process would operate, even though it had not been formally incorporated into Clemmer's scheme. But while this would have given us two descriptive labels for two different patterns of empirical results, it would not have moved us very far toward understanding the conditions under which one or the other pattern would be expected to occur. In attempting to move toward the latter aim we were forced to ask questions about the nature of the inmate culture itself, and particularly about the sources that give rise to it.

Almost all accounts of close custody prisons in the United States are in agreement on the fundamental qualities of the inmate world in such institutions (Sykes and Messinger, 1960). Very briefly, three features seem most important:

1. There is a normative order defined largely in opposition to the staff and placing great emphasis on loyalty to other inmates.

2. There is a system of informal social differentiation that is reflected in the series of social types or argot roles noted by Sykes (1958), Schrag (1944), and many others. Special labels are assigned to inmates depending on their mode of response to prison life and expressing the quality of their interaction with staff and inmates. The system of informally defined social types gives evidence both of the dominant values of the inmate world—for the pejoratives always apply to those inmates who support the staff or who exploit other inmates for their own benefit—and of the range of subcultures that form within the walls of the institutions.

3. Accounts of everyday life in American prisons point to numerous struggles for power, frequent involvement in illicit activities, and a fair amount of violence behind the walls. Every institution has its share of fistfights and occasional knifings, with force used as a means of social control. Though it would be easy to exaggerate such matters, it seems clear that the American prison is not a particularly warm, tolerant, or congenial cultural setting. Almost every institution finds that it needs, in addition to the unit designed to hold the assault-minded or escape-risk inmates, a special segregation unit to protect some inmates from others who are out to get them.

Why does the prison so typically show these patterns of inmate response? Two conflicting views can be found. One interpretation is along the lines of "cultural diffusion" theories in anthropology. Very briefly, inmate society is what it is because inmates have imported their antagonism toward law and order from the outside world. The single trait held in common by all inmates is participation in criminal activity. The capacity to engage in criminal acts suggests at least some degree of withdrawal of support from conventional values, and indeed can be viewed as indicating an opposition to conventional norms and values. By bringing together in a twenty-four-hour living establishment individuals who have deviated from conventional norms, the prison offers opportunities for mutual reinforcement of criminal values. Those inmates who occupy prominent positions within the inmate hierarchy and who spend the most time in interaction with their fellows should be the ones whose values are most likely to serve as the basis for the organization and culture of inmate life. And these same inmates, we know from other sources, are those who are likely to be most committed to a criminal value system—those who have followed systematic criminal careers, those who are most hostile and aggressive in their expression of opposition to the staff (Schrag, 1954; Wheeler, 1961a). And if the culture is viewed as an outgrowth of the dominant sort of attitudes entering inmates bring with them, it is reasonable to expect a reinforcement process operating throughout the duration of their confinement. This is consistent with the image of correctional institutions as "crime schools" and with a theory that accounts for the socialization processes in prison largely in terms of a concept such as prisonization. And this is very much the sort of process hinted at by Clemmer, although he very largely took the values of the inmate system for granted, and did not set out to explain them.

An alternative interpretation of the sources for the inmate culture emerged in the years following Clemmer's work, and received its fullest expression in an analysis of the inmate's social system presented by Gresham Sykes and Sheldon Messinger (1960). Instead of viewing inmate culture as a simple expression, and perhaps extension, of the individual values inmates may bring to the prison, Sykes and Messinger saw the inmate culture as a response to the adjustment problems posed by imprisonment itself, with all of its frustrations and deprivations. Among the important deprivations are included the low and rejected status of being an inmate, the material and sexual deprivations of imprisonment, the constant social control exercised by the custodians of the prison, and the presence of other offenders who may be perceived as dangerous and threatening. The normative order and the system of social differentiation discussed above can be seen as responses to the series of deprivations. The normative order may reinstate self-esteem by providing a meaningful reference group that will support an inmate's attack on the staff, and it may lessen the dangers of exploitation on the part of other inmates. Further, the system of social

differentiation itself reflects the variety of individual adaptations to the de-
privations in question. In short, an alternative to the cultural diffusion
scheme is a functional theory in which inmate culture is seen as a response
to the conditions of imprisonment rather than an extension of the values
men bring to prison.

If this interpretation is valid, we might expect that inmate culture would
exert its major impact on inmates during the middle of their stay in prison,
at the point in time when they are farthest removed from the outside world.
And if the inmate value system is a response to the deprivations of im-
prisonment, it would seem only natural that as men prepare to leave the
prison, those deprivations begin to wane in their significance. Thus they
move away from adherence to the inmate value system and toward the
values of the conventional society to which they are soon returning. Fur-
thermore, the deprivations themselves may be objectively less severe as
men approach release, when they are likely to be allowed more freedom
within the walls, and somewhat more of the few amenities prison life may
offer.

This provides us with a more substantial theoretical underpinning for the
empirical finding of a U-shaped socialization and resocialization cycle
within the prison. We are left, then, with two different patterns of change
over time in the prison, and with two different and conflicting ideas regard-
ing the sources of inmate culture itself, ideas that might possibly explain
one or another of the patterns of adjustment to the prison over time.

Social Organization in Scandinavian Prisons [1]

A clear opportunity to further refine and test these ideas would be provided
by a setting in which the prisons are relatively much like those found in the
United States, with all their accompanying deprivations, but where the
culture of the country as a whole is different. If the primary source of
inmate culture lies in the deprivations of imprisonment themselves, the
same inmate culture should be found wherever the deprivations are pres-
ent, and should not vary widely with differences in the nature of the crimi-
nal and noncriminal world outside the walls. If differences in the external
culture are very important, then we should find that despite a relatively
uniform pattern of deprivations, inmate life sharply reflects the culture of
the world outside the prison.

Some of the prisons in the Scandinavian countries provide a relevant
case in point. In what follows, I shall present two different types of evi-
dence from studies of Scandinavian prisons that enable us to elaborate on
the themes developed above. The first is based upon a case study of a
single institution in Norway, where we have both observational data and
survey research data concerning the nature of inmate organization. The

second type of evidence consists of survey data from some fifteen prisons spread throughout the Scandinavian countries, institutions which differ in the composition of their inmate population as well as in the nature of the goals and organization of the prisons themselves.

The major institution for normal long-term adult offenders in Norway is the Botsfengslet in Oslo. The prison houses about 200 offenders serving from six months to life, for crimes ranging from simple theft to treason and murder. It is a particularly interesting case for comparative analysis because its design and philosophy are modeled after American institutions based on the Pennsylvania system of prison architecture, and it is quite similar to Trenton prison, where Sykes' observations were made. Prison design was apparently one of the first elements of American culture to penetrate Norway, coming by way of English prison reformers of the early nineteenth century. Indeed, the deprivations mentioned in most functional accounts, such as the constant presence of guards, lack of women, attacks on self-esteem, and material deprivations, were clearly present at Botsfengslet, and were apparently felt as strongly by men there as they were by American inmates.

The most striking feature of inmate organization in Botsfengslet is the apparent weakness of the normative order and the lack of cohesive bonds. Almost all respondents volunteered that the inmates "lacked cohesion." Intensive interviews with a few of the inmates revealed that there was indeed general agreement regarding a minimal normative order, including the injunction not to rat or inform. But the inmates agree that even this rule was never enforced by coercive pressures. For example, two inmates offered the same story about a former inmate who upon his release had informed the staff about the presence of narcotics and alcohol in the prison. He did the same thing at another institution, and later was returned to Botsfengslet. There was some talk among the prisoners of doing something to him, but in fact after his return no one made a move to harm him. Other examples were given of a similar unwillingness to sanction inmates for violations of inmate norms.

Neither the interviews nor the survey data gave any evidence of organized opposition to the staff. In the questionnaire, for example, only 15 percent of the inmates said that other inmates often put pressure on them to work less hard than they otherwise would, and only 9 percent said that inmates often put pressure on other inmates to oppose the staff. One inmate, perhaps a bit extreme, suggested something of the lack of organization and clear opposition: "If someone unlocked all the cells and opened the front gate, not more than three inmates would take off. Most would run to the guard and ask what was happening."

It is important to note that the lack of organization was not the result of any sense of being well-treated and therefore having nothing to fight against. In fact, a larger percentage of inmates in this institution than in any others in Norway and Sweden felt that their stay was going to hurt them.

Individually, they indicated no great warmth of feeling for their keepers. But the individual complaints had not led to collective resistance. Rather, they seemed to be an atomized and depressed mass.

A similar deviation from the expected strong inmate culture characterizes the special vocabulary found at Botsfengslet. Unlike the American case, there has been almost no development of nouns with a special meaning to depict an inmate's social role in the prison. Patterns of behavior can be described that are similar to those for which a vocabulary has developed in American prisons, but there is no jargon, no institutional shorthand, to refer to them. Three exceptions, however, should be noted. There is a word for "rat," and an expression that literally means "noisemaker," referring to the occasional inmate who disturbs both staff and prisoners by talking too much, gossiping, and in general making a verbal nuisance of himself. Also, there are terms referring to the various roles involved in homosexual relations. But for the most part there is only an embryonic development of a special argot describing behavior patterns in the prison.

This may be a result, in part, of the small number of inmates in Norwegian prisons at any one time. In Norway no more than 500 inmates are serving sentences of more than six months, and it may take a much larger base community to support a separate vocabulary. But this explanation seems doubtful, for there definitely are many terms which have special meaning only to prisoners. Most of these, however, refer not to behavioral patterns and social roles, but to the crime committed by the inmate or the nature of his life outside the institution. Thus, there is a special word for offenders who committed indecent acts with children (as there is in the United States), and a clear distinction between those who committed their acts against boys or against girls (unlike the United States). Another expression, meaning "traveler," characterizes those inmates who were nomadic and wandering in their pre-institutional life. Indeed, if any aspect of the typical American behavior pattern is present at Botsfengslet to a strong degree, it is the norms against asking persons about their preprison background or their offense—not the norms against ratting or other prostaff behavior. The special language draws much more from the everyday vocabulary, and more frequently refers to life outside the institution than is the case in American prisons.

Finally, observations on characteristic behavior patterns in the institution reveal more deviations from the typical American case. I know of no way of getting an adequate picture of the amount of illicit activity in Norwegian institutions, but my impression is that the amount of gambling and homosexual activity, and probably the amount of drinking, is less than it is in comparable American institutions. And one fact is clear: there is almost no violence within the walls. Inmates and staff agreed that there had not been as much as a fist-fight between two Botsfengslet inmates for at least nine months preceding my contact with the institution. One inmate remembered a small fight in the short-term jail in which he had served some time

before, but apparently this was remembered simply because fights are so unusual. As a Norwegian colleague expressed it: "Our institutions are like Sunday schools compared to yours."

In short, the deprivations usually pointed to may be necessary conditions for the emergence of a strong and resistive inmate value system, but the Norwegian evidence suggests that they are not sufficient. Although the deprivations were present at Botsfengslet, the strong inmate culture was lacking. There are, however, four respects in which this is not a complete test of the functional argument.

First, it may be that *other* deprivations are more important than those usually cited, and that these deprivations vary from country to country. One major difference is length of sentence. The average stay in most American institutions is from two to five years. At Botsfengslet, it is much shorter, averaging slightly more than a year. Only life-termers are likely to be sentenced for more than two or three years. It is possible, then, that the differences in sentence length alone would account for much of the variation in the inmate culture.

A second condition concerns the rate of incarceration in Norway compared to the United States. Probation is used more, the crime rate is lower anyway, and officials are reluctant to give prison sentences if there is any alternative. As a result, a much smaller proportion of the criminal population is institutionalized. It may be that the inmate system fails to receive the type of inmate who is best at organizing and generating group opposition.

Third, the apparent normlessness at Botsfengslet may be partially accounted for by the structural constraints on interaction in the prison. One major way in which Botsfengslet departs from current American patterns is that the inmates there are more isolated. As in the American institutions of the turn of the century, inmates at Botsfengslet are locked in at 5 p.m., at the close of the work-day. They eat in their own cells, rather than in the dining hall. Those who go out in the evening must have a special task or assignment, such as band or a school course. Although inmates work together in the shops (as the American prisoners did after the industrial revolution had penetrated into the prison), the general policy is still against fraternization.

All these features make for a much greater degree of isolation than is found in modern American prisons. Indeed, 43 percent of the inmate population at Botsfengslet report that they have made no friends among other inmates. The comparable figure for the American prison described above is 10 percent. Thus the constraints on communication and interaction at Botsfengslet may well prevent formation of a solidary inmate culture.

Fourth, and perhaps most important, although it is possible to show that most of the deprivations in American prisons are also objectively present at Botsfengslet, it is not so easy to know whether they are subjectively defined as deprivations by Norwegian prison inmates. It may well be, for

example, that inmates from a society that lacks some of the material abundance of the United States do not experience confinement in the same ways that American inmates do. A warm shelter, a clean bed, and three square meals a day—features that both prison systems provide—may have relatively greater value in Norway, with the result that prison itself is experienced as less depriving. Unfortunately, we do not have evidence on these matters of relative deprivation.

Based solely upon the case study of Botsfengslet, however, the most plausible explanation of the difference between inmate culture in Norway and in the United States is that general features of Norwegian society are imported into the prison, and that they operate largely to offset tendencies toward the formation of a solidary inmate group united in its opposition to the staff. The most important element seems to be the virtual absence, in Norway, of a subculture of violence and antagonism. Few offenders use weapons. The police do not carry guns. There are only three or four offenders in the entire country who fit our model of a professional criminal. Younger offenders have not participated extensively in organized delinquent gangs, as have many in this country. Consequently, the thought of using violence as a means of social control simply does not arise. Even the fact that boxing is an important recreational activity in American prisons was surprising and dismaying to the Norwegian inmates. In short, the value American inmates place on being tough, being smart, seeing society in "we-they" terms, is characteristically absent. This in turn would seem to reflect the relatively narrow range of the stratification system, the virtual absence of American-style slums, and the greater homogeneity of Norwegian society.

The relatively greater sense of isolation in Norwegian life, and the related tendency to be more inward-looking, may yield personality components which also work against the formation of social bonds with other inmates. One gets the strong impression that many prisoners, like their counterparts outside, would rather not get deeply enmeshed in an extended social circle. They are more likely to go their own way.

This extended set of observations on a Norwegian prison may seem out of place in a chapter intended to deal generally with problems of socialization in prison communities. They are included here simply to indicate in the clearest possible way how much the cultural environment surrounding the prison is likely to influence the internal life of the institution, and along with it the processes of socialization that go on there.

Botsfengslet was one of fifteen institutions in the Scandinavian countries where we were able to collect systematic survey data relating to inmate culture and social organization. One way to examine further the relationship between influences from outside the prison versus the deprivations from within is to find out which of these possible sources of influence bears the strongest relationship to the formation of an antistaff culture and set of attitudes among the inmates (Cline and Wheeler, 1968). We developed an

index of the degree to which inmates felt that others held attitudes in opposition to those of the staff, an index which could be applied across the fifteen institutions. The range of responses on that index, without presenting the evidence here, indicates clearly that there is a wide variation in the extent to which an antistaff climate tends to develop in different institutions. It is thus a perpetuation of a stereotype to assume that all prisons are alike.

What is most striking is that the variation in antistaff culture and attitudes can be accounted for much better by examining the type of inmate that flows into the system than it can by examining the nature of the prison itself. The best single predictor of the antistaff climate in these fifteen prisons is the median age of their inmates at first arrest. The older the median age of first arrest, the less the climate of the institution is one that is polarized in opposition to the staff (−.80). The youth institutions in our sample tend to be the highest in antistaff climate scores and, of course, they have the institutions where the average age of first arrest is lowest. But even when those institutions are removed, other indicators of the criminal background inmates bring to prison continue to show the strong relationship to the nature of the climate that forms within. For example, if we order the institutions according to the percentage of men who have previously served a sentence in prison, the correlation between that index and the antistaff climate scores is +.73.

Relationships between antistaff climate scores and various indexes of deprivation, on the other hand, tend either to be inconsistent or nonexistent. Indeed, the one measure of deprivation that seems consistently related to the kind of attitudinal climate that forms behind the walls is a measure that reflects the extent of *social* deprivation faced by the inmates: the extent to which the institutions keep inmates from contacts with each other, with friends and relatives outside the prisons, and with prison officials. But this is a special kind of deprivation, for while it assuredly is generally discomforting for the inmates, and in that sense is a true "deprivation," it is the kind of deprivation that may well preclude the development of a strong culture of opposition to the staff. For to the extent that inmates are not free to associate with one another, it is clearly difficult for such a culture to emerge. Indeed, the direction of the relationship in our fifteen institutions is just the opposite from what one might anticipate given a simple deprivation model: in these institutions, the greater the degree of social deprivation, the less the extent to which the inmate culture is formed in opposition to the staff (−.36).

These data, then, point again to the importance of experiences inmates bring into the prison when they enter as a determinant of the general climate within the institution. But two important qualifications have to be noted. First, there is great danger of generalizing far beyond the particular institutions contained in this study. One qualification concerns the actual range in the nature of the deprivations presented in different prisons. Even

though we have institutions that were constructed as long ago as 1859 and as recently as 1959, even though they differ in many aspects of their organization, and even though these differing aspects can be shown to be related systematically to inmate feelings and attitudes on many issues, there remains a basic similarity in the degree to which a prison is likely to be perceived as a depriving experience from the perspective of the inmates. This is perhaps the one basic feature of prisons, and the one that is most difficult to change by altering prison organization, design, and program. And it may take a truly radical departure from traditional patterns if the socialization setting known as the prison is to produce major variations in the patterning of socialization itself. In a later section of this chapter, we turn to some examples of efforts to modify the general pattern of prison life through very intensive kinds of programs. Here I want simply to underscore the fact that our sense of the importance of external rather than internal features of imprisonment may be a limited historical judgment, rooted in the kinds of prisons our Western nations have so far developed.

The second qualification has to do with the nature of the materials themselves. The kind of survey data reported here are far from the intimate life experiences of individual inmates. When we get closer to those lives, as in autobiographies of individual prisoners, we get a much more dramatic feeling for the meaning of imprisonment in the personal lives of offenders. Whatever else such experiences reveal, they need to be viewed against a background of the general character of the prison. A most important quality of that general character, it appears from the above, is the nature of the ties its members have had with the outside world, and the nature of that outside world itself.

Socialization in an Institution for Juvenile Offenders

A detailed analysis of feelings and experiences of young inmates as they move through their first stay in a correctional institution for juveniles provides the empirical base for the observations that follow. These boys are between fourteen and sixteen years of age, and they have all been committed to youth institutions in the state of Massachusetts. Our study design called for them to be interviewed at the beginning of their stay in a correctional institution, at a point roughly in the middle, again just before they were released, and after they had been out in the community for three or four months. In this case, because of the panel design, we are in a better position to assert something about the changes the inmates undergo as they experience the correctional system. (For further details, see Baum and Wheeler, 1968.)

Our aim in this study was to attempt to capture the experience of imprisonment through the direct reports of the boys studied. Thus we asked

relatively simple and straightforward questions in an open-ended fashion, and treated the boys as respondents about the setting rather than as "subjects" in a more traditional sense. The observations here will be limited to describing some central themes that emerge from our interview data and that have direct bearing on the nature of the relationship between the world inside the prison and the world outside.

One of our central lines of questioning concerns whether the boys think their stay in a correctional institution will be helpful or harmful to them in terms of their ability to get along in the world after they get out. After asking about the general direction of their feeling, we probed in detail as to why they felt that way. Somewhat over half of the boys feel that their stay will be helpful to them, and the vast majority of those who feel this way see the help largely in a classic free-will deterrence framework. Being put away is helping them, they feel, because it is teaching them a lesson. Institutions are pretty lousy places, and it is very rough being away from home and family. In brief, it is an experience to be avoided and it will help them remain free from criminal activity after their release, because they don't want to come back again. They do not feel it is helping them because of the therapeutic qualities of the institutions, the warm and kind character of the staff, the education and trade-training opportunities, or most of the other reasons associated with current correctional philosophies and programs. Indeed, these reasons loom as relatively insignificant in comparison with the general status of being removed from the outside world.

Those who feel the stay will be harmful (and this constitutes a smaller proportion of the respondents) likewise do not attribute the harm to the dynamics of life within the institution, but rather to the way in which the institution is perceived by the outside world. It is not the institution's effect on *them* that they perceive as most important, but rather the effect of their having been there on others. It will harm them because it will make employment opportunities more difficult to find, because it may prevent them from being accepted by the armed services, and for a few, because of the general stigma attached to institutional confinement by community members. There is little mention of such factors as turning bitter while they are in confinement, learning crime from others, and the like. In other words, it is the fact of imprisonment per se that looms as most important, rather than any specific events that happen during confinement.

These are experiences reported by the boys at an early point in their stay. As they move through to the period just before their release, the only major change in response is that those who originally saw the institution as primarily harmful in its effect move to viewing it as neutral. This movement is apparently occasioned by their learning that juvenile records are handled differently from adult criminal records and that they may be able to conceal the fact of confinement from employers and others. Among those who still feel that their stay will help them, there is a slight increase in the number who attribute the help to something specific about institu-

tional programs, but the main thrust of their responses remains the same as before: they don't like being away from home and are motivated to stay out of trouble so that they won't come back.

It could be argued that these are only verbal mouthings and that they only serve to conceal the real dynamics of the socialization process within the institution. Indeed, the boys may be observed to fight and argue vigorously, to jockey for position in the status hierarchy among the boys, to play up to the staff in their presence while verbally attacking them in their absence, and in other ways to be going through the routines we have come to expect from persons in closed institutions. These observations might all be correct, but they would give only a partial indication of the significance of life within the institution for the boys in question. For when we ask them what they spend most of the time thinking about while they are in the institution, even during the middle of their stay, about twice as many report thinking most about the outside world as report thinking about what is going on within the institution. Their minds are likely to be on family, friends, activities they used to enjoy but now can't, and the like. And when asked what are the worst and the best times while they are in, the great majority report that their high points and their low points center around visits and contacts from the outside, rather than around activities within the institution. They are happiest when they get a visit, when they receive letters, when they go on weekend furloughs to their home community. They are lowest when a planned visit does not materialize, or when it is time for a visit to end, or when no one writes.

We might expect these feelings to be strongest among young offenders who are separated from free community life for the first time and whose length of separation is relatively short, and both of these characteristics are present for those we studied. But coupled with the other observations regarding their sense of the impact of the institution on them, these data on juvenile offenders show clearly how life outside the institution has real cognitive and motivational significance for those inside.

It may seem that we have been wandering through the vineyards of several unrelated studies, but a consistent theme appears to emerge from each additional piece of empirical data. There is a hint of the importance of the external world in our earliest finding regarding the U-shaped curve, for it suggests the ease with which inmates can begin adapting to the world beyond the prison even before they have emerged from behind the walls. The case study of a Norwegian prison pointed clearly to the importance of the culture outside the prison as a determinant of the life that forms within. The survey data from fifteen Scandinavian institutions show the relatively great impact of inmates' prior backgrounds outside the prison, the lesser importance of prison deprivations themselves. Finally, the reports of juvenile offenders give further evidence of the powerful impact of life outside while they are inside. Taken together, these observations force a redirec-

tion of interest from life in the inner regions of the prison to the world of experience that lies beyond its boundaries.

Discussion

The concept of socialization, like so many of the concepts in behavioral science, has been subjected to a wide variety of definitions and interpretations. The definition suggested in the introduction to this volume, "the process by which individuals acquire the knowledge, skills and dispositions that enable them to participate as more or less effective members of groups and the society," can be given either a narrow or a broad interpretation. As applied to the prison, for example, it can be taken to refer to the ways in which inmates learn how to manage their lives within the institution at some minimal level of effectiveness. A substantive focus on this concern would lead to an effort to answer the questions: What does an inmate need to know, in addition to what he already knows, that will enable him to make a minimal adjustment to the prison? What skills must he develop that he does not already have? What attitudinal or behavioral dispositions will be needed?

There are abundant documentary materials to suggest that, in terms of these questions, adaptation to the prison is not greatly different from adaptation to any other setting. The inmate will learn from others what the guards expect of him as a routine matter, what the inmates expect, and how he can successfully negotiate between these two conflicting sets of expectations. He may also learn how to achieve those minimum creature comforts that make life tolerable within the institution (Goffman, 1961b). What is learned will depend upon the local culture of the institution in question, and on the degree to which an individual inmate becomes involved in that culture. The chief difference between the prison and many other social settings in this connection is that, as a "total institution," the pains resulting from failure to become socialized are particularly severe, for there is literally no escape from the norms and role demands of the setting. As Goffman has pointed out, the prison shares this quality with many other forms of organization, including the ship, the mental hospital, the private boys' school, and the monastery (Goffman, 1961a). But aside from the "total" character of such settings, and the special importance that attaches to getting along, there is not a lot that distinguishes the total institution from other settings where socialization, in this narrow sense, goes on.

A more inclusive view of the socialization process would place less emphasis on problems of surface adjustment, more emphasis on deeper, more fundamental changes. It would emphasize the internalization of norms,

rather than overt compliance with the setting in question. It might give less attention to external features of adjustment, more to possible changes in one's basic conception of himself, his sense of worth and dignity. Many who speak of socialization within the prison indeed have these latter qualities in mind. The typical assumption has been that the harsh and dramatic circumstances of imprisonment as a form of human existence are likely to lead to deep-seated and fundamental changes in values, ideologies, and personal styles. And the assumption has typically been that these changes will have long-lasting effects. Similarly, when persons have talked about "rehabilitation" or "resocialization" they have been concerned with more than establishing a new surface adaptation to conventional ways of life. They have had in mind some relatively basic reconstruction or reconstitution of one's values, beliefs, and way of life (Studt, Messinger, and Wilson, 1968).

It is this broader meaning of socialization that has been implicit in the matters discussed in this chapter. The prison is often viewed as a setting within which fundamental changes in attitudes and values are likely to take place. A growing body of both evidence and thought suggests that this view may be incorrect. Indeed, the central argument of this chapter may be put as follows:

1. Persons do not enter prison motivated to seek a basically new and different vision of themselves.

2. To the extent that they do change, the change is produced as much by the reaction to being confined and separated from the free community as it is by the dynamics of life within the institution.

3. The values and attitudes expressed by prison inmates are shaped in important ways by the circumstances to which inmates have been exposed prior to their period of incarceration.

4. In addition to its impact on the values held by entering inmates, the external world influences the kind of culture and social organization that is formed within the prison, and which serves as the social context within which adaptation to imprisonment takes place.

5. As a result of these conditions, whatever impact the experience of imprisonment itself might have on inmates, either positive or negative, is sharply attenuated. *It is the social definition of the prison in society, rather than the social status of the inmate within the prison, that appears to be most relevant for the future life and career of prison inmates.*

6. It follows from all of the above that a full understanding of processes of socialization and resocialization within the prison requires much greater attention than has heretofore been given to the relationship of both the prison and the prisoner to the external world.

The remainder of this chapter will examine other studies of the prison to assess their bearing upon this argument.

Inmates obviously differ in the roles they come to play within the prison,

and these differences are related to the backgrounds they bring to prison. Further, such differences have been shown to be related to the way men change as they experience prison life (Garabedian, 1963; Wellford, 1967). But often, the divergent sociocultural backgrounds men bring to the institution are forgotten as analysts attempt to untangle the nature of prison life. This fact is noted clearly in the one report that is most closely related to the argument of this chapter (Irwin and Cressey, 1962). Irwin and Cressey call attention to the existence of three separate subcultures within the prison: a "convict" subculture, whose participants are oriented inward toward the internal life of the prison; a "thief" subculture, whose participants are oriented to the criminal culture outside the prison; and finally, there are prisoners oriented toward the legitimate culture in the broader society. To understand the prison behavior of the second and third types of men, it is crucial to understand the nature of their ties outside the prison. Although Irwin and Cressey make their case by examining individual differences within any one institution, their argument is entirely consistent with our findings on the degree to which inmate life generally reflects broader cultural conditions.

There are several studies of correctional communities that attempt to draw the link between the social organization of the prison and the individual adaptation of the inmates. Most of these studies focus on the nature of the formal authority system. For example, Street, Vinter, and Perrow (1966) are able to show that inmates in youth institutions ranged along a continuum from custody and discipline to group and individual treatment responded rather differently to the staff and to their fellow inmates. From their data, they are able to argue effectively that the "solidary opposition" model of inmate culture in prisons does not adequately describe institutions that develop a fairly rich and complex set of treatment goals and programs. Related studies of prison camps by Grusky (1959) and by Berk (1966) point to substantially the same conclusion, as do comparative studies of adult institutions where some are operating within a traditional custodial model and others within a psychiatrically oriented version of the correctional process (Mathiesen, 1965; Wheeler, 1968).

It is clear from all these studies that different patterns of formal organization and structure may produce differences in inmate organization and in attitudes toward the prison experience. But these studies have not gone on to demonstrate the relationship between participation in inmate society and future behavior. Thus, as much as these studies tell us about the different patterns of organization within the prison and potentially different socialization processes, they have not yet shown whether changes occur that are deep and long-lasting enough to produce real differences in rates of recidivism.

A number of other studies have examined rates of recidivism for men housed in different types of institutions. This has been part of a long-term series of studies supported by the California Correctional System. And if

there is any one conclusion that appears to be safely drawn from those studies, it is that differences in prison organization themselves apparently produce relatively little difference in recidivism rates. Once one takes account of the nature of the inmate population in the different prisons, the institutional differences in recidivism rates tend to disappear. Relatively small effects may be shown for one or another aspect of prison programs, but the overall sense one gets from such studies is that the differences attributable to institutions are small relative to the differences attributable to the prior backgrounds of individual inmates. A recent Danish investigation lends cross-national support to this finding. Larsen (1967–68) has produced one of the few studies that has both recidivism data, and data on inmate attitudes and perspectives toward the institutions. He is able to show that institutions ranging along a treatment-custody dimension do indeed produce differences in the perspectives inmates have with regard to their life within the prison. But, again, once one controls for the differences in type of inmate, there are only small differences in the rates of recidivism among those released from the institutions. Indeed, the one current study in the field of correction that has been successful in demonstrating what appears to be the real impact of an experimental program is a project which compares inmates in traditional institutions with those who remain outside the institutions entirely and are subject to a special and intensive treatment program on the outside (Warren, 1967). And even in this case, it remains unclear whether the results are due to merely not going to prison, to a more lenient recommitment policy for those in the treatment group, or to the effects of the treatment program itself.

Again, it is necessary to interpret these studies with caution, for in many respects the institutions do not offer really radical differences in their form of organization or in the kinds of treatment programs used with inmates. For the most part, it is a matter of providing more of what is already present in a minimum "treatment" model—more psychiatrists per inmate, more counseling facilities, more group therapy, better trade-training programs, and so forth. It may be that a much more radical reorientation of prison organization will be necessary in order to produce institutions that really make a difference. That such a reorientation is difficult to establish is suggested by the experiences of Elliot Studt and her colleagues (Studt et al., 1968).

Glaser's (1964) study of federal institutions provides further data that are relevant to the argument made above. He found a U-shaped pattern of response to prison life quite similar to that described for the State Reformatory, thus again suggesting that the changes that take place during the middle of imprisonment may not remain until the time of release. Further, when inmates in the institutions he studied were questioned regarding the effect of imprisonment on them, the responses were quite similar to those given in the study of juvenile institutions: inmates thought the primary impact of imprisonment was a deterrent effect, rather than anything spe-

cific about institutional programs, although there were a minority who felt that they benefited from the trade-training program of the federal prison system. And to the extent they felt the institution had a bad effect, they were likely to see it primarily in terms of what it meant to have a "record" when they returned to civilian life.

A final study that has bearing upon our argument is Giallombardo's (1966) research in the federal women's prison at Alderson, West Virginia. She too found functional theory wanting as an explanation of the nature of inmate society. She observed that the same general deprivations are present in women's institutions as in men's but that the form of inmate society is radically different. The difference has to do with differences in what inmates bring into the institution as a result of role definitions provided by the broader society:

> The deprivations of imprisonment may provide necessary conditions for the emergence of an inmate system, but our findings clearly indicate that the deprivations of imprisonment in themselves are not sufficient to account for the form that the inmate social culture assumes in the male and female prison communities. Rather, general features of American society with respect to the cultural definition and content of male and female roles are brought into the prison setting and function to determine the direction and focus of the inmate cultural systems (Giallombardo, 1966, p. 187).

Conclusion

The argument presented above is clearly based on partial and fragmentary evidence. Despite the growing number of studies of prison environments over the past score of years, there is still a relative absence of a truly cumulative body of knowledge about the prison as a social environment, and about the changes inmates undergo as they experience imprisonment. On the basis of that partial evidence, we argue that studies of the formal and informal social organization of the prison and its effects on new inmates need to be supplemented by a stronger concern for the relationship between both prison and prisoner and the external world. When such studies are completed, we should be in a better position to assess the relative impact of the external and internal world on the conduct of offenders both during and after imprisonment.

REFERENCES

Baum, M., and Wheeler, S. "Becoming an Inmate." In S. Wheeler, ed. *Controlling Delinquents.* New York: Wiley, 1968.

Berk, B. B. "Organizational Goals and Inmate Organization." *American Journal of Sociology* 71, no. 5 (1966): 522–534.

Brim, O. G., Jr., and Wheeler, S. *Socialization after Childhood.* New York: Wiley, 1966.

212 THE PRISON COMMUNITY

Clemmer, D. *The Prison Community*. New York: Rinehart & Co., 1958. First published in 1940.

Cline, H. F., and Wheeler, S. "The Determinants of Normative Patterns in Correctional Institutions." In N. Christie, ed. *Scandinavian Studies in Criminology*. Vol. 2, Oslo: Universitetsforlaget, 1968.

Garabedian, P. C. "Social Roles and Processes of Socialization in the Prison Community." *Social Problems* 11 (1963): 139–152.

Garrity, D. L. "The Effect of Length of Incarceration upon Parole Adjustment and Estimation of Optimum Sentences; Washington State Correctional Institution." Unpublished Ph.D. dissertation, University of Washington, 1956.

Giallombardo, R. *A Study of a Women's Prison*. New York: Wiley, 1966.

Glaser, D. *The Effectiveness of a Prison and Parole System*. Indianapolis: Bobbs-Merrill, 1964.

Goffman, E. "On the Characteristics of Total Institutions." In E. Goffman, *Asylums*. New York, Doubleday, 1961a, pp. 1–124.

Goffman E. "The Underlife of the Public Institution: A Study of Ways of Making Out in a Mental Hospital." In E. Goffman, *Asylums*. New York: Doubleday, 1961b, pp. 171–320.

Grusky, O. "Organizational Goals and the Behavior of Informal Leaders." *American Journal of Sociology* 67, no. 1 (1959): 59–67.

Irwin, J., and Cressey, D. R. "Thieves, Convicts, and the Inmate Culture." *Social Problems* 10 (Fall 1962): 142–155.

Larsen, F. B. "Aspects of a Strategy for Research in Criminology." *Sociologiske Meddelelser: A Danish Sociological Journal* 12 (1967–68): 25–52.

Mathiesen, T. *The Defense of the Weak*. London: Tavistock, 1965.

Merton, R. K. *Social Theory and Social Structure*. Rev. ed. Glencoe, Ill.: Free Press, 1957.

Schrag, C. C. "Social Types in a Prison Community." Unpublished master's thesis, University of Washington, 1944.

Schrag, C. C. "Leadership Among Prison Inmates." *American Sociological Review* 19, no. 1 (1954): 37–42.

Street, D.; Vinter, R. D., and Perrow, C. *Organization for Treatment*. New York: Free Press, 1966.

Studt, E.; Messinger, S. L.; & Wilson, T. P. *C-unit: Search for Community in Prison*. New York: Russell Sage Foundation, 1968.

Sykes G. M. *The Society of Captives*. Princeton, N.J.: Princeton University Press, 1958.

Sykes G. M., and Messinger, S. L. "The inmate social system." In R. A. Cloward, D. R. Cressey, G. H. Grosser, R. McCleery, L. E. Ohlin, G. M. Sykes, and S. L. Messinger, eds. *Theoretical Studies in Social Organization of the Prison*. New York: Social Science Research Council, 1960, pp. 11–13.

Warren, M. Q. "The Community Treatment Project after Six Years." *Bulletin of the California Youth Authority*, 1967.

Wellford, C. "Factors Associated with Adoption of the Inmate Code: A Study of Normative Socialization." *The Journal of Criminal Law, Criminology and Police Science* 58, no. 2 (1967): 197–203.

Wheeler, S. "Role Conflict in Correctional Communities." In D. R. Cressey, ed. *The Prison: Studies in Institutional Organization*. New York: Holt, Rinehart & Winston, 1961a.

Wheeler, S. "Socialization in Correctional Communities." *American Sociological Review* 26, no. 5 (1961b): 697–712.

Wheelers, S. "Legal Justice and Mental Health in the Care and Treatment of Deviants." In M. Levitt and B. Rubenstein, eds. *Orthopsychiatry and the Law*. Detroit: Wayne State University Press, 1968.

NOTES

1. The materials in this section are derived from a broader study of Scandinavian prisons being conducted by Hugh F. Cline and the author. We are indebted to many Scandinavian sociologists, but will not attempt to give full acknowledgment of that help here.

12: The Pains of Imprisonment / *Gresham M. Sykes**

The Deprivation of Liberty

Of all the painful conditions imposed on inmates, none is more immediately obvious than the loss of liberty. The prisoner must live in a world shrunk to thirteen and a half acres and within this restricted area his freedom of movement is further confined by a strict system of passes, the military formations in moving from one point within the institution to another, and the demand that he remain in his cell until given permission to do otherwise. In short, the prisoner's loss of liberty is a double one—first, by confinement to the institution and second, by confinement within the institution.

The mere fact that the individual's movements are restricted, however, is far less serious than the fact that imprisonment means that the inmate is cut off from family, relatives, and friends, not in the self-isolation of the hermit or the misanthrope, but in the involuntary seclusion of the outlaw. It is true that visiting and mailing privileges partially relieve the prisoner's isolation—if he can find someone to visit him or write to him and who will be approved as a visitor or correspondent by the prison officials. Many inmates, however, have found their links with persons in the free community weakening as the months and years pass by. This may explain in part the fact that an examination of the visiting records of a random sample of the inmate population, covering approximately a one-year period, indicated that 41 percent of the prisoners in the New Jersey State Prison had received no visits from the outside world.

It is not difficult to see this isolation as painfully depriving or frustrating in terms of lost emotional relationships, of loneliness and boredom. But what makes this pain of imprisonment bite most deeply is the fact that the confinement of the criminal represents a deliberate, moral rejection of the criminal by the free community. Indeed, as Reckless has pointed out, it is the moral condemnation of the criminal—however it may be symbolized—that converts hurt into punishment, i.e., the just consequence of commit-

* From Gresham M. Sykes, *The Society of Captives: A Study of Maximum Security Division* (copyright © 1958 by Princeton University Press; Princeton Paperback, 1971), pp. 65–78. Reprinted by permission of Princeton University Press.

ting an offense, and it is this condemnation that confronts the inmate by the fact of his seclusion.

Now it is sometimes claimed that many criminals are so alienated from conforming society and so identified with a criminal subculture that the moral condemnation, rejection, or disapproval of legitimate society do not touch them; they are, it is said, indifferent to the penal sanctions of the free community, at least as far as the moral stigma of being defined as a criminal is concerned. Possibly this is true for a small number of offenders such as the professional thief described by Sutherland [1] or the psychopathic personality delineated by William and Joan McCord.[2] For the great majority of criminals in prison, however, the evidence suggests that neither alienation from the ranks of the law-abiding nor involvement in a system of criminal value is sufficient to eliminate the threat to the prisoner's ego posed by society's rejection.[3] The signs pointing to the prisoner's degradation are many—the anonymity of a uniform and a number rather than a name, the shaven head,[4] the insistence on gestures of respect and subordination when addressing officials, and so on. The prisoner is never allowed to forget that, by committing a crime, he has foregone his claim to the status of a full-fledged, *trusted* member of society. The status lost by the prisoner is, in fact, similar to what Marshall has called the status of citizenship—that basic acceptance of the individual as a functioning member of the society in which he lives.[5] It is true that in the past the imprisoned criminal literally suffered civil death and that although the doctrines of attainder and corruption of blood were largely abandoned in the eighteenth and nineteenth centuries, the inmate is still stripped of many of his civil rights such as the right to vote, to hold office, to sue in court, and so on.[6] But as important as the loss of these civil rights may be, the loss of that more diffuse status which defines the individual as someone to be trusted or as morally acceptable is the loss which hurts most.

In short, the wall which seals off the criminal, the contaminated man, is a constant threat to the prisoner's self-conception, and the threat is continually repeated in the many daily reminders that he must be kept apart from "decent" men. Somehow this rejection or degradation by the free community must be warded off, turned aside, rendered harmless. Somehow the imprisoned criminal must find a device for rejecting his rejectors, if he is to endure psychologically.[7]

The Deprivation of Goods and Services

There are admittedly many problems in attempting to compare the standard of living existing in the free community and the standard of living which is supposed to be the lot of the inmate in prison. How, for example, do we interpret the fact that a covering for the floor of a cell usually consists of a

scrap from a discarded blanket and that even this possession is forbidden by the prison authorities? What meaning do we attach to the fact that no inmate owns a common piece of furniture, such as a chair, but only a homemade stool? What is the value of a suit of clothing which is also a convict's uniform with a stripe and a stenciled number? The answers are far from simple, although there are a number of prison officials who will argue that some inmates are better off in prison, in strictly material terms, than they could ever hope to be in the rough-and-tumble economic life of the free community. Possibly this is so, but at least it has never been claimed by the inmates that the goods and services provided the prisoner are equal to or better than the goods and services which the prisoner could obtain if he were left to his own devices outside the walls. The average inmate finds himself in a harshly Spartan environment which he defines as painfully depriving.

It is true that the prisoner's basic material needs are met—in the sense that he does not go hungry, cold, or wet. He receives adequate medical care and he has the opportunity for exercise. But a standard of living constructed in terms of so many calories per day, so many hours of recreation, so many cubic yards of space per individual, and so on, misses the central point when we are discussing the individual's feeling of deprivation, however useful it may be in setting minimum levels of consumption for the maintenance of health. A standard of living can be hopelessly inadequate, from the individual's viewpoint, because it bores him to death or fails to provide those subtle symbolic overtones which we invest in the world of possessions. And this is the core of the prisoner's problem in the area of goods and services. He wants—or needs, if you will—not just the so-called necessities of life but also the amenities: cigarettes and liquor as well as calories, interesting foods as well as sheer bulk, individual clothing as well as adequate clothing, individual furnishings for his living quarters as well as shelter, privacy as well as space. The "rightfulness" of the prisoner's feeling of deprivation can be questioned. And the objective reality of the prisoner's deprivation—in the sense that he has actually suffered a fall from his economic position in the free community—can be viewed with skepticism, as we have indicated above. But these criticisms are irrelevant to the significant issue, namely that legitimately or illegitimately, rationally or irrationally, the inmate population defines its present material impoverishment as a painful loss.

In modern Western culture, material possessions are so large a part of the individual's conception of himself that to be stripped of them is to be attacked at the deepest layers of personality. This is particularly true when poverty cannot be excused as a blind stroke of fate or a universal calamity. Poverty caused by one's own mistakes or misdeeds represents an indictment against one's basic value or personal worth, and there are few men who can philosophically bear the want caused by their own actions. It is true some prisoners in the New Jersey State Prison attempt to interpret

their low position in the scale of goods and services as an effort by the state to exploit them economically. Thus, in the eyes of some inmates, the prisoner is poor not because of an offense which he has committed in the past but because the state is a tyrant which uses its captive criminals as slave labor under the hypocritical guise of reformation. Penology, it is said, is a racket. Their poverty, then, is not punishment as we have used the word before, i.e., the just consequence of criminal behavior; rather, it is an unjust hurt or pain inflicted without legitimate cause. This attitude, however, does not appear to be particularly widespread in the inmate population, and the great majority of prisoners must face their privation without the aid of the wronged man's sense of injustice. Furthermore, most prisoners are unable to fortify themselves in their low level of material existence by seeing it as a means to some high or worthy end. They are unable to attach any significant meaning to their need to make it more bearable, such as present pleasures foregone for pleasures in the future, self-sacrifice in the interests of the community, or material asceticism for the purpose of spiritual salvation.

The inmate, then, sees himself as having been made poor by reason of his own acts and without the rationale of compensating benefits. The failure is *his* failure in a world where control and possession of the material environment are commonly taken as sure indicators of a man's worth. It is true that our society, as materialistic as it may be, does not rely exclusively on goods and services as a criterion of an individual's value; and, as we shall see shortly, the inmate population defends itself by stressing alternative or supplementary measures of merit. But impoverishment remains as one of the most bitter attacks on the individual's self-image that our society has to offer and the prisoner cannot ignore the implications of his straitened circumstances.[8] Whatever the discomforts and irritations of the prisoner's Spartan existence may be, he must carry the additional burden of social definitions which equate his material deprivation with personal inadequacy.

The Deprivation of Heterosexual Relationships

Unlike the prisoner in many Latin-American countries, the inmate of the maximum security prison in New Jersey does not enjoy the privilege of so-called conjugal visits. And in those brief times when the prisoner is allowed to see his wife, mistress, or "female friend," the women must sit on one side of a plate glass window and the prisoner on the other, communicating by means of a phone under the scrutiny of a guard. If the inmate, then, is rejected and impoverished by the facts of his imprisonment, he is also figuratively castrated by his involuntary celibacy.

A number of writers have suggested that men in prison undergo a reduc-

tion of the sexual drive and that the sexual frustrations of prisoners are therefore less than they might appear to be at first glance. The reports of reduced sexual interest have, however, been largely confined to accounts of men imprisoned in concentration camps or similar extreme situations where starvation, torture, and physical exhaustion have reduced life to a simple struggle for survival or left the captive sunken in apathy. But in the American prison these factors are not at work to any significant extent and Linder has noted that the prisoner's access to mass media, pornography circulated among inmates, and similar stimuli serve to keep alive the prisoner's sexual impulses.[9] The same thought is expressed more crudely by the inmates of the New Jersey State Prison in a variety of obscene expressions and it is clear that the lack of heterosexual intercourse is a frustrating experience for the imprisoned criminal and that it is a frustration which weighs heavily and painfully on his mind during his prolonged confinement. There are, of course, some "habitual" homosexuals in the prison—men who were homosexuals before their arrival and who continue their particular form of deviant behavior within the all-male society of the custodial institution. For these inmates, perhaps, the deprivation of heterosexual intercourse cannot be counted as one of the pains of imprisonment. They are few in number, however, and are only too apt to be victimized or raped by aggressive prisoners who have turned to homosexuality as a temporary means of relieving their frustration.

Yet as important as frustration in the sexual sphere may be in physiological terms, the psychological problems created by the lack of heterosexual relationships can be even more serious. A society composed exclusively of men tends to generate anxieties in its members concerning their masculinity regardless of whether or not they are coerced, bribed, or seduced into an overt homosexual liaison. Latent homosexual tendencies may be activated in the individual without being translated into open behavior and yet still arouse strong guilt feelings at either the conscious or unconscious level. In the tense atmosphere of the prison with its known perversions, its importunities of admitted homosexuals, and its constant references to the problems of sexual frustration by guards and inmates alike, there are few prisoners who can escape the fact that an essential component of a man's self-conception—his status of male—is called into question. And if an inmate has in fact engaged in homosexual behavior within the walls, not as a continuation of an habitual pattern but as a rare act of sexual deviance under the intolerable pressure of mounting physical desire, the psychological onslaughts on his ego image will be particularly acute.[10]

In addition to these problems stemming from sexual frustration per se, the deprivation of heterosexual relationships carries with it another threat to the prisoner's image of himself—more diffuse, perhaps, and more difficult to state precisely and yet no less disturbing. The inmate is shut off from the world of women which by its very polarity gives the male world much of its meaning. Like most men, the inmate must search for his iden-

tity not simply within himself but also in the picture of himself which he finds reflected in the eyes of others; and since a significant half of his audience is denied him, the inmate's self-image is in danger of becoming half complete, fractured, a monochrome without the hues of reality. The prisoner's looking-glass self, in short—to use Cooley's fine phrase—is only that portion of the prisoner's personality which is recognized or appreciated by men and this partial identity is made hazy by the lack of contrast.

The Deprivation of Autonomy

We have noted before that the inmate suffers from what we have called a loss of autonomy in that he is subjected to a vast body of rules and commands which are designed to control his behavior in minute detail. To the casual observer, however, it might seem that the many areas of life in which self-determination is withheld, such as the language used in a letter, the hours of sleeping and eating, or the route to work, are relatively unimportant. Perhaps it might be argued, as in the case of material deprivation, that the inmate in prison is not much worse off than the individual in the free community who is regulated in a great many aspects of his life by the iron fist of custom. It could even be argued, as some writers have done, that for a number of imprisoned criminals the extensive control of the custodians provides a welcome escape from freedom and the prison officials thus supply an external superego which serves to reduce the anxieties arising from an awareness of deviant impulses. But from the viewpoint of the inmate population, it is precisely the triviality of much of the officials' control which often proves to be most galling. Regulation by a bureaucratic staff is felt far differently than regulation by custom. And even though a few prisoners do welcome the strict regime of the custodians as a means of checking their own aberrant behavior which they would like to curb but cannot, most prisoners look on the matter in a different light. Most prisoners, in fact, express an intense hostility against their far-reaching dependence on the decisions of their captors, and the restricted ability to make choices must be included among the pains of imprisonment along with restrictions of physical liberty, the possession of goods and services, and heterosexual relationships.

The loss of autonomy experienced by the inmates of the prison does not represent a grant of power freely given by the ruled to the rulers for a limited and specific end. Rather, it is total and it is imposed—and for these reasons it is less endurable. The nominal objectives of the custodians are not, in general, the objectives of the prisoners.[11] Yet regardless of whether or not the inmate population shares some aims with the custodial bureaucracy, the many regulations and orders of the New Jersey State Prison's

official regime often arouse the prisoner's hostility because they don't "make sense" from the prisoner's point of view. Indeed, the incomprehensible order or rule is a basic feature of life in prison. Inmates, for example, are forbidden to take food from the mess hall to their cells. Some prisoners see this as a move designed to promote cleanliness; others are convinced that the regulation is for the purpose of preventing inmates from obtaining anything that might be used in the *subrosa* system of barter. Most, however, simply see the measure as another irritating, pointless gesture of authoritarianism. Similarly, prisoners are denied parole but are left in ignorance of the reasons for the decision. Prisoners are informed that the delivery of mail will be delayed—but they are not told why.

Some of the inmate population's ignorance might be described as "accidental;" it arises from what we can call the principle of bureaucratic indifference, i.e., events which seem important or vital to those at the bottom of the heap are viewed with an increasing lack of concern with each step upward. The rules, the commands, the decisions which flow down to those who are controlled are not accompanied by explanations on the grounds that it is "impractical" or "too much trouble." Some of the inmate population's ignorance, however, is deliberately fostered by the prison officials in that explanations are often withheld as a matter of calculated policy. Providing explanations carries an implication that those who are ruled have a right to know—and this in turn suggests that if the explanations are not satisfactory, the rule or order will be changed. But this is in direct contradiction to the theoretical power relationship of the inmates and the prison officials. Imprisoned criminals are individuals who are being punished by society and they must be brought to their knees. If the inmate population maintains the right to argue with its captors, it takes on the appearance of an enemy nation with its own sovereignty; and in so doing it raises disturbing questions about the nature of the offender's deviance. The criminal is no longer simply a man who has broken the law; he has become a part of a group with an alternative viewpoint and thus attacks the validity of the law itself. The custodians' refusal to give reasons for many aspects of their regime can be seen in part as an attempt to avoid such an intolerable situation.

The indignation aroused by the "bargaining inmate" or the necessity of justifying the custodial regime is particularly evident during a riot when prisoners have the "impudence" to present a list of demands. In discussing the disturbances at the New Jersey State Prison in the spring of 1952, for example, a newspaper editorial angrily noted that "the storm, like a nightmarish April Fool's dream, has passed, leaving in its wake a partially wrecked State Prison as a debasing monument to the ignominious rage of desperate men."

The important point, however, is that the frustration of the prisoner's ability to make choices and the frequent refusals to provide an explanation

for the regulations and commands descending from the bureaucratic staff involve a profound threat to the prisoner's self-image because they reduce the prisoner to the weak, helpless, dependent status of childhood. As Bettelheim has tellingly noted in his comments on the concentration camp, men under guard stand in constant danger of losing their identification with the normal definition of an adult, and the imprisoned criminal finds his picture of himself as a self-determinant individual being destroyed by the regime of the custodians.[12] It is possible that this psychological attack is particularly painful in American culture because of the deep-lying insecurities produced by the delays, the conditionality and the uneven progress so often observed in the granting of adulthood. It is also possible that the criminal is frequently an individual who has experienced great difficulty in adjusting himself to figures of authority and who finds the many restraints of prison life particularly threatening insofar as earlier struggles over the establishment of self are reactivated in a more virulent form. But without asserting that Americans in general or criminals in particular are notably ill-equipped to deal with the problems posed by the deprivation of autonomy, the helpless or dependent status of the prisoner clearly represents a serious threat to the prisoner's self-image as a fully accredited member of adult society. And of the many threats which may confront the individual, either in or out of prison, there are few better calculated to arouse acute anxieties than the attempt to reimpose the subservience of youth. Public humiliation, enforced respect and deference, the finality of authoritarian decisions, the demands for a specified course of conduct because, in the judgment of another, it is in the individual's best interest—all are features of childhood's helplessness in the face of a superior adult world. Such things may be both irksome and disturbing for a child, especially if the child envisions himself as having outgrown such servitude. But for the adult who has escaped such helplessness with the passage of years, to be thrust back into childhood's helplessness is even more painful, and the inmate of the prison must somehow find a means of coping with the issue.

The Deprivation of Security

However strange it may appear that society has chosen to reduce the criminality of the offender by forcing him to associate with more than a thousand other criminals for years on end, there is one meaning of this involuntary union which is obvious—the individual prisoner is thrown into prolonged intimacy with other men who in many cases have a long history of violent, aggressive behavior. It is a situation which can prove to be anxiety-provoking even for the hardened recidivist and it is in this light that we can understand the comment of an inmate of the New Jersey State

Prison who said, "The worst thing about prison is you have to live with other prisoners."

The fact that the imprisoned criminal sometimes views his fellow prisoners as "vicious" or "dangerous" may seem a trifle unreasonable. Other inmates, after all, are men like himself, bearing the legal stigma of conviction. But even if the individual prisoner believes that he himself is not the sort of person who is likely to attack or exploit weaker and less resourceful fellow captives, he is apt to view others with more suspicion. And if he himself is prepared to commit crimes while in prison, he is likely to feel that many others will be at least equally ready. But for the moment it is enough to point out that regardless of the patterns of mutual aid and support which may flourish in the inmate population, there are a sufficient number of outlaws within this group of outlaws to deprive the average prisoner of that sense of security which comes from living among men who can be reasonably expected to abide by the rules of society. While it is true that every prisoner does not live in the constant fear of being robbed or beaten, the constant companionship of thieves, rapists, murderers, and aggressive homosexuals is far from reassuring.

An important aspect of this disturbingly problematical world is the fact that the inmate is acutely aware that sooner or later he will be "tested"—that someone will "push" him to see how far they can go and that he must be prepared to fight for the safety of his person and his possessions. If he should fail, he will thereafter be an object of contempt, constantly in danger of being attacked by other inmates who view him as an obvious victim, as a man who cannot or will not defend his rights. And yet if he succeeds, he may well become a target for the prisoner who wishes to prove himself, who seeks to enhance his own prestige by defeating the man with a reputation for toughness. Thus both success and failure in defending one's self against the aggressions of fellow captives may serve to provoke fresh attacks and no man stands assured of the future.

The prisoner's loss of security arouses acute anxiety, in short, not just because violent acts of aggression and exploitation occur but also because such behavior constantly calls into question the individual's ability to cope with it, in terms of his own inner resources, his courage, his "nerve." Can he stand up and take it? Will he prove to be tough enough? These uncertainties constitute an ego threat for the individual forced to live in prolonged intimacy with criminals, regardless of the nature or extent of his own criminality; and we can catch a glimpse of this tense and fearful existence in the comment of one prisoner who said, "It takes a pretty good man to be able to stand on an equal plane with a guy that's in for rape, with a guy that's in for murder, with a man who's well respected in the institution because he's a real tough cookie. . . ." His expectations concerning the conforming behavior of others destroyed, unable and unwilling to rely on the officials for protection, uncertain of whether or not today's joke

will be tomorrow's bitter insult, the prison inmate can never feel safe. And at a deeper level lies the anxiety about his reactions to this unstable world, for then his manhood will be evaluated in the public view.

NOTES

1. Cf. Edwin H. Sutherland, *The Professional Thief* (Chicago: The University of Chicago Press, 1937).

2. Cf. William and Joan McCord, *Psychopathy and Delinquency* (New York: Grune and Stratton, 1956).

3. For an excellent discussion of the symbolic overtones of imprisonment, see Walter C. Reckless, *The Crime Problem* (New York: Appleton-Century-Crofts, Inc., 1955), pp. 428–429.

4. A Western culture has long placed a peculiar emphasis on shaving the head as a symbol of degradation, ranging from the enraged treatment of collaborators in occupied Europe to the more measured barbering of recruits in the armed forces. In the latter case, as in the prison, the nominal purpose has been cleanliness and neatness, but for the person who is shaved the meaning is somewhat different. In the New Jersey State Prison, the prisoner is clipped to the skull on arrival but not thereafter.

5. See T. H. Marshall, *Citizenship and Social Class* (Cambridge, England: Cambridge University Press, 1950).

6. Paul W. Tappan, "The Legal Rights of Prisoners," *The Annals of the American Academy of Political and Social Science* 293(May 1954): 99–111.

7. See Lloyd W. McCorkle and Richard R. Korn, "Resocialization Within Walls," *The Annals of the American Academy of Political and Social Science* 293(May 1954): 88–98.

8. Mirra Komarovsky's discussion of the psychological implications of unemployment is particularly apposite here, despite the markedly different context, for she notes that economic failure provokes acute anxiety as humiliation cuts away at the individual's conception of his manhood. He feels useless, undeserving of respect, disorganized, adrift in a society where economic status is a major anchoring point. Cf. Mirra Komarovsky, *The Unemployed Man and His Family* (New York: The Dryden Press, 1940), pp. 74–77.

9. See Robert M. Lindner, "Sex in Prison," *Complex* 6 (Fall 1951): 5–20.

10. Estimates of the proportion of inmates who engage in homosexuality during their confinement in the prison are apt to vary. In the New Jersey State Prison, however, wing guards and shop guards examined a random sample of inmates who were well known to them from prolonged observation and identified 35 percent of the men as individuals believed to have engaged in homosexual acts. The judgments of these officials were substantially in agreement with the judgments of a prisoner who possessed an apparently well-founded reputation as an aggressive homosexual deeply involved in patterns of sexual deviance within the institution and who had been convicted of sodomy. But the validity of these judgments remains largely unknown and we present the following conclusions, based on a variety of sources, as provisional at best: First, a fairly large proportion of prisoners engage in homosexual behavior during the period of confinement. Second, for many of those prisoners who do engage in homosexual behavior, their sexual deviance is rare or sporadic rather than chronic. And third, as we have indicated before, much of the homosexuality which does occur in prison is not part of a life pattern existing before and after confinement: rather, it is a response to the peculiar rigors of imprisonment.

11. We have suggested earlier, in our discussion of the defects of prison as a system of power, that the nominal objectives of the officials tend to be compromised as they are translated into the actual routines of day-to-day life. The modus vivendi reached by guards and their prisoners is oriented toward certain goals which are in fact shared by captors and captives. In this limited sense, the control of the prison officials is partly concurred in by the inmates as well as imposed on them from above. We will explore this issue at greater length in the analysis of crisis and equilibrium in the society of captives, but in discussing the pains of imprisonment our attention is focused on the frustrations or threats posed by confinement rather than the devices which meet these frustrations or threats and render them tolerable. Our interest here is in the vectors of the prison's social system—if we may use an analogy from the physical sciences—rather than the resultant.

12. Cf. Bruno Bettelheim, "Individual and Mass Behavior in Extreme Situations," in *Readings in Social Psychology,* T. M. Newcomb and E. L. Hartley, eds. (New York: Henry Holt and Company, 1947).

13: Sexual Assaults in Prison / *Report on Sexual Assaults in a Prison System and Sheriff's Vans**

Sexual assaults are epidemic in some prison systems.

Virtually every slightly built young man committed by the courts is sexually approached within a day or two after his admission to prison. Many of these young men are overwhelmed and repeatedly "raped" by gangs of inmate aggressors. Others are compelled by the terrible threat of gang rape to seek protection by entering into a "housekeeping" relationship with an individual tormentor. Only the toughest and more hardened young men— and those few so obviously frail that they are immediately locked up for their own protection—escape penetration of their bodies.

After a young man's body has been defiled, his manhood degraded, and his will broken, he is marked as a sexual victim for the duration of his confinement. This mark follows him from institution to institution. He eventually returns to the community ashamed, confused, and filled with hatred.

This then is the sexual system existing today in some prisons. It is a system which imposes a cruel, gruesome punishment which is not, and could not be, included in the sentence of the court. Indeed, it is a system under which the least hardened criminals and many later found innocent suffer the most. Since it is a system which exists under the aegis of the court and the community, it is the duty of the court and the community to destroy it.

The sexual system can be destroyed by identifying and eliminating the conditions which foster it. But first, the scope and nature of the system must be understood. That is the function of this chapter.

* "Sexual Assaults in Prison," from Report on Sexual Assaults in a Prison System and Sheriff's Vans, an investigation in a major U.S. city (1968), pp. 17–29.

A. Typical Assaultive Patterns

A few typical examples of sexual assaults convey the enormity of the problem. In an earlier draft of this report an attempt was made to couch this illustrative material in sociological, medical, and legal terminology less offensive than the raw, ugly, and chilling language used by the witnesses and victims themselves. This approach was abandoned. The incidents are raw, ugly, and chilling. Any attempt to prettify so outrageous a situation would be hypocrisy. Here then are a few of the stories, told as they really were.

A witness describes the ordeal of John MacNamara, 24 years, and mentally disturbed:

That was June 11th, I was assigned to "E" Dorm. Right after the light went out I saw this colored male, Cheyenne. I think his last name is Boone. He went over and was talking to this kid and slapped him in the face with a belt. He was saying come on back with us and the kid kept saying I don't want to. After being slapped with the belt he walked back with Cheyenne and another colored fellow named Horse. They were walking him back into "E" Dorm. They were telling him to put his hand down and stop crying so the guard will not know what is going on. I looked up a couple of times; they had the kid on the floor. About 12 fellows took turns with him. This went on for about two (2) hours. After this he came back to his bed and he was crying and he stated that they all took turns on me. He laid there for about twenty minutes and Cheyenne came over to the kid's bed and pulled his pants down and got on top of him and raped him again. When he got done, Horse did it again and then about four (4) or five (5) others got on him. While one of the guys was on him, raping him, Horse came over and said "Open your mouth and suck on this and don't bite it." He then put his penis in his mouth and made him suck on it. The kid was hollering that he was gagging and Horse stated "You better not bite it or I will kick your teeth out." While they had this kid they also had a kid named William in another section in "E" Dorm. He had his pants off and he was bent over and they were taking turns on him. This was Horse, Cheyenne, and about seven (7) other colored fellows, two (2) of the seven were brothers.

Horse came back and stated "Boy I got two virgins in one night, maybe I should make it three." At this time he was standing over me, I stated what are you looking at and he said "We'll save him for tomorrow night."

George White, 18 years old:

White stated that he has been in prison since March 29, 1968, and that about a week and a half ago, on Thursday he was in "I" block, his cell was number 926. On this date in the morning after breakfast W. called him into his cell, he went into W's cell, Donald R. was in there also. Further that he had owed Williams 4 cartons of cigarettes. W. said to him that he would have to give the cigarettes back right now or he would have to give them something else. He (White) then started to walk out of the cell and W. pushed him down, W. picked up the window pole, R. picked up a bench and stood blocking the door. R. told him that if he goes to the Guard they are going to get him anyway, there were other men outside the cell.

Further that he walked out of the cell, they were all around him and walked to cell #971 and they pushed him inside. He went over and sat on the toilet seat (clothed). Twin came into the cell, they made him lay down on the floor and Twin pulled his (White's) pants down and made him lay face down. Twin pushed his (White's) legs apart and Twin put his penis into his (White's) rectum, he was on him

until he discharged, when he got through, White saw that he was bleeding from the rectum. Then Twin, W., R., and M. told him that if he went to the Guard their boys would get him to "D" block and he was scared then to tell the Guard. Further that he did cry out when Twin did this to him but the Guard wouldn't be able to hear him because the block is long.

White went on to say that the next day after chow (breakfast) W., M., I., and L. got him in cell #972 (J's cell), they told him that everything is cool now as long as he doesn't tell. Further that he had never been in jail before and he was too scared to tell anybody. Then four of them did it to him, they put their penises into his rectum, J. first, I. second, L. third, M. fourth. Twin did not bother him that time. That after they did this he was bleeding and got sick.

That night R. came into his cell and changed with his partner. R. told him that he would have to do it. When the guard came to check the cells, R. turned over so he wouldn't be recognized. After the guard counted and left R. got on top of him, put his penis into his (White's) rectum and discharged.

William Blake, 19 years old:

On Tuesday morning, the first week of June at about 9:30 a.m., I was in my cell #412 on "D" block and I had started to clean up. A tall heavy set fella came into the cell and asked for a mirror and shaving brush and a comb, and that my cell partner said he could borrow. He then said that he had heard something about me concerning homosexual acts. I told him what he had heard was not true. He then started to threaten me if I didn't submit to him. Then I hit him with my fist in his face before he could hit me. Then about three more men came into the cell, and they started to beat me up too. I fought back the best I could and then I fell on the floor and I got kicked in the ribs. Three guys were holding me while the other one tore my pants off; I continued to fight until one of the guys knocked me out. One of the guys was holding me on the floor and had my arm pinned to the floor. And about 7 or 8 guys came into the cell and they took turns sticking their penises up my a—. When they finished they left my cell, and I was still laying on the floor.

B. Frequency of Sexual Assaults

One hundred fifty-six sexual assaults during the twenty-six month period June 1966 to July 1968 have been documented and substantiated either through polygraph examination, institutional records, or other corroboration. Table 13–1 analyzes by place of occurrence:

TABLE 13-1

	No. of Assaults
Detention Center	81
County Prison	47
House of Correction	21
Sheriff's Vans	7
Total	156

The total of 156 incidents involved assaults on at least 97 different victims by at least 176 different aggressors. Including unidentified victims and aggressors, there may well have been as many as 109 different victims and 276 different aggressors.

The types of assaults were as follows:

TABLE 13-2

Buggery (anal penetration)	82
Sodomy (oral penetration)	19
Attempts and Solicitations with Force or Threats	35
Other Coercive Solicitations to Commit Sexual Acts	20
Total	156

These figures represent only the tip of the iceberg. A number of factors make it possible to document only a tiny fraction of the true total. First, investigators interviewed only 3,304 of the approximately 60,000 persons who passed through the prison system since June 1966. Ninety-four assaults, exclusive of those reflected in institutional records, were discovered. This suggests that had all 60,000 been interviewed, approximately 20 times 94 or 1,880 additional assaults would have come to light.

Second, almost all of the victims who are still in prison are so terrified of retaliation that they are very reluctant to complain. Third, many of the victims and their families want to avoid the shame and dishonor they feel would be attendant upon disclosure. Finally, many of the victims would not even consider disclosure because they themselves mistrust and are hostile to constituted authority.

Taking these factors into consideration, the present investigators conservatively estimate that the true number of assaults in the last two years was approximately 2,000. One guard put the figure at 250 per year in the detention center alone. The superintendent and the wardens agreed that virtually every slightly built young man admitted to the prisons in the past two years was at least approached sexually. They believe that the extent of the assault depended primarily on their individual resistance, except for those inmates who were so obviously incapable of self-defense that the prison could isolate them in one of a small number of maximum security units.

In any event, having established the horrifying number of 156 as an absolute minimum, a controversial estimate of the actual number is unnecessary. The situation is intolerable.

C. The Relationship between Forcible and Consensual Homosexuality

Sexual assaults are a major cause of "consensual" homosexuality in the county prison system. In many, if not in a majority of cases, both continuing and isolated homosexual relationships originate with a gang rape, or with the ever-present threat and fear of a gang rape.

Typically, an experienced inmate, or the leader of a young man's tormentors, will offer protection in return for a "housekeeping arrangement." Many of these perverse marriages of convenience are consummated annually in the county prisons.

Similarly, many individual homosexual acts are possible only because of the fear-charged atmosphere generated by the ease and frequency with which sexual assaults occur. A threat of rape, expressed or implied, will cause an already broken or fearful young man to submit without physical resistance.

Some prison officials are too quick to label such activity "consensual." They should recognize that a youth who parts with his manhood in the face of otherwise certain torture and ruin acts no more willingly than a merchant who parts with his money in the face of a gun.

A homosexual act is truly "consensual" only where both parties are motivated by their own desires without force, threat of force, or fear of force. While it is probably true that in any institution segregated by sex there will usually be more consensual homosexual activity than in the general population, truly consensual homosexual activity must be sharply distinguished from those acts which are a by-product of the assaultive pattern, and which could be eliminated once the assaults were brought under control.

D. Economic Coercion and Homosexuality

Homosexual favors can be purchased with luxuries such as cigarettes, sedatives, stainless steel blades, candy or extra food pilfered from the kitchen. Although theoretically segregated from the general prison population, confirmed homosexuals known as "sissys," "freaks" or "girls" are readily available as male prostitutes. Investigators learned of repeated instances where homosexual "security" units were left unguarded by an overextended and sometimes indifferent staff, and even of some cases where guards unlocked cells housing homosexuals, or turned their backs, so that certain favored inmates could have homosexual relations.

In some instances male prostitutes are created by a combination of brib-

ery, persuasion, and the threat of force. Typically, an inexperienced young man will be "given" cigarettes, candy and other items by another more experienced inmate, who after a few days will demand sexual "repayment." Similarly, an inexperienced inmate will be enticed into large gambling debts and then told to either "pay or f—." Of course, the initial "voluntary" homosexual act indelibly stamps the victim as a "punk boy," and he is pressed into prostitution for the remainder of his imprisonment.

The common thread in this category of cases is the employment of economic advantage to obtain sexual advantage. Unfortunately it is virtually impossible to obliterate economic distinctions between inmates. In a prison economy where a shop-worker earns 15¢ to 25¢ a day, where more than half the inmates have no prison job at all, and where most inmates get little or no help from outside the institution, even a small accumulation of luxuries or money can give an inmate substantial economic leverage.

However, it is the clear duty of prison officials to keep at a minumum the economic power that any inmate might exercise over another. Regrettably, investigators discovered one area where through either gross neglect or indifference, the prison officials completely disregarded this duty. As a result, at least one inmate became so economically powerful that he was able to choose as cellmates a series of young men attractive to him, and sexually subvert each one by bribery.

14: Sexual Tensions in a Woman's Prison / *David Ward / Gene Kassebaum**

Problems in Defining Homosexual Behavior

When we use the term homosexual behavior we are referring to *kissing and fondling of the breasts, manual or oral stimulation of the genitalia, and simulation of intercourse between two women*. Our definition of homosexual behavior does *not* include emotional arousal over another woman, or kissing, handholding, or embracing when these actions are not followed by

* Reprinted by permission from David Ward and Gene Kassebaum, *Women's Prisons* (Chicago: Aldine Publishing Company); copyright © 1965 by David Ward and Gene Kassebaum, pp. 80–93, 98–101.

overt sexual behavior. Our definition of homosexuality thus differs slightly from that of Kinsey, Pomeroy, Martin, and Gebhard, who distinguished between erotic responses to other females, physical contact with other females which, at least on the part of one of the partners, is deliberately and consciously intended to be sexual, and activity resulting in an orgasm.[1]

Staff definitions of what constitutes homosexual behavior at Frontera vary considerably as can be seen in the following excerpts from disciplinary reports describing "immorality":

X and Y were lying across X's bed. Y had an arm across X's abdomen.

. . . sitting in living room with legs across X's lap. Had been spoken to before about physical contacts.

. . . was observed walking on sidewalk in front of cottage—arms entwined about the waist of X. Stood in that position for a few moments before parting.

. . . showering in same stall with Y.

They were sitting very close, kissing occasionally and embracing.

X placed herself in a compromising position which might lead to the commission of immoral acts. Staff found her lying prone on the bed beside Y with her arm around Y.

While checking halls at 7:05 p.m., found X kissing Y on the lips. X was lying on Y's bed. Y was also lying on the bed. There appeared to be no other bodily contact.

I was walking down the hall . . . when my attention was directed to a room occupied by two women, one of whom was bending over the other and kissing her. The woman seated on the bed, leaning way back on it, was X. Bending over her and kissing her so loudly that I could hear the smack of their lips was Y.

X and Y were standing face to face, Y was fondling X with her hand low on X's body and faces were together. X had on only a light-weight robe at that time—not fastened—and she had been told early today to dress before she had company.

. . . X and her friend were found back of the bushes . . . X was lounging with her weight on her arms and her legs sprawled out. The upper part of her body was protected from viewers by Y's trunk as she sat beside and facing her. As I came closer X grabbed the front of her blouse and buttoned it. They went to a bench as I came closer but returned to the same spot and same positions as soon as I left the area.

Two girls were lying on the bed—I could not see their heads and shoulders but their legs were entwined one upon the other. The girl next to the wall had her dress above her waist and the other girl was reaching under her slip with her right hand.

One reason for the ambiguity of some of these write-ups is the apparent reluctance of staff members to describe more explicitly the behavior they observed. Another reason is that with the exception of overt sexual contact, there is an area of judgment which must be exercised in deciding what is a violation of institutional rules. Becker has pointed out that what is regarded as deviant depends on more than the behavior itself:

[Deviant behavior] is the product of a process which involves responses of other people to the behavior. The same behavior may be an infraction of the rules at one time and not at another; may be an infraction when committed by one person, but not when committed by another; some rules are broken with impunity, others are not. In short, whether a given act is deviant or not depends in part on the nature of the act (that is, whether or not it violates some rule) and in part on what people do about it.[2]

During the course of the study the staff, in an effort to reduce the incidence of overt behavioral manifestations of homosexuality on the grounds, were told to write disciplinary reports when physical contact, including handholding, embracing, and kissing was observed. Those women playing the masculine homosexual role were required to allow their hair to grow to a certain length. These specific instructions permitted more ready distinctions between deviant and legitimate behavior than had been the case earlier when "immorality" was not specifically defined. Reports of homosexuality as disciplinary infractions are thus affected by the degree to which the behavior to be sanctioned is explicitly defined. There is no evidence that there has been an actual increase in homosexuality at Frontera, but current rates reflect more precise definitions of homosexual behavior, the extension of prohibitions to previously uncovered areas, and a "drive" on the part of the staff to take action against this behavior.

For some inmates (both homosexual and nonhomosexual), homosexuality does not connote a wide variety of behavioral expressions. They are concerned with reserving that term only for overt sexual behavior. Because some inmates hold hands, walk arm-in-arm, or embrace friends, they do not wish to have these actions construed as manifestations of homosexual involvement. But, as can be seen in Table 14–1, this view is not shared by all inmates. Forty-seven percent of this sample of the inmate population view kissing and handholding as either having sexual connotations, or as symbolic of more explicit sexual behavior. The response of the staff to the same item indicates that overt displays of affection among nonhomosexual inmates will likely raise the suspicion of many staff members.

TABLE 14-1

Staff and Inmate Replies to the Statement:
Handholding and kissing among inmates is usually
evidence of a sexual relationship

	Inmates	Staff
Agree	47%	52%
Disagree	53	48
	100%	100%
Frequency	280	61

No answer: Staff 5% (3)
 Inmates 4% (13)

The difficulty here is that behavior that is permissible in the free world becomes problematic in prison. Once these actions have been defined as meaning more than friendship, they draw suspicious attention on all women. In the following statement the problems caused by acting spontaneously in the prison setting are described by a nonhomosexual inmate:

It's tough to be *natural*. The thing that most of us are trying to accomplish here, we're trying to get our minds at a point to where we can handle whatever comes our way, to get our emotions balanced, to maybe straighten up our way of thinking. You know, it just makes it hard when you're trying to be a natural person—to react to things normally—when the staff won't let you be normal—when you do a normal thing that being a woman makes it normal, and then have them say no, you can't do that because if you do that's personal contact and that's homosexuality. So there's our mental hassle.

I know that when women are thrown together without men or without the companionship of men it makes it pretty rough on them—women being the emotional people that they are. They have to have a certain amount of affection and close companionship. You know, a woman, if she's with a man she'll put her hand on him or maybe she'll reach up and touch him. This is something that a woman does naturally without thinking, and so if a woman has a good friend here, or an affair, she does the same thing because this is her nature. The thing of it is—like I have a friend at the cottage—neither one of us have ever played. We're never gonna play. And if somebody tried to force us into it, we couldn't, wouldn't, or what have you. But being a woman and after being here for quite a while, we put our arms around each other, we don't think there's anything the matter with it, because there's nothing there—it's a friendship. We're walking down the hall, our records are both spotless, she's a council girl, I'm Minimum A [minimum custody classification]. I've never had anything on my record that was bad and my god, the supervisor comes out and says, "Now, now, girls, you know we don't allow that sort of thing here." And we look at her and say "What sort of thing?" "This personal contact." And yet this same supervisor, we saw her up at the corner putting her arm around another supervisor the very same way we were doing. So this is where part of our mental hassle comes in.

At issue here is the interpretation of certain behavior by staff and inmates. While there may be direct evidence of deviance, e.g., two women engaged in mutual masturbation or a woman whose hair is crewcut and whose dress and mannerisms are strongly masculine, problems arise over indirect evidence such as gossip, rumors, and stories about an individual or couple. Such information then forms the basis for what Kitsuse calls "retrospective interpretation" of the behavior.[3] Staff and inmates review and reinterpret the behavior of the couple and find that handholding and walking arm-in-arm, which did not arouse suspicions in the past, may be viewed as evidence of a sexual relationship that has been going on all the while.

Kitsuse, in discussing the nature of evidence for judging one to be a homosexual, notes that there are fewer behavioral gestures and signs which indicate homosexuality on the part of females than males. The masculine appearance of women in the community, for example, is less likely to be linked to homosexual suspicions.[4] This is somewhat less the case in prison where staff and inmates are attuned to clues and symbols of female homo-

sexuality and where differences are readily apparent to a one-sex group living in a small physical area. Thus, judgments about prison homosexuality are based on more than direct evidence of sexual activities.

Another reason for the differences in perception of homosexual behavior is that there are differences in the degree of homosexual involvement. Some women have affectional ties which can be objectively designated as homosexual, without actual intercourse having taken place. One interviewee, for example, reported that shortly after her arrival at Frontera she was asked by an "aggressive acting homosexual" if she *had people* (had a homosexual partner). She was questioned in the other girl's room and during their conversation two other inmates were engaged in homosexual activity on the bed. Our respondent said that in her opinion this was coincidental and was not meant as a demonstration for her benefit. She said, "My friend asked me if I wanted to go with her and I said 'no,' but it wasn't an emphatic 'no.' " She admitted that the "no" was meant and interpreted as "maybe." Her reason, she said, was that she was "curious" about homosexuality. She started seeing the girl frequently, waiting for her each day after work. The other girl soon became "very jealous and possessive" and was angered by the subject's close friendship with a third inmate. Our respondent was by now receiving love notes from her girlfriend which were ". . . pretty passionate, but I thought they were cute so I hid them in my closet where they were discovered in a shakedown. The notes said she wanted my warm body near her, she wanted to have me, etc." In describing this relationship the subject said, "We necked in each other's rooms and kissed and petted, but when she tried to draw me into sexual intercourse, I always stopped her, sometimes by pushing her away and sometimes by saying I heard a staff member coming. I would jump up and run off. . . . [The aggressive girl] was very frustrated and would want me to say why I would go no further, she'd call me cold and want to know why I would stiffen up." The subject claimed that she was "just teasing" and asserted that she "got nothing" emotionally or physically from the necking sessions. She reported that the other girl became so seriously involved with her that she tried to ease things off before the girl was released on parole. She said she did not become more deeply involved because she wanted to maintain her "self-respect" and not because she was afraid that reports of her affair would reach her parents or the parole board.

Clearly the subject derived satisfaction from the attention she received from her friend and a number of her statements suggested that this relationship was meaningful for her. Finally, in discussing homosexual versus platonic relationships, she remarked "maybe I got the wrong girl," implying that she might have been won by a girl who wooed her in a different manner.

While this inmate was regarded by the staff as being homosexually involved, she did not conceive herself to be homosexual. Her effort to maintain a heterosexual self-image took the form of distinguishing between

homosexuality and what she called "playing around." This line beyond which she said she refused to go seems quite similar to the line drawn by women who permit necking, but refuse to "go all the way" to sexual intercourse with men. The subject employed her "rule of thumb" for differentiating homosexual couples from couples who were just friends. She said she would assume that two women are homosexually involved if they "go into a room [cell], close the door and stuff a towel in the wicket" [an eight-by-two-inch slit in each door]. During her "necking sessions," the door to her room was always open. She pointed out that while this action was ostensibly to prevent the arousal of staff and inmate suspicion, it really served to keep the amorous gestures of her suitor in check.

Regardless of her self-image, this inmate behaved in a manner which suggested homosexual involvement to staff and inmates. She embraced her girlfriend, walked hand-in-hand with her and violated prison rules by taking a shower in the same stall with her friend.

The distinction between sexual involvement and sexual restraint is as difficult to make regarding a definition of homosexuality as it is regarding heterosexual behavior in the outside community. The self-conception of our subject and other inmates like her who do not "go all the way" is heterosexual, regardless of what others think. These differences between objective and subjective evaluations of affectional behavior should be kept in mind in considering the estimates of the incidence of homosexuality made by staff and inmates.

The Prevalence of Homosexual Involvement Among Prison Inmates

Once having determined what is meant by homosexual behavior, it is still very difficult to determine accurately the amount of homosexual behavior at Frontera. Homosexuals, like others engaging in any kind of deviant behavior, have a variety of reasons for concealing their activities. Some inmates are fearful that prison staff members will inform their families of their affairs. Many inmates feel that staff knowledge of homosexual involvement hurts chances of early parole and draws extra staff surveillance. Such concerns are not groundless, for the label of homosexual by a staff member has important consequences for the inmate. The designation becomes a permanent part of her file information, available to all the staff. It may affect decisions about her housing and work assignments and other activities in prison, and as a violation of prison rules it calls for an appearance before the disciplinary committee. Being adjudged guilty means punishment and designation as a rule violator in addition to being labeled homosexual. Homosexuality, like other sexual behavior, is private behavior which takes place, for the most part, behind closed doors with only the participants knowing what actually transpires.

While some data on the incidence of female homosexuality in the larger community have been collected by Kinsey and his associates, the general neglect of the women's prison as an object of study is reflected in the fact that there is virtually no reliable information available on the incidence of homosexuality among adult female prison inmates. The one exhaustive study of characteristics and behavior of adult female prisoners (the Gluecks' *500 Delinquent Women*) does not mention homosexuality. Those estimates which are reported in the literature are impressionistic and generally made by prison staff members.

In our effort to judge the number of inmates who participate in homosexual affairs in prison, we distinguished inferences and allegations made by staff members from reports of clinicians, admissions by inmates, and actual observation of sexual activity. Although reports of clandestine behavior based on cases which come to official attention are always underestimates of the true prevalence, such data are worth examining to measure the degree to which official concern is actually implemented in actions taken against such behavior.

Homosexual behavior is indicated in inmate record files in the form of: (1) disciplinary reports; [5] (2) the reports of community investigations by probation officers; (3) case materials from other prisons; (4) reports by psychiatrists and psychologists; (5) admissions by inmates to custodial or

TABLE 14-2

Official Prison Records of Extent of Homosexual
Involvement for Male and Female Prisoners

Homosexual Involvement	Female	Male[*]
None Reported or Inferred	81%	89%
Reported in Prior Confinement Only	2	1
Reported on Outside Only	3	3
Reported in Prior Confinement and Outside, but Not Current Confinement	1	2
Reported Prior to and during Current Confinement	4	1
Observed, Reliably Reported, only in Current Confinement	4	—
Inferred, Alleged only in Current Confinement	3	1
Actual Homosexual Act Never Reported, but Homosexual Traits Ascribed to Subject	2	3
	100%	100%
Frequency	832	972

[*] Inmates of a California medium security prison.

social service personnel. These data for the Frontera population can be seen in Table 14–2, along with comparative data from the medium security prison for men.

In addition to data from the inmates' files, we included on our questionnaire to inmates and staff an item which asked respondents to estimate the number of women who have *sexual* affairs with other women while in prison. The question was so worded as to take into account the ambiguities in the definition of homosexuality, such as the distinction between handholding and explicit sexual activity. As can be seen in Table 14–3, staff and inmate estimates were higher than the 19 percent figure obtained from our examination of official records.

Estimates of the prevalence of homosexuality varied with the method of obtaining the data as well as with the source. In the interviews with forty-five inmates, estimates of the extent of homosexuality were never less than 50 percent, with most respondents estimating 60 to 75 percent. Individual conversations with staff members yielded similar high estimates. In these judgments, made in interview, the respondents knew specifically the kind of behavior in question and the basis on which their estimates were made could be questioned and evaluated.

While there was no major disparity between the estimates of homosexuals and nonhomosexuals, those who had been or were homosexually involved may have tended to enlarge their estimates as they projected their own feelings and experiences. Staff concern with the problems created by homosexuality, such as the frequent requests by inmates for job and housing changes, the need to control and sanction overt displays of affection,

TABLE 14-3

Estimates of Prevalence of Institutional Homosexuality

Replies of women's prison staff and female and male inmates to the statements "A rough estimate of the number of women (men) who have sexual affairs at one time or another with other women (men) in prison would be:"

Estimate of Homosexuality	Women's Prison Staff	Female Inmates	Male Inmates
5 percent or less	12%	12%	29%
15 percent	31	12	25
30 percent	29	25	25
50 percent	14	22	12
70 percent	9	22	6
90 percent or more	5	7	3
	100%	100%	100%
Frequency	58*	263*	744*

*Six staff members, 30 female inmates, and 127 male inmates refused or were unable to make an estimate.

and the distress and anxiety of women unhappy in their affairs, perhaps accounts for the high estimates made by top supervisory, administrative, case work, and clinical personnel.

Reconciling all estimates, including the grossly underreported official incidence of homosexuality and the overestimated reports of some of our interviewees, it appears that about *50 percent of the inmates at Frontera are sexually involved at least once during their term of imprisonment.*[6] (This figure should not be construed to mean, however, that all of those involved were initiated into homosexuality at Frontera.) While about half of the inmate population comes to assume a homosexual role during their sentences, it should be emphasized that *every* inmate at Frontera must come to terms with the homosexual adaptation. Those who reject homosexuality as an attempted solution to their problems must learn to live in a society dominated by homosexual ideology and behavior. This point applies as well to the staff who must become accustomed to working in a community where deviant sexual roles are an everyday fact of life.

The Techniques and the Locale of Prison Homosexuality

Data gathered in interview, such as the statement below, suggested that homosexual behavior at Frontera is characterized by the need to employ a variety of sexual techniques, including simulation of intercourse.[7]

Q. What form does the sexual behavior usually take—oral-genital, breast fondling, manual manipulation, or what?
A. Well, actually, you see, there is what we call *giving some head* [oral-genital contact]. Or what they call *dry fucking*—I don't know how to explain it. That's more or less a *bulldagger's* [a woman who plays the masculine homosexual role] kick, this dry fucking. You get in a position, one's on the top and one's on the bottom, and you more or less use your legs on their sensitive parts to get a rocking motion. Sometimes it's put into an act, at least part of it. Sometimes you combine all of these things together. But all women are different. Some women dig one thing, and some dig another. You have to kind of feel them out but usually, like in a heterosexual relationship, it usually follows a set pattern unless you get with a freak and they're usually freaky about only one or two things. But as a rule it's never a set pattern that's followed, and in a sexual act with a woman her moods and her emotional desires and her physical desires change so fast that you have to change the act five or six times in the course of one act to stay with her feelings, and it takes a while to learn a woman and even after you learn her it's a challenge each time you go to bed with her, to try to stay with her.

While public displays of affection such as handholding and embracing are subject to ambiguous interpretation, the intimate behavior described above makes clear the relationship between two women. Because Frontera is a prison, one might wonder where and under what circumstances it is possible for inmates to engage in such intimate sexual activities. Staff surveillance and punitive sanctions are designed to discourage illicit meetings.

Opportunities for intimacy are limited and usually require the cooperation and silence of fellow inmates, attributes not easily found in a population of snitches. These obstacles, however, do not seem to deter the meetings for several reasons: (1) inmates greatly outnumber staff, (2) lovers take the initiative in setting up meetings, (3) sanctions are viewed as illegitimate or worth risking to demonstrate affection, and (4) lovers can find one or two friends who will help them and keep quiet about their meeting.

The room of one of the lovers is the most frequent locale for sexual activity. It is especially convenient for women who reside in the same cottage, and particularly dangerous when it becomes necessary to rendezvous in the cottage of one's lover, where one of the partners is an obvious stranger in an all-too-familiar group cottage residents. Homosexual activity in one's room, as indicated earlier, usually calls for closing the door. This action may, however, alert the cottage supervisor whose glassed-in office is at the end of the corridor. Two corridors run at forty-five degree and eighty degree angles from each side of the central dining and recreation areas and each set of corridors may be observed from the supervisor's office. Thus the usual practice is for the lovers to utilize a close friend or a trusted inmate to act as a lookout, referred to as *pinning*. This may involve making certain sounds if a staff member comes down the corridor or engaging the staff member in extended conversation in her office. The latter is often done under the guise of discussing an inmate's problems.

In addition to using rooms, some homosexuality takes place in the shower rooms.[8] Fondling and deep kissing may also occur in out-of-the way rooms in various service and industries buildings such as the library and the warehouse. At one time a large semi-trailer truck which brought laundry in and out of the institution, and which was left on the grounds between loads, was reputedly used as a trysting place.

In short, there are a variety of places where inmates may meet despite the rigorous efforts of staff to prevent them. There are not enough staff members to constantly supervise each inmate and until that custodial millennium is reached, lovers will find ways to be together.

NOTES

1. Alfred C. Kinsey, Wardell B. Pomeroy, Clyde E. Martin, Paul H. Gebhard, *Sexual Behavior in the Human Female* (Philadelphia: W. B. Saunders Company, 1953), pp. 452–453.

2. Howard S. Becker, *Outsiders: Studies in the Sociology of Deviance* (New York: Free Press, 1973), p. 4.

3. John L. Kitsuse, "Societal Reactions to Deviant Behavior: Problems of Theory and Method," *Social Problems* 9 (Winter 1962): 250–253. See a related article dealing with the designation of persons as mentally ill, by Thomas J. Scheff, "The Societal Reaction to Deviance: Ascriptive Elements in the Psychiatric Screening of Mental Patients in a Midwestern State," *Social Problems* 11 (Spring 1964): 401–413.

4. Kitsuse, "Societal Reactions," p. 252.

5. For 476 files we tabulated the number of cases of homosexuality reported as violations of institution rules. Eight percent (thirty-eight cases) of this sample received such reports.

There were fifty-three reports for "immorality": thirty-two offenders having a single report, four having from two to five reports, and two with more than six write-ups. Disciplinary reports, like arrest records in the outside community, are clearly not the best source of data on which to base estimates of the incidence of illegal behavior.

6. It should also be pointed out that since we made public our estimate of homosexuality, not one member of the administrative staff, the professional treatment staff, or the inmate population, has agreed with it. All have indicated surprise and said they personally thought the incidence was higher than 50 percent.

7. For additional discussion of the techniques used in homosexual contacts, see Frank S. Caprio, *Female Homosexuality* (New York: Grove Press, Inc., 1954), pp. 19–22; and Kinsey, Pomeroy, Martin, and Gebhard, *Sexual Behavior,* pp. 466–468.

8. Several interviewees made reference to a homosexual activity called the *daisy chain,* which calls for three or more persons to form a line and fondle the person in front of them. This activity allegedly took place in shower rooms where it would be possible for a number of women to be gathered in various stages of undress. Because of the hazard of being observed by the staff and other inmates and the fact that most homosexual behavior is private and personal, this activity is apparently infrequent.

15: Emerging New Prison Structures / *James B. Jacobs**

Prison studies have most often emphasized the inmate code, inmate distributive systems, and the colorful argot roles which are said to be functional for the emergence and persistence of both normative and distributive systems. Little systematic attention has been paid to the significance of racial, political, and religious stratification or to formal inmate organizations. Yet, systems of stratification and formal organizations are the background against which primary groups, attitudes, and individual and group conflict develop. Inmate behavior cannot be understood without reference to these allegiances and commitments.

Donald Clemmer, the pioneer student of this subject, did offer some indication of the significance of intermediate level structures and allegiances among the confined when he spoke of the elite, middle, and hoosier classes.[1] These classes were rooted in preprison residency (urban versus rural) and criminal careers. There was a diffuse sense of class consciousness among the inmates in the penitentiary that Clemmer studied, and we

* James B. Jacobs, "Stratification and Conflict Among Inmates," reprinted by special permission of the *Journal of Criminal Law and Criminology,* (Copyright © 1976 by Northwestern University School of Law, vol. 66, no. 4), pp. 476–482.

may assume that primary group relations developed among individuals already linked by class ties. We may hypothesize that primary groups are formed among members of the same class, faction, or secondary group because of the emotional and to a lesser degree material advantages of friendship cliques. Primary groups, however, do not necessarily reinforce the norms and values of the *inmate society*. Instead they may be said to reinforce the norms and values of those classes and secondary groups from which the primary groups are drawn.

What is at stake in focusing attention on inmate stratification systems and formal organizations is the viability of the background imagery which informs research on prison organization. The view of prisoners as isolated individuals who may or may not become socialized into an inclusive inmate culture through participation in primary groups is no longer useful in describing the contemporary prison. Issues of class and class conflict have been imported from the street into the prison so that inmate society is highly factionated at the intermediate or group level.

New analyses of prison organization must shake loose from the "total institution" model of imprisonment, with its emphasis on individual and small group reaction to material and psychological deprivations. Perhaps a reexamination of the prisoner-of-war camp literature will yield a more fruitful perspective. Descriptions of prisons as diverse as Andersonville [2] and the camps of the Gulag Archipelego [3] have pointed to broad cleavages among inmates based upon preinstitutional allegiances to social classes, and upon participation in subcultures and formal organizations. At Andersonville, the "New Ya'arkers" brought with them a solidarity based upon common cultural antecedents and upon an intact military formal organization. In the Gulag, the common criminals found a latent solidarity which served as a basis for collective action in their roots in a criminal subculture and exploited this solidarity in the brutalization of a weaker class—the politicals.

Racial Stratification

It is not surprising that in recent years of heightened racial consciousness throughout American society, racial identity within prison has become increasingly prominent.[4] Young prisoners today are supplanting their criminal identities with a racial-ethnic identity.[5] The development of race consciousness among blacks in recent years has been documented in the daily press and in a considerable black studies literature. Black awareness is not limited, however, to groups like Panthers and Muslims. It is the most significant referent even for those prisoners without formal and informal group ties.

At Illinois' Stateville Penitentiary, the racial lines are impregnable. It is

unheard of for members of different races to cell together. Even under the ameliorative conditions of the minimum security facility at Vienna (as well as in Illinois' juvenile institutions) Latinos, blacks, and Caucasians constitute three separate and frequently conflicting societies. The following statement of a Soledad prisoner is indicative of the racial tension experienced in California.

CTF-Central at Soledad, California is a prison under the control of the California Department of Corrections. . . . However, by the 1960s the prison had earned the label in the system of "Gladiator School," this was, primarily, because of the never-ending race wars and general personal violence which destroyed any illusions about CTF-Central being an institution of rehabilitation. . . . Two of the wings—O and X—are operated under maximum custody under the care of armed guards. There is no conflict between policy, intent and reality here; these are the specially segregated areas where murder, insanity and the destruction of men is accepted as a daily way of life. It is within the wings that the race wars become the most irrational; where the atmosphere of paranoia and loneliness congeal to create a day-to-day existence composed of terror.[6]

For most of American history, prisons were rigidly segregated societies. Even today, issues of segregation in prison are being debated in the courts.[7] As the movement toward racial equality gained momentum through the 1950s and 1960s, minority groups increasingly came to see themselves as a solidary community. Beyond identifying with primary groups, minority group members began to form formal organizations and to identify with racial leaders.

Heightened racial awareness among whites for whom race was never before a particularly important identification is one consequence of continual racial tension. Whites outside of prison rarely have the experience of having been treated on the basis of their race per se, but on the inside they soon realize that their racial identity has the greatest implications for their inmate career. During the turbulent years of 1970 and 1971, white inmates at Illinois' Stateville Penitentiary began passing messages and meeting secretly in order to organize a common defense against racial harassment by the black majority. More recently, they have begun to organize around neo-Nazi symbolism and ideology. In addition, white inmates appeal to racial solidarity when attempting to coalign with the mostly white custodial force. Tacit coalitions between white inmates and custodians in prison are not at all uncommon. White custodial officers at Stateville in 1972 identified with the difficulties of the white minority and frequently tried to insulate them from vulnerability by finding for them safe "up front" jobs. In California prisons the rapid growth of the neo-Nazi Aryan Brotherhood can be explained as a movement in the direction of racial awareness and solidarity. The broad racial division in the inmate community is the background against which primary and secondary group behavior is to be understood.

The predominance of modern day "super-gangs" at Stateville Penitentiary and other Illinois prisons illuminates the way in which racial solidarity can generate formal organizations that make the prison look like a multi-

national prisoner-of-war camp.[8] Four "super-gangs" (three black, one La-
tino) with alleged memberships of thousands on Chicago streets, have im-
ported their organizational structure leadership hierarchies and activities
into Illinois prisons. What proportion of the many hundreds of Stones,
Disciples, Vicelords, and Latin Kings in Illinois prisons were members on
the streets and how many were recruited in the county jail or at the prison
itself is not known, although gang leaders and independents estimate an
even split. Dozens of interviews with gang leaders, old cons, and young
blacks illuminate the difficulty for those wishing to remain unallied. One
twenty-eight-year-old black who did manage to remain independent at
Stateville for over a year had to fight every day against "recruiters" from
the Stones and Disciples. In the morning he was awakened by taunts and
sundry objects hurled by Stones who where out of their cells for work on
the early shift. In the afternoon, he was regularly required to fight Disciples
in the officers' dining room. An ugly scar on his neck evidences the seri-
ousness of the dilemma. For an individual to remain "neutral" under such
extreme conditions of group conflict may not be possible. If so, the situa-
tion is not substantially different from what has been said to occur within
prisoner-of-war camps, where the apathetic are coerced into joining under-
ground units.[9]

The gangs have attempted to operate in the prisons as they have on the
streets. They have established formal chains of command in cell houses
and on work assignments. They have forced independents out of the prison
rackets and have themselves taken control. In addition, lower echelon
members frequently are involved in the extortion and shakedown of inde-
pendents, blacks, and whites. Finally, the gang leadership, like the leader-
ship of the Jehovah's Witnesses and Black Muslims before them, claim to
be the spokesmen for their "people," and have attempted with varying
success to have the administration accept their interventions in prisonwide
matters as legitimate.

Since 1970, when the gangs rose to prominence in Illinois prisons, there
have been regular outbursts of conflict *between* them. There were gang
wars at Pontiac prison in August 1971 and December 1972, with several
deaths and numerous serious injuries. The first major gang clash at State-
ville occurred in April 1973 and resulted in a prison "lock-up" (prisoners
confined to cells twenty-four hours per day) for more than six months.
Fights on a lesser scale between the groups are a part of the prison's day-
to-day life.

The point here is that the old picture of the prison as an inclusive norma-
tive and moral community toward which the individual had to take a stance
is no longer accurate. The prison is now a conflict-ridden setting where the
major battles are fought by intermediate level inmate groups rather than by
staff and inmates or by inmates as unaligned individuals.

The situation of large-scale gangs actively organizing and competing
within the prisons for prestige, power, recruits, and control of illicit activi-

ties is not unique to Illinois. Similar situations have been reported in California and New York. In California, officials have identified four gangs: [10] Mexican Mafia, Nuestra Familia, Black Guerilla Family, and the Aryan Brotherhood. During 1973, there were 146 stabbings and twenty deaths in California prisons and over the course of the past two years there have been 268 stabbings and fifty-six deaths. Most of these have been attributed to the four gangs and especially to the two Chicano gangs whose combined membership is estimated at 700. On December 14, 1973, the situation came to a head when a guard was stabbed to death and the entire California prison system was placed on "lock-up." [11]

While the California gang situation appears to differ from the Illinois situation in its indigenous prison origins and, in some cases, in its greater politicization, the point remains that the inmate organization in these states is best characterized by latent and manifest conflict between well-organized secondary groups.

Religious Stratification

Membership in traditional religious sects has not historically served as a basis for collective inmate behavior in prison. This may be explained by the fact that traditional Judeo-Christian values are offended by criminals and offer no radical redefinition of their situation upon which organized protest can be based. Unconventional religions, however, have achieved considerable success in providing an ideological shield to the assaults on self-conception that attend imprisonment.

Perhaps the first instance of a large, well-organized secondary group emerging within the prison is represented by the Jehovah's Witnesses.[12] During World War II, 3,992 Jehovah's Witnesses were incarcerated in federal prisons for refusing military service for reasons of conscientious objection. The highly knit, clannish, and well disciplined Jehovah's Witnesses posed a challenge to prison administrators that was never fully resolved.[13]

While the Jehovah's Witnesses were the first group to come to prison with the intention of serving "group time" rather than individual time, their impact was limited to the federal system and to a relatively short number of years. During that time they did engage in numerous work slowdowns, strikes, and other protests involving collective action. Their influence on American prisons is slight, however, in comparison to the sweeping organizational successes of the Black Muslims in prisons across the country.

The Black Muslims are undoubtedly the largest and most organized group ever to reside in American prisons. Their impact upon the field of corrections, particularly on prisoners' rights litigation, has yet to be adequately assessed.[14] Under the direction of Elija Muhammad, the Black

Muslims throughout the 1950s and 1960s strove to become a broad-based mass movement. Prisoners were not excluded from the movement. On the contrary, they were from the beginning, seen as a potentially important source of recruitment. In fact, when Lincoln wrote his history of the Black Muslims in 1961 there were three temples behind prison walls.[15] For convicted men the Black Muslims offered a redefinition of their situation which replaced individual guilt for criminal behavior with an explanation placing blame on white racism and oppression. This allows the individual a rationale by which he can "reject his rejectors." [16] The active proselytization of prisoners into the Muslim religion is alluded to in the writings of both Malcolm X [17] and Eldridge Cleaver.[18] That this Muslim activity within the jails and prisons consisted of more than the self-aggrandizing exploits of a few hard-core members is nicely brought out by Claude Brown in his autobiographical account of life in Harlem in the late 1950s.[19]

It seemed to me that everybody who was coming out of jail was a Black Muslim. While he was raving, I was thinking about this. I said, "Damn, Alley, what the hell is going on in the jails here? It seems that everybody who comes out is a Muslim."

It is scarcely possible at this time to even estimate the numbers of Muslims who have passed through American prisons since World War II. In a survey of a "random sample" of seventy-one wardens and superintendents of federal and state penal institutions across the country in 1967, Caldwell found that 31 percent claimed substantial Muslim activities, while 21 percent acknowledged some or limited Muslim activities.[20] Those administrators who reported no Muslim activities "came from states with relatively small Negro populations and small percentages of Negroes in prison." [21] How many Black Muslims there were in each prison was not asked, but Caldwell cites a correspondence with California prison officials indicating 400 to 500 inmates in California's thirteen major correctional institutions who can be identified as Black Muslims.[22]

At Attica the organizational discipline of the Black Muslims in protecting the D yard hostages and in contributing to the negotiation process during the 1971 turmoil has been extensively reported.[23] The Black Muslims at Attica had a lengthy history of organizing, recruiting, and waging legal battles. By 1960, the Muslim activity had spread rapidly through the whole New York prison system. An Attica inmate testifying before the House Committee on Internal Security in the aftermath of the Attica riot estimated Muslim membership at Attica at 230 to 300.[24] This does not seem an extravagant figure in light of the New York State Special Commission's statement that in March 1971, thirty Orthodox Muslims and 200 members of the Nation of Islam attended the first Muslim service in the history of Attica.[25] In any case, the Black Muslims clearly represented a sizable faction of an inmate population numbering 2,243.

What is significant for our purposes is the contrast this poses to the traditional description of the prison community as composed of primary

groups and solitary men. Today to ask inmates at Attica, Stateville, or San Quentin whether they have two or more close friends (a popular question in studies of prison societies) would not contribute information most relevant to understanding the social organization of prison inmates.

Political Stratification

The allegiance of incarcerated men to political groups is something new in this country. At least until recently, the political parties did not evince much concern with prisons or convicts. Since the prisoners have been disenfranchised in all states either by law or by inability to get to the polls, they were never seen as the basis of a political constituency.

Radical groups, however, have seen in prisoners not merely bodies to swell their membership, but a revolutionary force that needs only to be mobilized. The prison is at the center of radical politics. Revolutionary politics have become a part of prison society through the efforts of prisoners like George Jackson,[26] Eldridge Cleaver,[27] and Huey Newton.[28]

The two most significant radical political groups to emerge to date are the Black Panther party and the Young Lords party, although there also appears to have been a small group of Weathermen and other radicals at Attica.[29] Both the Panthers and the Young Lords figured prominently in the events leading up to the Attica riot, and representatives of both groups were among those in the negotiating party of neutral observers brought to Attica in the hopes of finding a peaceful settlement. Before the House Committee on Internal Security, witnesses estimated the number of Black Panthers at Attica before the riot at 300 [30] and 200.[31] An official of the California Department of Corrections has estimated the membership of the Black Panthers at San Quentin at its height under the leadership of George Jackson to have been 200 to 300.[32]

The Black Panthers have described themselves as a Marxist-Leninist revolutionary party, although in recent years some members have turned toward working within the system. During the late 1960s and early 1970s, radical leaders of the Panthers saw prisoners as a disgruntled, embittered, and potentially revolutionary force. Offering them a redefinition of their situation as "political prisoners," the Panthers sought to earn the commitment of former apolitical individuals. The Panthers linked the prison and its authorities to "repressive" organizations within American society and attempted to generate symbols with appeal for all inmates. This appears to be the contribution of both political and religious organizers within organizations. Their appeal attempts to bridge local cleavages and to subordinate other ties and interests to a more inclusive ideology. Thus, the Panthers argued against racism, for example, urging that white prisoners were also

oppressed victims of reactionary political forces. Huey Newton explained from his cell in Los Padres, California:

The black prisoners as well as many of the white prisoners identify with the program of the Panthers. Of course by the very nature of their being prisoners they can see the oppression and they've suffered at the hands of the Gestapo. They have reacted to it. The black prisoners have all joined the Panthers, about 95 percent of them. Now the jail is all Panther and the police are very worried about this. The white prisoners can identify with us because they realize that they are not in control. They realize there's someone controlling them and the rest of the world with guns. They want some control over their lives also. The Panthers in jail have been educating them and so we are going along with the revolution inside of the jail.[33]

The Young Lords party, composed of Puerto Ricans, began as a Chicago street gang and moved to New York in 1969. Like the Panthers, it describes itself as a revolutionary, anti-imperialist organization guided by Marxist-Leninist principles. At the time of the Attica riot, its membership was estimated to have been twenty-five to seventy-five. Most interesting is their role in carrying out a truce between the Black Muslims and the Black Panthers.

In mid-August, shortly after the transfer of the Muslim leader, officers in one of the exercise yards observed a ceremony that seemed to confirm their worst fears. Standing in a line along one side of the yard, arms folded across their chests, was a group of inmates recognized as Muslims. Facing them was another group, similarly stationed, and recognized as Panthers. Seated and standing around a table between them were leaders of both groups and a number of Young Lords, apparently serving as intermediaries. The officers' apprehensions soared at the prospects of an inmate population unified in its hostility, and capable of speaking with a single voice.[34]

The implications of radical political organization in prison are profound. The prison experience becomes defined as a period for the development of political consciousness and revolutionary organization. Under such circumstances, the "program" of the prison administrator interested in rehabilitation is interpreted as irrelevant, and counterrevolutionary. Political radicals do not want to be adjusted to the system.

This instance toward the formal organization should be distinguished from the position of other groups. The Illinois gangs and the Black Muslims are interested in prison programs. They desire to have their members educated and trained. The gangs might aptly be described as "illegitimate capitalists," as Newton has neatly rephrased Merton's "innovative deviants." The Black Muslims might best be characterized as legitimate capitalists who urge a program of economic self-sufficiency based upon notions of black capitalism. The Chicago gangs have never been cordial to the Panthers, on the streets or in prison. For their part, the Panthers view both gangs and religious groups like the Muslims as counterrevolutionary.

Conclusion

We have attempted to emphasize two main points. First, the individual, primary group and inmate group are not the only relevant units in the social organization of the prison. Indeed, the primary group has been eclipsed as the most important constituent of prison society. We have identified crisscrossing secondary groups active within prison competing for the loyalties of prisoners. No longer can the individual without a primary group be thought of as unintegrated within the prison society. His identity with and participation in various organizations makes him very much *of* the prison.

The model of the lone inmate struggling against the pangs of imprisonment through assimilation into an integrated normative community and through participation in a functional inmate distributive system needs reexamination. The inmate system, at least in some of our larger states, finds inmates committed to racial, political, and religious symbols and to organizations characterized by large size, charismatic leadership, varying degrees of bureaucratic organization, and close contact with sympathetic outside groups.

Perhaps the prison community is more fruitfully viewed as an arena where competing groups seek at each other's expense larger memberships and greater power. In such a struggle the administration may become irrelevant except as it serves as a symbol around which political leaders can unite all dissident factions. The secondary groups described above are rooted in the wider society. Within, the prison conflicts have consequences which may have ramifications beyond the prison walls. Prison should thus be understood as an arena in which solidary groups may emerge, recruit membership, organize for the future, and promote their ideologies.

A revised imagery of the prison community might well have important implication for penal policy at the legislative, judicial, and administrative levels. It must become clear to decision-makers, particularly to those outside the prison world, that "reforms" do not always benefit a solidary and unified inmate community in their struggle to limit the exercise of administration authority. Where the prison community is characterized by organized groups locked in conflict with one another, reforms may have the effect of benefiting one group at the expense of another, or even at the expense of the equilibrium of the social system as a whole. This is not to say, of course, that reforms should not be implemented. Quite the contrary; reforms should be designed, implemented, and evaluated in light of concrete, empirical situations rather than according to a historical imagery which no longer accurately describes the situation.

NOTES

1. Donald Clemmer, *The Prison Community* (New York: Holt, Rinehart & Winston, 1958).
2. John McElroy, *Andersonville: A Story of Rebel Military Prisons* (New York: Arno, reprint of 1879 edition).
3. Alexander Solzhenitsyn, *The Gulag Archipelago* (New York: Harper & Row, 1973).
4. *Official Report of the New York State Special Commission on Attica* (New York: Bantam Books, 1972), p. 119; and Leo Carroll, *Hacks, Blacks and Cons* (Lexington, Mass.: Lexington Books, 1974).
5. John Irwin, *The Felon* (Englewood Cliffs: Prentice-Hall, 1970), pp. 80–82.
6. Micha Maguire, "Racism II," in Robert J. Minton, ed., *Inside: Prison American Style* (New York: Random House, 1970), p. 84.
7. See, e.g., *McCelland v. Sigler*, 327 F. Supp. 829 (D. Neb. 1971).
8. James B. Jacobs, "Street Gangs Behind Bars," *Social Problems* 21 (1974): 395.
9. Michael Walzer, "Prisoner of War: Does the Fight Go On After the Battle?" *American Political Science Review* 63(1969): 781.
10. *Law & Order* 11(1963): 63. For an account of the Chicano organizations in California prisons during the late 1960s see T. Davidson, *Chicano Prisoners: The Key to San Quentin* (New York: Holt, Rinehart & Winston, 1974).
11. *Los Angeles Times,* December 14, 1973, p. 3.
12. S. Mulford and A. Wordlaw, *Conscientious Objectors in Prison, 1940–1945* (1945). It should also be pointed out that the Jehovah's Witnesses presented significant management problems within Nazi concentration camps as well. See Eugen Kogon, *The Theory and Practice of Hell; The German Concentration Camps and the System Behind Them,* trans. Heinz Norden (New York: Berkley Publishing Corp., 1958), p. 43: "One cannot escape the impression that, psychologically speaking, the SS was never quite equal to the challenge offered them by the Jehovah's Witnesses."
13. Perhaps the most unconventional religion is the recently organized prison religion, the Church of the New Song, about which comparatively little is known at this time. See "Church of the New Song," *Christianity Today* 17(1973): 73.
 A two-year sect made up primarily of prison inmates, it is gaining considerable recognition throughout the United States, much to the consternation of corrections officials. The Church of the New Song, founded by Maine-born Harry W. Theriault, who is serving sentences for theft and escape (currently in a La Tuna, Texas prison), seems to focus its doctrines upon the rights of prisoners. Or at least that has been the source of its popularity. Wardens in several federal penitentiaries where the movement is strong have refused to accomodate these "rights," and the prisoners have taken the resulting disputes to courts.
 Theriault has made the most headway in litigation before Federal Judge Newell Edenfield of Atlanta. A year ago Edenfield ruled in effect that the Church of the New Song was a legitimate religious group as worthy of recognition by prison officials as a group of Protestants, Catholics, Jews, or Muslims would be.
 The New Song has a 600-page "Bible" drawn from an assortment of sources and using exotic terminology. Theriault, who calls New Song "the highest fulfillment of the Christian prophecy," has a ministerial license from the mail-order Universal Life Church in Modesto, California. (ULC also elevated a rapist at California's Folsom prison to "cardinal," causing a furor there.)
14. For some suggestion as to the role of the Black Muslims in stimulating litigation on prisoners' rights, see David Rothman, "Decarcerating Prisoners and Patients," *The Civil Liberties Review* 1(1973): 8–30. It is actually remarkable that this movement in the prison has stimulated hardly a single scholarly article.
15. C. Eric Lincoln, *The Black Muslims in America* (Boston: Beacon Press, 1961).
16. Lloyd W. McCorkle and Richard R. Korn, "Resocialization Within Walls," *The Annals of the American Academy of Political and Social Science* 293(1954): 88.
17. Alex Haley, ed., *Autobiography of Malcolm X* (New York: Grove, 1964).
18. Eldridge Cleaver, *Soul on Ice* (New York: McGraw-Hill, 1968).
19. Claude Brown, *Manchild in the Promised Land* (New York: Macmillan, 1965), p. 336.
20. Caldwell, "A Survey of Attitudes Toward Black Muslims in Prison," *Journal of Humanism and Religion* 16(1968): 220.
21. Caldwell, "Survey," p. 221.

22. Caldwell, "Survey," p. 223.

23. Attica, *supra* note 4, p. 123.

24. *Hearings on Revolutionary Activities Directed Toward the Administration of Penal or Correctional Systems Before the House Comm. on Internal Security*, 93d Cong., 1st Sess., pt. 1, at 113 (1973) (testimony of Thomas Henry Hughes) [hereinafter cited as *Hearings*].

25. Attica, *supra* note 4, at 73.

26. George Jackson, *Blood in My Eye* (New York: Random House, 1972); George Jackson, *Soledad Brothers; The Prison Letters of George Jackson* (New York: Coward-McCann, 1970).

27. Cleaver, *Soul on Ice.*

28. Huey Newton, "Prison, Where is Thy Victory?" in Philip S. Foner, ed., *The Black Panthers Speak* (Philadelphia: Lippincott, 1970), p. 75.

29. *Commission on Attica*, p. 118.

30. *Hearings on Revolutionary Activities*, p. 109.

31. Ibid, p. 169 (testimony of John Stratten).

32. Ibid, p. 1184 (testimony of William E. Harkins).

33. Huey Newton, "Huey Newton Talks to the Movement About the Black Panther Party, Cultural Nationalism, SNCC, Liberals and White Revolutionaries," in Philip S. Foner, *Black Panthers Speak*, p. 65.

34. *Commission on Attica*, p. 139.

16: Prisoners' Bill of Rights / *American Friends Service Committee**

Most of the projects discussed would be on more solid ground if a Prisoners' Bill of Rights were implemented. Groups might choose working for this implementation as a primary focus. Progress toward the system of criminal justice we envision cannot proceed very far without the acceptance of basic civil rights for prisoners.

The concept of prisoners' rights stems directly from consideration of human dignity and the rights of citizenship. These rights should not be annulled by the fact of imprisonment. Rights for prisoners, once established, should be tools prisoners can use in influencing public policy about the penal system and in defending themselves against an oppressive bureaucratic system.

The following Bill of Rights for Prisoners is based upon these premises:

1. Prisoners are entitled to every constitutional right exercised by the outside population except for those inherently inconsistent with the opera-

* Reprinted with the permission of Farrar, Straus & Giroux, Inc. from *Struggle for Justice: A Report on Crime and Punishment in America*, prepared for the American Friends Service Committee, copyright © 1971 by Hill and Wang, Inc. (now a division of Farrar, Straus & Giroux, Inc.).

tion of the institution. The burden must be on the institution to show why it is necessary to deprive inmates of certain rights, rather than on the inmates to show why they should not be deprived of them.

2. Since prisons are governmental institutions, the public has a right to information about the operation of prisons and access to the prisons. Prisoners have the right to public scrutiny of prisons for the same reason that the accused have a right to a public trial.

3. Prisoners are persons dependent for their survival and well-being on the same essentials as their fellow citizens outside the walls.

For these reasons the Bill of Rights for Prisoners includes the following:

1. Unrestricted access to the courts and to confidential legal counsel from an attorney of the individual's choosing or from a public defender. Adequate opportunity to prepare legal writs.

2. Freedom from the actuality or threat of physical abuse whether by custodial personnel or other prisoners.

3. Adequate diet and sanitation, fresh air, exercise, prompt medical and dental treatment, and prescription drugs.

4. Maintenance of relationships by frequent meetings and uncensored correspondence with members of the immediate family, personal friends, public officials, and representatives of the community. Regular opportunity for conjugal visitation by the granting of home furloughs.

5. Reasonable access to the press, through both interviews and written articles.

6. Freedom of voluntary religious worship and freedom to change religious affiliation.

7. Established rules of conduct available to prisoners in written form. Prohibition of excessive or disproportionate punishments. Procedural due process in any disciplinary hearing that might result in loss of good time, punitive (involuntary) transfer, or an adverse affect on parole decisions. Due process includes the right to independent counsel, the right to cross-examination, the right to subpoena witnesses, and the right to avoid self-incrimination.

8. Opportunity for the prisoner voluntarily to avail himself or herself of uncensored reading material and facilities especially provided for vocational training, counseling, and continuing education.

9. Opportunity in prison through work-release for work at prevailing wages. Eligibility for Social Security, unemployment compensation, and public assistance benefits upon release. Exclusive title to and control over all products of literary, artistic, or personal craftsmanship produced on the prisoner's own time. Freedom from compulsion to work.

10. A judicial proceeding for the determination of parole that incorporates full due process in the determination of sentence and parole date, including established rules of parole-board conduct. Parole may be revoked only upon conviction of a crime and only after a judicial hearing.

11. Full restoration of all civil rights and privileges upon release from prison. The right to vote in any election in which a prisoner would be entitled to vote if he had not been confined.

12. Unrestricted ability to petition for a redress of grievances. A separate authority with the power to correct instances of maladministration, abuse, or discrimination. Freedom from reprisals for making complaints.

Although prisons even with rights would still be punitive, we feel strongly that the Bill of Rights for Prisoners offers a method of working for change in the justice system that would begin to lessen the human costs of penal coercion. The movement for prisoners' rights runs directly counter to the growth of unfettered discretionary powers; it calls for shifting power from administrators toward those who are on the receiving end. This was vividly illustrated recently by a statement of the New York City commissioner of corrections, when attorneys for accused Black Panthers succeeded in getting the federal court to compel "Corrections" to allow them reasonable opportunity to consult with their jailed clients. The commissioner is, of course, aware that bargain-basement justice, including his own operation, depends upon maintaining a large proportion of "subjects" who are cowed and manipulatable and who do not demand their "rights." When the court order came down against him, his predictable complaint to reporters was: "What if all our inmates demanded the same thing?" Translated, what he said was: What if all our powerless inmates suddenly started demanding rights that defendants with a higher socioeconomic status enjoy as a matter of course?

Recent court decisions are beginning to recognize the constitutional rights of prisoners. A judge ordered the release of inmates of a particularly atrocious jail in Gallup, New Mexico, on the grounds of cruel and unusual punishment. Judge Constance Baker Motley awarded monetary damages to Martin Sostre for having been held in solitary confinement for more than a year. Judge Motley insisted that requirement of due process be met in future disciplinary proceedings. Although this decision is being appealed, this case might be a harbinger of a reversal of the courts' long-standing policy of refraining from interference with prison administration.

Two groups dedicated to fundamental change in the prison system through litigation and other steps have emerged: the Prisoners Rights Council in Philadelphia, which involves agency people, ex-prisoners, and lawyers, and the Coordinating Council for Prisoners Rights in New York. These groups might be the forerunners of a nationwide network enabling the exchange of briefs and legal research.

As prisoners and their lawyers organize around the Bill of Rights for Prisoners, citizen groups can join with them, their families, and the numerous ex-prisoner groups. Particular emphasis should be placed on access to the prisons for public and press to pierce the wall of secrecy behind which the prisons operate. The Bill of Rights provides a useful tool for educating

the public and legislative bodies and could be used as a legislative pro-
posal. Outsiders can help by providing publicity for prisoner demands, by
seeing to it that legal support is available, and by demonstrating their soli-
darity with prisoners' demands to indicate to administrators and govern-
ment the seriousness of their determination that conditions be changed.

17: A Prison Manifesto / *The Folsom Prisoners' Manifesto**

Prison strikes and rebellions have become more commonplace during the
past decade simply because of an increased political awareness on the part
of the prisoner and his or her unwillingness to accept the dehumanization
of prison life. This new awareness is clearly articulated in the manifesto
issued during the Folsom Prison (1970) rebellion. The grievances listed are
real and appalling. The violence that ensued was virtually predictable, for
the indignities suffered by the inmates were either sanctioned or ignored by
those in a position to eliminate them.

The Folsom Prisoners Manifesto of Demands and Anti-oppression Platform

WE THE IMPRISONED MEN OF FOLSOM PRISON SEEK AN END TO THE INJUSTICE
SUFFERED BY ALL PRISONERS, REGARDLESS OF RACE, CREED, OR COLOR

The preparation and content of this document has been constructed under
the unified efforts of all races and social segments of this prison.

 We the inmates of Folsom Prison totally and unlimitedly support the
California statewide prison strike on November 3, 1970, under the united
effort for designated change in administrative prison practice and legisla-
tive policy.

 It is a matter of documented record and human recognition that the ad-
ministrators of the California prison system have restructured the institu-

* From "The Folsom Prisoners Manifesto of Demands and Anti-oppression Platform," in
James E. Turpin, ed., *In Prison* (New York: New American Library, 1975), pp. 201–208.

tions which were designed to socially correct men into the FASCIST CON-
CENTRATION CAMPS OF MODERN AMERICA.

DUE TO THE CONDITIONAL FACT THAT FOLSOM PRISON IS ONE OF THE
MOST CLASSIC INSTITUTIONS OF AUTHORITATIVE INHUMANITY UPON
MEN, THE FOLLOWING MANIFESTO OF DEMANDS IS BEING SUBMITTED:

1. We demand the constitutional rights of legal representation at the time
of all Adult Authority hearings, and the protection from the proce-
dures of the Adult Authority whereby they permit no procedural safe-
guards such as an attorney for cross-examination of witnesses, wit-
nesses in behalf of the parolee, at parole revocation hearings.

2. We demand a change in medical staff and medical policy and proce-
dure. The Folsom Prison Hospital is totally inadequate, understaffed,
prejudicial in the treatment of inmates. There are numerous "mis-
takes" made many times, improper and erroneous medication is given
by untrained personnel. The emergency procedures for serious injury
are totally absent in that they have no emergency room whatsoever;
no recovery room following surgery, which is performed by practi-
tioners rather than board member surgeons. They are assisted by in-
mate help neither qualified, licensed, nor certified to function in oper-
ating rooms. Several instances have occurred where multiple injuries
have happened to a number of inmates at the same time. A random
decision was made by the M.D. in charge as to which patient was the
most serious and needed the one surgical room available. Results
were fatal to one of the men waiting to be operated upon. This is
virtually a death sentence to such a man who might have otherwise
lived.

3. We demand adequate visiting conditions and facilities for the inmates
and families of Folsom prisoners. The visiting facilities at this prison
are such as to preclude adequate visiting for the inmates and their
families. As a result the inmates are permitted two hours, two times
per month to visit with family and friends which of course has to be
divided between these people. We ask for additional officers to man
the visiting room five days per week, so that everyone may have at
least four hours visiting per month. The administration has refused to
provide or consider this request in prior appeals using the grounds of
denial that they cannot afford the cost of the extra officers needed for
such a change. However, they have been able to provide twelve new
correctional officers to walk the gun rails of this prison, armed with
rifles and shotguns during the daytime hours when most of the prison
population is at work or attending other assignments. This is a waste
of the taxpayers' money, and a totally unnecessary security pre-
caution.

4. We demand that each man presently held in the Adjustment Center be given a written notice with the Warden of Custody's signature on it explaining the exact reason for his placement in the severely restrictive confines of the Adjustment Center.

5. We demand an immediate end to indeterminate Adjustment Center terms to be replaced by fixed terms with the length of time to be served being terminated by good conduct and according to the nature of the charges, for which men are presently being warehoused indefinitely without explanation.

6. We demand an end to the segregation of prisoners from the mainline population because of their political beliefs. Some of the men in the Adjustment Center are confined there solely for political reasons and their segregation from other inmates is indefinite.

7. We demand an end to political persecution, racial persecution, and the denial of prisoners' right to subscribe to political papers, books, or any other educational and current media chronicles that are forwarded through the United States Mail.

8. We demand an end to the persecution and punishment of prisoners who practice the constitutional right of peaceful dissent. Prisoners at Folsom and San Quentin Prisons, according to the California State Penal Code, cannot be compelled to work, as these two prisons were built for the purpose of housing prisoners and there is no mention of prisoners being required to work on prison jobs in order to remain on the mainline and/or be considered for release. Many prisoners believe their labor power is being exploited in order for the State to increase its economic power and continue to expand its correctional industries which are million dollar complexes, yet do not develop working skills acceptable for employment in the outside society, and which do not pay the prisoner more than the maximum sixteen cents per hour wage. Most prisoners never make more than six or eight cents per hour. Prisoners who refuse to work for the two- to sixteen-cent pay rate, or who strike, are punished and segregated without the access to privileges shared by those who work. This is class legislation, class division, and creates class hostilities within the prison.

9. We demand an end to the tear-gassing of prisoners who are locked in their cells. Such action led to the death of Willie Powell in Soledad Prison in 1968, and of Fred Billingslea on February 25, 1970, at San Quentin Prison. It is cruel and unnecessary.

10. We demand the passing of a minimum and maximum term bill which calls for an end to indeterminate sentences whereby a man can be warehoused indefinitely, rehabilitated or not. That all prisoners have the right to be paroled after serving their minimum term instead of the cruel and unusual punishment of being confined beyond his minimum eligibility for parole, and never knowing the reason for the extension

of time, nor when his time is completed. The maximum term bill eliminates indefinite lifetime imprisonment where it is unnecessary and cruel. Life sentences should not confine a man for longer than ten years, as seven years is the statute for a considered lifetime out of circulation and if a man cannot be rehabilitated after a maximum of ten years of constructive programs, etc., then he belongs in a mental hygiene center, not a prison. Rescind Adult Authority Resolution 171, arbitrary fixing of prison terms.

11. We demand that industries be allowed to enter the Institutions and employ inmates to work eight hours a day and fit into the category of workers for scale wages. The working conditions in prisons do not develop working incentives parallel to the money jobs in the outside society, and a paroled prisoner faces many contradictions on the job that add to his difficulty to adjust. Those industries outside who desire to enter prisons should be allowed to enter for the purpose of employment placement.

12. We demand that inmates be allowed to form or join Labor Unions.

13. We demand that inmates be granted the right to support their own families. At present thousands of welfare recipients have to divide their checks to support their imprisoned relatives who without the outside support could not even buy toilet articles or food. Men working on scale wages could support themselves and families while in prison.

14. We demand that correctional officers be prosecuted as a matter of law for shooting inmates, around inmates, or any act of cruel and unusual punishment where it is not a matter of life or death.

15. We demand that all institutions that use inmate labor be made to conform with the state and federal minimum wage laws.

16. We demand that all condemned prisoners, avowed revolutionaries and prisoners of war be granted political asylum in the countries under the Free World Revolutionary Solidarity Pact, such as Algeria, Russia, Cuba, Latin America, North Korea, North Vietnam, etc., and that prisoners confined for political reasons in this country, until they can be exchanged for prisoners of war held by America, be treated in accord with the 1954 Geneva Convention; that they and their personal property be respected, that they be permitted to retain possession of personal property and that they not be manacled.

17. We demand an end to trials being held on the premises of San Quentin Prison, or any other prison without a jury of peers—as required by the United States Constitution—being picked from the county of the trial proceedings; peers in this instance being other prisoners as the selected jurors.

18. We demand an end to the escalating practice of physical brutality being perpetrated upon the inmates of California State Prisons at San Quentin, Folsom, and Soledad prisons in particular.

19. We demand that such celebrated and prominent political prisoners as Reies Tijerina, Ahmad Evans, Bobby Seale, Chip Fitzgerald, Los Siete, David Harris, and the Soledad Brothers be given political asylum outside this country as the outrageous slandering of the mass media has made it impossible either for a fair trial or for a safe term to be served in case of conviction, as the forces of reactions and repressions will be forever submitting them to threats of cruel and unusual punishment and death wherever they are confined and throughout the length of their confinement.

20. We demand appointment of three lawyers from the California Bar Association for full-time positions to provide legal assistance for inmates seeking post-conviction relief, and to act as liaison between the administration and inmates for bringing inmate complaints to the attention of the administration.

21. We demand update of industry working conditions to standards as provided for under California law.

22. We demand establishment of inmate workers insurance plan to provide compensation for work-related accidents.

23. We demand establishment of unionized vocational training program comparable to that of the Federal Prison System which provides for union instructors, union pay scale, and union membership upon completion of the vocational training course.

24. We demand annual accounting of Inmate Welfare Fund and formulation of an inmate committee to give inmates a voice as to how such funds are used.

25. We demand that the Adult Authority Board appointed by the Governor be eradicated and replaced by a parole board elected by popular vote of the people. In a world where many crimes are punished by indeterminate sentences, where authority acts with secrecy and vast discretion and gives heavy weight to accusations by prison employees against inmates, inmates feel trapped unless they are willing to abandon their desire to be independent men.

26. We strongly demand that the State and Prison Authorities, conform to recommendation #1 of the "Soledad Caucus Report," to wit:

 "That the State Legislature create a full-time salaried board of overseers for the State Prisons. The board would be responsible for evaluating allegations made by inmates, their families, friends, and lawyers against employees charged with acting inhumanely, illegally, or unreasonably. The board should include people nominated by a psychological or psychiatric association, by the State Bar Association or by the Public Defenders Association, and by groups of concerned, involved laymen."

27. We demand that prison authorities conform to the conditional requirements and needs as described in the recently released Manifesto from the Folsom Adjustment Center.

28. We demand that the California Prison System furnish Folsom Prison with the services of Ethnic Counselors for the needed special services of Brown and Black population of this prison.
29. We demand an end to the discrimination in the judgment and quota of parole for Black and Brown People.

We the men of Folsom Prison have been committed to the State Correctional Authorities by the people of this society for the purpose of correcting what has been deemed as social errors in behavior, errors which have classified us as socially unacceptable until reprogrammed with new values and a more thorough understanding of our roles and responsibilities as members of the outside community. The structure and conditions of the Folsom Prison program have been engraved on the pages of this manifesto of demands with the blood, sweat, and tears of the inmates of this prison.

The program which we are committed to under the ridiculous title of rehabilitation is likened to the ancient stupidity of pouring water on the drowning man, inasmuch as our program administrators respond to our hostilities with their own.

In our efforts to comprehend on a feeling level an existence contrary to violence, we are confronted by our captors with violence. In our effort to comprehend society's code of ethics concerning what is fair and just, we are victimized by exploitation and the denial of the celebrated due process of law.

In our peaceful efforts to assemble in dissent as provided under the nation's United States Constitution, we are in turn murdered, brutalized, and framed on various criminal charges because we seek the rights and privileges of *all American people*.

In our efforts to keep abreast of the outside world, through all categories of news media, we are systematically restricted and punished by isolation when we insist on our human rights to the wisdom of awareness.

18: Anatomy of a Prison Riot: Attica /

*Report of the New York State Commission on Attica**

The Assault

Sunday night was a sleepless night in D yard. Rain fell hard throughout the night, and even the makeshift shelter erected by the inmates for the hostages failed to keep out the downpour.

By dawn, the rain had turned into an intermittent drizzle and the day was gray. As inmates and hostages tried drying themselves over campfires, troopers armed with .270's and shotguns assembled in front of the administration building. The leaders of the various details met with Major Monahan for their assignments, briefing, and warning against a "turkey shoot."

In Mancusi's office, Oswald prepared his final ultimatum to the inmates, and instructed correction officers that no more observers were to be admitted to the prison, and those there, with the exception of Senator Dunne, who was in Mancusi's office, were not to be let out of the steward's room.

THE ULTIMATUM

At 7:40 A.M., Oswald, in the presence of Deputy Corrections Commissioner Dunbar and General O'Hara, met some of the inmate spokesmen at the DMZ and delivered the written ultimatum reading as follows:

For four days I have been using every resource available to me to settle peacefully the tragic situation here at Attica. We have met with you. We have granted your requests for food, clothing, bedding, and water, for medical aid, for an immediate court order against administrative reprisals. We have worked with the special citizens committee which you have requested. We have acceded to 28 major demands which you have made and which the citizens committee has recommended. In spite of these efforts you continue to hold hostages. I am anxious to achieve a peaceful resolution to the situation which now prevails here. I urgently request you to seriously reconsider my earlier appeal that, one, all hostages be released immediately, unharmed, and two, you join with me in restoring order to the facility. I must have your reply to this urgent appeal within the hour. I hope and pray your answer will be in the affirmative.

* *Attica: The Official Report of the New York State Special Commission on Attica* (New York: Bantam Books, 1972), pp. 2–5, 28–82, 104–113, 366–374.

After the ultimatum was read aloud in the yard, the inmates were asked whether anyone wanted to accept. Over 50 percent of the inmates polled by the Commission stated that they were in favor of accepting the 28 points, and against holding out for amnesty. Yet, on Monday morning, only one inmate spoke in favor of accepting the ultimatum. His dissent was so solitary that a member of the inmates' committee urged that the dissenter not be attacked by other inmates who shouted down the ultimatum.

The inmates' committee was, however, reluctant to report the negative response to Oswald. Near the end of the hour deadline, an inmate spokesman returned to the DMZ to speak to Oswald. According to the Commissioner, the following colloquy took place:

Then this individual came back to the gate and said, "What are you going to do about those demands?"
I said, "I don't understand what you're saying."
He said, "Well, you haven't approved the demands."
I said, "Of course, I've approved the demands."
And he said, "I don't know about that."
I said, "Well, I don't know how you can say that because, after all, Mr. Jones went over in detail these demands with you and we sent several copies of them in there."
And he said, "Well, I don't know what you mean."

Dunbar and Oswald were incredulous, but Dunbar produced a copy of the 28 Points and handed it to the inmate. The inmate asked for another 20 minutes to talk it over; Oswald offered 15 minutes, until 9:00 A.M. Oswald then returned to the command center in Mancusi's office, where he remained throughout the day.

What discussions then ensued among the inmate leadership is not completely known. Some inmates have reported hearing voices raised in argument. Whatever the discussion, it ended with a fateful decision on which the inmate population was not consulted, to move some of the hostages to the catwalks in full view of the authorities.

All of the hostages were blindfolded, and some were bound by hands and feet. Eight of the hostages were then removed from the hostage circle—apparently chosen because their feet had not yet been bound, and they were therefore ambulatory. The eight were taken to a trench and told that at the sound of the first shots they would be burned with gasoline. The inmates hoped that the sight of the hostages at the trench would deter the assault. One inmate exclaimed: "This isn't going to work because they are not going to be able to see us." The eight hostages were then led blindfolded to the catwalk where they were fully visible to the police in A and C blocks.

The hostages were spaced in the area near Times Square and A catwalk, facing A and C blocks. Each was held by at least one inmate, most with knives at their throats, or pointed objects at their torsos. They were told

that they would be killed when the authorities made their move. One hostage described it:

> From there he held me with a blunt instrument like—I don't know whether it was a nightstick or a two-by-four or what. Held it in the small of my back and arched my back.
> Then he held something to my throat. At that point all I could feel was like the back of his thumb against my throat.
> We stood there for a while and then he slid over a crate and had me sit down and he gave me a cigarette and I had just taken one or two drags off the cigarette and this other person came along and took it out of my mouth and told us he did not want smoking up there.
> Then we just sat there and then come the time, they were asking, "Are you nervous?" Yeah, I was a little scared, naturally. And he gave me a Tums and he says, "Well, this will do you for now. In a little while it will be all over with anyhow."
> While I had the Tums in my mouth, the one behind me started to comb my hair, he told me he wanted me to die pretty.

This same hostage also told the Commission he had asked, "Why me?" and was told, "Because you're white."

If taking the hostages to the catwalk made them more conspicuous, it also made the inmates guarding them more vulnerable. It would have been far safer for the inmates to have remained with the hostages in the hostage circle. The display of the eight hostages on the catwalk can be understood only as an act of bravado intended to deter the authorities from commencing the assault. The belief persisted among the inmates that the authorities would hesitate to risk the lives of their own.

Back in the hostage circle, inmates were also preparing for the assault. Some hostages have reported that they heard inmates tell their Muslim guards that they were being replaced by a new group who described themselves as "soldiers."

The changeover was, however, not complete. Many Muslim guards remained until the end.[1] A number of the hostages in the circle were held with knives at their throats and told they would die if any inmate was shot.

At about 9:00 A.M. Dunbar, who was the only official waiting by A gate for an answer from the inmates, observed the first hostages being taken to the catwalk near Times Square with their hands behind their backs. Dunbar testified that at 9:12 inmates shouted at him:

> "If you want us, you know what we want. Come and get us."

At 9:22, according to Dunbar, inmates shouted another response down A tunnel to him:

> "Come in now with the citizens' committee and Oswald in D block yard."

Dunbar reported this message to the command center, and replied to the inmates:

"Release the hostages now and Commissioner Oswald and the citizens committee will meet you—with you."

At 9:30, the answer came back from inmates: "Negative, negative."

The ultimatum had been rejected. The last opportunity to halt the assault had now passed.

THE FORCES TAKE THEIR POSITIONS

Following their briefing by Major Monahan early that morning, the various group leaders began assembling their troopers and taking their positions. Some had difficulty rounding up their men and did not get in place until as late as 15 minutes before the assault began. Others were in position even before 9:00 A.M. The two rifle teams on the roofs of A and C blocks had to remain out of sight, lying in a prone position behind the low retaining walls on the roofs for almost 45 minutes before the gas was dropped. Most took quick looks at the activity on the catwalk, and their commanding officers also provided them with descriptions of the locations of the hostages and their executioners. As they took up their positions, the team of troopers on the roof of A block was joined by three correction officers, at least one of whom was accepted as part of the rifle team by the State Police lieutenant in command. All three correction officers were armed with personal rifles equipped with scopes.

The catwalk and rescue details of troopers waited in A and C blocks to move on to the catwalks while beneath them, the tunnel details waited to advance inside A and C tunnels. According to plan, two correction officers were assigned to the rescue detail for the purpose of identifying hostages.

The first objective of the rescue details was to be the barricades which had been erected by inmates on A and C catwalks between the cellblocks and Times Square, about 45 yards from the cellblock doors. The barricade on A catwalk was about 7 feet high and was solidly constructed of chicken wire, chain-link fencing taken from the fence enclosure atop Times Square, and furniture. The C catwalk barricade was only 3 to 4 feet high and had gaps between the pieces of furniture through which a trooper could pass without great difficulty.

On the third floor of A block, one state trooper and approximately 11 correction officers were posed with their guns pointed out of the windows in the direction of D block. Some of the correction officers had shotguns; others were armed with personal rifles or rifles issued from the prison arsenal; one had a submachine gun. The presence of the correction officers was not known to Major Monahan or Inspector Miller.

In addition, three Genesee County Park policemen, armed with shotguns and rifles, stationed themselves at a window in a stairway between the second and third floors of C block.

The troopers and correction officers watched from the cellblock win-

dows and roofs as the eight bound and blindfolded hostages were brought onto the catwalks, and bizarrely garbed inmates paraded the hostages before the loaded guns and shouted taunts to their largely unseen audience.

The eight hostages were spaced along A and B catwalks and on the roof above Times Square, three facing A block and five facing C block. Seven were seated; one kept standing. Beside or behind each hostage stood one or more inmates brandishing weapons. Films show a total of 21 inmates on the catwalks in the immediate vicinity of the hostages just prior to the assault.

Possibly to impress the police and deter the attack, the hostage closest to A block, his head pulled back, was forced to scream over and over again, "I don't want to die." The troopers and correction officers also heard inmates declare their willingness to die and their readiness to kill the hostages and advancing troopers. A black liberation flag was unfurled over D catwalk. Although virtually every State Police member addressing himself to the subject claims that he was able to maintain his calm at the sight of the hostages and inmates on the catwalks, there is evidence from some onlookers that it sharpened the emotions of anger, rage, and fear which had been building up for four days.

The transfer of the eight hostages to the catwalks necessitated a change in plans. Now the sharpshooters on the roof had the mission of not only providing covering fire for advancing troopers, but also attempting to prevent the inmates from slashing the throats of the hostages on the catwalk.

Shortly after the eight hostages were brought on the catwalk, a police captain reported to the command post that the riflemen could probably get a clear shot at most of the inmate executioners. He requested instructions. Inspector Miller replied, "Hold your fire until there is an overt act by the executioners against the hostages." It was left to each trooper's judgment to determine whether the overt act occurred, with the knowledge that if he waited too long the hostage he was expected to protect could be killed.

THE GAS AND THE GUNFIRE

Shortly after 8:45, a yellow helicopter borrowed from the State Conservation Department took off from the side of the prison, and headed toward D yard. This was a decoy, intended to divert the inmates' attention from the gas-laden National Guard helicopter waiting to take off in front of the administration building.

General O'Hara went to the third floor of A block to give the signal for the gas drop. He testified he did not notice the 11 correction officers with their guns pointed out the windows of that gallery. The General picked up his radio set to order the electricity in the prison cut and the National Guard helicopter airborne. But his radio did not work. Finally, a trooper found him and lent him a radio which operated. At 9:44, the General gave the orders: the power was shut off and the National Guard helicopter rose

straight up in front of the administration building, and in a matter of seconds, dropped CS gas on Times Square where the hostages were standing. The time was 9:46 A.M.

As the gas descended, there was movement by the inmates and hostages on the catwalks, and the riflemen on A and C roofs—troopers and three correction officers—commenced firing. Then troopers and correction officers on the third floor of A and C blocks joined in the firing.

Almost simultaneously, troopers began moving out of A and C blocks onto the catwalks. They too began firing. Beneath them, troopers advanced inside A and C tunnels with heavy firing in C tunnel.

Within about three minutes, the catwalk teams had cut through the barricades and moved on to B and D catwalks overlooking D yard. The rescue detail proceeded behind the A catwalk team to B catwalk, dropped its ladders, descended into D yard, and moved toward the hostage circle, with a lieutenant, Joseph Christian, leading the way in a sprint. Meanwhile, a second National Guard helicopter made passes over D yard, dropping canisters of CN gas.

At 9:50, four minutes into the assault, a State Police helicopter began to circle the yard broadcasting a message to the inmates to surrender, but the shooting continued for at least several more minutes. All told, the inmates were under heavy fire for six minutes, though understandably it seemed longer to many inmates. After that, only an occasional round was expended, primarily from gas guns.

THE TOLL

When the shooting ceased, 10 hostages and 29 inmates were dead or dying of bullet wounds inflicted by the authorities; 3 hostages and 85 inmates had suffered nonlethal gunshot wounds, and one trooper—Lieutenant Joseph Christian—suffered leg and shoulder wounds from shotguns fired by troopers trying to protect him. No hostages were killed by inmates on September 13. But two hostages who survived the assault on the catwalks suffered slash wounds on their necks at the hands of inmates—one requiring 52 stitches, the other 30; two of the hostages who were killed by gunfire on the catwalks also had minor nonlethal knife wounds. Several other hostages were struck with blunt instruments wielded by inmates.

No accounting was kept of the ammunition issued to the police and correction officers, but in statements given after the assault, state troopers acknowledged firing 364 rounds; correction officers, 74 rounds; the Genesee County Parks personnel, 12 rounds. Of these, approximately 230 rounds were "00" buckshot from shotguns, each containing at least 9 lethal pellets. Thus, based on acknowledged rounds fired, it may be concluded that, including "00" pellets, at least 2,200 lethal missiles were discharged from the guns of the authorities that day. Almost 10 percent of all persons in the yard were struck by bullets or shotgun pellets, and 13 of the 38 hostages were killed or wounded by the gunfire.

Of those who died, 8 hostages and 13 inmates were struck in D yard, 2 hostages and 13 inmates on the catwalks, 1 inmate in A yard, and 2 inmates in locations which could not be determined on the available information.

All of the hostages struck in D yard were in the hostage compound in the center of the yard, but inmates were killed or wounded in scattered locations in many parts of the yard, Five hostages and 11 inmates were killed by shotgun fire, 10 inmates and 5 hostages by rifle fire, 1 inmate by revolver fire, 6 inmates by a combination of shotguns and rifles or pistols, and 1 inmate by a firearm which could not be identified ballistically. Most of the wounded were hit in D yard with stray "00" pellets. Three hostages and at least three inmates were killed in D yard by rifle bullets fired from the cellblock.

SUMMARY

On the day the Attica uprising began, with smoke still pouring from parts of the prison destroyed by inmates, Vincent Mancusi, then the superintendent of the correctional facility in western New York State, shook his head in disbelief and asked: "Why are they destroying their home?"

Their home was a complex of barred cells 6 feet wide, 9 feet long, and 7 feet high, in buildings hidden from public view by a solid gray stone wall 30 feet high and 2 feet thick, not very different from, and certainly no worse than New York State's five other maximum security prisons. But it did not have to be better or worse than the others for it to explode, as it did, in September 1971. For the Atticas of this country have become lethal crucibles in which the most explosive social forces of our society are mixed with the pettiness and degradation of prison life, under intense pressure of maintaining "security."

The titles "correctional facility," "superintendent," "correction officer," and "inmate," which the Legislature bestowed on the prisons, wardens, guards, and prisoners in 1970 were new. But these euphemisms expressed goals that dated back to the founding of the modern prison system in the early 19th century by men who believed that prisons should serve the purpose of turning prisoners into industrious and well-behaved members of society. Prison administrators throughout the country have continued pledging their dedication to the concept of rehabilitation while continuing to run prisons constructed in the style and operated in the manner of the 19th-century walled fortresses. "Security" has continued to be the dominant theme: the fantasy of reform legitimatized prisons but the functionalism of custody has perpetuated them.

The rhetoric about rehabilitation could not, however, deceive the men brought together inside the walls: the inmates, 54 percent black, 37 percent white, and 8.7 percent Spanish-speaking, almost 80 percent from the cities' ghettos, and the correction officers, all white and drawn from the rural areas in which we build our prisons.

For inmates, "correction" meant daily degradation and humiliation:

being locked in a cell for 14 to 16 hours a day; working for wages that averaged 30 cents a day in jobs with little or no vocational value; having to abide by hundreds of petty rules for which they could see no justification. It meant that all their activities were regulated, standardized, and monitored for them by prison authorities and that their opportunity to exercise free choice was practically nonexistent: their incoming and outgoing mail was read, their radio programs were screened in advance, their reading material was restricted, their movements outside their cells were regulated, they were told when to turn lights out and when to wake up, and even essential toilet needs had to be taken care of in view of patrolling officers. Visits from family and friends took place through a mesh screen and were preceded and followed by strip searches probing every orifice of the inmate's body.

In prison, inmates found the same deprivation that they had encountered on the street: meals were unappetizing and not up to nutritional standards. Clothing was old, ill-fitting, and inadequate. Most inmates could take showers only once a week. State-issued clothing, toilet articles, and other personal items had to be supplemented by purchases at a commissary where prices did not reflect the meager wages inmates were given to spend. To get along in the prison's economy, inmates resorted to "hustling," just as they had in trying to cope with the economic system outside the walls.

The sources of inmate frustration and discontent did not end there: medical care, while adequate to meet acute health needs, was dispensed in a callous, indifferent manner by doctors who feared and despised most of the inmates they treated; inmates were not protected from unwelcome homosexual advances; even the ticket to freedom for most inmates—parole— was burdened with inequities or at least the appearance of inequity.

For officers, "correction" meant a steady but monotonous 40-hour-a-week job, with a pension after 25 years' service. It meant maintaining custody and control over an inmate population which had increasing numbers of young men, blacks, and Puerto Ricans from the urban ghettos, unwilling to conform to the restrictions of prison life and ready to provoke confrontation, men whom the officers could not understand and were not trained to deal with. It meant keeping the inmates in line, seeing that everything ran smoothly, enforcing the rules. It did not mean, for most officers, helping inmates to solve their problems or to become citizens capable of returning to society. For the correction officers, who were always outnumbered by inmates, there was a legitimate concern about security; but that concern was not served by policies which created frustration and tension far more dangerous than the security risks they were intended to avert.

Above all, for both inmates and officers, "correction" meant an atmosphere charged with racism. Racism was manifested in job assignments, discipline, self-segregation in the inmate mess halls, and in the daily interaction of inmate and officer and among the inmates themselves. There was

no escape within the walls from the growing mistrust between white middle America and the residents of urban ghettos. Indeed, at Attica, racial polarity and mistrust were magnified by the constant reminder that the keepers were white and the kept were largely black and Spanish-speaking. The young black inmate tended to see the white officer as the symbol of a racist, oppressive system which put him behind bars. The officer, his perspective shaped by his experience on the job, knew blacks only as belligerent unrepentant criminals. The result was a mutual lack of respect which made communication all but impossible.

In the end, the promise of rehabilitation had become a cruel joke. If anyone was rehabilitated, it was in spite of Attica, not because of it. Statistics show that three-quarters of the men who entered prison in New York State in the sixties had been exposed to the "rehabilitative" experience in prison before. If Attica was a true model, then prisons served no one. Not the inmates, who left them more embittered than before. Not the correction officers, who were locked into the same confinement and asked to perform an undefined job made impossible by the environment. Not the prison officials, who became accomplices in maintaining the fiction that maximum security prisons serve a useful purpose. And not the public, which requires penal institutions that serve a useful role in the reduction of crime.

The following chapters describe the reality of Attica and the state's prison system as the Commission found it. The only bright spots at Attica were two experimental programs available to less than 4 percent of the inmates—the Division of Vocational Rehabilitation (DVR) and work release. These programs showed that when inmates were given responsibility and the opportunity to engage in meaningful activity, rehabilitation was possible.

In less time than it will take to implement those principles, most of the inmates now at Attica will be returned to the streets, and every risk that the prisons have declined to take in affording these men the freedom and opportunity to develop a sense of self-control will be passed to the public. There is no rebuttal to the testimony of one inmate shortly after his release from Attica:

The taxpayers paid thousands of dollars per year to keep me incarcerated. They didn't get anything for their money. It was a waste.

THE INMATES

There were 2,243 inmates at Attica in September 1971. Statistics maintained by the department show the following:

Race: 54 percent of the population was black, 9 percent Puerto Rican, and 37 percent white. Attica had a slightly larger white population than the 33 percent total in the state correctional system, because of its role as a receiving institution for a predominantly white, rural area.

Age: 40 percent of inmates were under 30 years old.

Crime: 62 percent of the inmates were convicted of violent crimes including homicide, robbery, assault, and rape; 14 percent were convicted of burglary; and 9 percent were convicted of possession or sale, or both, of drugs.

County of Commitment: 77 percent of the inmates were committed from urban areas: 43 percent from New York City and 34 percent from Buffalo, Rochester, and Syracuse.

Education: 80 percent had not completed high school, 16 percent had; an additional 4 percent had gone beyond high school.

Drug Use: 28 percent of the inmates admitted they used drugs when they entered Attica although only 9 percent had been committed there after conviction for possession or sale. The 28 percent figure may be low, because the institution did not attempt to verify inmates' statements. Marijuana was considered a drug in compiling these figures.

Prior Record: Almost 70 percent of the population had served time in a state, Federal, or local prison before coming to Attica. Only 12 percent had no prior police record; the remainder had been arrested but not convicted, or had been given probation after conviction.

Parole and Conditional Release Violators: Approximately 155 inmates, or 7 percent of Attica's population, were serving the balance of interrupted terms, after their parole or conditional release had been revoked for various violations.

Sentences: More than half the inmates had an unspecified minimum sentence which was to be set by the parole board after an initial ten months' incarceration. The term set could not be less than ten months, nor more than one-third of the inmate's maximum sentence. Fifty-five percent of the population had a maximum sentence of 7 years or less.

These figures profile the trends which characterized inmates admitted to state prisons over the preceding five years: the number of black and Spanish-speaking inmates increased; more and more inmates came from urban areas; they were younger, were more likely to admit drug use, and had shorter sentences. These trends are important elements in the themes of several succeeding chapters.

Whatever their background, Attica inmates share one experience in common—they have been through the criminal justice system in the state.

Many blacks, as the National Advisory Commission on Civil Disorders (Kerner Commission) observed, believe that there is a " 'double standard' of justice and protection" for blacks and whites. There are similar inequities between rich and poor. Both white and black inmates thus arrive at Attica convinced that the entire judicial system is hypocritical and unjust.

As members of the lowest income class, most inmates cannot afford to make bail after arrest, and they spend months in county or city jails awaiting disposition of their cases. They see others who are accused of similar or more serious crimes go free on bail. Thus, no matter how serious their

crimes, most inmates enter prison conscious that they are being detained before trial not for what they are accused of doing, but because they are poor.

Inmates are further reminded of the relationship between money and justice when they are assigned over-worked Legal Aid lawyers or public defenders.

But what makes inmates most cynical about their preprison experience is the plea bargaining system. Under this system, criminal defendants are offered the opportunity to plead guilty to a lesser offense if they are willing to forego a trial. Plea-bargaining has become a part of the state criminal justice system, which lacks the personnel to try more than 4,000–5,000 of the 32,000 felony indictments returned each year.

Even though an inmate may receive the benefit of a shorter sentence, the plea-bargaining system is characterized by deception and hypocrisy which divorce the inmate from the reality of his crime.

The New York Joint Legislative Committee on Crime headed by Senator John H. Hughes described the process:

> The final climactic act in the plea bargaining procedure is a charade which in itself has aspects of dishonesty which rival the original crime in many instances. The accused is made to assert publicly his guilt on a specific crime, which in many cases he has not committed; in some cases he pleads guilty to a non-existing crime. He must further indicate that he is entering his plea freely, willingly, and voluntarily and that he is *not* doing so because of any promises or considerations made to him.[2]

The system also results in unequal sentences for the same conduct, depending on whether the inmate is willing or able to strike a good bargain. In upstate New York, where court calendars make pressure for plea bargaining less intense, sentences tend to be more severe than in New York City. An inmate who commits a property crime, such as burglary, may find himself in a cell next to an inmate who committed a violent crime but who, because of a plea bargain, was permitted to plead to a lesser offense and received a shorter sentence.

The Hughes Committee made a study of prisoner attitudes toward plea bargaining at Attica, Greenhaven, and Ossining prisons and found that almost 90 percent of the inmates surveyed had been solicited to enter a plea bargain. Most were bitter, believing that they did not receive effective legal representation or that the judge did not keep the state's promise of a sentence which had induced them to enter guilty pleas.

As the Hughes Committee observed, the large segment of the prison population who believe they have been "victimized" by the courts or bar "are not likely to accept the efforts of another institution of society, the correction system, in redirecting their attitudes." The Hughes Committee warned that no program of rehabilitation can be effective on a "prisoner who is convinced in his own mind that he is in prison because he is the victim of a mindless, undirected, and corrupt system of justice."

The prison vans brought to Attica men whose experiences in court made

them cynical about the system of justice. The experiences that awaited them there only made them even more antisocial.

FIRST IMPRESSIONS—RECEPTION AT ATTICA

Inmates entered Attica's front gate in leg-irons and shackles, and were processed at the reception building. They exchanged their street clothes for gray prison garb, were searched for contraband, fingerprinted, photographed, assigned a number, given a haircut, and told to fill out forms. They were then taken to one of the cell galleries in A block reserved for incoming inmates; on September 9 there were three such companies.

Once there, inmates received a bar of soap and a roll of toilet paper. They were kept in their cells 24 hours a day—"keeplocked"—until a "P.K.'s interview" with the Deputy Superintendent, usually within two days. The P.K. sought to determine whether the inmate had job skills or interests and any special problems: enemies in Attica or homosexuality. After the interview, inmates were allowed to leave their cells only to go to meals and to the yard.

For a few years prior to November 1970, a rulebook—printed only in English—was given to new inmates. After that no money was available to print new books. Most of an incoming inmate's orientation was provided by parole violators and recidivists in the reception company who had been there before.

Some interviewing and testing was conducted during the initial reception period. Counselors spoke with new commitments and prepared case analyses, which contained biographical and criminal information and program recommendations. Inmate transfers were accompanied by their case analyses from another institution. A test to determine their academic level was also administered to new inmates; each man was visited by a chaplain; and a complete physical examination was performed. Until the beginning of 1970, when they were discontinued for lack of staff, psychological tests were also given.

These activities did not begin to fill the day. Apart from trips to the mess hall for meals and a few hours in the yard, new inmates spent 18 to 20 hours in their cells every day with only the prison radio station for diversion. Not even the prison library was open to them.

Until they were given an assignment to a job or program, which took four to eight weeks, inmates remained in a reception company. The assignment determined in which block the inmate would live thereafter.

It was the Deputy Superintendent's responsibility to make individual inmate work assignments, with particular emphasis on security. Recommendations for jobs of new inmates and parole violators were made by a seven-member assignment board [3] which met once a week to interview inmates. Transferees were assigned directly by the Deputy Superintendent.

Inmates testing below a fifth-grade reading level were required to go to school. Apart from that, assignment board members were theoretically

guided by two criteria: the skills and preferences of the inmate, based on his case analysis and his statements to the board, and job vacancies. In practice, not only were inmates often unaware of the jobs that existed, and thus unable to state a preference, but even the board did not have current information on job vacancies. The Dep., who was free to disregard the board's recommendations, made the final decision.

Since the uprising, a number of changes, largely designed to limit the autonomy of the Deputy Superintendent, have been made in the job assignment procedure. The assignment board is now informed of job openings, and all inmates, including transferees, are interviewed by the board before being placed. While the Deputy Superintendent still reviews the board's decisions, any changes he makes are discussed with a board member. Moreover, the board's new practice is to review an inmate's performance at his assignment at 30- and 60-day intervals.

HOW INMATES SPENT TIME

Once among the general population, inmates' lives settled into a routine which varied very little through the entire term of their sentences. They were alone in their cells 14 to 16 hours a day. At the same hours each day they left their cells for work or school (5 hours for most), recreation in the yard (an average of 1–1½ hours), and for meals (20–40 minutes each). "Call-outs" for weekly showers, commissary trips, packages, visits, sick call, parole officer interviews, or other special appointments were scheduled during the day and interrupted work or school time. On weekends, when most inmates did not work, there was more yard time, with some organized sports, religious services, and, from October to April, when it was cold in the yard, an afternoon movie. For many inmates, weekends signaled increased idleness in their cells.

Inmates were not permitted to walk through the institution unescorted without a pass, and as a general rule, they walked in two columns from place to place accompanied by officers who always walked behind them giving voice commands.

On July 4, inmates were permitted to roam from yard to yard. For the remaining 364 days of the year they were limited to their own cellblock's yard; and since men assigned to the same work details lived in the same blocks, inmates could see friends from other blocks only if they were at the mess hall, sick call, commissary, or other central location at the same time. Thus, the security-conscious administration created five separate prisons within the walls of Attica.

Cell Time: Inmates were locked in every evening at 5:50,[4] until breakfast the next morning at 6:30. The original 19th-century therapeutic justification for isolation had long since been discarded; but the routine of solitude still served the needs of economy and security. According to the administrators, there were insufficient officers to assure security for evening programs, and most inmates could not be trusted outside their cells without

supervision. Locking inmates up at night was the cheapest way to assure safety.

Cells at Attica are small cubicles approximately 6 feet wide, 9 feet long, and 7 feet high. A, B, and D block cells have three solid walls and a fourth consisting only of iron bars. The nearest window is across the corridor, 8 feet away. C block cells have a window in the back wall, and a heavy metal door with a small grilled opening; from the inside they seem to afford more privacy. All cells contain a bed, a stool, a small table, a two-drawer metal cabinet, a naked light bulb, earphones for the radio system, a toilet, and a cold-water sink. There is not much room left for a man to move about.

Inmates could talk until the 8:00 P.M. silence bell and then read, write, or study until lights out at 11:00 P.M.; [5] they could also listen to the three-channel radio until midnight. Men with six months' good behavior and sufficient money could apply to the Superintendent for a hobby permit and order crafts material through the mail.

Communication on the galleries was difficult. Cells were side by side and back to back, and inmates could only look down the gallery through mirrors they held outside the bars. Messages and books were delivered hand to hand from cell to cell. In the many idle hours adjoining inmates played chess, checkers, or cards on boards placed on the floor between the cells or they called out moves on numbered boards.

Legal work or cell study programs filled other time but the noise level in the early evening when inmates communicated by shouting across the gallery was distracting. The light bulb had no shade and because of the antiquated wiring system could not be stronger than 60 watts.

In spite of these handicaps, working on their own legal cases was a major occupation for many inmates. Once an inmate's direct appeals from his conviction were exhausted, free legal help was often unavailable. Nevertheless, most inmates kept alive the hope of freedom by filing petitions for writs, often in several courts at a time, which they often prosecuted themselves. In addition, in the wake of recent court decisions on prison conditions, the number of civil lawsuits by inmates concerning their grievances was increasing.

The institution maintained a law library for use by inmates, but its collection was limited.[6] Moreover, inmates had to take turns using it, could not remove the books, and had to copy relevant authorities out longhand. Once back in their cells, inmates spent long hours painstakingly drafting and redrafting their writs.

Several inmates gained considerable skills in legal work and became respected "jailhouse lawyers." These men were much in demand to assist other inmates. One such inmate, who had studied law through correspondence courses, became so proficient that in July 1972 he conducted a trial before a Federal Court jury on a claim he had filed against the detective who had arrested him in 1962, and won a $7,500 judgment.[7]

Cells were searched at sporadic intervals for weapons and contraband; it was a reminder to inmates, if they needed one, that privacy is illusory in prison. Officers were directed to "use care and not destroy personal property, [and] . . . not to make a shambles of the cell or misuse items belonging to the inmates." [8] But as one inmate described a cell search: "They don't have to live there . . . they pull the books off the wall and throw them on the bed and turn the mattress over. When they get done they walk out." For inmates whose cells held all of their carefully preserved possessions, these forays represented a trespass.

Work and Other Programs: Five of the eight or ten hours inmates spent out of their cells each weekday were allotted for work or school; they were in reality primarily opportunities for socializing between inmates.

Part of the problem was caused by unavoidable featherbedding. There were too many inmates for too few jobs and places in school. Men swept and mopped the same already clean section of floor several times a day. Others stood by in the metal shop while one of them used a machine to which three or four were assigned. Most assignments to the school were for a half day and inmates were given a work assignment for the other half. Even so, teachers complained that classes were too large to be effective. Even if an inmate began with some desire to develop work habits, or achieve a sense of ability and accomplishment, he soon fell into the pattern of lethargy which prevailed among the other inmates. Some, but not many, preserved and acquired skills or improved their educational level. Roughly 60 percent of the men at Attica in September 1971 worked at jobs related to the maintenance of the prison; 20 percent worked in the industrial shops; and another 20 percent were divided among the school (12 percent), vocational classes (5 percent), and the special Division of Vocational Rehabilitation program housed in E block (3 percent). Six inmates participated in a work-release program. Wages ranged from 25¢ to $1.00 per day.

In theory, work was not compulsory at Attica. But inmates had the choice of working or being keeplocked without pay until they changed their minds.[9]

Institutional Maintenance: Prior to the uprising, about 1,400 men were assigned to jobs which helped maintain the prison. The jobs could have been handled by a small fraction of the assigned inmates, but featherbedding kept more inmates busy, at least part of the time. Assignments fell into three categories: "inside," "outside," and "servicing other inmates."

Inside assignments included porters who performed janitorial duties, and carpenters, electricians, plumbers, masons, painters, roofers, and locksmiths.

Jobs as clerks and messengers ("runners") were among the most coveted positions in the prison, because they carried with them status and privileges. Clerks assisted in record-keeping in the blocks and in the hospital and other offices. They worked closely with officers, with whom they

could develop helpful relationships, and had first access to prison scuttle-butt. The prison's six runners had passes and were allowed to move through the institution without an escort.

There were approximately 300 jobs in outside work gangs and at the farm, where some meat (mostly pork), dairy products, and vegetables were produced for the mess halls. All outside jobs were considered desirable assignments except the "grading" companies, which did menial labor in-side the walls, such as shoveling snow. The term "grading company" origi-nated when Attica was built and the uprooted land had to be graded and rocks removed. In recent years, the grading companies were often idle and largely reserved for "incorrigible troublemakers."

Other outside work included the grounds crew for the Superintendent's house, and utility gangs, which maintained the prison lawns and parking lots outside the walls; the farm crew; the coal gang, which unloaded incom-ing coal cars; and the disposal detail, which eliminated the institution's trash and waste.

The coal gang was considered one of the best assignments: the officer in charge kept a coffeepot going all day and allowed the inmates to tend their own vegetable patch in the work area. In addition, as one inmate testified: "It's a seven-day-a-week job and that's a help. It gets you out of the cell and it kills time . . . and by and large, it's the best of a bad lot."

Jobs in food service, the commissary, the laundry, and the hospital were also considered among the better assignments. Inmates in the kitchen and mess halls worked seven days a week and were permitted to take extra food back to their cells. The commissary had similar fringe benefits. Laun-dry workers had clean clothes as often as they liked, and they could make "contacts" with other inmates to do their laundry. Inmates assigned to work in the hospital had the advantage of being able to live in rooms on the hospital's third floor, rather than in cells.

Industry: Approximately 450 inmates—76 percent of them black and Spanish-speaking—worked in the metal shops at Attica assembling shelv-ing, lockers, cabinets, and tables. The professed purpose of prison industry was "to teach inmates occupations and skills and to develop good work habits comparable to and employable in free industry." [10] But the supervi-sor of the industrial shops at Attica was quick to add, "We have to make a profit as well. . . . If we don't make a profit, we don't exist. How will we get money for the new equipment?"

Under a state law adopted at the urging of organized labor, goods made in prison can only be sold to the state, state agencies, and municipalities. Revenues from all prison industries in the state were pooled and used to pay the salaries of civilian industrial supervisors and inmates' wages, and to purchase raw materials and new machinery.

Conditions in the metal shops at Attica precluded for all but a few any hope of achieving vocational skills and good work habits. Featherbedding was the main problem; supervisors had no control over the number of men

assigned to the shops, and there was work for only 250 of the 450 inmates assigned at the time of the uprising. Nothing close to a normal workday was possible. The four to five work hours were punctuated by lunch and midday count, and call outs for commissary, showers, packages, lawyers, and other visits.[11]

The metal shops were also used as a dumping ground when no other jobs were open for incoming inmates, or for inmates who had difficulty in other jobs. Few inmates who heard about the metal shops before being assigned there began with any motivation; once there, they found nothing to encourage them. Most jobs were mechanical and repetitious. Others were also dirty, and a shower was available only once a week, although a few metal-shop inmates who unloaded steel were able to shower almost daily. In the summer, the shops were shut down only when the temperature reached 90° inside. Among inmates, the metal shops were notorious for "bandits" (homosexuals). With half the men idle while the other half manned machines, gambling was widespread.

The industrial supervisor testified that inmates in the metal shop who were self-motivated "could acquire skills that were usable on the outside." However, he could not estimate how many inmates found jobs in related industries on the outside, because the prison had no placement service and made no effort to cultivate outside employers to hire inmates upon release.

Conditions in the metal shop were not the only grievance of inmates working there. They felt that they were being exploited. They saw their labor, compensated at an average rate of 30¢ to 50¢ per day, used to produce profits of $150,000 in the year prior to the uprising. The cycle of generating profits to buy new machinery and to pay their supervisors was not viewed sympathetically by inmates.

Job Discrimination: Even inmates who had "good" jobs believed there was racial discrimination in job assignments. The Commission's examination of the racial breakdown of inmates in various jobs and the statements of prison officials who made the assignments supports this claim.

Although they constituted only 37 percent of the total population, white inmates constituted 74 percent of the workers in the powerhouse, 67 percent of the clerks, 70 percent of the runners, 62 percent of the help in the officers' mess, and 54 percent in the inmates' mess halls, the commissary, and the farm. White inmates held more than half of the positions in 11 job categories; of these, 10 were considered highly desirable.

In contrast, 76 percent of the inmates in the metal shop and 80 percent of those in the grading companies—both regarded as undesirable jobs—were black and Spanish-speaking, although blacks constituted 54 percent and Spanish-speaking inmates only 9 percent of the Attica population. None of the clerks, runners, officers' mess, or commissary inmates was Spanish-speaking.

There were, however, some "good" jobs in which blacks predominated,

such as the laundry (66 percent black), the superintendents' grounds gang (65 percent black); the coal gang (35 percent Spanish-speaking).

Attica officials were aware of the charges of racial discrimination, and some acknowledged that it had existed in the past. Deputy Superintendent Leon J. Vincent, however, testified that he had introduced a quota system to ensure racial balance in jobs and that discrimination no longer existed. He explained the underrepresentation of blacks and Spanish-speaking inmates in some jobs: "You have to understand that the black man isn't always the best-qualified man. Let's talk about somebody who can type or someone who might be a bookkeeper. You don't find too many black men that will qualify in these areas."

Such a consideration hardly applied to the officers' mess, where 62 percent of the inmates were white. Moreover, there were approximately 200 black and Spanish-speaking inmates who had high-school education, and none of the jobs at Attica required more than that.

With a view toward assessing the actual workings of the assignment system, the Commission studied files of 22 inmates (1 percent of Attica's population), who came before the assignment board in April or May 1971 and who were still at Attica in March 1972. Of the 7 black inmates in the group,[12] 4 were placed in the metal shop, and only 1 was given the assignment he requested. Of the 15 whites, 1 was assigned to the metal shop and another to a half day at school and a half day in the metal shop. Ten were assigned to the area they requested for a full or a half day.

Educational Programs: 12 percent of the inmates were enrolled in the school program, which consisted of five courses ranging from basic reading and arithmetic up to a high-school equivalency course. Inmates who attended classes for a half day were assigned jobs for the other half. There were approximately 30 to 35 inmates enrolled in each class. Attendance averaged two-thirds of enrollment. The education staff also supervised a 14-week program in public speaking and self-confidence by the Dale Carnegie Institute.

The school faculty consisted of an education supervisor and five teachers, one of whom was black. All but one of the teachers were in their twenties or early thirties. All had bachelor's degrees, and some had done graduate work.

All inmates who scored below 5.0 on the Stanford Achievement Test administered during the reception period were compelled to attend school until they reached at least that level.[13] Because school was an easy assignment, there were inmates who deliberately scored low on the test in order to be placed there. Others enrolled because they believed it would impress the parole board. Inmates who scored as functionally illiterate, particularly older men, resented forced schooling. The wage paid to students was 25¢ a day, the lowest in the institution, discouraging some inmates who would have been interested and increasing the resentment of those who were forced to attend. Like the metal shop, the school was used by the adminis-

tration as a "dumping ground," since the number of inmates in a class could be increased without an appreciable threat to security.

No class was taught in Spanish, nor was there a course in English as a second language for Spanish-speaking inmates, at least 10 percent of whom were illiterate in English. Such a class had been offered for a time, but by a Spanish-speaking inmate who proved ineffective as a teacher. A few Spanish-speaking inmates were assigned to regular classes with other inmates, which, an instructor commented, "didn't help me and didn't help them. . . ."

The high-school equivalency course offered by the school was a relatively successful program. While not all of the enrollees took the state-administered examination given at the end of the course, the percentage of those who passed was slightly higher than the statewide percentage of non-inmates who took the examination. However, the course was not always given and enrollment was limited.

Summarizing the school program, one teacher testified: "We were laboring under so many frustrations that there was no way it could be termed adequate."

Independent Study: Cell study and correspondence courses were the only educational opportunities at Attica for inmates not assigned to the school.

About 50 inmates were enrolled in correspondence courses leading to certification—3 or 4 in International Correspondence Schools, and the remainder in Nassey Vocational and Technical School. The cost had to be borne by the inmate and was several times the average annual wage of Attica inmates.

About 500 inmates were enrolled in cost-free cell-study courses, which were offered in a variety of subjects using International Correspondence Schools texts. The program was supervised by one of the teachers; to enroll, an inmate dropped him a "tab" and in return received a textbook. His assignments were corrected by inmate teachers and returned to him. Inmates believed the Parole Board would view cell study as evidence of rehabilitation, and inmate teachers received cigarettes and other bounty from their "students" in exchange for passing marks on written assignments. Four cell-study courses, Afro-American history, Spanish, sociology, and Hebrew, had scheduled weekly meetings in the school.

Vocational Training: 5 percent of Attica's population was involved in vocational training programs. There were 11 courses offered, 5 taught by civilians (silk screen and printing, drafting, barbering, machine shop, and auto mechanics) and 6 by inmate instructors (art, typing, carpentry, typewriter repair, bookbinding, and sheet metal).

Conditions here were better than in most other jobs and classes. The civilian instructors all had previously worked in the trade or industry they taught, classes were small, and instructors made some attempts to assess the capabilities of their students prior to enrollment; the drafting course

required a high-school diploma for entrance and the auto mechanics in-structor administered a test to new entrants. Several of the classes met for a full day. Because groups were small (the barbering course, at 40, was the largest) the instructors got to know their students and the atmosphere was more relaxed.

Classes were still overcrowded, however; there were sometimes as many as 15 men assigned to the printshop's two presses, each of which requires only one operator. The typing class had a great many applicants, but could accommodate only 15 men.

Equipment was also a problem. The printing operation was run on presses which had become obsolete after World War II; there were no linotype machines and all print was set by hand.[14] For two years the auto mechanic had been unable to obtain gasoline from the institution for the car and truck on which his students practiced; gas was deemed to be a security risk, although the instructor had obtained a lock for the gas tank.

Recreation: Recreation at Attica was limited by western New York win-ters, the absence of indoor facilities, a severely restricted budget, and ad-ministrative security regulations.

Because there was no gymnasium or dayroom for the 2,000 inmates housed in the four main cellblocks, virtually all their recreation took place in the yards. During each weekday, inmates were free to spend an average of an hour to an hour and a half there;[15] on weekends the yards were generally open for about six hours, but this time was reduced in bad weather. From November to March, the temperatures were generally subfreezing, with snow covering the ground for much of the period.

Each yard was a square, 100 yards on each side. In one corner was a softball field, in another a television set was mounted on the wall. A ce-ment wall for handball and a basketball court were constructed by inmates in 1971. A few benches and tables for cards, chess, or checkers were placed at the edges of the yards. Homemade weights, fashioned from iron bars and cans filled with cement, were also available.

When the weather was good, the yard was often crowded and chaotic. Baseball players collided with basketball players while attempting to field balls in the basketball court. Inmates who were not good athletes found it difficult to get into a game, and had to content themselves with standing around talking, watching television, performing individual exercises, or jogging.

Each block had its own football, softball, basketball, and volleyball teams, and contests between blocks were held on weekends. Bridge and chess tournaments for the prison were held in the school.

The annual recreation budget allotted from commissary profits was used to purchase and replace sports equipment and supplies. It amounted to an annual sum of a little more than $1 per inmate. There was no trained recre-ation director on the staff, although Superintendent Mancusi wrote to Al-bany several times seeking funds for such a postion.

Beginning in early 1970, there was a correction officer in charge of recreation, who despite lack of budget, training, and time (he had other duties as an officer) made a number of improvements and changes in facilities and programs, including the construction by inmates of handball and basketball courts in the yards; this was accomplished over the protests by many of his fellow officers that 100 inmates working together at one time constituted a threat to security. Some of his other suggestions—that the Ponderosa be used as an extra football field and that two of the yards be used for sports and two for more quiet recreation—were vetoed for security reasons. A recommendation that four outdoor showers be placed in each yard (at a cost of about $1,000) for use after strenuous activity was rejected on budgetary grounds.

Movies and Entertainment: Movies were shown to inmates in the auditorium on Saturday and Sunday afternoons from October to April, when it was likely that the weather would leave the yards filled with snow or mud. The movie rental budget, funded from commissary profits, was approximately $25 per film. Comedies and westerns predominated. Among the films shown in the spring of 1971 were the following: *The Good Guys and the Bad Guys, You Can't Win 'Em All, One More Time, Two Mules for Sister Sarah, Rosemary's Baby, The Sterile Cuckoo,* and *The Ballad of Cable Hogue.* On Labor Day, less than a week before the uprising, inmates saw *The Computer Wore Tennis Shoes.*

An inmate band, which had 13 members on September 9, often played for the inmates entering and leaving the movies. Performances by outside entertainers, however, were rare; the administration prohibited soliciting for them. In 1971, four groups who volunteered to come gave six performances.

THE NECESSITIES OF PRISON LIFE

"It is very expensive to live in prison," testified a 23-year-old former inmate. Shelter at Attica was provided free. But to have sufficient clothing, a complete diet, and the necessities for personal hygiene, inmates had to look beyond the provisions supplied by the state. Living standards varied with resources, and inmates whose families could not supply them with money for use in the commissary or with regular packages from home were often forced to augment their allotments by "hustling."

Clothes and Hygiene: Prison uniforms in the first penitentiaries of the early 19th century were intended to be a demeaning and constant reminder to the inmate of his shameful condition. The language of penology changed, but the clothing remained the same—coarse, drab, and ill-fitting. It was used and reissued to inmates until it wore out.

On arrival at Attica, an inmate could retain his underwear and socks (if they were not blue), his shirt (if it was gray or white), and his shoes, if they were not two-toned, zippered, or steel-toed, did not have large buckles, and were not over six inches high. A pair of gray cotton pants and any

other necessary items were issued to him. His street clothes could either be held for him, mailed out at his expense, or destroyed, at his option. Within the next few days, each inmate received a hip-length gray coat, three pairs of gray pants, two gray work shirts, three pairs of underwear, six pairs of socks, and a belt. He was issued a pair of prison shoes as soon as he received a job assignment. A pair of pants, two sets of underwear, and three pairs of socks were replaced every six months.

The clothing, made by inmates in the tailor shop, was too hot in the summer and too flimsy for the harsh upstate winters. In 1972, the correction officers' union included in its bargaining points for a new contract the demand that the inmate clothing issue be improved. One sergeant testified to the Commission: "Clothing has always been a critical thing at Attica. . . . A shirt looks like a reasonable thing to get, yet it's almost impossible to replace. I might add that is true today, seven months after the uprising."

Myriad rules governed inmates' appearance. Shirts and sweaters had to be tucked inside the pants, shirts had to be buttoned except for the top button. Nothing, not even underwear, could be any shade of blue—inmates might attempt escape by impersonating officers whose uniforms and shirts were blue. One inmate told what happened when his family unwittingly sent him underwear and pajamas of light blue: "I could not have those three pair of shorts and one pair of pajamas because I violated security by having blue underwear nobody could see but myself. . . . How can you tell a grown man that he is violating security by wearing a blue pair of shorts? I mean, this is the type of juvenile attitude they treat us. They actually think that we believe that. You know why that rule was made? For harassment and for harassment only."

Some toilet articles were issued to inmates: a comb, toilet paper (one roll a month), soap (one bar a month), and a towel. Toothbrushes, toothpaste, shampoo, razors, and blades were not provided, although the rules required a neat and clean-shaven appearance. Such items, as well as additional soap and toilet paper, were either bought by inmates at the commissary or sent by their families.[16]

Maintaining personal cleanliness was a struggle. While inmates in a few jobs could take daily showers, the majority of the population could shower only once a week.[17] The sinks in the cells had only cold water, but two quarts of hot water were distributed to inmates in pails each afternoon or evening. Inmates had to use that water for washing, shaving, cleaning the cell, and rinsing clothes. The prison laundry washed pants and prison-issued shirts and underwear once a week, but each inmate was required to wash his own socks and all nonstate-issue clothing. Depending on the inmate water boy and the correction officer on the gallery, supplemental pails of water could be negotiated by inmates for a price.

Meals: According to old-timers, Attica was once "the best feeding joint in the state." That was during Harry Joyce's 30 years as supervisor of the

prison's food services. Joyce retired in the mid-1960s, and inmates date the deterioration in meals from his departure.

In August 1971, Commissioner Oswald discovered that the 63¢ budgeted for each inmate's daily food was not sufficient to meet the minimum dietary standards set by Federal guidelines. A directive went out from the Commissioner, one month before the uprising, to spend what was necessary to achieve nutritional standards, even if this resulted in a budget deficit.

In his 1971 annual report, Superintendent Mancusi wrote that Attica provided "meals which are tasty, possess eye appeal and contain the necessary nutritional ingredients to provide a balanced diet." The Commission's experience with the Attica food did not fit that description. The ingredients were of good quality, but the preparation rendered some food virtually inedible. The segmented metal trays from which inmates ate were not thoroughly cleaned, and the food placed in them was, at times, half-cooked or cold.

The principal meal was at midday and consisted of meat, potatoes or rice, a vegetable, bread, coffee or tea, and, sometimes, dessert. Menus were heavy in starch. Breakfast, for example, included cereal and bread every morning, fruit occasionally, but never eggs. Supper, which was optional for the inmates, consisted of a light main dish (sometimes only soup), bread, and milk or coffee. Inmates could take uneaten food back to their cells, and many did carry away bread to eat during the 13 hours between supper and breakfast.

Meals were served in the two mess hells located behind C block, each seating 768 men. Inmates were "run" to meals in groups of two companies each, accompanied by one correction officer. A and C blocks went to A mess, B and D blocks to B mess. All inmates were required to attend breakfast (except on weekends) and dinner, which were served in two shifts. Supper usually drew about half the population.

With so many inmates in the mess halls at the same time, officers were particularly security-conscious. Inmates filed by a food counter and picked up their metal trays. They ate in groups of eight at metal tables seated on immovable metal stools. Tables had to be filled in sequence as men came off the food line. It was forbidden to get up or turn around once seated, and inmates jockeyed in line so that they would end up at the same table as friends. Many inmates, blacks and whites alike, used these maneuvers to effect self-segregation during meals. The entire meal lasted for 20 to 40 minutes and as inmates filed out of the mess hall they dropped their eating utensils into a bin under a watch of an officer. They were usually allowed only a spoon but never knives.

Muslims had more to contend with than other inmates. Their religion forbade the eating of pork and Attica held its food costs down through frequent recourse to its swineherd for main dishes and cooking fat. On July 7, 1971, Commissioner Oswald issued a bulletin to all correctional institu-

tions citing the language of a recent decision of the Appellate Division of the New York Supreme Court:

Muslims shall be provided whenever possible with meals that are wholly free of pork and pork products, and when that is not practicable then there shall be available at each meal some food free of those substances.[18]

At the same time, Attica began phasing out its swineherd. But the credibility of these efforts was undermined by general mistrust of the state as well as by rumors that pork products were being described as beef on the menus. Pork and pork products had, in fact, been frequently used, mixed with other meats in loaves, hamburgers and meatballs, or lard for frying and as seasoning in sauces, beans, etc. Muslims were not prepared to trust the claims that such practices had been discontinued. As one young Muslim stated: "If it is not a chicken or if it is not a fish stick, you leave it alone."

Packages: Inmates were allowed to receive monthly packages of up to 15 pounds from persons on their approved correspondence or visiting lists. On five holidays, Christmas, Easter, July 4, Thanksgiving, and Rosh Hashanah, packages could weigh up to 25 pounds and could include special items such as a chicken or a ham. After complaints by the Muslims, corned beef was added to the authorized special items. A variety of foods was permitted as long as they were not packaged in glass containers, which were prohibited for security reasons. The nonfood items carried by the commissary could also be sent to inmates in packages.

When a package arrived, the inmate recipient was called down to the package room just outside of A block, and the parcel was opened in his presence and inspected for contraband. Unauthorized items could be returned to the sender (with the inmate paying costs), contributed to a charitable institution, or otherwise disposed of, at the choice of the inmate.

Approved package items varied from prison to prison, and unexplained inconsistencies frustrated inmates transferred from more permissive institutions. As one inmate explained: "If I was in Clinton today, I could get cigars from home. I smoke cigars. I can't get them in Attica, because I am in Attica."

Besides glass jars, cans over two pounds, pressurized cans, and combs over six inches long or with handles were forbidden at Attica for security reasons, either because they could be turned into weapons or used to conceal contraband.

Changes in the list were made without notice. One inmate recalled: ". . . they had a notice on the package room you couldn't get [packaged iced-tea mix] no more. They didn't notify me. They didn't put no notice in the housing area. I just found it. It's mental harassment. It's a mental thing. They just degrade you. You don't have to put your hands on me to degrade me or upset me."

Wages: In September 1971, all inmates at Attica, except those who re-

fused their assignments or were in disciplinary keeplock or segregation, were paid a wage ranging from 20¢ to $1.00 a day.[19] "Unemployed" inmates—for whom no positions were available—and inmates who were hospitalized or under psychiatric observation were paid 20¢ a day. Those who attended school received 25¢ a day.

All other jobs were classified into a statewide four-grade system:

Grade I "Helpers," janitors, and other unskilled workers, with a wage of 25¢ per day.
Grade II Semiskilled workers and positions carrying some responsibility, with a wage scale of 30¢–50¢ per day.
Grade III Skilled workers, including hospital nurses, with a wage scale of 55¢–75¢ per day.
Grade IV Supervisory positions such as head nurse and head mechanic, with a wage scale of 80¢–$1.00 per day.

Inmates began at the lowest wage level of the grade to which their job was assigned. Workers in Grades II, III, and IV received 5¢ increments every 6 months until they reached the highest wage for their grade.[20] Since there was a fixed wage rather than a range in Grade I, an inmate assigned to a Grade I position had to be reassigned to a new job in another grade to increase his earnings. In August 1971 there were 1,005 inmates in Grade I positions, more than in all other wage grades combined.[21]

No money was actually given to inmates; their earnings and money sent to them from the outside were credited to their accounts. Until November 1970, only half their wages could be spent; the rest was accumulated and given to the inmate on his release. Subsequently, the full wages could be spent, subject to a limitation of $40 per month on all purchases, both at the commissary and by mail order.

The income range for working inmates was $4.40–$22.00 a month, and the average monthly wage was $7.00–$7.50.

Wages were clearly not used as incentives for rehabilitation. On the contrary, most inmates regarded the wages as degrading; valuing a man's services at 25¢ a day denied him any sense of self-worth.

Commissioner Oswald testified that if inmates were paid the state minimum wage, and charged for room, board, and medical services, they would owe money to the state. But the Commission's psychiatrist stated in his testimony that a realistic wage and payment structure would be therapeutic not only in instilling self-respect, but also in training inmates to handle their own finances—an enterprise at which many had failed on the outside.

Commissary: Most inmates spent whatever they earned at the commissary, and commissary visits, scheduled about once every two weeks, assumed an extraordinary importance.[22] Items not issued by the state were purchased then, together with a few personal items to ease the bareness of prison living. Shopping at the commissary provided inmates with one of the very rare opportunities for exercising individual choice.

But there were limitations. Most inmates had little money and some of it

went for essentials like toothpaste. The selection was limited, and popular items sometimes sold out.

The commissary sold cigarettes and tobacco, toilet articles, a few clothing items such as sweatshirts, writing materials, vitamins, and food, including bread, coffee, canned meats and vegetables, soup, and candy. Prices were comparable to those on the outside: a 10-ounce jar of instant coffee cost $1.37, a pack of cigarettes 35¢. But wages averaged only $7.50 a month and a cigarette smoker who had no other resources could buy little else.[23] As one inmate explained:

A man has to have coffee, sugar, toothpaste. And this is an adult. And nobody cares. He walks up there and he has a list in his hand. He gets to the commissary. Maybe they are out of peaches or maybe they are out of sardines. So he has to make that whole list over again, trying to squeeze pennies.

Can you imagine how degrading that is? This man worked all week long. He ran a punch press or worked on the spot weld or on the shaper, all month long and he made $3.05 or something. . . . And he goes to the commissary. Maybe he can get a jar of coffee. "I better not, I will get a smaller jar of coffee so I can get some sugar. Maybe I can get two packs of cigarettes and a can of Bugler [tobacco]."

He gets up there and maybe they are out of Bugler. He has to go over there and make that list. I seen guys take up that list and tear it up and throw it on the floor.

There were other problems, once an inmate decided how to spend the few dollars he had. Coffee, soup, and many canned foods sold in the commissary were made to be eaten after they were heated or mixed with hot water. Cells had only cold water and heating devices were prohibited. But two improvised devices were in wide use: "droppers"—homemade immersion coils—and stoves made from a hollowed-out brick into which a nichrome wire had been inserted. Possession of such implements was grounds for disciplinary action, but most officers disregarded their use, especially by "well-behaved" inmates. Nevertheless, the rule was in existence and was selectively enforced.

Net commissary profits were limited to 5 percent; in 1970–71 they amounted to approximately $15,000. Commissary profits were placed in a "recreation fund," two-thirds of which was used to buy tobacco grown at Auburn. This was distributed to inmates willing to roll their own cigarettes.[24] The remaining third, a little over $5,000 was divided: 18 percent for sports and recreation equipment, 6 percent for film rental, and 6 percent, or less than $1,000, for everything else—law books, musical instruments, televisions, prizes for holiday events, and an annual stage show produced by inmates.

At times, unspent funds were accumulated and used for special purchases, such as the expansion of the radio system from one to three channels in the mid-1960s at a cost of $30,000.

Hustling: For most inmates, "hustling" is a necessary and accepted part of daily life on the streets. In general, hustling is activity which either

exploits the desires of others, or involves deception or fraud. Few hustles, which range from tapping gas lines to selling drugs, are legal.

Undoubtedly many Attica inmates began their criminal careers by hustling. Sent to Attica for rehabilitation by society, inmates faced the same pressures to hustle inside the walls: "If you are poor and can't get money from home, you have to hustle to make ends meet," said one inmate, and another wrote, "I used to make $2.50 a month [in prison] and with that money I had to swing everything . . . you had to make some deals to get by." [25]

One of the most common hustles involved the laundry. To keep personal articles of clothing clean, many inmates "bought a laundry man" with cigarettes, the most common medium of exchange. An inmate testified: "You usually get a contract with one man and you pay him like maybe a carton of cigarettes every month and he will take care of your laundry for you." Similarly, if an inmate needed a new pair of pants between scheduled clothing issues he made a deal with a contact in the tailor shop or through a middleman.

Since most hustles originate with a need, it is not surprising that deals were also made for sex. Denied conjugal visits, heterosexual men turned to other men for sex, and homosexual prostitution and pimping provided some inmates with extra income.

Hand-drawn pornography, known as "short-heist," was popular and, depending on the artist, was a salable commodity.

Moonshine of varying potency was produced all over the insitution wherever a small still could be hidden. Chopped potatoes, rice, and various juices were fermented with yeast generally stolen from the bakery. The beverages produced were not extremely high in alcohol content.

A high could also be produced by some of the pills dispensed at sick call, if they were taken in certain ways. Although medication was required to be taken in the presence of the doctor or officer dispensing it, some inmates managed to hide pills under their tongue. Drugs were also said by inmates to enter Attica from the outside, during visits, in packages, and even by means of letters soaked in solutions which were undetectable in the normal censorship procedure.

COMMUNICATION WITH THE OUTSIDE WORLD

Isolation has long been rejected as a means of preparing inmates for return to society. In principle, New York State recognizes that an inmate who has maintained contact with his family and friends, and has kept informed of developments in society, will have a better chance of adjusting on his release. In practice, however, concerns about security in a large institution housing over 2,000 inmates, created barriers to all forms of communication with the outside world.

Radio and Television: Inmates were not allowed to have their own radio receivers. Instead, each cell was equipped with earphones which could

receive the three channels broadcast from a radio system located in the administration building. The only television sets available to inmates in A, B, C, and D blocks were located in the yards—one in each yard for approximately 500 inmates. E block, which housed the experimental DVR unit, had a television in the recreation room.

All programs transmitted on the radio were subject to the approval of the Superintendent. Programs deemed controversial were avoided. Generally, one channel of the radio system was devoted to the audio portion of selected television programs, another channel to "easy listening music," and the third to sports, rock, and "specialties" such as black and Spanish programming.

The Superintendent refused to permit inmates to receive black-oriented cultural and news programs such as *Soul, Black Journal,* and *Express Yourself.* Until March 1971, the Muslim religious program *Muhammad Speaks* was not allowed. With only three channels available, programs oriented to Spanish-speaking inmates were sparse. Four hours of Latin music, primarily from the institution's 18 Spanish records, were played each week. Half of the Latin-oriented programming was presented during the weekend when yard time was increased.

Programs inmates could see on the yard television sets were limited by the yard time. During the week, when yard time ended at 4:50 P.M., the programs on the air were generally cartoons, game shows, soap operas, and grade-B film reruns. On weekends, sports events were shown, but inmates generally had to leave the yard for supper before the games ended. In addition, inmates gathered in the yard corners watching a program contended with competing noise from other yard activities, the glare of the sun, and, in the winter, snow and below-freezing temperatures.

Literature: For many inmates, reading offered the only diversion during long hours in their cells. But acquiring a book or a magazine to read was a discouraging process.

Inmates entering prison were, for reasons of security, required to leave their books and magazines behind. Theoretically, contraband could be concealed in the bindings or between the pages. For the same reason, they could receive books, magazines, or newspapers only from the publisher directly (at their own expense) or from the prison library.

Attica's library, located in the prison school, contained approximately 50,000 volumes in September 1971. School personnel described it as adequate. Inmates did not. Whatever its merits, security considerations barred inmates from going to the library and browsing. Instead, they were required to make their selections from a typed catalog kept by the inmate who distributed the evening hot water.[26] Inmates were allowed one book and three magazines a week. The rules required them to list on a request form not less than 30 books or publications in order of preference.

No newspapers were available in the library; the magazines received by the library were *Time, Life, Ebony, Jet, Black World, Downbeat, Atlantic,*

Argosy, Popular Science, Popular Mechanics, Gentlemen's Quarterly, National Geographic, True, Outdoor Life, Field and Stream, American Home, and *House Beautiful*. There was only one copy of each issue for over 2,000 inmates.

The library had fewer than 20 Spanish books for a Spanish-speaking population of over 150. Black literature was also sparse. Of the 40 books on black thought, history, and culture approved by Commissioner Oswald in a memo circulated on March 24, 1971, Attica had purchased approximately half by September 9, 1971.

The prison budget did not allow for a trained librarian, although requests for such a position had been made to Albany by the Superintendent. An inmate was in charge of the library, and subject to the approval of the education director, he selected and ordered new books once a year. Funds were allocated from commissary profits. The allocation of popular books regularly requested by inmates allowed the inmate librarian to develop a lucrative hustle.

If an inmate could afford to purchase books, magazines, or newspapers from publishers, his next hurdle was censorship. Prior to March 1971, the director of education was the institution's censor. All publications passed through his hands and his decisions were subject to reversal only by the Superintendent, who rarely concerned himself with the problem. When interviewed by the Commission, he described his procedure:

> If while reading the first few pages, I came upon something objectionable, I would read no further. Instead, I would send the book to the dead storage area in the Correspondence Office for delivery to the inmate when he left the institution. I never approved books on psychology, physics, and chemistry, because we wanted to discourage inmates from becoming amateur psychologists or using their chemistry books to make bombs.

Reforms were in progress at the time of the uprising. In March 1971, Commissioner Oswald established a media review committee in each institution, which was to measure incoming material against the standard of whether "this material [is] acceptable for legal mailing in the United States, [is] not obscene and [does] not tend to incite activities posing a threat to prison discipline."

By July 1971, the criteria had been expanded as follows:

1. In general the material should be acceptable for regular mailing in the United States.
2. The publication should not appeal predominantly to prurient, shameful, or morbid interest in nudity, sex, excretion, sadism, or masochism, or go beyond the customary limits of candor in describing or representing such matters. (See Penal Law § 235.00.)
3. The publication should not defame, vilify, or incite hatred toward persons because of their race, religion, creed, or national origin.
4. The publication should not advocate the violent overthrow of the existing form of government of the United States or of this state. (See Penal Law § 240.15.)

5. The publication should not advocate lawlessness, violence, anarchy, or rebellion against governmental authority or portray such conduct as a commendable activity.
6. The publication should not incite hatred or disobedience toward law enforcement officers or prison personnel.
7. The publication should not depict the use or manufacture of firearms, explosives, and other weapons.
8. The publication should not be of such a nature as to depict, describe, or teach methods and procedures for the acquisition of certain physical manipulations and skills which expertise will, in the opinion of Department authorities, constitute a threat to the safety, welfare, and health of other inmates and employees.

The former censor was designated chairman of the Attica media review committee. One of the other members stated that he rarely called meetings of the committee; and when he did, he dominated the discussions. The committee spent as much as three months "reviewing" controversial items which had been received by inmates.

The authority of the institutional committee was not absolute. Another reform, implemented at the same time, established a central committee in Albany to review material rejected by the institutional committee. This reform was intended to promote a uniform policy with regard to censorship.

In November 1971, after the uprising, the Albany media review committee began publishing its decisions. In 55 percent of the cases, they reversed decisions made at a prison to reject material.[27]

Since the uprising the department has also circulated a list of acceptable literature containing 360 periodicals, including *Black Scholar, Playboy,* and the *Amsterdam News,* and 40 books on black studies. Items on the approved list are passed on to inmates without review and inmates can now read approved magazines in the same week or month that they are published.

Some items which do not appear on Albany's approved list are symbolic of prison administrators' apprehensions concerning the increased assertion of their rights by inmates. Attica inmates have been unsuccessful for over two years in gaining approval for the *Fortune News* published by the Fortune Society, a prison reform organization founded and run by ex-inmates. In a lawsuit brought by inmates in 1970, the state argued that *Fortune News* could properly be excluded from prisons, because its articles did not accurately portray prison conditions. The court in *Fortune* v. *McGinnis* [28] *dismissed this argument, stating:*

However distasteful or annoyed or sensitive those criticized may be by what they consider unfair criticisms, half-truths or information, it does not justify a ban of the publication carrying the alleged offending comments. Censorship is utterly foreign to our way of life; it smacks of dictatorship.

But Attica and other institutions continued to withhold selected *Fortune News* issues, including the January 1972 issue, which contained articles

critical of New York prison food and describing the retiring Superintendent at Great Meadow as "Little Caesar." The Albany media review committee upheld the prison's decision to exclude this issue, because "it vilifies prison personnel" and "shows poor objective reporting." Albany's reasons for censorship were the same which had been rejected by the court in the *Fortune* opinion two years earlier.

The inmates returned to court in April 1972, and the chairman of the media review committee in Albany stated that *Fortune News* would be placed on the approved list of publications, and that back issues would be distributed to inmates who requested them. But as late as July 1972, the correspondence officer at Attica was refusing to return back issues to the inmates because, he said, he had not been instructed by Albany to do so.

Correspondence: Because of Attica's isolation and the fact that inmates were not permitted to make or receive telephone calls, inmates depended more on letters than on visits to maintain contact with their families and friends. Upon entering Attica, inmates signed a "consent" to mail censorship. If they refused to sign, they could not receive or send mail. They were permitted to correspond only with an approved list of relatives and such others as were approved by the Superintendent. As an additional security precaution, all incoming and outgoing mail was censored except letters to or from attorneys, public officials, and judges. These were exempted from censorship as a result of a Federal Court decision.

Regular correspondence was generally limited to members of the inmate's immediate family, with others added to the correspondence list only by special permission. Females under 18 and males under 21 were required to present birth certificates and parental permission before they could be added to the list. Although 26.6 percent of the Puerto Rican and 20.4 percent of the black population of Attica on September 9, 1971, claimed common-law marriage status, neither common-law wives nor children of such unions were recognized as relatives for the purpose of mail or visits until April 1971. At that time, Commissioner Oswald changed the rules, but subject to the approval of the Superintendent, and on proof that the relationship was "sound."

The restrictions led inmates to conceive various ploys, such as having friends use the names of approved relatives when they wrote. A confiscated letter written by an inmate stated:

Darling . . . I know you will be surprised to get this, so read it carefully several times. I had it smuggled out. . . . Here are my instructions, you can write to me, address it like this. . . . When you write be sure that you don't make a mistake and write your name. . . . I have your two pictures. I put them in frames and it's all I have to remember you by.

Incoming and outgoing mail (other than to attorneys, judges, and public officials) was censored by correction officers in the correspondence office. Outgoing letters had to be written on special prison stationery. Each sheet

listed, on a detachable legend, the warning that prison censors could reject the letter for various reasons, including:

It contains criminal or prison news.
Begging for packages or money not allowed.
Correspondence with newspaper or newspaper employee is not permitted.
You did not stick to your subject.
Cannot have a visit with the person named in your letter unless approved by the Superintendent.

Moreover, the inmate's rulebook stated: "Inmates shall confine their correspondence to their own personal matters; institutional matters and other inmates are not to be discussed in letters." [29] When an outgoing letter was found to violate a guideline, it was returned to the inmate.

When an incoming letter was judged unacceptable—and there were no guidelines given to the senders—it was placed in a file in the correspondence office bearing the inmate's name. The inmate was never informed of the letter's existence, nor was the sender told that it had not reached the inmate. Misunderstandings and anxieties between inmates and their families multiplied when each waited for a reply in ignorance of the withheld letter.

The burden of censorship fell heaviest on Spanish-speaking inmates. Neither of the two censors understood Spanish and until late 1970, English was the only acceptable language for correspondence. On November 25, 1970, incoming letters in foreign languages were allowed, and bilingual inmates were utilized as censors. But no inmate was regularly assigned to this task, and mail in a foreign language, most often Spanish, was put aside for up to two weeks before delivery. Outgoing letters in Spanish were not permitted. Spanish-speaking inmates not literate in English had to use a bilingual inmate as a translator.

Several months after the uprising, Commissioner Oswald took steps to broaden inmates' correspondence rights. The restrictions on the persons with whom an inmate may correspond have been relaxed. The new rules require only that the correspondent is willing to receive mail from the inmate, and in addition the permission of the Superintendent in the case of unrelated minors, married women, codefendants, inmates in other institutions, and parolees.

The Commissioner has also directed that all objectionable incoming letters must be returned to the sender.

Visits: The department was of the view that inmate visits with "family members, desirable friends, business associates, former or prospective employers, state officials, and counsel" were to be encouraged in order to maintain good morale and ease the adjustment of inmates when released. Yet the department riddled this principle with rules based on security considerations of little practical value.

Inmates were allowed, as a matter of right, to receive visits from their wives, children, parents, brothers, sisters, attorneys, and clergymen. All

others, including relatives and friends, were required to apply for permission at least ten days before the anticipated date of the visit.

Former inmates could never visit unless they were members of an inmate's immediate family, and then only with the approval of the Superintendent.

Additions to an inmate's approved visiting list were within the discretion of the prison's service unit. If the inmate was regularly receiving visitors, his request for permission to add additional visitors was denied.

For many at Attica, the right to receive visitors was illusory, even when persons were approved. Most inmates were poor and 43 percent came from New York City. There was no direct transportation between New York and Attica. The bus trip from New York to the nearest depot, Batavia, cost $33.55 round trip and took 9 hours one way. Visitors had to leave Manhattan shortly after midnight to reach the prison by 10:30 in the morning. There was no public transportation between Batavia and the town of Attica, and the 20-minute ride from the bus station to the prison had to be made by taxi at a cost of $6 each way. A weekend visit from New York could cost over $100, with 20 hours spent in transit. Because of the hardship, visitors from New York City could see inmates on two successive days.

When visitors did come, the experience was degrading for both visitors and inmate. Before entering and after leaving the visiting room, the inmate was subjected to a strip search designed to uncover contraband. All possible places of concealment were investigated, including "his mouth, ears, hair, the bottom of his feet, under his arms, around the testicles, and in the rectum."

The visiting room contained a large horseshoe-shaped table with seats on either side. A mesh screen ran along the center of the table, preventing all but minimal physical contact.

Two officers observed from a raised platform at one end of the room.

Prior to 1964, there were no screens. In that year, a mesh screen was erected. In 1966, when the visiting room was moved to its present location in the administration building annex, a new screen with wider mesh was put up.

The purpose of the screen was security, and in particular to prevent the passage of drugs to inmates. However, after the 1966 move, openings in the screen were at least one inch square, and inmates were strip-searched when they left the room. Paradoxically the visiting room in HBZ, the special housing unit for troublesome inmates, had no screen. Thus, the screen was seen by inmates not as a security device, but as another example of senseless harassment and dehumanization.

Many inmates could not bring themselves to receive visitors under these circumstances. Said one:

I have two children and during the entire time I was in Attica . . . I didn't have my children visit me. If they want to see an animal, they can go to the zoo.

In May 1972 major changes were made in the visiting rules at Attica. Inmates may now receive visits from almost anyone without the prior approval of the Superintendent or the service unit. Women, whether married or single, may freely visit married or unmarried inmates. The only restriction is that a married, unrelated female must obtain her spouse's permission before visiting. Attorneys may also be accompanied by third-year law students or investigators. Former inmates who are not family members may now visit after gaining the approval of the Superintendent and their parole officer (if on parole). There is no longer any restriction on the frequency of visits.

The trip to Attica is not shorter or easier, but the visiting room atmosphere has been improved. The screen has been removed, and inmates may now embrace their visitors at the outset and the conclusion of the visit, and hold hands throughout. Vending machines have been installed. Finally, inmates may examine photos brought by visitors and pass notes, provided they are first read by the officer in charge.

Inmates are still denied, however, the right of a confidential interview with a newsman. A journalist who wishes to interview an inmate must make a written request. If approved, the interview is monitored by a member of the service unit.

MEDICAL CARE

The visiting room was not the only place at Attica that had a screen. The prison doctors conducted the daily sick call from behind a mesh screen.[30]

Medical care was one of the primary inmate grievances. In order to evaluate these grievances, the Commission called upon a recognized authority in the field of hospitals and health services, Dr. E. D. Rosenfeld, to examine the prison's health facilities and interview the medical personnel.[31] The Commission has drawn upon his report for professional evaluations in the following section.

It is not possible to describe medical care adequately in any setting without examining the purposes to be served by the medical program. It was the conclusion of the Commission's consultant that the purpose of medical care at Attica was limited to providing relief from pain or acute anguish, correcting pathological processes that may have developed before or while the inmates were serving their terms, and preventing the transmittal of sickness among the prison population.

Chronic physical or emotional disabilities, unless subject to easy correction, which most are not, were generally not assessed, nor were significant attempts made to correct or modify them while the inmate was serving his term. Some correctable problems which would have required physical medicine and rehabilitative facilities and staff, such as complex and difficult orthopedic or other surgical procedures, were simply not treated. Part of this, of course, was due to lack of personnel and time, but much re-

flected a lack of commitment to attempt restorative efforts or, perhaps, doubt that such efforts might be successful.

Lack of staff time to conduct such programs was a very real constraint, but lack of time was not limited to staff. The mandatory time inmates spent in their cells limited the actual hours during which any prolonged treatment of a medical, dental, psychiatric, or rehabilitative nature could be carried out.

There were four types of services within Attica with three different staff groups, each responsible to a different state agency. The services were (1) medical, (2) dental, (3) psychiatric, and (4) the Vocational Rehabilitation project (DVR).

Medical: Medical personnel were under the Department of Corrections and were directly responsible to the Superintendent. The staff was headed by two doctors who were also engaged in general practice in nearby communities. Dr. Selden T. Williams, who had been at Attica 22 years, and Dr. Paul G. Sternberg, who joined the staff in 1957. Both spent mornings at Attica Monday through Friday, and attended to private practice in the afternoons while remaining on call for emergencies at Attica. Both doctors enjoyed full civil service ratings and drew full salaries in the $29,000–$31,000 range, in addition to their incomes from private practice. Even considering their part-time service, the ratio of doctors to prisoners compares favorably with the norm in rural communities such as Attica.

At full strength, the medical staff also included four nurses,[32] one full-time pharmacist, a full-time laboratory technician, and a stenographer. Ambulatory care was administered via a daily sick call held in the pharmacy and in-patient care in the 26-bed prison hospital or, occasionally, in Meyer Memorial Hospital or Roswell Park Memorial Institute in Buffalo. The Buffalo hospitals were also used, in some cases, for specialized outpatient diagnosis and therapy.

Although laboratory and other diagnostic facilities were available in the prison, adequate personnel for their effective use were only intermittently available. Inmates and nurses were sometimes utilized when the technician was not on duty but there were times when indicated tests could not be conducted. After the death of the technician who had been employed there for many years, no replacement could be found for over three years. A similar situation occurred when the pharmacist's position became vacant.

The prison kitchen had no facilities for the preparation of special diets. Limited diet care was possible only from the preparation of some foods for patients in the hospital pantry by the nursing staff.

Most inmate contact with the medical services was through sick call, which began at 8:00 or 8:30 A.M. and lasted for 2 to 2½ hours, Monday through Friday. Any inmate who wished to see the doctor identified himself to the officer supervising his company and was taken to the pharmacy instead of to his morning assignment. Average attendance was 100 to 125.

No examinations were given at sick call; there was not enough time and neither doctor felt it was necessary. A counter topped by a mesh screen which extended to the ceiling divided the pharmacy in two, and separated the doctor from the inmate. At sick call, the doctors asked the nature of the inmate's complaint and either sent him back to his assignment or to his cell after dispensing whatever medication he thought was appropriate. Only in rare cases, the doctors directed an officer to conduct the man to the examination room. The approach was very businesslike, very direct, and very authoritarian, and usually took but a few seconds. The time and effort necessary to explain, to help provide insight, to gain acceptance, to achieve confidence, were absent. As is often true when the doctor-patient relationship is imposed, not chosen, there was no element of faith and confidence. This was a major complaint by inmates, who further stated that the doctors regularly made disparaging comments, and asked insulting questions, such as "How do you know you have a headache?" or "Pain? I don't see any pain." If an inmate objected to the doctor's disposition of his complaint, he was often threatened with commitment to the psychiatric ward, a threat which Dr. Williams confirmed had been carried out.

Inmates did use sick call to escape a boring job and see friends as well as to get treatment for illness, but the number of such "malingerers" is not known. Both doctors claimed that the majority of those on sick call were not ill and that it was possible in a few seconds by "looking into their eyes" to distinguish these from inmates with valid complaints. They also expressed the opinion that inmates make more demands for medical treatment than they would outside of prison. Inmates, however, complained that the doctors often didn't believe that they were sick and routinely dispensed a few drugs, such as aspirin, for almost all complaints. A few inmates expressed the opinion that the medication they were getting was harmful to them.

To conduct such a sick call, it is manifestly impossible for any doctor to spend more than a few moments with each inmate. Part of this time must be devoted to the process of weeding out those who need medical attention from those who simply desire a repeat of some previous drug or medication or from those who are faking their problems. Institutionalized persons also tend to develop vague symptoms, which though real, cannot be traced to a physical dysfunction, and the pressures under which inmates live give rise to emotionally based disorders. Ulcers and ulcerlike symptoms are common. Little is or can be done for them in this setting except for palliative therapy which most will eventually obtain through this sick-call process. The process nevertheless does provide a practical mechanism for finding and treating acute, urgent, or new clinical problems.

In fact, there were often as many as 300 to 350 inmates on routine maintenance doses of various drugs, including tranquilizers. At sick call, only sick-call records, and not medical records, were available to the doctor, and his diagnosis was usually based on the inmate's description of the

problem and a few moments' observation during the questioning. Specific drugs (sometimes placebos) were routinely dispensed for particular types of complaints and the routineness of the procedure undercut such confidence as inmates might have had.

According to the Commission's consultant, there is a reasonable level of competence on the part of both doctors in their diagnostic and treatment capabilities. Nevertheless, numerous inmates recounted instances of medical neglect which, if true, would suggest either deliberate disinterest or negligence. These stories could not be confirmed but their nature and persistence reveal the distrust with which the doctors were held by many inmates.[33]

If an inmate became ill after the daily sick call, he could get treatment by speaking to a correction officer who would call the hospital. A male nurse would examine the inmate in his cell, take corrective action if the problem was minor, or call the doctor. Although the doctors seem to have responded whenever they were called, inmates maintained that to get treatment they had to become ill when the doctor was in prison. This may not have been the fault of the medical personnel, but of officers who did not believe inmate complaints.

Drug-related disorders were frequently brought into the prison by new arrivals, but there was no treatment provided for addicts. Some inmates arrived under the influence of drugs, with withdrawal symptoms, or in an agitated state caused by a recent "cold turkey" experience. No significant assistance was available for them. However, drugs were apparently available within the prison, since inmates often showed up at sick call evidencing drug-related symptoms.

In interviews, both doctors expressed strong negative feelings, even antagonism to many of the inmates. They showed an undisguised lack of sympathy for them—not necessarily to all, but generally. The doctors' attitudes are, however, in large measure inevitable. Since the population as a whole is physically healthy, most of the purely physical problems are minor and routine, or among the older, long-term inmates are chronic problems seen over and over again in the same group of inmates. These do not stimulate the interest of physicians; it is hard for any physician to see the same problems day in and day out, year in and year out, and to continue a high level of concern, to perform in other than a routine way. Most of the work required by the prisoner population is of this nature. Occasionally, there are some urgent or acute problems. Trauma occurs, coronary diseases with acute episodes occur, there are a significant number of diabetic inmates and some epileptics. These are given reasonably prompt and good attention. Despite their expressed negativism, both doctors reconsidered decisions to resign after the uprising, when no replacements could be found.

Neither of the prison doctors performed surgery; for many years a general surgeon from a nearby community came regularly to Attica for consul-

tation and surgery. The eventual volume of work and lack of support and inadequate postoperative staff and facilities led to an arrangement whereby residents and attending surgeons from Meyer Memorial Hospital performed minor surgical procedures at the prison hospital, and the more serious cases were taken to that hospital. Although inmates' attitudes toward outside doctors, especially specialists, were more favorable than toward the prison doctors, the arrangement with Meyer Memorial was terminated because of the lack of air conditioning in the prison operating room, inadequate supplies and personnel for diagnostic work and/or postsurgical care. Surgery has since been done only in urgent and emergency situations at Meyer Memorial Hospital.

Treatment at Meyer required the approval of the Superintendent, since the fees involved came from the prison's budget. The availability of a bed in the hospital's prison ward, as well as an attending physician willing to take the patient and a satisfactory arrangement for the payment of fees, were also prerequisites to treatment at Meyer. All of these matters were not always worked out and frequent delays resulted.

Since Roswell Park Memorial Institute, which has one of the finest programs of cancer care and research in the country, is only 60 miles from Attica, it has become a more or less routine policy to transfer all New York State inmates with cancer to Attica, and for them to be taken to Roswell for treatment, consultation, and outpatient care. If nothing else was feasible, these inmates were hospitalized in the prison for terminal or long-term care.

A major problem inhibiting the provision of adequate care was that inmates' previous medical records were unavailable even when they were transferred from other prisons. There was no uniform, consistent medical record system within the Department of Corrections and no centralized files.

Recruitment of paramedical or allied personnel is difficult at Attica on many counts and plays a role in the essential availability of these services. Factors in the difficulty of recruitment are not only the prison atmosphere or working with inmates, but the isolation of the facility, the noncompetitive salary levels (civil service), the rigidity of routines, the oppressiveness and monotony of the atmosphere, and the lack of backup personnel in the specific jobs. One additional problem with the prison hospital is the staffing demands, which fluctuate greatly and cannot be anticipated. The phenomenon is always true of a small unit. In an effort to provide adequate nursing staff, for the first time female nurses, who are easier to recruit, were employed in the spring of 1972 on the day shift both in the hospital and in the clinic (first floor) to provide direct nursing attention. In long-range terms, solutions to such problems will depend on the development of some alternate system for delivery of care in which these essential services are provided for the inmates of Attica by a larger well-staffed medical center, or inmates in need of care are transferred to some facility with large enough

volume to support more comprehensive staffing patterns. This same observation would apply not only to support personnel but to all types of professional care requirements.

Dental: Two full-time dentists, employed by the Department of Corrections and responsible to the Superintendent, worked for approximately six hours a day, five days a week, and were on call for emergencies. Neither maintained a private practice, and dental assistant and technician services were provided by inmates. All inmates were examined on admission and the condition of their mouths found to be generally poor, showing few signs of previous care. Because of the limited time available in the inmates' schedule and the large amount of essential restorative work to be done, little effort was made to save teeth which would require extensive treatment. In addition, like many people, inmates often refused all but emergency help through fear of the pain commonly associated with dentists. There were thus far fewer complaints lodged against the dental services than the medical care.

Psychiatric: Psychiatric services were provided through the staff and budget of the Department of Mental Hygiene, with part-time psychiatrists and psychologists.[34]

Sixty percent or more of the staff time was spent in evaluating inmates for parole hearings, transfers to facilities such as Dannemora State Hospital, and in response to a myriad of requests from courts and various officials. In addition, staff availability fluctuated over time and in response to budget limitations in the Department of Mental Hygiene and to the exigencies of the winter weather in the area which was often so bad that the psychiatrists would not drive to the institution.

It was impossible for the psychiatrists to provide other than an occasional consultation and direct supervision when a true crisis occurred. Some 40 percent of the inmates had requested appointments but it took months before an inmate could be seen, and most were not seen at all unless a crisis arose. There have been attempts at group therapy, but these were largely frustrated by lack of time and of facilities. A psychiatric or therapeutic milieu in which group psychotherapy was possible did not exist at Attica.

Because of the great need among inmates in the area of operational and emotional distress, the medical department has, over the years, developed a procedure in sick call which compensates, but in an eventually damaging way, for the lack of psychiatric availability. Inmates whose complaints were such as might seem indicative of mental or emotional disturbances were given tranquilizers and other support and maintenance drugs in the hope that they would carry the inmates as long as possible without serious or repeated episodes of uncontrollable behavior, with their consequent disturbances. Of course, since the earlier stages were not adequately treated, some inmates tended to become worse than they would have otherwise. This in turn led to increasing numbers of highly disturbed inmates which

necessitated a closed ward [35] which was then no longer available for less disturbed persons, who were then merely continued on drugs.

In substance the Department of Psychiatry at Attica was overwhelmed and preoccupied with meeting purely technical and legal requirements involved in inmate movement in and out of the prison and with emotional disturbances when those got beyond the level which the correction officers and the general medical personnel could adequately handle. It is interesting to note that the build-up of emotional tension, the increased number of emotionally disturbed inmates, and the lack of effective means of defusing the increasing pressures as these were generated were all anticipated and identified by the supervising psychiatrist before the uprising and he had expressed his fears and misgivings about the rising tension and disturbed climate within the prison on several earlier occasions to the prison authorities.

Vocational Rehabilitation Project: The staff of this program—the director, a vocational rehabilitation counselor, two teachers (one academic, one vocational), two part-time psychologists, and a parole officer—were employed by the Division of Vocational Rehabilitation (DVR). The program was instituted in 1967 to utilize behavior modification techniques and intensive medical help for inmates with psychiatric and medical disabilities in a model which would have implications for the overall rehabilitative program within prisons. Much of the medical and psychiatric capability was to be gained through the cooperation of those departments within Attica, and the inability of the psychiatrists to devote a significant amount of time had limited the project to those with physical health-related disabilities. The inmates with such problems included diabetics, epileptics, orthopedically disabled inmates, and paraplegics, all with varying degrees of disability which were either correctable or could be stabilized and the individual hopefully trained for some productive occupation. However, since Attica itself has no physical therapy, recreational therapy, occupational therapy, or other facilities, the program was largely centered at the prison in a workshop setting, which had difficulty in gaining acceptance and support from the prison authorities who viewed the whole approach as too permissive and who did not understand or trust the methodologies being used. The medical services provided for DVR inmates were much broader than those available to the general population; chronic disabilities were treated and efforts made to increase the functional capacity of participants.

However, since the project's budget did not allow it to obtain the anticipated services from outside the system, the dependence on institutional sources for services which the institution had not the capacity to supply limited its operation.

RELIGION

Before the uprising, religious services were regularly held in the chapel for Catholics, Protestants, Jehovah's Witnesses, Christian Scientists, and

Jewish inmates. Only 15 percent of the population attended services on any regular basis, and many did because it provided them with an opportunity to leave their cells and socialize. There were two full-time chaplains, Father Eugene Marcinkiewicz, a Catholic priest, and Reverend Eligius Ranier, a Protestant minister; other clergymen came in on a part-time basis.

Both chaplains, in addition to conducting services for inmates of their respective faiths, provided counseling and personal services to them. These included interviewing new inmates and inmates eligible for parole, supervising an Alcoholics Anonymous chapter, conducting a choir, and distributing greeting cards and calendars. The part-time clergymen who came to Attica conducted much more restricted programs.

There was no minister for the Black Muslims. Assistant Deputy Superintendent Pfeil told the Commission that efforts had been made a year before the uprising to secure a minister of the Nation of Islam, but that those contacted had refused to come. Inmates pointed out that their effort was undercut from the beginning by the requirement that the minister not have a criminal record, since many Black Muslims who become ministers have been recruited in prison. The tenets and practices of the religion have enabled many to rehabilitate themselves, often through the example of a minister who had followed the same path at an earlier time.

In March 1971, Dr. Ranier did arrange for a Muslim minister. However, when a dispute arose during the service he discovered that he had secured an Orthodox Muslim minister for a group consisting of about 30 Orthodox Muslims and 200 members of the Nation of Islam.

No meeting place or organized services were provided for Black Muslims and some regularly attended Jewish services as a substitute. Without their own regular service, Muslims gathered in the yard during recreation periods to worship and engage in physical fitness programs, as encouraged by their religion. Orientation material for new officers warned them to be wary of "inmates congregating in large groups," and instructed them to "move over . . . to ascertain what the group is discussing and the reason for the gathering."

The administration and officers never understood the Muslims. They were never given information about what Muslims believed, and Muslims saw no reason to explain themselves to hostile officers. Officers, ignorant of Muslim beliefs, assumed that a black group which conducted itself with an internal, almost military, discipline and conditioning was committed to violence.

While important Christian and Jewish holidays were observed in the prison, the Islamic holy month of Ramadan, when Muslims fast from sunrise to sunset, was not recognized. Muslim inmates were required to attend meals, although their religion forbade them to eat.

RULES AND DISCIPLINE

Rules assume a special prominence in prisons, where adherence to un-varying routines reassures the security-conscious correction staff. In addition, the public expects that serious efforts will be made to encourage the observance by inmates of rules governing their conduct, so that they will observe the law when they return to society. But the rules at Attica were poorly communicated, often petty, senseless, or repressive and they were selectively enforced.

A departmental inmate handbook, containing statewide rules, was printed at Great Meadow in 1961, and revised in 1968. The book stated: "Ignorance of the rules will not be accepted as an excuse for violation," but no rulebooks were distributed to Attica inmates after November 1970 and there was no other systematic method adopted for communicating the rules either to inmates or officers.

In addition, each institution had wide discretion to establish its own rules. Additional regulations could be imposed by hall captains, who regulated the inmates' conduct in their blocks.

In theory, officers were required to explain the reason for the rules to inmates but new officers had almost as much difficulty as new inmates in ascertaining what the rules were. As a result, a group of experienced officers prepared an unofficial guide. The document states: "Until you are familiar with what is allowed, tell inmates 'No' when they ask for any special permission."

Inmates often learned the rules only when they broke them. The situation was especially difficult for Spanish-speaking inmates, many of whose knowledge of English was limited. As one testified:

Q. Were you given any indoctrination in Spanish about the rules of the institution?
A. Well, you might call it indoctrination. Every time I violated a rule, a keeplock was indoctrination.

In the absence of generally understood guidelines, correction officers had great discretion in interpreting and enforcing the rules. Even where rules were clearly defined, the strictness of their enforcement varied from officer to officer, depending on each one's experience, perspective, and personality. For example, some officers insisted that inmates stand at the front of their cells for roll call; others allowed inmates to remain in bed or seated, as long as they were visible. Some allowed quiet talking in line; others did not. Some were rigid and insensitive, others understanding and patient.

Inmates might have adapted to such discrepancies if they had spent the majority of their time under the supervision of one or even several officers. But in August 1968, the organization of correction staff shifts was changed, and officers were no longer assigned to individual companies. Instead, day men were assigned to blocks, night officers wherever they were needed. Moreover, a rotating system of days off resulted in the frequent assignment

of relief officers. Inmates had to master the idiosyncrasies not of two or three officers but of dozens during a year. From day to day, they could never be sure what to expect.

The system as it existed made favoritism, discrimination, and harassment by officers easy. The possession of heating droppers was generally permitted, but some men considered troublemakers or who were otherwise disliked were punished when the devices were found in their cells on shakedowns. Inmates widely reported that special searches were made of disfavored inmates' cells, in order to find the same contraband which was ignored when in the possession of others.

The administration was aware of the problems created by rules enforced by men of different personalties. One supervisory officer testified that there were "a few officers who should not be in contact with inmates." An older black inmate, respected by officers, testified that there were three or four officers he considered racist, who "come into work in the morning, and they are going to find what they can do to irritate an inmate." The few officers who bothered could make life miserable for hundreds of inmates simply by enforcing strictly their interpretation of the rules.

Many of the rules were senseless, juvenile, and served no purpose. Inmates at Attica, but not at other prisons, were prohibited from chewing gum, because discarded gum had created a housekeeping problem; they were required to march to the mess hall and to their jobs with their hands at their sides, to stand up in their cells when they were counted, to avoid loud conversation in the halls, to turn out their lights at a prescribed hour; they could not wear hats indoors, grow a mustache, or have sideburns of more than a prescribed length.

Even where seemingly arbitrary rules had a legitimate basis in security, they were rarely explained to inmates. They found out only the dos and don'ts, not the whys.

Some of the rules seemed transparently hypocritical, such as the prohibition against droppers. Why, inmates reasoned, did the administration sell items in the commissary which required heating, like coffee, tea, and soup, if they expected inmates to observe the prohibition against heating devices?

While officers could, at will, find daily minor infractions by an inmate of the myriad written and unwritten rules at Attica, punishment was inhibited by court decisions and new administrative regulations. Until October 1970, penalties for minor infractions were determined by the Deputy Superintendent, who could keeplock an inmate or send him to solitary confinement in HBZ as punishment, as he saw fit.

A keeplocked inmate was not allowed to leave his cell during the entire time of his keeplock. Meals were brought to him there. If his commissary day came up during a keeplock, he missed it.

HBZ (Housing Block Z) is a special disciplinary housing unit located in the reception building. The cells are similar to those in the main housing

blocks, but inmates spent 23 hours a day in HBZ cells. Confined HBZ inmates were not permitted to work or to go to school or to meals, and they could leave their cells only for an hour's solitary recreation in a small, open-roofed room. A prison doctor toured the HBZ galleries daily.

In 1970, a Federal district judge upheld the contention of an Attica inmate that the punishment procedures in New York prisons violated the United States Constitution.[36] In response, the department adopted new rules which provided an inmate charged with an infraction the opportunity to defend himself.

The new rules directed officers to "deal with minor infractions that do not involve danger to life, health, security, or property by counseling, warning, and/or reprimand" without reporting them. An officer was authorized, at his discretion, to keeplock an inmate for up to 72 hours, which had to be reported to the Superintendent. The inmate was then scheduled to appear before the adjustment committee at its next meeting.

The adjustment committee was composed of an officer of lieutenant rank or above, a civilian employee, and another officer.[37] The inmate was called before the committee, but the accusing officer was not; the committee relied instead on the officer's written report. On the basis of the report, the inmate's explanation and his prior disciplinary record, the committee could choose a number of courses: dismiss the charge, direct the loss of specified privileges for not more than 30 days, keeplock the inmate for up to two weeks, assign him to HBZ for up to one week, recommend a change in the programs or facilities of the institution, defer action for up to three months, or recommend a Superintendent's hearing. During 1970 and 1971, no recommendations were made for changes in the institution's programs or facilities. Of the 3,219 complaints considered in 1971, only 6 were dropped at the hearing. The others resulted in punishment or, when considered more serious, referred to a Superintendent's hearing.

At the Superintendent's hearing, the inmate received a written charge, and a correction officer was appointed to assist him in his defense. If the charge was affirmed, he could be assigned to HBZ for up to 60 days, subject to review by the Correction Commissioner, or he could be deprived of earned "good time" previously subtracted from his sentence.

The new procedures did not satisfy either inmates or officers. The absence of any opportunity to cross-examine the complaining officer deprived the inmate of the sense of fairness and impartiality the procedure was intended to instill. In addition, the inmate could be held in keeplock until the hearing, thus punishing him before "conviction" very much like the detention he had likely experienced before Attica while awaiting a trial which would determine his innocence or guilt.

Officers, who were not allowed to appear at hearings, felt they had little influence on the verdict or punishment, and they believed their authority was undermined. They complained that, frequently, the only punishment given an inmate was the day or two the inmate had already served in

keeplock waiting for the hearing. The new procedure also increased the officers' paperwork, and some officers stated that they reacted by over-looking offenses rather than go through the routine.

Protecting the Inmates: In a maximum security prison in which they were allowed no privacy, inmates at Attica were insecure concerning their safety. The Commission found that popular conceptions of homosexual advances and assaults in prison were not exaggerated.

The first weeks at Attica were especially frightening for a young man who had never been in prison. Some were lucky enough to be warned where not to walk alone and what kind of advances to reject. But the unwary or careless often had to choose between a fight or consenting to homosexual acts. Typically, a young inmate would be approached by an older man offering him food, advice, or protection. The inmate who ac-cepted these offers only as friendly gestures to help him get adjusted often found he had made a deal and was expected to reciprocate with sexual favors. The only alternative was to fight and risk the consequences. If he consented, he was likely to be tabbed for the rest of his term as a "homo" by officers and inmates alike and to discover that his only hope of compan-ionship and protection from frequent assault was in continuing submission. Even if an inmate did not choose to submit, the apprehension of being "ripped off" by another inmate or group of inmates was very real for young inmates. Many always carried crude but effective knives fashioned from metal scraps in order to defend themselves.

Officers, who were responsible for the welfare of inmates, could not offer them constant surveillance because of a low officer-inmate ratio. In addition, the officers' negative attitudes toward criminals and blacks cre-ated an indifference to what some believed was the normal sexual conduct of many inmates. One officer stated in a Commission interview that he had witnessed five men sexually assault another inmate. He did nothing to stop it, but assumed without investigation that the activities were consensual.

Some officers said they made efforts to discipline inmates caught in the act of assaulting another inmate. But often it was easier to report both inmates involved instead of attempting to determine who was at fault. As a result, inmates had no confidence in the ability and determination of offi-cers to protect them from assault, just as on the outside many were accus-tomed to police who offered them no protection. They relied instead on their homemade "shivs," which were carried everywhere at Attica. If an officer was sympathetic to an inmate and believed him to be in danger of homosexual attack, he often would overlook the "shiv" if it had been left where it could be found in a cell search.

The irony was not lost on the inmates. They perceived themselves sur-rounded by walls and gates, and tightly regimented by a myriad of written and unwritten rules; but when they needed protection, they often had to resort to the same skills that had brought many of them to Attica in the first place.

RACISM IN OFFICER-INMATE INTERACTION

The relationship between officer and inmate was the central dynamic of life at Attica, as it must be in every prison. The civilian staff was inadequate for the task of rehabilitation: the doctors were unsympathetic, the two psychiatrists were booked months in advance, and the civilian teachers and counselors were few in number. By default, the burden of helping inmates with their problems fell on the officers. The Commission engaged Dr. Robert E. Gould to analyze the psychiatric aspect of the officer-inmate relationship, and part of this section draws on his insights.

Most officers perceived themselves as custodians who were there to enforce the rules and to keep the inmates in line, not to help solve their problems. They were not trained to counsel inmates and they generally lacked the motivation to try. Albany may have changed the title of the position from guard to correction officer, but it did not change the attitude of the men.

Some officers tried to help inmates with prison matters such as straightening out their commissary accounts, or gave advice on family problems. But the relationship between most officers and inmates was characterized by fear, hostility, and mistrust, nurtured by racism.

The relationship was probably inevitable when predominantly poor, urban, black, and Spanish-speaking inmates were placed under the supervision of white officers from rural areas equipped with only three weeks of training. Most whites in society have not met blacks on equal social terms and except for their service in the military, many Attica officers were exposed to blacks only after they were convicted criminals. They began with little or nothing in common, and Attica was not a catalyst which made people want to learn about each other.

Attica also had a history of racial segregation which existed into the 1960s. A black inmate, who grew up in an integrated neighborhood, testified:

I was in Mississippi in the army, in Alabama in the army, and I was all over. I want to tell you something about Attica in 1960. I have never seen so much discrimination in one place in my life.

There were black and white sports teams, different barbers for blacks and whites, and separate ice buckets for black and white inmates on July 4.

Segregation was officially abandoned by the mid-1960s, but, as in the larger society beyond the prison walls, racism still pervades all of Attica in varying degrees. It is manifested by both officers and inmates.

The vast majority of officers denied on direct questioning that they harbored any prejudices against black or Spanish-speaking inmates. They do not view racism as a problem at Attica.

This claim, however, conflicts with a number of objective findings:

1. Statistics and observations of which inmates have the "good" and the "bad" jobs.

2. Unconscious slips (anecdotal material, jokes, use of racist expressions) by officers in general discussions and in answering questions.

3. Specific accounts of biased treatment cited by black and Spanish-speaking inmates, and perhaps most significantly, supported by white inmates.

Many officers have racist feelings they are not consciously aware of. One, for example, said that there was no racism in Attica, not even among the inmates themselves. When asked about the daily phenomenon of voluntary self-segregation that goes on in the mess hall, where tables end up being filled mostly with inmates of one race, his reply was, "How would you like to sit between two coloreds while you were eating?" Another officer, also disclaiming any racist attitudes, was asked why whites were predominant in the "good" jobs such as clerical and hospital posts, while black and Spanish-speaking inmates were very much overrepresented in the "bad" jobs such as duties in the metal shop and grading companies. He answered as follows: "They [black and Spanish-speaking inmates] are better suited for those jobs." And another officer stated: "It is hard to find coloreds who can do good clerical work." There are in fact enough blacks qualified to do the kind of clerical work needed. Moreover, the use of the term "colored," common among correction officers despite the known wish of black men to be called black, conveys some degree of underlying prejudice.

Another position some officers take is discouragement, in active or nondirect ways, of black-white friendships. Several whites who were friendly to one or more blacks were told they would not get certain privileges they wanted while they kept up such friendships. Job discrimination has been used, according to some white inmates, as a penalty for their fraternizing with blacks. They were often called "niggerlover" and were sometimes the target of snide remarks implying that there must be a homosexual basis for the liaison, since there could be no other explanation for such an unnatural relationship.

Racism among Attica officers may be no greater than what is present in society at large, but its effect is more intense at Attica. The prisoner can find no escape from it—there is no way to avoid confrontations and unpleasant experiences when the interaction is so ever-present, and the quarters so close.

There is also racism among inmates, most of whom, reflecting society at large, carry fairly strong prejudices into Attica. Self-segregation is practiced not only in the mess halls, as mentioned, earlier, but in the yards and the E block dayroom as well.

Racist attitudes in the institution were an undeniable factor among the tensions leading to the uprising. Aggressive responses to racial bias are increasingly common outside prison, and this trend exists inside as well. Inmates today feel that they have the right, even as prisoners, to rebel against being further put down on the basis of race.

Racism has always been an unsettling force in this country. The openly rebellious reaction to it developed gradually, but by now must be recognized as an explosive reality, within prison as well as "outside." While it is a microcosm reflecting the forces and emotions of the larger society, the prison actually magnifies and intensifies these forces, because it is so enclosed. In prison there is no possible escape from oppression.

Summary

In attempting to answer the first major question presented by its mandate—why did Attica explode—the Commission was presented with no lack of explanations.

Correction personnel and some older inmates tended to take a conspiratorial view of the uprising, calling it the work of left-wing radicals and "troublemakers" among the inmate population and insisting that it was planned in advance. That view was expressed in a report dated October 7, 1971, prepared for Executive Deputy Commissioner Walter Dunbar by a group of parole officers who were assigned to investigate the uprising, essentially by interviewing the hostages. The parole officers' report concluded that the disturbance was the result of a "long thought-out, well-organized plot, conceived and implemented by a group of hard core radical extremists—mostly from the New York City area." Writing in the March 31, 1972, issue of *National Review*, a 40-year-old white inmate offered a similar view:

I was there and to my way of thinking there was absolutely no valid reason for the riot, rebellion or whatever the hell you want to call it.

The rebellion was instigated and carried out by no more than 10 percent of the prison population. They were radical political fanatics. They belonged to the Black Panthers, People's Liberation Party, Young Lords and Sam Melville's group of Commie fanatics. . . . They wanted a rebellion for political reasons.[38]

No less pat are explanations found in the blossoming literature of the "prisoners' liberation" movement. Those partisans would be the last to dispute the conclusion that the uprising was spawned "for political reasons." But they would glorify the prison rebels as heroes and place the blame squarely on the political and economic system against which the uprising was, in their view, directed. "The realization is growing, especially in the black community," wrote one such advocate, "that prisoners are the real victims of this society. One must look outside the prisons for the criminals." According to that thesis, revolts such as Attica "will recur so long as men and women are put behind bars for disobeying the inhuman laws of the society and struggling against its inequities—that is, as long as capitalism remains intact."[39]

Contrary to these popular views, the Attica uprising was neither a long-planned revolutionary plot nor a proletarian revolution against the capitalist system. After talking with inmates, correction officers, administrators, observers, and experts, and after much reflection, the Commission has concluded that:

- Rather than being revolutionary conspirators bent only on destruction, the Attica rebels were part of a new breed of younger, more aware inmates, largely black, who came to prison full of deep feelings of alienation and hostility against the established institutions of law and government, enhanced self-esteem, racial pride, and political awareness, and an unwillingness to accept the petty humiliations and racism that characterize prison life.
- Like the urban ghetto disturbances of the 1960s, the Attica uprising was the product of frustrated hopes and unfulfilled expectations, after efforts to bring about meaningful change had failed.
- The uprising began as a spontaneous burst of violent anger and was not planned or organized in advance; the relative ease with which the inmates took control of large areas of the prison was due not to a preconceived plan but to a combination of fortuitous circumstances, including the failure of the central Times Square gate and an outdated communications system which prevented the authorities from quickly mobilizing force to quell the disturbance.
- The highly organized inmate society in D block yard developed spontaneously, after a period of chaos, rather than by prearrangement; in the hours following the initial violence the leaders of political and religious groups with preexisting structures, and inmates who were politically motivated, well versed in the law, or otherwise respected by their peers, emerged as spokesmen and took the lead in organizing the yard and drafting demands.
- In reaching these conclusions concerning the causes of the uprising, the Commission nevertheless condemns the taking of hostages as a means of bringing about changes in society, even where peaceful efforts at reform have failed. Whether carried out in a commercial jetliner, or in a prison, the holding of human lives for ransom is wrong and only leads to more violence and to a backlash that makes change more difficult.

WHY IT HAPPENED

Attica happened at the end of a summer marked by mounting tensions between inmates and correction officers, but also by rising expectations and improving conditions. Attica was no longer the jim crow institution it was even in the early sixties. Prison discipline had become more relaxed. The courts had responded to inmates' complaints and begun to order limited reforms. And the new Commissioner had liberalized rules and was promising new programs, new facilities, and a new attitude toward inmate problems.

But the new Attica was increasingly populated by a new kind of inmate. Attica, like most of our prisons, had become largely a black and Spanish-speaking ghetto, and the new inmate was shaped by the same experiences, expectations, and frustrations that culminated in eruptions in Watts, Detroit, Newark, and other American cities. The young inmate was conscious of the changes in attitudes in the black and Puerto Rican communities, on

the campuses, in the churches, and in the antiwar movement. The increasing militancy of the black liberation movement had touched him. Names like Malcolm X, George Jackson, Eldridge Cleaver, Angela Davis had special meaning to him.

The new inmate came to Attica bitter and angry as the result of his experiences in the ghetto streets and in the morass of the criminal justice system. Very likely, he already did, or would soon, see himself as a "political prisoner"—a victim, not a criminal. For all its changes, Attica was still a prison, the very symbol of authoritarianism, and in the summer of 1971, it was caught up in an era of decline and rejection of authority.

Attica's all-white correctional staff from rural western New York State was comfortable with inmates who "knew their place," but unprepared and untrained to deal with the new inmate, much less to understand him. Unused to seeing their authority challenged, officers felt threatened by the new inmate. Viewing the recent relaxation of rules and discipline, the intervention of the courts, and the new programs for inmates, they felt that their authority was being undermined by Albany and that their superiors were not backing them up. The officers became increasingly resentful and insecure. The result was, inevitably, daily confrontations between the new inmate and the old-style officer.

The confrontations were accompanied by increasing societal awareness among inmates and the growth of organizations inside the institution determined to spread the consciousness and try to make changes. Groups such as the Muslims, Black Panthers, and Young Lords gained adherents and held meetings, but quarrels and rivalries among them and their leaders prevented them from coming together in concerted action.

Largely as the result of these groups' efforts, discussion groups began in the exercise yards. By the summer of 1971, an inmate-instructed sociology class in the school had become an informal forum for ideas about effecting change. There was, finally, a series of organized protest efforts at Attica in the months prior to September 1971. Some had moderate success, but others ended only in the discipline of participants. The reaction of the authorities became increasingly one of isolating and transferring suspected "ringleaders" and "troublemakers."

An inmate manifesto setting forth a series of moderate demands, and including a commitment to peaceful change, was sent to the Commissioner and the Governor in July 1971. The Commissioner responded with an acknowledgment and with a visit to Attica early in September. In the intervening eight weeks, tensions at Attica had continued to mount, culminating in a day of protest over the killing of George Jackson at San Quentin, during which few inmates ate at lunch and dinner and many wore black armbands. The inmates had demonstrated their ability and their willingness to act en masse, and there was now some talk about organizing a prison-wide sit-down strike. When Commissioner Oswald's visit produced nothing more than a taped speech promising future changes and asking for pa-

tience, the stage was set. No one really expected a violent takeover of the prison, but few at Attica thought the summer would pass without a major incident.

HOW IT HAPPENED

The initial explosion on Thursday, September 9, came in reaction to an incident the previous day which provoked anger and resentment among inmates in two companies in A block. A misunderstanding in the exercise yard on Wednesday afternoon led to an unusually intense confrontation between officers and inmates, during which a lieutenant was struck by an inmate. The officers were forced to back down, but that evening, two inmates were removed from their cells to HBZ, precipitating angry name-calling, hurling of objects from cells, and vows of revenge along the two galleries.

The following morning, uneasiness lingered on in one of the two companies, comprised largely of inmates considered "difficult" by the administration. An inmate who had been locked in his cell for throwing a soup can at an officer the previous evening was released from his cell by fellow inmates. After breakfast, a lieutenant who had been involved in the incident on Wednesday approached the company as it was lined up in A tunnel on its way back from breakfast. He intended to try to persuade the inmates to return to their cells, but as he reached them, he was attacked, and the uprising was underway.

After an initial outburst of chaotic violence, rebellious A block inmates regrouped and set upon the locked gate at Times Square, which separated A block from the rest of the institution. A defective weld, unknown to officers and inmates alike, broke and the gate gave way, giving the rioters access to the center square, and the keys which unlocked the gates in three directions. From Times Square, inmates from A block spread throughout the institution with little resistance, attacking officers, taking hostages, destroying property. As the rebellion reached other areas, some inmates joined in actively, but the majority tried to escape to secure areas, or were simply caught up in the tide.

The authorities were slow in responding, due largely to the absence of a riot control plan, the lack of available manpower, and an antiquated communications system. Connected with other parts of the prison only by single-line telephones, those in the administration building could not appreciate the full extent of the trouble, or summon help, until it was too late. By 10:30 A.M. the inmates had obtained control of four cellblocks and all of the yards and tunnels, and 1,281 inmates had gathered in D yard with over 40 hostages. Only then did the rudiments of organization begin to appear, with leaders of preexisting groups, inmates well versed in law, and other natural leaders among the inmates emerging as spokesmen. Most of those who took an active role in organizing the yard, drafting demands, and, later, negotiating with the state, had not been involved in the initial outbreak of

violence and did not join in it when the rioters reached their area of the prison.

WAS IT PLANNED?

The Commission has found no evidence that the Attica uprising was planned, either by avowed revolutionaries or anyone else. All of the objective evidence, especially the course the uprising actually took, points in the other direction.

To begin with, although the Commission has been able to document in some detail the growth of inmate organizations and the planning of nonviolent protests at Attica, it has found no indications that these organizations, or other inmates, were considering a takeover of the prison. Many inmates who were aware of and took part in efforts to organize inmates told the Commission that at most there was talk of a prisonwide sit-down strike. The public testimony of one inmate expresses the view of most of them:

Every inmate within the prison thinks about escape and I said to myself, if I knew it was going to be that easy to push them over, I should have tried to take advantage of it. I thought about that and I thought about escape before and since.

I never really thought in my own mind that I would ever escape and I think there were an awful lot of people that for years and years have said, boy, we ought to start a riot and played a little mental game with themselves, boy, if we ever started a riot, we will go into D block, we will take so many hostages. It was just a game playing in their heads. I don't think anybody could really say, well, on such and such a day we're going to do this.

Although correction personnel frequently cited the increasing militancy among inmates, the circulation of radical literature, and the growing influence of political groups among the inmates, they were unable to point to concrete indications of advance planning for a takeover of the prison. Indeed, some supervisors, including Deputy Superintendent Leon Vincent and Assistant Deputy Superintendent Karl Pfeil, told the Commission they believed from their familiarity with the facts that the uprising was spontaneous.

The course the rebellion took on Thursday morning leads to the same conclusion. To begin with, if a takeover was planned, it would not have been planned to commence in an enclosed area, such as A tunnel, where access to the rest of the prison was presumably sealed off by iron gates. The mess halls or exercise yards, where there were concentrations of inmates, were more logical choices. The company which started the violence had just come from the mess hall, where hundreds of other inmates were present, had passed through Times Square, where the keys to four corridor gates were kept, and had seen the Times Square gates locked behind them, all without incident. A planned rebellion, even if the planning were limited to that company, would surely have been touched off before the moment the inmates were confined to A tunnel, with no immediately apparent avenue of escape and no guarantee of access to the rest of the institution.

No one could have anticipated that the Times Square gate would give way. Had it held, as everyone expected it would, the uprising would have been limited to A block and A yard—where at that hour fewer than 300 inmates and 10 correction officers were located. Before the gate broke, the A block rebels called to inmates trapped in other corridors to join in the uprising, but their entreaties fell on deaf ears.

Only after the totally fortuitous failure of the Times Square gate were the rebels able to get the keys to other gates and gain access to the metal shops, where they obtained tools, acetylene torches, and an electric truck for use in breaking through still more gates. Had an uprising been planned, inmates in other areas of the prison would surely have been alerted to begin hostile action before the rioters from A block reached their areas. In fact, however, no violence erupted, no damage was done, and no hostages were taken anywhere in the institution until inmates who had broken into Times Square arrived. Even then, most inmates just did their best to stay out of the way. Significantly, most of the inmates who were later to emerge as leaders and negotiators in D yard were not part of the first wave of violence and destruction.

The rioters did not take over the prison according to any rational plan. After the initial flare-up, before Times Square fell, there was a 10-minute lull during which A block inmates hurriedly gathered sports equipment and broom handles, broke up benches in A yard, and fashioned makeshift masks from bed sheets. During this lull, some inmates retrieved crude weapons from old hiding places. But the quick emergence of homemade weapons is no indication of advance planning, since inmates in prisons everywhere keep such weapons hidden for self-protection or "just in case."

After the violence had subsided and the hostages were taken, the inmates continued for at least an hour to act in a manner inconsistent with the idea that there were any preexisting plans. They raided the commissary and officers' mess in helter-skelter fashion, not at first stockpiling supplies or preserving them for future use. Before the commissary could be completely stripped of food, it was set on fire and destroyed. Once the metal shops were entered and over 20 hostages taken, fires were set and the inmates deserted the shops, leaving behind large quantities of volatile materials, tools, metal scraps, and machines that could be used for making weapons.

When the uprising broke out, only one correction officer and two civilians were on duty in the powerhouse, control of which would include the capacity of cutting off the electricity in the entire institution. Yet, inmates never made a concerted effort to take over the powerhouse. Even when they all reached D yard, there was a long period of chaos and internal bickering among inmates before organization emerged.

The lieutenant who had first been struck in A tunnel told the Commission that while he was hiding in an A block cell, he heard an inmate somewhere

in A block shout, "Squad 1, go to your area, Squad 2, go to your area." To him, and others at Attica, this was a strong indication of preexisting inmate organization and planning. No similar reports were received from other sources and, in months of investigation, the Commission was never informed of the existence of the inmate "squads."

It is unclear exactly when the remark was heard, but it may well have been a considerable time after the initial flare-up, when the beginnings of inmate organization were emerging. Then, too, it is clear that tightly disciplined organizations, such as the Muslims, did exist at Attica and that they attempted soon after the uprising began to make some order out of the chaos. A group of Muslims, operating in A block, were responsible for protecting and releasing several injured officers that morning. Throughout the four-day uprising, the Muslims were always well disciplined and continued to protect the hostages from harm. The commands overheard by the lieutenant may well have been a part of that discipline. Standing alone, his report does not constitute persuasive evidence that the uprising was planned.

It is clear, therefore, that the Attica uprising was not planned in advance by a group of militant inmates. To continue to blame the uprising solely on a group of political "radicals" and "revolutionaries" merely perpetuates the dubious policy of isolating and transferring a few suspected "troublemakers" in response to mounting tensions, which prevailed prior to the uprising. It also fails to focus on the real reason why inmates were able to take over Attica so easily; insufficient manpower on the correction staff, lack of a plan for dealing with large-scale uprisings, and a completely inadequate internal communications system. If these failures are not corrected, every flare-up of tensions—and under present prison conditions there will continue to be such incidents—has the potential to become another Attica.

More fundamentally, if future Atticas are to be avoided, correction personnel must stop looking for individual scapegoats and concentrate on major efforts to train officers to understand and deal with the new breed of inmates, to eliminate the petty harassments and root out the racist attitudes which these inmates will never tolerate, and accelerate programs to make prisons—as long as they must exist—more humane environments for men to live in.

NOTES

1. When the troopers arrived they found many Muslim guards still there, and were told by some hostages that these inmates had protected them. Some of these Muslim guards have told the Commission that they succeeded in keeping inmates who wanted to harm the hostages out of the hostage area until the end.

2. *Guilty Plea-Bargaining and Prisoner Attitudes,* Report of the Joint Legislative Committee on Crime, State Senator John H. Hughes, Chairman, pp. 15–16.

3. Members were the service unit head or his representative, who chaired the meetings, the senior parole officer, the Deputy Superintendent or his designate, the Education Supervisor, and the head of the Office of Vocational Rehabilitation.

4. Exceptions were inmates who lived in E block and inmates on the night shift in the metal shop who worked without officer supervision. Together they made up less than 5 percent of the population.

5. Until April 29, 1971, lights went out at 10:00 P.M.

6. Since the uprising, the law library collection has been updated and expanded as a result of a federal grant to the Department of Correctional Services.

7. *New York Times,* July 29, 1972, p. 23, col. 4.

8. Orientation Material for New Officers, Attica Correctional Facility, p. 6.

9. The metal-shop strike and the institution's reaction to it illustrate the prison's attitude toward inmates who refused to work.

10. Work Rules and Regulations, Division of Industries.

11. One exception was the metal-shop night shift, begun in July 1971 in an attempt to make better use of the institution's facilities and offer a more normal working situation to selected inmates. The 41 men worked from 3:30 to 11:30 under the supervision of three civilians, and were paid an additional 10 percent in wages. The program was discontinued after the uprising.

12. Because Attica receives new commitments and parole violators from the surrounding area, whites are overrepresented in this sample. Most black inmates arrive as transfers from Ossining, and before the uprising, transfers did not appear before the assignment board.

13. Schooling is no longer compulsory.

14. The printing presses were destroyed by fire during the uprising. The printing instructor told the Commission he had not been consulted regarding the kind of new equipment to be ordered to replace them.

15. In May 1971, at the suggestion of Acting Deputy Superintendent Pfeil, Commissioner Oswald increased yard time 40 minutes. Officers' shifts were slightly rearranged to maintain the necessary coverage of yard time and supper. Since June 1972, inmates have been permitted to go to the yard two evenings per week.

16. Since the uprising, each inmate has been provided with toothbrushes, toothpaste, razors, blades, and toilet paper as needed.

17. Since the uprising, inmates have been given twice-weekly showers.

18. *SaMarion* v. *McGinnis,* 35 A.D. 2d 684, 314 NYS 2d 715 (4th Dept. 1970).

19. Until October 1, 1970, inmate wages ranged from 6¢ to 29¢ per day. The raise was precipitated by the metal-shop strike.

20. There was also a possibility of a "merit" increase of 10¢ a day, on the recommendation of the supervisor. It was not common.

21. Grade II had 556 positions, 307 of which were in the metal shop; Grade III had 237 positions; and Grade IV, 75. There were 119 students, 252 inmates for whom there were no jobs, and 17 who received no wage.

22. The commissary visits were scheduled in the order of inmates' admission to the prison. Since the uprising, inmates go to the commissary according to job assignments.

23. This reflects the situation after October 1970. Under the previous wage scale, monthly earnings ranged from about $1.32 to $6.38, of which one-half could not be spent while in prison. Commissary prices were no lower prior to the raise.

24. Two ounces of tobacco, papers, and matches were distributed to each inmate every other week.

25. "Inside Attica," *Christianity and Crisis* (May 29, 1972): 129.

26. Since the uprising, inmates have been allowed to visit the library two days a week. They also have been given access to the Wyoming County library, which absorbs the mailing costs of books sent to inmates.

27. These changes have led to a reduction in the number of books rejected. In addition, the present chairman of the Attica review committee has required the concurrence of three of the five committee members before an item of literature is excluded. In April and May 1972, 13 items of literature were found unacceptable by the Attica review committee; 4 of these 13 decisions were overturned by the departmental media review committee in Albany.

28. 319 F. Supp. 901, 905 (S.D.N.Y. 1970).

29. Inmate Rulebook, p. 15.

30. The screen was taken down after September 1971, although Dr. James Bradley, medical director for the department, said the order to remove it had been issued prior to the uprising.

31. Among the persons interviewed were the following: Selden T. Williams, M.D., physician in charge; Paul G. Sternberg, M.D., associate of Dr. Williams; Roger Van Wallendael,

D.D.S., dentist; Mr. Charles Van Boskirk, project director, Division of Vocational Rehabilitation; Mr. Siegel, recently employed pharmacist in the Attica Correctional Facility; Mr. J. Dennis Huff, head nurse; James Bradley, M.D., F.A.C., medical director, Department of Correctional Services, State of New York; and several inmates who had specifically complained to Commission interviewers about medical care at the facility. These inmates were interviewed privately; in addition, their medical and sick-call records were examined separately. Several other inmates' medical records were reviewed without reference to whether or not the inmate had complained about medical care. Finally, several correctional officers who were either on duty at or in the hospital facility and several clerks and other personnel on duty in the hospital facility were also interviewed, but for brief periods of time and not privately.

32. Prior to March 1972, all nurses were male and were difficult to recruit. Since that time female nurses have been added to the day shift. The layoff of one of the female nurses in July 1972 resulted in an inmate sit-down and hunger strike in which almost three-quarters of the population participated. The nurse was reinstated two days later.

33. Dr. Williams suffers from a chronic disability which inhibits facial and oral expressiveness, giving the impression of a flat, disinterested, hard person.

34. Although this was the organizational structure, the supervisory psychiatrist has never had a visit from, or direct involvement with, officers of that department in 18 years.

35. This was the ward to which the doctors threatened to send inmates who vigorously disputed their dispositions at sick call.

36. Sostre v. Rockefeller, 312 F. Supp. 863 (S.D.N.Y. 1970), modified subnom, Sostre v. McGinnis, 442 F. 2d 178 (2d Cir. 1971).

37. By union contract, this third position was rotated among all the officers at Attica.

38. Wiggins, "The Truth About Attica by an Inmate," National Review (March 31, 1972): 329.

39. Waters, "Why Attica Exploded," The Militant (October 1, 1971).

19: Prisoners as Research Subjects /

National Commission for the Protection of

Human Subjects of Biomedical and

*Behavioral Research—Staff Paper**

Introduction

Research activities involving prisoners in the United States are primarily of two kinds: (1) nontherapeutic research, which is mainly the evaluation of

* *Prisoners as Research Subjects*, National Commission for the Protection of Human Subjects of Biomedical and Behavioral Research: Staff Paper (October 31, 1975), pp. 1–17, 26–35.

new drugs as to safety (and sometimes, by first inducing a disease, effi-cacy), and (2) research involving new approaches to behavioral therapy or rehabilitation. The history of the use of prisoners in nontherapeutic re-search, and of the concern about such use, is long. By contrast, the use (and the concern regarding the use) of prisoners in innovative approaches to therapy and rehabilitation is relatively recent.

The circumstances under which nontherapeutic biomedical research and therapeutic behavioral research are conducted in prisons differ sufficiently enough that the two areas should be examined separately. The issues raised by the participation of prisoners in nontherapeutic biomedical re-search revolve around the question whether prisoners are in an environ-ment which is so restrictive or coercive that voluntary consent is impossi-ble. The issues raised by participation of prisoners in therapeutic behavioral research include not only the question of coercion but also the extent to which an individual retains the right to refuse treatment for de-viant behavior, or to refuse to be rehabilitated, following conviction by a court or commitment (as an alternative to criminal penalty) based upon psychopathy, insanity, or drug addition. Articles about one kind of re-search in prisons generally do not express concern about the other kind.

History: Nontherapeutic Biomedical Research in Prisons

The use of prisoners for nontherapeutic research has a long history.[1] An-cient Persian kings and the Ptolemys of Egypt are said to have employed the practice. It is attributed, as well, to Fallopius (in Tuscany, in the six-teenth century) and to Caroline (consort of George IV, in late eighteenth century England). At the turn of this century, criminals under sentence of death in the Philippines were infected with plague (without their knowl-edge) by Richard P. Strong, who later became professor of tropical medi-cine at Harvard. Colonel Strong used another group of Philippine convicts to study beriberi, reportedly rewarding them with tobacco in return for their submitting to a disease which caused paralysis, mental disturbance, and heart failure. In 1915, Goldberger induced pellagra in twelve white Mississippi convicts in an attempt to develop a cure. In this instance, for-mal contracts for subsequent parole were written with the assistance of the prisoners' attorneys. In 1934, a program was established at Leavenworth Penitentiary to assess the abuse potentiality of narcotic analgesics (ana-logues of morphine, codeine, etc.). These studies are continuing at the Addiction Research Center in Lexington, Kentucky.[2]

During World War II prisoner participation in research increased consid-erably in this country. Hundreds of inmates in Chicago and New Jersey prisons volunteered to be infected with malaria to test the safety and effi-cacy of experimental drugs in treating that disease. This involvement of

prisoners in research was considered acceptable and even praiseworthy, since malaria was a serious threat to our military men during the war, and the research project afforded the prisoners an opportunity to contribute to the war effort.[3] Nathan Leopold, who (with Richard Loeb) committed what became known as the "crime of the century," was one of the participants in the malaria project. Of that experience, he wrote:

The coming of the malaria project was probably the most stirring and exciting event of my prison term. Here, without any question, was a real chance to be useful. . . . The length of the war in the Pacific could be very well affected by those who got the answer to malaria first. . . . In some not too farfetched sense our bodies would be the battlefield in a not unimportant war. . . .
There were some who, I am convinced, went into the thing entirely on an idealistic basis. They didn't want the money . . . and they had little hope of getting their sentences reduced. But they saw a chance to do something decent and worthwhile for a change. They were more than willing to undergo the necessary discomfort and run the necessary risk in order to make their tiny contribution to humanity. . . .[4]

It was, of course, during the same war that the Nazi concentration camps became the site of infamous medical experimentation, which was at issue in the Nuremberg trials and led to the enunciation of the Nuremburg code, the archetype of codes for research involving human subjects. The German physicians who were accused of performing brutal experiments on nonconsenting inmates of the concentration camps cited in their defense the studies conducted in this country on prisoners.[5] The first principle of the Nuremburg code addresses the problem of research on nonconsenting individuals,[6] but does not distinguish between therapeutic and nontherapeutic research and never states explicitly whether or not prisoners should be considered acceptable subjects of biomedical, let alone behavioral, research:

The voluntary consent of the human subject is absolutely essential. This means that the person involved should have legal capacity to give consent; should be so situated as to be able to exercise free power of choice, without the intervention of any element of force, fraud, deceit, duress, over-reaching, or other ulterior form of constraint or coercion. . . .[7]

The cental issue regarding the use of prisoners in nontherapeutic research is whether or not they can be considered to be "so situated as to be able to exercise free power of choice. . . ."

In the years following the Nuremburg trials, a number of countries decided that prisoners are not acceptable subjects for certain kinds of experimentation. Thus, in 1955, the public health council of the Netherlands stated that:

Experiments on children; in institutions for children, old people, etc.; on the insane; or on prisoners, which involve dangerous risks, inconvenience or pain are not approved.[8]

The draft code of ethics on human experimentation which was presented to the World Medical Association in 1961 stated that:

Persons retained in prisons, penitentiaries, or reformatories—being "captive groups"—should not be used as subjects of experiment; nor persons incapable of giving consent because of age, mental incapacity, or of being in a position in which they are incapable of exercising the power of free choice.[9]

It is reported that pressure from the United States resulted in deletion of this provision from the final version of the code which was adopted in Helsinki in 1964.[10]

Renée Fox has described a number of factors which contributed to the interest of the United States in continuing its use of prisoners in nontherapeutic research.[11] In the decade following the war, clinical research came into its own. The United States enthusiastically supported biomedical research through government and private grants and the establishment of prestigious university positions in a manner which was apparently unique to this country. We were committed heavily (both emotionally and financially) to clinical research. In 1953, the National Institutes of Health (which was already supporting research through grants and contracts) opened its 500-bed Clinical Center hospital, which Fox called "a colossal version of the growing number of research wards specifically designed to carry out studies in American hospitals." [12]

Prison research was also endorsed during this period. Governor Green of Illinois convened a committee to study the ethical issues surrounding the participation of prisoners in projects such as the malaria study. In 1948 that committee reported that:

Since one of the purposes of the parole system is reformative, the reformative value of serving as a subject in a medical experiment should be considered. Serving as a subject in a medical experiment is obviously an act of good conduct, if frequently unpleasant and occasionally hazardous, and demonstrates a type of social consciousness of high order when performed primarily as a service to society.[13]

In like manner, the deputy commissioner of institutions and agencies of New Jersey said of the prisoners who had participated in research during the war that:

All prisoners who had participated in medical experiments were given certificates of merit, copies of which were put into their records and called to the special attention of the Court of Pardons or the Board of Managers when parole was under consideration. Apparently no definite policy was ever formulated, and the participation in a medical experiment was considered only as one favorable factor in the whole case.[14]

In 1949, after a prisoner from an Iowa penitentiary was enlisted by chance as a subject for their metabolic research ward, two investigators set up a formal arrangement with the Iowa state board of control to provide inmates on a regular basis for their research. When a state attorney general questioned the legality of their arrangement, they suspended operation for two years while they obtained enactment of legislation specifically permitting inmates to participate in medical research at the university hospitals.[15] They report, in retrospect, that:

We feel that the use of prison volunteers for medical research is justified and highly desirable for the investigator, for the subjects, and for society.[16]

Prisoner participation in research appeared to be such a salutary experience that the American Medical Association's house of delegates passed a resolution in 1952 expressing its disapproval "of the participation in scientific experiments of persons convicted of murder, rape, arson, kidnapping, treason or other heinous crimes. . . ." [17] The concern was that such prisoners might receive a pardon or parole through their participation in research, and they were deemed to be unworthy of such consideration.

Impetus was also provided by the Kefauver-Harris amendments to the Food and Drug Act in 1962, which established additional requirements for testing the safety and efficacy of all drugs to be sold in interstate commerce. Phase I of such testing involves evaluation of the safety of new drugs in normal volunteers. The deputy director of the FDA's Bureau of Drugs has been quoted as saying that "virtually all" of Phase I tests involve prisoners.[18] (Prisoners may also participate in Phase II tests, by submitting to a disease in order to test the effectiveness of a new drug in combatting the illness, as in the malaria studies of the 1940s.) The business arrangements between large pharmaceutical manufacturers, individual investigators, and state prisons have been described in detail by Jessica Mitford.[19] She suggests that biomedical research in prisons is a big business, precipitated in large part by the requirements of the Food and Drug Administration and perpetuated by the economic self-interest of the drug firms, the investigators, the prison authorities, and the inmates, themselves.

The use of prisoners in research in this country was first seriously challenged by several articles in the anthology edited by Irving Ladimer and Roger W. Newman for the Law-Medicine Research Institute of Boston University, in 1963.[20] Next came the classic "exposé," *Human Guinea Pigs,* by H. M. Pappworth, in 1967, cataloging questionable research activities. Hans Jonas and Louis Lasagna critically examined the problem in the *Daedalus* special issue on human experimentation in the Spring of 1969. In January 1970 the New York Academy of Sciences published the procedings of a conference on legal and ethical concepts in human research, chaired by Irving Ladimer.[21] In all of these, the arguments for and against research in prisons may be found. The conference published by the New York Academy of Sciences, however, was supported largely by four major drug firms,[22] which may explain the preponderance of articles in that symposium which support the participation of prisoners in drug research. Nevertheless, included among the articles is a classic in the field by John Arnold and others, which identifies the important factors contributing to prisoners' decisions to participate in research.[23]

History: Therapeutic Behavioral Research in Prisons

. . . [I]n the Future, when the Courts convict a prisoner, . . . he may have to undergo a course of treatment varied according to his special need, which may, or may not, be painful in its operation. . . . They will inflict no moment of unnecessary suffering; if they have to give any pain, there will be purpose in it, and a friendly purpose (G. Ives, *A History of Penal Methods* (1914), pp. 266, 335). [24]

In the late nineteenth century, the theory of retribution or punishment for criminal deeds was replaced by theories of rehabilitation. The original rehabilitation concept was that isolation from the temptations of the community and subjection to a highly disciplined existence would in *themselves* transform the criminal into a well-behaved citizen. [25] Later, fixed sentences based upon the nature of the crime gave way to a system of flexible sentencing which adjusted the "treatment" to the physical, mental, or social shortcomings of the offender. The idea of a conditional and therapeutic sentence was described by Ferri in 1917:

The application of a conditional sentence . . . is a wise concession to practical utility, being in perfect theoretical accord with the doctrines of anthropology and of criminal sociology. . . . As the sick person is kept in the hospital just as long a time as is necessary for his cure, and the insane patient remains in the asylum all of his life unless cured and leaves it when he is cured, so it should be with the delinquent. . . . [26]

The theory of curing the offender was applied, in this country, by creating a class of "defective delinquents." The first legislation was passed by Massachusetts in 1911, followed in the next three decades by similar legislation in over half the states and the District of Columbia. [27] Such legislation provides for the indefinite commitment of persons either accused or convicted of criminal acts, so that treatment may be provided and they may be released, when cured. These statutes apply generally to sexual offenders and habitual miscreants, or both. Maryland's law, for example, is aimed at the individual who "evidences a propensity toward criminal activity and who is found to have either such intellectual deficiency or emotional unbalance so as to require . . . confinement and treatment." [28] The states differ as to whether individuals may be committed before or after conviction, and as to whether they still may be convicted and imprisoned even following their release from treatment. Psychopaths are not generally considered "insane" nor are they acquitted on the basis of their defects. [29]

The relevance to research of legislation based upon the concept of rehabilitation is first, that the concept itself is uncertain, [30] and second, that it provides the framework for applying new and unproven approaches to treatment.

Throughout the first half of this century, it was widely thought that be-

havioral scientists could explain, diagnose, and treat the criminal offender. Psychiatrists became actively involved in the correctional programs [31] at the same time that psychiatry, as a profession, was doubling its membership every ten years.[32] Psychologists, having mastered the art of behavioral testing and classification for the military during World War I, applied their techniques to civil prisoners, following the war.[33] In 1909, a psychologist (William Healy) founded the Juvenile Psychopathic Institute in Chicago, a clinic which gave advice to the new juvenile court and offered therapy to youngsters under its jurisdiction.[34]

In the 1950s and 60s, behavioral scientists interested in criminology organized formally. The American Association of Correctional Psychologists (now with 300 members) began in 1951 and published the *Journal of Correctional Psychology* (now *Criminal Justice and Behavior*) three years later. In 1968, two more societies were formed: the American Psychology and Law Society, and the International Academy of Forensic Psychology. A year later, the American Academy of Psychiatry and the Law (350 members) was founded.

Courts and legislatures were impressed by the promise of the behavioral sciences. Legislatures repealed fixed sentences and gave the courts wide discretion to base sentences upon detailed personal information. Parole boards were given similar discretionary powers to release a convict upon demonstration of rehabilitation. Probation was another alternative made available to, and utilized by, the courts.[35] It was assumed that the practitioners knew what they were doing. As one noted jurist optimistically observed:

The criminal law cannot fulfill its function as a social tool if it continues to ignore the complexity of causation. . . . Though there are great gaps in our knowledge about the causation of behavior, this does not mean that we have no such knowledge from psychiatry, sociology, anthropology, physiology and other disciplines. We are not morally justified in ignoring what we know.[36]

Eight years later, that same judge noted that "our entire correctional process is a shambles," and chastised correctional psychologists for failing to realize their limitations. Noting that most crime in this country is committed by individuals "at the bottom of society's barrel," he said:

I fear that we may be trying to rehabilitate these offenders with techniques that can work, if at all, only on the middle class. Poor, black offenders are not necessarily sick. They may simply be responding to an environment that has impoverished them, humiliated them and embittered them. . . . Have we, perhaps, been focusing our attention on the wrong part of the problem, the offender and his mental condition, instead of the conditions which produce him? [37]

Other Kinds of Research Involving Prisoners

Although nontherapeutic biomedical research and therapeutic behavioral research are the most publicized (and cause the most controversy and concern), other research is being conducted in prisons. Most of the projects may be characterized as nontherapeutic behavioral research. They include, for example, studies of the factors contributing to criminal behavior (such as cytogenetic anomalies or socioeconomic and psychological stress), comparison of effectiveness of various rehabilitative programs in reducing recidivism, psychological assessment of criminals as compared with noncriminal counterparts, tracking the outcome of judgments concerning "dangerousness," and evaluating standards for determining competency to stand trial. In addition, the National Institute of Mental Health (NIMH) has been directed by Congress to study the factors contributing to homosexual rape in prisons.[38]

Therapeutic biomedical research is also conducted in prisons. Examples are studies to reduce the spread of infections in crowded environments, or to develop new methods of treating drug addiction. Other research may involve investigations to increase understanding of the nature and causes of narcotic or alcohol addiction. (These studies may or may not be therapeutic.) Therapeutic biomedical research has not been the focus of public concern, however, compared to nontherapeutic biomedical research programs or experimental programs for treatment or rehabilitation.

Issues: Nontherapeutic Biomedical Research in Prisons

As indicated earlier, the central question concerning the participation of prisoners in nontherapeutic research is whether or not they are so situated as to be able to volunteer, or whether the nature of a prison is such that free choice is impossible. Much has been written on this subject, and the issue does not simply position the ethicists against the scientists. Rather, reasonable people from various disciplines see the same conditions differently.

Hans Jonas believes that those who are poorer in knowledge, motivation, and freedom of decision (the "captive" in various senses) should be the last candidates for research. This, he explains, is the opposite of a standard of availability.[39] On the other hand, Paul Ramsey has written that it is possible to arrange matters so that prisoners "*may* be as free in volunteering as persons in normal life." [40] Agreeing that there are circumstances in which their participation may be unacceptable (for example, when prison authorities are corrupt), he still concludes that with proper precautions, "since we have deprived a prisoner of a large number of his consents, we

should yield to his consent to do good if it is an understanding, voluntary consent." [41]

Similarly, Paul Freund has written:

The basic standard ought to be that [the prisoners'] will should not be overborne either by threats of punishment or by promises of reward. Within those limits, although some investigators rule out prisoners as subjects, there seems to be no good reason for depriving this group of the satisfactions of participation on an informed basis, satisfactions that to them are often great, indeed, bolstering their self-esteem and furnishing links to the general community and its values. [42]

Others see the prison setting itself as so coercive and dehumanizing that the promise of better food, more comfortable quarters, additional contact with outsiders, and relief from the boredom (and fear) of the cellblock all constitute coercion. This is said to be true even if no reduction in sentence is promised, and even if the payment for participation is comparable to that of other jobs in the same facility.

In a study of why prisoners volunteer to participate in research, John Arnold and his colleagues found that over 50 percent of the prisoners volunteered, at least in part, out of a desire for better living conditions. Moreover, many of them were "loners," and sought membership in "the only group that would take them—the research project." [43] Altruism and patriotism have also been cited by prisoners as motivating factors. In addition, the relative security of the research ward has been cited, but on the other hand, the research (at least in the perception of the inmate) seemed to offer the status and personal satisfaction associated with risk-taking. Finally, it appeared that money had great appeal, for paying legal fees, supporting families, purchasing items at the canteen or for savings to use after discharge. [44]

Jessica Mitford has described in detail the business arrangements through which, she says, the pharmaceutical manufacturers and the physicians profit from the use of prisoners in research. She claims that even when paying rates which are greatly disproportionate to other pay available in the prison ($30 per month as against $2 to $10 per month), the drug firms are paying a prisoner roughly one-tenth of the compensation which would be required on the outside (although this is true of all prison jobs). Mitford says that through their contracts with drug companies, doctors conducting research in prisons may gross $300,000 per year, and participating physicians may double or triple their regular incomes. [45]

A complicating factor in the prison setting is the hope for early release or parole resulting from participation in research. As already noted, some research projects have incorporated this possibility in their negotiations with the prisoners. In other projects, even when reduction of sentence is explicitly not a consideration, the prisoners apparently continue to hope that it may be. Thus, as Leopold has written:

There was no assurance whatever that volunteers would be rewarded by having their time cut. Of that fact each group was solemnly and emphatically reminded

before they were allowed to sign their contracts. But the possibility did exist that
there would be time cuts. And that was a chance I could not afford to miss. . . . I
had some reason to hope that public opinion in my regard might be softened to
some degree. . . .[46]

Perhaps this hope is sustained by the ambiguity reflected by Hodges and
Bean (two investigators):

. . . for their participation in research activities [prisoners] receive no reduction of
their sentence nor any favoritism regarding paroles. We do, however, send a letter
to the warden at the termination of each experiment expressing our appreciation for
the inmate's participation in the study. It is possible that this letter in the prisoner's
file may favorably influence the parole board.[47]

Striking the proper balance may be difficult. On the one hand, prisoners
should not be offered so much (either in the form of pay or through favor-
able consideration) that the offer itself constitutes undue inducement. On
the other hand, not to compensate prisoners for discomfort and risk is to
take advantage of their captive state and availability; it is to capitalize on
the factors of deprivation which might make the induction of illness, for
example, appear to be an improvement over the prevailing conditions of
the cellblock.

An additional problem is that of the freedom to withdraw without preju-
dice. This is an integral aspect of informed consent, for consent is a contin-
uing process. The right of withdrawal may be difficult to exercise in a
prison setting, however, particularly in those facilities which limit access to
the outside. If telephone calls are difficult or impossible to make, and if
outgoing mail is censored, then a complaint to an advocate, or an appeal
for help, may be unachievable. In addition, the purpose of the communica-
tion may be frustrated if the reply never reaches the prisoner because it is
"Refused by the Censor." [48]

Some research involving prisoners may be countertherapeutic. If pris-
oners who have a documented history of drug addiction are offered money
to leave prison and enlist in a program where they will be given narcotic
drugs over a period of a year or so, this conflicts with detoxification. To the
extent that research in drug addiction utilizes anyone to test the addictive
potential of drugs, this should be considered countertherapeutic if the par-
ticipants are drug-free when enlisted. Even the testing of drug antagonists
is countertherapeutic if narcotic drugs must first be administered to a de-
toxified inmate in order to evaluate the efficacy of the antagonist.

A current operations manual of the Addiction Research Center in Lex-
ington, Kentucky, refers to the "statutory responsibilities" under the Nar-
cotics Manufacturing Act of 1960 (now incorporated in P.L. 93-351) for the
Secretary of the Department of Health, Education, and Welfare to identify
the drug abuse potential of strong analgesics. The manual describes the
procedures for induction of prisoners (who must have a history of two or
three treatments for drug abuse to qualify) in tests of this sort. If a prisoner
is over twenty-five, in good health, with "no major psychiatric disorders in

and above sociopathic or neurotic personality," and with at least eighteen months of a sentence left to serve, he may qualify for unrestricted partici- pation. Unrestricted participation, according to a 1968 memorandum of understanding with NIMH, "means that the subject can participate in any experiment involving narcotic analgesics, sedative-hypnotics, marijuana, cocaine, alcohol, or psychotomimetic agents as well as other centrally act- ing drugs." [49] For such participation, the prisoner will receive both good time and cash awards "commensurate with awards given to comparable prisoners by the Bureau of Prisons." [50] Although there is some indication that involvement of prisoners in tests of this sort is being phased out at Lexington, the testimony of HEW officials at a recent congressional hear- ing endorsed the participation of prisoners in studies to determine the ad- dictive potentiality of new narcotic analgesics, saying: "there is no alterna- tive way this information can be obtained at this time." [51]

An additional complication is that prisoners are not always adults, nor are they always free of mental disabilities. In fact, according to a survey conducted in the mid 1960s, approximately 9.5 percent of the individuals in all correctional institutions in this country (except local jails and work- houses) had I.Q.s below 70. The actual number of retarded individuals (based on the total prison population at that time) would have been 20,000.[52] Similarly, 1.6 percent of the surveyed population had I.Q.s below 55, which would indicate a total number of approximately 3,300 moderately to severely retarded inmates. (The range of I.Q. scores reported for 90,477 inmates was from 17 to 145.) The first critical issue identified by the NIMH report for which the survey was undertaken is "the lack of awareness of the complex legal, sociological and psychological problems of the mentally retarded offender." [53] This factor must be kept in mind when considering the competence of prisoners to consent to participation in research.

Issues: Therapeutic Behavioral Research

Perhaps the earliest "experiment" in behavior modification in prisons was an attempt mandated by the New York legislature in 1821, to test the effectiveness of total isolation.[54] Eighty prisoners were placed in solitude; and the results were less than successful. Before a year had elapsed, five men died, at lease one went insane, and so many became depressed that the governor pardoned twenty-six, and permitted the rest to leave the proj- ect. As to the rehabilitative effects, the warden reported "not one instance of reformation." [55] Severity and ineffectiveness are still major issues.

Between 1950 and 1960, disillusionment with standard rehabilitative methods and the emergence of procedures to alter the behavior of individ- uals through methods based on theories of learning coalesced.[56] The appli- cation of these procedures in the correctional system raises a number of

questions concerning: (1) the rights of prisoners to refuse to participate, and (2) the appropriateness and effectiveness of such programs in a prison setting. Central to the consideration of the rights of prisoners in programs designed to modify their behavior are questions regarding the purpose of incarceration, the severity of the techniques involved in the program, and the extent to which the program is experimental.

Criminologists list four possible reasons for imprisonment: punishment, the protection of society, deterrence, and rehabilitation. As noted earlier, the stated purpose of the "correctional" system in this country, since 1900, has been rehabilitation; and the introduction of programs designed to alter behavior is consistent with that purpose. Problems arise, however, when the design includes either the application of organic therapy (such as surgery, electric or chemical shock, psychotropic drugs, or drugs to induce extreme discomfort) or the deprivation of basic amenities.

Concern about this problem is not confined to any one profession. Ralph Schwitzgebel, a lawyer, has written:

Therapists should not be permitted to do under the label of treatment or behavior modification that which cannot also be done under the label of discipline. Ultimately, the justification of discipline or behavior modification is the safety of the community and not a supposed benefit to the offender.[57]

This concern is reiterated by David Rothman (an historian) who writes:

A willingness to accept the promise to do good as the equivalent of the ability to do good is certain to legitimate a network of intervention schemes which would otherwise be suspect. . . . We cannot debate preventive detention if it calls itself rehabilitation. And if we are incarcerating people for treatment purposes, then let us measure the effectiveness of the treatment. . . .[58]

Similarly, Gerald Klerman (a psychiatrist) has taken correctional psychologists to task for redefining basic rights as privileges which may be withdrawn in order to serve as incentives in a behavior modification program; [59] and a professor of law and ethics, Benjamin Freedman, suggests:

There are certain basic freedoms and rights which we possess which *entitle* us (morally) to certain things (or states of affairs). . . . When the "reward" is such as only to give us the necessary rights and freedoms—when all the reward does is bring us up to a level of living to which we are entitled, and of which we have been deprived by man—then the "reward," I think, constitutes duress.[60]

A more dramatic approach was taken by a research psychologist cataloging instances of "Psychiatric Violence Against Prisoners: When Therapy is Punishment." [61]

On the other hand, a number of writers suggest that a convicted felon, at least, has no standing to refuse to be rehabilitated. Two sociologists ask: "How can we justify asking a man to consent to behavior modification when he is not asked to consent to all the prison brutality to which he is subjected when imprisoned? [62] They distinguish between therapy as part of the criminal justice system and therapy as a health service:

We cannot use the criminal law to enforce therapy for health and welfare purposes, but we can use the law to prevent harm to others and to prevent crimes. Treatment can be a function of criminal law. . . .[63]

James V. McConnell, a professor of psychology, has been quoted as saying:

I don't believe the Constitution of the United States gives you the right to commit a crime if you want to; therefore the Constitution does not guarantee you the right to maintain inviolate the personality it forced on you in the first place [sic] if and when the personality manifests strongly antisocial behavior.[64]

In a paper submitted to the law and psychiatry seminar at the University of Pennsylvania Law School, a student stated the case with brevity:

The community need not protect a man's right to be a criminal by refusing to change his criminal mind (and through it, his criminal behavior) without his consent.[65]

Several courts, speaking of compulsory treatment for drug addiction, have agreed:

When a subject is within the proper scope of the State's police power, any exercise of that power is constitutional if there is a rational basis for the legislative act, *even where the state of knowledge is uncertain and conflicting theories exist as to the problem's solution* [emphasis added].[66]

Other courts have upheld the state's power to impose therapy when it is "recognized as appropriate by recognized medical authorities," but not when it is experimental; [67] and the involuntary injection of a disturbed prisoner with a tranquilizer has withstood constitutional challenge.[68] By contrast, the attorney general of Hawaii ordered that a prisoner's right to refuse anti-psychotic medication (on religious grounds) be honored.[69]

In 1944, a U.S. Circuit Court had said that a prisoner "retains all the rights of an ordinary citizen except those expressly, or by necessary implication, taken away from him by law." [70] (The case involved interference with the personal liberty of an inmate who claimed to have suffered "injuries and indignities" in the Public Health Service facility at Lexington, Kentucky.) The problem, of course, is in defining those rights which a prisoner retains, and those rights which he or she may forfeit, as a consequence of conviction.

Emerging Definition of Prisoners' Rights

Recent cases have begun to delineate those rights. In 1973, a U.S. Circuit Court held that aversive conditioning for undesirable behavior in prison is cruel and unusual punishment unless the prisoner has consented (*Knecht v. Gillman*).[71] Similarly, the claim that a prisoner was subjected, without his consent, to aversive conditioning in Vacaville was held to "raise serious

constitutional questions respecting cruel and unusual punishment or imper-
missible tinkering with mental processes" (*Mackey v. Procunier*).[72] Depri-
vation may also be unconstitutional. A Federal District court held, in 1973,
that it is cruel and unusual punishment to segregate prisoners for sixteen
months, for twenty-three hours a day, in a cell eight-by-six feet (*Adams v.
Carlson*).[73] (The case involved thirty-six men who were transferred into a
"control unit treatment program" in the federal penitentiary in Marion,
Illinois, following a work stoppage.) [74] The implications of this decision for
behavior modification programs are clear when one observes that the de-
sign of the program S.T.A.R.T. (in the Federal Bureau of Prisons), for
example, called for segregation (up to one year) in small cells, with no
prison privileges, and only two showers and two hours of recreation each
week.[75] When the constitutionality of S.T.A.R.T. was challenged, the
court held only that the transfer of prisoners into such segregation without
a proper hearing violated the right to due process. The court did not reach
the question of the constitutionality of enforced participation in such a
program, or of the deprivations involved (since the project had been termi-
nated by the time of hearing, and the questions were therefore deemed
moot), nor did it elaborate on its observation that "a prisoner may not have
a constitutional right to prevent such experimentation." [76] It did, however,
say that the labeling of a program as treatment instead of punishment "is
not a relevant factor in determining the due process question involved." [77]

It appears, then, that the rights of prisoners with respect to behavior
modification may depend not on a distinction between treatment and pun-
ishment, but on the distinction between research and routine or accepted
practice. There is a wealth of literature on the effectiveness (or, to be more
precise, the ineffectiveness) of behavior modification techniques in reduc-
ing recidivism in prisoners, or even in producing enduring alterations in
behavior.[78] In fact, there is some laboratory evidence that aversive condi-
tioning may increase the rate of undesirable behavior either from a para-
doxical effect, or because of the anxiety and deception associated with it.[79]
The Jefferys observed that "at this point in history we do not possess the
necessary knowledge to alter criminal behavior," [80] and the President's
Crime Commission concluded that "there is probably no subject of compa-
rable concern to which the nation is devoting so much effort with little
knowledge of what it is doing." [81] That being so, it is possible to argue that
behavior modification is not a proven or effective technique for rehabilitat-
ing prisoners, and its application should be considered experimental.

A suit filed by the ACLU National Prison Project has challenged the
aversive conditioning of sex offenders in Somers state prison, in Connecti-
cut, on the grounds that it is unproven as to effectiveness and is therefore
experimental. In addition, the suit claims that when prisoners "are encour-
aged to believe that their parole depends upon their participation" any
consent they may give is involuntary.[82] By contrast, it was recently re-

ported that a prisoner went to court for permission to enter an experimental drug therapy program from which he had been barred by the hospital's IRB because he was a prisoner.[83]

Consent and Benefits in the Institutional Setting

The question of the voluntariness of consent in an institutional setting is especially important when it involves procedures which the confined individual may believe will improve his or her chances for release. The fact that an inmate is willing to cooperate to the extent of participating in the program may seem to be important (to the inmate, if not to the staff) in a setting where release from confinement is contingent upon demonstrating appropriate behavior. These factors were discussed at length by the court in *Kaimowitz v. Department of Mental Health*, which challenged the validity of consent for psychosurgery by an individual who was being held under sexual psychopath laws.[84] The court held that involuntarily confined mental patients cannot give voluntary consent to hazardous experimental procedures because of the coercive nature of institutional life and the inherent inequality of their bargaining position.[85] (It is important to note that the court specifically held, on the other hand, that such individuals *can* give voluntary consent to accepted neurosurgical procedures.) [86] Although the case involved surgical intervention, the language of the opinion stands for the protection of privacy, per se:

Intrusion into one's intellect, when one is involuntarily detained and subject to the control of institutional authorities, is an intrusion into one's constitutionally protected right of privacy. If one is not protected in his thoughts, behavior, personality, and identity, then the right of privacy becomes meaningless.[87]

Frank Ervin, a psychiatrist, has said that "programs of all kinds labeled psychotherapeutic in the correctional system are a sham, insofar as they are coercive either explicitly or implicitly." [88] Similarly, Hugo Bedau, a professor of philosophy, concludes that prisoners probably cannot give voluntary consent (as an empirical, rather than an a priori, matter) but rejects the conclusion that therefore they cannot be subjected to interventions designed to make them less dangerous. Rather, he believes that there may be some conditions under which even physical intervention may be undertaken without consent.[89]

The idea of rehabilitation or treatment deserves further scrutiny, however, especially if it is categorized as therapeutic research. A number of writers have cautioned that the correctional psychologist or therapist acts as a double agent, serving the needs of both the inmate and the society; and when the two roles conflict, the demands of society for controlling deviant behavior usually override the needs of the "client." [90] In addition, the needs of the correctional institution, itself, may supervene; and the

inmate may be made "better" only with respect to being more manageable. Just as with therapeutic research in institutions for the mentally disabled the question must be asked in the prison: who benefits?

Summary

A. NONTHERAPEUTIC BIOMEDICAL RESEARCH

Although there is a long history of the use of prisoners in nontherapeutic biomedical research, the practice was not widely endorsed in this country until World War II, when it was considered patriotic for prisoners to participate, as research subjects, in the military effort. Following the war, although the European countries apparently rejected such participation, prisoners continued to be involved in even greater numbers in the United States as a result of our increased commitment to clinical research and our increased concern with evaluating the safety of new drugs. Only in the last decade have questions been raised regarding continuation of this practice.

The central issue is whether conditions within a prison permit a prisoner to give voluntary consent to participate in research. Even if it is possible to create conditions in some prisons under which the right to participate, or refuse to participate, can be protected, other questions must still be faced. To what extent are abuses still possible elsewhere? Should the potential for abuse in some prisons override the possibility for valid consent in others and require that research be prohibited in all correctional facilities? Should research in prisons be prohibited on principle, whatever the facts of the case?

Additional questions come to mind. Do prisoners have a right to participate in nontherapeutic research? If the presence of a research program in a prison provides the only opportunity for public scrutiny (or for an inmate's access to outsiders), would withdrawing that opportunity produce more problems than it would solve? Are those problems the proper concern of this Commission?

If research in prisons is to be prohibited, what are the alternatives? Shall we modify our requirements for testing the safety and efficacy of drugs, or shall the tests be conducted on other populations? How free from coercion are the alternative populations?

If research in prisons is to be permitted, what conditions should be imposed to protect the prisoners? How should these be enforced? Will the conditions, themselves, prove so burdensome that the net effect will be to end research in prisons, after all?

The first question the Commission must answer is whether to decide the matter on principle, or on the basis of evidence. Do the expressed wishes of prisoners matter? Do the conditions in the prisons have any bearing? If so, then the answers must be empirically based. If not, then the issue can

be decided on the basis of a general principle that (for example) no individual involuntarily confined in an institution should be the subject of research unless that research is for the direct benefit of that individual, or unless the research is designed to increase our understanding of the conditions for which the individual is confined.

B. THERAPEUTIC BEHAVIORAL RESEARCH

The involvement of prisoners in therapeutic behavioral research is a different matter. There is agreement in much of the literature that aversive conditioning, without consent, is unacceptable. Other methods of behavioral modification are equally unacceptable if they depend upon deprivation of basic human rights. Because the right of a prisoner to refuse treatment may depend upon whether or not the treatment is experimental, some mechanism for making that determination may be essential.

A number of suggestions advanced in the literature merit consideration:

1. Basic human rights, to which all prisoners are entitled, must be clearly defined.

2. No research should be permitted which depends upon deprivation of those basic rights.

3. No research involving behavior modification should involve a prisoner without his or her consent.

4. Mechanisms should be developed to determine whether a program for rehabilitation is research or accepted practice.

5. No prisoner should be subjected to aversive conditioning or organic therapy without his or her consent and, in addition, an administrative or judicial hearing to determine the validity of that consent.

6. Behavioral research in prisons should be subject to the same community scrutiny and accountability as biomedical research, especially with respect to risks and benefits (including the question of *who* benefits) and all aspects of informed consent.

7. No procedures should be permitted in the name of "treatment" or "rehabilitation" which are impermissible as punishment.

NOTES

1. See Henry K. Beecher, *Research and the Individual* (Boston: Little, Brown and Co., 1970), pp. 60–77; Andrew Ivy, "The History and Ethics of the Use of Human Subjects in Medical Experiments," in Ladimer and Newman, eds., *Clinical Investigation in Medicine* (Boston University), 1963, pp. 9, 45; Louis Lasagna, "Special Subjects in Human Experimentation," in Paul Freund, ed., *Experimentation with Human Subjects* (New York: Braziller, 1970), p. 262; H. M. Pappworth, *Human Guinea Pigs* (Boston: Beacon Press, 1967), p. 60ff.

2. National Institute on Drug Abuse, *Operations Manual* (Lexington, Ky.: Addiction Research Center), p. 3 (on file at Commission Office).

3. Renée Fox, "Some Social and Cultural Factors in American Society Conducive to Medical Research on Human Subjects," in Ladimer and Newman, *op. cit.*, pp. 102–105.

4. *Ibid.*, p. 105, from Nathan Leopold, *Life Plus 99 Years* (New York: Doubleday, 1958).

5. Lasagna, *op. cit.*, p. 262.

6. Beecher, *op. cit.*, p. 227.

7. *Ibid.*, p. 227 from *United States v. Brandt*, Trials of War Criminals Before the Nuremberg Military Tribunals, vols. 1 and 2, *The Medical Case* (Washington, D.C.: U.S. Government Printing Office, 1948).

8. This code may be found in Ladimer and Newman, *op. cit.*, p. 154. The quotation is on p. 158.

9. In Ladimer and Newman, *op. cit.*, p. 160.

10. Pappworth, *op. cit.*, p. 64.

11. Fox, *op. cit.*, pp. 81–89.

12. *Ibid.*, p. 84.

13. "Report of a Committee Appointed by Governor Dwight H. Green of Illinois," in Ladimer and Newman, *op. cit.*, p. 461.

14. Ivy, *op. cit.*, p. 46.

15. Robert E. Hodges and William B. Bean, "The Use of Prisoners for Medical Research," *Journal of the American Medical Association* 202, no. 6 (November 6, 1967): 177, 178. Excerpts appear in Jay Katz, *Experimentation with Human Beings* (New York: Russell Sage Foundation, 1972), pp. 1032–1034.

16. *Idem.*

17. American Medical Association House of Delegates, "Resolutions on Disapproval of Participation in Scientific Experiments by Inmates of Penal Institutions," in Ladimer and Newman, *op. cit.*, p. 466.

18. Michael Mills and Norval Morris, "Prisoners as Laboratory Animals," *Society* 11, no. 5 (July-August 1974): 60–61.

19. Jessica Mitford, "Experiments Behind Bars," *Atlantic Monthly* (January 1973): 64–65.

20. Ladimer and Newman, *op. cit.*

21. *Annals of the New York Academy of Sciences* 169, art. 2 (January 21, 1970): 293–593.

22. *Idem.* The publication carries the following notice: "The conference and publication of this monograph were supported, in part, by: Eli Lilly and Company, Schering Corporation, Schering Foundation, Smith Kline and French Laboratories, United Health Foundations, Inc."

23. John D. Arnold, Daniel C. Martin, and Sarah E. Boyer, "A Study of One Prison Population and its Response to Medical Research," *Annals of the New York Academy of Sciences* 169 (January 21, 1970): 463–470. Excerpts appear in J. Katz, *Experimentation with Human Beings* (New York: Russell Sage Foundation, 1972): 1020–1024.

24. Quoted in Nicholas Kittrie, *The Right to be Different* (Baltimore: Johns Hopkins University Press, 1971), p. 1.

25. David J. Rothman, "Behavior Modification in Total Institutions," *Hastings Center Report* 5 (February 1975): 17. See also Kittrie, *op. cit.*, pp. 24–39.

26. Kittrie, *op. cit.*, pp. 36–37, quoting Enrico Ferri, *Criminal Sociology*, translated by Joseph I. Kelly and John Lisle, edited by William W. Smithers (Boston: Little, Brown and Co., 1917), pp. xlii–xliii.

27. Kittrie, *op. cit.*, p. 178ff. (Chapter 4 describes the various state statutes and provides a good history and analysis of this legislation.)

28. *Ibid.*, p. 180.

29. *Ibid.*, p. 180ff.

30. *Ibid.*, pp. 203, 208.

31. Rothman, *op. cit.*, p. 19.

32. American Psychiatric Association, *Biographical Directory of the Fellows and Members* (New York: R. R. Bowker Company, 1973), pp. viii, ix.

33. Stanley L. Brodsky, ed., *Psychologists in the Criminal Justice System* (Marysville, Ohio: American Association of Correctional Psychologists, 1972), p. 6.

34. *Ibid.*, p. 6.

35. Rothman, *op. cit.*

36. David L. Bazelon, "The Future of Reform in the Administration of Criminal Justice," *Federal Rules Decisions* 35: 99, 104, 1964.

37. David L. Bazelon, "Psychologists in Corrections—Are They Doing Good for the Offender or Well for Themselves?" in Brodsky, *op. cit.*, Appendix A.

38. Pub. L. 94–63 (July 29, 1975), Title III—Community Mental Health Centers, Part D—Rape Prevention and Control, § 231(b)(1)(A)(vi) (89 Stat. 328).

39. Hans Jonas, "Philosophical Reflections on Human Experimentation," in Freund, *op. cit.,* pp. 19–20.

40. Paul Ramsey, *The Patient as Person* (New Haven: Yale University Press, 1970), p. 42.

41. *Ibid.,* p. 43.

42. Freund, *op. cit.,* p. xvi.

43. Arnold et al., *op. cit.,* See also John C. McDonald, "Why Prisoners Volunteer to be Experimental Subjects," *Journal of the American Medical Association* 202, no. 6 (November 6, 1967): 175.

44. *Idem.*

45. Jessica Mitford, *op. cit.,* pp. 64–65.

46. Fox, in Ladimer and Newman, *op. cit.,* p. 103, quoting Nathan Leopold, *Life Plus 99 Years.*

47. Lasagna, *op. cit.,* p. 266.

48. Jessica Mitford, *Kind and Usual Punishment* (New York: Random House, Vintage, 1974), p. viii. (See also Chapter 1.)

49. Bureau of Prisons and National Institute of Mental Health, Memorandum of Understanding, 1968. The operations manual, submitted to the Commission by William R. Martin, M.D., Director, NIDA Addiction Research Center on September 10, 1975, is undated.

50. *Idem.*

51. James F. Dickson III, Acting Deputy Assistant Secretary for Health, Department of Health, Education, and Welfare, statement before the Subcommittee on Courts, Civil Liberties, and Administration of Justice of the House Judiciary Committee, October 1, 1975.

52. Bertram S. Brown and Thomas F. Courtless, *The Mentally Retarded Offender,* National Institute of Mental Health, Department of Health, Education, and Welfare, publication no. (HSM) 72-9039 (1971), pp. 24–25.

53. *Ibid.,* p. 50.

54. Ralph K. Schwitzgebel, *Development and Legal Regulation of Coercive Behavior Modification Techniques with Offenders,* National Institute of Mental Health, Center for Studies of Crime and Delinquency, Department of Health, Education, and Welfare publication no. (ADM) 74–102 (1974), p. 3.

55. *Idem.*

56. *Ibid.,* p. 5.

57. *Ibid.,* p. 41.

58. Rothman, *op. cit.,* p. 23.

59. Gerald L. Klerman, "Behavior Control and the Limits of Reform," *Hastings Center Report* (August 1975): 40–45.

60. Benjamin Freedman, "A Moral Theory of Informed Consent," *Hastings Center Report* (August 1975): 32–39.

61. Edward M. Opton, Jr., "Psychiatric Violence Against Prisoners: When Therapy is Punishment," *Mississippi Law Journal* 45, no. 3 (1974): 65.

62. C. R. Jeffery and Ina A. Jeffery, "Psychosurgery and Behavior Modification," *American Behavioral Scientist* 18, no. 5 (May-June 1975): 714.

63. *Ibid.,* pp. 706–707.

64. Sharland Trotter and Jim Warren, "The Carrot, the Stick and the Prisoner," *Science News* 105, no. 11 (March 16, 1974): 180–181.

65. H. M. Silverberg, quoted in Schwitzgebel, *op. cit.,* p. 66.

66. *In re Spadafora,* 281 N.Y.S. 2d 923, 930 (1967). See also *People ex rel. Stutz v. Conboy,* 300 N.Y.S. 2d 453 (1969); *Haynes v. Harris,* 344 P. 2d 463 (1965). All are cited in Schwitzgebel, *op. cit.,* pp. 35–37, 52.

67. *Ramsey v. Ciccone,* 310 F. Supp. 600 (1970). See also *Veals v. Ciccone,* 281 F. Supp. 1017 (1968). Both cases are cited in *Individual Rights and the Federal Role in Behavior Modification,* a study prepared by the staff of the Subcommittee on Constitutional Rights of the Committee on the Judiciary, United States Senate, November 1974, p. 8.

68. *Peek v. Ciccone,* 288 F. Supp. 329 (1968), cited in Schwitzgebel, *op. cit.,* p. 37.

69. "Notes: Conditioning and Other Technologies Used to 'Treat'? 'Rehabilitate'? 'Demolish'? Prisoners and Mental Patients," *Southern California Law Review* 45 (1972): 616–661.

70. *Coffin v. Reichard,* 143 F. 2d 443, 155 A.L.R. 143 (1944); *cert. denied,* 325 U.S. 88 (1945). Cited in Schwitzgebel, *op. cit.,* pp. 28–29.

71. *Knecht v. Gillman,* 488 F. 2d 1136 (1973). Cited in report by Subcommittee on Constitutional Rights, n. 67 *supra,* p. 8.

72. *Mackey v. Procunier,* 477 F. 2d 877, 878 (1973). Cited in report by Subcommittee on Constitutional Rights, n. 67 *supra,* p. 9.

73. *Adams v. Carlson,* 368 F. Supp. 1050 (1973). Cited in report by Subcommittee on Constitutional Rights, n. 67 *supra,* p. 9.

74. Comptroller General of the United States, *Behavior Modification Programs: the Bureau of Prisons' Alternative to Long Term Segregation,* Department of Justice, August 5, 1975, p. 22ff.

75. *Clonce v. Richardson,* No. 73 CV 373-S (W.D. Mo., July 31, 1974). Full text appears in report of the Subcommittee on Constitutional Rights, n. 67 *supra,* pp. 560–571. The conditions of the S.T.A.R.T. program, as stipulated by the parties, are described on pp. 564–566.

76. *Ibid.,* p. 569.

77. *Ibid.,* p. 568.

78. See for example, Constance Holden, "Prisons: Faith in 'Rehabilitation' is Suffering a Collapse," *Science* 188 (May 23, 1975): 815–817; and Michael S. Serrill, "Is Rehabilitation Dead?," *Corrections Magazine* (May-June 1975): 3–32.

79. Schwitzgebel, *op. cit.,* p. 15.

80. Jefferys, *op. cit.,* pp. 714–715.

81. President's Commission on Law Enforcement and Administration of Justice, 1967, p. 273, cited in Jefferys, *op. cit.,* p. 692.

82. *Civil Liberties,* September 1975.

83. "Doctor Critical of HEW," *Baltimore Sun,* September 22, 1975.

84. *Kaimowitz v. Department of Mental Health,* Civil Action No. 73-19434-AW, Circuit Court for the County of Wayne, Michigan, 1973. Full text appears in report of the Subcommittee on Constitutional Rights, n. 67 *supra,* pp. 510–524.

85. *Ibid.,* pp. 519–520.

86. *Ibid.,* p. 523.

87. *Ibid.,* p. 523.

88. Frank Ervin, "Biological Intervention Technologies and Social Control," *American Behavioral Scientist* 18, no. 5 (May-June 1975): 633.

89. Hugo Adam Bedau, "Physical Interventions to Alter Behavior in a Punitive Environment," *American Behavioral Scientist* 18, no. 5 (May-June 1975): 657–677.

90. See for example, Bedau, *op. cit.,* p. 661; Holden, *op. cit.,* p. 816; and Klerman, *op. cit.,* p. 42.

Part IV

NEO-CLASSICAL REVIVAL

20: Struggle for Justice / *American Friends Service Committee**

Crime and Punishment

During the last century the professed aims of criminal justice have changed from retribution to rehabilitation and preventive imprisonment. The proper objectives, we have been told repeatedly, are the protection of society from crime and the treatment of the offender, not the exaction of revenge and the criminal's punishment. Indeed, the words "retribution," "revenge," and "punishment" are often used interchangeably, as if there were no significant differences of meaning among them. The resulting confusion is the source of many problems. Retribution and revenge necessarily imply punishment, but it does not follow that punishment is eliminated under rehabilitative regimes.

The criminal law philosophy against which humanitarian reformers have continuously rebelled is summed up in the following discussion of "retributive punishment" from a standard British treatise on jurisprudence:

It is to the fact that the punishment of the wrongdoer is at the same time the vengeance of the wronged, that the administration of justice owes a great part of its strength and effectiveness. Did we punish criminals merely from an intellectual appreciation of the expediency of so doing, and not because their crimes arouse in us the emotion of anger and the instinct of retribution, the criminal law would be but a feeble instrument. Indignation against injustice is, moreover, one of the chief constituents of the moral sense of the community, and positive morality is no less dependent on it than is the law itself. It is good, therefore, that such instincts and emotions should be encouraged and strengthened by their satisfaction; and in civilised societies this satisfaction is possible in any adequate degree only through the criminal justice of the state. There can be little question that at the present day the sentiment of retributive indignation is deficient rather than excessive, and requires stimulation rather than restraint. . . . We have too much forgotten that the mental attitude which best becomes us, when fitting justice is done upon the evildoer, is not pity, but solemn exultation.[1]

The rejection of this philosophy poses no great problems and is implicit in the way of life we espouse. Justice Oliver Wendell Holmes came closer to defining the problem of revenge in terms that begin to give us serious difficulties:

* Reprinted with the permission of Farrar, Straus & Giroux, Inc. from *Struggle for Justice: A Report on Crime and Punishment in America,* prepared for the American Friends Service Committee, copyright © 1971 by Hill and Wang, Inc. (now a division of Farrar, Straus & Giroux, Inc.).

The first requirement of a sound body of law is, that it should correspond with the actual feelings and demands of the community, whether right or wrong. If people would gratify the passion of revenge outside of the law, if the law did not help them, the law has no choice but to satisfy the craving itself, and thus avoid the greater evil of private retribution. At the same time, this passion is not one which we encourage, either as private individuals or as law-makers.[2]

We do not underestimate the strength of the feeling that a criminal should be punished for the purpose of making him hurt. Assuming a society without any criminal law, one must deal with the need to eliminate private vengeance or other substitute forms or returning hurt for hurt. In some tribal societies, in the absence of formal sanctions, the same result is obtained informally through ostracism or loss of status. We do not begin to know the dimensions of the determinants of the public demand for revenge, but we are convinced that such a demand exists and that it has a practical impact. It imposes limits on mitigation of penalty and on the use of forgiveness as official public policy.

We can identify three motives for punishment. The first is revenge or retribution. The second is the reformative motive, that is, to prevent future transgressions by that individual. This suggests the attitude "This hurts me more than it does you, but I'm punishing you for your own good." The third motive is deterrence, to discourage potential future offenders and to increase compliance with the law. In the words of Justice Holmes, this sort of punishment "treats the individual as a means to an end, and uses him as a tool to increase the general welfare at his own expense." Frequently, of course, motives for punishment are mixed, inviting self-righteousness when examining other people's motives and self-deception when examining our own.

The distinguishing feature of punishment, then, is not a particular motive but its result: the application of force to another person against his or her will. Since criminal law is the sanctioned official use of force, without compulsion it ceases to be law, at least in any formal sense. Violence, direct or implied, is the ultimate weapon reserved for those who disobey. Behind every criminal law, behind every arrest, and in every prison wall is the blunt message: your submission or your life. The offender either complies and surrenders all autonomy or is subjected to direct physical compulsion that can and sometimes does go to the extreme form of violence—death.

This aspect of punishment troubles us. Many of us are Quakers or pacifists or both. We reject the use of violence in war. Any coercion of another human being goes against our deep respect for every person's dignity. We believe that all people have the right to autonomy and privacy, to be left alone to find their own way. The very concept of criminal justice—which inevitably involves coercion—is thus an anomaly for us.

At the outset, therefore, let us set down our rationalization for the exis-

tence of *any* system of criminal justice. In some cases—though we differ on which—most of us accept the necessity of restraining someone against his will and depriving him of his liberty. Most of us will do this, moreover, not only when the person to be restrained appears to others as an immediate and obvious "danger" (itself a dangerously ambiguous concept), but also in general, that is, we accept the premise that at least some basic rules are necessary to organized society, mutual respect, and personal safety, and that these rules may require some sort of enforcement.

Do not read this as an endorsement of the present prison system. If the choice were between prisons as they now are and no prisons at all, we would promptly choose the latter. We are convinced that it would be far better to tear down all jails now than to perpetuate the inhumanity and horror being carried on in society's name behind prison walls. Prisons as they exist are more of a burden and disgrace to our society than they are a protection or a solution to the problem of crime.

However, we recognize this is not a real option. Many proposals that seem to urge the abolition of prisons are really exercises in label switching. Call them "community treatment centers" or what you will, if human beings are involuntarily confined in them they are prisons. If it is conceded that in some circumstances we might employ coercion against an individual to achieve some compelling social goal, it confuses analysis and obscures the moral nature of our act to pretend that we are not employing punishment. Complex social problems, especially those whose resolution demands an agonizing moral decision, cannot be reduced to slogans without serious distortion. Thus proposals that we should "abolish prisons" or "end the crime of imprisonment" are destructive of thought and analysis when all that is contemplated is a reshuffling of our labels or institutional arrangements for coercive restraint.

There is an easy test that can be applied to any purported abolition of punishment or imprisonment. Is the proposed alternative program voluntary? Can the subject take it or leave it? If he takes it, can he leave it any time he wants? If the answer to any of these questions is "no," then the wolf is still under the sheepskin.

If this test is applied to most so-called "voluntary" mental health commitments, the resulting classification is one of punishment. This is precisely what we intend, for to classify (and to sell to the unsuspecting) a commitment that cannot be terminated at will as "voluntary" is a fraud. "Consents" executed by subjects in coercive situations at the request of their coercers should be viewed with extreme skepticism. Without having to go so far as to endorse his position that there is no such thing as mental illness, we agree with Thomas Szasz that most involuntary commitments are a variant form of the criminal process (without due process). The resulting regime is one of punishment. Thus the sleight of hand that transforms prisons into something else, such as "civil institutions" for addicts

and reformatories for juvenile delinquents, does not alter the coercive reality. Most of what we say in this study is equally applicable to such situations.

We believe there is much to be gained from honesty in our semantics. By characterizing all penal coercion as punishment, we emphasize rather than dilute the critical necessity of limiting it as much as possible. As we will stress repeatedly, because punishment is at best a necessary evil, we regard the punishing power as society's "last resort," to be used only where imperatively required and when no other less stringent measures of education and social control will suffice. While humane conditions of such "street imprisonment" as parole or a halfway house will soften the more obvious cruelty, the fundamental contradiction remains: Coercive institutions deny our deepest religious and democratic conceptions about the nature and dignity of human beings and our noblest vision of a peaceful, noncoercive society.

This is not to deny that punishment may benefit the one who is punished. It may prove to be just what was needed. This consideration, however, should have no weight in determining whether it should be imposed. We emphasize this consideration for several reasons. First, the paternalism implicit in A's assumption that he knows better than B what is for B's benefit is treacherous under any circumstances and becomes an intolerable form of colonialism when invoked by middle-class whites to run the lives of blacks, Chicanos, Indians, and the poor. Second, the natural progress of any program of coercion is one of escalation, that is, the more it is relied upon, the easier it will be to employ it as an evasion of difficult problems and the larger the dosage that will have to be applied. Witness the growth of police power in recent years. Third, the availability of coercive solutions to a problem reduces the likelihood of trying more creative but more difficult and problematic voluntary alternatives. Thus we think it imperative to regard punishment not as a potential benefit to the subject but invariably as a detriment imposed out of social necessity.

For more than a century the ugliness of this conflict between the democratic concept of freedom and the force of punishment has been denied by treatment-oriented reformists. We have been led to believe that treatment somehow removes the sting of punishment from penal coercion. This displays a propensity for self-deception.

As experienced by the prisoner, imprisonment with treatment is identical with traditional imprisonment in most significant aspects. In both situations there is depersonalization, loss of autonomy, separation from family, denial of privacy, and the imposition of all the restrictions inherent in any institution. The reformist's range of vision excludes the reality of the viewpoint of the offender, just as it ignores the empirical results of the treatment. To the reformist, the only relevant criterion is the purity of the motives of society and its judges and jailers.

The obvious fallacy of this reasoning has been nicely put in a comment on the case of Willy Francis. The decision in this case held that putting the condemned man into an electric chair for a second time after it had malfunctioned on the first attempt did not constitute cruel and unusual punishment.

The reports show that four justices could discover nothing "cruel or unusual" in a second execution, because forsooth cruelty was not intended by the state authorities. This extraordinary reasoning recalls the ancient comment of Bion that, though boys throw stones at frogs in sport, yet the frogs do not die in sport but in earnest.[3]

Although punishment is no longer a fashionable rationale for criminal justice, the punitive spirit has survived unscathed behind the mask of treatment. Such an extraordinary transmogrification could hardly have established so tenacious a hold on all schools of reformist thought and maintained such an immunity from criticism unless it was simultaneously serving other more practical, if covert, functions. Three important and more or less contemporaneous developments in the nineteenth century are important to an unraveling of the punishment-treatment riddle and to an understanding of the complexity of the problems besetting us today. These were, first, the movement to mitigate the severity and humanize the conditions of penal punishment; second, the birth of a welfare philosophy that imposed on the state the obligation to provide educational, health, and other helping services for those unable to help themselves; and third, the threat to accepted values and established social stratification posed by waves of immigrants and newly liberated slaves.

In both the humanization of punishment and the development of social services many Quakers and other socially concerned pioneers played dedicated roles against great odds. Many of the same reformers were active in both developments. Nonetheless, it should be clear that in the humanization of criminal justice and the provision of social services for the needy (including many convicts) we are dealing with two very different state functions. The essence of punishment is the state's use of compulsion against the offender for the purported benefit of society in general, that is, to satisfy public retributive urges, to compel conformity to social norms, or to deter future violations by others through a demonstration that the state's threats of punishment are to be taken seriously. As imprisonment and death, the typical punishments, are obviously contrary to the offender's self-interest, the state's role is always at least potentially adverse to that of the offender. The provision of helping services, on the other hand, is devoid of this adversary element; the state is acting in behalf of society for the benefit of the recipient who, in the typical situation, can either accept or reject the proffered help. Thus in imposing penal sanctions, the state has both the coercive means and a potential motive for harming the prisoner; in the helping relationship it has neither. The one is the prototype of the adversary situation, the other poses no conflict of interest for either party.

These twin concerns of the reformers, to humanize criminal justice by reducing its severity, and to carry fellowship, education, and service directly to the prisoners in order to counteract some of the destructiveness of imprisonment, could have been achieved without conflict. In some European countries punishment and treatment have been conceptually segregated and the roles of judge and helper sharply delineated. By such a model, whether or not imprisonment is to be imposed and its possible duration are questions of law to be determined by legal standards, which make reference primarily to the offender's criminal act and past criminal record; opportunities for treatment are provided by agencies that have no power or effect upon the form or duration of the prisoner's term and can, therefore, serve his interests with undivided loyalty.

Unfortunately this was not the direction taken in this country. Instead, our development followed the logic of a seductive slogan, "Let the punishment fit the criminal, not the crime." Given this premise, it was but a short step to the indefinite or indeterminate sentence, which made the need for and response to treatment the formal standard for determining whether and for how long to imprison. This in turn fathered the two dominant characteristics of the system with which much of this report will be concerned: wide discretionary power, allegedly so that the offender's treatment could be matched with his individual needs, and the location of much of this discretionary power with the agencies responsible for protecting society from criminals.

It appears that the reformers had little or no awareness of the momentous consequences that were to follow on the heels of this unhappy marriage of incompatible elements. There is no evidence that they ever doubted that by attaching treatment gadgets to the punishment process they had somehow achieved its humanization. Nor did they recognize that the inevitable result of blending in the same process the state's adversary interest against the prisoner with its helping role for the prisoner would be the debasement of treatment.

The paradigm of the system they created is the role of the parole officer, whose job is simultaneously to help the parolee under his supervision and to protect society from that same parolee. The resulting role conflict of having to serve two masters—the client and the state—corrodes the mutual trust necessary for therapy and invites the pollution of service by reducing it to a manipulative device whereby the officer's control-police function can be facilitated.

If the reformers were naïve, the managers of the correctional establishment were not. Under the leadership of Zebulon R. Brockway of the Elmira Reformatory, by the latter part of the nineteenth century they had co-opted the reformers and consolidated their leadership and control of indeterminate sentence reform. Their two primary objectives were both practical and explicit. The first was to exploit the managerial potential of indeterminacy as a tool of institutional control. By 1874 we find one warden

reporting with satisfaction that the introduction of indefinite sentences and the mark system reduced the number of cases requiring corporal punishment by 75 percent—an early testimonial to the practical utility of suspense if you want to keep the powerless in line. Second, they were concerned to increase, not reduce, the power of the state to lengthen a prisoner's sentence. The result has been a high level of correlation between increased indefiniteness in sentencing power and increases in the median length of time actually served by prisoners.

This uncertainty is one of the more exquisite forms of torture. The extension of indefiniteness as the hallmark of sentencing has contributed to the dehumanization and personal disintegration of penal servitude, though this seems not to have been a matter of serious concern for those to whom it had utilitarian value as an aid in institutional discipline.

Concurrent with the emergence of a treatment-oriented prison reform movement and contributing significantly to the widespread adoption of its viewpoint were the stresses occasioned by immigration, growing industrial strife, and post-Civil War racial conflict. The relevant nineteenth-century literature is punctuated by cries of alarm at the rapid increase of crime by these newly emerging lower classes: warnings that city streets were no longer safe because of muggers, robbers, pickpockets, and merchants of vice; demands to get immigrant idlers and juveniles off the streets and train them to fit into the mainstream of American industrial life; and sometimes frantic proposals for meeting the threat to the status quo posed by the growing and increasingly restless populations of immigrants and blacks.

As perceived by an elite who saw in its own vision that industry and self-discipline were the sources of the country's emerging greatness, the most serious threat of the criminal elements in immigrant populations was their nonadherence to prevailing cultural norms, namely, the Puritan values of cleanliness, industry, saving, and accumulation. Thus the significance of conventional crime—theft, killing, pickpocketing, prostitutions, robbery— lay less in the violent or acquisitive act itself than in its challenge to the cultural norm.

Leaders in the fields of penal policy, education, and welfare, who were deeply concerned about how to assimilate immigrants, blacks, Indians, and other cultures, recognized that theft, deception, vice, and violence were not the monopoly of these groups but existed throughout society. What was required, therefore, was a rationale of criminal justice that would justify a sharp distinction between deviance that symbolized a threat to the established order and that which did not. The developing concept of criminality as individual pathology, the evolution of individualization, the rationalization of broad discretion as a legally legitimate technique, and "treatment" geared not to the crime but to the "total needs" of the offender provided the policy basis for developing a dual system of law enforcement.

Such a dual system was a political and practical necessity. Upper- and middle-class criminals, whether murderers, embezzlers, or shoplifters,

have slipped in practice but usually have retained as ideals the conventional values in which they have been reared; they may be morally weak or psychologically deficient, but they are not revolutionaries. Deviance that lacks this basic allegiance to society's core values is something else again. Immigrant juveniles, for example, were seen as a class that, as an 1853 report on New York City crime put it, "if unreclaimed . . . will assuredly poison society all around them." The poison to which reference was made was not primarily recidivism in crime, but the threat to the dominant culture of the whole subcultural value structure, of which street crime was merely one feature. It was of course true that fraud, bribery, commercial deception, embezzlement, and exploitation of the poor and helpless were deplorable and imposed costs to their victims' property, health, and life that exceeded by a factor in the hundreds that of conventional theft and robbery. In the nineteenth century, however, just as in our own, this systematic white-collar conduct was not what was meant by the crime crisis. Crime in the streets, though comparatively petty in its direct costs, consciously or unconsciously represented potentially revolutionary rejection of accepted values of private property, status, and the hard-work-and-save ethic. It thus required much more stringent measures for its control.

A retributive theory of criminal law that measured punishment according to the gravity of the offender's act, however, was ill-adapted for making such distinctions. If exploiters, who extracted hundreds of thousands of dollars from the defenseless, were to be ignored, admonished, or wrist-slapped, it would require a refined moral sophistication to justify severe penalties for run-of-the-mill pickpockets and burglars. Indeed, canons of morality might dictate just the reverse of the discrimination against street crime that was politically demanded. Exclusively moral considerations might lead to the conclusion that punishment for offenses against society should be imposed according to the moral responsibility of the offender; thus, under the ordinances of Manu in ancient Hindu administration, the high-caste Brahman who violated the law was subject to much more severe penalties than the lower-caste Sudra, who was not supposed to enjoy the Brahman's fine perception of the difference between right and wrong.

The emergence of treatment-oriented discretionary individualization and the undermining of the legitimacy of retribution provided a natural means out of this embarrassing dilemma. To punish the little man more severely for his little acts, which might appear as open hypocrisy by retributive standards, is no longer a problem if society can be persuaded that "treatment" is not "punishment" and if the criteria for the extent of state intervention are all the social and psychological, but not the moral, deficiencies of the offender. Thus the systematic discrimination in criminal justice administration against minorities, subcultures, and fringe groups is not an accidental malfunction of the treatment ideology. Rather, the practice and legitimation of such discrimination under the label of assimilation was one of its major objectives.

SEVERITY OF PUNISHMENT

Within professional circles and among the more informed and liberal public, there seems to be a widespread belief that severity of punishment is slowly diminishing. Most recent textbooks in penology assume that we are at least a little (and perhaps a lot) better off than we used to be, and that with a little more effort in the same direction, the future will be brighter still. Politicians and newspaper editorials complaining about the "coddling" of prisoners are heard less often than in the past, but the popular mythology of the country-club prison has by no means died out. While it is possible that the belief in steady progress has some substance, there are reasons for skepticism.

At the level of law enforcement and criminal procedure—excepting possibly the third degree—virtually every abuse documented by the Crime Surveys of the 1920s and by President Herbert Hoover's Wickersham Commission remains unreformed with its official sponsors more powerful than ever. Hundreds of citizens are killed by the police each year, often under circumstances that suggest gross neglect or summary execution. There is indiscriminate paramilitary police brutality on the streets. No effective redress for police victims or civilian controls over the police has been developed. The use of arrest rather than summonses is grossly disproportionate. There is excessive and discriminatory use of pretrial detention. Through confession processes that make a mockery of the adversary system there is usually conviction without trial. Prosecutors have excessive discretionary power, often exercised on the basis of favoritism, political influence, class bias, or caprice. Sentencing is grossly disparate, illogical, and unprincipled, with even such an elementary reform as appellate review of sentencing largely ignored.

Where more than trivial reforms have been attempted, they have advanced at a snail's pace, have proved far less effective than anticipated, and have had a tendency to backfire and leave the situation worse than it was before. For example, bail reform programs have not significantly ameliorated the pretrial detention problem where they have operated and have never become significant nationally, but have proved to be the royal road to preventive detention. Police review boards never caught on nationally, but where they existed, they never reached major victim groups; their existence, however, helped provoke a major escalation of right-wing police political repression.

At the correctional level there has been sporadic implementation of reforms of limited significance, such as work release, halfway houses, and conjugal visiting. These reforms reach only a handful of inmates in a limited number of jurisdictions. Jails—the most important institutional component by any statistical measure—in most localities have not changed at all. The aphorism that the difference between the best prison and the worst jail is not worth talking about is, of course, an exaggeration—but not by much.

Internal institutional reform is therefore of limited value in reducing the harm caused by imprisonment. The elimination of gratuitous cruelty, while desirable, does not get at the heart of the matter. Penal programs are inhibited by bureaucratic and custodial restraints. Most institutional employment and training programs are not relevant to the future employment possibilities of the prisoners. Only a minority of those who receive vocational training for some occupation while in prison then work at that trade when released—and in some jurisdictions they would actually be forbidden to do so by laws prohibiting convicts from practicing certain occupations. Much that passes for reform is a facade or serves strictly institutional ends. Dormitory housing, an ill-conceived reform, which is a horror to inmates, has been widely adopted because it is cheaper to build and operate. The decline in the incidence of corporal punishment is probably less a consequence of growing humanitarianism than a result of the superior efficacy of indeterminacy in sentence length as a management device.

Where "progressive penology" rules, the changes are trivial when measured against the magnitude of penal coercion's human cost. We submit that the basic evils of imprisonment are that it denies autonomy, degrades dignity, impairs or destroys self-reliance, inculcates authoritarian values, minimizes the likelihood of beneficial interaction with one's peers, fractures family ties, destroys the family's economic stability, and prejudices the prisoner's future prospects for any improvement in his economic and social status. It does all these things *whether or not* the buildings are antiseptic or dirty, the aroma that of fresh bread or stale urine, the sleeping accommodation a plank or an inner-spring mattress, or the interaction of inmates takes place in cells and corridors ("idleness") or in the structural setting of a particular time and place ("group therapy").

The Fallacy of the Individualized Treatment Model

Prior to the latter part of the eighteenth century, imprisonment in the Western world was usually used only for pretrial detention or short jail terms. Instead, the usual sanctions imposed after conviction were capital punishment (even for trivial offenses), dismemberment, banishment, flogging, and monetary fines. One of the gentlest punishments was public humiliation in the stocks.

The transformation from imprisonment as an exceptional measure to its use as the typical sanction for crime was the product of the complex economic, political, intellectual, social, and humanitarian changes that pervaded nineteenth-century life. The revolution against indiscriminate use of the death penalty demanded the development of alternative measures. Abandoned ships were pressed into service and at least one prison (California's San Quentin) was built where it was because that was the point at

which a prison hulk was swept ashore during a storm. Transportation of criminals, as from England to Australia, proved to be a short-term expedient both because of the predictable opposition of the receiving colonies and because colonization at government expense ultimately proved more of an inducement than a deterrent to crime.

The prison as we now know it is perhaps most of all the product of the Industrial Revolution, which created a need for cheap labor and for a time made the criminal as much an asset as a liability. Before business and union pressures curbed such "unfair competition," the exploitation of convict labor often enabled penal institutions to break even or perhaps show a profit.

Concomitant with these economic determinants of a productive penology were the burgeoning concepts of democracy and the inalienable rights of man. Democratic theory required the assimilation of deviance into the dominant culture and provided a new view of the criminal as someone to be reformed as well as punished. The new concept of the prison was rationalized both by the English utilitarian theorists and, on this side of the Atlantic, by the humanitarian reformers exemplified by the Pennsylvania Quakers. The utilitarians perceived crime as a natural phenomenon flowing directly from humanity's self-seeking nature. Since human beings are motivated to maximize pleasure and minimize pain, they can be expected to transgress when they see it is to their advantage to do so. To insure public safety, punishment for a criminal act needed only to offer sufficiently more pain than the transgression was worth, thereby deterring the offender from further crime and warning other potential offenders.

The Quakers in Pennsylvania differed largely by placing increased emphasis on reformation. They developed a solitary confinement system that, by holding the convict in total isolation and thus quarantining him from other prisoners, was supposed to encourage his meditation, reflection, and penitence. Though the expensiveness of this system never allowed it to be given a thorough trial, an attempt was made to perpetuate the isolation of convicts through such devices as the Auburn (silent) system.

The concept of a prison centered on forced convict labor was an apparently happy marriage of reformism and practicality. To view labor as therapy and idleness as the root of crime was an appealing notion for an economically expanding America with its Puritan moral heritage. The fact that the prisoner insofar as feasible paid the costs of his own imprisonment with his labor made long-term imprisonment economically and politically practicable. From the outset, however, there was an inherent dilemma in this approach. If prison was to reform, it had to provide incentives for conformity and hard work. But if it was to deter criminality, it must threaten a regime more unpleasant than that of the worst-off segments in the free society outside. This practical dilemma confined penal administration within narrow limits, for the rewards it could offer, whether monetary or psychological, were necessarily petty.

In the latter part of the nineteenth century and increasingly in the twentieth century, the decline of the prison as a productive economic institution has vitiated most of the purported therapy of "hard labor." Idleness or meaningless made-work is today the characteristic regime of many, perhaps most, inmates. More important, the concept of reformation as something achieved through penitence or the acquisition of working skills and habits has been de-emphasized because of developments in social and behavioral science. Varying scientific or pseudoscientific approaches to crime, although in conflict with one another and unconfirmed by hard scientific data, view criminals as distinct biological, psychological, or social-cultural types.

Such theories all share a more or less deterministic premise, holding that man's behavior is caused by social or psychological forces located outside his consciousness and therefore beyond his control. Rehabilitation, therefore, is deemed to require expert help so as to provide the inmate with the understanding and guidance that it is assumed he cannot achieve on his own.

The individualized treatment model, the outcome of this historical process, has for nearly a century been the ideological spring from which almost all actual and proposed reform in criminal justice has been derived. It would be hard to exaggerate the power of this idea or the extent of its influence. In recent years it has been the conceptual foundation of such widely divergent approaches to criminal justice as the President's Crime Commission Report, the British *Why Prison?—A Quaker View of Imprisonment and Some Alternatives,* and the American Law Institute's Model Penal Code. Like other conceptions that become so entrenched that they slip imperceptibly into dogma, the treatment model has been assumed rather than analyzed, preached rather than evaluated.

The underlying rationale of this treatment model is deceptively simple. It rejects inherited concepts of criminal punishment as the payment of a debt owed to society, a debt proportioned to the magnitude of the offender's wrong. Instead it would save the offender through constructive measures of reformation, protect society by keeping the offender locked up until that reformation is accomplished, and reduce the crime rate not only by using cure-or-detention to eliminate recidivism, but hopefully also by the identification of potential criminals in advance so that they can be rendered harmless by preventive treatment. Thus the dispassionate behavioral expert displaces judge and theologian. The particular criminal act becomes irrelevant except insofar as it has diagnostic significance in classifying and treating the actor's particular criminal typology. Carried to an extreme, the sentence for all crimes would be the same: an indeterminate commitment to imprisonment, probation, or parole, whichever was dictated at any particular time by the treatment program. Any sentence would be the time required to bring about rehabilitation, a period which might be a few weeks or a lifetime.

The treatment model's judicious blend of humanitarian, practical welfare, and scientific ancestry was nicely illustrated sixty years ago by the Elmira Reformatory's Zebulon R. Brockway:

The common notion of a moral responsibility based on freedom should no longer be made a foundation principle for criminal laws, court procedure, and prison treatment. The claim of such responsibility need neither be denied nor affirmed, but put aside as being out of place in a system of treatment of offenders for the purpose of public protection. Together with abrogation of this responsibility goes, too, any awesome regard for individual liberty of choice and action by imprisoned criminals. Their habitual conduct and indeed their related character must needs be directed and really determined by their legalized custodians

The perfected reformatory will be the receptacle and refinery of antisocial humans who are held in custody under discretional indeterminateness for the purpose of the public protection. Legal and sentimental inhibitions of necessary coercion for the obdurate, intractable element of the institution population will be removed and freedom given for the wide use of unimpassioned useful, forceful measures. Frequent relapses to crime of prisoners discharged from these reformatories will be visited upon the management as are penalties for official malfeasance. The change will be, in short, a change from the reign of sentiment swerved by the feelings to a passionless scientific procedure pursuing welfare.[4]

As with any model, of course, its implementation has been uneven, often halting, and seldom complete. Perhaps the closest approximation to the ideal is in certain so-called sexual psychopath statutes under which an indeterminate and potentially lifelong incarceration can be ordered as a civil commitment without conviction of any crime. Judicial power is yielded grudgingly, however, and legislators cling to the notion that maximum penalties should be graded according to their ideas of relative blameworthiness, so that the result is a patchwork quilt of inconsistent rationales. Overall, however, the movement toward the individualized treatment model is unmistakable. Every state has some form of parole, which provides a core indeterminacy. Compared to the median time served, the maximum possible sentence for most crimes is so excessive that the disposition of almost any conviction utilizes the treatment process in some manner.

While opposition to "mollycoddling" prisoners still exists, the basic thrust of the model has been accepted by almost all liberals, reformers of all persuasions, the scientific community, probably a majority of judges, and those of law-and-order persuasion who perceive the model's repressive potential.

How has the model united such a motley collection of supporters? Its conceptual simplicity and scientific aura appeal to the pragmatism of a society confident that American know-how can reduce any social problem to manageable proportions. Its professed repudiation of retribution adds moral uplift and an inspirational aura. At the same time, the treatment model is sufficiently vague in concept and flexible in practice to accommodate both the traditional and utilitarian objectives of criminal law administration. It claims to protect society by incapacitating the prisoner in an

institution until pronounced sufficiently reformed. This prospect is unpalatable enough and sufficiently threatening in its uncertainty to provide at least as effective a deterrent to potential offenders as that of the traditional eye-for-an-eye model. Maximum flexibility is required to achieve the model's goal, that of treatment individualized to each offender's unique needs, so the system's administrators are granted broad discretionary powers. Whatever the effect on offenders, these powers have secured the support of a growing body of administrators, prosecutors, and judges, for it facilitates the discharge of their managerial duties and frees them from irksome legal controls. Even the proponents of retribution, although denied entry through the front door, soon discovered that harsh sentences could be accommodated within the treatment model as long as they were rationalized in terms of public protection or the necessity for prolonged regimes of reeducation.

The treatment model tends to be all things to all people. This partially accounts for the paradox that while the model's ideological command has become ever more secure, its implementation has tended to form rather than substance. In fact, the model has never commanded more than lip service from most of its more powerful adherents. The authority given those who manage the system, a power more absolute than that found in any other sphere of law, has concealed the practices carried on in the name of the treatment model. At every level—from prosecutor to parole-board member—the concept of individualization has been used to justify secret procedures, unreviewable decision-making, and an unwillingness to formulate anything other than the most general rules or policy. Whatever else may be credited to a century of individualized-treatment reform effort, there has been a steady expansion of the scope of the criminal justice system and a consolidation of the state's absolute power over the lives of those caught in the net.

The irony of this outcome emphasizes the importance of a searching examination of the assumptions underlying the individualized treatment model. Hopefully such an analysis will illuminate efforts to delineate the proper role of criminal justice in a free and democratic society. It may also help us to understand what factors have perpetuated our present criminal justice system decade after decade in the face of compelling evidence of its systematic malfunctioning.

UNEXAMINED ASSUMPTIONS

When one probes beneath the surface of the treatment model, one finds not only untenable factual assumptions, but also disturbing value judgments that pose serious policy questions for our society. Here are some of the more perplexing of these problems with which we will be concerned:

1. A model of criminal justice that rests on the proposition that at least in large measure crime is a problem of individual pathology; that is, the model assumes that crime rates can be reduced by the treatment and cure

of individual criminals and that future crimes can be prevented by the incapacitation of those predicted to be dangerous until they are cured. The difficulty of identifying the characteristics of such a pathology, if indeed it exists at all, will be noted below. To the extent that it is also acknowledged that social and environmental factors, such as slums, poverty, unemployment, and parental guidance or the lack of it, also "cause" crime, a program of individualized treatment is inadequate. If social factors cannot be controlled or predicted, the relevance of individualized treatment is decreased and may be negligible. If the social pathology assumed to encourage a criminal culture is not being changed, is there ethical justification for individualized preventive detention? A prisoner detained to prevent crimes that could be avoided by social reforms may bear a greater resemblance to a scapegoat than to either a patient or a public enemy. We do not and probably cannot know the relative contributions of individual and social pathology to criminality; to the extent that social causation is relevant, the rationale for individualization is undercut. To date, our society has largely ignored this dilemma.

2. At the level of individual pathology, treatment ideology assumes that we know something about the individual causes of crime. If it is to have any scientific basis, such knowledge must be based on the study of representative samples both of criminals and of control groups of noncriminals. Comparison of the two may reveal factors that distinguish the criminals from the control groups; whether such differences have any causal significance poses additional research problems which, in this context, we have no occasion to face. We have libraries full of criminological research on the etiology of crime, but most of it has been conducted without control groups and therefore tells us nothing about causation (and usually not much else, either). In all this research, moreover, the data about criminals are derived from those who have been subject to correctional regimes and therefore identified and made available for study. But only a small proportion of those who commit criminal acts are caught, convicted, and subjected to correctional treatment. The criminals who are the subjects of all our research are almost certainly not representative. Our available sample is heavily biased toward criminals from the poor and outcast classes and away from the white middle and upper classes. Bias is also introduced by selective enforcement of criminal law. Welfare fraud or manslaughter in a ghetto barroom brawl is likely to land the perpetrator on the rolls of diagnosed criminals; business fraud or manslaughter by automobile on the freeway goes largely unprosecuted and unstudied. Therefore, even if we had a body of adequately controlled research findings it would merely describe the kinds of persons subjected to criminal treatment in a society where race and poverty are major determinants for the application of the criminal label. Such data might afford revealing insights about the administration of criminal justice in such a society, but would hardly provide the basis for a usable science of individual criminal pathology. We think it is important to

ask why treatment ideology was embraced with such enthusiasm without bothering to inquire about the validity of the science on which it depends.

3. Even if the existence, significance, and characteristics of an individual criminal pathology are unknown, one might in theory still evolve treatment methods that turned criminals into noncriminals. It has been a frequent occurrence in medicine to stumble upon treatments that worked despite ignorance about the cause of the disease or the reasons for the treatment's success. The minimum methodological standards for investigating this possibility as to any particular treatment are (a) comparison with control groups of similar subjects who are not treated; (b) control of other variables, such as maturation or changed environmental or social conditions, to negate the possibility that factors other than the treatment process were responsible for the outcome; and (c) reasonably reliable criteria for determining success or failure. Most research fails the first and second tests. Control groups are conspicuous by their rarity in treatment evaluation investigations. But the apparently insoluble problem of such research is the third requirement: the necessity of establishing indicators to distinguish success from failure. This is true even if one proceeds at the most superficial level, defining failure as recidivism, the commission of another crime following treatment. We have no way of determining the real rate of recidivism because most criminals are undetected and most suspected criminals do not end up being convicted. Recidivism rates are also subject to both deliberate manipulation and unconscious bias. Parole revocation (failure) rates can be manipulated for public relations or other purposes. Documented examples of such research falsification are known and the practice is probably not uncommon. Unconscious bias is introduced by the tendency of predictive and diagnostic judgments to become self-fulfilling prophecies. For example, those released on parole from a treatment program are likely to be formally or informally classified for the purpose of parole supervision into good risks (responded favorably to treatment) and poor risks (resisted treatment). The "poor risks" are likely to be subjected to tighter surveillance; their violations are therefore much more likely to be detected; their parole is more likely to be revoked; and the resulting differences in recidivism rates emerge as a "research finding" validating the efficacy of the particular treatment program.

4. In the absence of credible scientific data on the causation or treatment of crime, the content of the correctional treatment program rests largely on speculation or on assumptions unrelated to criminality. Thus one finds that accepted correctional practice is dominated by indoctrination in white Anglo-Saxon middle-class values. In institutions this means learning a trade, establishing work habits through the therapy of labor, keeping clean and clean-shaven, minding your own business, and acquiring such basic or supplemental educational skills and religious training as the institution might provide and the parole board might think relevant. On probation or parole,

in addition to abstaining from crime, the ingredients for success are similar: sticking at a job, staying where you belong, supporting your family, avoiding bad companionship and bad habits, and abiding by the spoken ideals of conventional sexual morality. Without debating the merits of these ingredients of the good life—those of us not being corrected are free to take them or leave them—the fact that the correlation between such Puritan virtues and crime causation is speculative or nonexistent would, one might suppose, have raised some troubling questions. If the treatment has no proven (or likely) relationship to criminal pathology, what is its purpose? In the absence of such evidence, what is the propriety of coerced cultural indoctrination?

The closest parallel we can think of in American history, which developed at the same time as the correctional treatment model in response to the same kinds of reform pressures, was the policy of compulsory assimilation of American Indians, which the Indian Bureau attempted to carry out from 1849 through the end of the century. The deliberate discrediting of Indian cultural values, compulsory proselytizing, and the destruction of the tribal economic base were supplemented by government boarding schools, which Indian children were forced to attend throughout their formative years. The program and style of these schools bore striking resemblance to the correctional treatment model. There are other similarities as well. The correctional system also draws most of its clients from subcultures; perhaps half are from racial minorities (including some Indians on their second round of "treatment") and more than half from cultures of poverty or near-poverty. We do not suggest that the parallel is complete or that it follows that the motivation and purpose of the correctional system's treatment program is necessarily the same as the policy of the nineteenth-century Indian Bureau. But we are disturbed both by the similarities and by the absence of any probing dialogue that might explore the whole purpose and philosophy of correctional treatment.

5. Using rates of recidivism as the criterion for evaluating the success or failure of criminal justice programs poses more fundamental problems than the unreliability of the statistics. Surely it is ironic that although treatment ideology purports to look beyond the criminal's crime to the whole personality, and bases its claims to sweeping discretionary power on this rationale, it measures its success against the single factor of an absence of reconviction for a criminal act. Whether or not the subject of the treatment process has acquired greater self-understanding, a sense of purpose and power in his own destiny, or a new awareness of his relatedness to man and the universe is not subject to statistical study and so is omitted from the evaluation.

It will make a critical difference for the future of democracy whether our institutional and noninstitutional environments encourage the creation of morally autonomous, self-disciplined people who exercise independent

judgment and purposefulness from their own inner strength, or whether instead they tend to stunt the human potential by training programs that, as with animals, condition their subjects to an unthinking conformity to inflexible, externally imposed rules. In studying the criminal justice system we have found few things to be thankful for, but the ineffectiveness of correctional treatment may well be one of those few. The only kind of morality the sticks-and-carrots regime of indeterminate treatment in correctional institutions can teach is the externally imposed variety. If such correctional methods really did work, it might be more success than a free society could endure.

6. Remaking people is an educational function. What, then, of prison education? We typically find an inadequate staff in a depressing environment with minimal facilities and equipment (no field studies here) operating an adult educational program across class, race, cultural, and status barriers for inmates whose chief motivation is to chalk up attendance marks so as to satisfy The Man on the Parole Board. From this soil we expect to reap the miracle—the maturation of a unique human being. At least that is what one would conclude from the uncritical acceptance of prison education as a "good thing" and a hallmark of society's humanity to prisoners.

7. The discretionary power granted to prosecutors, judges, and administrators in an individualized treatment system is unique in the legal system, awesome in scope and by its nature uncontrollable. If the theory posits that any one of many variables can be determinative of any individual decision, standards are necessarily nonexistent or so vague as to be meaningless, and review by any sort of court or appellate process is impossible. Yet it is evidently accepted without question that absolute power does not corrupt when exercised by government agents upon criminals. The chronicles of criminology and jurisprudence are filled with paeans celebrating the wise discretion of humble and contrite judges and administrative agencies. Their authors, however, would not for one moment surrender to the discretion of those same judges and agencies the assessment of their income and property taxes in accordance with the official's individualized determination of the subject's value to his country and his ability to pay. Indeed, the best antidote to being swept off one's feet by the claims made for the necessity and importance of the discretion that permeates criminal justice administration is to engage in a comparative examination of criminal law and the laws governing taxation, corporations, and commercial transactions. One will speedily discover that when it comes to matters concerning their vested interests, the men who have the power to write the law in this country give short shrift to discretion. They are not about to delegate the determination of the size of the oil depletion allowance to the discretion of the local internal revenue agent. If discretion is written into major law, it is because legislators are confident from the outset that they will be able to control its exercise.

Criminal justice is the surviving bastion of absolute legal discretion. The last of its colleagues, of which it is reputed to be the heir, was the Office for the Administration of Colonial Affairs.

8. In coming finally to the end of this preliminary enumeration of problem areas, we reach the area that is the most perplexing and the culmination of what has gone before. We have sketched a number of problematic features of a correctional treatment model of criminal justice. Most of the problems and defects that have been posed are not very difficult to understand; one might even categorize a number of them as obvious. How is one to account, then, for the enthusiastic and uncritical acceptance by most of the liberal and progressive elements in our society of reformative, indeterminate, individualized treatment as the ideal goal of a criminal justice system?

There is something about this phenomenon akin to religious conversion, an acceptance of what appears to be true and valuable, what we want to be true, even though it cannot be reduced to anything more precise than vague generalities. It seems obvious that extremely complex forces lie behind liberal treatment ideology's mission to control not just the crimes but the way of life of others. Guilt about the gulf that separates our material well-being from poverty and oppression may account for some of the prejudice against and irrational fear of the poor and the oppressed; or it may help to account for our eagerness to hand over the problem to specialists as a way of relieving our anxiety. Once you have delegated a problem to an expert, you are off the hook.

If we could make some sense out of this extraordinary willingness to believe unreasonable things about criminal justice and corrections, we might begin to have some understanding of the forces that perpetuate so unjust a system. We explore this problem further below; it is hardly necessary to state here, however, that we cannot provide a satisfactory solution to this major puzzle. We do, however, hope to promote its analysis and encourage its study. Such an inquiry seems to us to be prerequisite to effectuating basic changes in our concepts and practices of criminal justice. The most stubborn obstacles to such change are not, in our opinion, the growing problem of violent crime or the hard-line advocates of punitive law-and-order repression or the rigidity and increasingly conservative polarization of our law enforcement and correctional bureaucracies or the perversity of adverse public opinion. Serious as they are, such forces can be contained if adequate options are developed and promoted. We suspect that much of the current strength of these conservative forces derives from the fact that there is no tenable alternative model of a criminal justice system that affords accommodation of such competing values as equality, respect for individual dignity and autonomy, encouragement of cultural diversity, and the need for a reasonably orderly society. The correctional treatment model does not begin to meet this need.

The Crime of Treatment

Most if not all the assumptions that underpin the treatment model are unsubstantiated or in conflict with basic humanitarian values. Despite these shortcomings the treatment approach receives nearly unanimous support from those working in the field of criminal justice, even the most progressive and humanitarian. How can this solid support be explained? Many persons admit the shortcomings we describe but nevertheless support treatment practices out of a belief that, if nothing else, they do help some prisoners. Is this the case? Does what passes for treatment actually help? Does prison rehabilitate?

Much of our discussion will be devoted to the California correctional system, which has pushed further toward full implementation of the rehabilitative ideal than any other correctional system in the United States. For example, Norman S. Hayner, in comparing correctional systems in various countries, says that California "easily ranks at the top from the standpoint of emphasis on treatment with a score of 122 points out of a possible 140." [5]

Before examining the impact of rehabilitation on convicts, we will sketch briefly some of the major contours of "rehabilitation" itself.

Rehabilitation as a direction for penal systems introduced three new characteristics: individualization, indeterminacy, and discretionary power. Individualization was needed because the focus of scientific perspective was not on law violation but on the criminal. The criminal is a different type of person, his infraction merely a manifestation of this difference. Decisions had to be tailored to the individual case to make the rehabilitative routine possible. This led to the indeterminate sentence system whereby the individual is released only when he has been "cured" of his criminality. Implementation of the rehabilitative system also demanded greatly expanded discretionary powers for the persons making decisions, such as judges, district attorneys, prison administrators, parole-board members, and parole officers.

Nevertheless, prisons never became hospitals and criminals have never been treated merely as sick persons. Interested segments of society have demanded that other goals be pursued in the handling of a convicted person. What was remarkable about the emergence of the rehabilitative ideal in the correctional world is that it was able to take contradictory ideas and, through intellectual gymnastics and a great deal of hypocrisy, combine these into a system that for the time being made everyone happy—except the criminal!

Despite its failure, the rehabilitative ideal has received overwhelming acceptance. Here we will examine attitudes toward it by three groups within our society: the humanitarian reformers, the punitively oriented citizens, and the prison administrators.

The eighteenth-century humanitarian's attitude of reform through penance was replaced in the late nineteenth century by the attitude of cure through rehabilitation. In both attitudes the criminal is seen as an undesirable person, formerly a moral inferior, later a mental or emotional inferior. These attitudes were considered humanitarian because they viewed some criminals as redeemable.

It did not disturb reformers pursuing the rehabilitative ideal that the person who was identified as sick or abnormal was forced into a treatment routine and that he might experience this not as help but as punishment. It was society's motives that counted. Since they were doing it for his own good and society's protection, it was treatment not punishment. (Isn't this similar to the handling of the mentally ill in mental hospitals?)

An important force in the reform movement was the mixture of hatred, fear, and revulsion that white, middle-class, Protestant reformers felt toward lower-class persons, particularly foreign-born, lower-class persons who did not share their Christian ethic. These difficult feelings were disguised as humanitarian concern for the "health" of threatening subculture members. Imprisonment dressed up as treatment was a particularly suitable response for reformers' complicated and inconsistent feelings.

The treatment-oriented correctional routine, with its serious theoretical inconsistencies, was embraced wholeheartedly by most persons involved in the administration of criminal justice, even the punitively oriented. District attorneys, police officers, and correctional administrators saw in the rehabilitative ideal increased latitude to imprison for longer periods of time criminals they viewed as especially dangerous. Previously, uniformly applied statutory sentences, specifying the maximum penalty, forced them to release prisoners they considered extremely dangerous. Indeterminate sentencing, however, allows them to avoid this. Furthermore, they are able to keep a released prisoner under surveillance by placing him on parole, another logical outgrowth of a rehabilitative correctional system. Indeterminate sentencing has increased the length of imprisonment for most crimes.

Prison administrators also embraced the rehabilitative ideal. Their enthusiasm and their concrete efforts in state legislatures helped bring about the shift from prisons that delivered straightforward punishment to the rehabilitative prison with treatment added. Academic penal theoreticians supplied the rhetoric and correctional workers won the political battles.

However, it wasn't treatment that excited them. It was the prospect of having greater control over their prisons. This increased control took two forms. Formerly corporal punishment was the main control mechanism, but this technique was becoming troublesome because outside parties were increasingly critical of it. The rehabilitative system, particularly indeterminate sentencing, offered them a highly effective and less objectionable control method. Today prison routines are manipulated largely to maximize conformity to prison regulations. The second area of control that the rehabilitative system offered prison administrators is that of the size and flow of

the prison population. Today they can increase or reduce the prison population as suits their purposes.

The rehabilitative prison satisfies nearly everybody except the uninformed general public. Not recognizing the sophistication of the system and believing the rhetoric generated and disseminated by the professionals, some portion of the public thinks criminals are being treated too well. Treatment-oriented prisons are perceived as "country clubs," where convicts are coddled and pampered. Courts are perceived as "too permissive." It is felt that the criminal is living better than ordinary hardworking folk. Politicians and prison administrators are far from insensitive to these sentiments, which are certainly a factor in preventing adherents of the treatment model from implementing it more fully.

CLASSIFICATION

Classification is the initial phase of the modern correctional routine. The earliest classifications and differentiations were on the basis of sex and age. The first was done to preserve the morals of prisoners. When it was recognized that young offenders were corrupted by older offenders, the two age groups were separated. From this point on there has been a steady movement in modern correctional institutions toward greater and greater differentiation of prisoners.

This differentiation is presently not only for segregation, but more for implementing different rehabilitative strategies. This is consistent with the contemporary view that the criminal has *something* wrong with him. This something is different from person to person. Therefore, a prison routine designed to treat the prisoner must have various rehabilitative strategies to treat the different kinds of problems and sicknesses of individual prisoners.

This classificatory routine might appear sound on paper; in actuality it does not come close to fulfilling its stated purposes. The diagnostic interviews are short, about half an hour per man. Evaluation made in this setting is of questionable validity. This is not simply a fault of time or of the particular instrument; we do not have the techniques for classifying offenders in a meaningful way—that is, in a manner that is related to their future criminal propensities or their treatment needs. Furthermore, there is considerable evidence that various treatment strategies do not make *any* significant difference in the future criminal behavior of inmates.

To some extent the classification process fails because of the basic conflict in the goals of the prison, that is, surveillance and treatment. Custody and housekeeping concerns usually take precedence over treatment matters. Even if it were possible to diagnose a particular offender's needs properly and recommend a treatment strategy, the actual recommendation would be based on the availability of space in the prison system or the custody level of the individual. For instance, about six thousand inmates in California are housed in San Quentin and Folsom, the two maximum-secu-

rity prisons. The treatment and educational and vocational training programs in these prisons can serve only a small minority of the inmates. The rest are there for surveillance. Furthermore, in recent years California has been expanding its conservation camps program. There are two Conservation Centers, which are the focal point for clusters of camps. It has been found that it is cheaper for the state to put more of the inmate population in this kind of situation, so it appears that the trend will grow. The purpose of sending people there is in no way related to treatment strategies. There are virtually no rehabilitative programs in the camps, unless one construes hard work as rehabilitation. Even in the California system, then, the primary factors in deciding where a man serves his time and what he does are custodial concerns. This appears to be the case in all prison systems.

PROGRAMMING

"I'm going to get a program."

"Get a program and you'll get a parole."

"Look at _____, he's programming."

Such statements, heard frequently in California prisons, reflect a general consensus of inmates and staff that inmates must participate in treatment programs in order to be paroled. The undisguised cynicism they exhibit implies that the programs are regarded as phony and that the motivation for participation is to manipulate the parole process.

A wide variety of therapeutic programs has been experimented with in California. Group counseling was introduced about 1955 and now involves a majority of inmates. Most convicts participate in these sessions only because they feel they have to. They lack commitment and are fearful that anything meaningful revealed in these sessions might be used against them and damage their chances of receiving a parole. Consequently, the sessions seldom move beyond the bland and the trivial. The essence of such sessions is perfectly captured in a novel by a former San Quentin inmate:

He found his group already gathered, sitting in the usual symbolic circle. The therapist, a Dr. Erlenmeyer, occupied what was intended as just one more chair, but the group automatically polarized wherever he seated himself. He was dressed entirely in shades of brown, and his shirt was darker than his coat. His glasses were tinted a pale tan, and his head full of hair seemed soft and dusty.

"You're late, Paul," he said, in a tone that didn't admit the obvious quality of his remark. His voice was opaque.

"I lost track of the day," Juleson said.

This hung in the air for a moment like a palpable lie, then settled into the heavy silence. The group had nothing going. No one, as they said, was coming out with anything. Juleson settled around in his chair, careful not to look at Erlenmeyer, who might try to make him feel responsible for this wasteful silence. Once Erlenmeyer had stressed how therapy was working on them even while they sat dumb, as sometimes happened, for the entire hour. But he didn't like their silences. . . .

Finally, Erlenmeyer cleared his throat to ask, "Why do you suppose Paul is late so often?"

They looked at each other to see if anyone was going to attempt an answer. Bernard only shrugged; he didn't care. After a moment Zekekowski said quietly, "He's got better sense than the rest of us." [6]

More ambitious therapeutic experiments have also been tried in California. Generally these have not been successful from the administration's point of view—that is, they have not had any measurable effect on recidivism. Often they have been disastrous from the inmates' viewpoint.

Educational-vocational programs have fared somewhat better. In California theoretically a person may learn the following trades: cooking, baking, butchering, dry cleaning, sewing-machine repair, auto mechanics, printing, auto body and fender, sheet metal, machinist, plumbing, painting, welding, and hospital techniques. In fact, however, few learn these trades. Though there has been great expenditure for vocational programs, there are only enough openings in these programs for a small percentage of the inmate population. Also, the training routine, actually an appendage of the prison housekeeping enterprise, is not related to outside occupational settings. For instance, men working in a prison bakery are ostensibly in a vocational bakery program; actually, however, they spend most of their time merely baking food to be consumed in the prison. After years of experience in the prison bakery, a person would have to learn a considerable part of the trade after leaving. In programs designed primarily for vocational training, such as the body and fender shop or some machine shops, often the equipment, the techniques, and the knowledge of the instructor are obsolete. As evidence that these programs are not effective, an unpublished study conducted by a regional office of the California Parole Agency discovered that only 36 percent of parolees receive any trade training and only 12 percent of that group later work in a field related to that training. The figures would probably be lower in other states.

PAROLE

The terminating program in the rehabilitative routine is parole. In many ways it epitomizes the treatment-punishment mixture. Theoretically the parole agent aids the parolee's transition back into the community by mixing the two functions, help and surveillance. On the one hand he enforces (with considerable leniency) special rules of conduct—the conditions of parole. In this way he protects the parolee from slipping back into harmful behavior patterns and likewise helps the community by keeping the parolee out of trouble. On the other hand he "works with the parolee," giving him counseling, moral support, and some concrete help, such as aid in securing employment and residence.

In practice there is a serious flaw in this helping-surveillance relationship. The parole agent is in theory required to enforce very restrictive rules of conduct, so restrictive that the parolee's life chances would be seriously reduced if he were forced to live by them. For instance, one of the rules in California is that the parolee must not "associate" with other ex-convicts

or persons with bad reputations. For a person who lives among other work-
ing- and lower-class persons, which is the case of most parolees, not asso-
ciating with ex-convicts or persons with "bad reputations" is clearly un-
realistic. Furthermore, the California parolee may not leave the county of
residence, drive a car, or change jobs without his agent's permission. And
he may not drink "to excess."

In actuality, the agent, in order to prevent having to "violate" the major-
ity of his case load and in order to increase the life chances of the parolee,
enforces a much more lenient set of informal rules. The problem with this
is that the formal rules still exist and are invoked when some outside atten-
tion is directed toward a particular parolee. When this occurs, the parolee
is often held to answer for behavior that the parole agent had known about
and had explicitly condoned.

Moreover, the agent is not in a good position to help the parolee. He is
not a professional therapist (if this would help) and has few resources to
supply concrete help, such as a job, which the parolee often needs desper-
ately. At best, parole is an obstacle the ex-convict has to contend with
among the many other obstacles in his path. At worst, it is a trap that when
sprung intensifies his feelings of injustice toward the hypocritical, unpre-
dictable rehabilitative system.

IMPACT ON CONVICTS

Three trends are significant in appraising the consequences of Califor-
nia's adoption of the rehabilitative ideal. First, the length of sentences has
steadily increased. From 1959 to 1969 the median time served has risen
from twenty-four to thirty-six months, *the longest in the country*. Second,
the number of persons incarcerated per 100,000 has continued to rise, from
65 in 1944 to 145 in 1965. This figure too is the highest in the country.
During a period when the treatment ideal was maximized, when vocational
training programs, group and individual therapy programs, milieu therapy,
and many other rehabilitative experiments were introduced, more than
twice as many persons served twice as much time. Third, there is evidence
that people are not being helped any more by a median stay of three years
in a rehabilitatively oriented prison than they were by approximately two
years in a basically punitively oriented prison. One indicator of this lack of
change is the consistent recidivist rates. Through the years approximately
40 percent of the persons released on parole in California have been re-
turned to confinement two to three years after release.

So that we can see how the California system works, let us briefly exam-
ine the procedure for determining length of sentence. This decision is abso-
lutely the most important to the prisoner. California, having one of the
most indeterminate forms of the indeterminate sentence system, leaves the
final determination of length of sentence and time of parole release in the
hands of a government-appointed nine-man panel—the Adult Authority.
This parole board has wide margins within which to work. For instance,

the statutory limits for second-degree burglary are one to fifteen years; first-degree robbery, five years to life. The most frequently occurring statutory sentence is one to fifteen years. The general procedure for determining the sentence is for the prisoner to appear annually before a panel, which will have one or two members of the Adult Authority and one or two "representatives"—persons of civil service rank whose decisions must be approved by the Adult Authority members. Before the prisoner makes his annual appearance, one of the members of the panel reads his "jacket"—a compilation of information, such as test results, psychiatric and psychological evaluations, work and disciplinary reports, and probation and arresting-officer reports. Key information from this file has been summarized in a fifteen- to twenty-page "Cumulative Summary" for the board appearance and the board member usually confines his examination to this "Cum Sum." Moreover, this five- or ten-minute perusal is being done while another board member questions another prisoner.

During the actual hearing the discussion, led by the panel member who is the chief examiner in a particular case, covers a variety of topics, such as the crime, the prison record of the inmate, and his future plans. The hearing lasts on an average of fourteen minutes, after which there is a determination of his sentence and a granting of a parole date or a "denial."

Several aspects of this process are worthy of mention. First, extraordinary power is lodged in the Adult Authority. It not only has the power to make the final determination of sentence, it can also rescind this determination after it has been made; for example, it can release on parole, rescind the determination, return to prison, and again refix the inmate's sentence. None of these powers can be checked by judicial review.

Second, in a rehabilitatively oriented system, those who determine a release date should be a panel of experts in the behavioral sciences. That such individuals actually have the required expertise is, as already emphasized, unlikely, but the supposition is that they do. In California the law that originally constituted the Adult Authority in 1946 specified that there would be three board members, one with a background in the social sciences, one with a legal background, and one from the correctional field. As the board grew, this initial conception of its composition remained unrealized. At present, six of its nine members have police work backgrounds.

Many prisoners are convinced that there are no valid or consistent criteria operative in this sentencing hearing. The decisions seem arbitrary and unjust. For instance, often one or more members will recommend that a prisoner follow some program for the next year. At his next annual board appearance the prisoner discovers an entirely different panel, uninterested in last year's hearing, which denies him parole even though the previous board's instructions were followed to the letter. Until recently no record was kept of the yearly recommendations of panel members.

There is considerable evidence, mainly in the form of testimony from prisoners and ex-prisoners of various California prisons, that indefinite sen-

tences are one of the most painful aspects of prison life. Here is the opinion of a woman imprisoned at Frontera:

> The total waste of time spent while here and the constant mental torture of never really knowing how long you'll be here. The indeterminate sentence structure gives you no peace of mind and absolutely nothing to work for.
> The total futility of this time is the most maddening thing to bear. You realize nothing but frustration from the beginning to the end of your confinement. This situation is compounded by the "never knowing" system of the indeterminate sentencing law.[7]

Moreover the determination of sentence and many other facets of the California rehabilitative routine strike many prisoners as hypocritical. They feel that denial of parole for the stated purpose of pursuing some treatment program often hides other reasons for the denial, including not having enough time served for a particular crime, suspicion of other crimes, outside concern over certain types of crime, or for factors having little to do with him or her, such as administrative exigencies. Prisoners react strongly to such injustice.

The suffering caused by indeterminacy and the hypocrisy of the newer systems may be different from that experienced in earlier, more openly punitive systems, but it is not necessarily any less severe, nor has the suffering really been alleviated by the introduction of various comforts, such as television and recreation programs. Those who were concerned about removing earlier forms of suffering have shown a curious insensitivity to the newer forms. The middle-class person who blanches at the thought of the cat-o'-nine-tails apparently accepts without undue feelings of guilt the cat-and-mouse game whereby the prisoner never knows whether the sentence is three years or ten and discipline is maintained by the threat of more time.

Besides suffering from the indeterminacy and the hypocrisy in the penal situation, convicts in rehabilitative prisons experience a more profound form of suffering. This is the pain of being treated unjustly. Probably many prisoners have always felt some diffuse sense of injustice about the way they have been treated, but in recent years this has grown. There is increasing sophistication among prisoners in understanding basic legal rights. There is a growing tendency among prisoners to view procedures based on the rehabilitative ideal as clever strategies for stripping them of constitutional rights. Several of these rights from the convict's perspective are regularly violated. The following case reported by a convict is an example in which the convict felt that he was being denied due process.

> S. was convicted for second degree burglary and served two years. While on parole, he states that his relations with his parole agent were not good even though he was working steadily and conforming to parole regulations. After completing eighteen months on parole he was arrested two blocks from his home at 11:00 p.m. He was on his way home from a nearby bar where he had just spent two or three hours. The police were looking for someone who had committed a burglary several blocks away about an hour earlier. When they discovered that S. had a record for

burglary he was taken to jail and charged with this crime. When his alibi was established and there was no evidence to connect him with the crime except for his being in the neighborhood, the judge dismissed the charge and admonished the arresting officers.

S.'s parole was cancelled, however, and he was returned to prison. When he appeared before the Adult Authority for a parole violation hearing he was asked if he knew why he had been returned. He replied that he did not. The Adult Authority member became irritated with him and told him that just because he "beat the charge" in court did not mean that he was not guilty, and that the best thing he could do was to admit that he was guilty. He refused to do this and tried to explain to the member that the judge clearly believed him to be innocent and that he could prove this from the transcript of the preliminary hearing.

S. was denied parole consideration and postponed for another year. The next year he brought the transcript of his case to the hearing and the member said that he did not want to read it and that it made no difference to him anyway. He was guilty as far as they were concerned. Once again he was denied parole and scheduled for another hearing in a year.

Many convicts serving time under the indeterminate sentence system feel that the crimes of others aggravate their own crimes. The following is an example in which the convict felt that this had taken place.

D., an armed robbery offender, appeared before the Adult Authority after serving 4½ years. He felt that because of his crime, the time served and his institutional record, he should be paroled at this time. However, approximately two months prior to this board appearance an armed robbery had occurred which, because of having excessive violence, received considerable news media coverage. Furthermore, many statements by law enforcement officers and political leaders had followed which requested harsher treatment of armed robbers. At D.'s appearance very little was said about his progress in prison; instead the conversation turned to the recent violent robbery and the attendant publicity given to this crime. D. was not granted a parole at this time and was scheduled to return for another board appearance when he had served 5½ years. Needless to say, D. felt that he was being punished for the acts of other persons.

Another complaint of persons living under rehabilitative routines is that parole authorities regularly are guilty of ex post facto law enforcement. They do this by increasing a person's penalty after he has been convicted and sentenced because in the meantime more stringent legislation has been passed.

In most rehabilitative prison systems that employ an indeterminate sentence system, the majority of the convicts serve a sentence very close to the median sentence. A minority, however, serve longer sentences for reasons they feel are vague, invalid, not constitutional, or not legally admissible in the sentencing procedure. For this, they and others around them feel a sense of injustice. This sense of injustice is contagious and its effects are profound.

Suffering within the penal system has not decreased. The opposite seems to be the case: rehabilitation has introduced a new form of brutality, more subtle and elusive. That rehabilitation is less disturbing to the deliverers

who, consequently, have spread it among a much larger number of persons is also true.

TREATMENT AND COERCION

Mixing treatment with coercion in the penal system not only lengthens sentences and increases the suffering and the sense of injustice, it also vitiates the treatment programs that are its justification.

Many have pointed to the difficulties inherent in implementing treatment in prison. For instance, David Powelson and Reinhard Bendix,[8] writing in 1951 about the rapidly expanding California system, identified a basic therapeutic flaw in the prisoner situation, in which custody concerns were necessarily primary and the moral depravity of the prisoner must be assumed in order to legitimate custody. They further warned of the danger that existed in disguising custody concerns as treatment, which inevitably happens. Donald Cressey and Lloyd Ohlin [9] recognized potential difficulties in implementing treatment in prison because of organizational obstacles stemming from the multiple and possibly conflicting goals of the prison.

Beyond the special problems of effecting "treatment" in prisons, is it possible to coerce people into "treatment" in any setting? Is the necessary therapeutic relationship between the helper and the helped possible if the person to be helped is forced into the relationship? Psychiatrists have argued that in order for psychotherapy to be effective, the client must enter the relationship voluntarily. When he is coerced, resentment, suspicion of the motives of the therapist, and lack of commitment to the therapeutic goals destroy any chances of success.

Though perhaps not universally true, such a criticism probably applies to most forms of help offered through the criminal justice system. Persons forced into group therapy, group counseling, "therapeutic communities," vocational training, or education probably resent the coercion, are suspicious of the motives of the helpers, or lack commitment to such a degree that the programs do not accomplish their explicit purpose, even though some of the programs may be very good.

There is another dimension to coerced help. "Coerced" does not simply mean that a person is ordered to do something. He is ordered to do so *or else*. The "or else" is usually a penal sanction, such as a jail sentence or a lengthened jail sentence. In rehabilitative prisons the person's release may be effected by the quantity and quality of his participation in "treatment programs." Since he knows this is true, he is greatly influenced to enter these programs not simply to help himself, but in order to manipulate the release system. In doing so he usually corrupts the treatment value of the programs.

VOLUNTARY PROGRAMS

Let us look briefly at the other side of the problem. Would help for convicts be more useful if it were completely voluntary? There is a belief

held by many, especially experts in the social service fields, that lower-class, emotionally disturbed, "deviant" or "criminal" persons most often are not aware of their real problems and will not seek services that can help them. We disagree totally with this proposition. In the first place, help must be defined from the viewpoint of the person in need, and in the second place, the reason a person in need turns his back on help is, by and large, that the services offered are shabby substitutes for help. When real services are available, those in need literally line up at the door.

We cannot stress too strongly the necessity that help be voluntary and be truly accessible to all elements of the population. After all, the needs of the defendant or prisoner are not unique. Because of stigmatization he may have special difficulties in securing a job. Because of long imprisonment he may have difficulties reentering society. But by and large the needs of the defendant and the prisoner are the same as those of most people. He or she has the need of good pay, meaningful work, leisure time and the resources to enjoy it, and perhaps counseling on special personal, vocational, or family problems. Beyond this, what is offered the defendant or prisoner, out of our sense of justice, should not be unavailable to other segments of the population. To do otherwise would encourage law violations as a way of seeking help. It would be yet another instance of the discriminatory distribution of available services.

The range of voluntary services that could be made available either to defendants or prisoners is endless. To substitute real helping services for the puny, the ineffective, or the somewhat harmful services that exist for both free persons in need and prisoners will require a major investment of public resources. As we stressed in our opening chapters, however, the prerequisite to an equitable criminal justice system is social justice, and social justice will be predicated upon a more equitable distribution of the goods and services in society.

An example of some of the concrete services that should be considered are such things as crisis centers for free persons, where counseling, job training, temporary housing, emergency funds, and temporary retreat could be sought. During imprisonment, education, vocational training, salaries for work performed, and a variety of counseling services are minimum items that could be offered.

We find it important that such services be voluntary not only on the part of those receiving aid, but also from the standpoint of those offering the services. Voluntary groups sometimes have the flexibility to meet human needs in ways that can only be approximated by institutionalized agencies. The freshness and compassion of a volunteer with only a few hours of training often outweighs the expertise of professionals.

In social service agencies, especially those run by government, bureaucracy and red tape tend to pyramid. Human concern tends to be replaced by a detachment that grows eventually into contempt for those the agency is intended to serve. This is as destructive to those offering the supposed

help as it is to those receiving it. Witness the coldness and inefficiency of most big-city welfare departments and medical clinics.

NOTES

1. *Salmond on Jurisprudence,* 11th ed. (1957), pp. 120–121.
2. *The Common Law* (1881), p. 36.
3. Edmund Cahn, *The Sense of Injustice* (Bloomington: University of Indiana Press, 1964), p. 113.
4. Zebulon R. Brockway, *Fifty Years of Prison Service* (New York: 1912; reprinted, Montclair, New Jersey: Patterson Smith, 1969).
5. "Correctional Systems and National Values," *British Journal of Criminology* (October 1962).
6. Malcolm Braly, *On the Yard* (Boston: Little, Brown and Co., 1967), pp. 103–104.
7. David A. Ward and Gene G. Kassebaum, *Women's Prison* (Chicago: Aldine, 1965).
8. "Psychiatry in Prison," *Psychiatry* (1951).
9. Donald Cressey, "Limitations on Organization of Treatment in the Modern Prison," and Lloyd Ohlin, "Conflicting Interests in Correctional Objectives," in *Theoretical Studies in Social Organization in the Prison* (pamphlet, Social Science Research Council, March 1960).

21: Reaffirming Some Traditional Standards / *James Q. Wilson**

I believe that our society has not done as well as it could have in controlling crime because of erroneous but persistent views about the nature of man and the capacities of his institutions. But I do not believe that, were we to have taken a correct view and as a consequence adopted the most feasible policies, crime would have been eliminated, or even dramatically reduced. Those who argue that we can eliminate crime if only we have the "will" to do so, whether by ending poverty (as the Left argues) or by putting more police on the street and more gallows in our jails (as the Right believes), seriously mistake what we are capable of under even the best of circumstances, and place the blame for our failings precisely where it should not be—on our will power, and by implication on our governing morality.

* James Q. Wilson, *Thinking About Crime* (New York: Basic Books, 1975), pp. 198–209. Reprinted by permission.

I argue for a sober view of man and his institutions that would permit reasonable things to be accomplished, foolish things abandoned, and utopian things forgotten. A sober view of man requires a modest definition of progress. A 20 percent reduction in robbery would still leave us with the highest robbery rate of almost any Western nation but would prevent about 60,000 robberies. A small gain for society, a large one for the would-be victims. Yet a 20 percent reduction is unlikely if we concentrate our efforts on dealing with the causes of crime or even if we concentrate on improving police efficiency. Were we to devote those resources to a strategy that is well within our abilities—namely, to incapacitating a larger fraction of the convicted serious robbers—then not only is 20 percent reduction possible, but even larger ones are conceivable.

Most serious crime is committed by repeaters. What we do with first offenders is probably far less important than what we do with habitual offenders. A genuine first offender (and not merely a habitual offender caught for the first time) is in all likelihood a young person who, in the majority of cases, will stop stealing when he gets older. This is not to say we should forgive first offenses, for that would be to license the offense and erode the moral judgments that must underlie any society's attitude toward crime. The gravity of the offense must be appropriately impressed on the first offender, but the effort to devise ways of reeducating or uplifting him in order to insure that he does not steal again is likely to be wasted—both because we do not know how to reeducate or uplift and because most young delinquents seem to reeducate themselves no matter what society does.

After tracing the history of nearly 10,000 Philadelphia boys born in 1945, Marvin Wolfgang and his colleagues at the University of Pennsylvania found that over one-third were picked up by the police for something more serious than a traffic offense, but that 46 percent of these delinquents had no further police contact after their first offense. Though a third started on crime, nearly half seemed to stop spontaneously—a good thing, because the criminal justice stystem in that city, already sorely taxed, would in all likelihood have collapsed. Out of the 10,000 boys, however, there were 627—only 6 percent—who committed five or more offenses before they were eighteen. Yet these few chronic offenders accounted for *over half* of all the recorded delinquencies and about *two-thirds* of all the violent crimes committed by the entire cohort.[1]

Only a tiny fraction of all serious crimes lead immediately to an arrest, and only a slightly larger fraction are ultimately "cleared" by an arrest, but this does not mean that the police function is meaningless. Because most serious crime is committed by repeaters, most criminals eventually get arrested. The Wolfgang findings and other studies suggest that the chances of a persistent burglar or robber living out his life, or even going a year, with no arrest are quite small. Yet a large proportion of repeat offenders suffer little or no loss of freedom. Whether or not one believes that such penal-

ties, if inflicted, would act as a deterrent, it is obvious that they could serve to incapacitate these offenders and thus, for the period of the incapacitation, prevent them from committing additional crimes.

We have a limited (and declining) supply of detention facilities, and many of those that exist are decrepit, unsafe, and overcrowded. But as important as expanding the supply and improving the decency of the facilities is the need to think seriously about how we wish to allocate those spaces that exist. At present, that allocation is hit or miss. A 1966 survey of over fifteen juvenile correctional institutions revealed that about 30 percent of the inmates were young persons who had been committed for conduct that would not have been judged criminal were it committed by adults. They were runaways, "stubborn children," or chronic truants—problem children, to be sure, but scarcely major threats to society.[2] Using scarce detention space for them when in Los Angeles over 90 percent of burglars with a major prior record receive no state prison sentence seems, to put it mildly, anomalous.

Shlomo and Reuel Shinnar have estimated the effect on crime rates in New York State of a judicial policy other than that followed during the last decade or so. Given the present level of police efficiency and making some assumptions about how many crimes each offender commits per year, they conclude that the rate of serious crime would be only *one-third* what it is today if every person convicted of a serious offense were imprisoned for three years. This reduction would be less if it turned out (as seems unlikely) that most serious crime is committed by first-time offenders, and it would be much greater if the proportion of crimes resulting in an arrest and conviction were increased (as also seems unlikely). The reduction, it should be noted, would be solely the result of incapacitation, making no allowance for such additional reductions as might result from enhanced deterrence or rehabilitation.[3]

The Shinnar estimates are based on uncertain data and involve assumptions that can be challenged. But even assuming they are overly optimistic by a factor of two, a sizable reduction in crime would still ensue. In other countries such a policy of greater incapacitation is in fact followed. A robber arrested in England, for example, is more than three times as likely as one arrested in New York to go to prison. That difference in sentencing does not account for all the difference between English and American crime rates, but it may well account for a substantial fraction of it.

That these gains are possible does not mean that society should adopt such a policy. One would first want to know the costs, in additional prison space and judicial resources of greater use of incapacitation. One would want to debate the propriety and humanity of a mandatory three-year term; perhaps, in order to accommodate differences in the character of criminals and their crimes, one would want to have a range of sentences from, say, one to five years. One would want to know what is likely to happen to the process of charging and pleading if every person arrested for a serious

crime faced a mandatory minimum sentence, however mild. These and other difficult and important questions must first be confronted. But the central fact is that *these are reasonable questions* around which facts can be gathered and intelligent arguments mustered. To discuss them requires us to make few optimistic assumptions about the malleability of human nature, the skills of officials who operate complex institutions, or the capacity of society to improve the fundamental aspects of familial and communal life.

Persons who criticize an emphasis on changing the police and courts to cope with crime are fond of saying that such measures cannot work so long as unemployment and poverty exist. We must acknowledge that we have not done very well at inducting young persons, especially but not only blacks, into the work force. Teenage unemployment rates continue to exceed 20 percent; though the rate of growth in the youthful component of the population has slowed, their unemployment shows little sign of abating. To a degree, anticrime policies may be frustrated by the failure of employment policies, but it would be equally correct to say that so long as the criminal justice system does not impede crime, efforts to reduce unemployment will not work. If legitimate opportunities for work are unavailable, many young persons will turn to crime; but if criminal opportunities are profitable, many young persons will not take those legitimate jobs that exist. The benefits of work and the costs of crime must be increased simultaneously; to increase one but not the other makes sense only if one assumes that young people are irrational.

One rejoinder to this view is the argument that if legitimate jobs are made absolutely more attractive than stealing, stealing will decline even without any increase in penalties for it. That may be true provided there is no practical limit on the amount that can be paid in wages. Since the average "take" from a burglary or mugging is quite small, it would seem easy to make the income from a job exceed the income from crime. But this neglects the advantages of a criminal income: One works at crime at one's convenience, enjoys the esteem of colleagues who think a "straight" job is stupid and skill at stealing is commendable, looks forward to the occasional "big score" that may make further work unnecessary for weeks, and relishes the risk and adventure associated with theft. The money value of all these benefits—that is, what one who is not shocked by crime would want in cash to forgo crime—is hard to estimate, but is almost certainly far larger than what either public or private employers could offer to unskilled or semiskilled young workers. The only alternative for society is to so increase the risks of theft that its value is depreciated below what society can afford to pay in legal wages, and then take whatever steps are necessary to insure that those legal wages are available.

Another rejoinder to the "attack poverty" approach to crime is this: The desire to reduce crime is the worst possible reason for reducing poverty. Most poor persons are not criminals; many are either retired or have regu-

lar jobs and lead conventional family lives. The elderly, the working poor, and the willing-to-work poor could benefit greatly from economic conditions and government programs that enhance their incomes without there being the slightest reduction in crime—indeed, if the experience of the 1960s is any guide, there might well be, through no fault of most beneficiaries, an increase in crime. Reducing poverty and breaking up the ghettos are desirable policies in their own right, whatever their effects on crime. It is the duty of government to devise other measures to cope with crime, not only to permit antipoverty programs to succeed without unfair competition from criminal opportunities, but also to insure that such programs do not inadvertently shift the costs of progress, in terms of higher crime rates, onto innocent parties, not the least of whom are the poor themselves.

One cannot press this economic reasoning too far. Some persons will commit crimes whatever the risks; indeed, for some, the greater the risk the greater the thrill, while others—the alcoholic wife beater, for example—are only dimly aware that there are any risks. But more important than the insensitivity of certain criminal activities to changes in risks and benefits is the impropriety of casting the crime problem wholly in terms of a utilitarian calculus. The most serious offenses are crimes not simply because society finds them inconvenient, but because it regards them with moral horror. To steal, to rape, to rob, to assault—these acts are destructive of the very possibility of society and affronts to the humanity of their victims. It is my experience that parents do not instruct their children to be law abiding merely by pointing to the risks of being caught, but by explaining that these acts are wrong whether or not one is caught. I conjecture that those parents who simply warn their offspring about the risks of crime produce a disproportionate number of young persons willing to take those risks.

Even the deterrent capacity of the criminal justice system depends in no small part on its ability to evoke sentiments of shame in the accused. If all it evoked were a sense of being unlucky, crime rates would be even higher. James Fitzjames Stephens makes the point by analogy. To what extent, he asks, would a man be deterred from theft by the knowledge that by committing it he was exposing himself to one chance in fifty of catching a serious but not fatal illness—say, a bad fever? Rather little, we would imagine—indeed, all of us regularly take risks as great or greater than that: when we drive after drinking, when we smoke cigarettes, when we go hunting in the woods. The criminal sanction, Stephens concludes, "operates not only on the fears of criminals, but upon the habitual sentiments of those who are not criminals. [A] great part of the general detestation of crime . . . arises from the fact that the commission of offenses is associated . . . with the solemn and deliberate infliction of punishment wherever crime is proved." [4]

Much is made today of the fact that the criminal justice system "stigmatizes" those caught up in it, and thus unfairly marks such persons and

perhaps even furthers their criminal careers by having "labeled" them as criminals. Whether the labeling process operates in this way is as yet unproved, but it would indeed be unfortunate if society treated a convicted offender in such a way that he had no reasonable alternative but to make crime a career. To prevent this, society ought to insure that one can "pay one's debt" without suffering permanent loss of civil rights, the continuing and pointless indignity of parole supervision, and frustration in being unable to find a job. But doing these things is very different from eliminating the "stigma" from crime. To destigmatize crime would be to lift from it the weight of moral judgment and to make crime simply a particular occupation or avocation which society has chosen to reward less (or perhaps more!) than other pursuits. If there is no stigma attached to an activity, then society has no business making it a crime. Indeed, before the invention of the prison in the late eighteenth and early nineteenth centuries, the stigma attached to criminals was the major deterrent to and principal form of protection from criminal activity. The purpose of the criminal justice system is not to expose would-be criminals to a lottery in which they either win or lose, but to expose them in addition and more importantly to the solemn condemnation of the community should they yield to temptation.

Anyone familiar with the police stations, jails, and courts of some of our larger cities is keenly aware that accused persons caught up in the system are exposed to very little that involves either judgment or solemnity. They are instead processed through a bureaucratic maze in which a bargain is offered and a haggle ensues at every turn—over amount of bail, degree of the charged offense, and the nature of the plea. Much of what observers find objectionable about this process could be alleviated by devoting many more resources to it, so that an ample supply of prosecutors, defense attorneys, and judges were available. That we do not devote those additional resources in a country obsessed with the crime problem is one of the more interesting illustrations of the maxim, familiar to all political scientists, that one cannot predict public policy simply from knowing popular attitudes. Whatever the cause, it remains the case that in New York County (Manhattan) there were in 1973, 31,098 felony arrests to be handled by only 125 prosecutors, 119 public defenders and 59 criminal court judges. The result was predictable: of those arrested, only 4,130 pleaded guilty to or were convicted on a felony charge.

One wonders whether the stigma properly associated with crime retains much deterrent or educative value. My strong inclination is to resist explanations for rising crime that are based on the alleged moral breakdown of society, the community, or the family. I resist in part because most of the families and communities I know have not broken down, and in part because, had they broken down, I cannot imagine any collective action we could take consistent with our civil liberties that would restore a moral consensus, and yet the facts are hard to ignore. Take the family: Over one-third of all black children and one in fourteen of all white children live in

single-parent families. Over 2 million children live in single-parent (usually father absent) households, almost *double* the number of ten years ago. In 1950, 18 percent of black families were female-headed; in 1969 the proportion had risen to 27 percent; by 1973 it exceeded 35 percent. The average income for a single-parent family with children under six years of age was, in 1970, only $3,100, well below the official "poverty line." [5]

Studies done in the late 1950s and the early 1960s showed that children from broken homes were more likely than others to become delinquent. In New York State, 58 percent of the variation in pupil achievement in 300 schools could be predicted by but three variables—broken homes, overcrowded housing, and parental educational level. Family disorganization, writes Urie Bronfenbrenner, has been shown in thousands of studies to be an "omnipresent overriding factor" in behavior disorders and social pathology. And that disorganization is increasing.[6]

These facts may explain some elements of the rising crime rate that cannot be attributed to the increased number of young persons, high teenage unemployment, or changed judicial policies. The age of persons arrested has been declining for more than fifteen years and the median age of convicted defendants (in jurisdictions for which data are available) has been declining for the last six years.[7] Apparently, the age at which persons begin to commit serious crime has been falling. For some young people, thus, whatever forces weaken their resistance to criminal activity have been increasing in magnitude, and these forces may well include the continued disorganization of the family and the continued deterioration of the social structure of inner city communities.

One wants to be objective, if not optimistic. Perhaps single-parent families today are less disorganized or have a different significance than such families in the past. Perhaps the relationship between family structure and social pathology will change. After all, there now seem to be good grounds for believing that, at least on the East coast, the heroin epidemic of the 1960s has run its course; though there are still thousands of addicts, the rate of formation of new addicts has slowed and the rate of heroin use by older addicts has dropped. Perhaps other aspects of the relationship among family, personality, and crime will change. Perhaps.

No one can say how much of crime results from its increased profitability and how much from its decreased shamefulness. But one or both factors must be at work, for population changes alone simply cannot account for the increases. Crime in our cities has increased far faster than the number of young people, or poor people, or black people, or just plain people who live in those cities. In short, objective conditions alone, whether demographic or economic, cannot account for the crime increases, though they no doubt contributed to it. Subjective forces—ideas, attitudes, values—played a great part, though in ways hard to define and impossible to measure. An assessment of the effect of these changes on crime would provide a partial understanding of changes in the moral structure of our society.

But to understand is not to change. If few of the demographic factors contributing to crime are subject to planned change, virtually none of the subjective ones are. Though intellectually rewarding, from a practical point of view it is a mistake to think about crime in terms of its "causes" and then to search for ways to alleviate those causes. We must think instead of what it is feasible for a government or a community to do, and then try to discover, by experimentation and observation, which of those things will produce, at acceptable costs, desirable changes in the level of criminal victimization.

There are, we now know, certain things we can change in accordance with our intentions, and certain ones we cannot. We cannot alter the number of juveniles who first experiment with minor crimes. We cannot lower the recidivism rate, though within reason we should keep trying. We are not yet certain whether we can increase significantly the police apprehension rate. We may be able to change the teenage unemployment rate, though we have learned by painful trial and error that doing this is much more difficult than once supposed. We can probably reduce the time it takes to bring an arrested person to trial, even though we have as yet made few serious efforts to do so. We can certainly reduce the arbitrary and socially irrational exercise of prosecutorial discretion over whom to charge and whom to release, and we can most definitely stop pretending that judges know, any better than the rest of us, how to provide "individualized justice." We can confine a larger proportion of the serious and repeat offenders and fewer of the common drunks and truant children. We know that confining criminals prevents them from harming society, and we have grounds for suspecting that some would-be criminals can be deterred by the confinement of others.

Above all, we can try to learn more about what works, and in the process abandon our ideological preconceptions about what *ought* to work. In 1968 I wrote that the billions of dollars the federal government was then preparing to spend on crime control would be wasted, and indeed might even make matters worse if they were merely pumped into the existing criminal justice system.[8] They were, and they have. In the next ten years I hope we can learn to experiment rather than simply spend, to test our theories rather than fund our fears. This is advice, not simply or even primarily to government—for governments are run by men and women who are under irresistible pressures to pretend they know more than they do—but to my colleagues: academics, theoreticians, writers, advisers. We may feel ourselves under pressure to pretend we know things, but we are also under a positive obligation to admit what we do not know and to avoid cant and sloganizing. The government agency, the Law Enforcement Assistance Administration, that has futilely spent those billions was created in consequence of an act passed by Congress on the advice of a presidential commission staffed by academics, myself included.

It is easy and popular to criticize yesterday's empty hopes and mistaken beliefs, especially if they seemed supportive of law enforcement. It is harder, and certainly most unpopular, to criticize today's pieties and pretensions, especially if they are uttered in the name of progress and humanity. But if we were wrong in thinking that more money spent on the police would bring down crime rates, we are equally wrong in supposing that closing our prisons, emptying our jails, and supporting "community-based" programs will do any better. Indeed, there is some evidence that these steps will make matters worse, and we ignore it at our peril.

Since the days of the crime commission we have learned a great deal, more than we are prepared to admit.[9] Perhaps we fear to admit it because of a newfound modesty about the foundations of our knowledge, but perhaps also because the implications of that knowledge suggest an unflattering view of man. Intellectuals, although they often dislike the common person as an individual, do not wish to be caught saying uncomplimentary things about humankind. Nevertheless, some persons will shun crime even if we do nothing to deter them, while others will seek it out even if we do everything to reform them. Wicked people exist. Nothing avails except to set them apart from innocent people. And many people, neither wicked nor innocent, but watchful, dissembling, and calculating of their opportunities, ponder our reaction to wickedness as a cue to what they might profitably do. We have trifled with the wicked, made sport of the innocent, and encouraged the calculators. Justice suffers, and so do we all.

NOTES

1. Marvin E. Wolfgang, "Crime in a Birth Cohort," in *The Aldine Crime and Justice Annual, 1973*, ed. Sheldon L. Messinger (Chicago: Aldine, 1973), pp. 110–112.

2. Shlomo and Reuel Shinnar, "A Simplified Model for Estimating the Effects of the Criminal Justice System on the Control of Crime," School of Engineering, The City College of New York, 1974. Unpublished.

3. William H. Sheridan, "Juveniles Who Commit Non-Criminal Acts," *Federal Probation* 31 (1967): 26–30, and Edwin M. Lemert, *Instead of Court* (Rockville, Md.: Center for Studies in Crime and Delinquency, National Institute of Mental Health, 1971), pp. 13–14.

4. James Fitzjames Stephens, *A History of the Criminal Law of England* (New York: Burt Franklin, 1973), vol. 2, pp. 80–81 (first published in 1883).

5. Urie Bronfenbrenner, "The Origins of Alienation," *Scientific American* 231 (August 1974): 53. See also Thomas P. Monahan, "Family Status and the Delinquent Child," *Social Forces* 35 (1957): 250–258.

6. Bronfenbrenner, "Origins of Alienation," p. 56.

7. Charles F. Wellford, "Age Composition and the Increase in Recorded Crime," *Criminology* 11 (1973): 61–70, and Benjamin Avi-Itzhak and Reuel Shinnar, "Quantitative Models in Crime Control," *Journal of Criminal Justice* 1 (1973): 196–197.

8. James Q. Wilson, "Crime and Law Enforcement," in *Agenda for the Nation*, ed. Kermit Gordon (Washington, D.C.: Brookings Institution, 1968), pp. 198–201.

9. Note, for example, the remarks of Deputy Attorney General Lawrence Silberman urging that all LEAA projects be subject to careful evaulation (*LEAA Newsletter*, August-September 1974).

22: The Principle of Commensurate Deserts /
*Andrew von Hirsch**

If one asks how severely a wrongdoer deserves to be punished, a familiar principle comes to mind: *Severity of punishment should be commensurate with the seriousness of the wrong.* Only grave wrongs merit severe penalties; minor misdeeds deserve lenient punishments. Disproportionate penalties are undeserved—severe sanctions for minor wrongs or vice versa. This principle has variously been called a principle of "proportionality" or "just deserts;" we prefer to call it *commensurate deserts,* a phrase that better suggests the concepts involved. In the most obvious cases, the principle seems a truism (who would wish to imprison shoplifters for life, or let murderers off with small fines?). Yet, whether and how it should be applied in allocating punishments has been in dispute.

In an earlier era, the principle of commensurate deserts had a firmly established place in criminal jurisprudence. Cesare Beccaria's *Of Crimes and Punishments,* written in 1764, gives it much emphasis.[1] Punishments, he stated, should be carefully graded to correspond with the gravity of offenses. To Beccaria and his followers,[2] the principle was grounded on common-sense notions of fairness—and on utilitarian considerations as well: if penalties were not scaled commensurately with offenses, criminals, it was feared, would as soon commit grave crimes as minor ones. Criminal codes of the era—such as the French Code of 1791 [3] and the Bavarian Code of 1813 [4]—reflected this conception. The framers of the original New Hampshire Constitution considered the principle so central to a fair and workable system of criminal justice that they embodied it in the state's Bill of Rights.† [5]

* Reprinted with the permission of Farrar, Straus & Giroux, Inc. from *Doing Justice: The Choice of Punishments* by Andrew von Hirsch, copyright © 1976 by Andrew von Hirsch.

† The 1783 New Hampshire Constitution provides: "All penalties ought to be proportioned to the nature of the offense. No wise legislator will affix the same punishment to the crimes of theft, forgery, and the like, which they do to those of murder and treason. When the same undistinguishing severity is exerted against all offenses, the people are led to forget the real distinction in the crimes themselves, and to commit the most flagrant with as little compunction as they do those of the lightest dye." Several other states included similar provisions in their constitutions.

Yet, with the rise of the rehabilitative ideology in the nineteenth century, the principle of commensurate deserts went into eclipse.[6]

One school of thought dismissed the principle entirely. Desert was seen as relevant only before conviction—when it was being decided whether the violator had acted with the requisite degree of culpability to be held criminally liable. After conviction, the seriousness of his offense was not to be considered at all; his punishment was instead to be determined by his need for treatment and his likelihood of returning to crime. The Model Sentencing Act (in both its 1963 and its 1972 versions) takes this view.[7] The act does not provide scaled maximum penalties for different categories of offenses. Instead, it gives the judge discretion to impose up to a five-year sentence on an offender convicted of any felony: within this limit, irrespective of the character of the offense, the judge is supposed to fix a sentence on the basis of the risk the offender poses to society.

Others have not been quite so uncompromising, conceding a residual significance to the seriousness of the offense. Most criminal codes provide maximum penalties for different offenses, ranked according to some approximate scale of gravity. But these legislative maxima are set so much higher than the sentences ordinarily expected that they have not much influence on actual dispositions.* [8] The American Law Institute's Model Penal Code recommends also that the judge should not set the sentence so low as to "depreciate the seriousness of the offense;" [9] the code fails, however, to clarify how much weight should be given this factor of "depreciating the seriousness" as contrasted with other possible goals of sentencing. Although H. L. A. Hart comments briefly in his "Prolegomenon" on how the principle serves as a constraint of fairness,[10] his thoughts on this subject (unlike so much else in his influential essay) did not stimulate much further interest. The justification for the principle; the weight to be assigned it as contrasted with other possible aims of punishing; the meaning of "seriousness;" and the relevance of the principle to the knotty question of sentencing discretion—all these have remained largely unexplored until quite recently.[11]

The principle looks retrospectively to the seriousness of the offender's past crime or crimes. "Seriousness" depends both on the harm done (or risked) by the act and on the degree of the actor's culpability. (When we speak of the seriousness of "the crime," we wish to stress that we are *not* looking exclusively to the act, but also to how much the actor can be held to blame for the act and its consequences.) If the offender had a prior criminal record at the time of conviction, the number and gravity of those prior crimes should be taken into account in assessing seriousness. (The

* A few courts have invalidated penal statutes authorizing the imposition of extraordinarily harsh penalties for minor offenses; see, e.g., the California Supreme Court's 1972 decision in *In re Lynch*, invalidating as "cruel or unusual" punishment a penalty of up to life imprisonment for the crime of indecent exposure.

meaning of "seriousness" and the significance of a prior criminal record will be explored more fully later.)

The principle of commensurate deserts, in our opinion, is a requirement of justice; * [12] thus:

1. The principle has its counterpart in common-sense notions of equity which people apply in their everyday lives. Sanctions disproportionate to the wrong are seen as manifestly unfair—whether it be an employee being fired for a minor rule infraction to make an example of him, or a school inflicting unequal punishments on two children for the same misdeed.

2. The principle ensures, as no utilitarian criterion of allocation can, that the rights of the person punished not be unduly sacrificed for the good of others. When speaking earlier of the general justification of punishment, we argued that the social benefits of punishing do not alone justify depriving the convicted offender of his rights: it is also necessary that the deprivation be deserved. A similar argument holds for allocation. When the offender is punished commensurately with his offense, the state is entitled to sacrifice his rights to that degree because that is what he deserves. A utilitarian theory of allocation (one based on deterrence, for instance) could lead to punishing the offender more severely than he deserves if the net benefits of so doing were to outweigh the costs. The excess in severity may be useful for society, but that alone should not justify the added intrusion into the rights of the person punished.† [13]

3. The principle ensures that offenders are not treated as more (or less) blameworthy than is warranted by the character of the offense. Punishment, as we noted earlier, imparts blame. A criminal penalty is not merely unpleasant (so are taxes and conscription): it also connotes that the of-

* There also are utilitarian arguments for the principle (e.g., Bentham's argument that penalties should be proportioned so as "to induce a man to choose always the least mischievous of two offences"). But were utilitarian arguments the only basis for the principle, it could be disregarded in those classes of cases where there would be still greater social benefits in so doing. We want to argue that departures from the principle—even when they would serve utilitarian ends—inevitably sacrifice justice.

† H. L. A. Hart has argued that even were one to take a wholly utilitarian view of the general justification of punishment (e.g., that punishment exists to deter), one *still* would be obliged as a matter of fairness to observe a proportion between the seriousness of the offense and the severity of the punishment. His words are worth quoting.

"The further principle that different kinds of offence of different gravity (however that is assessed) should not be punished with equal severity is one which like other principles of Distribution may qualify the pursuit of our General Aim and is not deducible from it. Long sentences of imprisonment might effectually stamp out car parking offences, yet we think it wrong to employ them; *not* because there is for each crime a penalty "naturally" fitted to its degree of iniquity (as some Retributionists in General Aim might think); not because we are convinced that the misery caused by such sentences (which might indeed be slight because they would rarely need to be applied) would be greater than that caused by the offences unchecked (as a Utilitarian might argue). The guiding principle is that of a proportion within a system of penalties between those imposed for different offences where these have a distinct place in a commonsense scale of gravity."

Our argument differs somewhat from Hart's because we suggest that desert is also essential to the general justification. On our view, it follows *a fortiori* that desert should also govern the distribution of penalties.

fender acted wrongfully and is reprehensible for having done so.* The offender, in other words, is being treated *as though he deserves* the unpleasantness that is being inflicted on him. That being the case, it should be inflicted only to the degree that it is deserved.

Where standards of criminal liability are concerned, this is a familiar point—for Henry M. Hart made it nearly two decades ago in his defense of the criminal law's *mens rea* requirements.[14] Since punishment characteristically ascribes blame, he contended, accidental violations should not be punished—because they are not blameworthy.

What is often overlooked, however, is that the same holds true after conviction. By then, it has been decided that the offender deserves punishment—but the question *how much* he deserves remains. The severity of the penalty carries implications of degree of reprobation. The sterner the punishment, the greater the implicit blame: sending someone away for several years connotes that he is more to be condemned than does jailing him for a few months or putting him on probation. In the allocation of penalties, therefore, the crime should be sufficiently serious to merit the implicit reprobation. The principle of commensurate deserts ensures this. If the principle is not observed, the degree of reprobation becomes inappropriate. Where an offender convicted of a minor offense is punished severely, the blame which so drastic a penalty ordinarily carries will attach to him—and unjustly so, in view of the not-so-very wrongful character of the offense. (This last argument, it should be noted, does not presuppose the general justification of punishment which we urged earlier. Whatever the ultimate aim of the criminal sanction—even if one were to defend its existence on purely utilitarian grounds— punishment still *in fact* ascribes blame to the person. Hence the severity of the penalty—connoting as it does the degree of blame ascribed—ought to comport with the gravity of the infraction.) † [15]

* The unpleasantness of punishment and its reprobative connotations are inextricably mixed. Being severely punished—sent to prison, for example—signifies a high degree of blame; but being imprisoned is painful not only because one is being deprived of one's freedom of movement but because one is being so deprived as a symbol of obloquy.

The reprobative connotations of punishment stem, essentially, from the context in which it is imposed—from the fact that it is inflicted mainly on persons who have intentionally done forbidden acts (acts that in most instances also strongly offend the society's moral norms). As long as that is the occasion for punishment, reprobation would be present even if the authorities were to try to label the disposition "preventive" or "therapeutic."

† This argument would not apply, admittedly, to a ritual so different from punishment that the reprobative overtones were largely absent. An example might be a purely preventive system that isolated "dangerous" persons regardless of whether any prohibited act was found to have been committed. But such a system would be open to other kinds of objections. Many of those confined would be false positives. Worse still, an individual would have no assurance that he can remain at liberty as long as he takes care to comply with the rules; his continued freedom "would depend not upon his voluntary acts, but upon his *propensities* for future conduct as they are seen by the state . . . his liberty would depend upon predictive determinations which he would have little ability to foretell, let alone alter by his own choices" (emphasis in original).

Equity is sacrificed when the principle is disregarded, even when done for the sake of crime prevention. Suppose there are two kinds of offenses, A and B, that are of approximately equal seriousness; but that offense B can more effectively be deterred through the use of a severe penalty. Notwithstanding the deterrent utility of punishing offense B more severely, the objection remains that the perpetrators of that offense are being treated as though they are more blameworthy than the perpetrators of offense A—and that is not so if the crimes are of equivalent gravity.

It is sometimes suggested that the principle of commensurate deserts sets only an upper limit on severity—*no more* than so much punishment.[16] We disagree. Imposing only a slight penalty for a serious offense treats the offender as *less* blameworthy than he deserves. Understating the blame depreciates the values that are involved: disproportionately lenient punishment for murder implies that human life—the victim's life—is not worthy of much concern; excessively mild penalties for official corruption denigrate the importance of an equitable political process. The commensurateness principle, in our view, bars disproportionate leniency as well as disproportionate severity.* [17]

Norval Morris has suggested that the principle sets only broad upper and lower limits [18]—and that, within those limits, the sentence should be determined on utilitarian grounds (e.g., deterrence). Again, we do not agree. Concededly, it is easier to discern gross excess in lenience or severity than to decide on a specific proportion between a crime and its punishment. But, as we have seen, the principle is infringed when disparate penalties are imposed on equally deserving offenders. If A and B commit a burglary under circumstances suggesting similar culpability, they deserve similar punishments; imposing unequal sanctions on them for utilitarian ends—even within the outer bounds of proportionality Morris proposes—still unjustly treats one as though he were more to blame than the other. Our view of the principle as requiring equal treatment for the equally deserving has important implications for the structure of a penalty system, as we will see.

It has also been objected (by the drafters of the Model Sentencing Act, for instance) [19] that applying the principle in sentencing decisions would aggravate disparities, given judges' divergent views of the seriousness of offenses. But that holds true only if, as in current practice, the assessment of seriousness is left to the discretion of the individual judge. The principle has to be consistently applied; and consistent application requires (as we will elaborate later) the articulation of standards and the placing of limits on individual decision-makers' discretion.

* If the concern is not to allow the punishment to become so lenient as to depreciate the blameworthiness of the conduct, the penalty scale could still be kept to modest dimensions. It would not be necessary, for example, to inflict as much suffering on the offender as he did on the victim ("an eye for an eye"), as the penalty would merely have to impart blame enough to express a sense of the gravity of the crime.

The commensurate-deserts principle may sometimes conflict with other objectives: for example, if an offense is not serious but can better be deterred by a severe penalty, commensurate deserts and deterrence may suggest divergent sentences. To deal with such conflicts, it becomes necessary to decide what priority should be given the principle.

We think that the commensurate-deserts principle should have priority over other objectives in decisions about how much to punish. The disposition of convicted offenders should be commensurate with the seriousness of their offenses, even if greater or less severity would promote other goals. For the principle, we have argued, is a requirement of justice, whereas deterrence, incapacitation, and rehabilitation are essentially strategies for controlling crime. The priority of the principle follows from the assumption we stated at the outset: the requirements of justice ought to constrain the pursuit of crime prevention.

In giving the principle this priority, we need not claim the priority to be absolute: perhaps there are some unusual cases where it will be necessary to vary from the deserved sentence. But the principle derives its force from the fact that it applies *unless* special reasons for departing from it are shown: the burden rests on him who would deviate from the commensurate sentence.

Giving commensurate deserts this prominence will have practical usefulness in sorting out decisions about punishment. An often-repeated theme in the literature has been that the offender's disposition should be decided by "balancing" the different aims of punishment: the diverse considerations—rehabilitation, predictive restraint, deterrence, possibly desert as well—are to be weighed against each other, to yield an optimum penalty in the offender's particular case.[20] When the different objectives are in conflict, however, saying they should be "balanced" against each other does not offer a principled way of resolving the issue. One escapes this difficulty by giving the commensurate-deserts principle *prima facie* controlling effect. No longer would it be necessary to weigh these conflicting objectives in each case. Rather, the disposition would be presumed to be—unless there are overriding grounds for deciding otherwise—the one which satisfies the principle of commensurate deserts. Instead of juggling competing rationales to reach a decision, one has a workable starting point.

Seriousness of Crimes

Having argued that the severity of the penalty should depend on the seriousness of the offense, we face the question: How should "seriousness" be judged?

With the rise of the rehabilitative ideology in the last century, the con-

cept of seriousness ceased to hold much interest—since the offender ostensibly was being treated, not punished as he deserved. Seriousness becomes a critical question, however, if the principle of commensurate deserts is given prominence.

Developing criteria for seriousness calls for a full study in itself. Here we shall only touch briefly upon some of the issues: our comments are meant to suggest that something *can* be said about seriousness—and that this inquiry is worth pursuing.

Legislatures have long been making judgments of seriousness in the maximum penalties they set. The prescribed maxima in criminal codes usually are scaled according to the legislature's sense of the gravity of the offenses involved, with murder and other heinous crimes carrying the greatest maximum penalties, and petty larcenies and other minor infractions the least. But these statutory limits are so seldom decisive in actual sentencing decisons * that drafters have had little need to consider questions of relative seriousness with much care.

Of greater interest are empirical studies that have been made of popular perceptions of the seriousness of offenses. The pioneering study was conducted in the 1960s by sociologists Thorsten Sellin and Marvin Wolfgang at the University of Pennsylvania.[21] They took a group of judges, college students, and policemen and asked them to rate the "seriousness" of various offenses on an eleven-point rating scale. The investigators found considerable agreement on the ranking of seriousness of crimes. The Sellin-Wolfgang findings were subsequently criticized on the grounds that their sample was unrepresentative;[22] but recently, the sociologist Peter Rossi obtained similar results with a more representative group.[23] Rossi showed those questioned a list of 140 offenses, described fairly specifically (e.g., "breaking and entering a house and stealing a radio"), and asked them to rate the "seriousness" of each offense from 1 to 9 in ascending order of gravity. A substantial degree of consensus was found in the ranking of crimes; and there was comparatively little variation in response among different racial, occupational, and educational subgroups. The researchers noted:

In asking the respondent to rate crimes, we did not specify what was "seriousness." Nor did we ask respondents what they meant by their ratings. Obviously, respondents imparted some meaning to the term, a meaning shared sufficiently by others to produce [this high] degree of consensus. . . .

[T]he norms defining how serious various criminal acts are considered to be, are quite widely distributed among blacks and whites, males and females, high and low socio-economic levels, and among levels of educational attainment.[24]

* Moreover, considerations other than seriousness enter, to an unknown degree, into the determination of statutory maxima. If the legislature sets the maximum prison term for selling narcotics above that for assault with a weapon, one often cannot tell whether that is because it regarded the narcotics offense as the more serious, or felt an exceptional punishment was necessary to deter such offenses, or wished simply to keep narcotics dealers off the streets longer.

Whatever the complexities in the concept of seriousness, such studies suggest that people from widely different walks of life can make commonsense judgments on the comparative gravity of offenses and come to fairly similar conclusions.

Analytically, seriousness has two major components: *harm* and *culpability*.

The seriousness of an offense depends, in the first instance, on how harmful the conduct is: that is, on the degree of injury caused or risked. (To cite an elementary example, armed robbery is more serious than a burglary, because the threatened harm is so much greater.)

An offense ought not be deemed serious unless the harm is grave. Among common victimizing crimes, for example, only those are serious which produce or threaten devastating consequences to the victim: inconvenience to the victim (even substantial inconvenience) should not be enough.

In assessing harmfulness, the emphasis should be on the harm *characteristically* done or risked by an offense of that kind. This emphasis on harm in the typical case is necessary, as we shall elaborate later, in order to control discretion and to assure that the severity of penalties is knowable in advance.

The other major component of seriousness is the degree of the offender's culpability: that is, the degree to which he may justly be held to blame for the consequences or risks of his act.* Here there is one well-established principle: that prohibited behavior causing (or risking) the same harm varies in seriousness depending on whether it is intentional, reckless, negligent, or punishable regardless of the actor's intent ("strict liability"); these distinctions usually are recognized in statutory definitions of crimes. But there are other factors bearing on the degree of culpability, such as (1) the extent to which the act was precipitated by the victim's own misconduct; and (2) whether (if the crime involved several persons) the defendant was a central or only a peripheral participant.

Culpability, in turn, affects the assessment of harm. In gauging seriousness, one should ordinarily look to the harm characteristically done or risked by the act of a *single* offender, rather than the totality of damage caused by behavior of that kind. (Shoplifting is a minor crime because the harm done by a single act of shoplifting is relatively trivial, although the total economic harm done by all acts of shoplifting may well be substan-

* Culpability, it should be noted, affects both questions of liability ("Should the person be punished at all?") and questions of allocation ("How severely should he be punished?"). Liability is the threshold question: whether the behavior involved sufficient culpability to be punishable at all. (In some jurisdictions, for example, the infliction of physical injury short of death is not punishable unless done intentionally or recklessly: negligence is not sufficient for criminal liability.) But once that threshold has been passed, the question of degree of culpability still has to be considered in deciding the seriousness of the offense. (It has to be decided, for example, how much more serious intentionally inflicted harm is than recklessly inflicted harm.)

tial.) This focus on the single act is based on notions of culpability: the individual may be held responsible for the risks or consequences of his own acts, but not for the cumulated damage done by others who happen to commit the same crime, since he has no control over their actions.*

There are a number of complications involved in the concepts of harm and culpability. One is: harm to what interests? Different crimes may not be readily comparable in harmfulness, because the interests affected are dissimilar.† Another question concerns risk of harm. How likely must the risk be? With respect to conduct that risks a given degree of harm, should it matter whether or not the injury actually occurs? Some issues concerning culpability will also prove troublesome—for instance, the question of the offender's motives. (Should it, for example, be a mitigating circumstance that the offender was motivated by a desire to help someone, or that he sincerely believed the law he violated to be wrong?) Finally, there is the matter of whose standards should govern. To what extent ought the governmental body charged with setting sentencing standards make its own assessments of seriousness? To what extent must it adhere to the community's perceptions of seriousness, as reflected in surveys such as Rossi's? ‡ (How this last question should be resolved would depend, in part, on one's theory of government—on how much one thinks officials should be permitted to rely on their own judgments rather than on popular preferences on particular issues.)

Yet, despite these complexities, we do not expect insuperable difficulties in developing a workable ranking of seriousness. Difficulty in grading of-

* Some conduct (e.g., an environmental offense such as littering) is prohibited primarily because of its aggregate effects, rather than because of the consequences of a single violation. But even here one should, in assessing the seriousness of a single violation, discount the aggregate harm in some approximate way to reflect the fact that *this* offender's contribution to the harm was minuscule.

† For instance: if someone steals a car, a valuable item of property is lost; if he breaks into a home and steals a TV set, the property loss is less but the occupant's privacy (and sense of physical security) is infringed. To determine which crime is the more serious, one therefore has to decide the relative importance of these interests. Commonsense judgments of seriousness appear to be guided by some informal sense of priorities of interests: most people would regard the burglary as more serious than the car theft and, if asked why, would say that a person's safety and privacy is more important than his belongings.

‡ Certainly, the criteria for seriousness will have to be distilled from the basic norms of conduct of this society. For the standard-setting agency is not deciding in a cultural vacuum: it is deciding seriousness for a system of penalties designed for this culture with its particular moral traditions. But the question remains: Must the criteria for seriousness reflect community attitudes *in detail?* If survey research shows that most people regard a particular offense as very serious, is the standard-setting agency obliged to reflect that view in classifying its gravity? Or may that agency question the popular view if, for example, it seems to be based on misconceptions about the amount of harm involved?

It is worth mentioning that this problem of whose standards is not unique to our theory of allocating penalties. Suppose, instead, that the state were to allocate penalties according to a theory of predictive restraint. It would then have to decide at what point the harm to be prevented becomes important enough to justify confining the individual—and that likewise raises the question: Important enough by whose standards?

fenses will occur mainly when making comparisons *across* major genera of crimes. (Familiar crimes such as burglary, robbery, and assault have enough in common to facilitate judging their comparative gravity; the problem arises when offenses are markedly dissimilar—e.g., how does bribery rank against burglary?) It also should be emphasized that we are speaking of only a few gradations of seriousness. While refined discriminations in relative gravity would undoubtedly be hard to make, it should be simpler to devise criteria capable of distinguishing, say, among five or six major degrees of seriousness. A small number of gradations may be all that is required in order to construct a workable penalty scale.

Arraying Penalties on a Scale

How should penalties be arrayed on a scale, and what should the overall dimensions of the scale be? Our rationale calls for the construction of a scale of modest dimensions. Penalties, like currency, can become inflated; and in this country, inflation has reached runaway proportions. A substantial deflation must be undertaken.

The internal structure of the scale—that is, the ranking of penalties relative to each other—should be governed by the principle of commensurate deserts. A presumptive sentence should be prescribed for each gradation of seriousness—with limited discretionary authority to raise or lower it for aggravating or mitigating circumstances. The scale should thus consist of an array of presumptive sentences, ranked in severity to correspond to the relative gravity of the offenses involved.

The weight given to prior offenses should *expressly* be built into the scale, with separate presumptive penalties set for first infractions and for repeated violations. Penalties for first offenses can then be scaled down substantially, for the reasons explained.

The scale should be two-dimensional. The dimensions should be: (1) the seriousness of the crime for which the offender currently stands convicted, and (2) the seriousness of his prior record. (The second factor is, in turn, composed of two variables: the number of his prior convictions and the seriousness of each. But a "seriousness of prior record" rating can readily be developed that combines both of these: the best "prior record" rating would be given someone never previously convicted, and the worst would be given someone with a record of more than one serious offense prior to the current conviction.)

There need be only a few gradations of seriousness, if refined discriminations in relative gravity are not practicable. (Conceivably, there could be as few as five categories—minor, lower intermediate, upper intermediate, lower-range serious, and upper-range serious.) An important advantage of

TABLE 22-1
Presumptive Sentences

		Hypothetical Penalty Scale			
	5	$P_{5.1}$	$P_{5.2}$	$P_{5.3}$	$P_{5.4}$ (most severe)
Seriousness	4	$P_{4.1}$	$P_{4.2}$	$P_{4.3}$	$P_{4.4}$
level of most	3	$P_{3.1}$	$P_{3.2}$	$P_{3.3}$	$P_{3.4}$
recent offense	2	$P_{2.1}$	$P_{2.2}$	$P_{2.3}$	$P_{2.4}$
	1	$P_{1.1}$ (least severe)	$P_{1.2}$	$P_{1.3}$	$P_{1.4}$
		1	2	3	4

Rating for seriousness of prior record
(based on number and seriousness
of prior offenses)

The penalty in the lower left-hand corner ($P_{1.1}$) is that prescribed for someone convicted of a minor offense who had no prior record. It would be the least severe penalty on the scale. That in the lower right-hand corner ($P_{1.4}$) is for the person whose current offense is minor but who had a record of serious prior offenses. (This penalty would be somewhat severer, but not very much so, since the offense of which the defendant now stands convicted is still a minor one.) The penalty in the upper right-hand corner ($P_{5.4}$) is that prescribed for someone convicted of a very serious offense who already had a record of major crimes. It would be the severest on the scale. That in the upper left ($P_{5.1}$) would be for someone convicted of a serious crime who had no prior record. Thus the penalties would increase in severity as one goes from left to right and from bottom to top.

a scale having two dimensions is that it has ample power to differentiate penalties, even if the number of gradations of seriousness is kept small. With five degrees of seriousness and four "prior record" gradations, for example, the scale would have room for twenty different penalty levels.*

A scale constructed in this fashion has the further advantage of simplicity. It would not be necessary to devise a lengthy sentencing code specifying a distinct presumptive penalty for each offense. The guidelines could simply list the few gradations of seriousness, and state which categories of

* With five seriousness gradations and four "prior record" gradations, the penalty scale would look something like the one above—with the *P*'s representing the presumptive sentences.

crimes fall into which gradations. Knowing the offender's crime and his prior record, one could then consult these guidelines to obtain the applicable seriousness rating and seriousness-of-prior-record rating—and, having these, look up the indicated presumptive sentence on the two-dimensional scale.

The magnitude of the scale is the next concern. Should the scale, for example, run up to a highest penalty of five years' confinement? or fifteen? or fifty?

While regulating the scale's internal composition in detail, the principle of commensurate deserts sets only certain outer bounds on the scale's magnitude. The upper limit, as we have seen, is: the scale may not be inflated to the point that the severe sanction of incarceration is visited on non-serious offenses. The lower limit is: the scale may not be deflated so much that the *most* serious offenses receive less-than-severe punishments. Within these limits, there remains considerable choice as to the scale's magnitude—where its overall deterrent effect may be taken into account. The difficulty is the absence of data: the deterrent impact of an untried scale of penalties is not known. It will be necessary to choose the scale's magnitude on the basis of surmise—on a best guess of what its deterrent effect is likely to be. Once a scale has been implemented, with its magnitude chosen in somewhat arbitrary fashion, it can then be altered with experience. If the magnitude selected leads to a substantial rise in overall crime rates,* an upward adjustment can be made (within the upper bounds of commensurate deserts). If no such rise results, it would then be appropriate to experiment with further reductions—diminishing the scale's magnitude in stages and observing whether any significant loss of deterrent effect occurs. (Such a step-by-step approach to reducing penalty levels should limit the risk of a large, unexpected jump in the crime rate.)

How, then, should one go about selecting a particular magnitude if the initial choice contains so much guesswork? We would suggest taking into account two factors touched upon earlier. One is our principle of "parsimony," that less intervention is preferred unless a strong case for a greater degree of intervention can be made. The other is the hypothesis of diminishing returns: once penalties reach modest levels of severity, further increases are unlikely to have much added deterrent usefulness.

With these two factors in mind, we recommend adoption of a scale whose highest penalty (save, perhaps, for the offense of murder) is five years [25]—with sparing use made of sentences of imprisonment for more than three years. If the hypothesis of diminishing returns is correct, the elimination of very long sentences could be undertaken without significant

* This measure—the impact on the crime rate—will reflect not only the scale's deterrent effect but (to the extent incarceration is utilized) its incapacitative effects as well.

In determining the effect of the scale's magnitude on the crime rate, it will be necessary to try to control for other variables that could have influenced the rates.

diminution of the overall deterrent usefulness of the system.* [26] (More-over, the sentences, while shorter, would be more certain—and greater certainty could have some additional deterrent benefits. *All* persons con-victed of sufficiently serious offenses would face a period of imprison-ment—rather than the situation with today's discretionary system, where a few such persons receive lengthy sentences but many other serious of-fenders only get probation.†) Bearing in mind our principle of parsimony and the fact that any initial choice of magnitude is somewhat arbitrary, we think that keeping most prison sentences well below three years is a risk worth taking. If events proved us wrong and such a scale led to a substan-tial increase in the crime rate, the magnitude of scale could still be adjusted upward, subject to the desert-imposed limit that incarceration could be used only for offenses that were serious.

Sentence Levels. Thus far, we have spoken only of the overall dimen-sions and formal characteristics of the scale. What kinds of penalties, then, should be imposed for various typical crimes? Answering that would re-quire an assessment of the seriousness of those crimes—thus calling for criteria of seriousness, which we have not supplied. We can, however, offer some surmises, based on our commonsense estimates of seriousness.

Suppose the penalties are those we have suggested: warning-and-release, intermittent confinement, and (for serious offenses only) incarceration. Then sentence levels might run approximately as follows:

1. *Minor offenses* should be punished least severely—by warning-and-release for the first offense, and by a light schedule of intermittent confine-ment (e.g., a loss of a few Saturdays) for repetitions. Petty thefts would fall in this category.

2. *Intermediate-level offenses* (from the slightly more than minor to the nearly serious) should be punished mainly by intermittent confinement, although warning-and-release should be used for first offenses in the lower range of this category. For offenses in the upper range, there would be stiff schedules of intermittent confinement involving substantial deprivations of offenders' leisure time. But incarceration should not be employed, since we are still speaking of crimes that do not qualify as serious. Included in this category would be most common thefts of personal belongings which do not involve the threat or risk of violence.

* Even if there is a diminishing *deterrent* effect of increasing severity, a larger magnitude will mean longer prison sentences—and hence some added *incapacitative* effect. But we are assuming that this added incapacitative effect will not be very large—at least if the use of incarceration is kept within the bounds of commensurate deserts.

It has been recently claimed—by James Q. Wilson and Reuel Shinnar, among others—that dramatic reductions in crime can be achieved through isolating a larger proportion of of-fenders for longer periods. The evidence to support these claims remains in dispute, however.

† For statistics on the relatively low percentage of serious offenders now sent to prison, see, e.g., Adrienne Weir, "The Robbery Offender," in *The Prevention and Control of Rob-bery*, ed. by Floyd Feeney and Adrienne Weir (Davis, Cal.: University of California at Davis, Center for Administration of Criminal Justice, 1973) (percentage of convicted robbery of-fenders sent to prison).

3. *Serious offenses (lower range)* might be punished by intermittent confinement for the first offense, reflecting our conception of a scaled-down penalty for first offenders. Repeated violations, however, should be punished by incarceration. Thefts involving the threat of violence (but not its actual use) would generally fall in this category.

4. *Serious offenses (upper range)* should receive sentences of incarceration in any event. Intentional and unprovoked crimes of violence that cause (or are extremely likely to cause) grave bodily injury to the victim fit here, as would the worst white-collar offenses such as those in which people's lives are knowingly endangered.* [27]

How long should the sentences of confinement be? We recommend that the presumptive sentences for lower-range serious offenses fall somewhere below eighteen months (with the possible exception of higher sentences—as much as three years, perhaps—for multiple recidivist infractions). Presumptive sentences for upper-range serious offenses would then fall somewhere between eighteen months and three years (except for repeat violations, where sentences could run as high as four and five years). Sentences above five years would be barred altogether—except for certain murders,† and possibly for sentences of predictive restraint in the exceptional circumstances discussed earlier.

When this suggested structure is compared with existing sentencing practice, several major differences emerge.

Under our approach, there will be much less disparity. Defendants having similar criminal records will receive similar dispositions. No longer will it be possible for one offender to be sent to prison for years, while another convicted of a similar crime walks out the courtroom door on probation. Moreover, the defendant will know for certain how much punishment he faces: indeterminacy of sentence is eliminated.

Penalties will be scaled down substantially. Incarceration will be re-

* Because of the complexity and variety of the criminal transactions involved, developing seriousness criteria for white-collar offenses will be no easy task. But some white-collar offenses are no less serious than crimes of violence. A striking instance was cited by Willard Gaylin in a recent guest editorial in *The New York Times:* the case of a doctor and drug manufacturer who knowingly sold children's emetics with the active ingredient missing. The emetics were supposed to induce vomiting in children who had accidentally swallowed poison, but would not do so in their adulterated form—so that the child's death could result. The defendant was put on probation. We regard this crime as heinous as shooting at someone with a pistol, and feel it deserves a period of incarceration.

† Murder, the most serious of crimes, presents special problems because of the diverse circumstances under which it is committed. Having a single presumptive penalty might require unduly wide discretionary variations to accommodate killings of varying degrees of gravity. It may be preferable to prescribe separate presumptive penalties for distinct kinds of murder: (1) murders stemming from personal quarrels, (2) unprovoked murders of strangers, (3) political assassinations, and (4) especially heinous murders, such as those involving torture or multiple victims. Five years might be the norm for the personal-quarrel situation, with longer presumptive sentences for the other three categories. This approach would have the additional advantage that the homicides that cause the most public outrage—those in the last three categories—would be dealt with separately: were there only a single presumptive penalty, it would tend to become inflated to accommodate the more shocking homicides.

stricted to offenses that are serious—and most prison sentences kept relatively short. (It is true that today the average time served for most major offenses other than murder is less than five years: [28] but those averages conceal many dispositions that are much longer. Our suggested limits on sentences are not averages but true limits.) The reduction in severity would be particularly marked for first offenders.

Severity would thus be substantially reduced, but we emphasize: these suggested punishments would not be so easily avoided. The discretionary features of the existing system allow individuals convicted even of the most serious crimes to be put on suspended sentence or probation. Under our scheme, terms of confinement would be shorter and more sparingly imposed—but a person convicted of a sufficiently serious crime would have to serve the prescribed time.

Two Other Views

JOSEPH GOLDSTEIN

I am in substantial support of the sentencing reforms outlined in the preface by Charles Goodell and attributed by him to the Committee's report. I share the report's reasons for rejecting as unjust and unworkable current sentencing policy which rests on meeting the "rehabilitative needs" of each convicted offender and which relies on trial judge and parole board to determine when an individual offender will be and is "rehabilitated" and thus safe for release from imprisonment. Even if such diagnostic and predictive powers were, as they are not, within anyone's competence, the assignment of such broad discretion to court and agency to fix the length of incarceration on a case-by-case basis is bound to lead, as it has, not only to a "runaway" inflation in the length of sentences but also to discrimination for the same crime in favor of the relatively well placed offender and against the already disadvantaged one.

Without precisely defined restraints on the power of the court to incarcerate and on the power of those who administer sentences to keep an offender in prison, one element critical to the criminal law of a democratic society is missing—i.e., a guarantee of fair warning of the consequences which will follow conviction for a specific crime. Thus the report correctly concludes that the authority to punish ought no longer be loosely left to court or administrative agency discretion and that the severity of punishment is to be fixed in advance for each type of crime and is to accord with the society's notions of its seriousness. With the elimination of the discretion of the sentencer and the sentence administrator, incarceration will be imposed and will only be imposed for a time certain in response to what the convicted offender has done, not what someone "expects he will do if treated in a certain fashion." Up to this point I am in substantial agreement

with the analysis and conclusions of the report and to that extent subscribe to it.

However, in proposing that the *principle of commensurate deserts* should become the guide to sentencing policy, the report retreats from its own analysis and conclusions. It reintroduces—albeit under another label—the traditional notions upon which current sentencing systems are based. As interpreted by the report, the deserts principle—which, by the way, is never sufficiently clarified to become an operational guide for lawmakers—invites the sentencing judge to take into account the prior record and "mental state" of the offender.

The report, to give but one example of the confusion introduced by the deserts principle, argues: "A repetition of the offense following [a prior] conviction may be regarded as more culpable, since he persisted in the behavior after having been forcefully censured for it through his prior punishment." This thinly disguised throwback to individualization and concern for an offender's "culpability"—i.e., failure to learn from (be reformed by) punishment for his prior offense—undercuts much of the report's most significant point, which is that in determining the seriousness of an offense, and hence the severity of the punishment, focus must be on the crime committed, not the individual who commits it. Further, the report urges that the amount of "time passed since the previous conviction" should also be taken into account in setting the sentence. Why these and other (or, for that matter, not other) factors are to be considered in establishing the severity of the punishment under the deserts principle is never clarified.

But what does become clear is that the report is forced to rationalize the reintroduction of a potentially discriminating sentencing discretion for the court. And it backs away from concluding what its initial analysis would have dictated, which is that parole boards would no longer have a function in criminal-law administration. An offender would be released upon completion of a sentence fixed, not just for him, but for all persons who are convicted for the same crime. The sentence would have been predetermined by the legislature to provide punishment severe enough to reflect society's notions about the seriousness of the offense. But the report abandons that conclusion and moves full circle under the deserts principle to an abuse-prone discretionary sentencing system not unlike the one it so thoroughly discredited in its opening chapters. It recommends that there be a "presumptive sentence" for each offense and that judges be authorized "to raise the penalty above or reduce it below the presumptive sentence, in cases where he finds there were special circumstances affecting the gravity of the violation and where he specifies what those circumstances of aggravation or mitigation were." Nothing in the *principle of commensurate deserts* gives guidance to sentencing judges and courts of review—let alone all of us who are subject to the criminal law—concerning the certainty or the appropriateness of a judge's "specifics" for increasing or reducing the presumptive—no longer fixed—sentence.

I do not suggest that legislatures should not provide, for example, fixed increments in the length of sentences to be imposed upon offenders who repeat offenses, even to the point of long-term incarcerations for those who repeat or repeatedly engage in the most serious crimes. But such terms would be fixed in advance by legislative decision. As the sentencing power of judges is thus restrained, the critical element of fair warning would be preserved. Of course, it must be recognized that a specific type of crime does not cause less or more serious harm because in one case it is the work of a first offender and in another that of a third offender. The more severe, though fixed, punishments, for example, would be justified, not because of some "moral claim" (whose source and meaning are never revealed in the report's discussions of the principle of commensurate deserts), but possibly because the legislature is less willing to assume the "additional" risk of having any repeaters at large and/or because the legislature wishes to reflect the exacerbation of society's retributive feelings toward recidivists.

Furthermore, the report fails to acknowledge that an inescapable and critical function of the criminal law is to satisfy and to channel the retributive feelings aroused by those who offend. Retribution, whether we like it or not, must be a factor in any calculation of seriousness of harm and of severity of punishment. But the report makes the deserts principle, not unlike the rehabilitative ideal, a cover for retribution and vengeance. It creates just another discretionary sentencing system with a new and protean slogan for justifying retributive excesses under a vaguely articulated "moral claim," in place of a "do-gooder" claim to cure the sick offender. Thus, I join Gaylin and Rothman, who in their introduction observe: "When we honestly face the fact that our purpose is retributive, we may, with a re-found compassion and a renewed humanity, limit the degree of retribution we will exact." Unfortunately, the report neither faces that fact nor provides that hope in its proffer of the commensurate-deserts principle.

Finally, the report does not give sufficient focus to living conditions in institutions of incarceration. Nor does the deserts principle give guidance to the management of such punishments. Further, insufficient emphasis is placed on the application of the criminal law to conduct within prisions, especially with respect to punishing crimes committed by prison administrators against incarcerated offenders. The report does not adequately develop the notion that prisoners should not be deprived of any rights or safeguards to which a person on the outside is entitled, unless such deprivations further the acknowledged purposes of the punishment.

LESLIE T. WILKINS

I cannot do other than add my signature to this report, but I do so without enthusiasm: my difficulty is not with the report but rather with the situation it reflects. Had it been possible for a different model to apply—economic/rational or even humanitarian/theraputic—I would have pre-

ferred it: but such models have proven still less appropriate. It seems that we have rediscovered "sin," in the absence of a better alternative!

The simplification of the problem of crime to the problem of the criminal has not paid off, and we in this report are still forced into oversimplifications of the issues of effective social control. We may have said something about what should be done with criminals, but we have added nothing to suggestions for dealing with crime.

I am content that the statement we have made serves as an interim declaration of policy. I cannot accept it as a declaration of a desirable policy—it is merely less unacceptable than any others which can be considered at this time. I would stress, therefore, the need for continuous review by research methods of the workings of the criminal-justice processes and, in particular, the sentencing procedures of the courts. We should link with exploratory research those methods which require controlled variation of the processes in operational terms. The variation would serve two purposes. Any system which cannot tolerate variation has already ossified. We desire equity, but not rigidity. Variation is essential in order to generate information, and information is necessary to indicate how progress may be achieved. There is a moral necessity for man to attempt to know more and more, even about man himself, even if this incurs some cost.

I do not think the report gives adequate emphasis to the need for experimentation, perhaps because it takes a thoroughly moralistic model. I do not disagree with that viewpoint, provided that the need to research into moral values is itself seen as a moral imperative. The moral perspective may devalue research because it reduces the importance of arguments about efficiency (such as resource-allocation problems) by dismissing these as "economic issues." I would not agree—every technical problem implies a moral problem, but we have few proven techniques for research into the latter.

The practice of parole and its philosophy is, of course, open to challenge insofar as it is based upon the idea of "treatment." Parole boards, however, can act as sentencing-review bodies and would seem to be capable of developing high levels of competence in this form of decision-making. Certainly, the United States Board of Parole (federal) was the first criminal justice agency to adopt a procedure not dissimilar to that advocated in the report. They have (as the report notes) adopted guidelines (based on research) for decisions setting the time inmates are held in prison before release on parole. The guidelines give most weight to the rated seriousness of the instant offense, with some additional weight to other factors, mainly classifications of the prior criminal record or its correlates. The times indicated by the guidelines may be departed from, but reasons for departure must be given. Inmates are informed of the reasons for decisions and they have access to various methods of appeal, both through administrative pro-

cesses and through the courts. Review of the policy coded into the guide-lines is facilitated by the appeal procedures, the analysis of reasons for departures from the indicated times, and by other statistical analyses. The board meets at regular intervals to consider these data and to ratify or modify the procedures accordingly. Of course, all persons about whom decisions are made by the Board of Parole have served some time in incar-ceration, whereas, in sentencing, the major determination to be made is with respect to "in" or "out." Nonetheless, some of the phrasing of the report does not seem (to my biased viewpoint) to give sufficient credit to the U.S. Board of Parole for adopting a revolutionary philosophy and im-plementing it in practice for assessing the time convicted offenders should serve in prison.

NOTES

As explained in this chapter, the principle of commensurate deserts—that the severity of punishment should, as a matter of justice, be commensurate with the seriousness of the offense—has not received much attention in traditional penological literature. There has, how-ever, been some recent interest.

Norval Morris, dean of the University of Chicago Law School, discusses it in his recent book on the aims of sentencing (Norval Morris, *The Future of Imprisonment* [Chicago: Uni-versity of Chicago Press, 1974], ch. 3). Morris argues that the principle is a requirement of justice that limits the pursuit of utilitarian sentencing aims; he holds that it sets an upper limit (and perhaps, although this is less clear in his book, also a lower limit) on the severity of the punishment for any given offense category. Within these desert-based limits, variations in severity would be allowed for deterrent and certain other utilitarian purposes. Our view of the principle differs somewhat from Morris's.

M. Kay Harris, associate director of the American Bar Association's Resource Center on Correctional Law and Legal Services, has also argued that sentences should be based primar-ily on the seriousness of the offense, rather than on deterrent, incapacitative, or rehabilitative grounds. M. Kay Harris, "Disquisition on the Need for a New Model for Criminal Sanction-ing Systems," *West Virginia Law Review* 77 (1975): 263.

With respect to juvenile delinquents, Professor Sanford Fox has urged that sentences be based on desert rather than on traditional rehabilitative notions. Sanford Fox, "The Reform of Juvenile Justice: The Child's Right to Punishment," *Juvenile Justice* 25 (1974): 2.

California's parole board, it also should be noted, has adopted new standards for parole release which rely more heavily than does current law upon the seriousness of the offense in determining the duration of prison terms. (State of California, Adult Authority, "Parole Con-sideration Hearing Procedures.") See also the governor of Illinois's proposed system of legis-latively fixed "flat" sentences (News Release from the Office of the Governor of Illinois, Springfield, Ill., Feb. 18, 1975), which is now pending in the state legislature.

1. C. Beccaria, *Of Crimes and Punishments*, trans. Henry Paolucci (New York: Bobbs-Merrill, 1963). Radzinowicz, *Ideology and Crime* (New York: Columbia University Press, 1966), ch. 1.

2. *Ibid.* Also J. Bentham, "An Introduction to the Principles of Morals and Legislation," in *The Works of Jeremy Bentham,* ed. John Bowring (New York: Russell & Russell, 1962), vol. 1, chap. 1.

3. H. Donnedieu de Vabres, *Traité de Droit Criminel et de Législation Comparée* (3d ed., 1947), pp. 27–28, cited in Radzinowicz, *Ideology and Crime,* p. 24.

4. *Strafgesetzbuch für das Koenigreich Baiern* (1813), cited in Radzinowicz, p. 23.

5. New Hampshire Constitution of 1784, Bill of Rights, § 18.

6. Radzinowicz, *Ideology and Crime*, ch. 2.

7. *Model Sentencing Act*, Introduction and §§ 1, 5, 9. Also the Act's first edition: Council of Judges, National Council on Crime and Delinquency, *Model Sentencing Act*, Second ed., reprinted in *Crime and Delinquency* 18(1972).

8. For citation in footnote: *In re Lynch*, 8 Cal. 3d. 410, 503 P.2d 921 (Cal. Sup. Ct., 1972).

9. American Law Institute, *Model Penal Code* (proposed official draft, 1962), §§ 7.01(1)(c).

10. H. L. A. Hart, "Prolegomenon to the Principle of Punishment," *Punishment and Responsibility* (New York: Oxford University Press, 1968).

11. See introductory comments to the notes for this chapter.

12. For citation in footnote: Bentham, *supra* note 2, p. 88.

13. For citation in footnote: H. L. A. Hart, "Prolegomenon," *supra* note 10, p. 25.

14. Henry M. Hart, "The Aims of the Criminal Law," *Law and Contemporary Problems* 23(1958).

15. For citation in footnote: Andrew von Hirsch, "Prediction of Criminal Conduct and Preventive Confinement of Convicted Persons," *Buffalo Law Review* 21 (1972): 717, 746.

16. See, e.g., K. G. Armstrong, "The Retributivist Hits Back," 70 *Mind* (1961): 471; F. Zimring and G. Hawkins, *Deterrence* (Chicago: U. of Chicago Press, 1973), pp. 40–41.

17. Cf. *Model Penal Code*, § 7.01(1)(c), requiring the sanction of imprisonment if a lesser sentence "will depreciate the seriousness of the defendant's crime."

For discussion in footnote: Joel Feinberg makes the same point in his "The Expressive Function of Punishment," *Doing and Deserving* (Princeton, N.J.: Princeton U. Press, 1970), p. 118. See also C. W. K. Mundle, "Punishment and Desert," *Philosophical Quarterly* 4 (1954): 216. The Kantian argument on which we rely also does not require "eye for an eye" punishments.

18. Norval Morris is somewhat unclear as to whether the principle sets lower as well as upper limits on punishment. At one point, he states that "the concept of desert . . . is thus limited in its use as defining the *maximum* of punishment that the community exacts from the criminal to express the severity of the injury his crime inflicted on the community." Morris, *The Future of Imprisonment* (Chicago: U. of Chicago Press, 1974) (emphasis added). But elsewhere in his book, he adopts the Model Penal Code's principle that the severity of the punishment may not fall so low as to "depreciate the seriousness of the crime(s) committed"—which seems to set a *lower* limit on severity, based on the idea of desert (*Ibid.*, p. 60).

19. *Model Sentencing Act*, introduction.

20. See, e.g., *Model Penal Code* § 7.01; M. Frankel, *Criminal Sentences* (New York: Hill & Wang, 1972), pp. 108–111.

21. Thorsten Sellin and Marvin E. Wolfgang, *The Measurement of Delinquency* (New York: John Wiley & Sons, 1964).

22. G. N. G. Rose, "Concerning the Measurement of Delinquency," *British Journal of Criminology* 6 (1966): 414.

23. Peter H. Rossi et al., "The Seriousness of Crimes: Normative Structure and Individual Differences," *American Sociological Review* 39 (1974): 224.

24. *Ibid.*, pp. 231, 237.

25. A five-year limit has been suggested before, on the basis of more traditional theories of sentencing. See, e.g., American Bar Association, Project on Minimum Standards for Criminal Justice, *Sentencing Alternatives and Procedures* (New York: ABA, 1968), § 2.1(d); National Advisory Commission on Criminal Justice Standards and Goals, *Corrections* (Wash., D.C.: Govt. Printing Office, 1973) Standard 5.2, *Model Sentencing Act*, § 9.

26. For citations in footnote: James Q. Wilson, *Thinking about Crime* (New York: Basic Books, 1975), ch. 10; Shlomo and Reuel Shinnar, "A Simplified Model for Estimating the Effects of the Criminal Justice System on the Control of Crime," School of Engineering, City College of New York, 1974 (unpublished), cited in Wilson, *Thinking about Crime*.

For a different view of incapacitative effects, see David F. Greenberg, "The Incapacitative Effect of Imprisonment: Some Estimates," Department of Sociology, New York University, 1975 (unpublished).

27. For citation in footnote: Willard Gaylin, "Not for the Gander, Though," *New York Times*, May 21, 1975, p. 43.

28. For 1969 statistics on time of first release for various major-crime categories in California, see State of California, Department of Corrections, *California Prisoners, 1969* (Sacramento, Cal.: undated).

23: The Future of Imprisonment / *Norval Morris**

Proper use of imprisonment as a penal sanction is of primary philosophical and practical importance to the future of society. With the increasing vulnerability of our social organization and the growing complexity and interdependence of governmental structures, reassessment of appropriate limits on the power that society should exercise over its members becomes increasingly important. Perhaps if the "prison problem" is solved, many of the uneasy tensions between freedom and power in postindustrial society will diminish. The effort made here will, I hope, contribute to the solution of the "prison problem" by offering a new model of imprisonment that recognizes fundamental principles of justice as well as the legitimate exercise of society's power over the individual.

We need to address two blunt questions in constructing a new model of imprisonment: (1) Why imprison a convicted criminal in the first instance? (2) Why not imprison all convicted criminals until risk of future criminality is past? Any useful response to these questions requires me to outline a philosophy under which imprisonment can be applied with restraint and humanity until it is no longer needed for social control.

My premise throughout is that penal purposes are properly retributive, deterrent, and incapacitative. Attempts to add reformative purposes to that mixture—as an objective of the sanction as distinguished from a collateral aspiration—yield neither clemency, justice, nor, as presently administered, social utility. We may utilize our rehabilitative skills to assist the prisoner toward social readjustment, but we should never seek to justify an extension of power over him on the ground that we may thus more likely effect his reform.[1]

* This chapter originally appeared as "The Future of Imprisonment: Toward a Punitive Philosophy," *Michigan Law Review 72* (1974) : 1161–1180 and subsequently, in modified form, in Norval Morris, *The Future of Imprisonment* (Chicago: University of Chicago Press, 1974); copyright © 1974 by University of Chicago and Norval Morris. Reprinted with permission.

Why Should a Convicted Criminal Be Imprisoned?

As usual, clarification of what is not involved in this question is a necessary prelude to answering what is. I am not discussing the challenging and significant problems involved in setting terms of imprisonment in a way that guarantees that like cases will be treated alike and all treated fairly. The principles suggested will, with suitable modifications, apply to the assessment of the appropriate duration of imprisonment by the legislature and by the judge, and to all sentencing decisions as they are later taken by parole boards and correctional authorities. However, for ease of analysis the present effort isolates the issue of imprisonment *vel non*. The objective is to offer principles to aid a judge in determining whether he should impose a sentence of imprisonment or some lesser sanction. Although these principles apply whenever this issue is addressed—by the legislator, the prosecutor, the judge, the parole board member—analysis is focused on the judge's decision.

Clarity is best served by sketching the complete model in relatively narrow compass before elaborating on its details. First, three principles to guide the decision to imprison are submitted:

1. Parsimony: The least restrictive or least punitive sanction necessary to achieve defined social purposes should be chosen.

2. Dangerousness: Prediction of future criminality is an unjust basis for determining that the convicted criminal should be imprisoned.

3. Desert: No sanction greater than that "deserved" by the last crime or bout of crimes for which the offender is being sentenced should be imposed.

Thereafter, three conjunctive preconditions to the judicial imposition of a sentence of imprisonment are developed in more concrete form:

1. Conviction by jury or bench trial or a procedurally acceptable guilty plea to an offense for which the legislature has prescribed imprisonment;

2. Determination that imprisonment is the least restrictive sanction appropriate in the particular case because either (a) a lesser punishment would depreciate the seriousness of the crime(s) committed; (b) imprisonment of some who have done what the particular criminal has done is necessary to achieve socially justified deterrent purposes, and his punishment advances that end; or (c) other less restrictive sanctions have been frequently or recently applied to him; and

3. Judgment that imprisonment is not a punishment that society would deem undeserved or excessive in relation to the last crime or series of crimes that the individual has committed.

It may assist to offer some commentary on the principles suggested to guide the decision to imprison and then to draw a sharp contrast between the preconditions to imprisonment submitted here and those adopted in most of the recent criminal codes.

PARSIMONY

The first principle recommends parsimony in the use of imprisonment. This principle is not novel. A presumption in favor of punishments less severe than incarceration pervades all recent scholarship and most legislative reforms. Justification for this utilitarian and humanitarian principle follows from the belief that any punitive suffering beyond societal need is, presumably, what defines cruelty. Emerging case law and commentary supports this principle of the least drastic means.[2] Specifically, the draftsmen of the American Law Institute's (ALI) Model Penal Code sought to include the principle in the Code's main article on sentencing. Section 7.01, enumerating "Criteria for Withholding Sentence of Imprisonment and for Placing Defendant on Probation," directs the court to order other punishments unless "imprisonment is necessary for protection of the public." [3] Over one-half of the states have undertaken substantial revision of their criminal codes during the past decade, all profoundly influenced by the ALI model. The same influence is apparent in current proposals for reform of the federal criminal code. In accord are the American Bar Association's Project on Minimum Standards for Criminal Justice [4] and the recommendations of the two national crime commissions of the past decade.[5] Moreover, although constitutional support for the parsimony principle is hesitant, the analogies are clear. Imprisonment as a sanction for a common cold or for being a narcotic addict would be unconstitutional; [6] to place a prisoner involved in a scuffle into maximum security segregation for two years may be invalid as punishment not reasonably related to the infraction for which it was imposed; [7] and the death penalty would be unconstitutional for a rape in which life was neither taken nor endangered.[8] Finally, courts and legislatures have expressly accepted the principle of parsimony in relation both to the civil commitment of the mentally ill and the conditions of their detention.[9] Goldstein, Freud, and Solnit, in their important new study, *Beyond the Best Interests of the Child,* offer a principle similar to that of the least restrictive or least punitive sanction, applicable to all situations in which child placement by a court is involved, expressly including juvenile delinquency matters involving violence. Even were the law to make society's immediate safety the primary goal, they would argue that the least detrimental alternative placement should be selected.[10]

The wisdom of parsimonious use of imprisonment is no longer questioned, unless doubt is cast upon it by the second fundamental question we face—why not imprison all criminals convicted of serious crime until risk of their recidivism is past? I will return to that question shortly.

DANGEROUSNESS

With the second principle—that dangerousness as a predictor of future criminality is an unjust basis for imprisoning—we move from the broadly accepted to the highly contentious.

Let me try to define the issue precisely before grappling with it. Courts around the world impose imprisonment instead of community-based punishments, or increase terms of imprisonment beyond the measure that the specific crime justifies, for a variety of grounds that resemble what I will call "dangerousness." The grounds include: The criminal committed crime before; he committed this type of crime before; he committed many crimes before; he has made a profession of crime; he committed many other crimes at about the same time as this one; he acted with peculiar brutality, or used a gun, or determinedly retained the proceeds of his crime; or there has been a recent rash of similar crimes. All these grounds merit consideration. I set them aside in favor of closer analysis of one other ground that seems to be gaining acceptance in the United States and in Europe, namely, that the crime and what we learn of the criminal lead us to the view that he probably will commit a serious crime of personal violence in the future. This prediction is what I will term the prediction of dangerousness.

There is a seductive appeal to separating the dangerous and the nondangerous offender and confining imprisonment principally to the former. It would be such a neat trick were it possible: prophylactic punishment—the preemptive judicial strike, scientifically justified—designed to save potential victims of future crimes and at the same time minimize the use of imprisonment and reduce the time served by most prisoners. But it is a trap. Social consequences are often counterintuitive. The concept of dangerousness is so plastic and vague, its implementation so imprecise, that it would not substantially reduce the present excessive use of imprisonment.

It must be admitted, however, that dangerousness as a determinative guide to the use of imprisonment does have impressive support. Perhaps most impressive are the reform efforts of Herbert Wechsler, Paul Tappan, Francis Allen, and a small group of other scholars and practitioners in the mid-1950s and early 1960s. Those efforts, doubtless the most important attempt to bring rationality to the criminal law since the codification efforts of Macauley and Stephen in the last quarter of the nineteenth century, are embodied in the sentencing provisions of the ALI Model Penal Code.[11] The themes behind the provisions are, in the main, sound and worthy of emulation. First, fines and community-based treatments such as probation, where reasonably applicable, are preferable to imprisonment as penal sanctions. Second, the range of prison sentences for felonies should be reduced to three or four categories of gravity. Third, within those categories, the grounds on which a court may exercise its discretion to impose imprisonment should be defined with some degree of precision. A principal aim throughout, if judges can be persuaded or required to give reasons for their sentences, is to build a common law of sentencing. Provisions for appeal against sentence have similar purposes. Finally, however, the Model Penal Code and its progeny provide for the imposition of "extended terms" of

imprisonment upon persistent, professional, psychologically disturbed, and dangerous or multiple offenders.[12]

The final provision, specifically as it makes dangerousness a determinative guide to the use of imprisonment, has been widely adopted. The National Council on Crime and Delinquency (NCCD), for instance, maintains that "confinement is necessary only for offenders who, if not confined, would be a serious danger to the public." [13] The 1973 Task Force on Corrections of the National Advisory Commission on Criminal Justice Standards and Goals recommends that "state penal code revisions should include a provision that a maximum sentence for any offender not specifically found to represent a substantial danger to others should not exceed 5 years for felonies other than murder." [14] Extended terms beyond five years, indeed up to twenty-five years, might be imposed on the "persistent felony offender," the "professional criminal," and the "dangerous offender." [15] The Code has also profoundly influenced the reshaping of the criminal codes of a number of states [16] and other states are in the process of emulation. If Congress acts on a new federal criminal code, I have no doubt that it will also incorporate sentencing provisions fashioned after the ALI Model Penal Code prototype.[17]

The various proposals share a desire to reduce the use of imprisonment as a penal sanction by favoring less drastic punishments, by shortening prison sentences imposed on those criminals who have to be imprisoned, and by selecting defined categories of criminals for protracted incarceration, largely on grounds of their dangerousness. Admittedly benevolent purposes inspire these legislative and scholarly reform efforts. Only the dangerous are to be imprisoned; only the very dangerous are to be protractedly imprisoned. However, we are far enough down the road of penal reform to realize that benevolent purposes do not guarantee beneficent results.

One can well understand the politics of the taxonomy without accepting the concepts on which it is based. An effort to confine imprisonment to the dangerous has obvious political appeal. Provision for extended sentences for the particularly dangerous may allow us to avoid the worst abuses of the habitual criminal and the sexual psychopath laws whose application has proved grotesquely unjust throughout this country.[18] Indeed, the political justifications for the use of the dangerousness concept are sometimes expressly recognized. For example, the report of the National Advisory Commission suggests that "[c]lear authority to sentence the 'dangerous offender' to a long term of incapacitation may induce the legislature to agree more readily to a significantly shorter sentence for the nondangerous offender." [19] In other words, let us continue to deal unjustly with a few so that we can persuade the legislature to deal more effectively and fairly with the many!

Predictions of future criminality, it is submitted, are an unjust basis for imposing or prolonging imprisonment. Despite the weight of authority sup-

porting the principle of dangerousness, it must be rejected because it pre-supposes a capacity to predict quite beyond our present or foreseeable technical ability. We are not inquiring whether the ill-educated, feckless, vocationally deprived ghetto youth is likely to be involved in crime—of course he is. We are not talking about minor crime or crime in general. The focus is on our capacity to predict crimes of some gravity, mostly crimes of violence to the person.

Although predictions of violent crime can fail in two ways, we have developed an extremely useful technique to conceal the most troublesome failures from ourselves. Illustratively, suppose that we attempt to project future violence to the person from among one hundred convicted criminals. Permit me to invent figures that are far superior to any we can now achieve. Assume that of the one hundred, we select thirty as likely future violent criminals. Despite our prediction, all one hundred are either re-leased or left at large. Observing their subsequent careers, we obtain the results with hypothetical precision. Of the thirty predicted as dangerous, twenty do commit serious crimes of violence and ten do not. Of the sev-enty we declare to be relatively safe, five commit crimes of violence and sixty-five do not. Table 23–1 summarizes the data.

TABLE 23-1

Prediction		Result	
		No Violent Crime	Violent Crime
Safe	70	65	5
Violent Crime	30	10	20
	100	75	25

Reading this chart one might claim "We had 80 percent success in our prediction, successfully preselecting twenty out of the twenty-five who later committed serious crimes of violence." We failed to select five of the one hundred who later proved to be dangerous, but that seems a minor failure compared with the twenty serious crimes we could have prevented. Note, however, that we also failed in another way. We selected ten as dangerous—as likely to commit crimes of violence—but they were not. Had we exercised greater power over the thirty that we predicted as dan-gerous we would have failed in our prediction by needlessly detaining ten persons. More succinctly, we made twenty "true positive" predictions of violence and ten "false positive" predictions.

To increase our claimed 80 percent success—to diminish the number we predicted as safe but who were in fact dangerous—we could certainly in-crease the number of our true positive predictions of dangerousness, but

only at the cost of substantially increasing the number of false positive predictions. There, if you will reflect on it, is the moral dilemma we face: How many false positives can we justify in exchange for preventing crimes perpetrated by the true positives? I shall return to this dilemma below.

Rarely in practice do we have an opportunity to confront the naked jurisprudential issues in the neat hypothetical form posed here. Moreover, we possess an extremely convenient mechanism by which to conceal from ourselves our critical incapacity as predictors—the mask of overprediction. If in doubt, put him in or keep him in. Why risk injury or death to potential innocent victims, particularly since the freedom involved is that of a person who has been convicted of crime? I do not mean to sound pejorative; I would no doubt feel pressured to do the same thing myself. If unsure about the future violent behavior of a person currently under control and for whom that control can legally be prolonged, the politically safe choice is to give the benefit of the doubt to any future victim rather than to the criminal or to the prisoner. What is wonderfully convenient about this overprediction of risk is that the predictor does not know who in particular he needlessly holds. Further, he is most unlikely to precipitate any political or administrative trouble in ordering or prolonging imprisonment. By contrast, one is quite likely to be in water too warm for comfort when those people whom one has released, but who could legally have been detained, *do* involve themselves in crimes of violence, particularly if those crimes are sensationally reported. Hence, the path of administrative and political safety is the path of the overpredicted risk.

A further important consequence of the mask of overprediction is that we lack sufficient empirical studies of our predictive capacity. All of us, of course, are masters at retrospective prediction, characterized by the tired phrase, "I told you so." We are less sure of our capacity as prospective predictors, in part because we are not in the position critically to test our predictions while those we have predicted as dangerous languish in institutions. Two recent opportunities to test the matter demonstrate the point. One occurred by force of a judicial decision, the other by the diligence of an imaginative and protracted research effort.

The United States Supreme Court's decision in *Baxstrom v. Herold* [20] presented a natural experiment in the overprediction of dangerousness. The state of New York had been classifying psychologically disturbed prisoners as suitable for detention in the institution for the criminally insane at Dannemora.[21] Some were held in this institution beyond the term of their sentence, if, after psychiatric examination, they were deemed mentally ill and dangerous to themselves or to others. The court affirmed the rather obvious proposition that such prisoners could not be held beyond the period of their original criminal sentence without receiving the usual due process protections of the ordinary civil commitment procedures. When the prisoner's criminal sentence expires he must be given the same protections given ordinary persons, not merely the lesser protections the state

extends to mentally ill prisoners. The immediate administrative effect of this decision was to compel the release or transfer to ordinary mental hospitals of each of the 967 "Baxstrom patients." They had to be either released into the community or committed to civil mental hospitals pursuant to ordinary civil commitment procedures.

Several studies of the subsequent careers of these predicted dangerous criminals have sought to determine the results of the mass release occasioned by the Supreme Court's decision. The broad conclusion is that there was gross overprediction of dangerousness. Perhaps the most intensive study was that reported in 1971 by Doctor Henry Steadman and his associates. They conclude, in part:

Two striking facts about the Baxstrom patients are the high proportion released after transfer to the civil hospitals and the low proportion subsequently readmitted. . . .
. . . [D]uring their first year of civil hospitalization the Baxstrom patients were not as troublesome as had been expected. Our findings suggest that they were equally not dangerous after they were released. Between 1966 and 1970, barely 21 of the 967 Baxstrom patients returned to Matteawan or Dannemora. All of the findings seriously question the legal and psychiatric structures that retained these 967 people for an average of 13 [years] in institutions for the criminally insane.[22]

The Baxstrom patients certainly proved less dangerous than predicted. The Steadman study worked with 246 of the 967 released. Only 3 percent of that group were returned to correctional facilities or institutions for the criminally insane between 1966 and October 1970. Their release rate from civil hospitals was higher than that of comparable patients civilly committed to state hospitals. With respect to their community adjustment, a large number—56 percent of the males and 43 percent of the females—had no subsequent readmission to mental hospitals during the four years covered by the study. Subsequent criminal activity was also low. Thirteen of the eighty-four released patients for whom there was adequate follow-up information had a total of eighteen criminal contacts with the police, a remarkably low rate considering the fact that all had been held as dangerous criminals, likely to be violent.

In effect, the Supreme Court in *Baxstrom* compelled the testing of our predictions of violence; the test revealed massive overprediction. To regard practice in New York and the institutions of Dannemora and Matteawan as lying outside the mainstream of practice in institutions for the criminally insane would be erroneous. The story of the Baxstrom patients could be told for many of the people we currently hold in prisons and mental hospitals in many parts of the world because we deem them likely to be involved in future violence.

A recent research project lends further support to this conclusion. In October 1972, Doctors Harry Kozol, Richard Boucher, and Ralph Garofalo reported on a ten-year study designed to test their capacity to define and predict dangerousness.[23] They selected a high risk group of offenders in

Massachusetts prisons. With unusually extensive clinical and social case work resources—independent examinations in every case by at least two psychiatrists and a social worker—they endeavored to predict the likely future dangerousness of each offender prior to his consideration for release. They identified for the releasing authority those offenders who in their view were dangerous and those who were not. Their thesis was that "[t]he validity of our diagnostic criteria and the effectiveness of treatment may be judged by comparing the behavior of patients released on our recommendation with the behavior of those who were released against our advice." [24] Table 23-2 summarizes the results of the Kozol study.[25]

TABLE 23-2

		Result	
Prediction		No Violent Crime	Violent Crime
Safe	386	355	31 (1M)
Violent Crime	49	32	17 (2M)
	435	387	48

The Kozol team was attempting to predict serious assaultive behavior. They were remarkably effective predictors, functioning at the forefront of our present clinical predictive capacity.[26] Though the likelihood of assaultive behavior was more than four times greater among those released against the researchers' advice than for those released on their advice,[27] consider the cost paid. Of the forty-nine who were released against the advice of the Kozol team, thirty-two did not subsequently commit any serious assaultive crimes during five years of freedom. Saving each true positive—benefiting the community and, indeed, the offender by preventing his inevitable commission of a serious assaultive crime—requires the detention of two others who were also expected to be involved in serious assaultive behavior, but who, in fact, would not be so involved were they released. Detention of two false positives is the cost of preventing one true positive. Kozol and his associates are, of course, fully aware of this tradeoff, and their report is a model of the careful collection of data that policy makers must have to face the difficult jurisprudential and ethical problems that underlie the proper use of imprisonment.[28]

We must not leave this area without appreciating the political danger in the current widespread acceptance of dangerousness as a justification for imposing imprisonment or as a basis for prolonging the duration of a prison term. So imprecise is the concept of dangerousness that the punitively minded will have no difficulty in classifying within it virtually all who currently find their miserable ways to prison, and, in addition, many offenders

who currently receive probation or other community-based treatments. One need not look too closely at the populations of city jails and state prisons before safely rationalizing their inclusion under the expansive rubric of "dangerousness."

Yet, it must be admitted, our inability to predict dangerousness with any acceptable measure of certainty does not alone compel the abandonment of dangerousness as a determinant of the decision to imprison. There are those, no doubt, who would accept the cost. Thus, any firm conclusion drawn from these observations on our modest capacity to predict violent behavior must await resolution of the second question addressed here— why risk any future criminality by releasing convicted criminals? My own conclusion may properly be foreshadowed: As a matter of *justice* we should never take power over the convicted person based on uncertain predictions of his dangerousness.

DESERT

The third general principle guiding the decision to imprison dictates a maximum of punishment limited by the concept of desert: No sanction greater than that "deserved" by the last crime, or series of crimes, for which the offender is being sentenced should be imposed. The principle strikes directly at the larger question I have deferred, namely, why not hold all convicted criminals until risk of recidivism is past? My answer, in part, is that the link between established crime and deserved suffering is a central precept of everyone's sense of justice, or, more precisely, of everyone's perception of injustice. To use the innocent as a vehicle for general deterrence would be seen by all as unjust, although it need not be ineffective if the innocence of the punished is concealed from the threatened group. Punishment in excess of what the community feels is the maximum suffering justly related to the harm the criminal has inflicted is, to the extent of the excess, a punishment of the innocent, notwithstanding its effectiveness for a variety of purposes.

That the concept of desert is not quantifiable and that it varies in time and place under the stress of changing circumstances does not reduce its central importance as a necessary ceiling of punishment.

PRECONDITIONS TO IMPRISONMENT

To take the matter beyond generalities and offer a more precise answer to the question of when a sentence of imprisonment may justly be imposed, we should contrast the provisions of the ALI Model Penal Code with the substantially different preconditions to imprisonment offered above.

Section 7.01 of the Model Penal Code directs the court not to sentence the convicted criminal to imprisonment unless:

(a) there is undue risk that during the period of a suspended sentence or probation the defendant will commit another crime; or

(b) the defendant is in need of correctional treatment that can be provided most effectively by his commitment to an institution; or

(c) a lesser sentence will depreciate the seriousness of the defendant's crime.[29]

Later state and federal reforms of sentencing practice have built upon, and, in varying degree, adopted these three criteria for resolving the question of whether or not to imprison.[30]

As we have seen, criterion (a) is entirely unacceptable as a matter of principle. We lack the capacity to predict dangerousness that this criterion assumes, and, even if we could predict with substantially greater precision, to take power based on such a prediction is, as discussed below, an abuse of human rights.

The second criterion—the need for correctional treatment—unambiguously accepts the worst assumptions underlying the coercive rehabilitative model. It too must be rejected as an abuse of power over the individual. "Rehabilitation," whatever it means and whatever the programs that allegedly give it meaning, must cease to be a purpose of the prison sanction. This does *not* mean that we must abandon the variety of treatment programs developed within prisons. On the contrary, they need expansion. However, it does mean that they must not be seen as purposive in the sense that criminals are sent to prison *for* treatment. We must draw a sharp distinction between the primary purposes of incarceration and available opportunities for the training and assistance of prisoners that may be pursued within those purposes.[31]

The third criterion—that any punishment other than imprisonment would not sufficiently reflect the seriousness of the defendant's crime (sometimes expressed, "that imprisonment is necessary to deprecate the crime")—has received universal acceptance, and, currently at least, provides an unavoidable justification for imprisonment. It reflects the obverse of the argument of the maximum deserved punishment as a ceiling to punishment. Retribution, socialized under the criminal law from its roots in individual vengeance, not only limits the worst suffering we can inflict on the criminal but also dictates the minimum sanction a community will tolerate. For example, the typical wife slayer convicted of murder is most unlikely to be involved in future criminality, would be a safe bet under Model Penal Code criterion (a) were it acceptable, and probably needs none of the retraining contemplated by criterion (b). Nonetheless, he cannot, as a routine matter, be put on probation or given a suspended sentence, even were a showing made that the incidence of wife slaying would not increase upon a reduction of the frequency of imprisonment of wife slayers. The criminal law has general behavioral standard-setting functions; it acts as a moral teacher, and consequently requires a retributive floor to punishment as well as a retributive ceiling.

If only one of the Code's criteria proves acceptable, what should we substitute? The three criteria I have offered could form the foundation for a

jurisprudence of the imprisonment decision for legislatures and courts that care to create a statutory and common law of imprisonment.

The first criterion derives directly from the Code and requires only brief amplification. Imprisonment should be the least restrictive punishment appropriate in a given case because any lesser punishment would depreciate the seriousness of the crime(s) committed. An example of a typical murderer has been suggested; many others come to mind based on the brutality of the crime or the particular circumstances or notoriety of the criminal. Many white-collar crimes or crimes by those in positions of public responsibility or high public office belong in this category. The criterion requires, in brief, the lowest level of clemency tolerable under current punitive mores.

My second criterion—the necessities of general deterrence and the appropriateness of this offender for deterrent purposes—finds no place in current codes but remains, in my view, inescapable.[32] For example, it forms the principle on which rests the entire structure of income tax sanctions. Not every tax felon need be imprisoned, only a number sufficient to keep the law's promises and to encourage the rest of us to honesty. Present arrangements for imprisoning federal tax offenders give an object lesson in the parsimonious application of general deterrent sanctions: Approximately 80 million tax returns were filed in 1972; only 43 percent of the 825 individuals convicted of tax fraud were jailed.[33]

General deterrent purposes are also justified in many other areas of the criminal law, although they will frequently not call for imprisonment in areas serving merely regulatory purposes. The limitation of the maximum deserved punishment for the particular offender precludes imprisonment in this context unless, of course, the violation follows repeated breaches of the law, in which event the third suggested justification of imprisonment will apply.

The third criterion for imposing imprisonment concerns cases in which lesser sanctions have frequently or recently been imposed on a given offender for earlier bouts of crime. This *faute de mieux* criterion is also subject to a retributive maximum; no repetition of the entirely inconsequential should lead to imprisonment. However, there must be a role for imprisonment if lesser sanctions have been appropriately applied and the offender comes yet again for punishment. The criminal law must keep its retributive promises, although it need not be precipitous in moving to its heavy weaponry.

These principles—the least restrictive sanction; imprisonment only when any alternative punishment would depreciate the seriousness of the crime, or is necessary for general deterrence, or when all else practicable has been applied; the whole limited by a concept of the maximum deserved punishment—offer a basis on which a rational use may be made of imprisonment.

One further comment is pertinent. No principled jurisprudence of sen-

tencing will emerge before legislatures bring order to their penal statutes or before judges routinely provide reasons for the sentences they impose. Only in this manner can the broad and detailed sweep of a common law of sentencing evolve.

Why Not Imprison All Convicted Criminals Until Risk of Future Criminality Is Past?

It was suggested above that the incarceration of persons beyond a just maximum period for the sake of preventing the future crimes of a "dangerous" minority is improper. But why should we not try coercively to "cure" criminals, either in the therapeutic sense of changing their behavior or in the sense of insulating ourselves from their future depredations? Is opposition to such cures a question of our inability to do so or an acknowledgment that it would cost too much? Or are there other reasons? Suppose we could, by an injection invented tomorrow, transform the criminal lion to the conforming lamb? For "cures" in the second sense—merely protecting the unconvicted from the convicted—we have the machinery at hand. Capital punishment is an unqualifiedly successful cure; castration, either surgically or chemically achieved, substantially diminishes rape-specific recidivism. Virtually all criminals can have their subsequent violent crime dramatically reduced by detaining them in prison until their fiftieth birthdays. Why should we not detain all predicted dangerous offenders beyond the just maximum period of imprisonment for what they have done? After all, such punishment will, as adequately demonstrated by the Kozol study, protect from serious personal injury the likely victims of at least one of each three so detained. Surely, some will no doubt argue, thus to prevent serious crime justifies protracted incarceration of those who are, after all, convicted felons.

The question pushes us to fundamentals. Is it a utilitarian issue or one of justice? The answer depends on the question's frame of reference. If the discussion of values be confined to the criminal law, surely imprisonment beyond the otherwise just punishment may be based on current predictions of dangerousness. We can in this manner prevent some serious crimes of violence—and those who pay the cost of the gradual capital punishment that is protracted imprisonment are not particularly valuable citizens anyhow. The community seems prepared to meet the relatively small costs of providing the prison cages; it seems, if anything, quite pleased to do so.

On the other hand, a different frame of reference leads to a different answer. Incarceration based on predicted dangerousness is unjust not because of a concern for the diminution of crime or the protection of prisoners. Rather, we should oppose excessive punishments because of fundamental views of human dignity. We do not suspect, we know, that respect

for the human condition requires drawing precise justifiable restraints on powers assumed over other persons. Slavery, in certain settings, provides a clearly desirable social and economic way of life—for other than the slaves. We reject it for a larger view of man and society in which we establish dogmatic prescriptions of human dignities, and, to the best of our governmental abilities, protect them. Fairness and justice in the individual case, not a generalized cost-benefit utilitarian weighing, dictate the choice.

Liberty, Rawls tells us, may only be limited in the interest of liberty itself and not for other social and economic advantages.[34] We may accept the proposition, and, with Rawls, test our principles of justice by asking whether "free and rational persons," ignorant of their own abilities and social positions and standing in what Rawls terms "the original position," would adopt minimum standards for prison and criteria for imprisonment. Rawls does not reach this question. At the "original position" he would exclude the prisoner from the group of "free and rational persons concerned to further their own interests . . . in an initial position of equality." [35] Thus, assuming the individual can by his behavior choose not to become a prisoner, one could argue that from behind "the veil of ignorance" that characterizes social contracting at the original position, no one would identify himself as a potential prisoner. No one would therefore concern himself with the presence or absence of fair and just criteria for imprisonment.

This seems a much too narrow view. I could swiftly persuade a mass of "original position contractors" (quite apart from any imprecise sentiments about "there, but for the Grace of God, go I") that they might well be born into a highly criminogenic social group—a disrupted family setting, membership within a prejudiced class with life experiences typified by fortuitous involvement in crime—bearing substantial risks of imprisonment for serious crime. Because all human behavior results from the interaction between endogeneous processes and exogenous pressures and circumstances, the blanket exclusion of prisoners from Rawls's "worst-off members of society" on the strength of a purported dominance of the individual's rationality and self-determination is unfounded. In considering prisons and prisoners from behind the veil of ignorance, therefore, we should include ourselves as potentially within the prison population; we would, in that context, subscribe to concepts of fairness and justice that preclude the sacrifice of the individual prisoner to a supposed larger social good.

Whatever my lack of clarity in relating Rawls's fundamental principles of justice to the sentencing of convicted criminals, and to the proper limits of imprisonment and prison punishments, this much seems clear: Not only lack of knowledge forces us to hesitate to impose dramatic or Draconian "cures" on criminals; basic views of the minimum freedoms and dignities rightfully accorded human beings stay our punitive hands.

Utilitarian values, of course, also limit punitive excess. Were the punishment for the most trivial crime as severe as that for the most serious any

efficacy in differential deterrence or in the moral force of the criminal law would dissipate. Nonetheless, the chief limitation remains our view of justice as fairness, according defined minimum freedoms and dignities to man *qua* man. The perception that abuse of governmental power is a central problem of the human condition and that treatment of the criminal is closely bound to that problem serves as the fundamental inhibitor of excess.

A proper cynicism about the likely abuse of power compels a limitation on maximum control over the criminal to that justified, wholly apart from considerations of curing him of his crime or protecting the rest of us permanently from future risk. We all know that if criminals are coercively cured today, the rest of us may tomorrow be regarded as in need of remedial training, both to achieve our maximum social potential and to minimize collateral injuries to others. If criminals, the mentally ill, or the retarded are subjected to coercive control beyond that justified by the past injuries they have inflicted, then why not you, and certainly me? We find ourselves in the business of remaking man, and that is beyond our competence; it is an empyrean rather than an earthly task.

NOTES

1. The proper use of rehabilitation in the prison context was fully explored by Professor Morris in the first Cooley lecture. The reader interested in a more complete exposition of Professor Morris's views may consult N. Morris, *The Future of Imprisonment* (Chicago: University of Chicago Press, 1974). For another recent view, see Lloyd Ohlin, "Correctional Strategies in Conflict," *Proceedings of the American Philosophical Society*, 118 (1974): 248–253.

2. *See, e.g.*, Singer, "Sending Men to Prison: Constitutional Aspects of the Burden of Proof and the Doctrine of the Least Drastic Alternative as Applied to Sentencing Determinations." *58 Cornell L. Rev.* 51 (1972). *Cf. Dunn v. Blumstein*, 405 U.S. 330 (1972); *Shapiro v. Thompson*, 394 U.S. 618 (1968); *Goodwin v. Oswald*, 462 F.2d 1237 (2d Cir. 1972); Wormuth & Mirkin, "The Doctrine of the Reasonable Alternative," *Utah L. Rev.* 254 (1961); Note, "Less Drastic Means and the First Amendment," 78 *Yale L.J.* 464 (1969).

3. *Model Penal Code* (Prop. Official Draft, 1962) [hereinafter *ALI Code*]. Of special interest are sections 7.01(1)(a), 7.01(2)(i), and 7.03(3). *Cf. id.*, Article 6.

4. *ABA Project on Minimum Standards for Criminal Justice, Sentencing Alternatives and Procedures* §§ 2.2, 2.3 (1968) [hereinafter *ABA Project*].

5. *President's Commn. on Law Enforcement and Administration of Justice, The Challenge of Crime in a Free Society* (1967): 141–43; *National Advisory Commn. on Criminal Justice Standards and Goals; Task Force on Corrections* (1973): 150–54 [hereinafter *Task Force on Corrections*].

6. *Robinson v. California*, 370 U.S. 660, 667 (1962).

7. *Fulwood v. Clemmer*, 206 F. Supp. 370 (D.D.C. 1962).

8. *Ralph v. Warden*, 438 F.2d 786 (4th Cir. 1970), *cert. denied*, 408 U.S. 952 (1972).

9. *See Covington v. Harris*, 419 F.2d 617 (D.C. Cir. 1969); *Lake v. Cameron*, 364 F.2d 657 (D.C. Cir. 1969); D.C. CODE ANN. § 21–545(b) (1966); "Developments in the Law—Civil Commitment of the Mentally Ill," HARV. L. REV. 1190, 1245–53 (1974).

10. A. Goldstein, A. Freud & A. Solnit, *Beyond the Best Interests of the Child* (New York: Free Press, 1973), p. 153.

11. *ALI Code, supra* n. 3, §§ 701–09.

12. *Id.* § 7.03. *See also Advisory Council of Judges of the National Council on Crime and Delinquency, Model Sentencing Act*, art. III, § 5 (1972); *ABA Project, supra* n. 4, §§ 2.5, 3.1.

An excellent guide to the literature in this area and the area of sentencing and correctional issues generally is R. Goldfarb and L. Singer, *After Conviction* (New York: Simon and Schuster, 1973).

13. "The Nondangerous Offender Should Not Be Imprisoned, A Policy Statement," *Crime & Delinquency* 19 (1973): 449.

Sometimes the same theme is developed in different and more apparently acceptable language. The American Assembly's Report on "Prisoners in America" recommended that "[h]igh risk offenders may be required to serve fixed periods of time. Low risk offenders should be released to community-based programs as soon as feasible." *Report of the 42d American Assembly* 7 (December 17–20, 1972). For the background reading to this report see *Prisoners in America* Lloyd Ohlin, ed. (Englewood Cliffs, N. J.: Prentice-Hall, 1973).

14. *Task Force on Corrections, supra* n. 5, p. 150.

15. *Id.,* p. 155–157.

16. *E.g.,* Ill. Rev. Stat. ch. 38, § 1005–6–1 (1973); N.Y. PENAL LAW § 65.00 (McKinney Supp. 1973).

17. *See National Commn. on Reform of Federal Criminal Laws, Study Draft of a New Federal Criminal Code* § 3202(5) (1970) [hereinafter *Study Draft*].

18. See generally Cohen, "Administration of the Criminal Sexual Psychopath Statute in Indiana," *Indiana Law Journal* 32 (1957):450; Granucci and Granucci, "Indiana's Sexual Psychopath Act in Operation," *Indiana Law Journal* 44 (1969):555; Hacker and Frym, "The Sexual Psychopath Act in Practice: a Critical Discussion," *California Law Review* 43 (1955):766; Swanson, "Sexual Psychopath Statutes: Summary and Analysis," *Journal of Criminal Law, Criminology and Police Science* 51 (1960):215; Tappan, "Some Myths about the Sex Offender," *Federal Probation* 19 (1955):7; Note, "Out of Tune with the Times; the Massachusetts SDP Statute," *Boston University Law Review* 45 (1965):391; Note, "The Plight of the Sexual Psychopath: a Legislative Blunder and Judicial Acquiescence," Notre Dame Lawyer 41 (1966):527; Note, "The Illinois Sexually Dangerous Persons Act," *University of Illinois Law Forum* (1966):449; Comment, "California's Sexual Psychopath—Criminal or Patient?" *University of San Francisco Law Review* 1 (1967):332.

19. *Task Force on Corrections, supra* n. 5, at 156.

20. 383 U.S. 107 (1966).

21. *See also Carroll v. McNeill,* 294 F.2d 117 (2d Cir. 1961), *vacated,* 369 U.S. 149 (1962).

22. Steadman & Halfon, "The Baxstrom Patients: Backgrounds and Outcomes," *Seminars in Psychiatry* 3 (1971):376, 384. The findings are updated in Steadman & Keveles, "The Community Adjustment and Criminal Activity of the Baxstrom Patients: 1966–70," *American Journal of Psychiatry* (1972):304. See also Henry J. Steadman and James J. Cocozza, *Careers of the Criminally Insane* (Lexington, Mass.: Lexington Books, 1974).

23. Kozol, Boucher & Garofalo, "The Diagnosis and Treatment of Dangerousness," *Crime and Delinquency* 18 (1972):371.

24. *Id.* at 389.

25. The figures "1M" and "2M" in the violent crime column refer to one murder and two murders, respectively.

26. The results here are far superior to parole boards' capacity to predict violence on parole. Two recent studies from the California Department of Corrections research group by Doctor Wenk and his associates should give pause to any member of a parole board who has confidence in his capacities as a seer of future violent crime. The effort by this skilled group to develop a "violence prediction scale" for use in parole decisions resulted in 86 percent of those identified as potentially dangerous failing to commit a violent act (more accurately, to be detected in a violent act) while on parole. *See* Wenk, Robison & Smith, "Can Violence be Predicted?" *Crime and Delinquency* 18 (1972):393 and the excellent study of this problem by Geis and Monahan, "The Social Ecology of Violence," soon to be published in *Man and Morality* (T. Lickona, ed.).

27. More than 34 percent of the "Violent" group were reportedly involved in violent assaultive behavior. This compares to an incidence of such behavior among the "Safe" group of slightly more than 8 percent.

28. A vigorous reanalysis of the implications of the Kozol study is being pursued by Doctor Kozol, Professor Alfred F. Conrad of The University of Michigan Law School, Professor Franklin E. Zimring of The University of Chicago Law School, and the author. It threatens to produce another methodological article on the predictability of dangerousness. At issue are (a) the implications of the nonrelease of certain offenders, not included in the study, who were

classified as dangerous by Doctor Kozol and his associates, and (b) the appropriate attribution of unreported or undetected crimes to those described in this text as the subjects of false positive predictions of violence.

29. *ALI Code, supra* note 3.

30. *See, e.g., Ill. Rev. Stat.* ch. 38, § 1005–6–1 (1973). *See also Study Draft, supra* note 17, § 3101.

31. *See* note 1 *supra*.

32. *See generally* F. Zimring & G. Hawkins. *Deterrence: The Legal Threat in Crime Control* (Chicago: University of Chicago Press, 1973).

33. The conviction figures include convictions after trial as well as pleas of guilty and nolo contendere. 1972 Commissioner of Internal Revenue Annual Report, pp. 18–19.

34. J. Rawls, *A Theory of Justice* (Cambridge, Mass.: Belknap Press, 1971), p. 244. The reader unacquainted with Rawls's theory may be assisted by a summary of his "Main Idea," and of his view that liberty may be limited only for the sake of liberty. Such summarization is a task not to be attempted without an intellectual safety net. So, let me offer the words of H.L.A. Hart:

> [P]rinciples of justice do not rest on mere intuition yet are not to be derived from utilitarian principles or any other teleological theory holding that there is some form of good to be sought and maximised. Instead, the principles of justice are to be conceived as those that free and rational persons concerned to further their own interests would agree should govern their forms of social life and institutions if they had to choose such principles from behind "a veil of ignorance"—that is, in ignorance of their own abilities, of their psychological propensities and conception of the good, and of their status and position in society and the level of development of the society of which they are to be members. The position of these choosing parties is called "the original position."

Hart, "Rawls on Liberty and Its Priority" *University of Chicago Law Review* 40 (1973):534, 535. "[L]iberty is given a priority over all other advantages, so that it may be restricted or unequally distributed only for the sake of liberty and not for any other form of social or economic advantage." *Id.* at 536.

Specifically, Rawls considers:

> strict compliance [or ideal] as opposed to partial compliance theory The latter studies the principles that govern how we are to deal with injustice Obviously the problems of partial compliance theory are the pressing and urgent matters. These are the things that we are faced with in everyday life. The reason for beginning with ideal theory is that it provides, I believe, the only basis for the systematic grasp of these more pressing problems.

J. Rawls, *supra,* at 8–9. I am, therefore, encouraged—with confidence in the value of the inquiry if not in the precision of the argument—to suggest that the same principles that move beyond utilitarian analysis in the assessment of justice in strict compliance legal theory are also applicable to criminal punishments.

35. J. Rawls, *supra* note 34, at 11. He therefore does not reach the issue of the prisoner's relationship to "justice as fairness."

24: Nordic Criticism of Treatment Ideologies

/ Norman Bishop*

Until fairly recently the Nordic countries did not differ greatly from many others in believing that a substantial proportion of offenders, more especially those deprived of their liberty by some form of imprisonment, were in need of "treatment." The rationale for this belief has been derived basically from the fields of biology, medicine, and traditional psychiatry. Offenders have been seen as being in some way sick or psychologically inadequately developed. These deficiencies on the part of the individual "explain" his inadequate social development and, it is held, his tendency to commit offences. The cure, at least in theory, consists in providing treatment using expertise from medicine, psychology, and psychiatry. In practice however the treatment philosophy has led more to diagnostic activity and clinical examination, rather than elaborate attempts to treat the individual offender.

A consequence of the treatment philosophy approach has been that special sanctions, usually of indeterminate length, have been instituted so that there should be adequate time for treatment and so that, as with classical psychoanalysis, it could be terminated at what the treaters regarded as the optimum moment. This has led in its turn to special institutions for the treatment of special categories of offenders, notably youth offenders, psychopaths and multi-recidivists. Historically the administration responsible for the treatment has been given considerable power over such prisoners, especially in deciding the matter of their release.

The complex of ideas and practice summarily described above is known for short in the Nordic countries as the "treatment ideology." It has had a long and powerful influence on correctional practice. It greatly influenced the Swedish legislators in the drafting of the Swedish Penal Code, which entered into force as late as 1965. But, it is increasingly coming to be recognized that the treatment ideology was accepted too readily and too optimistically. In fact it has come to be the object of some important objections and, in the Nordic countries, it has come to be increasingly questioned and attacked. These attacks have already produced important

* Norman Bishop, "Beware of Treatment," in Erland Aspelin et al., eds., *Some Developments in Nordic Criminal Policy and Criminology* (Stockholm: Scandinavian Research Council for Criminology, 1975), pp. 19–27. Reprinted by permission of the Scandinavian Research Council for Criminology and the author.

changes of emphasis in correctional practice in all the Nordic countries. I shall describe some of the more important reasons for the attack on the treatment ideology and some of the more important consequences. The difficulties which have been experienced in relation to the treatment ideology have been the consistently negative results of treatment revealed by research studies and unfairness, even injustice, occurring as a result of the attempt to treat.

Research Findings

Research on treatment results can be variously undertaken. Sometimes a comparison of treatment results means comparing the results after quite different sanctions such as imprisonment and probation. Sometimes treatment comparisons have meant comparing results from broadly the same kind of sanction but carried out in different ways, e.g., one form of imprisonment with fixed sentences is compared with another using indeterminate sentences. Sometimes studying treatment results means ascertaining the results of methods whose use is believed to bring about some change in personality or behavior, e.g., group counseling, vocational trade training, work programs, etc. The most important studies in the Nordic countries are probably of the first two kinds.

As long ago as 1966, Börjeson undertook a study in Sweden to measure the relative effectiveness of youth imprisonment—an indeterminate sanction—as against nonimprisonment used with 416 persons between eighteen and twenty years of age.[1] He used a statistical predictive instrument which permitted him to arrange his subjects in risk categories for purposes of comparison. The main result, in his words, was "a distinct and statistically demonstrated difference between the individual preventive effects in favor of nonimprisonment. When people in the age groups we are concerned with are sentenced to imprisonment the first or second time that they come in contact with the criminal justice system, they are also sentenced to a less probable readjustment." Börjeson's study, it can be seen, was of the kind where the two kinds of "treatment" compared were two different sanctions.

There have also been studies comparing different ways of carrying out somewhat similar sanctions to see if there are any differences in results. Thus Uusitalo [2] studied the effects of imprisonment in Finland using natural variations in the system. During the years 1949–50 a number of offenders deprived of liberty who ordinarily would have been sent into "work camps" were instead sent to ordinary prisons. The work camps were based on the idea of offenders doing necessary work for free community, e.g., road building, and were essentially free from the traditional re-

straints and controls used in prisons. Guards were few, the camps were open, there was no censorship of letters, etc. Uusitalo compared results with traditional imprisonment effects using a predictive instrument. He found no essential differences in the recidivism rates of the work camp and prison populations.

Christiansen, Moe, and Senholt [3] working in Denmark have recently published a detailed study comparing recidivism in relation to special institutions for psychopaths, ordinary prisons (fixed sentences), and internment prisons (indeterminate sentences). The internment prison sentences had a median length of thirty-two months as opposed to twelve months for the other two types of prison. The research workers have attempted to hold the varying risks for subsequent reconviction of the different groups of subjects under control by constructing a prediction instrument. Using discriminant analysis methods they then compared the results for their 479 subjects. For the 208 offenders distributed in prediction groups 1–4 (more favorable prognosis), the special psychopathic institution had the highest recidivism rates, 52 percent. The other types of prison were around 34 percent. For the prisoners in prediction groups 5–8 (least favorable prognosis), one internment prison was slightly lower in its recidivism rates than an ordinary prison, a special psychopathic institution or the other internment prison. Rates were 73, 85, 80, and 80 percent, respectively. The research workers hold that it has not been to demonstrate any real differences in the effect of these sanctions in favor of treatment-oriented institutions.

Hansson [4] in Sweden made a two-year follow-up study of 450 persons sentenced to conditional sentence (suspended sentence without supervision), probation, and probation with institutional treatment. This last sanction is for persons older than eighteen years and permits the court to order one or two months in an institution as a preliminary to probation proper. Until January 1, 1974, there were special institutions set aside for this sanction. They were supposed to give special attention to the offender's personal and social difficulties so that he could subsequently make the best possible use of his probation period. Hansson measured recidivism by new crime serious enough to be centrally registered by the police over the two follow-up years. The recidivism figures for conditional discharge, probation and probation with institutional treatment were 12, 30, and 61 percent, respectively. He also divided his offenders into different risk groups each having a different probability of recidivism, and then examined recidivism for similar risk categories under the different sanctions. There is little to say about conditional discharge. The categories of offenders selected by the courts for this sanction were clearly much better risks than those who got probation or probation with institutional treatment. But for these two latter sanctions, the overlap in risk groups was considerable. Hansson's findings, however, were that for the same risk categories there was signifi-

cantly higher recidivism associated with probation preceded by institutional treatment.

The foregoing represent some examples of Nordic studies. But in Scandinavia we have also been aware that many similar studies have been conducted elsewhere. Those available which have satisfactory standards of scientific rigor are most often to be found in American and English research. Space does not permit a recapitulation of these studies here. The reader is referred instead to the available summarizations of this research.[5] It suffices to say here that the overwhelming majority of well-conducted investigations has failed to detect positive treatment results arising from methods applicable to the general run of offenders. Such positive results as exist would appear to be limited to marginal groups of offenders. Why is it that when for several decades there has been a widespread belief in the efficacy of treatment that positive results are so hard to come by?

In most of the thinking which has characterized the treatment philosophy there has been a marked tendency to assume that penal treatments, however defined, are standardized and specific. This also follows from the medical framework so that penal treatment has been thought of as being like surgery or the use of antibiotics. Some standardized technique is assumed to be available which will "cure" the offender. But in fact penal treatments are not analogous to standardized antibiotic treatments or the precise interventions of surgery since they do not exist in some "pure" form. They are mediated by many different kinds of persons in many different environments. These complex interactions between offenders and those who in some way "treat" them as well as the influence of the social environment have been for too long ignored. Especially with regard to prison treatment the predominant influence of the prison environment would appear to be not only a complex matter but also one working against any positive effect. There is now a comprehensive research literature which shows the major experienced impact of the various forms of incarceration to be negative. Two of the best known Nordic studies have been the ones carried out in Norway by Thomas Mathiesen [6] and in Sweden by Ulla Bondeson.[7] The latter studied a range of institutions—youth reform schools, youth prisons, ordinary prisons, and internment prisons. All appeared to reinforce alienation, apathy, and a negative self-image as well as making identification with a criminal way of life easier, not harder, to accept. These findings are in line with those of many other studies.

One further group of studies has had a significant effect on Nordic attitudes to the treatment ideology. These are studies of unrevealed criminality. A series of such studies [8] has been conducted in the Nordic countries and they have confirmed that a considerable amount of crime which cannot be considered trivial is committed by perfectly ordinary persons who are never detected. The studies seriously undermine one of the basic original propositions in the treatment ideology, namely that the commission of crime is abnormal and requires "treatment." On the contrary there is now

every reason to suppose that many quite serious forms of crime (for example tax fraud) are, under certain environmental circumstances committed by quite normal people. This fact suggests that other measures than "treatment" appear to be called for.

Another Objection to the Treatment Ideology

Quite apart from the influence of studies of hidden criminality—which suggest that the commission of crime often cannot be considered abnormal—and the effect studies—which suggest that there are no generally demonstrated positive treatment effects—other currents of thoughts have led to criticism of the treatment ideology. In the first place it is pointed out that most of the treatment given to offenders is coercive in character. In this way it is different from the treatment given by a doctor to a patient. A person suffering from some illness ordinarily does not have to be coerced into following a prescribed treatment—he seeks treatment and follows it *voluntarily*, that is, there is no conflict of interest between the doctor and his patient. This is not true of the offender and his treatment, especially where imprisonment is concerned. What the authorities want and permit, conflicts sharply with what inmates want and what they think should be permitted. And in testing whether the authorities' claims are unreasonable and should therefore be changed, inmates are in a weak bargaining position. Prison treatment has not seldom been carried out without due regard for adequate legal safeguards for the rights of the offender. In particular there has been a tendency to use indeterminate sanctions for recidivists who can then spend long periods deprived of liberty even though the offence giving rise to the indeterminate sanction may have not been especially serious.[9] Straightforward punishment would often have resulted in a less severe deprivation of liberty.

Alternative Aims

The foregoing presents in highly summarized form the main objections to basing penal policy on a treatment ideology derived from an essentially medical framework. A preoccupation with trying to provide treatment means that important aims of criminal policy tend to be ignored. Among these aims are those of deterring others from crime, expressing and satisfying public ideas of justice, and providing for the adequate protection of society from serious criminality. But it should be emphasized that to point to these aims and to give up the notion that most offenders are sick is not

to say that offenders should instead be dealt with inhumanely and harshly. The first step is to try to avoid harmful and damaging effects from punishment to the greatest possible extent. This argues for using penalties which do not involve lengthy incarceration wherever possible. And for all offenders, whether incarcerated or not, it is essential to realize that they, like many persons not officially registered as criminal, have problems in living. It is a humane and ethical duty to provide help for such problems. And extending offers to help offenders in this way by, for example, ensuring they have adequate housing, work, enough money to live on, etc., does not have to be justified by being able to point out reduced recidivism rates. On the other hand, access to more satisfying ways of life may lead to a reduction of criminal behavior. Thus Christiansen and Berntsen report an experiment with serious offenders in a large Danish prison which offered intensive social work assistance to the experimental group but not to a control group.[10] A statistically significant reduction in recidivism was secured in the experimental group. Somewhat similar results are reported from two recent English studies.[11]

It can be said therefore that renunciation of the treatment ideology leads to a more honest acceptance of the fact that the basis of the criminal justice system is the provision of penalties for punishable acts rather than the provision of coercive treatment for character deficiencies. But offenders need social help and even on occasion medical or psychiatric treatment— and they are entitled to these forms of assistance on the same basis as other critizens. It is possible—though not conclusively proven—that comprehensive or continuing help may enable offenders to take up new rôles in society and reduce dependency on excessively deviant ways of life. The concept of the once-for-all treatment intervention, akin to surgery or a course of antibiotics, is replaced by the notion of providing opportunities for personal development. Much behavior is explained by the situational factors which operate "here and now" on individuals. In the present state of knowledge it appears to be worth trying to influence not just the individual but the social situation he is in. These more modest but probably more realistic aims in respect to offenders are already acquiring some expression in Nordic correctional policy and practice.

New Emphases in Nordic Practice

In Denmark the indeterminate sanction of youth imprisonment has been abolished. The courts now pass sentences on young offenders which, if they do involve imprisonment at all, are of determinate length. In Sweden the minister of justice has stated his intention to abolish youth imprisonment as an indeterminate sanction in the near future. A committee has

been set up to recommend alternative ways of handling young adult offenders which will ensure that their penal situation shall not become more severe as a consequence of the abolition of this special sanction. Norway is likely to take the same steps in the near future.

Hitherto in Denmark serious recidivists have been regarded as socially dangerous and dealt with by an indeterminate internment sanction. As a result of new proposals the grounds for using the internment sanction are sharply limited. Only those offences which represent a clear, serious danger to the community can be dealt with by internment. Serious recidivism with regard to property offenses, for example, will not result in internment but in a determinate sentence passed by the court.

In Finland a governmental committee presented a report in 1972 on conditionally suspended sentences and conditional release from prison. So far as suspended sentences are concerned, the committee has recommended that a distinction be made between control measures, such as reporting, which can be coercive, and treatment or social help measures, which must be offered for voluntary acceptance. Such treatment or help shall moreover be provided through the general social services available to society at large. The committee has also proposed a new sanction to be used where the general deterrence aspect is considered sufficiently important to warrant punishment.

But the proposed new sanction, called "punitive supervision," will not involve any form of imprisonment. Essentially it means that the offender must report to the police two or three times a week. The sanction, as already stated, is primarily punitive and a firm warning. Its duration is from three to nine months, and if it is used in combination with a suspended sentence it can only be for three months. So far as imprisonment is concerned the committee has recommended that release shall occur after half the sentence has been served, or after three months, whichever is the longer. Parole supervision as such, it is proposed, should be abolished since, in the committee's view, parole supervision is no treatment but little more than a continuation of punishment lacking in real significance both for the provision of help as well as the prevention of further criminality. The committee recommended that intensive contact with prisoners be undertaken by appropriate agencies during the period of actual imprisonment with a view to offering social support and help after imprisonment on a voluntary basis. This assistance would be organized through other agencies than the correctional administration.

In Sweden a parliamentary committee presented a report in 1972 [12] which provided entirely new guidelines for Swedish correctional practice. One of the basic conclusions of this committee was that there was so little certainty about the need for and effects of treatment that it was not possible to attempt to base correctional practice on the notion of providing treatment. Instead the committee urged that the first step was greatly to

improve the quality of practical help given to offenders and especially those serving sentences of any form of imprisonment. In general this practical help was to be provided through the ordinary social services available to everyone. The probation service was to put offenders in touch with the services or agencies needed. About half of all prisoners, it was estimated, could serve their sentences in small community-based prisons close to their homes under regimes of openness and flexibility. Practical preparations for work, housing, etc., in good time before release would thus be possible and contact with families and significant others facilitated. Other prisoners—usually presenting serious escape or other risks to society—would serve most of their sentences in national prisons but with a terminal period of four months in community-based prisons. New and much smaller regions were proposed for correctional administration which would approximate county organization for social services and thus facilitate contact with the latter. The committee's proposals were accepted by parliament and those relating to the handling of prisoners found expression in a new law which entered into force on July 1, 1974. During the period 1974–78 a major reorganization of the correctional services will take place in order to implement the proposals outlined above.

NOTES

1. Bengt Börjeson, *Om påföljders verkningar* (with English summary) (Stockholm: Almquist and Wiksell 1966).

2. Paavo Uusitalo, *Vankila ja työsiirtola rangarinstuksena,* (Helsinki, 1968).

3. Karl O. Christiansen, Mogens Moe, and Leif Senholt, *Effektiviteten af forvaring og saerfaengsel m.v.,* Betaenkning Nr. 644 (Copenhagen: Statens Trykningskontor, 1972).

4. Thomas Hansson, *Villkorlig dom, skyddstillsyn och skyddstillsyn med anstaltsbehandling* (Lund: Sociologiska Institutionen, Lunds Universitet, 1971). (stenciled report.)

5. Good summaries are to be found in the following: W. Bailey, "Correctional Outcome: an Evaluation of 100 reports," *Journal of Criminal Law, Criminology and Police Science,* 57 (1966). R. G. Hood and R. F. Sparks, *Key Issues in Criminology,* (London: Weidenfeld and Nicholson, 1970); C. H. Logan, "Evaluation Research in Crime and Delinquency: A Reappraisal," *Journal of Criminal Law, Criminology and Police Science* 63 (1972); R. Martinson, "Correctional Treatment: an Empirical Assessment," available from the Academy for Contemporary Problems, Columbus, Ohio, 1973; and D. Ward, "Evaluative Research for Corrections," in Lloyd Ohlin, ed. *Prisoners in America* (Englewood Cliffs, N.J.: Prentice-Hall, 1973).

6. T. Mathiesen, *The Defences of the Weak* (London: Tavistock, 1965).

7. U. Bondeson, *Fången i fångsamhället* (with lengthy English summary) (Stockholm: Norstedt, 1974).

8. Among these studies are: I. Anttila and R. Jaakkola, *Unrecorded Criminality in Finland,* (Helsinki: Kriminologinen Tutkimuslaitos, 1966); N. Christie, J. Andenaes, and S. Skirbeckk, "A Study of Self-Reported Crime," in *Scandinavian Studies in Criminology,* vol. 1 (London: Tavistock, 1965); K. Elmhorn, "Self-Reported Delinquency in School Children," in *Scandinavian Studies in Criminology,* vol. 1 (London: Tavistock, 1965); Ragnar Hauge, *Kriminalitet som ungdomsfenomen* (Oslo: Universitetsförlaget, 1970); B. Olofsson, *Vad var det vi sa!* (Stockholm: Utbildningsförlaget, 1971); L. Persson, *"Den dolda brottsligheten,"* Kriminalvetenskapliga Institutet, University of Stockholm 1972; and B. Werner, "Den falska brottsligheten," in *Nordisk Tidskrift for Kriminalvidenskab,* parts 1 and 2 (Copenhagen, 1971); and V. Greve, "Our Non-Deviant Criminals," in *Scandinavian Studies in Criminology,* vol. 5 (London: Martin Robertson, 1974).

9. I. Anttila, "Conservative and Radical Criminal Policy in the Nordic Countries," in *Scandinavian Studies in Criminology*, vol. 3 (London: Tavistock, 1971); I. Anttila, "Incarceration for Crimes Never Committed," Research Institute of Legal Policy (Helsinki, 1975); and W. H. Hammond and E. Chayen, *Persistent Criminals* (London: Her Majesty's Stationery Office, 1963).

10. K. O. Christiansen and K. Berntsen, "A Resocialization Experiment with Short-Term Offenders," in *Scandinavian Studies in Criminology*, vol. 1 (London: Tavistock, 1965).

11. M. Shaw, *Social Work in Prison* (London: Her Majesty's Stationery Office, 1974).

12. The new law, translated into English and Finnish, can be obtained from the National Correctional Administration, Box 12 150, 102 24 Stockholm 12, Sweden.

25: Conservative and Radical Criminal Policy in the Nordic Countries / *Inkeri Anttila**

When I use the designations conservative and radical, I do not allude to the meaning these terms had in textbooks on criminal law in my youth. At that time, the old, 'classical' criminal law was conservative, while, for example, von Liszt's criminologically oriented school was considered radical.

By the antithesis conservative-radical, I mean, in this connection, a difference of opinion concerning the rapidity with which institutions, opinions, legal systems, and attitudes shall be changed.

Everyone agrees that society is changing; everyone is also agreed in principle that criminal policy should be adjusted to meet these changes. However, some consider that we must be careful not to make errors relating to the means of criminal policy and that we must be extremely careful in regard to its goals. Another group wants criminal policy to quickly assimilate the knowledge that, for example, criminological research can offer, and requires that we must not let a sluggish and ill-informed public opinion exert influence.

With this as a point of departure, I will first briefly glance at developments during the last decades and then look ahead.

* Inkeri Antilla, "Conservative and Radical Criminal Policy in Nordic Countries," *Scandinavian Studies in Criminology*, vol. 3 (Oslo: Universitetsforlaget, 1971), pp. 9–21. Reprinted by permission.

Treatment Ideology's Breakthrough

First a backward glance. If we ask what has been the essential line of development in recent decades, it would seem reasonable to point to the breakthrough of treatment ideology. One can actually speak of a break-through—at least if we consider the entire area of society's programming for asocial behavior. It is not long since the nature of the offense committed, regardless of the individual characteristics of the criminal, determined the nature of the punishment. In nineteenth-century England, small children, guilty of petty theft, were imprisoned for years or deported. Then came the reaction, with its insistence on consideration for the characteristics of the individual. Young children should be educated not punished. Children, the insane, and the mentally retarded were the groups one first attempted to save from the threat of legal punishment and turn over to the physician's and the educator's protective hand. With the rising level of knowledge, qualitative classifications have changed to quantitative ones. We begin to ask whether it is meaningful to divide criminals into those to be punished and those to be treated; is it not more correct to seek an optimal balance between treatment and punishment?

Treatment—that has been equated with medical treatment.[1] Criminal psychiatrists found it natural to adhere to the same classification as they used in classifying their patients in need of care. This classification determined society's measures, and the manner of treatment. It is at this stage that psychiatrists come to the fore and begin to compete with lawyers for the role of society's criminal experts. One of medical treatment ideology's most extreme manifestations is expressed in the term "the asocial or antisocial psychopath," and in the demand for the establishment of special institutions for the treatment of psychopaths.

This new ideology naturally encouraged, in several ways, a sympathetic attitude towards criminals. However, increased understanding does not always mean more humane measures—from the criminal's point of view. The desire to force the nonconformist to behave normally, to behave like other people, can be as strong in the criminal psychiatrist as in the classical school's penal lawyer—at times even stronger. The individual must, at any price, even, if necessary, by means of intensive electroshock therapy or lobotomy, be molded to adjust, that is to say, to behave according to the norms of the majority. The nonconformist should receive treatment—in principle, until he conforms, has adjusted. And if it does not appear possible to adjust him, then he is to be subjected to treatment throughout his whole life.

The care afforded was, by its very nature, a coercive care. If his stay at the institution for psychopaths did not make a thief stop stealing, then, according to this ideology, he must be kept at the institution for psychopaths year after year, or even decade after decade. Purely medically ori-

ented treatment ideology had gradually taken on elements of practical so-
cial work and psychology, but, basically, the same ideology lies behind
institutions for psychopaths, schools for juvenile delinquents, workhouses
for vagabonds, alcoholic homes, and institutions for the incarceration of
habitual criminals.

Conventional prisons have also been reorganized so as to afford treat-
ment: more psychologists, psychiatrists, and social workers are hired. This
does not involve any important fundamental change as long as the point of
departure is still that while the lawbreaker is in prison he must be treated.
The nature of the punishment and the duration of the imprisonment is still
decided on the same grounds as earlier, even though we try to lessen the
negative effect of institutionalization by varying types of treatment.

From the standpoint of treatment ideology such a narrow framework for
treatment is, of course, unsatisfactory, and representatives of this ideology
have consistently stated that treatment attitudes should also decide the
nature and type of the punitive measures, including, inter alia, the decision
as to whether the subject shall be deprived of his freedom or not, and how
long he shall be kept imprisoned. It is proposed that the individual need for
care should be the decisive criterion in determining the measures adopted
by society.[2]

Criticism of Treatment Ideology

The advocates of treatment ideology have waged a hard battle for their
opinions and they have not lacked critics. Those who believe in a deterrent
penal policy have consistently warned of the treatment-ideology's destruc-
tive influence on respect for society and its threat to general law-abidance.
However, treatment ideology is also criticized on entirely different prem-
ises. Little by little the threat that this ideology implies for legal safeguards
has become evident, particularly if it is pushed to the extreme.

Warning voices have been heard earlier, but, in the Nordic countries,
criticism first became a central issue in public discussion in the 1960s. The
fact that the reaction from the defenders of legal safeguards came so late is
partly due to lack of objective data on the efficacy of treatment methods
and partly to the misleading nature of the very terminology, with its hu-
mane-sounding words, care, treatment, therapy. These conceptions suggest
associations with somatic medicine, the application of which has been rela-
tively successful, and in which there is usually no conflict of interest be-
tween the patient and the doctor. The fact that the conflict of interests was
not always observed, or that its existence was not admitted, is also due to
the fact that the interpreters and critics of the law often drew their conclu-
sions one-sidedly according to the motives for the treatment measures. The
fact that the lawmaker in his preparation of the law, or the law enforcement

agency in its reasons for a certain decision, has stated that it is a question of bestowing an advantage or providing assistance has at times been taken as sufficient proof that no conflict of interests exists.

The realization that a meaningful analysis of legal safeguards must be based, first of all, on how the individual experiences law enforcement and not on how the law enforcement officers do, has come rather late.[3]

The point of departure for the legal safeguards debate in the 1960s was perhaps particularly Nils Christie's book on the care of alcoholics in Norway.[4] Christie pointed out that, under the name of treatment and help for alcoholics, deprivation of freedom is used in a way which is reminiscent of punishment by deprivation of freedom and is just as ineffective in curing alcoholism. The client has even fewer legal safeguards than the prison convict, for the very reason that the measure is not called imprisonment.

How little the external form of the institution influences the effectivity of the punishment is made clear in a striking way by Paavo Uusitalo's investigation of the Finnish work colonies.[5] For labor market reasons, work colonies were not used for a short period in the late 1940s, and the types of prisoner that had been placed in a colony had to serve their sentence in prison. Inasmuch as the work colony is a completely open institution, without walls, iron bars, or wardens, where the internees perform ordinary labor for wages available on the open market, it was believed earlier, in Finland, that the risk of recidivism would be quite different than for those committed to the traditional type of prison. There were, it is true, differing opinions on the manner in which recidivism would vary. Supporters of deterrent and severe punishment were convinced that prisoners who served their sentence in work colonies would recidivate to a greater extent than the others—the punishment had not contained any lesson for them when the punishment situation, to so large an extent, resembled their normal life. Supporters of a prison system based on individual-psychological principles were, of course, of the opposite opinion: inasmuch as the social pressure is less in a completely open institution, the "prisonization"—adjustment to the institution milieu—would be less pronounced and the prisoners less apt to be influenced by their fellow prisoners. Finnish criminologists believed generally—in accordance with the common ideology in Nordic criminology at that time—that the investigation would show that open institutions were not only cheaper and more humane but also best suited to reduce the risk of recidivism. The results from both points of view were negative. When one compared recidivism in similar groups from the colony and the prisons, no essential difference was revealed. This result can perhaps best be interpreted as a confirmation of Börjesen's observations in Sweden, to the effect that the deprivation of freedom is, in itself, of decisive significance.[6] The way in which the deprivation of freedom is effectuated is perhaps, in spite of everything, of less importance for recidivism than is generally believed.[7]

The critical opinions on individual prevention in the prison system that I

have discussed can appear destructive and overly pessimistic from the point of view of the prison personnel. Are, then, all individual treatment, group work, and other things we have learned, in vain? They are not! In the first place, what I have said concerns the average criminal; I do not want to question that there are considerable groups among prisoners for whom group therapy and all the many treatment measures can appreciably influence the risk for recidivism. To identify these groups with certainty can be difficult. But there are other sides to this case. We can, surely, introduce ordinary humane elements into the treatment of prisoners—the complaint against large, closed institutions, that they create a neurosis and contribute to "prisonization," carries particular weight. Such measures do not need to be defended by more or less uncertain speculations as to whether neurosis and malcontentment are important recidivism-influencing factors. Furthermore, even if it were mainly for general-preventative reasons that we put criminals in prison, it is justifiable and reasonable that the prison should have at its disposal psychiatrists, psychologists, and social workers, not to cure these people of their criminal tendencies, but to help them to bear the mental-hygienically oppressive prison existence, and to ease their mental and social situation. I maintain that it can prove dangerous for prison authorities to defend the existence of the treatment personnel solely by referring to their supposed effect on crime prevention. To base everything on this motivation can lead to bitter disappointments when better statistical calculation methods and systematically controlled experiments offer data on how large—or small—this crime prevention effect actually is in the case of the average criminal.

Those who have begun to doubt the suitability of the analogy between criminals and the sick have received support from observations outside of the institutions. Studies of hidden criminality have, in many ways, brought about a revolution in criminology. The investigations that have been made among youth in the Nordic countries have, above all, shown that it is statistically normal to break the law. The average citizen has clearly been guilty of a number of major or minor crimes in his youth, perhaps also later. The crime has usually been mild but a considerable number of them have been so serious that, if discovered, they would have led to imprisonment. (I am here thinking of conditions in Finland.) But the interesting fact is simply that so few were discovered: in the investigations made in Finland only 2 to 5 percent of the lawbreakers in the types of crime investigated. These results give the hypothesis of the typical criminal as a psychologically disturbed or sick person a blow. It is, naturally, true that those who have committed several crimes have been discovered more often. But it is clear that there is not a complete correlation between the intensity of the criminal activity and the risk of discovery. There are, in other words, many other factors than the seriousness of the crime that lead to certain people being registered as criminals by the authorities; it is, for example, possible that lower social position and lower education increase the possi-

bility of committed crimes being discovered by the authorities.[8] In the light of these results it would seem questionable whether the average registered criminal should, without exception, be termed sick if we wish to retain a meaningful conception of sickness.

In his analysis of the sickness concept, Patrik Törnudd [9] claims that the best way out of the present conceptual confusion would be to completely discard the sickness concept itself and all related terminology and rather begin to use the strictly value-neutral expression "susceptibility to medical manipulation" or, in concrete situations, "specific susceptibility to medical manipulation." The assertion that, for example, a disposition for sexual relations outside of marriage, reckless driving, or sympathizing with a particular political party is something that can be regulated by medical manipulation, contains no recommendation for *the use* of this method. Such a sharply drawn line between social and individual value goals and the instruments used to reach these goals, should, in a decisive manner, raise the level of the discussion in speaking of predictability in penal law, as well as in speaking of social treatment measures for nonconformists. The present psychiatrically influenced terminology that is used in criminal-political debates and by representatives of, for example, officials of social institutions, is, with its concealed or half-conscious value-burden, a hindrance for a rational debate, and, not least important, a danger for legal safeguards.[10]

To summarize what I have said so far: treatment ideology in the Nordic countries has made a breakthrough insofar as the social control of criminals and other nonconformists is concerned. Treatment ideology's equating of criminals and the sick was, in the beginning when the ideology was still weak, often devoted to humanizing actual criminal care. But, as treatment ideology has increasingly dominated the system and as treatment personnel have gained increasing power, the negative sides of the ideology have become more evident and the criticism against treatment ideology has grown sharper. The parallel of the criminal-sick appears to be false, if one looks for effectivity of treatment and for the absence of a conflict of interest between the doctor and the doctored. This has led to an acute legal safeguards problem because of the absence of predictability and the absence of proportion between the seriousness of the crime and the strictness of treatment.

Who Is a Radical Today?

This has disturbed many advocates of reform. It has been customary to make a stand against the representatives of general prevention: it has been customary to see treatment as the alternative to punishment, as the substitute for punishment in the near future. The problem of the efficacy of

criminal care has been seen as a question of a lack of psychiatrists, institutional planning, and education of prison personnel. Now the avant garde position has become more complicated. Some of those who have previously considered themselves radical in their demands for a constantly more treatment-oriented criminal policy, have now noticed that, in the eyes of other radicals, they are now perhaps almost conservative, in that they defend the traditional thesis that criminals shall, first of all, have treatment. In Finland, among young radicals, the suggestion has been made that prostitution should either be legalized or again be made illegal. Before prostitution was decriminalized in the 1930s, prostitutes were sentenced to relatively short imprisonment; now they are confined for longer periods in workhouses in accordance with the rulings of the vagabond ordinance. The perhaps not too seriously intended suggestion to make it a criminal offense, would, in all probability, lead to a more humane treatment of prostitutes.

The fact that the debate is no longer dominated by the opposing demands of general prevention and individual prevention, deterrent versus educating measures, does not mean that the advocates of strict punishment and hard discipline have easier sailing. Quite the contrary. It is true that the research results that would directly undermine the general preventionist and the deterrent ideologists' basis for argument have not been brought out: the actual research problem is so incredibly complicated. But increased knowledge of the psychological background of punishment attitudes, of the criminals' inadequate knowledge of the legal norms, together with observations of social factors that to a great extent explain criminal variation in time and space—all this has left less leeway for the hypothesis that the crime level in a society can be regulated mainly by varying the strictness of the punishment. Separate investigations have been made attempting to cast light on the influence of this strictness factor, among other things, geographical areas in which a certain type of crime—for example drunken driving in Germany—generally punished by a conditional sentence, were compared with other areas where the punishment is unconditional.[11] In an experiment in Finland, the risk of a fine for apprehended drunkards was lessened in three towns. The alcohol situation in these places was strictly observed for some years and compared with other towns where the imposition of fines continued as before.[12] These investigations have not given conclusive results in either direction. At least no obvious general preventive effect is observed. The purely speculative reasoning about strict punishment as an instrument of criminal policy has in any case become sophisticated. In the report that the Juvenile Delinquency Committee sent to Finland's Ministry of Justice in 1966,[13] it was stated that increased punishment as an instrument of criminal policy is the more effective:

1. the more the type of crime is characterized by a deliberate weighing against each other of advantages and risks, and also, the higher the average criminal's training and intellectual level is,

2. the greater the risk for detection,

3. the less the criminal's ability to influence the risk of discovery and detection by his own cleverness,

4. concerning increase of punishment, the more concrete and clearly delimited the type of crime in question and the more effectively the knowledge of increase in punishment can be spread to potential perpetrators,

5. within the limits set by the above-mentioned factors, the sharper is the increase in the latitude of legal punishment.

Reasoning of this sort leads to a differentiating of the criminal policy debate, according to type of crime, type of criminal, and external circumstances, a method which is undoubtedly more sensible than to speak of strict or mild punishment in general.[14]

Criminal Policy of the Future

I return to the question of criminal policy of the future. If the reformers, the radical circles, are no longer able and do not wish to propose an even purer treatment ideology and an even more extensive treatment organization as the highest goal for reform efforts, what may be found to substitute for this?

Criminal policy's alternatives that, in today's situation, represent the new, the radical, apparently derive from a sociological view of society, in the same way that earlier radicals based themselves on a psychologically or even psychoanalytically colored picture of society and the criminal.

It is characteristic of the sociological view of criminal policy that criminality is seen as a conflict situation, and crime as the visible expression of a certain balance between differing social pressures. The balance ideology assumes that one no longer asks the question: "How can we eliminate crime?" because it is a meaningless question. Every society has, must have, crime and criminals, by whatever name we may call them. As early as in 1897 Durkheim pointed out that even a society of saints would have its social norms and its norm-breakers. We therefore cannot merely propose the elimination of crime as a fundamental goal, but, we can strive for a certain type of balance, we can try to influence the structure of criminality, its gravity. The fact that criminality is experienced as a conflict between dissimilar pressures which keep each other in balance has an important consequence; in every problem situation in criminal policy it becomes equally important to take a stand as to the possibilities of changing society's control, its evaluations, its organizations, including both laws and control apparatus, as it is to take a stand on the problem of how the criminal shall be influenced.

The classical example of this phenomenon is, of course, the experiment with prohibition laws that different countries tried before the Second World

War. An attempt was made to influence the general public with the threat of punishment, and to influence apprehended lawbreakers with punishment. The results of these methods were, for different reasons, disappointing. In this situation certain countries experimented with even harsher control measures; other countries chose the opposite alternative of decriminalizing the use and sale of alcohol.

There are many forms of decriminalizing. What followed the prohibition law example may most correctly be characterized as "legalizing:" special institutions and special legal norms are provided for behavior that was earlier defined as criminal.

Another type of decriminalizing is to be found in those sectors where treatment ideology has been particularly strong. I have already mentioned the treatment of prostitutes in Finland as an example. This decriminalization consists, in short, of substituting one kind of formal control for another kind of formal social control. It would perhaps be going a little too far to call this use of *alternative systems of social control* "feigned decriminalization." Nonetheless, a sociologist finds very few differences between these institutional measures and punishment, and workhouse internees undoubtedly experience these measures as a kind of punishment. Inasmuch as this decriminalization effects a lessening of the legal safeguards through tampering with the name of the measure, it is natural that the defenders of the legality principle and of the legal system's predictability do not approve of this sort of transformation trick.

It could, however, be that this type of decriminalizing does not show to advantage in the treatment area, where the terminology is likely to confuse the conception of legal safeguards, and the clientele belongs to a social layer that cannot very effectively guard its rights. It is possible that a transition to other systems for social control than that of penal law would be more successful within certain sectors of property crime. The model for a change of system is already to be found in traffic insurance legislation. Insurance equalizes, eases the suffering inflicted on the victim: society can therefore be satisfied with an economic sanction in the shape of heightened insurance premiums, even in cases where the traffic injury is caused by actual criminal negligence. To a certain extent, the collection of damages is even more effective in the modern data-machine-run society: extra charges or other economic sanctions should, in many cases, be able, wholly or partly, to take the place of punishment.

That such a development can be possible in respect to precisely property crime is obviously related to society's development towards a welfare society with a great wealth of commodities. The loss of a thing no longer means as much, does not cause the same suffering as earlier; this becomes even more pronounced if we introduce an insurance system that equalizes these losses, especially in cases when the guilty party is not caught or is not immediately in a position to pay for the damage. The structure of criminality has changed so that property crime has taken a completely dominant

place. This means, as the Finnish sociologist Allardt has pointed out, that the general public may presumably be better prepared to replace punishment with a compensation arrangement, to the extent that there is any question of damage that can be compensated for with money.[15]

Another type of decriminalizing is *complete "decriminalizing,"* where the punishment is not replaced by any measure at all from society. This type of decriminalizing is found particularly in the area of moral crime. Concerning problems within this area, it is obvious that criminological research can, here, in a decisive manner influence the structure of criminalization. Research can differentiate offense categories according to the consequences: for example, by finding out to what extent certain sexual behavior, drinking behavior, or a certain type of narcotic usage, causes suffering or risk of suffering to other people, and to what extent the behavior only harms the person concerned himself. Whether empirical studies of this sort can make possible the decriminalizing of certain types of narcotic crime depends entirely on what results are reached through research. The parallel with alcohol legislation or gambling legislation hints at least that the fundamental possibility for decriminalizing also exists in respect to certain types of narcotic crime, or in respect to certain types of narcotic drugs. An excellent example of a radical but well-motivated suggestion for decriminalizing of this type is the Danish proposal to abolish penal regulations for the distribution of pornographic literature.[16]

I have referred in detail to official decriminalizing through change of law; there may be cause to stress that the shifting of the emphasis of control which occurs by the laws being applied in different ways can be much more important, e.g., in traffic criminality. Here we are reminded of a very important alternative to the penalty sanctions and formal control, namely the informal control that operates through the approval or disapproval met within one's environment or from one's circle of acquaintances. It is this type of social control that perhaps most obviously regulates the average citizen's lawfulness in his daily life. A certain elasticity in traffic is accepted, but the average driver will, in general, keep within the limits of the local etiquette code. Society, of course, to a certain extent, makes use of the possibilities in this informal control system and tries to influence it by a restricted use of the formal sanctions and by different forms of educational activity.

In this manner decriminalization proceeds in different ways. But the balance situation I mentioned earlier has its own inner logic that does not permit decriminalization to go too far, nor does it permit the number of penal law provisions, crimes, and criminals to fall below a certain level. Side by side with decriminalization arise new criminalizations: our society becomes constantly more complicated, the number of laws, norms, and norm-conflicts increases uninterruptedly. We must expect an increase in crime in the traffic, embezzlement and fraud, offenses in public service and perhaps slander, bribery and deception of the authorities. But changes in

the structure of criminality do not necessarily assume any radical change in the number of crimes and criminals. Studies of the sociology of law in different countries indicate a remarkable constancy in the number of criminals, looking back at the long-term perspective. I am personally inclined to believe in a corresponding constancy if we look to the future, though perhaps it is more difficult to foresee the future now than ever before, because of the unique rapidity with which society and its institutions are now changing.

Decriminalization is not always possible. If we consider crimes of violence, for example, it is clear that we are dealing with a development that has gone in the opposite direction to property crime. While property crime has undergone what we could call inflation—the damage, or at least the suffering from theft is, today, noticeably less per crime than 100 years ago—the damage and suffering from crimes of violence have, however, rather increased. In our welfare society, materially safe, protected from war and disease, with long life expectancy, death or severe bodily injury is a greater evil than perhaps ever before. Here decriminalizing of the sort I mentioned as possible for certain property crimes does not come into question. It is also probable that the critical opinions I cited concerning the efficacy of and justification for medical treatment do not apply to the most serious crimes of violence. My reasoning concerning treatment ideology's failure applied expressly to the average criminal; this statistical fiction is either a property criminal or a traffic criminal, depending upon which definition of crime is used. The type of reallocation of control potential that is conceivable for crimes of violence is displacement in the direction of purely preventive measures, e.g., the protective arrangements preventing taxi robbery.

It is my impression that we will, in the future, more consciously than heretofore, make use of various preventive measures against many types of crime. We are used to obligatory steering locks; it will not be long before there are mandatory rules concerning safety devices for business premises and summer homes, rules concerning how much money may be kept in private safes, and how openly stores may display their wares on the shelves. In traffic it is important to bring out the underlying facts for our policy judgments in, for example, road layouts: what do different road layout alternatives cost in money and in human life. Crime emerges, perhaps, as a secondary feature in this appraisal but it must, nonetheless, be a topic that is of interest to criminologists and criminal policy makers. Research is still concentrated to far too great an extent on so-called causation research—for example, in the very case of traffic criminality. In spite of the fact that no general criminal theory has as yet been found within this field, the attempt is made to estimate the "causes" of, for example, traffic crimes or traffic accidents and perhaps arrive at such statements as that "80 percent of all traffic accidents are dependent on the human element." It has been asserted by others besides myself that such claims are meaning-

less phrases, but this is just the sort of meaningless result one gets so long as one seeks only the "causes" instead of looking for a realistic balance between theoretic research and research concerning criminal political alternatives. Practical policy-orientated research is just what is now more needed, posing questions of the type: how much would a liberalizing of alcohol distribution influence alcohol criminality, how much would an increased police control influence traffic and property criminality, or, even, how much would an intensification of punishment for income tax evasion increase the state's income?

As I have described the case, a radical policy should now, first of all, be based on a consciously balance-oriented ideology and recognize control of physical crime opportunities and control of the process by which acts and individuals are labeled deviant as fundamental instruments of society's criminal policy.

Measures of this type are nothing new, but it may be rather novel to formulate fundamental action programs on this basis: that decriminalization, etc. should be made a principle instead of as now perhaps rather a situation-conditioned emergency measure to be used only in cases when it becomes evident to all that the situation so requires.

One advantage in formulating abstract principles is that we can make use of them in long-term social planning which, of course, must usually be based on other evaluations than those of the moment: long-term planning must be able to foresee reforms which will be necessary and possible in ten or twenty years, even if, for example, the attitudes of the general public at the present time do not permit such reforms.

A radical criminal policy, in the sense in which I here use the word, should therefore be a policy prepared for a swift realization of, among other things, the future plans I mentioned, even at the risk of being wrong, while a conservative policy would be to let the changes occur at a slower pace, retain the present balance between, for example, treatment viewpoints and punishment motives until this appears obviously wrong.

I have now neglected one group: the extreme treatment supporters who would do away with punishment in its present form and go completely over to enforced treatment of criminals. I have no room for them in my scheme. They are not conservative, for they have not yet achieved the practical political goals they might wish to conserve. I would not call them radical either because their retention of the traditional treatment ideology is perhaps actually related to conservatism as far as attitudes go, perhaps an inability to accept newer research results and adjust their own attitudes accordingly. Voluntary care is of course quite another matter. The fundamental principle for sociolegal treatment arrangements should be that the nonconformist is offered the possibility of receiving care.[17] It is up to the individual to decide whether he will make use of the possibility or not.

With these speculations I do not wish, personally, to recommend either a radical or conservative criminal policy. But I believe that it is valuable to

attempt to map out and discuss the discernible trends in the new criminal policy, among other things, to provide a basis for a conscious planning of criminological research strategy.

NOTES

1. See e.g. Olof Kinberg, *Basic Problems of Criminology* (London, 1935).
2. See e.g. Marc Ancel, *Modern Methods of Penal Treatment*, 1955.
3. Kettil Bruun, "Samhällskontrollörer och frihetsberövanden" (Social control operators and deprivation of freedom) in *Varning for vård* (Beware of the Therapeutics) (Helsinki, 1967).
4. Nils Christie, *Tvangsarbeid og alkoholbruk* (Forced Labor and Use of Alcohol) (Oslo, 1960).
5. Paavo Uusitalo, *Vankila ja tyosiirtola rangaistukseng* (Prison and Labor Colony—a Comparison) (Helsinki, 1968).
6. Bengt Börjeson, *Påfoljdernas verkningar* (Effects of Sanctions) (Stockholm, 1966).
7. Nils Christie, "Reaksjonenes virkninger" (Effects of Sanctions), *Nordisk tidsskrift for kriminalvidenskab* 49 (1961): 121–144; R. F. Sparks, "Types of treatment for types of offenders." *Report for Fifth European Conference of Directors of Criminological Research Institutes* (Strasbourg, 1967).
8. Nils Christie, "A Study of Self-reported Crime," *Scandinavian Studies in Criminology* 1 (1965): 86–116. Inkeri Anttila and Risto Jaakkola, *Unrecorded Criminality in Finland* (Helsinki, 1966).
9. Patrik Törnudd, "Sairauden määritelmästä" (On the definition of the disease concept), *Sosiologia* 3 (1966).
10. Kaj Håkansson, "Psykisk sjukdom: illusioner och realiteter" (Mental illness: illusions and facts), *Research Reports from the Department of Sociology*, (Stockholm: University of Stockholm, 1968). Mimeographed.
11. Wolf Middendorff, "Desirable Development in the Administration of Justice," *Report for Fourth European Conference of Directors of Criminological Research Institute* (Strasbourg, 1966). Mimeographed.
12. Patrik Törnudd, "The Preventive Effect of Fines for Drunkenness," *Scandinavian Studies in Criminology* 2 (1968): 109–124.
13. "Nuorisorikollisuustoimikunnan mietintö," *Report of the Juvenile Delinquency Committee*, A2, p. 27 (Helsinki, 1966).
14. As regards general prevention, see Joseph Andenaes, "The General Preventive Effects of Punishment," *University of Pennsylvania Law Review* 114 (1966): 949–983.
15. Erik Allardt, *Samhällsstruktur och sociala spänningar* (The Structure of Society and Social Tensions) (Helsingfors, 1965), p. 228.
16. *Straffelovrådets betænkning om straf for pornografi*, (Penal Law Committee's Report on Sanctions against Pornography), 1966.
17. Alvar Nelson, "Rättssäkerheten och individen" (Constitutional Rights and the Individual), in *Brott och straff* (Crime and Punishment), pp. 34–60 (Stockholm, 1966).

26: Ideologies and Crime / *Sir Leon Radzinowicz / Joan King* *

The attempt to understand crime has a long history. We cannot fully comprehend the various attitudes prevalent today without reference to the cultural and social conditons which gave them birth in the past. Looking back over time, we can identify a series of constellations of ideas about crime and criminal justice. Often they have been taken for granted, implied rather than explicit. Yet, particularly in some countries and at some periods, they have been brought to the surface, consciously crystallized and expressed.

Where an explicit and coherent set of attitudes is shared by academic lawyers, judges, administrators and leaders of public opinion, we can speak of a "school" of criminal law or criminology. The Continent of Europe, where academics have been particularly influential in formulating attitudes towards crime and criminals, has seen a succession of rival schools of this kind. Until recently England and the United States, where legislatures and judges have played a far more decisive role, have stood aside from these controversies. That has, indeed, been true of the whole English-speaking world. These countries have taken a more pragmatic line, responding to the presssures of events, meeting the problems of crime as they came up. Now they too are being affected by the opposition between fundamentally different approaches to the understanding and control of crime, the nagging demands to have done with a compromise and commit themselves to a single unambiguous attitude.

Liberal Approach

The first modern school of criminal law emerged against a background of arbitrary severity in eighteenth-century Europe. The 'enlightenment' in Europe brought a revolt against the unquestioning acceptance of tradition and authority, protests against the pervading cruelty, appeals to what were seen as 'natural law' and 'natural rights,' demands that the law should

* Sir Leon Radzinowicz, "Ideologies and Crime," in Leon Radzinowicz and Joan King, *The Growth of Crime* (New York: Basic Books, 1977), pp. 57–73. Reprinted by permission of the publisher.

protect the citizen and his liberties. The liberal doctrine of criminal law, as summed up by the young Italian Cesare Beccaria, challenged, one by one, the assumptions and practices of arbitrary systems. These were its central tenets. First, the law should restrict the individual as little as possible, it should guarantee the rights of the accused at all stages of criminal justice, it was no part of its function to enforce moral virtues as such. Laws not essential to serve the needs of a particular society uselessly increased the tally of crime. Second, it should guarantee the rights of the accused at all stages of criminal justice. Third, it should give clear and precise knowledge of what was forbidden and the sanction attached to disobedience. Fourth, it should take the form of a complete written 'social contract,' so that people could judge how their liberties were being protected. Fifth, punishment was justified only in so far as the offender had infringed the rights of others. Sixth, its severity should be drastically curtailed: it should be no more than proportionate to the crime committed, and it should not go beyond what was necessary to deter the criminal and others from injuring their fellows. It should be just sufficient to ensure that the penalty outweighed the advantage derived from the crime. Seventh, the nature of the penalty should correspond with that of the crime: fines would suffice for petty theft, but corporal punishment or physical labor should follow crimes of violence. Imprisonment seemed a particularly appropriate penalty in an age that valued liberty above all; moreover, it lent itself well to the most exact gradation between crime and punishment. Eighth, punishments must be inflicted with speed and certainty, in order to create the closest possible association in people's minds between crime and its inevitable penalty. This would be easier to achieve if sanctions were seen as just and moderate. Ninth, exemplary punishment must be ruled out as unjust. Likewise 'reformation' must not be thrust upon criminals: they should not be compelled to undergo anything except the legal punishment. And, since the punishment was to be strictly related to the crime, it should not be varied to suit the personality or circumstances of the offender. He should suffer for what he had done, not for what he was or might become, or for danger he might threaten in future. Tenth, the criminal was to be treated as a rational responsible being, who could weigh up the consequences of crime and had the same power as anyone else to resist it. Eleventh, the prevention of crime was to be achieved by the clear code of offenses and punishments, supplemented by better education and better rewards for virtue: in the light of their experience the liberals of the enlightenment utterly rejected the idea that crime could be or should be forestalled by police watchfulness. The mainstay of prevention must be not the regulation of morals, nor control of suspects, but punishment of actual crime.

The principles of this doctrine were never fully translated into reality. But thinking, writing, and teaching were profoundly inspired by them. Even more important, new codes of criminal law and procedure all round the world aspired to follow the liberal creed. The process spanned most of

the nineteenth century, from the Declaration of the Rights of Man and the first criminal code of the French Revolution, by way of the Code Napoléon of 1810, the Bavarian code drawn up by Feuerbach in 1813, and the Zanardelli code for Italy of 1889. Even in England, with its suspicion of cut and dried systems, the abortive yet influential code constructed by Sir James Fitzjames Stephen, like Edward Livingston's famous "System of Penal Law" for the State of Louisiana in 1824 and the code drawn up for New York by David Dudley Field in 1865, all bore the unmistakable marks of this same influence. What had begun with the liberal and revolutionary impulses of the enlightenment acquired, in the sphere of criminal justice, the title of the classical school of criminal law and penal policy. Classical it certainly was in its apparent simplicity, its idealism, its emphasis on proportion and restraint, on logical rules to be known and accepted by all.

Positivist Approach

The first major onslaught upon the elegant structure of classicism reverberated in its turn all round the world. Launched towards the end of the nineteenth century, it was again the product of a European school, based on radical criticism of the immediate past and projecting a revolutionary program for the future control of crime. Though schools are inevitably identified with their leaders, their conception, growth, and acceptance depend upon the environment of their time. The liberal outlook had been born with the assertion of human rights, and the classical school had developed in response to the need for a reformed and stable order. But the new wave of reformers had but a dim perception of the arbitrary abuses that had impelled liberals and classicists to these ends. They were living in a Europe where it seemed stability could at last be taken for granted, and with it freedom from the tyrannies of the past. What concerned them was progress toward greater social justice.

The classical school, one of whose leaders instructed his pupils that crime was not an entity in fact but an entity in law, showed no interest in studying the sources of criminal behavior. But with Darwin opening up the natural sciences, with Comte and Spencer establishing the social sciences, with the beginnings of modern psychiatry and psychology, what more natural than that all these should be extended into the explanation and control of criminal behavior, whether seen as part and parcel of society or of the individual human personality?

When the classical school emerged the measurement of crime was in its infancy. But by the time the new school was born several European countries could offer criminal statistics which made it possible to compare the trends of crime over substantial periods, to recognize its persistence, to challenge the failure of classical doctrines to bring it into check, and to

claim that a totally new approach was essential for the protection of society.

Three major books, all the work of Italian scholars, heralded this second revolution in attitudes toward crime. The first was *L'Uomo Delinquente, The Criminal Man*, by Cesare Lombroso (1876). The second was *Criminal Sociology* (1878) by Enrico Ferri. The third was *Criminology* (1884) by Raffaele Garofalo. These three and their disciples adopted with pride the title of positivists, the term used by Comte to define his own system of philosophy. Like him, they insisted that what mattered was not idealistic speculation but positive facts and observable phenomena. They emphasized experiment rather than deductive reasoning. They might well have taken as their maxim the words of the veteran French statistician, André-Michel Guerry: "The time has gone by when we could claim to regulate society by laws established solely on metaphysical theories and a sort of ideal type which was thought to conform to absolute justice. Laws are not made for men in the abstract—but for real men, placed in precisely determined conditions." [1]

As so often happens, the central tenets of the positivist school reversed, in almost all respects, those of its rival. Where the classicists concentrated upon the crime, the positivists concentrated upon the criminal. Where the classicists saw the offender as rational and responsible, free to choose whether or not to break the law, the positivists saw his behavior as strongly influenced, if not completely determined, by his innate constitution and immediate environment. Where the classicists insisted that the punishment must be strictly related to the crime, the positivists took the line that it must be related to the offender. Where the classicists saw the sentence primarily as proportionate to the crime already committed, the positivists saw it as a measure for the prevention of future crimes. Where the classicists rejected adaptation of the penalty to the individual personality of the criminal, the positivists insisted upon it. Where the classicists ruled out attempts to reform the lawbreaker, the positivists advocated them. Where the classicists prohibited consideration of whether he threatened future danger, the positivists insisted that his future dangerousness should be the central criterion for deciding whether or not a criminal must be detained for the protection of others. The contrast between the two schools has been well summed up in the aphorism "The classical school exhorts men to study justice, the positivist school exhorts justice to study men."

In their fierce and prolonged confrontation with the classicists, the positivists never managed to take over the field. They got nearest to it in 1919, when Enrico Ferri was invited under royal decree to draft a code for Italy based upon positivist principles. But when it came to the crunch the code was rejected. One or two South American countries like Cuba adopted measures inspired by it, as did the first criminal code of Soviet Russia, that of 1927. Such concepts as 'dangerousness' fitted in only too well with the

need of revolutionaries to eliminate opponents. That, however, did far more harm than good to the reputation of the positivist school.

Though they did not crush their adversaries, the positivists nevertheless succeeded in infiltrating the classicist camp at several vital points. This resulted in a kind of compromise, an amalgam of classical and positivist elements. Their influence was reflected in the proceedings of the International Association of Criminal Law between 1889 and 1914, in those of the Société Générale des Prisons de Paris, even in those of the International Penal and Penitentiary Congresses, composed as they were of cautious and hard-bitten government administrators. It can be traced in the work of Garçon in France, Prins in Belgium, van Hamel in Holland, von Liszt in Germany. The penal codes of the period, while retaining their classical outlines, admitted important positivist modifications. There were radical departures in the treatment of young offenders, longer, even indeterminate, sentences for habitual criminals, extensions of the insanity rules and the idea of diminished responsibility, a new willingness to concede alternatives to imprisonment, like the suspended sentence in Europe, probation in the United States and England. The most harmonious blending of the classical and positivist elements was perhaps that achieved in the Swiss Code of 1937. But the Model Penal Code drawn up by the American Law Institute under the leadership of Herbert Wechsler shows similar characteristics. It has a classical logic and concern for legality in the main grouping of offenses in terms of their gravity, and of penalties in terms of corresponding but restrained severity. But this is modified by special positivist provisions for the young, the mentally abnormal, the dangerously persistent. Alongside the modification of the classical codes came a modification in penal practice, a move away from rigid and impersonal conceptions like solitary confinement toward more diversified and humane attempts to reform offenders rather than merely punish them.

The positivists gave a new and powerful impetus to movements for the rehabilitation of offenders, though they certainly did not initiate them. The desire to reform and restore those who break the law is as old a response to crime as any. It goes back to the old and new testaments, to the medieval church, to Tudor England, to the Rathaus in Amsterdam, to the houses of correction in the Hanseatic cities, to the Quaker penitentiaries, to the avant-garde establishments for children at Mettrai in France and at Elmira in the United States, and to the pioneers of probation. It sprang from philanthropic, religious, and humanitarian initiatives, essentially practical and experimental, based on faith rather than systematic theory. But the positivist insistence that treatment must fit personality, that penal policy and welfare policy could interact in the prevention and control of crime, gave a new political significance to this approach, as well as what then seemed a scientific framework and justification.

The towering figure of Sigmund Freud, with his impact on the way people have seen themselves and their experiences, could not fail, in due

course, also to influence attitudes to delinquents. Disciples of his who ventured into criminology acknowledged a debt to Lombroso but rejected his classifications and explanations. They used psycho-analytical concepts, particularly to interpret persistent juvenile delinquency. Such phrases as frustration, maladjustment, mental conflicts, anti-social or a-social attitudes, passed into the currency of diagnosis and treatment. With their medical overtones those were significant expressions in themselves. By way of reaction there grew up the suspicion that this whole approach offered elaborate excuses for offenders, implying that they could not help themselves.

Several features of the positivist creed combined to prevent its acceptance as a complete and exclusive system. It took little, if any, account of procedural protections for the suspect or offender. It replaced the familiar idea of criminal responsibility with the somewhat unconvincing concept of "social responsibility," based not on moral guilt but on the requirements of society, and leading not to punishment but to "measures of social defense." In stipulating that the measures taken to deal with offenders should be related to their personalities rather than their crimes, it could be seen as undermining general deterrence. And, in so far as some of its precepts were put into practice, they failed to achieve the impact on recidivism so confidently predicted by its advocates.

The positivist school is today in disarray, indeed it no longer exists as a coherent force, even in its native Italy. Though the theme of individual differences in offenders will always remain important, the more far-fetched and sweeping etiological explanations advanced by Lombroso and Ferri were long since discredited. Equally discredited by history has been their assumption that it was no longer necessary to bother about strict legal restraints on the discretion of administrators to detain or to treat offenders. In particular it has become all too clear how dangerous can be the very concepts of "dangerousness," and even of "reformation," as tools of oppression; and how easily measures of "social defense" can be used as weapons of social aggression. Modern research, far from demonstrating the success of attempts to classify and reform offenders, has drawn attention to their failures.

Sociological Approach

The opposition between the classicist and the positivist schools initiated by Lombroso should not blind us to what they had in common. Although the positivists took account of social conditions, they thought of them primarily in their impact on individuals. Both schools took it for granted that the starting point was the individual offense and the individual offender. Both hoped to achieve control of crime by way of the criminal law and the penal system. Their battles and their compromises were fought out in the shaping

of criminal codes and penal practice. Much more radical is the gulf be-
tween them, with their fundamentally individualist outlook, and those who
have seen crime as a social product, determined by social conditions, capa-
ble of being controlled, if at all, only in social terms.

Adolph Quetelet was the first great interpreter of criminal statistics when
they began to appear year by year in the 1820s. In characteristically dra-
matic style he announced his findings: "We can count in advance how
many individuals will soil their hands with the blood of their fellows, how
many will be swindlers, how many poisoners, almost as we can number in
advance the births and deaths that will take place." And he drew this
equally dramatic conclusion: "Society carries within itself, in some sense,
the seeds of all the crimes which are going to be committed, together with
the facilities necessary for their development." [2]

In a sense all subsequent attempts at social explanations of crime are
extensions or embroideries on that doctrine. In societies, as they exist,
crime is normal. The facts to be investigated in order to understand crime
are social rather than individual, its control must depend upon changes in
social conditions. Changing social conditions were indeed producing crime.
The state of the cities and of the poorest classes in the heyday of the
industrial revolution could be cited as glaring evidence of the overwhelm-
ing impact of the immediate environment. To Lombroso's conception of
the born criminal the French 'sociological' school, led by Professor Lacas-
sagne and supported by Manouvrier and Tardo, opposed that of the crimi-
nal milieu. The swollen cities could be seen as centers of criminal infection
and imitation, breeding grounds of crime—or, as Mayhew so graphically
described the process in the London slums, training schools for profes-
sional criminals. More broadly, the greater prizes offered by a more pros-
perous society, the lesser risks threatened by a more merciful penal sys-
tem, the maxims and passions, the cupidity and cunning of a society and
business community swayed by greed, all fostered crime. Stability, a fun-
damental condition of morality, was lacking. The individual could do little
against the tide: it was "the great logic of society" which drove him on. It
was Lacassagne who coined the now hackneyed phrase "societies have the
criminals they deserve." [3]

"Crime is normal because a society without it is utterly impossible,"
said Durkheim. He went further: "To classify crime amongst the normal
phenomena of sociology is not merely to say it is an inevitable, though
regrettable, phenomenon, due to the incorrigible wickedness of men; it is
to affirm that it is a factor in public health, an integral part of all healthy
societies." [4]

The great French sociologist deliberately chose the persistence of crime,
so generally regarded as an unmitigated social evil, to illustrate his thesis
that we should take nothing for granted about social facts. Since the phe-
nomenon of crime was to be found in all societies at all stages of their

development, it must be scientifically regarded as normal: that was a question of fact, not of moral or philosophical judgments. On its usefulness, he had two points to make. First, a society in which there was so great a consensus, so powerful a control, that the law was never broken would be a society so uniform, so rigid that it lacked the flexibility to adapt to a changing world. The presence of crime thus demonstrated the possibility of moral advance and transformation. In some cases, like that of Socrates, the criminal could be the direct precursor of a new morality. Second, he argued that crime and punishment must be taken together, with the combined effect of reinforcing the major collective values of a society. Where crime weakened them, its punishment reasserted and strengthened them. This latter theme has been taken up by certain criminologists who emphasize the role of criminal law and its enforcement in bringing home to people the specific kinds of behavior that are most strictly forbidden and, by implication, clarifying the central values of society against which they offend. To put it crudely, punishment of the bad is necessary to assert the good.

The sociological approach to the study of crime, unlike the positivist, emigrated very successfully from Europe to the United States, where it has prospered greatly during the present century, exporting its theories all over the world. Some sociologists would claim to be engaged in a disinterested search for truth, with no ulterior objectives. But criminologists, especially American criminologists, have seldom scrupled to deplore social evils they see as linked with crime, and to advocate changes in social arrangements and penal systems.

They have, nevertheless, shared the positivist failure to produce workable and effective solutions. Moreover, in so far as it tends to portray offenders as hapless victims of their environment, sociology invites the criticism that it is excusing crime. Though many criminologists retain a rather simple optimism about the possibility of engineering social change, their credibility is being increasingly called into question.

The Socialist Creed

Parallel to the sociological school, but distinguished from it by radical political commitment, was what was frankly known as the socialist school. Its leading exponents were to be found, in the last two decades of the nineteenth century, scattered all round Europe. There were the Italians Filippo Turati and Napoleone Colajanni, the French Paul Lafargue who was a son-in-law of Karl Marx, the Belgian Hector Denis who reinterpreted Quetelet, the German Karl Kautsky, who was the leading theoretician of the German Socialist Party, and K. J. Rakowsky, who eventually became the first Soviet ambassador to France. Not content with tracing links between crime

and various evils that might be regarded as by-products of industrialization, they insisted that it was bound up with the whole of the capitalist system. It could be eradicated only by the eradication of capitalism. Capitalism deprived the workers of their rights, forced many to live in squalor. Crime was to be seen as the result of their degradation, sometimes the embodiment of their protests.

The socialist school drew its inspiration from Karl Marx, yet neither Marx nor Engels ever developed a systematic socialist theory of crime. For that we have to turn to William Adrian Bonger, a Dutch professor of sociology, a man of great learning and sensitivity and a militant socialist. His book *Economic Conditions and Crime,* published in English in 1916, brought Marxist principles fully to bear on the interpretation of crime in capitalist societies.

Step by step, he implicated the very spirit of capitalism in the genesis of criminality. Capitalism taught men to compete, to accumulate property at the expense of others, to exploit others. Crime involved the robbing or exploitation of other people. Under capitalism the economic mechanism itself, since it set the interests of all in eternal conflict among themselves, made men more egoistic, less compassionate, and less concerned about the good opinion of others, and hence more capable of crime.

Capitalism also inevitably produced a class system and that system added characteristic pressures toward crime at each level of society. For the wealthy capitalists there were avarice and ruthless competition. For the small bourgeoisie there was the precariousness of their position. For the proletariat, above all the lumpen proletariat, there were the injustices and degradations under which they lived. It was by these pressures that crime, as a mass phenomenon, was shaped.

Replace capitalism by communism and all would change. The spirit of communism was a spirit of cooperation, of altruism, the very antithesis of crime. The practice of communism would abolish the corrupting privileges of the rich, the corrupting deprivations of the poor. It would care for those who were weakest in mind, morality or body, support them and save them from drifting into trouble. In proportion as communism gathered strength, crime would shrink and wither, starved at its very roots. The need for criminal laws and penal systems would virtually disappear.

The classicists saw the state as an impartial arbiter, maintaining a true balance between the rights of the wrongdoer and the wronged. The positivists saw the state as a paternal authority, capable of recognizing and forestalling danger, of restraining or restoring those who threatened the common good. The Marxists, on the contrary, challenged the capitalist state itself, seeing it as no more than a policeman serving the interests of those powerful enough to control the means of production. To them criminal laws and penal systems, like all the other social institutions of capitalism, were instruments for maintaining the class structure. The state was not merely an accomplice in this immorality, but an active participant in that it

held down the working classes and provoked them to crime. Changes in criminal law or in penal systems were beside the point. It was society itself that must be revolutionized.

In the days of Marx, even in those of Bonger, the socialist state was still a dream. It was possible for them, without fear of contrary evidence, to contrast the gross abuses of the capitalist systems under which they lived with the utopian virtues of the communist system for which they hoped. Now it is nearly sixty years since their disciples took over Russia, thirty since they acquired control of East Germany and the other satellites. They have been able to change the economic basis of the state, but they have not yet eliminated crime.

Until very recently their reaction to this situation could only be described as embarrassment inadequately concealed by bluster. They claimed spectacular reductions in crime but refused any statistics to prove it. Now, from East Germany we are getting admissions that criminality continues, that in some industrial areas it may even be increasing. Of course explanations accompany the admission. Although the economic conditions of life have been changed it may take many decades to change psychological attitudes inherited from the bad old days of capitalism. The state itself may have erred in not giving sufficient weight to education and moral instruction (a curiously Victorian sentiment). The fully communist state has not yet been achieved. But for all this the socialists still twit the capitalist countries with having resigned themselves to crime, whereas they still maintain that socialism will eliminate it in the end.

Meanwhile, they have been obliged, by these very arguments, to go back to the study of the individual offender. Since the whole social environment has been transformed they must turn to individual differences to explain why some people still remain entrapped in the old bourgeois criminality. Since they are activist regimes, calling upon their citizens for ever greater efforts, they again have to admit that not all are equally committed, that something depends, for better or for worse, on individual differences. And they are compelled to assume that those who prove incorrigible, whether as opponents of the regime or as vagrants or other deviants, are either mad or degenerate. Until recently all this would have been regarded as a dangerous deviation from the doctrine that the causes of crime must be sought in economic and social structures. But experience has inexorably brought them back to the individual differences. To quote *Socialist Criminology,* the latest treatise to emerge from East Germany, the individual disposition is to be regarded as "an independent variable amongst the complex causes of crime." That is a significant concession.[5]

Radical Approach

Various groups of "new criminologists," though by no means constituting a single "school" in the traditional sense, reflect a current of opinion, especially among the young in the United States and England. Its main directions can be traced in two recent collections, both compiled by Ian Taylor, Paul Walton and Jock Young: *The New Criminology* (1973) and *Critical Criminology* (1975).

The first to make their mark were American exponents of what were christened "interactionist" theories. This group rejects the study of crime as a separate phenomenon, preferring to see it as part of the wider field of deviance, which includes not only all departures from accepted social conventions but much of what is usually classed as mental illness. Not even stuttering has escaped their attention.

Since what is regarded as deviant varies from one place to another, it is emphasized that its definition depends not on the intrinsic characteristics of the behavior of people concerned, but on the interests and prejudices of those with power to enforce their standards. Similarly, whether a particular action or person is labeled as deviant or as criminal depends on the people—doctors, teachers, social workers, police, courts—who are entrusted with maintaining these standards. It is a misconception to assume that a person so labeled is, in himself, sick or wrong, or necessarily in need of treatment or correction. His behavior should be interpreted in terms of what it means to him, rather than dismissed as wanton or meaningless by conventional standards. Attempts at repression are often self-defeating.

The very measures taken to control or to change an offender may confirm and extend his deviance. The fact of being stigmatized will alter the way he sees himself, the way others see him, and the way he expects them to react to him. Rejection, or the anticipation of rejection, may lead him to seek support among similar outcasts, compensating by building up the very deviant values it was hoped to repress.

Both the distribution of crime, as officially recorded, and the characteristics of those labeled offenders, largely reflect the prejudices of those who enforce the law. It is upon the agents of control, as much as upon those stigmatized as criminals, that research should be focused. Above all it should be concerned with the interaction between the two.

The more radical criminologists would claim that even this fails to go to the heart of the problem. It is not, perhaps, unfair to say that the views of some of them are colored by strong radical commitments, with elements of Marxism, Trotskyism, Maoism, anarchism. Many of them would challenge the bulk of existing criminal law and correctional systems, as simply shoring up a social structure that ought to be brought down. They have no time for the conventional approach to the study of crime and its control. In their eyes it starts from a false assumption, in taking for granted the existing

criminal law. It compounds its error by using the results and records of law enforcement as the basis for its research into trends and explanations of crime.

The new criminologists would probably concede that classicists were on the right track in wanting to restrict to a minimum the scope of criminal law, the interference with individual liberty. They would certainly endorse the classical concern to control law enforcers, especially the police, together with the suspicion of attempts to reform offenders. The radicals would also argue that classicism did not go nearly far enough, since it took for granted the existing structure of society, the inevitability of the core of established criminal law. For the positivists, in their preoccupation with individual offenders, with defining, segregating, or eliminating the dangerous, the new criminologists would have very little time indeed. Even the sociological attempts to measure, analyze, and interpret links between crime and other social phenomena would get short shrift in that they have largely relied upon official statistics.

For the socialist approach the radicals would obviously have some initial sympathy: at least it started from the assumption that the roots of crime lay in the political economy, the very nature and structure of capitalism. But again they would contend it did not go nearly far enough: it still saw the crimes and delinquencies of the downtrodden as maladies and maladjustments, as passive symptoms of the degradation imposed upon them more often than as active protests against it. Nor would the new criminologists stop short at criticism of capitalist attitudes to crime. The treatment of political deviants as criminal in certain socialist countries could be seen as the exact opposite of the kind of society they would advocate.

The radical criminologists have their own utopian vision of a society in which there would be little need of the criminal law. But that would not come about because all citizens were united in a consensus of values. The very idea of such consensus is regarded as a myth fostered by those in power and supported by the assumptions of conventional criminology that individuals can or should be adjusted to some fictional norm. The radical ideal would be a pluralistic society in which many patterns of behavior, now disapproved or prohibited, would be given full play.

The new criminologists have their points. They have stressed that the criminal law and its enforcement can be used destructively and oppressively by ruling cliques. They have been among the foremost in portraying its overextension in ways that can be damaging and self-defeating. They have emphasized the significance of the offender's own view of his crimes and of the measures taken to check them. And the radicals in particular have drawn attention to the dangers of allowing criminology to serve as a mere prop of existing systems. In all these respects they have helped to remove blinkers, to widen our outlooks and attitudes.

Unfortunately they have seemed at times to don blinkers of their own. They have distorted and diminished the impact of their message by their

vivid exaggerations. In their anxiety to interpret crime simply as part of the whole spectrum of deviance they have blurred important distinctions, resorted to misleading analogies. The radicals have felt bound not merely to question but to contradict all that has gone before. They have talked as though conventional criminologists were unaware of the limitations of criminal statistics, and as though the statistics were rendered completely valueless by those limitations. They have overstated the heterogeneity of social values, ignoring the large measure of consensus, even among the oppressed, in condemning the theft and violence that make up the bulk of traditional crime. They have postulated an irreconcilable opposition between "law and order" on one hand and "human rights" on the other, blinding themselves to the genuine functions of law, police, and courts in safeguarding people's rights. And they have indulged in exaggerated hopes of human nature, and been overoptimistic about what society will tolerate, either now or in the future.

Radical criminology has not been alone in going to extremes. All new movements, in their first flush of enthusiasm and their determination to achieve the maximum impact, begin by distorting or denying the achievements, reversing the values and emphases, of their predecessors. All attitudes toward crime have their periods of challenge and eclipse. Yet they tend to persist, sometimes reappearing in fresh guises, under new names. Often they have to learn to coexist within a single system. They are perforce modified by their own experience, by mutual influences and antagonisms, and by the changing climate of the times.

Attitudes to the causes and control of crime are not the same thing as explanations. Yet they powerfully influence the directions in which explanations are sought, the ways in which findings are interpreted.

Some Implications

To live in a world of rising crime has both direct and indirect implications.

Even in the most law-abiding countries, we have to come to terms with the fact that we had tended to develop expectations of security for ourselves and our property which are no longer realistic. We have lost a measure of our freedom. We have been compelled to face the need for greater caution in our dealings with others. The possibility of falling a victim to crime, in its traditional sense, has increasingly to be taken into account in our daily lives. The extension of the political crimes of people against governments and of governments against people puts a much sharper edge on this, with its special overtones of ruthlessness, betrayal and unpredictability. And the white-collar crime of the powerful and prosperous, though it evokes less physical fear, erodes standards of economic life, inflicts severe financial losses, makes individuals, commercial undertakings, political par-

ties and even governments an easy prey to sophisticated fraud and bribery.

Alongside these direct consequences of expanding crime there are the indirect.

The spread of traditional crime breeds public apathy and defeatism. The police fall behind in bringing offenders to justice, their temptations to cut the corners increase, dangers of corruption rise. The courts, endlessly bogged down by long waiting lists, are under pressure to hurry cases through, to accept devices which offer short cuts, and to neglect legal protections. Penal institutions, overcrowded with the untried as well as with the sentenced, see tensions mount and standards deteriorate. All those who have to deal with offenders are frustrated by the widening gap between what is expected of them and what they can hope to achieve.

The injection of political crime adds to the stress throughout the system. Even the liberal are impelled towards ruthlessness when faced with the ruthless manipulation of their institutions. From very many parts of the world, solid evidence has been forthcoming that torture is as commonplace a tool today as it was in the middle ages. Though directed primarily against opponents of governments it infects the whole apparatus for enforcing criminal law. It is ironic that, in 1975, two hundred years after Cesare Beccaria voiced the gathering protests against the use of torture by the despots of Europe, a United Nations World Congress on Crime should have felt it necessary to pass a resolution banning torture, and that they regarded this as their major achievement.

The impact of white-collar crime, or of growing public awareness of it, has been less brutal but equally insidious. Durkheim saw crime and its punishment as a potent means of reasserting and strengthening social values. The virtual impunity and the vast gains of these macro-criminals, on the contrary, has produced a widespread disgust and cynicism which cuts at the very roots of social values.

Today we have a much better understanding of the complex social and individual elements in crime. But we have no evidence to demonstrate that advances in prosperity, welfare and education have reduced its incidence or even restrained its rise. Nor has it been shown that more elaborate devices in the classification and treatment of offenders have made any impact upon the rates of recidivism.

In peaceful England, in the middle of the affluent sixties, Professor F. H. McClintock estimated, on the basis of trends then existing, that one man in every three would be convicted of an indictable crime at some time in his life. And that leaves out of account the very many offenders who escape conviction altogether. The wide-ranging survey of research prepared by Robert Martinson on behalf of New York State, and the recent report on the effectiveness of sentencing published by the Home Office Research Unit in England, have tended to reinforce feelings of pessimism about our ability to prevent relapse into crime amongst known offenders.[6] The latest analysis by the F.B.I. of offenders found guilty of serious crimes in the

United States has revealed that at least half of them were already known recidivists and at least a quarter had already no less than five convictions behind them. These conclusions differ little from estimates of recidivism made in Europe from time to time over the past century. There seems to be remarkable stability about the proportions, regardless both of social conditions and penal practice.

The natural response to rising crime, declining standards of justice, failing hopes, is to hit out and demand change.

The tough authoritarian approach to the control of crime has its own ideological vitality. It aims to support a regime, to preserve a set of values, to hold a community together and maintain order within it. Yet it exacts a very high price of the whole society, as well as of those suspected or convicted of crime.

In all ages it has widely been taken for granted that crime must be kept down by sheer severity, if not outright terror. This attitude, even in its extreme form, is by no means dead. Some of us have seen it revived in the civilised heart of Europe during our lifetime. The Nazi regime in Germany regarded crime simply as expressing the antisocial will of an individual in revolt against the laws of his community. That will must be broken or annihilated by intimidation, retribution or elimination. The limits of what was counted criminal were at once vague and perpetually extending. Respect for individual rights was rejected as decadent, since the highest duty of everyone must be to efface himself before the State and its leader. As Professor Donnedieu de Vabres expressed it, "We see here the close correlation, the inevitable correspondence, of these two activities of government; its general policy and its penal policy, the first giving impulse and direction to the second." What was true of Nazi Germany was true also of Fascist Italy, though it was all on a much smaller scale: Hitler had his concentration camps for millions whereas Mussolini was content with one small island. But the inexorable attitude to those suspected of crime or political dissidence was the same under both regimes.

Today a ruthlessly punitive attitude has been gaining ground in many parts of the world. Some countries, though well on the threshold of development in other respects, remain in the dark ages in terms of crime and punishment. In others, terror and counter-terror, linked with political turmoil, have become the order of the day. In yet others there is a struggle to maintain a precarious stability by using the machinery of criminal law to hold down oppressed majorities. Then there are the monolithic regimes which justify relentless measures against dissidents as an essential stage in ultimate ideological fulfilment. There are yet others which have escaped the controls of colonialism only to impose new tyrannies. And there are countries where enforcement of the law, in all its stages, has been allowed to stagnate, become corrupt and oppressive, less through deliberate intent than through sheer poverty, weakness and neglect. At the turn of the century Enrico Ferri was cheerfully consigning the liberal principles of crimi-

nal law to the historical archives, alongside free trade as advocated by Adam Smith. He thought the battle to protect the individual against the state had been won once and for all. By now we ought to have learned better than that.

The 'get tough' attitude has been endemic even in free societies, flaring up strongly in response to rising crime and violence, though its more extreme manifestations are restrained by established liberal traditions. Its theme is, nevertheless, that the protection of the criminal against injustice should yield place to the protection of society against crime. The police, and others entrusted with enforcing the law, should be given a freer hand. There should be a tightening of the screw throughout the penal system; severer punishments, more strictly enforced and, indeed, a return to the death penalty. If only, in a common phrase, the kid gloves were removed and offenders were given their just deserts, they would be taught that crime did not pay and the rest of us could be saved from their depredations.

More sophisticated advocacy of the central role of punishment is being taken up by certain academics and policy-makers. Though they differ in many respects, they all start from the assumption that proportionate punishment is important for the protection of the offender, as well as for that of society. They would, accordingly, limit the discretion of courts in sentencing and of administrators in enforcement. In particular, they would abolish indeterminate sentences at the beginning of the process and parole at the end. They would also eliminate anything that smacked of pressure to accept treatment or to demonstrate reformation as a condition of release. In these things they may be called neo-classicists, expressing, in various ways, a return to the idea that the right and duty of the state, when acting through the criminal justice system, is limited to the imposition of punishment proportionate to the crime.

An influential group of American Quakers has protested against the use of the penal system, and especially penal institutions, to coerce offenders into accepting prolonged "rehabilitative" treatment. Their report, *Struggle for Justice,* sparked off a whole train of investigations, books, public statements and discussions. Certain leading Scandinavian criminologists have similarly called for a retreat from the idea that reformation should come within the scope of the criminal law and those who enforce it. In England there have been attacks, though milder than those in the States, upon the system of parole, with its elements of uncertainty and administrative discrimination.

Thus where, until very recently, the zeal to reform by adapting the sentence to offenders as well as to the offence was something taken for granted in progressive countries, now it is under attack both as being impracticable and as opening the way to oppression.

It cannot be denied that there have been serious distortions and exaggerations in sentencing in the United States. In too many cases there has been either excessive leniency or excessive severity. But, as a general rule,

when it comes down to the practical business of sentencing, especially in relation to adult offenders and serious offences, the gravity of the crime and the protection of the public have been the decisive factors. To suggest that, because of unjustifiable departures from these principles, we need to exclude discretion from a substantial sector of our system, is irrational, retrogressive and inhumane. Whether we attempted to effect such a change by detailed prescription or by mandatory sentences, we should find, as history has shown again and again, that it would not work. In so far as it was enforced it would make for rigidity rather than justice. It would be defeated by the healthy reaction of the judiciary and, when its operation was seen in individual cases, even of public opinion. The remedy for distortions in sentencing does not lie in a cut and dried list of penalties. It depends upon measures to improve rationality and consistency in the way discretion is used and to ensure adequate redress when it goes astray. A whole range of devices and proposals to achieve this has been evolving in recent years. To quote a recent and important Australian committee on criminal law and penal methods, "It is too little realised that in a modern developed community it is impossible to have a simple sentencing system."

A period when criminal justice is subject to so much strain also breeds a mood of recrimination. This is only too understandable, in some senses inevitable. Stagnation and abuses are very real. But the criticisms of what exists are often combined with wishful thinking about what might be: dreams that we could police ourselves, abolish prisons or discover new approaches that would miraculously transform the social response to offenders. Moreover, recriminations, in so far as they are misdirected, are self-defeating. Generalised denigration is not only unjust but dangerous, more likely to aggravate than to improve. It is unjust because those dealing with crime and criminals are constantly beset by dilemmas which society as a whole has left unsolved, dependent upon resources that society has left inadequate. It is dangerous because people with the qualities and qualifications needed for these responsibilities are hard to find and to keep. A constant barrage of criticism and discouragement may well leave us with only rascals and bullies to undertake such onerous tasks. It is not only the suspects and prisoners who are entitled to their dignity and to respect for their rights.

Yet if the massive growth of crime of all kinds is allowed to continue, where will it end? Perhaps it is possible to offer a little historical reassurance. In Germany, after the second world war, everything seemed to be breaking down. In Berlin there were twelve times as many complaints of theft as there had been before the war, seven times as many burglaries and robberies. And that at a time when many people felt it useless to go to the police at all. In the dire shortage of necessities, money had lost its value and respect for property was shattered. Trains and lorries were cleared of their loads as they travelled, farmhouses, fields and barns raided by looting

parties. Food, building materials, electrical equipment, disappeared wholesale. It was estimated that in 1946 crime had swollen to five times its normal scale. Yet in 1947, as the value of money began to be restored, as social and commercial normality returned, crime was already beginning to shrink. It was the bankruptcy of the state, the falling apart of society that had released the flood of crime, not the flood of crime that destroyed the value of money or the authority of the state. Criminals do not determine what becomes of society: they merely show an extraordinary power to adapt to the social climate, whatever it may be. What is remarkable is that most people, most of the time, even in periods of violent upheaval, go about their legitimate business in legitimate ways.

So far there has been no sign of reversal, even stabilisation, in the trends of crime. For the time being we have to live with it and try to contain it. For all its imperfections, the criminal law is designed not merely as a buttress for the privileges of the powerful but as a shield for the elemental human liberties of the poor and the weak against the assaults of the strong and the treacherous. In that context the rigour of the law must be seen as an expression of social concern. There is a place for severity of sentence in response to deliberate and callous crime. But that does not mean that we must also accept, let alone collude in, the erosion of criminal justice or deliberate inhumanity in dealing with offenders. To do so is as unlikely as any other approach to bring about a lasting reduction. It would simply heap other evils on top of the evil of crime.

Above all, in a world where so few countries still pay more than lip-service to the ideal of freedom under law, it is vital that these few do not allow it to become extinguished.

NOTES

1. A.-M. Guerry, *Statistique morale de l'Angleterre comparée avec la Statistique morale de la France* (Paris, 1864), p. lvii.

2. L. A. J. Quetelet, *Physique Sociale,* vol. II, rev. ed. (Brussels, 1869), pp. 299–308.

3. A. Lacassagne, in *Actes du Premier Congrès International d'Anthropologie Criminelle* (Rome, 1885), p. 167.

4. Emile Durkheim, *The Rules of Sociological Method,* trans. S. A. Solovay and J. M. Mueller, ed. G. E. G. Carlin (Glencoe, Illinois: The Free Press, 1958), p. 67.

5. Erich Buchholz, Richard Hartmann, John Lekschas, and Gerhard Stiller, *Socialist Criminology: Theoretical and Methodological Foundations,* trans. Ewald Osers (Lexington, Mass.: Lexington Books, 1974), p. 185.

6. Martinson, R., "What Works?" in *Journal of Public Interest,* No. 36, June, 1974, p. 22; Lipton, D., Martinson, R., and Wilks, J., *The Effectiveness of Correctional Treatment,* New York: Praeger, 1975; Brody, S. R., *The Effectiveness of Sentencing,* H.M.S.O., London, 1975.

Index

Adams, S., 9–11, 13, 15
Adamson, L., 15
Age: as factor in arrest, type of court, dispositions, and conditions of release or incarceration, 48
Allardt, E., 428
Allen, F., 397
American Friends Service Committee, 248–51
Andersonville (prison), 239
Anttila, I., 419–31
Argyle, M., 96
Arnold, J., 316, 320
Assessment methods, 79–111; applications of prediction methods, 100–3; base rate in, 89–90; clinical assessment as avenue to improvement of prediction, 97–98; clinical assessment and delinquency prediction, 98–100; and criterion problem, 81–83; evaluation and prediction in, 87–88; factors influencing utility of prediction in, 88–93; implications of, 103–5; methods of combining predictors, 90–93; and nature of prediction problem, 80–81; predictive information and, 93–97; predictors in, 87; probability and validity in, 86; requirements of predictor classifications, 85–86; sampling in, 93; selection ratio in, 88–89; simplifying assumptions in, 84; and steps followed in prediction studies, 83
Attica (prison): cell time in, 269–71; commissary in, 281–82; communicating with outside world from, 283–90; correspondence to and from, 287–88; dental treatment in, 295; educational programs of, 266, 274–75; how inmates spend time in, 269–77; hustling in, 282–83; independent study in, 275; inmates of, 265–68; institutional maintenance of, 271–72; job discrimination in, 273–74; literature in, 284–87; meals in, 278–80; medical care in, 290–96; movies and entertainment in, 277; necessities of prison life in, 277–83; packages for inmates, 280; political stratification in, 244–45; population of, 263–65; protecting the inmates of, 301; psychiatric treatment in, 295–96; and racism in officer-inmate interactions, 302–4; radio and television in, 283–84; reception in, 268–69; recreation in, 276–77; religion in, 296–97; rules and discipline in, 298–301; special (medical) diets

in, 292; visiting, 288–90; vocational training in, 275–76, 296; wages in, 280–81; work and other programs in, 271
Attica riot, 257–312; assault phase of, 257–66; Black Muslims in, 243, 310; forces take up positions in, 260–61; gas and gunfire in, 262; how it happened, 307–8; as planned, 308–10; reason for, 305–7; summary of, 263–66; toll taken at, 262–63; ultimatum in, 257–60
Auburn system, 345
Avi-Itzhak, B., 139–61

Babst, D. V., 20, 92, 181
Ballard, K. B., Jr., 92
Baum, M., 204
Bavarian Criminal Code (1873), 374, 434
Baxstrom patients, 400–1
BCC (project), 66
Bean, W. B., 321
Beccaria, C., 137, 374, 433
Bechtoldt, H. P., 83, 84
Becker, G. S., 124–39
Becker, H. S., 230
Bedau, H., 326
Behavior modification: earliest experiment in (1821), 322; prisoners' rights and, 324; *see also* Research subjects
Belkin, J., 147
Bendix, R., 363
Bentham, J., 136, 137, 376
Berk, B. B., 209
Bernsten, K., 10, 16, 416
Bill of Rights for prisoners, 248–51
Billingslea, F., 253
Birth cohort, 161–74; chronic recidivists and, 168; defined, 161–62; generalization of, 163; and offenses as stochastic process, 165; percentage of delinquents in, 162; and seriousness of offense, 164
Bishop, N., 411–19
Black Muslims, 239, 241, 306; in Attica riot, 243, 310; food for, at Attica, 279–80; lack of minister for, 297; officers and, 297; organization of, in prison, 242–43; in political stratification, 245
Black Panther party, 239, 244, 245, 250, 306
Blake, W., 225
Blumstein, A., 147, 177

Tappan, P., 397
Taylor, A. J. W., 11
Taylor, I., 442
Tardo, 438
Therapeutic research, *see* Research subjects
Tibbets, C., 97
Tiedman, D., 94
Tijerina, R., 255
Toby, J., 101
Tornudd, P., 424
Traditional standards, 365–73; attack poverty approach, 368–69; employment policies and, 368; and family disorganization, 370–71; and stigma of punishment, 369–70; in use of prisons and prison terms, 367
Tranquilization: recidivism and, 37–38
Treatment: classification of prisoners and, 356–57; coercion and, 363, 406–8, 421; crime of, 354–64; fallacy of individualized model of, 344–53; impact on convicts, 359–63; parole and, 357–59; programs, 357–59; punitive spirit behind, 339–40; unexamined assumption in individualized model of, 348–53; voluntary programs, 363–64
Treatment ideologies: alternatives to, 415–16; breakthrough of, 419–21; coercion in, 415; criticism of, 421–24; Nordic criticism of, 411–19; research findings on, 412–14; sickness concept and, 423–24
Trevvett, N. B., 118–19, 122
Truax, C. B., 12
Turati, F., 439

Uusitalo, P., 413, 422

Van Couvering, T., 23
Vengeance, *see* Retribution
Vera Wildcat Supportive Work Program, 62–63, 66, 69, 71
Vienna (prison), 240
Vintner, R. D., 209
Violence: punishment and, 336

Vincent, L. J., 308
Vocational training: of adult inmates, 8–9; in Attica, 275–76, 296–97; effect of, on adult male rehabilitation, 35; effects of, on young male rehabilitation, 34; evaluated, rehabilitative on boys, 6–7; Folsom Manifesto and, 255; rehabilitation and diversion services and, 73

Wages: in Attica, 280–81
Walters, A. A., 89, 94
Walton, P., 442
Ward, D., 13, 228–38
Warren, M. Q., 210
Warren studies, 20–25
Washington State Reformatory, 195
Wechsler, H., 397, 436
Wellford, C., 209
Wheeler, S., 193–212
White, G., 224–25
Wilkins, L. T., 20, 91, 92, 181, 392–93
Wilks, J., 32–45, 70, 72
Williams, J. H., 41
Williams, S. T., 291, 292
Wilner, D., 13
Wilson, J. Q., 71, 143, 174–82, 365–73
Wilson, T. P., 208
Wiltwyck School, 13
Wirt, R. D., 95
Wolfgang, M. E., 151, 161–74, 366
Work, *see* Convict labor
Work Activity Program (Children's Village), 7

Young, A., 177
Young, J., 442

Zakolski, F. C., 96
Zanardelli code, 434
Zivan, M., 6